Cinema and E

WEIMAR AND NOW: GERMAN CULTURAL CRITICISM
Edward Dimendberg, Martin Jay, and Anton Kaes, General Editors

Cinema and Experience

Siegfried Kracauer, Walter Benjamin,
and Theodor W. Adorno

———

Miriam Bratu Hansen

UNIVERSITY OF CALIFORNIA PRESS
Berkeley Los Angeles London

University of California Press, one of the most distinguished university presses in the United States, enriches lives around the world by advancing scholarship in the humanities, social sciences, and natural sciences. Its activities are supported by the UC Press Foundation and by philanthropic contributions from individuals and institutions. For more information, visit www.ucpress.edu.

University of California Press
Berkeley and Los Angeles, California

University of California Press, Ltd.
London, England

Library of Congress Cataloging-in-Publication Data

Hansen, Marian Bratu, 1949–2011.
 Cinema and experience : Siegfried Kracauer, Walter Benjamin, and Theodor W. Adorno / Miriam Bratu Hansen.
 p. cm.—(Weimar and now: German cultural criticism ; 44)
 Includes bibliographical references and index.
 ISBN 978-0-520-26559-2 (cloth : alk. paper)
 ISBN 978-0-520-26560-8 (pbk. : alk. paper)
 1. Motion pictures. 2. Kracauer, Siegfried, 1889–1966—Criticism and interpretation. 3. Benjamin, Walter, 1892–1940—Criticism and interpretation. 4. Adorno, Theodor W., 1903–1969—Criticism and interpretation. I. Title.
 PN1994.H265 2012
 791.4309—dc23 2011017754

Manufactured in the United States of America

20 19 18 17 16 15 14 13 12
10 9 8 7 6 5 4 3 2 1

In keeping with a commitment to support environmentally responsible and sustainable printing practices, UC Press has printed this book on Rolland Enviro100, a 100 percent postconsumer fiber paper that is FSC certified, deinked, processed chlorine-free, and manufactured with renewable biogas energy. It is acid-free and EcoLogo certified.

For Michael Geyer
In memory of Karsten Witte (1944–1995)

CONTENTS

PREFACE

The question of how "to engage a living thought that is no longer historically current," raised by Fredric Jameson with regard to Theodor W. Adorno, has a particular urgency when the body of thought revolves around the cinema, especially in today's rapidly changing media environment.[1] If that ongoing future increasingly became one of the concerns ticking in the background of this study, it also made me more keenly aware of the specific historicity of the writings discussed—less in the sense of their loss of "currency" than in their contemporaneity with key junctures in the history of the cinema and the social and political histories of the twentieth century. Much as they illuminate those junctures, they often do so from an untimely angle, which lends them a different kind of actuality in the present.

At the same time, I couldn't fail to realize the extent to which this project was bound up with my own history, a history that entailed switching countries, languages, and fields—from Germany to the United States, from German to English, from the study of literary modernism and the avant-garde to the study of film. When I began to read my way into American cinema studies around 1980, the field was dominated by psychoanalytic-semiotic film theory, with its grounding in Lacan and Freud, Althusserian Marxism, and feminism, which had taken Anglophone shape in the British journals *Screen* and *Edinburgh Magazine* and the then-Berkeley-based *Camera Obscura*. This hegemony soon waned, challenged by the competing and asymmetrical paradigms of, on the one hand, cultural studies and, on the other, neoformalism or historical poetics and cognitivism. Yet the intellectual energy that had made psychoanalytic-semiotic theory a magnet for

film scholars and a motor in the academic legitimation of cinema studies—at a time when the humanities were under the sway of poststructuralism—seemed to have migrated into the exploration of early cinema, beginning with the legendary Brighton symposium of 1978 and richly fed by the annual Pordenone Giornate del Cinema Muto and other retrospectives. I felt drawn to the study of early cinema, not least because it engaged film history in a theoretically inspired mode that interlaced careful attention to formal and stylistic features with empirical research into conditions of production, distribution, and exhibition as well as broader questions concerning the complex set of transformations commonly referred to as modernity.

I had come from a country in which there was effectively no tradition of film qualifying as the object of academic inquiry (with a few exceptions during the early decades of the twentieth century). There was nothing comparable to the organizational efforts in instruction, archiving, and research in the United States and France, which in recent years have themselves become the object of historical research. To be sure, film history and film theory were part of the curricula of the film academies (Ulm, Munich, Berlin) that had been founded thanks to the film politics following the 1962 Oberhausen manifesto, but these topics had no place at the universities. At the Johann Wolfgang Goethe University of Frankfurt am Main, where I was a student from 1967 to 1976, Karsten Witte's courses on National Socialist film and on "theory of cinema" (1970–71) were an early exception, followed by the first film courses in American Studies, which was one of my fields.[2] In addition, Alexander Kluge taught a series of compact seminars on film and media in 1975–76, which I attended (and which initiated an enduring relationship of collaboration between us).

It was not that Germany—more precisely, West Germany or the Federal Republic—was lacking a film culture. While commercial theaters had been closing in great numbers and audiences were staying home to watch television, a new wave of alternative repertory theaters, both private and municipally sponsored (*Kommunale Kinos*), took off around 1970; the same year, a festival of independent cinema (Frankfurter Filmschau '70) was held on the campus of Frankfurt University. In the aftermath of the student movement, a new moviegoing public emerged, eager to overcome a history still deeply compromised by Nazi cinema's usurpation of cinematic affect and pleasure. We watched everything: "Young German" and European auteurs, New Hollywood and old, Spaghetti Westerns, the canonic works of international silent and sound cinema, contemporary experimental and underground films. This new film culture crucially included intellectually pointed critical writing on film—in the *Feuilleton* or cultural sections of major papers such as *Frankfurter Rundschau, Süddeutsche Zeitung,* and occasionally, *Frankfurter Allgemeine* and *Die Zeit*—by authors such as Frieda Grafe, Helmut Faerber,

Wolfram Schütte, Karsten Witte, Gertrud Koch, Hartmut Bitomsky, and others. And not least, there was the flourishing of independent filmmaking that benefitted from public television stations and from subsidy legislation fought for by Kluge and others, and from which a group of *Autoren* or auteur directors (Fassbinder, Herzog, Wenders, et al.) was to become New German Cinema once their work was shown at the New York Film Festival and other international venues such as the Goethe Institutes.

When I studied at Frankfurt University, Critical Theory was the leading intellectual tradition, one that had early on analyzed the economic, social, and political conditions of fascism and had presciently warned of the rise of National Socialism; it also had assumed a critical role vis-à-vis the social and cultural order of postwar Germany, in particular its inability to "come to terms" with that historical legacy.[3] By the 1960s, the term *Critical Theory* was used in a broader sense to name both the Frankfurt School (referring to the members of the Institute for Social Research who had returned from exile, notably Max Horkheimer, who had coined the term *Critical Theory*; Adorno; and former members such as Herbert Marcuse and Leo Löwenthal who had opted to stay in the United States) and writers associated with various forms and degrees of Marxist thought, such as Walter Benjamin, Ernst Bloch, Georg Lukács, and Siegfried Kracauer, as well as a younger generation of writers such as Jürgen Habermas, Oskar Negt, and Kluge.[4]

If I now, in this book, think of Kracauer, Benjamin, and Adorno not only as Critical Theorists but also as part of the German-Jewish intellectual tradition, this was not necessarily the case when I first encountered their writings (and, with Adorno, his teaching); and one would probably not have thought of Adorno in that tradition before 1933. Being Jewish was not a topic of conversation at the university when I was a student, nor anywhere else beyond the small, newly emerging Jewish congregations and organizations devoted to Christian-Jewish cooperation. Jewishness was a relatively abstract, yet highly charged symbolic—philosophical, moral, and political—category, bound up with the history of anti-Semitism and annihilation. It had presence primarily as a repressed past that had to be brought to public consciousness and justice: this had been the twofold intention, at least, of the Frankfurt Auschwitz trials of 1963–65 (which I occasionally attended because my mother was involved in taking care of survivor witnesses).[5] But Jewishness referred to neither a living cultural identity nor the legacy of fractured biographies. This situation began to change only during the 1980s, after the broadcasting of the NBC miniseries *Holocaust,* with major retrospectives of Yiddish film in Frankfurt in 1980 and 1982; with the controversy surrounding Fassbinder's play *Garbage, the City and Death* (1985); with the emergence of Jewish Groups at universities in Frankfurt and Berlin; and with the founding of the journal *Babylon* in 1986 (by, among others, Dan Diner, Gertrud Koch, and Cilly Kugelmann).[6] For me, who

had left Germany in 1977, it took living in the United States and encountering a Jewish culture that could be both secular and religious to recover that part of my history and identity.[7]

It is well known that cinema occupied a rather marginal place in Critical Theory, especially within the narrower circle of the Frankfurt School. Conversely, however, Critical Theory exerted a significant influence on film theory and criticism, as well as filmmaking and cinema politics. Adorno and Horkheimer's critique of the capitalist culture industry—and Adorno's continuation of that critique for the administrative cultural order of the Federal Republic[8]—was widely shared, yet led to different conclusions among those seeking to create and enable alternative forms of cinema, notably Kluge, and in debates conducted in journals such as *Filmkritik* and later the feminist journal *Frauen und Film*. When the writings of Benjamin and Kracauer were (re)discovered in the wake of the protest movements of 1968, the paradigm of the culture industry, renamed "consciousness industry," had turned into a call to oppositional practice, and been radicalized with recourse to Brecht and Soviet avant-garde intellectuals such as Sergei Eisenstein, Dziga Vertov, and Sergei Tretyakov.[9] While Benjamin's writings were championed in new-left magazines (in particular *Alternative,* which leveled charges of censorship against Adorno), his work quite early on entered academic disciplines, especially literature and philosophy. In contrast, the reception of Kracauer's work until the 1980s remained largely extra-academic, limited to the genre of the *Feuilleton,* in which he himself had published the bulk of his Weimar writings (which does not diminish them into mere "journalism").[10]

The reception of Kracauer's writings on film can be considered a seismograph for the major fault lines in the development of West German discourse on film since 1968. The first collection of Kracauer's film essays and reviews, *Kino,* published by Witte in 1974, opens with the programmatic piece "The Task of the Film Critic" (1932), whose most often quoted phrase—"the film critic worth his salt is conceivable only as a social critic"—was written under the threat of the Nazis' rise to power.[11] At the same time, Kracauer's *Theory of Film,* which had met with consternation or was largely ignored when first published in German in 1964, assumed an inspirational role a decade later when it was assimilated by the Munich movement of "Sensibilismus," which galvanized around Wim Wenders's writings and films such as *Alice in the Cities* (1974) and *Kings of the Road* (1976). This cineaste sensibility acclaimed films for "bringing the corporeal world into visibility," celebrated the film experience qua experience, and pitted "looking" and "description" against "interpretation," Marxist critique of ideology, and critical disagreement in conversations about film.[12] Needless to say, the polarization between social and political concerns on the one hand and aesthetic experience on the other was as reductive of Kracauer's work, from early to late, as it was of efforts in the tradition of Critical Theory (Witte's writings on film, indebted to Kracauer, being exemplary

of these) to analyze formal-stylistic elements and aesthetic effects both in relation to and against the films' economic and social dependencies.

· The tension between political and aesthetic approaches to film, and between both of these and theoretically grounded efforts to mediate these approaches, became manifest as well in the feminist journal *Frauen und Film*. Founded in 1974 by filmmaker Helke Sander and closely entwined with the emergence of women's cinema and the women's movement, the journal published manifestos of feminist cinema; reviews of films by women as well as "women's films" by their male auteur competitors; critical analyses of the conditions of production, distribution, and training for women filmmakers; and articles and interviews toward a genealogy of women directors, film workers, and critics. From 1977 on, with the increased participation of Frankfurt-based writers, in particular Koch and Heide Schlüpmann, the journal published several issues on topics such as feminist film theory, women's cinema as counter-cinema, female spectators, the pornographic gaze, and eroticism. It was in these issues that the reception of psychoanalytic-semiotic film theory in its feminist, primarily Anglophone elaboration began (including reports about the "women's event" at the 1979 Edinburgh film festival and translations of texts by Claire Johnston and Christine Gledhill), and that the paradigmatic impulses of this work, in particular Laura Mulvey's groundbreaking essay "Visual Pleasure and Narrative Cinema," were absorbed, criticized, and pushed further. The point was not just to rehearse the apparatus-based critique of masculinist cinema but also to conceptualize female subjectivity in the cinema in terms other than absence and negativity; to offer accounts of cinematic pleasure that did not simply revolve around classical psychoanalytic categories of voyeurism, fetishism, and castration but that, within the larger framework of Critical Theory, had recourse to anthropology, phenomenology, and other discourses, as well as to early film history.[13] These efforts had an enabling influence on my own work, beginning with my essay on Rudolph Valentino and female spectatorship, of which an early version appeared in *Frauen und Film*.

There was also a more general, if indirect, lineage between *Frauen und Film* and Critical Theory. The notion of women's cinema as counter-cinema, and of a journal as a medium of organization, expression, critique, and debate, was part of a discourse—and a vital ensemble of practices—indebted to the idea of the public sphere, in particular alternative and oppositional forms of publicness. If Habermas's book *The Structural Transformation of the Public Sphere* (1962) had been the basis for the militant demand for publicness (general access, transparency, discussion) so central to the protest movement around 1968, Negt and Kluge's response to Habermas, *Public Sphere and Experience* (1972), became the key text for the new social movements of the 1970s (women's and gay movements, urban grassroots organization, pedagogic and environmentalist causes, etc.). That book broadened Habermas's category of the public from the formal conditions under

which individuals could speak and act regardless of origin and status to a more comprehensive understanding of the public as a "social horizon of experience," grounded in the subjects' "context of living" (*Lebenszusammenhang*), that is, the lived relationality of social and material, affective and imaginative re/production.[14]

The concept of experience (*Erfahrung*) that Negt and Kluge invoked resonates deeply with the tradition of Critical Theory, especially its emphatic elaboration in the writings of Benjamin and Adorno. Even in its ordinary usage, the German term *Erfahrung*—with its etymological roots of *fahren* (riding, journeying, cruising) and *Gefahr* (danger, peril)—does not have as much of an empiricist connotation as its English counterpart, inasmuch as it stresses the subject's precarious mobility rather than a stable position of perception vis-à-vis an object. Benjamin, theorizing the conditions of possibility of *Erfahrung* in modernity, had linked its historic decline with the proliferation of *Erlebnis* (immediate but isolated experience) under the conditions of industrial capitalism; in this context, *Erfahrung* crucially came to entail the capacity of memory—individual and collective, involuntary as well as cognitive—and the ability to imagine a different future.

For Negt and Kluge, writing at a time when experience had allegedly all but vanished, the fragmentation, alienation, and blockages of experience were themselves already part of experience (persisting despite lamentations of its decline), along with needs and fantasies in response to that condition. Hence they saw the political significance of the public as that of a social horizon or matrix in which individual lived experience could be recognized in its relationality and collective dimension, even as—and not least because—the dynamics of market-driven media worked to appropriate and abstract that experience. In his writings and films, Kluge offered a theory of cinema as a public sphere, with aesthetic devices that encouraged viewers to mobilize their own experience; at the same time, he situated the cinema in relation to a larger, heterogeneous and unstable public sphere in which traditional bourgeois forms of publicness were cohabitating and competing with those spawned and marketed by the new media (then referring to the increasingly privately owned electronic media).

Understanding the public in terms of this conceptualization of experience has been a guiding framework in my thinking about cinema, in particular early cinema and its relations to modernity. It has steered me toward questions concerning the relationship between institutional norms, like those associated with the classical Hollywood paradigm, and the unpredictable dynamics of mass-mediated publicness (as in the case of the Valentino craze). Today, I find Negt and Kluge's insistence on the mixed, conjunctural, rapidly forming and disintegrating character of contemporary public spheres remarkably prescient as I am trying to understand the transformations of publicness and experience in the digitally based media environment—and the implications of these developments for cinema, film theory, and film history.

Sketching these intersections of Critical Theory and film, ones I consider important to the history of the present book, makes me keenly aware of the distance between American cinema studies circa 1980 and the sets of questions, concerns, and knowledges that had been part of my luggage.[15] This was particularly the case with the concept of the public sphere, which I took to offer the possibility of mediating the textual and apparatus-based analysis of film with social, cultural, and political concerns, and of situating the history of formal-stylistic development in relation to the longer-term histories of modernization and modernity, including changes in gender roles and sexuality. But the word *publicness* was all but impossible to find in the academic's dictionary, at least until the late 1980s when it burst onto the scene in a wide range of disciplines (e.g., anthropology, philosophy, history, area studies, literary studies) and discourses (e.g., postcolonial, feminist, gay and lesbian). The hesitation, even then, with which the concept entered cinema studies may have been due to the primary reliance of these debates on Habermas's book, which is not particularly helpful when it comes to technologically mediated forms of publicness (besides, cultural studies seemed to offer a simpler, more easily adaptable alternative).

The broader reception of Critical Theory in English-language contexts, of course, dates back to the 1970s, thanks in large part to the scholarship of Fredric Jameson, Martin Jay, and Susan Buck-Morss.[16] And there was the phenomenal success of Benjamin's work, beginning with Hannah Arendt's edition of Benjamin's *Illuminations* (1969), followed by *Reflections* (1978), which was perceived as a novel and different type of writing on literary and cultural objects. Benjamin's famous essay "The Work of Art in the Age of Technological Reproducibility" eventually entered the canon of classical film theory and, along with his writings on Baudelaire and the Arcades Project, became an important source for the exploration of early cinema's relationship to modernity, as well as reflections on cinema and the postmodern.[17]

However, the bulk of commentary—exegesis, critique, transformation—of Critical Theory, including Benjamin, took place in the contexts of German Studies and of critical social and political theory, specifically in such journals as *New German Critique* and *Telos*. Founded in 1973, *New German Critique* (whose editorial board I joined in 1984) sought not only to make key texts available in translation and to situate them historically but also to develop the critical and cross-disciplinary impulses of that tradition for different times and a wider range of topics and fields, including the visual arts, cinema, and the new media. Following a double issue on New German Cinema (1981–82), we published a special issue on Weimar film theory (1987), which included essays by Tom Levin, Thomas Elsaesser, Schlüpmann, Koch, and Richard Allen. (It also included my first article on Benjamin, cinema, and experience, "The Blue Flower in the Land of Technology," of which some remnants still haunt the present book.) In later years, there were special

issues on Kluge, Kracauer, and Fassbinder; on Edgar Reitz's *Heimat*; on Weimar mass culture, Nazi cinema, film and exile; and on postwall cinema and transnational cinemas; among others.

Beginning in the 1990s one could observe a more differentiated reception of Critical Theory in a range of fields, in particular literature, philosophy, and art. While this new wave of discovery owed much to the availability of more and better translations, it also had something to do with a renewed interest in aesthetics, which had been banished first by semiotics, then by new historicism and cultural studies. Benjamin offered a theory of aesthetics qua *aisthesis,* more comprehensive than a work's formal and stylistic features, linked to his inquiry into the transformation of sensory perception and experience in modernity. Adorno's microanalyses of literary and musical works demonstrated a dialectical mode of reading that took seriously these works' claims to aesthetic autonomy while tracing socioeconomic dependency in their very negation of the empirical world. And Kracauer's early writings on mass-cultural and urban phenomena combined an acuteness of aesthetic observation and description with a rhetorical practice of ambivalence, which in his late work evolved into a cognitive side-by-side principle. All three presented the reader with different modes of thinking, including speculative theorizing, and more literary styles of critical writing—marked by images, metaphors, wordplay, paradox, acrobatic sentence structures—that offered a relief from the poverty of much academic language.

But cinema studies, too, had been changing considerably. In 2002, after years of discussion about how to acknowledge television studies, the Society for Cinema Studies changed its name to the Society for Cinema and Media Studies. Closer to home, in 1998 the University of Chicago had established a Ph.D.-granting Committee for Cinema and Media Studies (an undergraduate program in CMS having existed since 1995), which in 2009 became a full-fledged department. In this instance, the name was meant to designate a broad diversity of media; to encourage critical inquiry into cinema's interactions with other forms and institutions, artistic and vernacular, traditional and experimental; and thus to apprehend cinema in its intersections with (or disjuncture among) different histories, aesthetic and technological, social and political.

Given the academic expansion of the field, there no longer seems to be any ruling paradigm, but rather a plurality—and healthy eclecticism—of theories and methodologies, ranging from phenomenological to Deleuzian, Wittgensteinian, Cavellian, cinemetrical. If anything today makes the field coalesce it is the recognition (almost already a cliché) that, now that cinema studies is finally becoming a legitimate discipline in the humanities, its very object seems to be dissolving into a larger stream of—global and globalizing—audiovisual, electronic, digital, and web-based moving image culture. That cinema from its earliest days has survived, adapted, and metamorphosed in a competitive media environment is nothing new.

But the vast proliferation of films across digital storage devices and distributed media, diverse platforms, and smaller and smallest screens has been challenging our assumptions about what we mean by cinema and the extent to which we delimit or open up the boundaries of its *dispositif.* This challenge has provoked a rethinking of key concepts that were more or less taken for granted, or at least were assumed to be central to classical film theory, such as medium specificity and photographic indexicality, and their significance to what we understand by realism; it has made us reconsider the importance of basic cinematic categories such as movement, animation, and life. Rather than a threat, I consider this a productive, energizing push for reopening ostensibly closed chapters of film theory, just as I believe that digital cinema, especially in its independent versions, will change the shape of past film history.

As far as the contemporary situation of cinema is concerned, we could find impulses in Kracauer's and Benjamin's efforts to understand the history of the present, or the present as history, and to imagine different futures whose potentialities may be buried in the past. At the very least, they could save us from cinephile nostalgia by turning our attention to the question of how films and the cinema experience relate to the ongoing, generationally marked reconfiguration of experience (in the full sense of *Erfahrung*) in daily life and social relations, in labor, the economy, and politics. By the same token, Adorno's seemingly most paranoid, empirically based studies on the convergence of the different branches of the culture industry, especially radio and television, could be said to have been vindicated by subsequent developments, even prior to the emergence of globalized media networks and digitally amplified marketing and information culture.[18] In that sense, they offer a sobering antidote to any facile optimism vis-à-vis media technology as such—regardless of its political, economic, and cultural usages—which often claims Benjamin as a precursor.

As a legacy to film and cinema theory at the current threshold(s) of moving image culture, I don't think these writers contribute new ontologies. They were more interested in what cinema *does,* the kind of sensory-perceptual, mimetic experience it enabled, than in what cinema *is.* And whatever it was doing was too contingent upon institutional and social and political constellations to isolate ontological features of film, although Kracauer frequently gestured in that direction. They considered the cinema as part of an evolving phenomenology of modernity, and their interest was in the particular modalities of the nexus between cinema experience and the viewing public's lived experience. Thus, when Benjamin attributes the popularity of the Mickey Mouse films to "simply the fact that the audience recognizes its own life in them," he dismisses any direct, reflectionist representation of the audience's mechanized working and living conditions and instead foregrounds the films' expression of the collective experience of those conditions in terms of sensorily, bodily transmitted rhythms, hyperbolic humor, and fantasies

of disruption and transformation.[19] At stake here, too, is the possibility of aesthetic play (or "room-for-play")—an idea shared by Kracauer but not Adorno—by which cinema not only trains viewers in a mimetic, nondestructive adaptation of technology but also offers the chance to defuse the pathological effects of an already failed technological adaptation. Not an ontology of film, then, but the apprehension of cinema's place in a materialist phenomenology of the present, and a (still) startling appreciation of cinema's possible role in effecting a not-yet-apprehensible future.

This book has been far too long in the making. I occasionally wondered whether I was working on Penelope's web or a palimpsest. Some chapters began as articles in journals and other publications. With the exception of chapters 4 and 6, these articles have been substantially modified; some splinters, though, have made it even into the chapters written from scratch. In a number of cases, my views have changed over the years—changes not unrelated to the transformation of cinema as an institution and practice and the development of cinema and media studies as a field.

The book offers neither a complete nor representative survey. In the oeuvres of the three writers discussed, film commands attention in highly uneven proportions and intensities. It seems fair to say that Kracauer was the only regular moviegoer, with a thick knowledge of film history as it was evolving. Although cinema occupied a central place in Benjamin's efforts to theorize the crossroads of modernity, he probably watched little more than the Soviet, Chaplin, and Disney films he wrote about (and, according to Gershom Scholem, films with Adolphe Menjou, about whom, to my knowledge, he did not write). And Adorno's relationship with film, as Kluge once quipped, could be summed up in the phrase "I love to go to the cinema; the only thing that bothers me is the image on the screen"[20]— though we now know that, especially during his exile in Santa Monica, he saw many more movies (in addition to his beloved Marx Brothers) than are mentioned in the chapter on the culture industry, and that he was involved in a number of film projects. Methodologically, this unevenness suggested extrapolating observations from texts by the three writers that are not primarily or explicitly concerned with film, which is how I had proceeded all along in my efforts to illuminate key concepts in the texts by them that are. One of my initial goals had been to put them in a conversation—conversations that actually took place, virtual conversations that could have occurred, and in the case of Adorno and Kracauer, conversations that had become ritualized exercises in talking past each other. I hope that *my* conversations with these writers will inspire readers to engage *them* in their own.

Chicago
November 2010

ACKNOWLEDGMENTS

Several institutions have generously supported the research and the writing of this book. I have held fellowships from the Alexander von Humboldt Foundation and the John Simon Guggenheim Foundation, as well as residential fellowships at the American Academy in Berlin and the Berlin Institute for Advanced Study (Wissenschaftskolleg zu Berlin). The latter two provided stimulating environments for discussion and excellent library services (no small matter for anyone who has tried to navigate Berlin's many-branched library holdings). I have also benefitted from presenting early lecture versions of parts of this book in various places, among them the Humanities Center at Johns Hopkins University, Indiana University, Princeton University, and the Whitney Humanities Center at Yale, and at a memorable centennial symposium on Benjamin at Wayne State University, Detroit. The German Literature Archive in Marbach am Neckar gave me access to the Kracauer Papers and invaluable help in deciphering all-too-Gothic scripts. The Division of the Humanities at the University of Chicago supplemented the external fellowships and provided me with a steady research fund; it has also nurtured this book in more immaterial ways.

Since joining the Chicago faculty in 1990, I have been fortunate to find extraordinary interlocutors among my colleagues and friends, both within the Departments of English and of Cinema and Media Studies and across the disciplines. For useful comments and challenges, conversations and expert advice, I am grateful to Lauren Berlant, Dipesh Chakrabarty, James Chandler, Bradin Cormack, Tom Gunning, Elizabeth Helsinger, Berthold Hoeckner, James Lastra, David Levin, W. J. T. Mitchell, Richard Neer, Robert Pippin, Eric Santner, and Yuri Tsivian. My

thanks also go to the superb students, both graduate and undergraduate, whom I have taught here over the years: whether in seminars or advising situations, I have continually enjoyed the chance to learn from them. In particular, I would like to single out the Graduate Workshop on Mass Culture (where I presented parts of the book), which—together with the New Media Workshop—has provided an energetic, tough though congenial forum for discussions about cinema and media among doctoral students, faculty, and visitors.

Beyond Chicago, I am indebted to numerous friends and colleagues who have been instrumental in the genesis and shaping of this book. My longest-standing debt is to the friends whose names have already appeared in the preface: Alexander Kluge, Gertrud Koch, Heide Schlüpmann, and Karsten Witte, whose memory I wish to honor with this book. I owe thanks to Albrecht Wellmer, who acted as my mentor for the Humboldt-Stiftung when I first embarked on the project, for, among other things, urging me to approach the question of Adorno's significance for film theory from the perspective of his aesthetics of music. Andreas Huyssen shared with me his interest in theories of mass culture and modernity, his insights into contemporary art, and his expertise in German literature and visual culture. I am grateful to him and to Martin Jay for acute and useful readings for the University of California Press. For comments on all or parts of the manuscript at various stages and for encouragement and support in various forms, I wish to thank Paula Amad, Ingrid Belke, Harold Bloom, Horst Bredekamp, Susan Buck-Morss, Victoria de Grazia, Frances Ferguson, Heiner Goebbels, Lydia Goehr, Michael Jennings, Rob Kaufman, Roberta Malagoli, Reinhart Meyer-Kalkus, Klaus Michael, Laura Mulvey, Alexander Nagel, Gary Smith, and Lesley Stern.

It has been a pleasure working with Mary Francis at the University of California Press; her patience and persistence were essential to the completion of the book. Eric Schmidt steered the book through the editorial and production process with great efficiency. Christina Petersen and James Hodge, my Chicago research assistants, did their best to tame and check the multitude of endnotes and played an important part in the preparation of the manuscript.

My special thanks go to Bill Brown, whose work on "play" and "things" in modernity has been an inspiration to me for many years and who commented on many drafts with deft and elegant suggestions; to Edward Dimendberg, who believed in this book almost before I did, closely read every chapter, and brainstormed with me on the conception of the preface; and to Daniel Morgan, who made me think simultaneously harder and with greater ease about particular arguments and the book as a whole. The strongest impulse to make me clarify and raise the stakes of what I was doing came from Michael Geyer, dearest friend and husband, whom I cannot thank enough. He cast the historian's long gaze on the project and challenged assumptions I had taken for granted. He has also been keeping me alive, in every sense of the word, through difficult times.

ABBREVIATIONS

Unless an English source is cited, translations are my own. An additional reference to the German source indicates that the translation has been modified.

SIEGFRIED KRACAUER

BN *Berliner Nebeneinander: Ausgewählte Feuilletons, 1930–33.* Ed. Andreas Volk. Zurich: Edition Epoca, 1996.

FT *Frankfurter Turmhäuser: Ausgewählte Feuilletons, 1906–30.* Ed. Andreas Volk. Zurich: Edition Epoca, 1997.

FZ *Frankfurter Zeitung*

H *History: The Last Things Before the Last.* Ed. Paul Oskar Kristeller. New York: Oxford University Press, 1969.

MO *The Mass Ornament: Weimar Essays.* Trans., ed., and with an intr. by Thomas Y. Levin. Cambridge, Mass.: Harvard University Press, 1995.

S *Schriften.* Vols. 1, 2, 7, 8, ed. Karsten Witte. Frankfurt a.M.: Suhrkamp, 1978, 1984, 1973, 1976; vol. 5.1–3, ed. Inka Mülder-Bach. Frankfurt a.M.: Suhrkamp, 1990.

SM *The Salaried Masses: Duty and Distraction in Weimar Germany.* Trans. Quintin Hoare. With an intr. by Inka Mülder-Bach. London and New York: Verso, 1998.

T *Theory of Film: The Redemption of Physical Reality.* 1960. Repr., with an intr. by Miriam Hansen. Princeton: Princeton University Press, 1997.

W *Werke.* Vols. 1, 3, 4, 6–9. Inka Mülder-Bach and Ingrid Belke, general
 eds., with Sabine Biebl and Mirjam Wenzel. Frankfurt a.M.: Suhrkamp,
 2004–2009.

WALTER BENJAMIN

AP *The Arcades Project.* Trans. Howard Eiland and Kevin McLaughlin. Pre-
 pared on the basis of the German volume, ed. Rolf Tiedemann [1982].
 Cambridge, Mass.: Harvard University Press, 1999.
CWB *The Correspondence of Walter Benjamin, 1910–1940.* Ed. and annot.
 Gershom Scholem and Theodor W. Adorno. Trans. Manfred R. Jacob-
 son and Evelyn M. Jacobson. Chicago: University of Chicago Press,
 1994.
GB *Gesammelte Briefe.* 6 vols. Ed. Christoph Gödde and Henri Lonitz.
 Frankfurt a.M.: Suhrkamp, 1995–2000.
GS *Gesammelte Schriften.* 7 vols. Ed. Rolf Tiedemann, Hermann Schwep-
 penhäuser, et al. Frankfurt a.M.: Suhrkamp, 1972–1989.
SW *Selected Writings.* 4 vols. Ed. Michael W. Jennings et al. Trans. Rodney
 Livingstone, Edmund Jephcott, H. Eiland, et al. Cambridge, Mass.:
 Harvard University Press, 1996–2003.

THEODOR W. ADORNO

ABB Theodor W. Adorno and Walter Benjamin. *Briefwechsel, 1928–1940.* Ed.
 Henri Lonitz. Frankfurt a.M.: Suhrkamp, 1994.
AGS *Gesammelte Schriften.* Vols. 1–20. Rolf Tiedemann, general ed., with
 Gretel Adorno, Susan Buck-Morss, Klaus Schultz. Frankfurt a.M.:
 Suhrkamp, 1970–86.
AKB Theodor W. Adorno and Siegfried Kracauer. *Briefwechsel, 1923–1966.*
 Ed. Wolfgang Schopf. Frankfurt a.M.: Suhrkamp, 2008.
AT Theodor W. Adorno. *Aesthetic Theory* (1970). Ed. Gretel Adorno and
 Rolf Tiedemann. Newly trans., ed., and with an intr. by Robert Hullot-
 Kentor. Minneapolis: University of Minnesota Press, 1997.
ÄT Theodor W. Adorno. *Ästhetische Theorie.* 1970. Repr., Frankfurt a.M.:
 Suhrkamp, 1996.
CC Theodor W. Adorno and Walter Benjamin, *Complete Correspondence,*
 1928–1940. Ed. Henri Lonitz. Trans. Nicholas Walker. Cambridge, Mass.:
 Harvard University Press, 1999.
CF Theodor [W.] Adorno and Hanns Eisler. *Composing for the Films.* Intr.
 Graham McCann. London and Atlantic Highlands, N.J.: Athlone Press,
 1994.

CI Theodor W. Adorno. *The Culture Industry: Selected Essays on Mass Culture.* Trans. Nicholas Walker. Ed. with and intr. by J. M. Bernstein. London: Routledge, 1991.

DE Max Horkheimer and Theodor W. Adorno, *Dialectic of Enlightenment: Philosophical Fragments.* Ed. Gunzelin Schmid Noerr. Trans. Edmund Jephcott. Stanford, CA: Stanford University Press, 2002.

FT "Filmtransparente." Partially published in *Die Zeit,* 18 November 1966. In *Ohne Leitbild* (1967), in *AGS* 10.1:353–61.

TF "Transparencies on Film" (1966). Trans. Thomas Y. Levin. *New German Critique* 24–25 (Fall–Winter 1981–82): 199–205.

PART I

Kracauer

Film, Medium of a
Disintegrating World

*No pacifism, no communism, but an aesthetic defense of the dissociated
world in the awareness of death. Roughly like that.*
—KRACAUER ON THE LAST CHAPTER OF HIS NOVEL GINSTER,
LETTER TO ERNST BLOCH, 5 JANUARY 1928.

Among the first generation of Critical Theorists, Siegfried Kracauer rightly ranks
as the only one who had significant expertise in matters of cinema. This repu-
tation rests largely on his two later books written in English, *From Caligari to
Hitler: A Psychological History of the German Film* (1947) and *Theory of Film: The
Redemption of Physical Reality* (1960), and his collection of Weimar essays trans-
lated as *The Mass Ornament* (1963; 1995), while the bulk of his early writings on
film remains unknown in English-language contexts.[1] It would be shortsighted,
however, to restrict an account of Kracauer's early film theory to writings that
explicitly and exclusively deal with film, whether reviews of particular films or
more general reflections on the film medium and the institution of cinema. Like
Walter Benjamin, Ernst Bloch, Theodor W. Adorno, and others, Kracauer under-
stood the cinema as a symptomatic element within a larger heuristic framework
aimed at understanding modernity and its developmental tendencies. While this
framework was grounded in a philosophy, if not a theology, of history, it translated
into a programmatic attempt to understand contemporary cultural phenomena
in relation to the social and economic conditions that gave rise to them and to
which they were thought to respond.

In Kracauer's case, these theoretical perspectives evolved both with and against
the pragmatic pressures of daily journalistic writing. Between 1921 and 1933, the
year of his forced exile, Kracauer published close to two thousand articles—notices,
reviews, essays—most of them in the *Frankfurter Zeitung,* a liberal daily of which
he became feuilleton (arts and culture) editor in 1924.[2] Having abandoned his job
as an architect to join the paper as a local reporter, he covered just about every-
thing that figured under the rubric of culture—and increasingly areas and topics

that did not. In addition to reviewing films on a regular basis (about one-third of the articles), he wrote on urban space and spaces: on streets, squares, and buildings; on train stations, subways, underpasses, and traffic lights; on bars, hotel lobbies, department stores, trade fairs, and arcades; homeless shelters and unemployment agencies; on picture palaces, the circus, and the variety stage; on radio and photography; on electric advertising and illustrated magazines; on courtroom trials, traffic, tourism, and sports; on typewriters and suspenders, *pianellas* and umbrellas. Kracauer's interest in the quotidian and ephemeral phenomena of modern life was no doubt indebted to the philosopher-sociologist Georg Simmel, but his exploration of the artifacts, sites, and rituals of an emerging consumer culture also points forward to semiological analyses such as Roland Barthes's *Mythologies* (1957) and more recent work in urban ethnography and the critique of everyday life.[3]

While film and cinema held a special position among Kracauer's topics, they were part and parcel of his larger project to read the "inconspicuous surface-level expressions" of the time as indices of historical change, in an effort to "determine the place" that the present "occupie[d] in the historical process."[4] His attempts to grasp the specificity of film and cinema were bound up with the historico-philosophical inquiry into modernity or, more precisely, with the question of how the struggle over the directions of modernity took shape, and was being played out, in the photographic media and their respective institutions. This approach crucially distinguishes his early writings on film from the more standard debates over whether or not film was "Art," for the most part associated with, or opposed to, the movement of *Kinoreform,* or cinema reform, and over how film could and should become art if it ever was to gain cultural and social legitimacy.[5] Kracauer's bypassing of the art question, however, makes him no less interesting from the vantage point of film aesthetics or an aesthetic theory of cinema. On the contrary, if Kracauer still speaks to issues closer to current concerns, it is because he approached the question of the aesthetic in the more comprehensive sense that Benjamin, too, was to insist upon—as relating to the organization of human sense perception and its transformation in industrial-capitalist modernity. Both writers discerned the aesthetic significance of cinema in the possibility of a new sensory relationship with the material world; yet, while Benjamin's interest in the photographic media was part of his larger engagement with the question of technology, Kracauer's exploration of new modes of mimetic experience, identification, and sociability was guided by questions of a more sociological and ethnographic nature.

In the following, I trace the development of Kracauer's thinking on cinema and modernity in some detail, not only because most of his early texts are scarcely known in English, compared to the relatively greater availability of texts in translation by Benjamin and Adorno. This attention is also warranted because

Kracauer's early speculations on film decisively counter his long-standing reputation in cinema studies as a "naive realist," a reputation based largely on a reductive reading of his later works written in English.[6] In addition to the tradition of film theory in the narrow sense, my frame of reference will be Kracauer's conversation, actual or virtual, with other Critical Theorists. Therefore, I will try to highlight particular concepts and theoretical tropes in Kracauer's early texts—such as the motif of an aesthetics of reification, the turn to the surface, the valorization of distraction, the notion of film's particular capacity to reanimate and reconfigure material objects—that were taken up (though this was for the most part unacknowledged), elaborated, and revised by Benjamin, Bloch, Adorno, and others.

Nonetheless, such conceptual distillation should not make us forget that Kracauer was not a systematic theorist in the manner of, for instance, Marcuse or even Horkheimer and Adorno. By philosophical standards, Kracauer's mode of analysis sometimes appears slippery and inconsistent, if not contradictory. This is not simply or necessarily a shortcoming. Rather, what ensures continued fascination with Kracauer's texts is that they are suffused with another kind of logic, a style of theorizing that we might call writerly or poetic. Kracauer argues as much through images and tropes, through figures of chiasmus, paradox, understatement, and literalization, as through analytic reasoning and allegorical abstraction. While his academic background included philosophy and sociology (in addition to professional training as an architect), he never held an academic position; he was a critical intellectual for whom journalism was not a default career but a chance and challenge to engage in writing as a public medium. No less, though, was Kracauer's choice of theoretical style(s), like Benjamin's, motivated by a critique of the academic discipline of philosophy as a totalizing, systematic discourse that could not adequately address the contemporary transformation and crisis of experience.[7] As I hope to show, this critique translates into critical practice not only by virtue of its turn to noncanonical topics but also because of a rhetorical mode that persistently undermines the traditional distance between the perceiving/describing/analyzing subject and the (mass-cultural) objects under scrutiny.

Kracauer's discovery of film and mass culture around 1923–24 reaches back into the lapsarian layer of his earlier writings, for the most part philosophical and sociological reflections on the problem of modernity. When he begins to develop a theoretical interest in film, he hails it as the perfect medium for a fallen world, an at once sensory and reflexive discourse uniquely suited to capturing the experience of a disintegrating world, a "life deprived of substance."[8] In this capacity, film assumes an important function from the perspective of Kracauer's philosophy or, if you will, theology of history: specifically, the eschatologically tinged idea that modernity could be overcome—and could overcome itself—only by fully realizing all its disintegrating and destructive potential. Paradoxically, as we shall

see, this desire to transcend modernity prompts a turn to a postmetaphysical politics of immanence, in which film figures as both symptom of the historical process and sensory-reflexive horizon for dealing with its effects. Accompanying this turn is Kracauer's discovery of the institution of cinema, including but exceeding the projected film, as an alternative public sphere—alternative, that is, to the institutions of both bourgeois culture and the labor movement. Many of Kracauer's early film reviews are actually cinema reviews, in the sense that they include remarks on theater design, performance practices, musical accompaniment, and audience response. From 1925 on he began to reflect on the cinema more generally as a catalyst of a new kind of public, symptomatic of the culture of leisure and consumption that he saw emerge in Germany with the introduction of principles of mass production and the concurrent mushrooming of the class of white-collar workers or employees. When, toward the end of the decade, his writings on film and cinema increasingly shifted from a materialist physiognomy of modernity to a critique of ideology—prefiguring the approach of *From Caligari to Hitler* (1947)—it was because, in the face of the mounting political crisis, contemporary cinema was failing on two counts: it neither advanced the negativity of the historical process, or "self-sublation" of modernity, nor lived up to the liberating, egalitarian impulses in which Kracauer had discerned the contours of a democratic mass public.

I will trace these movements and countermovements from two complementary angles. The present chapter deals with Kracauer's efforts to develop an aesthetics of film from the perspective of a particular experience and critique of modernity. The following chapter focuses on his exploration of modernity as a mass-produced and mass-consumed, highly ambivalent and contested formation, in which film and cinema were playing only one, albeit a crucial, role. As a hinge between these perspectives, I discuss Kracauer's essay "Photography" (1927), a text that displays key traits of his peculiar method—his shifting among the registers of ethnographic observation, micrological analysis, critique of ideology, and philosophy of history; his effort to grasp the historical moment in both its devastating and liberating possibilities; and the inclusion of himself as experiencing subject in the cultural practices he describes.

Kracauer's writings prior to the mid-1920s by and large participate in the period's pessimistic, lapsarian discourse on modernity.[9] Within a predominantly philosophical and theological framework, modernity appears as the endpoint of a historical process of disintegration, spiritual loss, and withdrawal of meaning from life, a dissociation of truth and existence. Expelled from a traditional order of life and a corresponding religious sphere, the individual is "thrown into the cold infinity of empty space and empty time," a state summed up in Georg Lukács's phrase "transcendental homelessness."[10] Drawing on contemporary sociology, in particular that of Simmel, Max Scheler, and Max Weber, Kracauer ascribes this state to the

progressive unfolding of the *Ratio,* a formal, abstract, instrumental rationality—or perverted form of reason—propelled by capitalist economy, modern science, and technology. With the encroachment of mechanization and rationalization on all aspects of life, human beings are alienated not only from the spiritual sphere but also from all forms of communion and community (*Gemeinschaft,* as opposed to *Gesellschaft*).[11] They are thus deprived of an experiential, discursive horizon that would help them make sense of these very processes.

That Kracauer participates in this culturally pessimistic discourse on modernity, with its worn-out idealist rhetoric, is not all that surprising, nor do his early writings differ in this regard from those of other Critical Theorists, in particular Benjamin, Bloch, and the early Lukács. What is remarkable, however, is the distance that Kracauer will travel, in a rather short time, from the metaphysics of *Weltzerfall* (disintegration of the world) to a more sober, analytic, politically astute, and yet passionately curious attitude toward the concrete phenomena of modern life, in particular mass culture. The beginnings of this transformation can be traced back to the experience of World War I, which for Kracauer, as for many of his generation, shattered the illusions of high idealism and cast its monstrous shadow on the subsequent decade; it is no coincidence that his semiautobiographical novel, *Ginster,* written toward the end of the 1920s, is set during the war and its aftermath.[12] Hence Kracauer's turn to a more materialist perspective should be imagined neither as a sudden conversion nor as a progressive development toward a more critically correct position, but rather as a process of reorientation and complication in which earlier perspectives both give rise to and persist, even if incongruently, with later ones. His interest in film and mass culture does not just emerge with his often-flagged turn to Marxist thought and empirical sociology around 1925–26. As I will argue, the effort to theorize film precedes that turn and has its roots in precisely the lapsarian construction of history he had initially assumed toward modernity, specifically, in the peculiar form of materialism that this construction entailed.

It is significant that Kracauer elaborates his early metaphysics of modernity in a "philosophical fragment" on the detective novel, a genre of popular fiction that thrived on serial production and that in Germany occupied a lower rank on the ladder of cultural values than in England or France.[13] Rather than considering this genre from the outside, as a sociological symptom, Kracauer reads it as an allegory of contemporary life, incarnating the "idea of a thoroughly rationalized civilized society" (*W* 1:107). The critical distinction of the detective novel vis-à-vis mere affirmation of that society consists in the way the detective's methods mimic the mechanisms of the autonomous *Ratio:* "Just as the detective reveals the secret buried between people, the detective novel discloses, in the aesthetic medium, the secret of the de-realized society and its substanceless marionettes." It thus transforms, by virtue of its construction, "incomprehensible life" into a "counter-

image" of reality, a "distorting mirror" (*Zerrspiegel*) in which the world can begin to read its own features (*W* 1:119, 107).

Kracauer elaborates the trope of a distorting mirror in an essay on the circus, written around the same time, in which he attributes a similarly allegorical—and allegorizing—function to the clowns. If the acrobats miraculously triumph over the laws of gravity and the human *physis*, the clowns point up the "unreality" of that triumph: "While the *real* actors suspend the conditions of the life assigned to us, [the clowns] with their off-key seriousness in turn suspend the unreality of those actors. This should lead one to expect that they restore normal reality but, on the contrary, they are only a caricature of caricature; it feels like being in a hall of mirrors, and from the successively arranged mirrors the beholder's own countenance radiates in ever more distorted form."[14] It should be noted that not only does the clowns' mimicry render strange an already estranged reality but the hall-of-mirrors effect also affects the self-perception of the beholder, confronting the viewing subject with its own precarious reality.

The idea of representation as a distorting mirror is a familiar trope of modernist aesthetics, implying that, since the world is already distorted, reified, and alienated, the iteration of that distortion, as a kind of double negation, is closer to the truth than any attempt to transcend the state of affairs by traditional aesthetic means, be they classicist or realist. In Critical Theory, for instance, we find one highly influential articulation of this trope in Benjamin's *The Origin of German Tragic Drama* (1928), with its revision and rehabilitation of allegory, which, in contrast to the romantic symbol's semblance of organic beauty and totality, showed the petrified, fragmented landscape of history for what it was.[15] Likewise, the trope resonates in Adorno's philosophy of modern music and aesthetic theory, in particular his insistence, against Lukács, on the distinction between objective and reflective reification, the latter being the task of any truly modern art.[16] Yet, if Benjamin elaborates this idea in writings on the Baroque *Trauerspiel* and on Proust, and Adorno on Schönberg and Webern, Kracauer develops it in the context of popular fiction, live entertainments—and film. This to say, he insists on finding the antidote to modern mass culture within mass culture itself, by focusing on its disjunctive devices and reflexive possibilities.

While reviewing films was part of his local reporting duties from 1921 on, it was not until the fall of 1923 that Kracauer displayed a more theoretical interest in the medium. In the reviews that followed over the next few years, he frequently uses phrases like "the spirit" or "essence of film," "film aesthetics," "film language"; speaks of topics "proper to film" (*filmgerecht*); and discusses individual titles as examples from which to develop an "as yet unwritten metaphysics of film" (*FZ*, 16 December 1923). His earliest notions of what is and is not "proper" or specific to film actually sound remarkably like the criteria of the later, more familiar Kracauer, though there are still important differences. Reviewing two contemporary

German films dealing with imposters, *Der Frauenkönig* (Jaap Speyer, 1923) and *Die Männer der Sybill* (Friedrich Zelnick, 1922), he praises them for their looseness of construction and refusal of interiority: "Compared to the historical spectacles which have recently become fashionable, [these films] after all have the advantage that they do not show carefully rehearsed scenes and elaborate plots which one could just as well see on stage but, instead, improvise thrilling events out of the quotidian and, moreover, renounce the display of soul [*seelischer Gehalte*] in favor of a film-specific rendering of phantomlike surface life."[17] The difference, or distance, of this position from what *Theory of Film* will call the "redemption of physical reality" hinges, of course, on what Kracauer means by "surface life" and which particular cinematic techniques, modes of representation, and genres he considers appropriate for capturing that life.

The most graphic account of the world "assigned" to the medium of film can be found in Kracauer's enthusiastic, almost rhapsodic reviews of Karl Grune's film *Die Straße* (*The Street*, 1923). Following the Frankfurt premiere in February 1924, Kracauer reviewed the film not just once but twice (with some overlap), first in the local section and the following day in the feuilleton section of the paper.[18] He returned to the film the following year in his programmatic essay "Der Künstler in dieser Zeit" (The Artist in Our Time), in which he calls upon it to illustrate the dilemma of the contemporary artist—how to engage the gap between "truth" and "existence," the phenomenal world—and to make a case for a particular philosophical and political stance.[19] As late as 1929, in a review of one of Grune's subsequent works, Kracauer still refers to *Die Straße* as "one of the best and most forward-pointing films."[20] Like many titles he reviewed during the Weimar period, the film resurfaces in his writings in exile, in particular the *Caligari* book, though without reference to the earlier accounts and with a decidedly different valence.[21]

In the 1924 reviews, Kracauer hails *Die Straße* as nothing less than a manifesto of metaphysical malaise, of the "suffering of the languishing soul in the lifeless bustle" of modern existence. In an exemplary way, the film captures the experience of modern life—"a life deprived of substance, empty as a tin can, a life which instead of an internal relationality [*statt des innerlichen Zusammenhangs*] knows nothing but isolated events that form ever new series of images in the manner of a kaleidoscope" (*W* 6.1:56).[22] With its emphasis on fragmentation and discontinuity, the film visualizes the spatialized experience of time typical of modernity: "the moment, which is only a point in time, becomes visibility." Accordingly, the individual's experience of space dissociates into random encounters with the fragmented material world, epitomized by the modern city street:

What intrudes upon the lonesome wanderer in the voracious streets of the night is expressed by the film in a vertiginous sequence of futurist images, and the film is free

to express it this way because the pining inner life releases nothing but fragmentary ideas. The events get entangled and disentangled again, and just as the human beings are living dead, inanimate things participate in the play as a matter of course. A lime wall announces a murder, an electric sign flickers like a blinking eye: everything a confused side-by-side [*Nebeneinander*], a chaos [*Tohuwabohu*] of reified souls and seemingly waking things. (*W* 6.1:57)

The passage displays a number of topoi that recur throughout Kracauer's Weimar writings: the chiastic relation between the living and the mechanical, animate and inanimate, people and things; the emphasis on externality, on the breakup and flattening out of vertical hierarchies of meaning into paratactic (dis)order (for which he ironically, though not coincidentally, uses the vernacular Hebrew word from Genesis *tohuvabohu*); and the metaphoric elevation of the city street as the key site of cinematic modernity (pointing toward its canonic inscription in *Theory of Film* but also resonating with the resurgence of the figure of the *flâneur* in Weimar culture).[23]

Most important, Kracauer attributes the film's contemporaneity to its use of specifically cinematic codes, in particular editing. In the *Feuilleton* version of the review, he introduces *Die Straße* as "one of the few works of modern film production in which an object takes shape in a way that only film can give shape, a work which realizes possibilities that only film can realize. . . . Film patches together shot after shot and from these successively unfurling images mechanically recomposes the world—a mute world in which no word passes between human beings, in which the incomplete speech of optical impressions is the only language. The more the represented object can be rendered in the succession of mere images, the ensemble of simultaneous impressions, the more it corresponds to the filmic technique of association" (*W* 6.1:56). In other words, the affinity between the medium and its presumed object is grounded not in film's photographic capability, the iconic representation of a presumably given reality, but rather in its *syntactic* procedures—in the structural affinity of cinematic montage with the logic of fragmentation and random juxtaposition that for Kracauer defines the current stage of the historical process.

Kracauer conceives of film as a *material expression*—not just representation— of a particular historical experience, an objective correlative, as it were, of the ongoing process of distintegration. The solitude of the individual in a fragmented, empty world that the critic finds evoked in Grune's film rings with the pathos of personal experience; and the film in turn lends this pathos an allegorical significance and collective resonance. What is remarkable here is the extent to which the critic identifies with the film's nameless protagonist and his nomadic desire. The figure of the "lonesome wanderer" is referred to as "*Sehnsüchtiger*," someone driven by longing, and the narrative situation that propels his odyssey through the "peripheral world" is marked as one of a double exile. Kracauer describes

the protagonist (Eugen Klöpfer) as lying on a sofa "in a petty-bourgeois living-room which is supposed to be home [*Heimat*] yet fails to be just that." Fascinated with the play of light and shadow on the ceiling, the dreamer gets up to look out of the window. While his wife sees the street only as street, to him the look "unveils the senselessly tempting jumble of reeling life which, alas, is no more a home [*Heimat*] than the living-room but, instead, adventure and untasted possibility" (*W* 6.1:54).

In such ekphrastic accounts, the writer acknowledges his own fascination with the same alienated surface life that the lapsarian critic of modernity deplores. Likewise, he identifies with the protagonist's rejection of bourgeois domesticity, which the film's misogynist economy associates with the unseeing wife (just as it will later associate female sexuality with prostitution and death). This configuration of a *double homelessness*—between the sham of the bourgeois interior and the anonymous otherness of the modern street—was to become emblematic of Kracauer's intellectual persona throughout the Weimar period.[24] Just as emblematic, however, is the curious ambivalence by which his writing betrays an affinity with, an awareness of being part of, the allegedly fallen world whose transformation he sought to advance.

When Kracauer returns to *Die Straße* in his "psychological history of the German film," written in actual exile, both the perspective of transformation and the dimension of critical affiliation have disappeared. In the *Caligari* book, Grune's film is dismissed as a "nonpolitical *avant-garde* product." The film, Kracauer explains, had a considerable success: "it ingratiated itself with a rather broad public composed mainly of intellectuals." While he still praises the "realistic" effort in the everyday quality of the (studio) setting, the film now figures as an allegory for the regressive movement from rebellion to submission. Its wandering protagonist is reduced to a social type, a philistine acting out historically specific—and in retrospect, politically fatal—psychological mechanisms.[25] With this analysis, not only has Kracauer shifted frames, from a metaphysics of modernity to a critique of ideology, but he has also disavowed his own earlier fascination with the film, his critical identification with the experience of the doubly exiled wanderer.

But not every film that received his stamp of approval did so because it could be construed as an expression of metaphysical malaise or "transcendental homelessness." On the contrary, many reviews written between 1923 and 1926 disclose a discriminating engagement with the actual film practice that unfurled on Frankfurt screens, a remarkable attention to the diversity of genres, modes of representation, and spectatorial effects. To be sure, Kracauer's stance remains normative throughout (there was probably never a time when he was not to some extent normative, whether in the name of a lapsarian philosophy of history or a politics of realism); still, the terms and criteria he puts into play cast a fairly wide net. The result is a canon that seems to be at odds, in part at least, with the "realist"

standards of his later writings. Echoing Lukács's praise for film's imbrication of strictly nature-bound reality with the "fantastic," Kracauer emphasizes cinematic effects of "unreality" and "improbability," the "miraculous," "marvelous," and "grotesque";[26] he delights in moments of "kaleidoscopic" vision, "chance," "improvisation," and "mobility." Accordingly, he favors such genres as thrillers and adventure dramas revolving around detectives, impostors, and the circus; animated and trick photography; fairy tales; and slapstick comedy or any form of high-speed physical farce.

What these reviews amply document is that Kracauer considers film's historic chance to truthfully express its time to be as much a matter of *aesthetic choice* as of structural affinities between cinematic technique and contemporary experience. The point is not just to mirror the world that is, literally, going to pieces but to advance that process. If anything, this demands a mode of representation decidedly antinaturalist. Praising an animated short of Munich scenes, Kracauer writes: "Its improbability, which runs counter to any naturalism, fully corresponds to the essence of film which after all, if it is to achieve its very specificity, has to completely break apart the natural contexts of our lives."[27] Similarly, he commends a fantastic drama about a missing lottery ticket for making happen "what has to happen in film: the continual transformation of the external world, the crazy displacement of its objects [*die verrückte Verrückung ihrer Objekte*]."[28]

One strategy of displacement and transformation is the "bracketing" of the represented world by means of irony, hyperbole, satire, or caricature—that is, by the supplementary logic of a "distortion of distortion" that we have seen in his analysis of the circus clowns. On the occasion of an adventure drama set in a cosmopolitan, high-tech milieu of generic Anglo-American origins, Kracauer asserts: "Genuine film drama has the task of rendering ironic the phantomlike quality of our life by exaggerating its unreality and thus to point toward true reality." The hyperbolic doubling of modern surface life promotes a demolition and transcendence of that world by way of humor. A "deeper meaning" of this "amusing joke" is that it "reveals the nothingness of a world that lets itself be set in motion over a nothing and provokes laughter over its previously detoxified seriousness."[29]

Kracauer's preference for films that, in his reading, hyperbolize contemporary reality's "unreality" is rooted in the historico-philosophical assumption that modernity could and would ultimately be overcome, that a different life, the "true reality" that was now absent and inaccessible, was still conceivable beyond the present state. The utopian residue in Kracauer's thinking during this period accounts for his early endorsement of the fairy tale film, a genre in which "film has conquered a domain that fully belongs to it."[30] Because of its liberation from the norms of verisimilitude, the fairy tale provides a modality that allows us "to get to a happy ending without lying" (Alexander Kluge),[31] a utopian moment under erasure that, as Kracauer will elaborate a few years later with regard to Chaplin,

nonetheless radiates with visions of justice and peace. Much as the substance of the ending matters, Kracauer seems interested in the fairy tale as a mode of all-but-impossible imagining, a way to uphold the longing for a different world in the face of overwhelming facticity. In his enthusiastic review of Murnau's *Der letzte Mann* (*The Last Laugh*, 1924), he defends the film against critics' objections to the tacked-on happy ending—"a fairy tale–like *postlude* [*Nachspiel*] which is so unbelievable that you may just believe it." Chance alone, thanks to the "providential interven-tion of the ironic author," can raise the "last man" (Emil Jannings's demoted hotel porter) to the position of the "first," and his random inheritance enables him to dispense temporary economic justice in the phantom world (*Scheinwelt*) of the Hotel Atlantic.[32] If anything, by Kracauer's standards, the film's ending is not fan-tastic enough: "The epilogue would have to have been rendered even more unreal and playful for it to appear as the fairy tale–like anticipation of a different world." In the *Caligari* book, he still calls the film's unlikely happy ending an "ingenious" conclusion, but interprets it as "a nice farce jeering at the happy ending typical of the American film."[33]

Whatever disjuncture there may be between Kracauer's early preferences for particular styles and genres and his later judgments, his *disapproval* of certain types of film crystallizes quite early on and remains rather persistent throughout his life. The titles he reviews in the key of ironically amused to caustic critique usually belong to genres such as literary or theatrical adaptations, mythological or historical spectacles, and "society films" (*Gesellschaftsfilme*). A review of *The Merchant of Venice* (1923), for instance, criticizes the film in terms of qualities that violate the "spirit of film": "instead of grotesque surface, false profundity of soul; instead of surprise improvisations, carefully prepared scenes."[34] Thus, in the practice of daily reviewing, especially of culturally prestigious productions, he formulates and recalibrates an aesthetics of film that seems to turn on assumptions about medium specificity.

If there is a common denominator to the films and genres Kracauer criti-cizes, it is their strict adherence to principles of the classical narrative film, which means the stylistic system formulated most clearly and hegemonically in American cinema from the 1910s on but emerging as well, in alternative forms and with delay, in other national cinemas.[35] The classical system is defined, roughly, by principles of thorough causal motivation, mostly centering on the psychology and actions of individual characters, linear and unobtrusive narration, verisimilitude, intel-ligibility, and compositional unity—principles that ensure the effect of a coherent and closed diegesis, or fictional world of the film, to which the viewer has access as an invisible guest. In contrast to the well-made plots of classical films, Kra-cauer prefers narratives whose motivation is loose (*unsolid*) and defies academic logic (*Schullogik*), narratives that have "neither beginning nor end."[36] He finds this counterlogic at work in the seriality of American slapstick comedy, as a defining

characteristic of that genre; by 1925, he frequently extols, in an almost ritualistic gesture, the comic shorts in the surrounding program as a relief from and antidote to the pretensions of the dramatic feature. But he also praises noncomedic narrative films (including Hollywood features) constructed loosely enough to leave space for relatively independent details—epiphanies, episodes, elements of performance and improvisation. And he increasingly pinpoints conditions and practices of exhibition that either advance or restrict the range of improvisation and chance in the way films are experienced in the theater.[37]

The most remarkable articulation of Kracauer's anticlassical stance can be found in his essay "Calico-World," in which he describes a tour through the backlots of the UFA studio in Neubabelsberg.[38] Marveling at the vast array of fragmentary sets and props that defy natural interconnections and proportions (including sets for well-known films like Fritz Lang's *Nibelungen* and *Metropolis* and F. W. Murnau's *Faust*), he highlights the fact that, to produce the effect of a coherent diegetic world in a film, the world is first cut to pieces. "This dismantling of the world's contents is radical; and even if it is undertaken for the sake of illusion, the illusion is by no means insignificant" (*MO* 281–82). With obvious irony yet also wide-eyed delight, he evokes the mortification and disorganization of the seemingly natural world—the surreal assembly of the "ruins of the universe . . . representative samples of all periods, peoples, and styles," inventoried and stored in warehouses (*MO* 282)—in terms that resonate with his essay "Photography" of the following year. Similarly, if less explicitly, "Calico-World" links the paradoxical relation between fragmentation and diegetic unity to the historical dialectics of nature, arrested in the appearance of the social order as natural. Classical cinema perpetuates this appearance through its adaptation of bourgeois aesthetic principles, such as theatrical illusionism based on the invisible boundary between viewer and the fictional space of the proscenium stage. The director has the task to organize "the visual material—which is as beautifully disorganized as life itself—into the unity that life owes to art" (*MO* 288; *W* 6.1:197). By means of continuity editing and intertitles he turns the "huge chaos" into a "little whole: a social drama, a historical event, a woman's fate." Tongue-in-cheek, Kracauer acknowledges that most of the time the desired effect is achieved: "One believes in the fourth wall. Everything guaranteed nature" (*MO* 288).

Kracauer's interest in forms of cinematic expression that exceed narrative motivation and integration is coupled with a more porous conception of spectatorship. In a review of a film by E. A. Dupont, for instance, Kracauer singles out ephemeral interludes—"little *entrefilets*"—not only for the digressive glimpses they afford but also for the way their arrangement appeals to the viewer: "The sequencing of shots is exemplary: the alternation of close-ups, optical fragments, transitions, and master shots leads the imagination [*Phantasie*] up kaleidoscopic mountains."[39] Even as these montage sequences serve to evoke the "desired atmosphere," the

notion of propelling the viewer's imagination into kaleidoscopic gyrations is quite distinct from the effects of diegetic absorption, illusionist mastery, or, for that matter, hypothesis-forming attention that have been attributed to classical narrative.[40] It rather suggests a centrifugal movement away from the film—toward a more autonomous agency that Alexander Kluge was to call "the film in the spectator's head," the disavowed source of experience, of the social wealth of fantasies, wishes, daydreams, and associations appropriated by commercial cinema.[41]

At certain moments, Kracauer's enthusiasm for nondramatic optical delights betrays less the disposition of an anticlassical critic than that of a preclassical moviegoer, which Tom Gunning has described as an "aesthetic of astonishment."[42] Until he developed a more critical stance toward the ideology of so-called "nature films" and travelogues (from about 1926 on), Kracauer relished their strange and marvelous sights in a manner harking back to early cinema when scenics and travel films were highly popular genres and landscape views were perceived as attractions in their own right.[43] Thus, he often singled out "nature scenes" and other views of touristic appeal, even in films that he rejected on aesthetic and political grounds (e.g., shots of Venice in *The Merchant of Venice*).[44]

It is in this vein that we have to read his initial enthusiasm for the so-called mountain films, the genre that made Leni Riefenstahl and Luis Trenker famous and that, in Kracauer's later critique, promoted a mixture of heroic idealism, immaturity, and "antirationalism on which the Nazis could capitalize."[45] As late as 1925, Arnold Fanck's *Der Berg des Schicksals* (*The Mountain of Fate*, 1924) moves Kracauer to this enraptured account:

> More important than the plot with its beneficial solution are the *magnificent nature views* [*herrliche Naturaufnahmen*] which were taken under the most difficult circumstances during months of patient persistence. The rock formations of the Dolomites—Cimone della Pala, Latemar, Rosengarten, whatever their names may be—stretch toward the sky under every conceivable kind of lighting, they are reflected in the lakes and surrounded by agglomerations of clouds: cumulus clouds, giant cloud massifs that are fraying, oceans of clouds that ebb and flow, striped drifts and flocks of cirrus clouds. They rush close faster than in reality, cheated out of their duration by time-lapse photography. They shroud the peaks, encircle them, and briefly desist from their siege: a kaleidoscopic spectacle, always the same and ever new. Rarely has one seen in a film such heavenly scenes; their curious fascination above all derives from the fact that processes which in nature take hours to unfold are here presented in a few minutes. The cloud events concentrate and the distortion of time creates a delightful optical intoxication.[46]

The concluding remark recommending the film to as many viewers as possible—"it shows the impassioned community between human beings and nature from a peculiar angle"—would have been highly unlikely only a few years later. Not only did Kracauer amplify the negative connotations in his concept of nature on

philosophical and political grounds (as in the essay "The Mass Ornament"), but he also embarked on impassioned expeditions into urban modernity and came to prefer the artifices of second nature over the increasingly abused mystique of the first—which he discerned, among other things, in the proliferation of vernacular imagery of the Alps (see chapter 2).

The "optical intoxication" or fascination Kracauer pinpoints in his viewing experience of the mountain film has its referent less in the sights of an ostensibly more primary nature than, more generally, in the cinema's technical ability to render the world of "things," a designation at once more opaque and in excess of the qualities that define material objects in quotidian usage.[47] While he still excoriates modern science for promoting a "loss of our relation to things" (as in his obituary on Rudolf Steiner, FZ 18 April 1925), he discovers in film and particular kinds of film practice a way to recover, transform, and reanimate the world of things, in modes of consciousness not unrelated to dreams and involuntary memories.[48] Film is capable not only of rendering objects in their material thingness and plasticity, bringing them into visibility, but also of giving the presumably dead world of things a form of speech. Reviewing an adaptation of an Andersen fairy tale, Kracauer attributes this effect to the role of movement and mobility—through techniques of framing, staging, lighting, editing—in translating the plot "into a sequence of light and shadows, a rondo of figures in the snow, a silent scurrying and flitting on stairs and along bridge railings, a rhythmic condensation of all visibilities which begin to speak without words."[49]

By foregrounding the material qualities of objects through cinematic techniques, film has the capacity to reveal things in their habitual, subconscious interdependence with human life, to capture in them the traces of social, psychic, erotic relations. Reviewing Jacques Feyder's (lost) film Thérèse Raquin (1928), Kracauer extols the film's representation of the petty-bourgeois Paris apartment, "which is populated by ghosts. . . . Every piece of furniture is charged with the fates that unfurled here in the past. There is the double bed, the high armchair, the silver dishes—all these things have the significance of witnesses: they are palpably infused with human substance and now they speak, often better than human beings might speak. In hardly any film—except for the Russian films—has the power of dead things been forced to the surface as actively and densely as here."[50] Kracauer describes an aesthetic quality that Benjamin, in his defense of Battleship Potemkin, had referred to as a "conspiratorial relationship between film technique and milieu" (a quality he was soon to elaborate in terms of the concept of the "optical unconscious")—except that in Kracauer's account of Thérèse Raquin the oppressiveness of the petty-bourgeois interior predominates over the liberatory energies emphasized by Benjamin.[51]

More generally, the idea that film may lend special articulation to the world of things is reminiscent of Béla Balázs's concept of film as modern physiognomy,

in particular his notion that cinematic technique is capable of conveying the "expressive" quality of material objects, landscapes, and faces; likewise, there are important resonances with the writings of Jean Epstein.[52] Indebted like Balázs to Simmel's philosophy of art, Kracauer assumes that what animates the cinematic representation of things has as much to do with the emotion of the subject as with the moving object.[53] Film's physiognomic capacity offers a mode of perceptual experience that blurs analytic distinctions between subject and object and allows things to appear in their otherness. But while Balázs, even as a Marxist, adheres to the romantic and idealist undercurrents of *Lebensphilosophie,* or the philosophy of life, Kracauer, as we shall see, enlists film's physiognomic ability in a materialist philosophy of death.

TOWARD A MODERNIST MATERIALISM

That Kracauer's film theory has its motor in a particular relationship to the world of things is one of the many insights in Adorno's ambivalent homage to his old friend and mentor on the latter's seventy-fifth birthday.[54] As shrewd as it is condescending, Adorno's portrait of Kracauer concludes with the observation that the "primacy of the optical" in him was not just, as suggested earlier in the essay, a matter of his architectural training or talent: "Presumably, [it] is not something inborn but rather the result of this relationship to the world of objects." Adorno speculates that Kracauer's special penchant for visuality has its roots in a "fixation on childhood, as a fixation on play," that compensates for the suffering inflicted upon the self by human beings with a "fixation on the benignness of things." This translates, in Adorno's judgment, into a major theoretical and political deficiency: "One looks in vain in the storehouse of Kracauer's intellectual motifs for rebellion against reification." Considering that the concept of reification is a cornerstone of Adorno's own theory of modernity, we can easily imagine how Kracauer's engagement with the world of things seemed tantamount to a critical sellout, a nostalgic yearning for a place beyond critique: "The state of innocence would be the condition of needy objects, shabby, despised objects alienated from their purposes."[55]

What eludes Adorno is that Kracauer's allegedly uncritical immersion into the world of things, his lack of protest or indignation vis-à-vis reification, is perhaps responsible for the enormous historiographic and cognitive wealth his writings yield, his careful registering of modernity's multifaceted and contradictory realities. And what Adorno elides is the extent to which this immersion also allowed Kracauer to revise and reconfigure the terms of critical subjectivity. For in his forays into the fallen world, Kracauer had no problem seeing himself as both belonging to this world and advancing its analysis and transformation.

Kracauer's truck with the material world allowed him to experience—and to discern theoretically—a different constitution of the subject that manifested itself

in that new relationship with things, in particular things modern.[56] The subject that enters the movie theater with/as Kracauer is clearly not the sovereign, unitary, critically distanced subject of transcendental philosophy or the connoisseur of haut-bourgeois culture; it is, to vary on Adorno's characterization of Kracauer, a subject "without skin," and it knows its boundaries to be precarious. What is more, this subject seems to seek out situations in which its very sense of identity, stability, and control is threatened by the otherness of the material world, betraying a masochistic sensibility of the kind that we find stylized in Kracauer's novel *Ginster* and that resurfaces in the early drafts of *Theory of Film.*

In his beautiful essay "Boredom" (*FZ* 16 Nov. 1924), for instance, Kracauer compares the effect of listening to the radio, with its boundless imperialism of bringing the whole world into our living room, to "one of those dreams provoked by an empty stomach: a tiny ball rolls toward you from very far away, expands into a close-up, and finally crashes over you; you can neither stop it nor escape, but lie there chained, a helpless little doll" (*MO* 333; *S* 5.1:280). A similar, somewhat less threatening though just as visceral encounter appears earlier in the essay when the impersonal subject of boredom takes a stroll through the nightly streets, filled "with a feeling of unfulfillment from which a fullness might sprout." While his "body takes root in the asphalt," his spirit "roams ceaselessly out of the night and into the night" with the luminous advertising and returns only to pull him into a movie theater—where it allows itself to be polymorphously projected: "As a fake Chinaman it squats in an opium den, turns into a well-trained dog that performs ludicrously clever tricks to please a film diva, gathers up into a storm amid towering mountain peaks, and turns into both a circus artist and a lion at the same time. How could it resist these metamorphoses? . . . One forgets oneself gawking, and the huge dark hole is animated with the illusion of a life that belongs to no one and consumes everyone" (*MO* 332; *S* 5.1:279).

Kracauer does not simply fall back on the nostalgic complaint that film destroys the sovereign subject by displacing a presumably intact, well-grounded, autonomous spirit with an invasion of alien, heteronomous images (as in Georges Duhamel's polemic quoted by Benjamin: "I can no longer think what I want to think. My thoughts have been replaced by moving images").[57] Rather, despite his ambivalence over the sense of loss and emptiness that comes with the cinema illusion, Kracauer does not disavow the pleasure in the sensory expansion it affords, along with the theoretical insights it might yield. For the passage quoted describes a form of involuntary mimetic identification operative in film viewing, a phenomenon theorized in contemporary biomechanical discourse as Carpenter's Effect (referring to the ideomotoric phenomenon that muscular contractions of a person in motion are unconsciously imitated by another person observing the former).[58] What is more, it also suggests that, inasmuch as the moving objects on screen seem to metamorphose into something other than they appeared, such psycho-

physiological mimesis affords the viewing subject the sensation of participating in this transformation, evoking the possibility—both threatening and liberating—of liquefying fixed structures of social, critical-intellectual, gendered identity.

The subject of experience in Kracauer's texts cannot be said entirely to dissolve into a "subjectless" subjectivity akin to what Martin Jay discerns in Benjamin's writing as a prose equivalent of a modernist *style indirect libre*.[59] On the contrary, Kracauer needs the distinctions between personal pronouns for a particular rhetorical strategy—a shifting of perspectives from a third-person, impersonal distance to a more personal voice, whether first-person plural or second-person singular (the latter, as in the above example of the radio, used to evoke a sense of imminent violation).[60] This rhetorical strategy more often than not signals a shift in the critic's attitude toward the phenomenon or mode of behavior described, a revaluation of an earlier negative stance.

The shift in pronouns is particularly salient when it refers to forms of cultural consumption that were previously criticized from what appeared as an external, intellectually superior position. In his essay "Travel and Dance" (*FZ* 15 March 1925), for instance, Kracauer reads the rise of tourism and modern forms of dancing ("and other outgrowths of rational fantasy" like radio and "telephotography") as symptoms of mechanization and rationalization, of "a depraved omnipresence in all dimensions that are calculable" (*MO* 70; *S* 5.1:293). Accordingly, these leisure activities are symptomatic of the "double existence" imposed on human beings cut off from the spiritual sphere. And yet, not only is this "*Ersatz*" real, even if compromised, but it also offers "a liberation from earthly weight [*Erdenschwere*], the possibility of an *aesthetic* behavior vis-à-vis organized toil" (*MO* 72; *S* 5.1:294). The turn from pessimistic critique to critical redemption culminates in an emphatic switch of personal pronouns:

> We are like children when we travel; we playfully delight in a new velocity, the relaxed roaming and roving, the synoptic viewing of geographical complexes that previously could not be seen at once. We have fallen for the ability to have all these spaces at our disposal; we are like conquistadors who have not yet had a quiet moment to reflect on the meaning of their acquisition. Likewise, when we dance, we mark a time that did not exist before, a time prepared for us by a thousand inventions whose substance we cannot gauge, perhaps because for now their unfamiliar scale appears to us as their substance. Technology has taken us by surprise, and the regions that it has opened up are glaringly empty. (*MO* 49; *S* 5.1:296)

This almost technophile vision strikingly anticipates Benjamin's notion of a "room-for-play" (*Spiel-Raum*) that has opened up with film, which allows human beings to appropriate technology in the mode of play, that is, in a sensory-somatic and nondestructive form. What is more, by acknowledging presumably stereotypical and alienated behavior as part of his own experience and imagination, Kracauer

refused to let his intellectual privilege deceive him as to his actual social status—which, unlike Adorno's, was all too close to that of the salaried masses whose habits of leisure he observed. This awareness, among other things, enabled him to recognize in these habits the emergence of a new type of public sphere.

Before shifting the focus to the social and political parameters of Weimar modernity, I wish to return to Kracauer's attitude toward the world of things and its implications for his early film theory. How does film turn from a medium of the fallen world into a catalyst for the fascination with that very world of things, into a matrix for new forms of sensory experience, into an object of supreme aesthetic, cognitive, and political significance? As I indicated earlier, it is important that Kracauer's "materialist turn" preceded his encounter with Marxist theory in 1925–26; that his theoretical interest in film and mass culture took shape already within the framework of his early philosophy of history. This is to say that Kracauer's distinct brand of materialism derives from sources other than the Marxist tradition, even if he subsequently, and rather selectively, absorbed elements of that tradition. Adorno rightly sensed that his friend's concept of material objects was not dominated by a Marxist theory of reification, as it had been formulated at the time most influentially by Lukács in *History and Class Consciousness* (1923), a book that Kracauer took issue with on several counts.[61] If Lukács grounds his concept of reification in Marx's theory of the commodity, in particular the opposition of use value and exchange value, Kracauer's approach to reification takes a more observational and experiential form. Predicated on the structure of the commodity, Lukács's argument depends on positing an unmediated, originary substantiality of things (which is abstracted and alienated by the commodity form), as it does on the project of restoring labor as the only true source of value in the empowerment of the proletariat qua subject of history.[62] Kracauer would have resented such language as nostalgic. Centering on *production* and *reified labor,* Lukács's account of the loss of the "character of things as things" (92) and the new "thingness" (*Dinghaftigkeit*) that takes its place and informs the totality of social life and consciousness remains philosophically abstract. By contrast, Kracauer's descriptions of practices of *consumption* emerging in contemporary urban society evoke a concrete, sensorily experienced materiality that complicates Marxist concepts of commodity fetishism and reification.

What I wish to argue here is that Kracauer's modernist materialism was at least as much shaped, in its basic assumptions, motifs, and obsessions, by the traditions of Jewish messianism and gnosticism, however secular the implications and the issues that were at stake. Like other Critical Theorists whose intellectual socialization took place during World War I, in particular Bloch, Benjamin, Erich Fromm, and Leo Löwenthal, Kracauer has to be read in the context of modern, secular Jewish messianism. As Anson Rabinbach has shown with regard to Bloch and Benjamin, this tradition is impossible to describe in any pure form, as it

persisted in a variety of radical sensibilities, hermeneutical motifs, and combinations with other discourses (psychoanalysis, Marxism, libertarian anarchism, Zionism, etc.).[63]

Kracauer's relation to Jewish messianism is a complex issue. Raised in a practicing Jewish environment and briefly active in the Freies Jüdisches Lehrhaus (a Frankfurt circle of learning and debate surrounding Rabbi Nehemiah Nobel and crucially shaped by its first director, Franz Rosenzweig),[64] Kracauer began to voice vehement criticism of the ongoing revival of messianic thought, especially in its combination with a socialist (in Kracauer's reading, protestant) mystique of community. In his programmatic essay of 1922, "Those Who Wait" ("Die Wartenden"), for instance, he castigates the "*messianic Sturm und Drang* types of the communist persuasion," a label most likely referring to Bloch, whose book on Thomas Münzer he had savaged in a review earlier that year.[65] Like other contemporary movements of religious renewal, the Jewish messianists, in Kracauer's view, superimposed a transcendental reality upon an immanent historical process and thus, by abstracting from the real world "filled with corporeal things and people," ended up just as ignorant of the divine that they presumed to know so well (*MO* 140; *S* 5.1:169). Kracauer's politics of "waiting," of a "*hesitant openness*" (*MO* 138), was directed against the absolutism with which messianic thinkers leaped over the imperfect yet existing reality from the perspective of a future break; by contrast, he turned his gaze toward the changing realm of the here and now, the mundane zone of the ordinary and ephemeral. "Access to truth is now in the profane," he proclaimed at the end of his 1926 polemical review of Martin Buber and Rosenzweig's translation of the Bible (*MO* 201; *S* 5.1:365).[66]

Nonetheless, Kracauer participated in the discourse of secular Jewish messianism in significant ways. Much as he abhorred notions of an imminent and immanent instantiation of the Messiah, an "aura of eschatological longing" emanates, as Michael Schröter observes, from the "luminous metaphors" of his texts.[67] And even when he updates his metaphysical language with concepts indebted to the Enlightenment (the French materialist lineage rather than the German idealist one) and to early Marx, a distinctly apocalyptic undercurrent continues to characterize his observations of contemporary life—a perception of modernity as a traumatic upheaval heading toward catastrophe. Like Benjamin at this point, Kracauer rejects all promises of immanent and gradual change and defers any envisioning of a different order to history's inevitable cataclysmic break. Accordingly, the only attitude available to the Jewish intellectual is a hesitant form of waiting, as opposed to more fervent anticipation or even active intervention. As he writes to Löwenthal in 1924: "We must remain hidden, quietistic, inactive, a thorn in the side of others, preferring to drive them (with us) to despair rather than give them hope."[68] This "revolutionary negativity," which Kracauer still endorsed as late as 1929, is theologically grounded in the axiom to refrain from direct asser-

tions and to preserve empty spaces (*Hohlräume*) for the "unsaid"—and as yet unsayable—positive.[69]

In his 1925 essay "The Artist in This Time" (published in the first issue of the Jewish journal *Der Morgen*), Kracauer unfolds the implications of this stance with recourse, as already mentioned, to Grune's film *Die Straße*. Reflecting on the dilemma of the modern artist, Kracauer extrapolates from *Die Straße* an intellectual attitude that spells out the politics of his own earlier implicit identification with the film. He argues that the film's grim view is shared by "people who seriously engage with reality and hence are doubly and profoundly affected by the power of the forces that today deform the world into a city street." Knowing "that only the taking along and transforming [*Mitnahme und Verwandlung*] of the unreal life will lead to reality and that disintegrated ideals cannot be patched up or hypocritically asserted," these contemporaries "strictly resist the romantic attempt to gloss over the realities of technology and economy and to inhibit the unfolding of the civilizing process with means that are not up to its magnitude." Instead, Kracauer continues, "they will do anything in their power to make the world disclose its phantom character, to let nothingness reign as far as it may. They are *nihilists* for the sake of the potential positive and hasten toward the end of despair lest a 'yes' might halfway impede that process ineffectively. . . . [T]hey hyperbolize the negation, stretch the void, and reject soul where it is only make-up. They believe that America will disappear only when it completely discovers itself."[70] Obviously, Kracauer leans toward the party of these "nihilists," even as he urges them not to abandon hope for the revelation of the absent divine (which would amount to perpetuating the abyss between "film image and prophecy").

The often-cited last sentence of the passage expresses the eschatologically tinged hope that disenchanted modernity, troped in the Weimar period's popular catchword *Amerika*, can and will be transcended; yet, at the same time, it mandates the materialist project of modernity's complete and thorough discovery.[71] This project is driven by a no-less-messianic motif, that of redemption—the idea that the intellectual's task is to furnish an archive for the possibility, even if itself unrepresentable, of a utopian restoration of all things past and present as implied in the cabbalist concept of *tikkun*.[72] The writer therefore seeks to register things as yet unnamed, as Kracauer sums up his lifelong efforts in his posthumously published book *History: The Last Things Before the Last*: "They all have served, and continue to serve, a single purpose: the rehabilitation of objectives and modes of being which still lack a name and hence are overlooked or misjudged."[73] However, the language in which the earlier Kracauer imagined this work of redemption—as well as the historical process that makes this work both necessary and possible—has a materialist slant to it that more specifically recalls the tradition of Jewish gnosticism.

While he found Jewish gnosticism just as suspect as other variants of religious mysticism, Kracauer seems temperamentally closer to the cool stoicism of secular or literary gnostics such as Kafka than to any messianic fervor.[74] Like Weber, Simmel, Lukács, and other critics of modernity, Kracauer evokes the fallen world through images of petrification and mortification, of detritus, fragments, empty shells, larvae, and masks.[75] In the gnostic tradition, such imagery marks the negative traces of the withdrawal of God, the divine as radical absence. Yet, as material evidence of the negativity of history, these traces have to be preserved and interpreted so that, when the eventual break occurs, the world can be redeemed in as complete a shape as possible, and the sparks of creation encrusted in even the most fallen matter can be released. Hence Kracauer defines the intellectual's task as one of collecting, registering, and archiving: "The new shape [*das Gestaltete*] cannot be lived unless the disintegrated particles are gathered and carried along."[76] However, this ambulant archiving entails a "transformation." In a letter to Bloch, Kracauer pinpoints as the great motif of "this kind of philosophy of history . . . the postulate that nothing must ever be forgotten and nothing that is un-forgotten must remain unchanged."[77]

If modern life is envisioned in gnostic terms, it does not seem too far-fetched to discover in film and photography the contemporary media, art forms, and archives singularly suited to express such a vision—given the material, physiochemical connection of photographic images and photographically based film with the world represented (an issue to which we will return); the mortification and fragmentation involved in photographic exposure and framing; the transformation and reconfiguration of the material through cinematic editing. What is more, Kracauer's gnostic and messianic sensibility not only attracted him to the photographic media but, more generally, made him develop a specific form of *modernist* materialism that puts him in the vicinity of the contemporary avant-garde, including constructivism, dadaism, and surrealism, as well as atonal music.[78] At the very least, his historico-theological framing of modernity provided him with an existential stance or ethos against efforts to restore bourgeois German culture notwithstanding the shattering defeat of the nation in a war conducted in the name of that very culture, efforts he discerned in the circle around Stefan George, the academic Goethe cult (Friedrich Gundolf), and the continuing glorification of the classics on the traditional stage. Paradoxically, Kracauer's grounding in an ancient theological tradition not only made him more receptive to the ongoing upheavals in the material world but also authorized a radical critique of values and positions that he considered perilously out of touch with contemporary social, aesthetic, and political realities.

This critical ethos can be seen in at least three distinct yet related motifs. One is the programmatic direction of Kracauer's gaze toward material phenomena and

aspects of daily life marginalized by dominant culture, whether they lack (moral, aesthetic) value in the eyes of the educated bourgeoisie (like cinema), are assigned to oblivion by the presentism of ever-changing fashion (especially in architecture and design), or elude public awareness (as do unemployment offices, homeless shelters, the organization of urban traffic, etc.). Kracauer's penchant for the detritus of history, both literally and metaphorically, for the ephemeral and quotidian, led Benjamin to characterize him as a (Baudelairean) *chiffonnier*, a "ragpicker."[79] But he could just as well have compared him to contemporary artists who deliberately chose ordinary, worthless, or devalued materials for their collages (such as Hannah Höch, Marianne Brandt, or Kurt Schwitters) or to the dadaist readymades and happenings that polemically exposed the contradictions of aesthetic hierarchies of value. Likewise, Kracauer would have gone part of the way with the surrealists (though avoiding their more mystical flights), on their excursions to flea markets and through the arcades, finding there the banished props of the body, porno-graphic specialities, odd souvenirs, and "homeless images" reminding the passerby of long-forgotten impulses and desires.[80]

In an article that reads almost like an exercise in "profane illumination," a key concept in Benjamin's 1929 essay on surrealism, Kracauer meditates on the "gentle glow" that emanates from the Kaiser Wilhelm Memorial Church at night.[81] The glow is actually a reflection, effecting a spatial interpenetration of the traditional façade with the picture palaces on the Berlin Kurfürstendamm, which, with their pillars of light, glaring posters, and mirror-glass showcases, "turn night into day in order to banish the horror of the night from the working-day of their patrons" (S 5.2:184). Playing with literal and metaphoric senses of light, Kracauer switches with unusual pathos to an allegorical reading ("a flaming protest against the dark-ness of our existence . . . which flows, as if by itself, into the desperate embrace of the pleasure business") and ends with a meditation on the "mild radiance" unintentionally bestowed by "this sinister glow." "What the spectacle of light leaves over and what business has cast out is preserved by bleak walls. The outside of the church, which is not [used as] a church, becomes the refuge of what has been spilled and forgotten and shines as beautifully as if it were the Holy of Holies. Secret tears thus find their place of memory [*Gedächtnisort*]. Not in the hidden interior—in the middle of the street the neglected and inconspicuous is gathered and transformed until it begins to radiate, a comfort to everyone" (S 5.2:185).

A waste product of the relentless glare of modern entertainment and advertise-ment, the glowing exterior of an unused site of interiority becomes a surface for remembrance (Kracauer puns on the name of the church)—a public screen or, as the title suggests, a picture postcard inviting us to reflect upon what is being eclipsed, yet also unintentionally illuminated, by modernity's spotlights: areas as yet undefined and unspectacular. To take this *Denkbild* or thought-image a step further, while deriving its light from the commercial theaters, the configuration of

a reflexive surface in the dark, contingent sensory effects and mnemonic impulses, anonymous emotion in a public space—this configuration could well be read as Kracauer's minimalist utopia of *Lichtspiel,* or light-play, the German word for cinema.[82]

A second, related motif in Kracauer's critical arsenal is his own turn to the surface (*Oberfläche*) and his transvaluation of that term from a locus of sheer negativity, an atomized world of mere appearances, to a site in which contemporary reality manifests itself in an iridescent multiplicity of phenomena.[83] Although the very trope of the surface still implies the vertical topography of idealist philosophy—essence and appearance, the hierarchy of truth and empirical reality—in Kracauer's critical practice the *Oberfläche* increasingly loses its prefix and becomes a *Fläche* that offers a *Denkfläche,* an epistemological plane for tracing new configurations (such as the one he famously dubbed the "mass ornament") and for reading surfaces as indices of the possible directions the historical process might take.[84] This is not just a matter of reversing particular idealist hierarchies (as one might infer from his focus on the inconspicuous, degraded, ephemeral). Rather, Kracauer flattens any vertical and deep-rooted hierarchies into lateral relations, often by juxtaposing unequal elements on a two-dimensional plane.

In "Analysis of a City Map" (1926), he confronts the humanly teeming yet lackluster, marginalized life of the Faubourgs with the splendor of the Paris boulevards. He does not simply invert the hierarchy of center and periphery, for example, by nostalgically idealizing the Faubourgs as the domain of use value and neighborhood community. Rather, he puts into question the very opposition of use value and exchange value with an account of the new sites of consumption that, while critical, concludes, "Nevertheless, the streets that lead to the center must be traveled, for its emptiness today is real" (*MO* 44). By interrelating phenomena on a lateral force field, he draws attention to competing orders of significance and to the mechanisms that regulate public visibility and invisibility. The meaning of the phenomena themselves is no longer given or is as yet undefined; they are symptoms that need to be observed, described, deciphered, and interpreted.[85]

Kracauer's turn to the surface is more than a methodological device; it marks a political move that derives its ethos from his historico-theological stance. Against the conservative denigration of the new entertainment and leisure culture, he defends the "modern urban surface culture" that mushroomed in Berlin between 1924 and 1929 in picture palaces and shopwindow displays.[86] In his signal essay "Cult of Distraction" (*FZ* 4 March 1926) he valorizes the superficial glamour, the "pure externality" that draws the urban masses into the picture palaces, for no other purpose than *Zerstreuung,* or distraction—all pejorative terms in the dictionary of the educated bourgeoisie (probably the majority of the readers of the *Frankfurter Zeitung,* where the article was first published).[87] He does not even like the new picture palaces (the article entails a critique of the gentrifica-

tion of exhibition practices); but he insists on the cultural significance of these sites because they make visible to society and to the patrons themselves a new public and a new form of mass subjectivity. The polemical edge is directed against all and any attempts to resurrect forms of subjectivity, interiority, and individuality that have been rendered anachronistic by the traumatic impact of war and inflation.

> It is not externality that poses a threat to truth. Truth is threatened only by the naive affirmation of cultural values that have become unreal and by the careless misuse of concepts such as personality, inwardness, tragedy, and so on—terms that in themselves certainly refer to lofty ideas but that have lost much of their scope along with their supporting foundations, due to social changes. . . . In a profound sense, Berlin audiences act truthfully when increasingly they shun these art events (which, for good reason, remain caught in mere pretension), preferring instead the surface glamour of the stars, films, revues, and production values. (*MO* 326; *W* 6.1:210–11)

Similar to artistic avant-garde movements dating back to the war, Kracauer's attack is aimed at the hypocrisy of bourgeois-idealist culture, specifically efforts to restore "the spirit" against the onslaught of mechanization, which was often used as a synonym for standardization, mass production, and mass consumption. Even if technology was not Kracauer's primary theoretical focus (as it was for Benjamin), he would never have conceived of technically produced, mediated, and disseminated culture as a contradiction in terms, let alone a social disgrace or moral abomination.

Finally, a third motif characteristic of Kracauer's historico-theological stance returns us to Adorno's complaint about his friend's insufficient rebellion against reification, pointing up a different deployment of gnostic imagery in their respective theorizing of modernity. Adorno, reared on the same sociological discourse as Kracauer, was wont to evoke the effects of reification in images of mortification, rigidification, and death by freezing (*Kältetod*), just as he often invoked Ferdinand Kürnberger's dictum "*Das Leben lebt nicht*" (life does not live) as the fundamental experience of his generation.[88] Kracauer, not quite as threatened by the contamination with the inanimate as his younger friend, visualized the process of petrification and withdrawal of meaning in modern society as a process of fragmentation and disintegration that simultaneously entailed a mobilization of fixed arrangements and conditions. Once he had moved beyond an account of modernity as the penultimate stop in a history of decline, Kracauer could see the fracturing of all familiar, "natural" relations and shapes, the "perforation" of traditional forms of living, increasingly as an opportunity—a chance to point up the "*provisional status* of all given configurations," to highlight their transitory and transitional character.[89] Focusing on sites of flux and improvisation, the historian of the present will watch the fragments reconfigure themselves, perhaps into something more livable.

PHOTOGRAPHY AND THE *VABANQUE* GAME
OF HISTORY

The paradoxical relation between mortification and transformation emerges most strikingly in Kracauer's major essay "Photography" (*FZ*, 28 Oct. 1927) and may help us to understand the centrality of the photographic to his theory of film. This text entwines several strands of his early film theory: lapsarian critique of modernity; phenomenological description of quotidian and ephemeral phenomena impelled by a gnostic-modernist materialism; avant-garde iconoclasm; and critique of ideology that resonates with the more immanent political approach his writings take from the mid-1920s on. It is also exemplary of the way in which he traces alternative perspectives and possibilities *within* the phenomena under critique, leaving room for an ambivalence grounded in the material, for stereoscopic and conflicted views. Finally, the essay commands attention as a mode of theoretical writing that enacts its argument as much in its stylistic procedures as in conceptual terms.

A common reading of Kracauer's essay "Photography" takes its most important insight to be the opposition between the photographic image and the memory image, including the claim that the proliferation of technologically produced images threatens the very possibility and truth character of images preserved by memory.[90] Against such a reading, which effectively assimilates Kracauer to a genealogy of media pessimism (from Baudelaire and Proust through Virilio and Baudrillard), I contend that the essay's radical insights lie elsewhere. For Kracauer does not simply puncture the ideologically available assumption that the meaning of photographs is given in their analog, iconic relation to the object depicted; rather, he examines how meanings are constituted at the pragmatic level, in the usage and circulation of photographic images in both domestic and public media practices. Another, equally far-reaching concern of the essay is with the aging and afterlife of photographs, the transformation they undergo over time, especially once they have lost their original reference and presence effect. In the precarious temporality and historicity of photography, its alienation from human intention and control, Kracauer traces a countervailing potential, neither positivistic nor nostalgic, that he believes can be actualized in the medium of film. It is this potential that places photography at the crossroads of modernity: "The turn to photography is the *go-for-broke game* [*Vabanque-Spiel*] of history" (*MO* 61; *S* 5.2:96).

The question of historicity no less concerns the aging and afterlife of the text itself. It takes the by now ritual form of asking whether and how an essay that emphatically seeks to theorize photography in relation to the historical moment— Weimar democracy between economic stabilization and crisis, the larger trajectory of technological capitalist modernity—can speak to a present in which the photographic paradigm, to the extent that it props its claims to authenticity and accuracy on an indexical (physical or existential) relation with the object depicted

(the registration of reflected light on a photochemical surface at a particular point in space and time), seems to have been radically displaced and reframed by digital modes of imaging.[91] What's more, since the digital is not just another, more current medium, it has challenged traditional concepts of mediality and has made the idea of medium specificity, commonly taken to be central to classical film theory, appear as a high-modernist preoccupation.[92] As I hope to show, Kracauer's photography essay, much as it responds to a particular stage of media culture, points up issues of technological image production and usage, proliferation and storage that persist, in different forms and infinitely vaster dimensions, in the ostensibly postphotographic age; it likewise complicates key concepts of this debate—such as indexicality—by unfolding them as historically contingent and mutable. Finally, with a view to film theory and, not least, Kracauer's own *Theory of Film*, the photography essay projects a film aesthetics that compels us to rethink the question of cinematic realism.

Like Benjamin's artwork essay, which it prefigures in important ways, Kracauer's photography essay is organized in discrete sections that frame the object of investigation in the manner of different camera positions or separate takes. The protagonists of the resulting theory film, so to speak, are two photographs that the writer introduces by way of juxtaposition: the contemporary image of a film star (caption: "our demonic diva") on the cover of an illustrated journal and the portrait, more than six decades old, of an unspecified grandmother, possibly Kracauer's own, cast in the private setting of family viewing. Both images show women twenty-four years old; both images become the respective focus of later sections; and both metamorphose in the course of the essay—until they are united, in the eighth and last section, in the surreal panorama of modernity's "general inventory" or "main archive" (*Hauptarchiv*).

The image of the film star, posing in front of the Hotel Excelsior on the Lido, embodies the present moment ("time: the present")—not just a fashionable cosmopolitan modernity but also a culture of presence, performance, perfection: "The bangs, the seductive tilt of the head, and the twelve eyelashes right and left—all these details, diligently enumerated by the camera, are in their proper place, a flawless appearance" (*MO* 47). Kracauer emphasizes the photograph's double status as a material object that can be perceived in its sensory texture and a symbolic representation whose referent is elsewhere. Looking through a magnifying glass, one would see "the grain, the millions of dots that constitute the diva, the waves, and the hotel" (*MO* 47); at the same time, the image is an "optical sign" (*MO* 54) whose function it is to evoke the star as a unique, corporeal being. However, the referent that validates the sign in the eyes of the general public is not the star in person but her appearance in another medium: "Everyone recognizes her with delight, since everyone has already seen the original on the screen" (*MO* 47). Resuming the duodecimal figure of the well-groomed eyelashes, Kracauer goes

on to assert the paradoxical effect of the star's mass-mediated individuality with recourse to yet another entertainment intertext, that of the revue: "It is such a good likeness that she cannot be confused with anyone else, even if she is perhaps only one-twelfth of a dozen Tiller girls."[93] And he concludes the presentation of the star photograph with a deadpan refrain of the beginning of the paragraph: "Dreamily she stands in front of the Hotel Excelsior, which basks in her fame—a being of flesh and blood, our demonic diva, twenty-four years old, on the Lido. The date is September" (*MO* 47).

As he mounts his case against the ideology of presence and personality connoted by the mass-addressed image, Kracauer's writing already punctures that effect, even before the passage of time will have disintegrated the photograph and relegated it to history's vast central archive. The microscopic look that reveals "the millions of dots that constitute the diva, the waves, and the hotel" evokes the materialist, egalitarian pathos of Kracauer's frequent observation that in film, the actor is nothing but "a thing among things." The abstraction of the image into minimal units—halftone dots, a precursor to pixels[94]—defamiliarizes the resemblance with a particular living being; it also deflates the authority of the indexical bond (in the narrow sense of referring to the photochemical process of inscription) by foregrounding the image's mediation, if not de/composition, at the level of raster reproduction. The image's claim to depicting a singular referent is further undercut by the tongue-in-cheek remark that attributes its recognizability to the slippage between the image of the actual person and her representation in another medium—film—just as the suggestion that the star might be "only one-twelfth of a dozen Tiller girls" corrodes the aura of her uniqueness. Yet, lest the object of critique be prematurely demolished, Kracauer restores her image by closing the paragraph with a refrain of the opening lines.

The photograph of the diva functions as a synecdoche for the emerging mass culture of industrial-capitalist image production that Kracauer saw flourishing in the illustrated journals and weekly newsreels. By 1927, the term *illustrated magazine* was actually becoming something of a misnomer: the main purpose of the photograph, according to publisher Hermann Ullstein, was "no longer to illustrate a written text but to allow events to be seen directly in pictures, to render the world comprehensible through the photograph."[95] In Kracauer's analysis, such ideological investment in photographic representation corresponds to the false concreteness by which the individual image mimics the logic of the commodity form; it goes hand in hand with the massive increase—not simply mass reproduction—of photographic images on an imperial, global scale. "The aim of the illustrated magazines is the complete reproduction of the world accessible to the photographic apparatus" (*MO* 57–58).[96]

Kracauer sees in the relentless "blizzard" of photographic images a form of social blinding and amnesia, a regime of knowledge production that makes for a

structural "indifference" toward the meanings and history of the things depicted. "Never before has an age known so much about itself, if knowing means having an image of objects that resembles them in a photographic sense. . . . Never before has an age known so little about itself. In the hands of the ruling society, the invention of illustrated magazines is one of the most powerful weapons in the strike [*Streikmittel*] against understanding" (*MO* 58; *S* 5.2:93).

Understanding is prevented above all by the contiguous arrangement of the images—"without any gaps"—thereby systematically occluding reflection on things in their relationality (*Zusammenhang*) and history, which would require the work of consciousness. The illustrated magazines, like the weekly newsreels, advance a social imaginary of complete coverage (anticipating later media genres such as twenty-four-hour cable news and online news services) that affords an illusory sense of omniscience and control. The surface coherence of the layout glosses over the randomness of the arrangement and, with it, the arbitrariness of the social conditions it assumes and perpetuates; the illustrated magazines offer an image of the world that domesticates otherness, disjunctions, and contradictions. But, Kracauer adds, "it does not have to be this way" (*MO* 58).

Kracauer's critique of these practices should not be mistaken for a lapsarian complaint that the media of technical reproduction are distorting an ostensibly unmediated reality. Rather, "photographability" has become the condition under which social reality constitutes itself: "The world itself has taken on a 'photographic face'; it can be photographed because it strives to be absorbed into the spatial continuum which yields to snapshots" (*MO* 59). Here he works toward a medium- and institution-specific account of what Heidegger, a decade later, will call the "age of the world picture"—"world picture" understood not as a picture of the world, "but the world conceived and grasped as picture."[97] From this condition, there is no way back, either conceptually or ontologically, to an unmediated state of being that would release us from the obligation to engage contemporary reality precisely where it is most "picture"-driven—which for Kracauer is as much a political as a philosophical and psychotheological concern.[98]

Let me note parenthetically that Kracauer's critique of illustrated magazines was not exactly fashionable at the time. Avant-garde artistic and intellectual circles—for example, the Berlin group assembled around the magazine *G: Material zur elementaren Gestaltung* (1923–26), an important platform of German constructivism—valorized mass-marketed journals such as the *Berliner Illustrirte Zeitung* for their innovative layout, the dynamic integration of photographs, text, and typography.[99] The pedagogic potential of this graphic form inspired not only the layout of *G* and other avant-garde journals but also László Moholy-Nagy's famous book *Malerei, Fotografie, Film* (1925; 1927). And Benjamin, a member of the *G* group, wrote a defense of the *Berliner Illustrirte Zeitung*, "Nichts gegen die 'Illustrirte' "

(1925), that praised the journal for its contemporaneity, its "aura of actuality," documentary precision, and conscientious technological reproductions.[100]

If Kracauer remains skeptical toward the illustrated magazines, it is for the same reason that he indicts the vernacular style of New Objectivity in his analysis of the Berlin entertainment malls: "Like the denial of old age, it arises from dread of confronting death" (SM 92). Benjamin, too, comments on the juncture of photography and death, as do later writers such as André Bazin, Roland Barthes, Susan Sontag, and Georges Didi-Huberman. For Kracauer, the fact that the world "devours" this image world is a symptom of the fear and denial of death, inextricably linked to German society's refusal to confront the experience of mass death in the lost war. (This refusal is not incompatible with the fascination with disasters, crashes, and catastrophe that Kracauer observes in the media's sensationalist exploitation of violence and death.)[101] "What the photographs by their sheer accumulation attempt to banish is the recollection of death, which is part and parcel of every memory image." Yet the more the world seeks to immortalize itself qua "photographable present," the less it succeeds: "Seemingly ripped from the clutches of death, in reality it has succumbed to it" (MO 59).

The concept of the "memory image" appears to furnish an epistemological and spiritual counterpoint to photography, especially in its mass proliferation. As an immaterial, unstable, and degenerative image, it belongs to a different order of reality and works on a fundamentally different principle of organization. From the perspective of photographic representation, with its claims to accuracy and fullness, memory is fragmentary, discontinuous, affectively distorted and exaggerating; from the perspective of memory, however, "photography appears as a jumble that partly consists of garbage" (MO 51). The memory image relates to those traits of a person that resist being rendered in the spatiotemporal dimensions of photographic representation, and that in fragmentary form may survive after death as the person's actual or proper "history." In a photograph, by contrast, "a person's history is buried as if under a layer of snow" (MO 51).

The opposition between photography and memory image participates in a broader discourse, associated with Lebensphilosophie, that sought to reconceptualize perception, time, and memory in response to modernity's alleged reduction of experience to spatiotemporal terms. While Kracauer does not mention Bergson by name, the notion of durée resonates in the essay's critique of pretensions to chronological and spatial continuity, as manifested, respectively, in historicism and photography.[102] Likewise, he assumes the Proustian distinction between voluntary and involuntary memory, which Benjamin was to mobilize in his work on Baudelaire. Benjamin links the "increasing atrophy of experience" to the fact that devices like photography and film "extend the range of the mémoire volontaire." But this expansion comes at a cost: "The perpetual readiness of voluntary,

discursive memory, encouraged by the technology of reproduction, reduces the imagination's scope for play [*Spielraum*]."[103] Similarly, Kracauer warns that, instead of serving as an aid to memory, "the flood of photos sweeps away the dams of memory. The assault of these collections of images is so powerful that it threatens to destroy the potentially existing awareness of crucial traits" (*MO* 58).

The problem with this kind of argument is that it casts memory and technological reproduction as antithetical, exclusive terms, rather than analyzing their complex interactions.[104] What's more, it assumes an economic logic by which the expansion of the photographic (and, for that matter, phonographic) regime inevitably entails the withering away of human capacities of memory, reflection, and imagination. Given the exponential growth of media technologies, this logic cannot but imply a trajectory of cultural decline. It occludes the possibility that film and photography have also enabled new and qualitatively different types of experience—a possibility in which both Kracauer and Benjamin had a great stake.

I take the opposition of photographic and memory image to be only one element in the rhetorical movement of Kracauer's essay, part of a larger, more dialectical argument that turns on the constellation of photography, historical contingency, and film. As we have seen, the corrosive, allegorical gaze that drains the pretension of life and coherent meaning from contemporary media culture—a sensibility germane to Benjamin's treatise on the baroque *Trauerspiel*—is a function of critical reading, beginning with the opening section.[105] Yet at least as important is the essay's effort to ascribe this effect to the temporality and historicity of the medium itself, performed by the two photographs as material objects. For much as photography and film were becoming complicit with the social denial of death, Kracauer still discerned in them the unprecedented possibility of confronting the subject with contingency and mortality, and of challenging the natural appearance of the prevailing social order.

Kracauer builds up to this turn from his meditation on the portrait of the grandmother, viewed as part of the family archive by the grandchildren. Because of its age, the temporal gap of more than sixty years that separates the moment of recording from its reception, the image of the grandmother poses the question of photographic referentiality in a different way from that of the diva. With the death of the "*ur*-image," the connection with the living person may survive for a while by way of oral history but is ultimately loosened, literally defamiliarized, to the point of randomness—"it's any young girl in 1864" (*MO* 48). Barely remembering the grandmother and the fragmentary stories about her, the children perceive in her photograph only a "mannequin" in an outmoded costume or, rather, a collection of once-fashionable accessories—the chignons, the tightly corseted dress—that have outlived their bearer. What makes the grandchildren giggle and at the same time gives them the creeps, Kracauer suggests, is that the photograph amalgamates

these remnants with the incongruous assertion of a living presence. It is this "terrible association" that haunts the beholder like a ghostly apparition and makes him "shudder"; like the early films screened in the "Studio des Ursulines" in Paris, the aged photograph conjures up a disintegrated unity, a reality that is *unredeemed.*" The configuration of its elements "is so far from necessary that one could just as well imagine a different organization of these elements" (*MO* 56).

Kracauer relates photography's precarious afterlife to the split-second nature of photographic exposure—that is, he locates the problem precisely in the technologically supported indexical bond traditionally invoked to assert the photograph's accuracy and authority. In the mechanical reduction of time to the moment of its origin, Kracauer observes, the photograph is intrinsically more vulnerable (than, for instance, film) to the subsequent passage of time: "If photography is a *function of the flow of time,* then its substantive meaning will change depending upon whether it belongs to the domain of the present or to some phase of the past" (*MO* 54). While the photograph of the diva maintains a tenuous connection, mediated by film, between the corporeal existence of the original and her still-vacillating memory image, the grandmother's photograph affords no such comfort. In the measure that the photograph ages and outlives its referential context, the objects or persons depicted appear to be shrinking or diminishing in significance—in inverse proportion to memory images, which "enlarge themselves into monograms of remembered life." The photograph represents merely the dregs that have "settled from the monogram"; it captures the remnants "that history has discharged" (*MO* 55). However, in the tension between history and that which history has discarded, photography begins to occupy the intermediary zone that appeals to Kracauer: the ragpicker, the intellectual seeking to gather the refuse and debris, the ephemeral, neglected, and marginal, the no longer functional.

Kracauer aligns the temporality of photography with that of fashion and discerns in both a characteristic feature of capitalist modernity—a connection already implicit in the German word for fashion, *Mode*.[106] Like Benjamin, Kracauer is interested in fashion here primarily for its paradoxical imbrication of novelty and accelerated obsolescence, the moment when both photography and fashion, like all outdated commodities, join the ever-faster-growing garbage pile of modern history.[107] While the very old traditional costume, which has lost all contact with the present, may attain "the beauty of a ruin," the recently outmoded dress, pretending to photographic life, appears merely comical (*MO* 55).

The grandchildren's giggles are a defense against dread, a shocklike, visceral recognition of their own contingency and mortality, of a history that does not include them. In a rhetorical gesture discussed earlier, Kracauer switches from the third person to the first, assuming the grandchildren's shudder as his own: "This once clung to us like our skin, and this is the way our property clings to us even today. We are contained in nothing and photography assembles fragments

around a nothing" (*MO* 56). Rather than affording a prosthetic extension into a period not lived by consciousness, the photograph irrupts into the beholder's living present in an unsettling way, signaling his own physical transience along with the instability of the social and economic ground of his existence. In its emphasis on discontinuity and estrangement, this account anticipates Kracauer's later discussions, in *Theory of Film* and his posthumously published *History,* of a passage from Proust in which the narrator, describing a visit to his grandmother after a long absence, actually equates the sudden, terrifying sight of her as a sick, dejected old woman with a photograph. For Kracauer, this passage marks photography as a "product of complete alienation," epitomized by the view of a stranger unclouded by incessant love and memories, but also the vision of the exile who "has ceased to 'belong'" (*T* 15; *H* 83).

Benjamin, too, in his "Little History of Photography" (1931), comments on the haunting quality of early photographs—something that remains in them "that cannot be silenced."[108] Likewise, he attributes this haunting quality to the photograph's association with death, as in his evocation of the portrait of the nineteenth-century photographer Dauthendey and his fiancé, who was to commit suicide after the birth of their sixth child. But where Benjamin suggests the mystical possibility of a spark that leaps across the gap between the photograph's time and his own, Kracauer stresses irreversible disjuncture and dissociation into dissimilarity. (It is important to note that he is talking less about the physical, chemically based process of decay than about a disintegration of the depicted material elements.) The photograph of the young grandmother-to-be does not return the gaze across generations. For Kracauer, the chilly breeze of the future that makes the beholder shudder conveys not only intimations of his own mortality but also the liberating sense of the passing of a history that is already dead, depriving the bourgeois social order of its appearance of coherence and continuity, necessity and legitimacy.[109]

More than an existential memento mori, the outdated photograph assumes the status of evidence in the historical process (or "trial," as Benjamin will pun).[110] What up to this point in the essay has remained a private, individual encounter emerges as a public and political possibility toward the end of the essay. It is precisely *because* of the medium's negativity—its affinity with contingency, opacity to meaning, and tendency toward disintegration—that Kracauer attributes to photography a decisive role in the historical confrontation between human consciousness and nature. Shifting to the historico-philosophical register, he sees photography assigned to that stage of practical and material life at which an at once liberated and alienated consciousness confronts, as its objectified, seemingly autonomous opposite, "the foundation of nature devoid of meaning" (*MO* 61). In other words, it is the problematic indexicality at the heart of photographic representation that enables it to function as an index in the sense of deixis, an emblem pointing to—and pointing up—a critical juncture of modernity.[111]

As a category inseparable from history, nature refers both to the historically altered *physis* (including its ostensibly untouched preserves) and to the "second nature" of a society "[secreted by] the capitalist-industrial mode of production"— a social order that "regulates itself according to economic laws of nature" (*MO* 61).[112] I'd like to stress that in this phase of Kracauer's work his concept of nature, including the bodily and instinctual nature of human beings, has a ferociously pejorative valence, lacking the philosophical solidarity with nature as an object of domination and reification one finds, for instance, in Benjamin and Adorno and, with a different slant, in Kracauer's own *Theory of Film*. As in the essay on the "mass ornament" (published earlier the same year), nature becomes the allegorical name for any reality that posits itself as given and immutable, a social formation that remains "mute," correlating with a consciousness "unable to see its own material base." "One can certainly imagine a society that has fallen prey to a mute nature which has no meaning however abstract its silence. The contours of such a society emerge in the illustrated journals. Were it to endure, the emancipation of consciousness would result in the eradication of consciousness; the nature that it failed to penetrate would sit down at the very table that consciousness had abandoned" (*MO* 61).

However, if historically emancipation and reification have gone hand in hand, consciousness is also given an unprecedented opportunity to reoccupy the place at the table with a different agenda: "Less enmeshed in the natural bonds than ever before, it could prove its power in dealing with them." In this alternative, Kracauer pinpoints the significance of the photographic media for the direction of the present, the fate of modernity: "The turn to photography is the *go-for-broke game* of history."

In the eighth and final section of the essay, Kracauer steps up the rhetorical stakes of this gamble to highlight the historical chance that presents itself with photography, an argument that turns into a case for the photographic foundation of film. In a vast panoramic collage, he evokes the image of a "*general inventory*" or "main archive" (*Hauptarchiv*) that assembles the infinite totality of outdated photographs. "For the first time in history, photography brings to light the entire natural cocoon; for the first time, it lends presence to the world of death in its independence from human beings" (*MO* 62; *S* 5.2:96). In the dialectics of presence effect and disintegration, the medium-specific negativity of photography comes to define its politically progressive potential, indeed its task "to disclose this previously unexamined *foundation of nature*" (*MO* 61–62). In the confrontation with "the unabashedly displayed mechanics of industrial society," photography enables consciousness to view "the reflection [*Widerschein*] of the reality that has slipped away from it" (*MO* 62).

Understood as a general warehousing of nature, photography provides an archive that makes visible, in a sensually and bodily experienced way, both the

fallout of modernity and the possibility of doing it over, of organizing things differently. This archive, though, is anything but easy to access and navigate; it is rather an *an*-archive—a heap of broken images—that lends itself to the task precisely because it lacks any obvious and coherent organizational system.[113] It is closer in spirit to dadaist or surrealist montage (or, for that matter, the essay's epigraph from Grimm's Fairy Tales and "Calico-World"):

> Photography shows cities in aerial shots, brings crockets [*Krabben*] and figures from the Gothic cathedrals. All spatial configurations are incorporated into the main archive in unusual overlaps [*Überschneidungen*] that distance them from human proximity. Once the grandmother's costume has lost its relationship to the present, it will no longer be funny; it will be peculiar, like a submarine octopus. One day the diva will lose her demonic quality and her bangs will go the same way as the chignons. This is how the elements crumble since they are not held together. The photographic archive assembles in effigy the last elements of a nature alienated from meaning. (*MO* 62; *S* 5.2:96–97)

From a future vantage point that shows the present intermingled with everything else that's past, and the human nonhierarchically cohabiting with the nonhuman, even the illustrated magazines lose their market-driven actuality and coverage effect; their images become as random, fragmentary, and ephemeral as the portraits and snapshots in the family album. Kracauer's photographic an-archive evokes Benjamin's image of the backward-flying Angel of History facing the wreckage piled up by a storm from paradise, written at a time when the historical gamble seemed all but lost. Kracauer's vision is not quite as desperate: it still discerns concrete images of disfiguration, assembled in a textual bricolage.

The passage cited reinforces the essay's programmatic subordination of photographic resemblance or iconicity to the idea that photographs do not simply replicate but are themselves part of nature; they are material objects like the commodities they depict in their configuration of and with the human.[114] More than that, Kracauer's text materializes the photographs of the star and the grandmother as "things"—in the emphatic sense of "thingness" theorized by Heidegger.[115] Like Heidegger's famous jug, the two exemplary images take on an amazing plasticity, tactility, and agency; they spawn and participate in public life and disclose their meanings through social usage and cultural practices. Unlike the jug, however, which seems to exist—and endure—in an abstract timeless, if not mythic, space, Kracauer's photo-things are temporal and transient; their very thingness emerges in the dynamics of split-second exposure, commodified presence effect, and archival afterlife. The encounter with aged photographs does not put the beholder in touch with a reality repressed by scientific reason and capitalist appropriation, let alone with nature, but rather with the historical reality of irreducible mediation and alienation.

Kracauer's investment in photographic negativity is fueled by photography's potential to point up the disintegration of traditional and reinvented unities, the arbitrariness of social and cultural arrangements at the level of both the individual image and the protocols of public media. Once the bonds that sustained the memory image are no longer given, the task of artistic and critical practice is "to establish the *provisional status* of all given configurations." Kracauer finds a model of writing that "demolishes natural reality and displaces the fragments against each other" (*MO* 62; *S* 5.2:97) in the works of Franz Kafka, whose novel *The Castle* he had reviewed enthusiastically a year earlier.[116] If that review reads like a blueprint for Kracauer's early gnostic-modernist theory of film, the photography essay makes this connection explicit. By putting techniques of framing and editing to defamiliarizing effect (associating "parts and segments to create strange figurations"), film has the capacity not only to make evident the "disorder of the detritus reflected in photography" by suspending "every habitual relationship among the elements of nature," but also to "stir up," to mobilize and reconfigure those elements (*MO* 62–63; *S* 5.2:97). Combining photographic contingency with cinematic montage, film can "play" with "the pieces of disjointed nature" in a manner "reminiscent of *dreams*" (*MO* 63). In other words, similar to the oneiric imbrication of the remains of the most recent and ordinary with the hidden logic of the unconscious, film could animate and reassemble the inert, mortified fragments of photographic nature to suggest the possibility of a different history.

Although film becomes the overt object of Kracauer's reflections only at the end, the whole essay is central to his emerging film theory, if not conceived from this vantage point.[117] In that sense, it provides the foundation for his later effort, in *Theory of Film*, to ground a "material aesthetics" of the cinema in the photographic basis of film. In that text, the earlier essay remains curiously unmentioned, perhaps relegated to forgetting by the catastrophic defeat in modernity's hitherto most extreme gamble. Nonetheless, as I argue in chapter 9, whatever cinema's potential for "the redemption of physical reality," Kracauer's advocacy of realism in the later book remains tied to a historical understanding of *physis* and a concept of reality that depends as much on the estranging and metamorphic effects of cinematic representation as on the role of the viewer. As the photography essay makes sufficiently clear, Kracauer's conception of film's relationship with photography is not grounded in any simple or "naive" referential realism. On the contrary, it turns on film's ability to mobilize and play with the reified, unmoored, multiply mediated fragments of the modern *physis,* a historically transformed world that includes the viewer as materially contingent, embodied subject. The concept of realism at stake is therefore less a referential than an experiential one, predicated on the encounter with that world under radically changed and changing conditions of referentiality.

Kracauer does not posit the relationship between photography and film in evolutionary terms, but seeks to articulate an aesthetic of film in the interstices of

the two media. In this intermedial space, film does not "remediate" photography by way of containing it;[118] rather, photography, running alongside and intersecting with film both institutionally and ideologically, provides radical possibilities that film can draw on. To the convergence of film and photography in contemporary capitalist media culture—as prefigured in the cognitive regime that links weekly newsreels and illustrated magazines, and as metonymically present in the photograph of the film star—he opposes an alternative configuration of intermedial relations in which the unstable specificity of one medium works to cite and interrogate the other.[119]

Around the time the photography essay was written, the kind of film it envisioned may not have existed, though there are clearly affinities with experimental films of the period (e.g., René Clair, Jean Vigo, Dziga Vertov, and Kinugasa Teinsuke, all of whom Kracauer reviewed). By and large, contemporary commercial cinema had no use for the defamiliarizing and disjunctive aesthetics projected in the essay. Kracauer was well aware that, with the stabilization of German film production from 1925 on and mounting political instability toward the end of the decade, critical reviewing required a more direct language than that indebted to photographic negativity or, for that matter, to material expression of *Weltzerfall* and hyperbolic distortion of distorted conditions. A signal juncture in this regard, preceding the photography essay, was his intervention in the political controversies surrounding the 1926 German release of *Battleship Potemkin*.[120] Defending Eisenstein's film against the charge of *Tendenzkunst* (art with a message), Kracauer's decisive review of *Potemkin* brings together aesthetic criteria developed in his early writings on film—the restriction to physical exteriority appropriate to the medium, an associative fantasy ("filled with indignation, terror, and hope") that guides the sequencing of optical impressions, and a fairy-tale ending—with an enthusiastic endorsement of the "truth" presented by the film, its dealing with a "real" subject such as "the struggle of the oppressed against the oppressors" and "the moment of the revolution."[121] He praises the film's engagement with the real not least because it highlights, by contrast, the regressive and escapist bent of capitalist film production that takes on inequality, injustice, poverty, and revolt only to the extent that their representation does not threaten the dominant social order.[122]

The positivization of truth and concretization of the social reality that film can and should confront mark a shift in Kracauer's writing toward a more immanent, politically grounded critique of ideology that takes aim at the films' recycling of outdated bourgeois forms, settings, and values, the gentrification of exhibition practices, and the shaping of a mass-cultural imaginary in collusion with the emerging white-collar class. Increasingly, his critique of these developments tends to imply a betrayal of cinema's anarchic and materialist legacy: its beginnings in the habitat of popular entertainments and dime novels; its capacity to register and advance the disintegration and transformation of the phenomenal world. Kracauer

invokes this forgotten potential both as a critical standard for the present and as a promise that the discarded possibilities of film history could yet become decisive for the cinema's future.

In its inscription of the technological media as a historic gamble, the photography essay highlights an important dynamic in Kracauer's early work on film and mass culture, which at once dates it and makes it prescient. For its radicalism still participates in the 1920s' break with the "long nineteenth century," a century prolonged by efforts, enhanced by the capitalist entertainment industry, to restore a cultural façade that Kracauer, like the avant-garde artists of his time, strongly believed could not be patched up. Moved by a modernist impulse that made him defend the cinema against the educated bourgeoisie, he found in the technological mass media a sensory-perceptual discourse on a par with the experience of modernity, encompassing its traumatic, pathological effects as well as its transformational, emancipatory possibilities. Accordingly, the essay discerned in technologically and mass-based media institutions like the illustrated journals and cinema the emergence of new forms of publicness (different from the traditional liberal public sphere of the newspaper, to whose readers it was addressed) that demanded recognition and critical debate, insisting that these new publics were key to the political future of Weimar modernity.

Beyond its prognostic purchase on the imminent future, the photography essay contains a remarkably acute premonition that the issue was not merely that a discourse equal to the challenges of modernity was *lacking*—a lack to which film and photography supplied a certain answer—but that these same media generated and circulated an exponentially increased abundance of images, a random multiplicity and an indifferent interchangeability and convergence. It thus anticipates a key feature of contemporary media culture, in a changed socioeconomic and geopolitical landscape, to be sure, and in new, infinitely more powerful technological forms. The point is not just that Kracauer's disintegration of the star photograph into an abstract grid of halftone dots intuits something of the logic of digital procedures. It is at least as important that his rhetorical magnifying glass discovers a similar logic of abstraction and recombination at another level, in the protocols governing the use of photographs in contemporary media practices. What is just as remarkable, however, is that this analysis, if not the driving ethos of Kracauer's early film theory, is fueled by a gnostic-materialist vision of modernity that converts the photographic media's participation in disintegration into new sorts of animation and at once aesthetic and political possibilities of reconfiguration.

Curious Americanism

As we saw in the preceding chapter, Kracauer's early reflections on film and photography suggest a range of specific meanings that the term *modernity* might have for film theory and film history. These reflections in turn contribute to the archive of modernist aesthetics insofar as they expand the canon of aesthetic modernism to include the technological media, not just with experimental film and photography but also with the vernacular practices of commercial cinema. In this chapter, I reverse emphasis to focus on the significance Kracauer ascribed to cinema and other new entertainment forms as indices of the direction(s) of twentieth-century modernity, which he increasingly saw as defined by mass production, mass consumption, and the emerging contours of mass society.[1] In particular, I trace the ambivalences and revaluations surrounding his utopian proposition that, like their American prototypes, these entertainment forms might provide something like "a self-representation of the masses subject to the process of mechanization," that is, the conditions of possibility for a democratic culture.[2]

Kracauer's exploration of modern mass culture was part and parcel of the discourse of Americanism that catalyzed debates on modernity and modernization in Weimar Germany and elsewhere. As has been well documented by historians of Weimar culture, the metaphor of "Amerika" encompassed a wide range of ideas, images, and clichés: Fordist-Taylorist principles of production—standardization, rationalization, calculability, efficiency, and speed, the assembly line—and attendant promises of mass consumption; mass democracy and civil society, that is, freedom from traditional authority and hierarchies, egalitarian forms of interaction, and social as well as sexual and gender mobility (the "new woman" and the alleged threat of a "new matriarchy"); and not least the cultural symbols of the new era—skyscrapers, jazz ("Negermusik"), boxing, revues, radio, cinema. Whatever its particular articulation (to say nothing of its reference to the actual United States), the discourse of Americanism crystallized positions on modernity, from cultural-conservative jeremiads through euphoric hymns to technological progress. Within pro-American discourse, the political fault lines were usually drawn between those who found in the Fordist gospel a solution to the ills of capitalism and a harmonious path to democracy ("white socialism") and those who believed that modern

technology, and technologically based modes of production and consumption, furnished the conditions, but only the conditions, for a truly proletarian revolution ("left Fordism").[3]

As has often been pointed out, the discourse of Americanism should not be conflated with the actual historical process of "Americanization," that is, the transfer of American-style business practices to Germany (and other parts of Europe).[4] Still, with the introduction of Fordist-Taylorist principles of production in both industry and the service sector, along with the accompanying spread of cultural forms of mass consumption, the very categories developed to comprehend the logics of capitalist modernity assumed a more concrete, and more complex and contradictory, face. To be sure, Germany had seen experiments in and debates on rationalization earlier, in fact before World War I.[5] And while there was a distinct push for Fordist-Taylorist methods of production in the mid-twenties, they were not implemented everywhere and at the same pace, and thorough rationalization remained largely an aspiration.[6] But to the extent that it was becoming a reality, the American system of mass production and consumption signaled a paradigmatically distinct set of values, visions, sensibilities—less a dichotomously understood assault of modern civilization on traditional culture than a specific material, perceptual, and social regime of modernization that competed with European versions of modernity.

I am less interested here in situating Kracauer within canonical Weimar debates on modernity than in tracing his engagement with American-style mass and media culture as it evolved between 1924 and 1933—not only as a response to the mounting political crisis and bourgeois culture's failure to address it but also as an elaboration of issues that point beyond both the historical moment and the national frame of reference. During the brief period between the great inflation and the end of the Weimar Republic, Kracauer turned "Amerika" from a metaphysically grounded metaphor of disenchanted modernity into a diagnostic framework for exploring the manifold and contradictory realities of modern life under the conditions of advanced capitalism. As elaborated in chapter 1, the materialist impulse to register, transcribe, and archive the surface manifestations of modernity was initially motivated—as well as licensed—by the eschatologically tinged hope that modernity could and would be overcome: "America will disappear only when it completely discovers itself."[7] However, the self-reflexive construction of this phrase also suggests that the object of discovery harbors its own means and media of cognition and self-understanding; by the same logic, it implies that the discovering subject cannot remain outside or above the terrain explored. Accordingly, the more Kracauer immersed himself in the project, the less sanguine he became about the possibility of *transcending* modernity, and the more passionately he engaged in immanent critique. Thus, in the face of rising National Socialism, he sought to describe the particular ways in which technologi-

cally mediated and market-based culture seemed at once to furnish the conditions for self-reflexivity and self-determination on a mass scale and to neutralize and undermine those very principles.

In the first years of the Weimar Republic, the connection between Americanism qua industrial rationalization and the new mass-mediated culture, in particular cinema, was by no means established—at least not until the implementation of the Dawes Plan in 1924, which ushered in at once a large-scale campaign of rationalization and the consolidation of Hollywood's hegemony in the German market.[8] In a report for the *Frankfurter Zeitung* on a conference of the Deutsche Werkbund in July 1924, Kracauer presents this gathering of designers, industrialists, educators, and politicians as a site of missed connections. The conference was devoted to two main topics, "the fact of Americanism, which seems to advance like a natural force," and the "artistic significance of the fiction film."[9] Kracauer observes a major shortcoming in the speakers' basic approach to Americanism: they went all out to explore its "total spiritual disposition," but, true to the Werkbund's professed status as an "apolitical organization," they left the "economic and political conditions upon which rationalization . . . is based substantially untouched." While both proponents and critics of rationalization seemed to articulate their positions with great conviction and ostensible clarity, the second topic of the conference, concerning the fiction film, remained shrouded in confusion. "Curiously, perhaps due to deep-seated prejudices, the problem of film was dealt with in a much more biased and impressionistic way than the fact of mechanization, even though both phenomena, Americanism and film composition, after all belong to the same sphere of surface life."

The metaphysically grounded concern over the "disintegration" of the world had prompted Kracauer to turn his attention to that very "sphere of surface life," to the seemingly inconspicuous phenomena of the modern urban everyday and the culturally despised practices of popular literature and entertainment. This turn entailed an epistemological valorization of the term *surface*, previously associated with lapsarian laments over mechanization and the hegemony of instrumental reason or rationality (*Ratio*), the ascendance of *Gesellschaft* over *Gemeinschaft*, the crisis of the self-determined individual, and the breakdown of traditional belief and value systems ("transcendental homelessness"). Instead, Kracauer increasingly came to view the surface or *Oberfläche* as a *Denkfläche*, or plane for thinking, an as-yet-uncharted map for the exploration of contemporary life.[10]

Kracauer's empirical efforts to trace "the inconspicuous surface-level expressions" of modern life were guided, though, by the theoretical objective to determine "the position that an epoch occupies in the historical process," that is, the direction(s) that modernity would or could take.[11] Key to this project was the critique of capitalism, without which the critique of modernity would have remained marooned in metaphysical pessimism. As is often noted, Kracauer's reading of

Marx and Marxist theory beginning in 1925 radicalized his earlier materialist impulses into a critical program. At the same time, actual developments in the process of modernization, in particular the implementation of Fordist-Taylorist methods of production and the increased circulation of American entertainment products from the mid-twenties on, both confirmed and challenged the Marxist analysis of capitalism in specific ways.

The effort to grasp the ongoing transformations posed heuristic and methodological problems—concerning the relationship of theory and empirical reality and that of totality and the particular—to which Kracauer found no satisfactory answers in the established academic disciplines, least of all philosophy, in particular German idealist thought in the tradition of Kant and Hegel.[12] Theoretical thinking schooled in that tradition, he felt, proved increasingly incapable of grasping a changed and changing reality, a "reality filled with corporeal things and people" (*MO* 140; *S* 5.1:169). Accordingly, his earlier despair over the direction of the historical process turned into a concern over the lack of a heuristic discourse, over the fact that "the objectively-curious [*das Objektiv-Neugierige*] lacks a countenance."[13]

Neither did he find such a discourse in the discipline of sociology and social theory, which should have been the place for conceptualizing concrete changes in social organization and social behavior under the conditions of capitalist modernity.[14] It was not that the critique of Western rationality, notably Max Weber's, ignored capitalist modes of production and exchange. In Kracauer's view, however, this critique still operated at an idealist level of abstraction because it posited the *Ratio* as a transhistorical, ontological category of which the current phase of capitalism was just a particular inevitable and unalterable incarnation. He extended this reproach even to Georg Lukács, whose *History and Class Consciousness* (1923) had persuasively fused Weber's theory of rationalization with Marx's theory of the commodity and was to become major impulse for Critical Theory and the Frankfurt School. Kracauer not only rejected Lukács's notion of the proletariat as both object and subject of a Hegelian dialectics of history but also balked at the conception of reality as a totality.[15] For Kracauer, the diagnosis of the historical process required the construction of categories from within the material; bringing Marx up to date, he wrote to Ernst Bloch, required "a dissociation of Marxism in the direction of the realities."[16]

In this regard, Kracauer, like many of his generation, found inspiration in Georg Simmel, a thinker who moved between, across, and beyond the disciplines of philosophy and sociology and who, as early as 1903, had asserted the significance of the "seemingly insignificant traits on the surface of life."[17] Having attended Simmel's lectures and corresponded with him, Kracauer devoted a substantial monograph to him in 1919: "Simmel was the first to open for us the gateway to the world of reality."[18] He authorized the exploration of the quotidian, ephemeral,

and coincidental, the mundane reality of everyday life and leisure and attendant modes of social interaction. Unlike "thinkers rooted in transcendental idealism who try to capture the material manifold of the world by means of a few wide-meshed general concepts" and end up missing precisely the "existential plenitude of these phenomena," Simmel, according to Kracauer, "snuggles much closer to his objects" (*MO* 242). He offered a theorizing mode of description grounded in "perceptual experience"—"he observes [the material] with an inner eye and describes what he sees" (*MO* 257)—that is, an aesthetic disposition to which Kracauer was to add the eye for spatial dynamics and precision of an architect, the kinaesthetic imagination of a moviegoer, and a literary sensibility closer to Kafka, dada, and surrealism.

However, he rejected Simmel's vitalist penchant to show every object as inter-connected with everything else, thus making individual phenomena symbolize the infinite connectedness of the manifold as a living totality. Not only had Kracauer lost the confidence in any meaningful interconnectedness; the very breakdown of totality was for him a defining feature—and opportunity—of the historical moment, marking the difference of modernity from preceding periods. Hence, he insisted vis-à-vis Simmel on treating the sundered fragments *as fragments,* in their own mode of being ("*Eigensein*").

Kracauer's curiosity about contemporary realities made him drift, more radi-cally than Simmel, toward the proliferating sites, media, and practices of con-sumption, including their shadow counterpart, the public yet "unseen" sites of deprivation and misery. Beginning around 1925, his articles increasingly revolve around objects of daily use, metropolitan spaces and modes of circulation, and the media, rituals, and institutions of an expanding leisure culture. As remarkable as the range of topics is the change of tone and differentiation of stance in Kra-cauer's writing. Although the critique of the capitalist grounding of modernization continues—and actually becomes fiercer by the end of the decade—it is no longer linked to a metaphysically based pessimistic attitude. If in his programmatic essay of 1922, "Those Who Wait," Kracauer had already endorsed a "*hesitant openness*" toward modernization, by 1925 he professes an "uncertain, hesitant affirmation of the civilizing process" (*MO* 138, 73). Such a stance, Kracauer argues in his essay "Travel and Dance," is "more realistic than a radical cult of progress, be it of rationalist lineage or aimed directly at the utopian. But it is also more realistic than the condemnations by those who romantically flee the situation they have been assigned." With an openness that does not abdicate critical awareness, the observer "views the phenomena that have freed themselves from their foundation not just categorically as deformations and distorted reflections, but accords them their own, after all positive possibilities" (*MO* 73; *S* 5.1:295).

Which particular possibilities did Kracauer perceive in Weimar modernity, especially the cultural manifestations of Americanism? What in this specific

regime of modernization did he see as different and potentially liberatory? While he occasionally still deplores the "machinelike" quality of modern existence, he begins to be fascinated by new entertainment forms that turn the "fusion of people and things" into a creative principle. He first observes this principle at work in the musical revues then sweeping across German vaudeville stages: "The living approximates the mechanical, and the mechanical behaves like the living."[19] With an enthusiasm that sounds untypically close to the language of "white socialism," Kracauer reports on the Frankfurt performance of the Tiller Girls, whose tour inaugurated the "American age" in Germany.[20] "What they accomplish is an unprecedented labor of precision, a delightful Taylorism of the arms and legs, mechanized charm. They shake the tambourine, they drill to the rhythms of jazz, they come on as the boys in blue: all at once, pure duodeci-unity [Zwölfeinigkeit]. Technology whose grace is seductive, grace that is genderless because it rests on joy of precision. A representation of American virtues, a flirt by the stopwatch."[21]

Kracauer's pleasure in such precision does not rest with forms inspired by technology but with the aesthetic rendering of social and sexual configurations coarticulated with the new technological regime. It is significant that he does not conflate mechanization and rationalization with an a priori negative concept of standardization, or feel threatened by the flaunted loss of individuality. In the stylized economy of the revue, its fragmentary, serial, incessantly metamorphosing patterns, standardization translates into a sensual celebration of collectivity, a vision, perhaps a mirage, of equality, cooperation, and solidarity. It is also a vision of gender mobility and androgyny (girls dressed as sailors)—a mark of Americanism for both its proponents and enemies—though perhaps at the price of a retreat from sexuality and denial of sexual difference. Still, Kracauer's account conveys a glimpse of a different organization of social and gender relations—different at least from the patriarchal order of the Wilhelmine family and norms of sexual behavior that clashed with both the reality of working women and Kracauer's own sensibility.[22]

The Taylorist aesthetics of the revue also suggests a different conception of the body from that subtending traditional humanist notions of a unitary, autonomous self. Writing about two "excentric dancers" (Exzentriktänzer) performing live in the Ufa Theater, Kracauer asserts that the precision and grace of their act "transform the body-machine into an atmospheric instrument." They defy physical laws of gravity, not by assimilating technology to the phantasm of a complete, masculine body (such as the armored body of the soldier-hero), but by playing with the fragmentation and dissolution of that body: "When, for instance, they throw one leg around in a wide arc . . . it is really no longer attached to the body, but the body, light as a feather, has become an appendix to the floating leg."[23] This image evokes similar visions in contemporary visual art and experimental film,

such as of Dudley Murphy and Fernand Léger's *Ballet méchanique,* Hans Bellmer's broken dolls, or Hannah Höch's collages.[24] Within Kracauer's oeuvre, the aesthetic pleasure in the suspension of the "natural" body's boundaries may also be read as a playful variant of his masochistic imagination, which (in a number of his essays and in his novel *Ginster*) again and again stages the violation of physical and mental identity by extraneous objects and sensations.[25] As a creative critique of ideology, the jumbling of the hierarchy of center and periphery in the dancers' bodies, their fragmentation as well as prosthetic expansion, undermines both older bourgeois notions of an "integrated personality" and ongoing attempts (in sports, in "body culture") to reground "the spirit" in an organic, natural unity.[26]

Not least, Kracauer's valorization of Taylorist revue aesthetics and the "American influence" on the genre served to excoriate the retrograde style of the show's German numbers, with their mélange of monarchism ("Queen Luise descending from a perron in historical costume"), militarism, mother love, and Viennese *Gemüt*. However, when he returns to these examples in an all-round polemic against the genre a few months later, the Tiller Girls likewise fall prey to sarcastic condemnation (mindless "automata" "produced by Ford"). The refrain that ironically punctuates the essay, "in the age of technology," highlights the gap between technological modernization and a culture not up to its challenges.[27] The phrase also suggests a lack of consciousness in the very cultural products that flaunt their synchronicity and presentness, a point that anticipates his concern about the "muteness" of the mass ornament.

Kracauer's fascination with—and growing ambivalence toward—aesthetic forms corresponding to the Americanist regime of rationalization was not limited to the serial displays of the revues. In fact, some of his most interesting writing concerning such aesthetics can be found in his articles on the circus.[28] His review of Zirkus Hagenbeck, published a year before his essay "The Mass Ornament," reads like a sketch for the latter. Kracauer introduces the appearance of the giant menagerie in Frankfurt as an "International of animals," describing the animals as involuntary delegates from globally extended regions, united under the spell of Americanism: "The fauna moves rhythmically and forms geometrical patterns. There is nothing left of dullness. As unorganic matter snaps into crystals, mathematics seizes the limbs of living nature and sounds control the drives. The animal world, too, has fallen for jazz. . . . Every animal participates in the creation of the empire of figures according to its talents. Brahmin zebus, Tibetan black bears, and massifs of elephants: they all arrange themselves according to thoughts they did not think themselves."[29]

The regime of heteronomous reason rehearsed on the backs of the animals would be merely pathetic if it weren't for the clowns whose anarchic pranks debunk the imperialist claims of rationalization: "They too want to be elastic and linelike, but it doesn't work; the elephants are more adroit, one has too many

inner resistances, some goblin crosses out the elaborate calculation" (*FT* 110).[30] While their antics have a long tradition, the clowns assume alterity in relation to the ongoing process of modernization; they inhabit the intermediary realm of *improvisation* and *chance* that, for Kracauer, is the redeeming supplement of that process and that has come into existence only with the loss of "foundations" or a stable order.[31]

The institution in which the clowns could engage rationalization on, as it were, its own turf was of course the cinema, which assured them an audience far beyond local and live performances. In numerous reviews, Kracauer early on praised slapstick comedy (*Groteske*) as a cultural form in which American-ism supplied a popular and public antidote to its own system. Like no other genre, slapstick comedy seemed to subvert the economically imposed regime in well-improvised orgies of destruction, confusion, and parody. "One has to hand this to the Americans: with slapstick films they have created a form that offers a counterweight to their reality: if in that reality they subject the world to an often unbearable discipline, the film in turn dismantles this self-imposed order quite forcefully."[32]

To the extent that Kracauer's theorizing of slapstick concerns the assimilation of human beings to the mechanical, it harks back to Bergson's famous essay on laughter, *Le rire* (1900). However, Kracauer's interest in the genre is decisively more anarchistic and iconoclastic. He extolled slapstick as a creative critique not only of the regime of the assembly line but also of a culture predicated on bourgeois individualism and anthropocentrism. Thus he emphasizes the *mutual* imbrication of the living and the mechanical, the "revolt of the slaves" (Simmel) that animates material objects and puts them on a par with human agents.[33] Human beings in turn assume a thinglike physiognomy (a case in point is Keaton's deadpan face); lacking the authority and interiority of a sovereign ego, they are vulnerable to the push and pull, the malice of objects as well as people.[34] Reviewing Chaplin's *Gold Rush*, Kracauer writes: "He [Chaplin] shrinks back from the door that leaps ajar behind his back because it too is an ego; everything that asserts itself, dead and living things alike, possesses a power over him toward whom one has to take off one's hat, and so he keeps taking off his hat."[35]

Kracauer was only one among a great number of European avant-garde artists and intellectuals (such as dadaists and surrealists) who celebrated slapstick film, and their numbers grew with the particular inflection of the genre by Chaplin.[36] Benjamin, too, ascribed to slapstick comedy a radical social and political signifi-cance, which complemented his often dutiful and at best sporadic endorsements of Soviet film. He considered Chaplin an exemplary figure primarily because of his mimetic "innervation" of assembly-line technology, a "gestic" rendering of the experience of perceptual and bodily fragmentation. In abstracting the human body and making its alienation readable, Chaplin joins Kafka and other figures in

which Benjamin discerned a return of the allegorical mode in modernity—except that Chaplin's appeal combines melancholy with the force of involuntary collective laughter.

Where Benjamin emphasizes self-fragmentation and "self-alienation" in Chaplin, Kracauer locates the figure's appeal in an already missing self: "The human being that Chaplin embodies or, rather, does not embody but lets go of, is a *hole*. . . . He has no will; in the place of the drive toward self-preservation or the hunger for power there is nothing inside him but a void that is as blank as the snow fields of Alaska" (*W* 6.1:270, 269). In this regard, Chaplin resembles the protagonist of Kracauer's novel *Ginster* (1928), a connection first made by Joseph Roth: "Ginster in the War—that's Chaplin in the department store!"[37]

Whether from lack of identity or inability to distinguish between self and multiplied self-images (as Kracauer observes with reference to the hall-of-mirror scene from *Circus*), Chaplin instantiates a "schizophrenic" vision in which the habitual relations among people and things are shattered and different configurations appear possible (*W* 6.1:269); like a flash of lightning, Chaplin's laughter "welds together madness and happiness."[38] The absent center of Chaplin's persona allows for a reconstruction of humanity under alienated conditions—"from this hole the purely human radiates discontinuously . . . the human that is otherwise stifled below the surface, that cannot shimmer through the shells of ego consciousness" (*W* 6.1:269–70). A key aspect of this humanity is a form of mimetic behavior that disarms the aggressor or malicious object by way of mimicry and adaptation, and that assures the temporary victory of the weak, marginalized, and disadvantaged, of David over Goliath.[39]

For Kracauer, Chaplin is both a diasporic figure and "the pariah of the fairy tale," a genre that makes happy endings imaginable and at the same time puts them under erasure. The vagabond again and again learns "that the fairy tale does not last, that the world is the world, and that home [*die Heimat*] is not home" (*W* 6.2:494). If Chaplin has messianic connotations for Kracauer, it is in the sense that he represents at once the appeal of a utopian humanism and its impossibility, the realization that the world "could be different and still continues to exist" (*W* 6.2:34).[40] Chaplin exemplifies this humanism under erasure both in his films and by his worldwide and ostensibly class-transcendent popularity. While Kracauer is skeptical as to the ideological function of reports that, for instance, the film *City Lights* managed to move both prisoners in a New York penitentiary to laughter and George Bernard Shaw to tears, he nonetheless tackles the question of Chaplin's "power" to reach human beings across class, nations, and generations (*W* 6.2:492)[41]—the possibility, ultimately, of a universal language of mimetic transformation that would make mass culture an imaginative horizon for people trying to live a life in the war zones of modernization.

Compared to Benjamin's, Kracauer's interest in Chaplin and slapstick comedy—as in cinema in general—was less focused on the question of technology, either in the Marxist sense as a productive force or as a Heideggerian enframing or *Gestell*. He was primarily concerned with the ways in which Fordist-Taylorist technology gave rise to a distinct socioeconomic and cultural formation that, more systematically than any previous form of modernization, addressed itself to the *masses*, thus constituting a specifically modern form of subjectivity. Since I focus on this concern in the following sections, I refrain from offering any general definition of Kracauer's concept of the mass, or masses, not least because that concept is subject to significant fluctuation and ambiguity. Suffice it to note that, explicitly and implicitly, Kracauer's exploration of this particular aspect of "Amerika" sets itself off, on the conservative side, against the long-standing lament about mass-marketed culture as well as late-nineteenth-century elitist-pessimistic theories of the crowd (as synthesized by Gustave Le Bon) that essentialized, psychologized, pathologized, and demonized the crowd, or mass in the singular, as an atavistic force that required a leader.[42] On the politically progressive side, as we shall see, Kracauer tries to complicate leftist conceptions of the masses predicated on the industrial working class and the idea of a revolutionary proletariat. The metaphor of "discovering America," after all, refers not simply to an *object* of exploration but to a heuristic strategy for discovering whatever might be qualitatively and historically distinct, as yet unrecognized and undefined, in a subject so overdetermined by competing discourses. Accordingly, rather than engaging directly with sociological, psychological, or political debates on the nature of the modern masses, Kracauer takes the detour through the ephemeral phenomena of the burgeoning entertainment culture—as configurations that at once spawn and respond to a new type of collective.

THE MASS AS ORNAMENT AND PUBLIC

The locus classicus of Kracauer's analysis of Fordist mass culture is his 1927 essay "The Mass Ornament." In this essay, the Tiller Girls have evolved into a historico-philosophical allegory that, as is often noted, anticipates key arguments of Horkheimer and Adorno's *Dialectic of Enlightenment* (1944; 1947).[43] Once exuberantly portrayed, the dance troupe now figures as a critical emblem of displays that proliferate internationally in cabarets, stadiums, and newsreels, patterns formed by thousands of anonymous, uniform, de-eroticized bodies ("sexless bodies in bathing suits" [*MO* 76]). The abstraction of the individual body into elements or building blocks for the composition of larger geometrical figures corresponds, as an "aesthetic reflex," to the Taylorist principle of breaking down human labor into calculable units and refunctioning them in the form of working masses that

can be globally deployed (*MO* 79). As a figure of capitalist rationality, Kracauer argues, the mass ornament is as profoundly ambivalent or ambiguous (*zweideutig*) as the historical process that brought it forth. On the one hand, it participates in the "process of demythologization" that emancipates humanity from the forces of nature and that, in Kracauer's words, "effects a radical demolition of the positions of the natural" (in particular the powers of the church, monarchy, and feudalism) (*MO* 80; *S* 5.2:61). On the other, this process ends up reestablishing the natural in ever-new forms. By perpetuating socioeconomic relations "that do not encompass the human being," capitalist development reproduces these relations as natural—as given and immutable, instead of historical and political—and thus reverts to myth; rationality itself has become the dominant myth of modern society (*MO* 81; *S* 5.2:62).

Unlike other Critical Theorists, however, Kracauer does not locate the problem in the concept of Enlightenment as such (which he associates less with German idealism than with the utopian reason—justice and happiness—of fairy tales canonized in the French eighteenth century). Rather, he argues that the permeation of nature by reason has actually not advanced far enough—the problem with capitalism is not that "it rationalizes too much" but that it rationalizes "*too little*" (*MO* 81). This hyperbole implies the distinction, key to subsequent debates within the Frankfurt School, between instrumental rationality—the unleashed *Ratio* "that denies its origins and no longer recognizes any limits"—and reason as *Vernunft*, which reflects upon its own contingency, goals, and procedures.[44] The mass ornament embodies the incomplete advance of rationalization, that is, one without self-critical reason, by stopping halfway in the process of demythologization and thus remaining arrested between the abstractness endemic to capitalist rationality and the false concreteness of myth. Yet, just as he knows that the emergence of humanist reason is inseparable from the development of capitalism, Kracauer rejects any thought that this development could be reversed: "The process leads right through the center of the mass ornament, not back from it" (*MO* 86; *S* 5.2:67).

The essay on the mass ornament has been criticized for its reductionist analogy between "the legs of the Tiller Girls" and "the hands in the factory" (*MO* 79; *S* 5.2:60), an analogy that allegedly ignores the aesthetic specificity of the revues, their playful negation of the abstract regime they reflect.[45] Such criticism fails to see that the relationship Kracauer delineates is neither literal nor obvious but heuristic and symptomatic. Since he first reviewed the Tiller Girls in 1925, the connection between the new dance form and Fordist-Taylorist rationalization, between chorus line and assembly line, had more or less become a topos, notably with Fritz Giese's illustrated paean to "girl culture" published the same year.[46] This topos, however, remained stuck in the binary discourse of Americanism, which either welcomed the revues as a "new culture of training" (*Trainingskultur*)—that

is, a means of social discipline—or decried them as a yet another manifestation of mechanization and standardization, the "growing drive toward uniformity" and "complete end of individuality."[47] In contrast with either enthusiastic or lapsarian accounts, Kracauer's essay assumes a more dialectical stance toward the phenomenon, reading it as an index of an ambivalent historical development. Above all, where the Americanist discourse extols technological rationality or, respectively, laments mechanization, Kracauer develops his argument from within a Marxist critique of capitalism.

If Kracauer at this point shares the Marxist (or more specifically Lukácsian) assumption of the totality of capitalism, this does not mean that he subscribes to a determinist model of base and superstructure. Methodologically, he rather borrows from the language of psychoanalysis, extending it into the political and social realm, in particular the ideological mechanisms of public consciousness. The simultaneous omnipresence and occlusion of capitalism takes the form of a paradox: "The production process runs its secret course in public" (MO 78; S 5.2:60). Yet it remains encrypted, unread, sub- or preconscious. In his 1929 study of employee culture, Kracauer invokes the "purloined letter" in Poe's well-known story (later famously analyzed by Lacan) to describe a similar paradox—that of the salaried masses who increasingly dominate the appearance of Berlin's cityscape but whose life eludes consciousness, both their own and that of the bourgeois public.[48] Like Poe's letter, the salaried masses remain unnoticed "*because* [they are] out on display" (SM 29; emphasis added). The cover of unconsciousness, Kracauer ventures in the already-cited epigraph to "The Mass Ornament," actually offers a cognitive gain. "The inconspicuous surface-level expressions" of an epoch yield more substantial insights about "the position [this] epoch occupies in the historical process" than the "epoch's judgments about itself" (MO 75). Like the image configurations of dreams, they require a conscious work of "deciphering."[49] Echoing Freud's *Interpretation of Dreams*, Kracauer links this work in other texts to the metaphor of hieroglyphics, a figure that, like the mass ornament, combines abstract, graphic lines with visual concreteness and ostensible self-evidence.[50]

The mass ornament requires critical deciphering for two reasons. First, the educated bourgeois public fails to recognize the significance of these displays, which, Kracauer asserts, capture contemporary reality more aptly than older forms predicated on concepts of community such as folk and nation as well as outdated notions of individual personality. Second, the work of deciphering is needed because the mass ornament itself remains "*mute*," unpermeated by reason, and therefore lacks the ability, as it were, to read itself. "The *Ratio* that gives rise to the ornament is strong enough to mobilize the mass and to expunge [organic] life from the figures constituting it. It is too weak to find the human beings in the mass and to render the figures transparent to cognition" (MO 84; S 5.2:65)—cognition,

that is, of the social and economic conditions that they inhabit and unwittingly perpetuate. Instead, the modernizing impulse is deflected into the mere physicality of body culture (gymnastics, eurhythmics, nudism, fresh air), much as that movement may dress itself up in neospiritual ideologies (*MO* 85, 86).[51]

Against a bourgeois humanism to which the mass ornament gives the lie Kracauer seeks to delineate the contours of a modernist humanism that would combine the precarious and anonymous subjectivity of mass existence with the principles of equality, justice, and solidarity, a humanism grounded in reason aware of its contingency. It is no coincidence that he invokes the example of Chinese landscape paintings: a representational space from which "the organic center has been removed" (*MO* 83).[52] This comparison, however, begs the question as to *who* reoccupies the empty space in front of or, in the case of the mass ornament, above the representation—specifically, which invisible hand or eye organizes its patterns, and to which purposes and effects.

Whether the mass ornament is merely an "end in itself" (a travesty of Kantian aesthetic autonomy) or organized by the "invisible hand" of the capitalist system (which also appears as an "end in itself"), Kracauer seems to leave the answer deliberately vague. Since his concept of the mass ornament is transnational, if not emphatically internationalist, as well as implicitly opposed to Le Bonian crowd theory, he does not at this point consider the fusion of mass ornament aesthetics with an extreme nationalist ideology focused on a fascist leader. When he resumes the term "mass ornament" in *From Caligari to Hitler* (1947) with reference to *The Triumph of the Will* (1935), he does suggest a genealogy linking the Nazi regime's "ornamental inclinations," as choreographed and eternalized by Leni Riefenstahl, with Fritz Lang's *Die Nibelungen* (1924), though he does not mention his earlier analysis of American-style mass displays (nor, for that matter, the Busby Berkeley musicals which developed that style to exuberant perfection by cinematic means).[53]

Even in the mass ornament essay, though, one can already discern the contours of Benjamin's analysis, in the epilogue of his artwork essay, of fascism as a politics that aestheticizes the masses, thus giving them an expression, instead of giving them their right (that is, to change property relations).[54] Kracauer's distress over the "muteness" of the mass ornament relates to a particular structure of miscognition and denial that he would soon focus on in his study on the salaried employees. Benjamin was to observe similar psychosocial mechanisms at work in the success of fascist mass politics, in particular the aesthetic pleasure in spectacles amounting to total destruction and self-destruction. A further trajectory could be drawn from Kracauer's mass ornament to Adorno's analysis of mass culture as hieroglyphic writing—as a modern form of pictographic script that facilitates the internalization of domination by keeping its author, namely, monopoly capitalism, invisible: "'no shepherd but a herd.'"[55]

Still, Kracauer is reluctant to name the transcendental subject of the mass ornament in an unequivocally pessimistic way. Despite his growing ambivalence, I would argue that he still wants to leave the space of the author and ideal beholder open for the empirical subjects who are present at these displays and to whom they are addressed. For the mass in the "ornament of the mass" (as the essay's German title translates literally) refers not only to the abstract patterns of moving bodies qua spectacle but also to the *spectating* masses "who have an aesthetic relation to the ornament and who do not represent anyone"—that is, nobody other than themselves, a heterogeneous crowd drawn "from offices and factories" (*MO* 77, 79). While the mass ornament itself remains "mute," it acquires meaning under the gaze of the masses that have adopted it "spontaneously" (*MO* 85). Against its detractors among the "educated" (who have themselves unwittingly become an appendix of the dominant economic system while pretending to stand above it), Kracauer maintains that the audience's *"aesthetic* pleasure" in the "ornamental mass movements is *legitimate*" (*MO* 79); it is superior to an anachronistic assertion of high-cultural values because at the very least it acknowledges "the facts" of contemporary reality. And even though the spectating masses are, in tendency, just as unaware of their situation and similarly stuck in mindless physicality, there is no question for Kracauer that the subject of critical self-encounter has to be, can only be, the masses themselves.[56] Whether or not such collective self-representation will have a chance to prevail is a matter of the "go-for-broke game" of history by which the technological media could either advance or defeat the liberatory impulses of modernity (*MO* 61).

Already in his 1926 essay on the Berlin picture palaces, "Cult of Distraction," Kracauer's argument revolves around the possibility that in these metropolitan temples of distraction something like a self-articulation of the masses might be taking place—the possibility of a "self-representation of the masses subject to the process of mechanization." Bracketing both cultural disdain and critique of ideology (though not without deadpan irony), he observes that in Berlin, as opposed to his native Frankfurt and other provincial cities, "the more people perceive themselves as a mass, the sooner the masses will also develop creative powers in the spiritual and cultural domain that are worth financing." As a result, the so-called educated classes are losing their provincial elite status and cultural monopoly. "This gives rise to the *homogeneous cosmopolitan audience* in which everyone is of *one* mind, from the bank director to the sales clerk, from the diva to the stenographer" (*MO* 325; *W* 6.1:210). That they are "of one mind" (*eines Sinnes*) means no more and no less than that they have the same taste for sensual attractions, diversions, or distractions.

The concept of *Zerstreuung,* diversion or distraction, in the radical twist that Kracauer gives the originally cultural-conservative term, combines the mirage of social homogeneity with an aesthetics of decentering and diverse surface effects,

at least as long as it prevails against industrial strategies of high-art aspirations and gentrification. In "the discontinuous sequence of splendid sense impressions" (which likely refers to an elevated version of the variety format that early cinema had adapted from live popular entertainment), the audience encounters "its own reality," that is, a social process marked by an increased heterogeneity and instability. Here Kracauer locates the political significance of distraction as a structurally distinct mode of perception: "The fact that these shows convey precisely and openly to thousands of eyes and ears the *disorder* of society—this is precisely what would enable them to evoke and keep awake that tension that must precede the inevitable radical change [*Umschlag*]" (*MO* 327; S 6.1:211).

It should be noted that Kracauer does not (at least not yet) assume an analogical relation between the industrial standardization of cultural commodities and the behavior and identity of the mass audience that consumes them—an assumption derived from Lukács's theory of reification that would become axiomatic both in Horkheimer and Adorno's critique of the culture industry and, with a more positive slant, in Benjamin's theses on art and technological reproducibility. For one thing, Kracauer does not condemn commodification, serial production, and standardization as such, as can be seen in his many positive reviews of popular fiction, especially detective and adventure novels, as well as in his repeated, if sometimes grudging, statements of admiration for Hollywood over UfA products.[57] For another, Kracauer would not have presumed that people who watched the same thing necessarily were thinking the same way; and if they did pattern their appearance and behavior on the figures and fables of the screen, the problem was primarily with the German film industry's circulation of escapist ideology on screen and the compensatory gentrification of exhibition. Again and again, in daily reviews as well as the series reprinted under the titles "The Little Shopgirls Go to the Movies" and "Film 1928," Kracauer castigated films that advanced their audience's denial of growing economic uncertainty and social volatility.[58] In other words, his critique was directed less against the lure of cinematic identification in general, as an ideological effect of the apparatus, than against the economic and political conditions responsible for the unrealistic tendency of such identification.[59]

The cinema is a signature of modernity for Kracauer not simply because it attracts and represents the masses but because it is the most advanced cultural institution in which the masses, as a relatively heterogeneous, undefined, and as yet little understood form of collectivity, constitute a new form of *public* (*Öffentlichkeit*). Lacking the coherence and familiarity of a traditional community, the metropolitan cinema audience represents a formation of primarily strangers defined by the terms of publicness. As Kracauer writes approvingly of Helmuth Plessner's *Grenzen der Gemeinschaft* (*Limits of Community*, 1924), "The forms and relations in the realm of the public . . . are rules of the game that forgo investing the real

'I' and, before anything else, grant respect to all players."[60] Strangers gather at the motion picture shows as spectators; that is, they engage in relatively anonymous yet collective acts of reception and aesthetic judgment in which they may recognize and mobilize their own experience in the mode of play. As Heide Schlüpmann has argued, Kracauer sketches a theory of a specifically modern public sphere that resists thinking of the masses and the idea of the public as an opposition (as still upheld by Jürgen Habermas in his 1962 study *The Structural Transformation of the Public Sphere*). Kracauer "neither asserts the idea of the public against its [actual or putative] disintegration and decline, nor does he resort to a concept of an oppositional public sphere" (in the sense of Negt and Kluge).[61] Rather, Kracauer sees in the cinema a blueprint for an alternative public sphere that can realize itself only through the destruction of the dominant, bourgeois public sphere that draws legitimation from institutions of high art, education, and culture no longer in touch with reality.

Alternative too, I would add, because, unlike the partial publics of the traditional labor movement, the cinema offers a public sphere of a different kind. Epitomizing the multiplication and interpenetration of spaces already advanced by other media of urban commercial culture (shop windows, billboards), the cinema systematically intersects two different types of space, the local space of the theater and the deterritorialized space of the film projected on the screen. It thus represents an instance of what Michel Foucault has dubbed "heterotopias": places that "are absolutely different from all the sites that they reflect and speak about." Sites of transportation like trains and planes, sites of temporary relaxation like cafés, beaches, and movie theaters function, in Foucault's words, as "something like counter-sites, a kind of effectively enacted utopia in which . . . all the other real sites that can be found within the culture are simultaneously represented, contested, and inverted."[62] Taking our cue from Foucault, we could read Kracauer's acknowledgment of the specifically modern type of publicness of cinema not just as sociological observation but also as a theoretical insight into the significance of the cinema's intersection of an anonymous yet collective theater experience with a product whose simultaneous mass circulation exceeded the local, national, and temporal boundaries of live events.[63]

As can be expected, Kracauer's leap of faith into a commercially based collectivity has earned him the charge that he naively tries to resurrect the liberal public sphere, thus unwittingly subscribing to the ideology of the marketplace.[64] To be sure, he insists on political principles of general access, equality, and justice and—perhaps more steadfastly than some of his Marxist, specifically Leninist, contemporaries—on the right to self-determination and democratic forms of living and organization. Yet Kracauer is materialist enough to know that these principles do not miraculously emerge from the rational discourse of inner-directed subjects, let alone from efforts to restore the authority of a literary public sphere.

Rather, cognition has to be grounded in the very sphere of experience in which modernization is most palpable and most destructive—in a sensory-perceptual, aesthetic discourse that allows for "a self-representation of the masses subject to the process of mechanization."

As I suggested earlier, Kracauer's concept of the masses developed within a force field defined by, on the on hand, elitist-pessimistic crowd theory (popularized by Le Bon and adapted by thinkers as disparate as Spengler and Freud) and, on the other, socialist and communist conceptions of the masses as traditional or revolutionary heroic working class. If Kracauer shared with crowd theory the assumption that the modern mass blurred traditional boundaries of class, he linked that assumption with the recognition of a new kind of publicness and a passionate inquiry into the conditions of possibility of mass democracy (in that sense pointing forward to Hardt and Negri's concept of the "multitude").[65] Where conservative crowd theory turns on the bourgeois intellectual's fear of the mass as powerful other, Kracauer displays an amazing lack of fear—fear of touch, violence, contagion—toward a social formation that he knew himself to be part of, whose experience he shared in a number of respects. Like his protagonist Ginster, he felt drawn to transitional, heterotopic spaces—such as train stations, harbors, and movie theaters—that allowed him to disappear in the anonymous, amorphous, circulating crowd, to be "between people" rather than "with them."[66] While going some way toward accounting for his cinephilia, Kracauer's nonphobic relation to the modern mass also made him a kind of seismograph, attuned as much to what was new and promising in this formation as to its political volatility.

The specifically modern mass that Kracauer was to track began to enter public awareness in Germany with World War I. Industrialized warfare, mass killing and death, mass starvation and epidemics had brought into view the masses as *object* of violence and disease (rather than, as in crowd theory, their putative subject and source). While social privilege protected to some extent against these ravages, the sheer scale made suffering as much a statistical probability as a matter of class. Following the revolution of 1919, which mobilized the image of the masses as a powerful agent, mass existence continued to be associated with the stigma of misery, culminating in the 1923 hyperinflation, which spread the experience of destitution far beyond the industrial working class. During the short-lived phase of economic recovery, however, the masses began to appear less as a suffering and more as a consuming mass—a mass that became visible as a social formation in collective acts of consumption.[67] And since consumer goods that might have helped improve living conditions (for instance, refrigerators) were still a lot less affordable than in the United States,[68] major objects of consumption were the fantasy productions, images of consumer goods, and environments of the new leisure culture. In these phenomena Kracauer discerned the contours of an emerging mass society that, for better or for worse, was productive in its very need and acts of consumption.

MASS CULTURE, CLASS, SUBJECTIVITY

The essay on the mass ornament invokes the language of conservative crowd theory while effectively undermining it. Seemingly rehearsing the standard oppositions, Kracauer delineates the mass against the organic community of the people qua *Volk*; against the higher, "fateful" unity of the nation; and, for that matter, against socialist and communist notions of the collective. While the community had secreted individuals "who believe themselves to be formed from within" (*MO* 76), the mass consists of anonymous, atomized particles that assume meaning only in other-directed contexts, whether mechanized processes of labor or the abstract compositions of the mass ornament. But for Kracauer the progressive aspect of the mass ornament rests precisely in this transformation of subjectivity—in the erosion of bourgeois notions of personality that posit "a harmonious union of nature and 'spirit'" and in the human figure's "*exodus* from lush organic splendor and individual shape toward the realm of anonymity" (*MO* 83; *S* 5.2:64). The mass ornament's critique of outdated concepts of individual personality turns the Medusan sight of the anonymous metropolitan mass into an image of liberating alienation and open-ended possibility, at times even a vision of diasporic solidarity; that is, Kracauer sees possibilities for living where others see only leveling and decline.[69] Put another way, the democratization of social, economic, and political life, the possibility of the masses' self-determination, is inseparably linked to the surrender of the self-identical masculine subject and the emergence of a decentered, disarmored and disarming subjectivity exemplified by figures such as Chaplin and Kracauer's own Ginster.

This vision, however, as Kracauer knew all too well, had more to do with the happy endings of fairy tales than with ongoing social and political developments. His more empirically oriented work on mass society focused on a group that personified the modern transformation of subjectivity and at the same time engaged in a massive effort of denial: the mushrooming class of white-collar workers or salaried employees to whom he devoted a groundbreaking series of articles in 1929, subsequently published as *Die Angestellten*.

Although by the end of the twenties salaried employees still made up only one-fifth of the workforce, Kracauer considered them, more than any other group, the subject of modernization and modern mass culture. Not only did their numbers increase fivefold (to 3.5 million, of which 1.2 million were women) over a period during which the number of blue-collar workers barely doubled, but their class profile was deeply bound up with the impact, actual or perceived, of the rationalization push between 1925 and 1928. The mechanization, fragmentation, and hierarchization of the labor process and the resulting threat of dequalification, disposability, and unemployment made the working and living conditions of the employees effectively proletarian. Yet, while actually a rather heterogeneous group

(comprising both upwardly mobile working-class and déclassé members of the bourgeoisie), they fancied themselves as a new *Mittelstand,* a middle estate rather than class, asserting their distinction from the working class by, among other things, recycling the remnants of bourgeois culture.[70] Unlike the industrial proletariat, they were "spiritually homeless," seeking escape from the everyday in the metropolitan picture palaces and entertainment malls like the Haus Vaterland or the Moka-Efti—in the very cult of distraction to which Kracauer, three years earlier, had still ascribed a radical potential. With the impact of the international economic crisis, the employees' self-delusion and frustrated ambition, as Kracauer was one of the first to warn, made them vulnerable to National Socialist propaganda; it was these "stand-up collar proletarians" who were soon to cast a decisive vote for Hitler.[71] In this sense, then, Kracauer's report "from the newest Germany" (the book's subtitle) reads not just as "a description of the modernization of everyday life" but at the same time as "a diagnosis of the beginning of the end of the first German republic."[72]

The salaried employees had been the object of research from unionist and sociological perspectives both before and during the Weimar period.[73] As a number of commentators have noted, several features distinguish Kracauer's study from these publications. Methodologically, while the study is directed toward empirical social reality, Kracauer problematizes the very notion of an empirically given reality: "Reality is a construction" (*SM* 32). This in turn mandates a method of self-aware critical construction that explores the subject "from its extremes," that is, through exemplary instances of the reality of salaried employees in Berlin, Germany's most advanced site of modernization (*SM* 25). Kracauer pioneers an eclectic mode of writing that combines literary and sociographic methods, though he distances his approach from that of the fashionable Weimar genre of left-wing reportage.[74] Claiming to reproduce authentic reality, he argues, reportage shares the limitations of photography as defined by its predominant positivist usage (a point Bertolt Brecht was to echo two years later).[75] "A hundred reports from a factory do not add up to the reality of the factory, but remain for all eternity a hundred views of a factory" (*SM* 32)—what is missing is a sense of context or relationality. By contrast, Kracauer experiments with a form he likens to a "mosaic," made up of quotations, conversations, and reflections, scenes and situations, images and metaphors. The fragmentary and citational character of the textual material also recalls Kracauer's earlier affinity with avant-garde practices of collage, in particular their valorization of ordinary, discarded, and found objects, and his explicit endorsement of modernist aesthetics in the visual arts and music.

The literary-aesthetic sensibility that informs Kracauer's text allows his own fascination with employee life and leisure to shine through and to complicate the study's more overt critique of ideology. Conversely, the critique of ideology also provides a means of distancing himself from this fascination.[76] A tension

between critique and fascination, distance and familiarity inflects the writing subject's position vis-à-vis the object of study. Kracauer understands himself as a "participant observer" and more than once draws attention to his own status as a salaried intellectual.[77] At the same time, he maintains a critical stance by seeking to render strange the new that is all too quickly naturalized, by drawing attention to the "exoticism of the everyday"—that is, "normal existence in its imperceptible dreadfulness"—which tends to elude "even radical intellectuals" (*SM* 29, 101; *W* 1:218, 304).

Like none of the period's other studies on the topic, *Die Angestellten* aims its heuristic lens at the junctures between the process of production and the sphere of consumption, between the rationalization of business and the business of distraction. The salaried employees emerge as the linchpin between the most advanced methods of capitalist production and the new entertainment culture. Specifically, they display a psychosocial profile that fuels Kracauer's exasperation in his essay on "contemporary film and its audience [*Publikum*]" (reprinted as "Film 1928"), in which he extends his critique of the German film industry to the "public sphere which allows this industry to flourish" (*MO* 307–8). Already in this context he comments on the changing composition of the cinema audience, a mainstreaming that draws not only working-class patrons from the small neighborhood theaters but also members of most other social strata to the downtown picture palaces; within this new audience, he singles out the "low-level white-collar workers," whose number had been rapidly increasing with rationalization, as the major moviegoing constituency. Furthermore, in both *Die Angestellten* and his 1927 article series on the "little shopgirls," Kracauer draws attention to the unprecedented prominence, and simultaneous subordination, of women in the employee workforce and their growing presence in the heterosocial environment of the movie theaters. The discrepancy between these women's new economic relevance, primarily as consumers and cheap labor, and their lack of real equality in social and legal status and the workplace increased their need for compensatory fantasies; in turn, they emerged as the subcultural addressee of the fables on screen.[78]

The reconfiguration of class, gender, status, and ideology is captured with epigrammatic precision in the juxtaposition of two anecdotes that open Kracauer's study:

I.

Before a Labor Court, a dismissed female employee is suing for either restoration of her job or compensation. Her former boss, a male department manager, is there to represent the defending firm. Justifying the dismissal, he explains *inter alia*: "She did not want to be treated like an employee, but like a lady." In private life, the department manager is six years younger than the employee.

II.

An elegant gentleman, doubtless a person of some standing in the clothes trade, enters the lobby of a metropolitan night club in the company of his girlfriend. It is obvious at first glance that the girlfriend's other job is to stand behind a counter for eight hours a day. The cloakroom lady turns to the girlfriend: "Perhaps Madam [*gnädige Frau*] would like to leave her coat?" (*SM* 27; *W* 1:215)

The juxtaposition of these vignettes illustrates the discrepancy between the employees' consciousness and their material conditions of living and yields a more nuanced account of the ideological tug-of-war that defines the ongoing "process of social mixing."[79] In the first vignette, the discrepancy results from the déclassé employee's bourgeois set of values, according to which age and gentility still command a certain respect—an expectation thwarted by rationalized business with its fetishization of youth and denigration of experience and the capitalist interest in a mobile labor force. The second vignette inverts the direction of social mobility: for the sales girl, barriers of class and status appear transcended in the medium of romance, antithetical yet not unrelated to the sphere of work (the "*Nebenberuf*," or "other job"). Ironically, class transcendence is facilitated, on the part of the entertainment business, by resurrecting the very discourse of genteel femininity that capitalist rationalization had deprived of its social and economic foundations.

As in the essay on the mass ornament, Kracauer does not posit the nexus between rationalized production and mass-cultural consumption as a simple analogy but complicates it through a series of subtle mediations. In the section devoted to the employees' leisure activities, "Shelter for the Homeless," he explores the reconfiguration of public and private in employee culture through an extended architectural-geopolitical metaphor that links images of home, homelessness, and a new global space. The discrepancy between the employees' consciousness and their increasingly precarious socioeconomic status makes them "spiritually homeless," as Kracauer varies on Lukács's influential phrase, all the more so since "the house of bourgeois ideas and feelings in which they used to live has collapsed, its foundations eroded by economic development" (*SM* 88). The literal dwelling or abode (*Zuhause* rather than *Heim*) that they inhabit does not afford them any of the traditional, that is, bourgeois-familial, ideals of protection, warmth, and intimacy. Kracauer reenacts this erosion of boundaries by metaphorically extending the space of "home" from a mere lodging to "an everyday existence outlined by the advertisements in the magazines for employees." These advertisements mainly concern "things"—material objects and tools—as well as the small breakdowns of the human body: "pens; Kohinoor pencils; haemorrhoids; hair loss, beds; crêpe soles; white teeth; rejuvenation elixirs; selling coffee to friends;

dictaphones; writer's cramp; trembling, especially in the presence of others; quality pianos on weekly installments; and so on" (ibid.).

The misery signaled by these public intimations of personal needs and anxieties drives the salaried masses to seek "shelter" (*Asyl*) at night in the "pleasure barracks" that beckon them with the glamour and light missing from their monotonous working day. Behind the international-modern façade of New Objectivity or Sobriety, the fantasy of a national home, eponymic in the *Haus Vaterland,* mingles with emblems of an exoticized global space, the Bavarian landscape of the Löwenbräu bar, "'Zugspitze with Eibsee—alpenglow,'" with the generic Americana of the Wild West Bar, "'Prairie landscapes near the Great Lakes—Arizona—ranch—dancing . . .—Negro and cowboy jazz band.'" From the Bavarian Alps to America, "the Vaterland encompasses the entire globe" (*SM* 92).[80] "The true counterstroke against the office machine . . . is the world vibrant with color. The world not as it is, but as it appears in the popular hits. A world every last corner of which has been cleansed, as though with a vacuum cleaner, of the dust of everyday existence" (*SM* 93).

The compensatory traffic between an all-too-close physical existence and the glamour of faraway places, like that of work and leisure, ultimately calls the very notion of home into question, as a sentimental residue of failed bourgeois promises propped onto an actual space. Kracauer's exploration of the entertainment malls' architectural geopolitics resonates with his evocation of a double exile—from both the stifling dreariness of the petty-bourgeois home and the alienating bustle of the modern city—in his reviews of Karl Grune's film *The Street* (discussed in chapter 1). If in the earlier texts he rhetorically identified with the film's lonesome wanderer, he now observes almost clinically how this mode of being was becoming paradigmatic of a modern, provisional, postconventional identity, a social identity no longer founded on tradition, origin, and class. In the meantime, however, the experience of the exiled individual had taken on mass proportions, with accordingly amplified social and political implications. In the entertainment malls, Kracauer states, "the masses play host to themselves; . . . not just from any consideration of the commercial advantage to the entrepreneur, but also for the sake of their own unavowed powerlessness." Mass culture furnishes, if not a home, then at least a house of mirrors. "People warm each other; together they console themselves for the fact that they can no longer escape from the herd [*Quantität*]" (*SM* 91–92; *W* 1:292). I read this observation less as a sarcastic commentary than as a trace of Kracauer's earlier insistence on the ambiguity of mass formations theorized in the essay on the mass ornament. Even in *Die Angestellten,* the pessimistic tenor of the study is punctured by the possibility, though weak at this point, of self-representation and self-reflection on a mass scale.

Rationalization and distraction dovetail specifically in the emergence of new forms of socialization and identity fashioning. Under the heading "Selection," Kracauer examines the criteria by which individuals succeed, or fail, in a competitive labor market. In addition to youth, which is paramount to employability and accordingly fetishized in employee culture, a generally "pleasant appearance" is as important as regular physical features and proper dress. The ideal personality is " 'not exactly pretty,' " Kracauer quotes a staff manager of a Berlin department store as saying; " 'what's far more crucial is . . . oh, you know, a morally pink complexion' " (SM 38). Neither too severely moral nor too passionately pink, the proper skin color is supposed to warrant an instantaneous legibility of inner qualities through outwardly visible features. This shift toward the visible exterior in turn encourages the cultivation of a uniform appearance on the part of the subjects under scrutiny. "It is scarcely too hazardous to assert that in Berlin a salaried type is developing, standardized in the direction of the desired complexion. Speech, clothes, gestures, and physiognomies become assimilated and the result of the process is that very same pleasant appearance which can be widely reproduced by means of photographs" (SM 39; W 1:230).

If the employees are taking on "a photographic face," to invoke Kracauer's photography essay (MO 59), they are assisted in this effort by the movies. The circularity of mass-cultural identity formation becomes a topos in Kracauer's writing around this time, as in the notorious statement from the shopgirls essay: "Sensational film drama and life usually correspond to each other because the mademoiselles-typists [Tippmamsells] fashion themselves after the models on screen; it may be, however, that the most spurious models are stolen from life itself" (MO 292; W 6.1:309). Kracauer's observation of a loop effect in the way mass culture has come to mediate the social construction of subjectivity anticipates similar observations in postmodern media criticism.

Kracauer's insights into the workings of mass-cultural subjectivity are thrown into relief by a comparison with Benjamin's reflections on the masses. As I discuss in more detail in chapter 3, these reflections oscillate between a turn-of-the-century pessimistic view of the mass or crowd, as distinct from the proletariat, and his attempt (famously in the artwork essay) to reclaim a progressive concept of the masses—in the plural—as revolutionary productive force by way of a structural affinity with technological reproduction, in particular film. Indebted to Béla Balázs, the assumption of such an affinity turns on the phenomenological claim that film, in Kracauer's paraphrase, "by breaking down the distance of the spectator that had hitherto been maintained in all the arts, is an artistic medium turned toward the masses."[81] Benjamin establishes the revolutionary potential of film from the by now familiar argument aligning the fate of art and the aesthetic with the rise of industrial-technological re/production. As a result, the masses figure primarily as the hypothetical subject of a technologically mediated mode of perception

rather than an empirical entity defined by the social, psychosexual, and cultural profile of the moviegoing public. The masses that Benjamin sees structurally corresponding to the cinema do not coincide with the actual working class (whether blue-collar or white-collar) but with the proletariat as a category of Marxist philosophy, a category of negation directed against existing conditions in their totality. As the self-sublating prototype of the proletariat, the cinematic masses are attributed a degree of homogeneity that misses the actual and unprecedented mixture of classes—as well as genders and generations—that had been observed in cinema audiences early on (notably by sociologist Emilie Altenloh in her 1914 study).[82] This construction ultimately leaves the intellectual in a position outside, at best surrendering to the masses' existence as powerful, though still unconscious, other. Where Kracauer self-consciously constructs the reality of the salaried employees through at once participatory and critical observation, Benjamin's image of the masses, whether projected backward into the nineteenth century or forward into the not-yet of the proletarian revolution, ultimately remains a philosophical, if not aesthetic, abstraction.

One could argue that Kracauer's analysis of mass culture as employee culture is just as one-sided as Benjamin's linkage of film and proletariat. He himself stresses the specificity of Berlin's leisure culture as a pronounced *Angestelltenkultur*, "i.e. a culture made by employees for employees and seen by most employees as a culture" (*SM* 32). Yet to say that this particular focus eclipses the rest of society, especially the working class, would be as misleading as to conceive of mass culture and employee culture as an opposition.[83] Rather, Kracauer's analysis recognizes the dynamic by which the subculture of the employees, with their self-image as new middle estate, was becoming hegemonic for society as a whole; in its fantasies of class transcendence and fixation on outward appearance and visuality, employee culture provided a matrix for a specifically modern, social and national, imaginary. In an article "on the actor" (occasioned by a radio lecture by Max Reinhardt), Kracauer links this process to the shift from industrial to finance capital, which makes even the executive director a salaried employee. "More and more people today turn into employees; they are employed, though, by a power that has no meaning."[84] The ostensible inevitability of the economic system encourages a social behavior of "role-playing." Increasingly removed from the production of material goods, individuals resort to acting in a double sense: "For one thing, they have to *play* a role because there is no substance that would tie them to a particular part; for another, they want to play a *role* because they are who they are not by themselves but by means of external recognition" (*S* 5.2:233).

This double sense of social role-play implies the possibility of a performative self-fashioning; at the same time, it circumscribes that creativity as specular and narcissistic. The cinema facilitates both tendencies through a phantasmatic mode of perception in which the boundaries between self and heteronomous

images are liquefied, revealed to be porous in the first place, allowing viewers to let themselves "be polymorphously projected" (*MO* 332; *S* 5.1:279). While in the mid-twenties this psychoperceptual mobility still beckoned Kracauer with pleasures of self-abandonment and anonymity, by the end of the decade it made him view "the unreal film fantasies" as the "*daydreams of society*," and thus symptomatic of contemporary ideology: "In reality it may not often happen that a scullery maid marries the owner of a Rolls Royce. But don't the Rolls Royce owners dream that the scullery maids dream of rising to their level?" (*MO* 292; *W* 6.1:309). In other words, by channeling legitimate dreams of upward mobility into a narrative *dispositif* that couples romance and class transcendence, the film industry organizes the "interplay of the fantasies of the ruling class with those of the ruled" (Benjamin);[85] it thereby generates and perpetuates a social imaginary that prevents the recognition of—and action upon—economic and class inequality.

In granting such film fantasies—and the desire bound up in them—a substance of their own, Kracauer implicitly distances himself from more orthodox Marxist concepts of ideology. To be sure, he shares and emphatically endorses the insight "that the form of our economy determines the form of our existence. Politics, law, art, and morality *are* the way they are because capitalism *is*."[86] And while he pinpoints particular ideologies and their internal dynamics, he nevertheless recognizes the logic of ideology in the singular, as a matrix that structures social relations and the cultural practices that work to diffuse the contradictions endemic to capitalist society. But for Kracauer the systemic character of ideology is not sufficiently accounted for by the commodity form or a Lukácsian logic of reification. Rather, he identifies equally important sources of systematicity in areas that orthodox Marxists would assign to a deterministically understood superstructure, in particular language and the unconscious. "This after all is the genius of language," he writes analyzing the signs in an unemployment office, "that it fulfills orders that were not given to it and erects bastions in the unconscious."[87]

In one of his two reviews of *Die Angestellten*, Benjamin acclaims Kracauer's literary, in particular satiric, forays into the psychic disposition that constitutes ideology as "false consciousness." As long as the Marxist doctrine of the superstructure does not address the genesis of false consciousness, he glosses Kracauer, one can only resort to the Freudian model of repression (*Verdrängung*) to answer the key question "How can the contradictions of an economic situation give rise to a form of consciousness inappropriate to it?"[88] The film fantasies not only reveal society's repressed wishes but also participate in the repression of those aspects of reality that would disturb the illusion of imaginary plenitude and mobility: "The very things that should be projected onto the screen have been wiped away, and its surface has been filled with images that cheat us out of the image of our existence" (*MO* 308)—an image that includes, we might fill in, "the tiny catastrophes that make up the everyday" (*SM* 62; *W* 1:258).

Kracauer's growing concern over the collective denial of misery and vio-lence makes him refrain from the more dialectical argument pursued by Ben-jamin regarding nineteenth-century mass culture, which would read fantasies of class transcendence and abundance as at once ideological and utopian, as myths expressing the desire for a classless society. Rather, he perceives an economic nexus between the reality of mass-cultural fantasies and the missing representa-tion of another, and other, reality: "The flight of images is a flight from revolution and from death" (*SM* 94). In his review, Benjamin radicalizes this insight by invert-ing the emphasis: "The more thoroughly [the immense desolation] is repressed from the consciousness of the strata overcome by it, the more creative it proves—according to the law of repression—in the production of images" (*SW* 2:308). In the economy of image production and repression, the business of distraction assumes a systematic function in capitalism's effort to generate and perpetuate a "consciousness inappropriate to it"—that is, to invest in a mass culture that demobilizes any potential resistance on the part of its customers and inures them to contradiction.

Kracauer's prescient insights into the functioning of mass-cultural ideology, specifically the psychoperceptual processes constituting subjectivity as a social imaginary, could well be considered in light of poststructuralist concepts of ideol-ogy, in particular film theory of the 1970s and '80s drawing on Lacan, Althusser, and Foucault, as well as postmodern media criticism in the vein of Guy Debord and Baudrillard.[89] This lineage, however, also elucidates the difference, both his-torical and philosophical, that speaks from his writings. The loop effect touched on earlier—"Does film imitate reality or does reality imitate film?"—is still to some extent hyperbole, troping on Oscar Wilde's apothegm of nature imitating art.[90] For one thing, Kracauer remains astonished that the cinema, itself a culturally despised phenomenon little more than a decade earlier, has assumed a key role in constructing social identity and thus has the power to marginalize and exclude whole areas of experience or to transmute any radical implications their represen-tation might have into narratives of uplift and upward mobility. For another, as he discerns how signature fads of Weimar culture—nature worship, body culture, sports, kinky eroticism—had acquired the systematicity of a social discourse, he confronts the question (for example in the photography essay and the shopgirls series) of how the media's simultaneous *exclusion* of vital realities tallies with their voracious *inclusion* of these realities, and what kind of mechanisms operate in the process of their coming into discourse.[91]

Kracauer's distress over what and how this discourse excludes is not necessar-ily synonymous with an endorsement of representational realism, to which his position was reduced by later critics. As I argue with regard to the photography essay, the reality in transition that he insisted mandated acknowledgment crucially included the experience of the materially contingent subject. The transformations

he was tracking in everyday existence, labor, and leisure culture revolved around the nexus between forms of subjectivity symptomatic of modern mass culture and the social and economic conditions that both enabled and regulated them. If he discerned in the cinema a powerful agent of these changes, he also imagined it as a sensory-perceptual *dispositif* that allowed a new kind of audience to grasp and engage with the discontinuities and contradictions of modern experience, and to do so in a public and collective form.

COMPETING MODERNITIES, NARROWING OPTIONS

I have traced Kracauer's reflections on mass culture from his welcoming of Americanist entertainment forms as surface phenomena more truthful to contemporary reality than efforts to restore bourgeois culture and as playful relief from traditional social norms; through his perception of the mass as public and of mass culture as a form of collective self-representation; to a more critical assessment of mass culture as an ideological matrix that advances an imaginary social and national identity. While these shifts do not necessarily mark an evolution toward a more "mature," realistic stance that would cancel out the earlier positions, they clearly respond to acute political and economic developments.

After the 1929 stock market crash and a sharp rise in unemployment internationally, American cultural imports such as jazz and chorus lines could not but seem inadequate and posthumous. As Kracauer writes in "Girls and Crisis" (1931), "as much as they may enthusiastically swing their legs, they come as a procession of phantoms out of a dead past."[92] At this point, the "muteness" of the mass ornament seems absolute, irredeemable; the chances that American-style entertainments could provide a critical supplement to rationalization were dwindling. Devoid of promises of abundance and equality, Fordist-Taylorist technology assumed a more sinister face; as Bloch put it regarding James Whale's *Frankenstein* (1931), the "golem" represents "technology with false consciousness, the fear of an America, without *prosperity*, of itself."[93] At the same time, the crisis of liberal democracy and rise of National Socialism brought into sharper view different national variants of modernization, whether adaptations of the American model or indigenous modernities competing with it.

In concluding this chapter, I sketch Kracauer's attempts to delineate alternative modernities and to assess them in light of mounting political pressure and diminishing options. The onset of the Great Depression reinforced Kracauer's critical stance toward technological modernization unaccompanied by changes in property relations and a public reflection on its psychosocial effects. Resuming his earlier critique of rationalization as a regime that seizes all domains of experience and reduces them to spatiotemporal coordinates, he increasingly assails the destruction of memory advanced as much by modern architecture and urban

planning as by illustrated magazines and the entertainment business. While occasionally still echoing the pessimistic critique of mechanization and a mechanistic reduction of life by the natural sciences on the part of *Lebensphilosophie*, Kracauer directs his misgivings not at technology as such but at the social conditions and protocols that regulate its uses and abuses. Praising *Battleship Potemkin* for, among other things, showing the "matter-of-fact interaction between humans and technology" in Soviet Russia, he pinpoints the separation of technological and spiritual spheres as a specifically German, and bourgeois, problem: "Where we engage in 'interiority' [*Innerlichkeit*], anything machinic meets with contempt. Where technology is the thing, spiritual matters are not exactly a concern. Cars travel through geographical space; the soul is cultivated in the parlor" (*W* 6.1:236). This split, in Kracauer's analysis, advanced a development in which the discourse of technological rationality increasingly served to naturalize the contradictions of capitalist modernity and turn it into a new mythical eternity.

It is not surprising that Kracauer rejected the tabula rasa mentality of what came to be called "hegemonic modernism." He remained skeptical throughout of aesthetic efforts to ground visions of social change in the model of technology, in particular as elaborated by the functionalist school of modern architecture and urban planning (Le Corbusier, Mies van der Rohe, Gropius, the Bauhaus). The "culture of glass" that Benjamin so desperately welcomed as the deathblow to bourgeois culture (and attendant concepts of "interiority," "trace," "experience," "aura") leaves Kracauer, an architect by training, filled with "scurrilous grief" over the historical-political impasse that prevents the construction of housing responsive to human needs.[94] He counters the functionalist crusade against the ornament (initiated by Adolf Loos) by showing how the repressed ornament returns in the very aesthetics of technology that ordains the mass spectacles of chorus lines, sports events, and party rallies. And he criticizes the knockoff Bauhaus style of *Neue Sachlichkeit* in the Berlin entertainment malls and picture palaces for its secret complicity with the business of distraction and the social repression of the fear of aging and death.

The site and symbol of modernist contemporaneity, simultaneity, and presentness is the city of Berlin, the "frontier" of America in Europe.[95] "Berlin is the place where one quickly forgets; indeed, it appears as if this city has a magical means of wiping out all memories. It is the present and puts its ambition into being absolutely present. . . . Elsewhere, too, the appearance of squares, company names, and stores change; but only in Berlin these transformations tear the past so radically from memory."[96] This tendency is particularly relentless on the city's major commercial boulevard, the Kurfürstendamm, which Kracauer dubs "street without memory." Its façades, from which "the ornaments have been knocked off," "now stand without a foothold in time and are a symbol of the ahistorical change that takes place behind them."[97] The spatialization of time and memory into a

seemingly timeless present, its uncoupling from temporality in the emphatic sense, blocks from public view any sites of actual decay, failure, and misery.

Like Benjamin, Kracauer found a counterimage to contemporary Berlin in the city of Paris. There, the "web"—"maze," "mesentry"—of streets allows him to be a real *flâneur*, to indulge in a veritable "street high" (*Straßenrausch*).[98] There, history is allowed to live on, and the present in turn has a glimmer of the past, inspiring memories "in which reality blends with the multistory [*vielstöckigen*] dream we have of it and garbage mingles with celestial constellations."[99] There, the crowds are constantly in motion, circulating, unstable, unpredictable, an "improvised mosaic" that never congeals into "readable patterns."[100] The impression of flux and liquidity in Kracauer's writings on Paris is enhanced, again and again, by textual superimpositions of ocean imagery (reminiscent of Louis Aragon's vision of the Passage de l'Opéra in *Paris Peasant*) and evocations of the maritime tradition and milieu. The Paris masses display a process of mingling that does not suppress gradations and heterogeneity and which goes so far that, as Kracauer somewhat naively asserts, even people of African descent can be at home—and be themselves—without being "jazzified" or otherwise exoticized.[101] There, too, the effects of Americanization seem powerless, deflected into aesthetic surplus, as in the case of the electric advertisements that project undecipherable hieroglyphs onto the Paris sky: "It darts beyond the economy, and what was intended as advertising turns into an illumination. This is what happens when businessmen meddle with lighting effects."[102] In Kracauer's play with literal and metaphoric senses of illumination, the aesthetic surplus eludes commercial intention and opens up a space for experience.

Paris, for Kracauer, is also the city of surrealism and the site of a film production that stages the jinxed relations between people and things in ways different from films adapting to the regime of the stopwatch. In the films of René Clair, Jacques Feyder, and Jean Vigo, Kracauer praises a physiognomic capacity that endows inanimate objects—buildings, streets, furniture—with memory and speech, an argument that bridges Balázs's film aesthetics with Benjamin's notion of an "optical unconscious."[103] It is this quality that Kracauer extols in the best Soviet films—for instance, when he refers to Dziga Vertov as a "surrealist artist who listens to the conversation that the died-away, disintegrated life conducts with waking things."[104] The physiognomic aesthetics of such films makes them enact the surrealist objective to "render strange what is close to us and strip the existing of its familiar mask," a formulation that echoes Benjamin's trope of a "dialectical optic" in his 1929 essay on surrealism.[105] What is more, the films' dreamlike, mnemonic power opens up a different temporality (different from both chronological-industrial time and the regularized pace of classical narrative films) and exposes the viewer to involuntary, physiologically experienced encounters with material contingency. Increasingly, however, Kracauer also took contemporary French filmmakers, especially Clair, to

task for lapsing into sentimentality and artsiness and for their romantic opposition to mechanization.[106]

As much as it offered the German writer asylum from the reign of simultaneity, speed, and dehumanization, Paris was not the alternative to Berlin or, for that matter, "Amerika." Nor did Kracauer—at least not until his "social biography" of Jacques Offenbach (1937)—seek to understand the crisis of contemporary mass modernity, as Benjamin did, in terms of the political legacy surrounding the emergence of mass culture in nineteenth-century France. For one thing, "Berlin" was already present in the topography of Paris, in the constellation of faubourgs and center (the latter corresponding to modernized Berlin) that he traces in his "Analysis of a City Map" (*MO* 41–44). For another, notwithstanding his alarm over the destruction in Germany of a basic civility that he found still existing in France,[107] Kracauer recognized that Berlin represented the inescapable horizon within which the contradictions of modernity demanded to be engaged. France was, after all, "Europe's oasis" as far as the spread of rationalization and mass consumption was concerned, and Clair's "embarrassing" spoof on the assembly line (in *A nous la liberté*) was only further proof of the French inability to understand "how deeply the mechanized process of labor reaches into our daily life."[108]

In his first longer essay on the French capital, "Paris Observations" (1927), Kracauer assumes the perspective "from Berlin," sketching the perceptions of someone who has lost confidence in the virtues of bourgeois life and who "even questions the sublimity of property," who "has lived through the revolution [of 1919] as a democrat or its enemy," and whose "every third word is *America*." While he does not exactly identify with this persona, by the end of the essay he clearly rejects the possibility that French culture and civility could become a model for contemporary Germany. "The German cannot move into the well-warmed apartment that France represents to him today; but perhaps one day, France will be as homeless [*obdachlos*] as Germany."[109] The price of Paris life and liveliness is the desolation and despair of the *banlieu* and the provinces that Kracauer describes in his unusually grim piece "The Town of Malakoff." Contemplating Malakoff's melancholy quarters, he finds, by contrast, even in the barbaric mélange of German industrial working-class towns signs of hope, protest, and a will toward change.[110] When he returns from another trip to Paris in 1931, he is animated by a political conversation on the train, and as the train enters Berlin's Bahnhof Zoo, the nightly city appears to him "more threatening and torn, more powerful, more reserved, and more promising than ever before."[111] In its side-by-side of "harshness, openness . . . and glamour," Berlin is not only the frontier of modernity but also "the center of struggles in which the human future is at stake."[112]

Paradoxically, the more relentlessly Kracauer criticizes the pathologies of massmediated modernity, the less he seems to subscribe to his earlier utopian thought that, someday, "America will disappear." In fact, the more German film production

cluttered the cinemas with costume dramas and operettas reviving nationalist and military myths, and the more the film industry accommodated to and promoted the political drift to the right, the more it became evident that America *must not* disappear, however mediocre, superficial, and inadequate its current mass-cultural output might be. The constellation that is vital to Kracauer's understanding of cinema and modernity is therefore not that between Paris and Berlin, but that between a modernity that can reflect upon, revise, and regroup itself, albeit at the expense of (a certain kind of) memory, and a modernity that parlays technological presentness into the timelessness of a new megamyth: monumental nature, the heroic body, the re-armored mass ornament—in short, the kind of Nazi modernism exemplified by Albert Speer and Leni Riefenstahl.

This constellation emerges from the juxtaposition of two vignettes that, like his writings on the circus, project the problems and possibilities of mass-mediated modernity onto an earlier institution of leisure culture, the Berlin Luna Park. In an article published on Bastille Day, 1928, Kracauer describes a roller coaster whose façade shows a painted skyline of Manhattan: "The workers, the small people, the employees who spend the week being oppressed by the city, now triumph by air over a super-Berlinian New York." Once they've reached the top, however, the façade gives way to a bare "skeleton":

> So this is New York—a painted surface and behind it nothingness? The small couples are enchanted and disenchanted at the same time. Not that they would dismiss the grandiose city painting as simply humbug; but they see through the illusion and their triumph over the facades no longer means that much to them. They linger at the place where things show their double face, holding the shrunken skyscrapers in their open hand; they have been liberated from a world whose splendor they nevertheless know.[113]

In the shrieks of the riders as they plunge into the abyss, Kracauer perceives not just fear but ecstasy, the bliss of "traversing a New York whose existence is suspended, which has ceased to be a threat." This image evokes a vision of modernity whose spell as progress is broken, whose disintegrating elements become available in a form of collective reception in which self-abandonment and *jouissance* provide the impulse for critical reflection.

Two years later, in an article entitled "Organized Happiness," Kracauer reports on the reopening of the same amusement park after major reconstruction. Now the attractions have been rationalized, and "an invisible organization sees to it that the amusements push themselves onto the masses in prescribed sequence," he writes, anticipating Adorno as much as Disney World.[114] Contrasting the behavior of these administered masses with the unregulated whirl of people at the Paris *foires*, Kracauer makes the familiar reference to the regime of the assembly line. Like the rationalized Sarrasani Circus, where the space for improvisation and

playful parody has disappeared with "the elimination [*Ausfall*] of the clowns," the organization of the refurbished Luna Park does not leave "the slightest gap."[115] When he arrives at the newly refurbished roller coaster, the scene has changed accordingly. Most of the cars are driven by young girls, "poor young things who are straight out of the many films in which salesgirls end up as millionaire wives." They relish the "illusion" of power and control, and their screams are no longer that liberatory. "[Life] is worth living if one plunges into the depth only to dash upward again as a couple [*zu zweit*]." The seriality of the girl cult is no longer linked to visions of gender mobility and equality, but to the reproduction of private dreams of heterosexual coupledom and fantasies of upward mobility. Nor is this critique of the girl cult available, let alone articulated, in the same sphere or medium as the phenomenon itself (unlike Hollywood's own *demontage* of the girl cult that Kracauer had celebrated in his review of Frank Urson's film *Chicago*[116]); rather, it speaks the language of a critique of ideology in which the male intellectual remains outside and above the largely female, and feminized, public of mass consumption.

The hallmark of stabilized entertainment, however, is that the symbol of the illusion has been replaced. Instead of the Manhattan skyline, the façade is now painted with an "alpine landscape whose peaks defy any depression [*Baisse*]." All over the amusement park, in fact, Kracauer notes the popularity of "alpine panoramas"—"a striking sign of the upper regions that one rarely reaches from the social lowlands." The image of the Alps not only naturalizes and mythifies economic and social inequity but also asserts an untouched, timeless nature, a place beyond contradiction and political crisis. Against the mass-mediated "urban nature"—with "its jungle streets, factory massifs, and labyrinths of roofs"—the alpine panoramas, like the contemporary mountain films, proffer a presumably unmediated nature as the solution to modernity's discontents.[117] The recourse to antimodern symbols does not make this alternative any less modern: As Kracauer increasingly excoriates the return, in German films and revues, of the Alps, the Rhine, Old Vienna and Prussia, of lieutenants, fraternities, and royalty, he recognizes it as a specific version of technological modernity, an attempt to nationalize and domesticate whatever liberatory, egalitarian effects this modernity might have had.

In his earlier discovery of "Amerika," Kracauer had hoped for a German version of mass-mediated modernity that would be capable of enduring the tensions between a capitalist economy in permanent crisis and the principles and practices of a democratic society. Crucial to this modernity would have been the ability of cinema and mass culture to function as a sensory-reflexive matrix in which a heterogeneous mass public could recognize and negotiate the contradictions they were experiencing, and in which they could confront otherness and mortality instead of repressing or aestheticizing it. Whatever stirrings of such modernity the Weimar Republic saw, it did not find a more long-term German,

let alone European, elaboration—Berlin never became the capital of the twenti-eth century. Instead, "Berlin" was polarized into an internationalist (American, Jewish, diasporic, politically and artistically radical) modernism and a Germanic one that assimilated the most advanced technology to the reinvention of tradi-tion, authority, community, nature, and race. When the National Socialists per-fected this form of modernism into the millennial modernity of total domination and mass annihilation, "America" had to become real, for better or for worse, for Kracauer and others to survive.

Benjamin

3

Actuality, Antinomies

While Kracauer's early writings on film, mass culture, and modernity have barely entered English-language debates, Benjamin's presence in these debates seems hopelessly overdetermined. During the past three decades, his famous essay "The Work of Art in the Age of Its Technological Reproducibility" (1936) may have been quoted more often than any other single source, in areas ranging from new-left theory to cultural studies, from film and art history to visual culture, from the postmodern art scene to debates on the fate of art, including film, in the digital world. In the context of these invocations, the essay has not become any less problematic than when it was first written, nor has it always acquired new meanings.

"Benjamin is enjoying a boom, but does he still have actuality?"[1] This question is inevitable at a time when our political, social, and personal lives seem more than ever to be driven by developments in media technology, and thus by an accelerated transformation, disintegration, and reconfiguration of the structures of experience. Indeed, if we pose the question of Benjamin's actuality in light of the tremendous changes associated with digital technology, it could easily be argued that his theses concerning the technological media, in particular their proclaimed revolutionary potential, belong to an altogether different period than ours, and that his major prognostications have been proven wrong, at the latest with the advent of the digital and the global consolidation of capitalism.[2] But to reach such a conclusion is perhaps not the reason we read Benjamin today.

To begin with, Benjamin's own, avowedly esoteric concept of *Aktualität* (evoked in the above quotation) should caution us not to measure him against a standard defined by the inexorable advance of media technology, especially if the latter is posited as an epistemic if not ontological apriority rather than a development inflected by economic and political conditions and cultural practices. Fusing a messianic notion of *Jetztzeit,* or time of the Now, with the project of a materialist historiography, Benjamin's concept of actuality sets itself off against any unreflected contemporaneity, be it the market-driven new or the ostensibly neutral up-to-date of its intellectual proponents.[3] For Benjamin, actuality requires standing at once within and *against* one's time, grasping the "temporal core" of the present

in terms other than those supplied by the period about itself (as Kracauer put it), and above all in diametrical opposition to developments taken for granted in the name of "progress."[4]

Whether we dismiss Benjamin in the name of current media theory or try to assimilate him to it, we would miss out on much of his contribution to a theory of modern culture. Benjamin's concern with film and technological media is inseparable from, on the one hand, his philosophy of history, which pivots on the question of modernity, and, on the other, his theory of the aesthetic, which encompasses both the organization of sensory perception, understood historically, and the fate of art and artistic practice in the narrower sense. In his persistent efforts to interrelate those domains, the cinema came to figure as the linchpin between the transformations of the aesthetic and the impasses of contemporary history. Unless we keep in view these larger stakes of Benjamin's project, we cannot fully grasp what lent his reflections on film and the technological media and their paradigmatic impact on art and culture such prescience for decades to come. In tracing the complex and often contradictory logic of this project, we may gain a more nuanced and more realistic purchase on his actuality for film and media theory today.

Questions of modernity, the aesthetic, and technological reproduction are nowhere as tightly entwined as in the artwork essay. As is often pointed out, Benjamin conceived of the essay in conjunction with his vast work on nineteenth-century Paris, *The Arcades Project*. Their common focus, articulated most clearly in the 1935 exposé of the latter, was the effects of industrial capitalism on art and the reorganization of human sense perception. He considered the essay "most intimately related" to the historiographic project, less in terms of subject matter than in its function as a methodological device: that of an epistemological "telescope," the building of which led him to discover "some fundamental principles of materialist art theory."[5] In a letter to Max Horkheimer, he described the artwork essay as an effort "to determine the precise point in the present to which my historical construction will orient itself."[6] Far from assuming a stable observation platform (which he imputed to hermeneutical historicism), this "vanishing point" in the present was defined by the ongoing crisis—the triumph of fascism in Germany and the threat of its expansion in France, the collapse of an existing socialist alternative with the reign of Stalinism—and the challenge to imagine an all-but-impossible future.[7] "If the project of the book is the fate of art in the nineteenth century, this fate has something to say to us only because it is contained in the ticking of a clock whose striking of the hour has just reached *our* ears."[8] The heightened stakes of the situation made Benjamin discover, as he wrote to Gretel Karplus (later Adorno) around the same time, "that aspect of art in the nineteenth-century that only 'now' becomes recognizable, in a way in which it has never been before and will never be again." And he calls this discovery a "decisive example" of his concept of the

" 'Now of recognizability [*Jetzt der Erkennbarkeit*],' " a "very esoterically" understood concept around which "crystallizes" his theory of cognition.[9]

The crescendo of the time machine, the tolling of the bell, the pairing of danger and cognition—such imagery attunes us to the rhetorical form of the artwork essay: a set of militant theses defined by their tactical, interventionist value rather than their validity as an empirical account, a partisan manifesto rather than a presumably neutral scholarly treatise. If Benjamin's theses claim actuality for the time they were written, they do so because they were also, in the Nietzschean sense, untimely. This was not lost on Max Horkheimer, who recognized that Benjamin's "fundamental statement" was directed at the "problematic of the French situation," that is, the issue of the (in)adequacy of the cultural politics of the Popular Front against the threat of fascism; he therefore insisted on its swift publication in French in the *Zeitschrift für Sozialforschung,* the organ of the Institute for Social Research, then being published in Paris. At the same time, Horkheimer saw to it that passages referring explicitly to Marx and communism, along with the methodological first section, were omitted in the French translation, for fear that the essay would be read as an attack of Popular Front politics and that a public controversy might endanger the work of the institute in exile.[10]

Such an attack, however strategically encoded, seems indeed not far from Benjamin's line of argument, even if the ostensible target of the essay was the more extreme case of belated aestheticism on the right. He sought to launch his theses in the wake of the Congress for the Defense of Culture, held in Paris June 21–25, 1935, which preceded the forming of the political alliance against fascism by bourgeois democratic parties, socialists, union politicians, and communists on July 14 of the same year.[11] The congress had been convened in response to the mounting alarm among French intellectuals that after the defeat of the left in Germany fascism would also rise to dominance in France—a fear massively confirmed by the bloody riots of February 1934 in which forty thousand right-wing demonstrators threatened to take over the streets of Paris. The writers' congress, with the exception of the famously dissenting speeches by Bertolt Brecht and André Breton, provided a cultural platform for the Popular Front that advocated the preservation of the "literary heritage," in particular the great works of "realism"; absolute aesthetic values; socialist humanism; and an organic relationship of the artist with the community of "the people." In terms of communist literary politics, the espousal of these ideals (by, among others, Johannes R. Becher and ex-surrealist Louis Aragon) entailed not only surrendering important Marxist positions—and the very mention of Marx—but also a turning away from avant-garde, experimental, and in the widest sense, modernist work. In that regard, the communist left merely followed suit with the suppression of such work by Stalinist cultural politics beginning in 1931, sanctioned by a more general political rapprochement between Paris and Moscow.[12]

In view of the cultural-political platform of the Popular Front, which Benjamin considered stuck in regressive and dangerous illusions, the artwork essay was untimely on several counts. It explicitly invoked Marxian axioms but transformed and updated them to address the current crisis; what's more, it imbricated them—in the essay's original versions—with the tradition that Benjamin, in the 1929 essay on surrealism, referred to as "anthropological materialism."[13] In the spirit of that tradition, the artwork essay foregrounded the question of technology, with its fundamental implications for the fate of art and sensory experience under industrial capitalism and its central role in the political confrontation with fascism. But his concept of technology was at least as indebted to Charles Fourier and other utopian socialists as to Marx.[14] Moreover, where Benjamin elaborated on film as the art of technological reproducibility par excellence, he drew his examples—Chaplin, Mickey Mouse—just as freely from Western commercial film production as from Soviet cinema; by contrast, references to French poetic realism (for instance, the films of Jean Renoir, Julien Duvivier, and Marcel Carné), the type of cinema most obviously in accord with Popular Front cultural politics, were conspicuously absent.

Above and beyond the immediate target of its intervention, Benjamin's essay still commands actuality on account of its complex temporality, which is deeply entwined with his philosophy of history.[15] For the telescope as which he conceived the artwork essay combines two temporal registers. One is aimed at the nineteenth century, in particular the effects of industrialization on art and the aesthetic as brought into view by the current crisis; the other is pointed "through the blood-heavy mist at a mirage of the nineteenth century" that Benjamin was "attempting to depict according to the features that it will manifest in a future state of the world liberated from magic."[16] In other words, the historical-materialist perspective that allows Benjamin to formulate a more astute and prescient assessment of the ongoing crisis than that offered by contemporary leftist cultural politics intersects with a utopianist, in a messianic sense ahistorical, if not antihistorical, perspective that seeks in the dreams of the past the promises of a future beyond the ongoing catastrophe. Hence the very historicity of Benjamin's theses enables them to have another actuality—and other, virtual actualities—in the present, whether indirectly, as a methodological and cognitive impulse, or substantively, inasmuch as they prompt us to trace, in their analysis of the major crisis of Western capitalist modernity in the twentieth century, both the transformations of this modernity and the legacy of its continuing impasses in the twenty-first.

Broadly speaking, if Benjamin's theses still "reach our ears," this is due to the way he linked his critique of the Western aesthetic tradition (primarily German and French), specifically an institution of art perpetuating notions of beautiful semblance, timeless truth, mystery, and creative genius, to a wider concept of the aesthetic that he understood, echoing Alexander Baumgarten, as the "theory

[*Lehre*] of perception that the Greeks called aesthetics."[17] In both narrow and expanded senses, he considers the aesthetic in relation to the changing conditions of human experience (*Erfahrung*), a term that pertains not only to the organization of sensory perception but crucially to—individual and collective, conscious and unconscious—memory, the imagination, and generational transmissibility.[18] At this point in history, Benjamin warns, the aesthetic can no longer be defined in terms of artistic technique alone, let alone by the idealist values developed in the nineteenth century. Rather, the political crisis demands an understanding of the aesthetic that relates artistic technique to urban-industrial technology and its impact on the conditions of perception, experience, and agency.

It is at this juncture that Benjamin locates the historic role of film—as the most advanced technological medium of his time that, more than any other art form, demonstrated the shift in political significance from an individual to a collective subjectivity. This role turns on the cinema's particular, at once metonymic and reflexive, relationship with technology. As he writes in the artwork essay: "*The function of film is to train human beings in apperceptions and reactions needed to deal with a vast apparatus whose role in their lives is expanding almost daily*" (SW 3:108). And, in a less optimistic vein: "*The most important social function of film is to establish equilibrium between human beings and the apparatus*" (SW 3:117).

This function of film, however, is as much cognitive and pedagogical as it is remedial and therapeutic—insofar as it responds to an adaptation of technology that had *already failed* on a grand scale and seemed to be heading for worse. While he was more acutely aware than most German intellectuals of his generation (except, perhaps, Ernst Jünger and Martin Heidegger) of the centrality of technology in the struggle over the direction of modernity, Benjamin's position on technology was at least as ambivalent as his attitude toward art and tradition. If he discerned the cinema as the foremost battleground of contemporary art and aesthetics, it was not because of a futurist or constructivist enthusiasm for the machine age, but because he considered film the only medium that might yet counter the devastating effects of humanity's "bungled [*verunglückte*] reception of technology," which had come to a head with World War I.[19]

The reception of technology had miscarried, in Benjamin's view, because the capitalist and imperialist exploitation of technology, in his rendition of the familiar Marxian argument, had turned this productive force from its potential as a "key to happiness" into a "fetish of doom."[20] Whether in industrialized warfare, rationalized labor, or urban living, technology was implicated in the process that Susan Buck-Morss has analyzed as a dialectics of anaesthetics and aestheticization.[21] Like Simmel and other theorists of modernity, Benjamin was interested in the nexus between the numbing of the sensorium in defense against technologically caused shock and the emergence of ever more powerful aesthetic techniques, thrills, and

sensations in the nineteenth-century industries of entertainment and display (world exhibitions, panoramas, and other viewing/moving machines)—the phantasmagoria of the nineteenth century he explored in *The Arcades Project*. Designed to pierce the defensive shield of consciousness in the momentary experience of shock, awe, or vertigo, such hyperstimulation further contributed to the thickening of the protective shield and thus effectively exacerbated sensory alienation. By the 1930s, this dialectics of anaesthetics and aestheticization had impaired human faculties of experience, affect, and cognition on a mass scale, thereby paralyzing political agency and the collective ability to prevent the deployment of technology toward self/destructive ends.

In delineating the place of film and the technological media in Benjamin's account of modernity, I therefore want to reactivate a trajectory between the alienation of the senses that preoccupied Benjamin in his later years and the possibility of *undoing* this alienation that he began to theorize beginning with *One-Way Street* (1923–26; 1928), and I will do so through his concepts of innervation, mimetic faculty, optical unconscious, and *Spiel* (play, performance, game, gamble). He assigns film a key role in this trajectory because, on the one hand, film participates in the pathologies of industrial-capitalist technology at large, inasmuch as it subjects the sensorium to yet more shock and compounds the effects of defensive numbing with an aesthetics of phantasmagoria; and because, on the other, film provides a medium of experience that, more effectively than the traditional arts, enables both a sensory recognition of human self-alienation and a nondestructive, mimetic adaptation of technology. Put another way, the alienation of the senses that abets the deadly violence of imperialist warfare and fascism can be undone only on the terrain of technology itself, by means of new media of reproduction that allow for a collective and playful (that is, nonfatal) innervation of the technologically transformed *physis*.

As I hope to show, the problems that Benjamin addressed and the solutions he variously proposed elude classification in either techno-utopian or media-pessimistic terms. His speculations on film and mass-mediated culture still speak to our concerns because the problems he articulated and the antinomies in which his thinking moved persist in the globalized media societies of today—in different forms and on a different scale, to be sure, but with no less urgency and no more hope for easy solutions. His actuality consists, not least, in the ways in which the structure of his thinking highlights contradictions in media culture itself, now more so than ever.

My approach in this respect shares the emphasis on the antinomic structures in Benjamin's work that critics have described in various ways, following his own observation that his thinking, like his life, "moved by way of extreme positions."[22] Benjamin's "radical ambivalence" (John McCole) or "*ontology* of extremes" (Irving Wohlfarth) was not just a matter of his temperament and friendships but

also the mark of a methodical, tactical self-positioning within the contemporary intellectual field at a time of major upheaval and crisis.[23] If his epigrammatic, at times authoritarian style rarely admitted ambivalence within one and the same text (unlike Kracauer's rhetorical staging of ambivalence), Benjamin was capable of unflinchingly switching positions from one essay to the next, to the point of assigning to identically phrased observations diametrically opposed valences.[24] Rather than mere inconsistency, I consider such position-switching a radical attempt to think through the implications of the contradictory developments he confronted, guided by an experimental, performative attitude acutely aware of the risks involved in each position.

At the risk of being reductive, let me tentatively describe the antinomic structure of Benjamin's thinking with regard to the technological mass media. Position A welcomes the then-new media—photography, film, gramophone, radio— because they promote the "liquidation" of the cultural heritage, of bourgeois-humanist notions of art, education (*Bildung*), and experience that have proved bankrupt in, if not complicit with, the military catastrophe and the economic one that followed—at any rate inadequate to the social and political reality of the masses after the failed revolution of 1919. At this historic crossing, Benjamin turns his back on the decaying aura, the medium of beautiful semblance that cannot be salvaged anyway, and tries to promote "a new, positive concept of barbarism," most radically in his programmatic essay "Experience and Poverty" (1933), which finds the contours of such a new barbarism in the contemporary "glass-culture" (Loos, Le Corbusier, Klee, Scheerbart, Brecht) broadly associated with the Bauhaus and the vernacular of Neue Sachlichkeit, or New Objectivity (*SW* 2:732, 734). (This liquidationist, presentist, collectivist position, commonly taken to be the message of the artwork essay, has for a long time dominated Benjamin's reception in cinema and media studies, from Brechtian film theory of the 1970s through cultural studies.)

Position B, formulated in the wake of the Nazis' rise to power and in view of the "approaching war" (which Benjamin foresaw as early as 1933) and to be found in his essays on Baudelaire, Proust, and Leskov, laments the decline of experience, synonymous with "the demolition of the aura in immediate experience of shock [*Chockerlebnis*]."[25] The decline of experience, *Erfahrung* in Benjamin's emphatic sense, is inseparable from that of memory, the faculty that connects sense perceptions of the present with those of the past and thus enables us to remember both past sufferings and forgotten futures.[26] On this account, the media of audiovisual reproduction merely consummate the process inflicted on the human sensorium by the relentless proliferation of shock in Taylorized labor, urban traffic, finance capital, and industrial warfare, by further thickening the defensive shield with which the organism protects itself against excessive stimuli and thus numbing and isolating the faculties of experience. Moreover, by vastly expanding the archive

of voluntary memory or conscious recollection, the technological media restrict the play of involuntary memory. What is lost in this process is the peculiar structure of auratic experience, that is, the investment of the phenomenon we experience with the ability *to return the gaze*—a potentially destabilizing encounter with the other. What is also lost is the element of *temporal disjunction* in this experience, the intrusion of a forgotten past that disrupts the fictitious progress of chronological time.

But Benjamin's positions on film and mass-mediated modernity cannot be reduced to the antinomy of "liquidationist" versus "culturally conservative" (McCole), nor to the antinomic opposition of "distraction" versus "destruction" (Gillian Rose).[27] For both positions hook into each other in ways that may generate the possibility of change, but may just as well turn into a *mise-en-abîme*. The problem Benjamin recognized is that each position contains *within* itself another antinomic structure whose elements combine with those of its opposite in either more or less destructive ways. The most disastrous combination was currently pioneered by fascism, while alternative possibilities were eroded, in different ways, in the liberal capitalist media and Stalinist cultural politics. In the fascist mass spectacles and glorification of war, the negative poles of both positions outlined above combine to enter into a lethal, catastrophic constellation. That is, the atrophy of perceptual and cognitive capabilities resulting from the defense against industrially generated shock described in position B is compounded with the technologically enhanced monumentalization of aesthetic effects, the aestheticist perpetuation or, rather, simulation of the decaying aura whose rejection defines position A. Thus, in the fascist mise-en-scène of nationalist phantasmagoria and war, "a sense perception altered by technology" reaches a degree of "self-alienation" that makes humanity "experience its own annihilation as a supreme aesthetic pleasure" (*SW* 3:122).

In view of this constellation, the historical trajectory of shock-anaesthetics-aestheticization analyzed by Buck-Morss looks less like a dialectic than an accelerating spiral or vortex of decline, culminating in a catastrophe that only the revolution or the Messiah could stop. The crucial question therefore is whether there can be an imbrication of technology and the human senses that is not swallowed into this vortex of decline; whether Benjamin's egalitarian, techno-utopian politics could be conjoined with his emphatic notion of experience turning on memory and temporality; and whether and how the new mimetic technologies of film and photography, in their imbrication of "body- and image-space," could be imagined as enabling the "collective innervation" of technology he discerned in the project of the surrealists (*SW* 2:216, 217).

In what follows, I delineate Benjamin's reflections on film as both an aesthetic phenomenon with its own logics and a medium through which he registered salient tendencies and contradictions of mass-based modernity. The remainder of

this chapter is devoted to the artwork essay—its history of reception, its textual and rhetorical strategies, and the resulting conceptual limitations. In particular, I put into question the liquidationist tenor of the essay (especially in its familiar third, 1939 version)—and, by implication, the facile reproduction of this tenor in the essay's standard reception—along with the politically progressive purchase derived from it. The subsequent chapters move outward from the textual body (or bodies) of the artwork essay, focusing instead on key concepts either present in all versions, such as *aura, self-alienation,* and the *optical unconscious,* or cut from the second (first typewritten) version of 1936, such as *innervation, play,* and, not to be forgotten, the figure of Mickey Mouse. I will trace these concepts through Benjamin's work of the surrounding period, particularly his writings on surrealism, hashish, photography, and the "mimetic faculty," on Proust, Kafka, and Baudelaire, as well as the Arcades Project. One of my goals is to defamiliarize the artwork essay, rethink its claims more generally, and make it available for different readings. The other, larger goal is less a faithful reconstruction of what Benjamin said about film and the technological media (though that, too) than an attempt to extrapolate from his observations and speculations elements of a Benjaminian theory of cinema, of a media aesthetics and politics in his expanded sense of both terms, that might still claim actuality.

THE ARTWORK ESSAY: TEXTUAL STRATEGIES, CONCEPTUAL CASUALTIES

There was never a time when Benjamin's artwork essay was not controversial— from the moment the typewritten, "second" version (the first was a handwritten draft) arrived on Horkheimer's desk and provoked Adorno's substantial response of March 18, 1936; through the cuts imposed by Horkheimer on the essay's first publication—translated into French by Pierre Klossowski—in the *Zeitschrift für Sozialforschung* (vol. 5.1, 1936); to the revised, "third" German version, which remained a work in progress as late as 1939 and appeared only posthumously in *Illuminationen* (1955), edited by Adorno and Friedrich Podszus.[28] There it rested until the late sixties when Benjamin's writings were discovered by the German new left and student movement.[29] The artwork essay became something of a red flag, in a literal sense, held up as a revolutionary alternative to Horkheimer and Adorno's pessimistic critique of the "culture industry" in *Dialectic of Enlightenment* (1944; 1947). Part of the ongoing revival of the repressed legacy of leftist debates of the 1920s and '30s, the essay—along with other Benjamin texts written under the influence of Brecht, such as "The Author as Producer" (1934)—offered students a different vision of intellectual and cultural practice than that represented by their teachers, even and especially scholars on the left affiliated with the Frankfurt School. Adorno in particular was attacked for his mandarin stance, and he soon became

the target of a persistent polemic against the textual and interpretive monopoly of Benjamin's Frankfurt editors, with charges of censorship pointing back to the institute's handling of Benjamin's more explicitly Marxist and Brechtian writings of the 1930s.[30] These controversies set the pattern for the more genteel quarrels to come, with critics and friends asserting the priority of a primary, singular identity for their elusive subject, be it that of Jewish-messianist, Brechtian modernist, surrealist, esoteric man of letters and elegiac critic of modernity, materialist historian, media theorist, or deconstructionist *avant-la-lettre*.

With the English-language publication of selected essays by Benjamin in *Illuminations* (1969), some of the earlier terms of reception were replayed and expanded.[31] Within film theory, the artwork essay was soon assimilated to debates on Brechtian cinema that took place during the 1970s in the British journal *Screen* and elsewhere; its particular blend of Marxism and formalism, different from yet complementing the simultaneously rediscovered writings of the Russian formalists, made the essay part of a genealogy for "political modernism."[32] Its reputation as a revolutionary and popular alternative to Horkheimer and Adorno's pessimistic-elitist analysis of the culture industry became a topos in English-language reception across the disciplines, from new-left theories of mass culture to Cultural Studies.

During the past two decades, the essay has gained renewed currency in the field of film history, specifically with efforts to situate *early* cinema (from the 1890s to the 1910s) in relation to the perceptual, aesthetic, and cultural transformations associated with modernity.[33] Such efforts have in turn provoked criticism of the essay itself, in particular its assumption of the historical mutability of human sense perception, leading to a dispute over the usefulness of the very category of modernity for an empirically and stylistically oriented film history.[34] To the extent that they are concerned less with the correctness of Benjamin's politics of film and media culture than with the questions he raised and the historical and theoretical perspectives he opened up, these debates provide a useful background for the following.

My discussion of the artwork essay in this chapter implicitly responds to some of the more common assumptions about the essay (largely based on the familiar third version published in *Illuminations*), especially the misreading of its revolutionary politics as an endorsement of proletarian, if not popular, culture and its concomitant concepts of the masses and distraction. These assumptions derive, in no small measure, from problematic aspects of the text itself, its rhetorical and conceptual operations, which I will trace in some detail. The point of my discussion is not a matter of getting the artwork essay "right" as against oversimplified readings and appropriations, but of clearing a space for more productive ways of reading it.

While the first and second versions of the essay differ in important ways from the third, the basic argument is already in place. A rough sketch of that argument might go somewhat like this: The technological reproducibility of traditional works of art and, what is more, the constitutive role of technology in the media of film and photography have affected the status of art in its core. Evolving from the large-scale reorganization of human sense perception in capitalist-industrial society, this crisis is defined, on the one hand, by the decline of what Benjamin refers to as aura, the unique modality of being that has accrued to the traditional work of art, and, on the other, by the emergence of the urban masses, whose mode of existence correlates with the new regime of perception advanced by the media of technological reproduction. The structural erosion of the aura through the technological media converges with the assault on the institution of art from within by avant-garde movements such as dada and surrealism. In terms of the political crisis that is the essay's framing condition, two developments have entered into a fatal constellation: first, the cult of the decaying aura qua belated aestheticism (from *l'art pour l'art* to Stefan George) and on the part of avant-gardists such as futurist F. T. Marinetti who supply an ideological link to fascism; second, fascism's wedding of aestheticist principles to the monumental, particularly in the spectacular formations of the masses that give them an illusory sense of expression and that culminates in the glorification of war. In this situation of extreme emergency, Benjamin concludes, the only remaining strategy for intellectuals on the left is to respond to the fascist aestheticization of politics with the "politicization of art" as advanced by communism.

As has often been noted, this conclusion raises more questions than it answers. What did communist art politics mean in 1936 (or for that matter, in 1939)? What did Benjamin mean by politics? What was his concept of revolution? Which "masses" did he have in mind—a utopian collective, the proletariat, the moviegoing public, or the psychopathological mass mobilized by racist-nationalist politics? How does the dichotomous conclusion tally with his argument about the revolutionary role of film in relation to art, sense perception, and urban-industrial technology?

Before addressing any of these questions, we need to understand that the artwork essay is neither "about" film as an empirical phenomenon nor, for that matter, about any other preconstituted, given object. Rather, it is concerned with the structural role Benjamin ascribes to film as a hinge between the fate of art under the conditions of industrial capitalism and the contemporary political crisis, which pivots on the organization of the masses. As a medium at once causally and reflexively related to the "crisis in perception" (*SW* 4:338), film emerges as an exemplary battleground for the realization of the progressive possibilities of a technologically based art form against the industrial and political fabrication of

auratic effects on a mass scale. In that sense, the essay delineates a larger "force field" in which film emerges as "the most important subject matter, at present, for the theory of perception which the Greeks called aesthetics" (SW 3:120).[35]

That said, if Benjamin's understanding of film has any basis in historical film practice, it is clearly not the cinema of the 1930s (be it Hollywood, French Poetic Realist, or German under National Socialism). On the contrary, many of the aesthetic qualities he ascribes to film in general are more characteristic of a preclassical mode of film practice that Tom Gunning, adapting Eisenstein, has dubbed the "cinema of attractions." For instance, Benjamin elaborates his notion of an "optical unconscious" by way of examples in which scientific curiosity and aesthetic pleasure coincide, singling out cinematic techniques such as the close-up, slow motion, and montage that function both as tools of cognition and as objects of fascination in themselves. Likewise, the idea that *"every person today can lay claim to being filmed"* (SW 4:262; GS 1:492) harks back, beyond Soviet cinema, to early nonfiction films that focalized cinematic pleasure around the self-representation of bystanders, workers leaving a factory, or crowds milling about fairgrounds and other local sites.[36] Moreover, in the sections on photography and on the screen actor, Benjamin observes a dehierarchization of the human figure in relation to the inanimate but lived environment, a materialist interplay between humans and things, actors and props already extolled by Kracauer. This nonanthropocentric tendency, too, is more pronounced in early cinema, especially slapstick comedy, trick films, adventure serials, and early nonfiction genres, than in classical cinema, which works to rehumanize the technological medium through modes of narration and composition centering on psychologically defined, individuated characters.

Above all, the difference from traditional art that Benjamin ascribes to cinema's relations of *reception* is more characteristic of early cinema than of the classical paradigm that became hegemonic after World War I. Specifically, his point that film images assault the viewer in a tactile, shocklike manner makes more sense vis-à-vis the *presentational* style of early films (as well as Soviet montage films) than the *representational* style of classical cinema. Whereas the former tend to organize their space frontally and thus appear to directly address a collective audience in the theater space, the latter resorts to strategies derived from the proscenium stage and the well-made play, offering the viewer (virtual) access to a closed diegetic world through continuity editing, narrative absorption, and focalization on psychologically motivated characters.[37] Moreover, the artwork essay's valorization of distraction (as opposed to the contemplative reception of traditional works of art) presupposes a type of cinema experience still patterned on the variety format, that is, the programming of shorter films (interspersed with or framed by live performances) on the principle of maximum stylistic or thematic diversity.[38] The radical potential of a distracted mode of reception, however, theorized by Kracauer

a decade earlier, was by then being neutralized by the gentrification of exhibition and a more integrative style of programming centering on the classical narrative feature or a prestigious art film.

How are we to understand this anachronism? Is it simply that Benjamin, not exactly a regular moviegoer and cinephile like Kracauer, had formed his aesthetics of film at an early stage and failed to update it with the transition to classical cinema? Not very likely. For one thing, as film historians focusing on the entire cinema experience (rather than just the development of film style) have pointed out, preclassical modes of programming and reception persisted long after the classical paradigm had been systematically elaborated and become a stylistic norm in American film production and, to varying degrees, in other national cinemas as well.[39] Also, the aesthetics of attractions did not simply disappear or get absorbed by narrative integration but, as Gunning contends, continued as an underground current, in marginal practices such as avant-garde films and animation and even in mainstream genres such as the musical (to say nothing about its reincarnation since the 1970s in a cinema of special effects). For another, if Benjamin emphasizes pre- or nonclassical aspects of cinema, he resumes the dual perspective articulated by avant-garde artists and intellectuals of the 1920s—that is, an enthusiasm for the radical, utopian possibilities of the new medium and a simultaneous critique of cinema's actual development, in particular its opportunistic recourse to traditional literary and theatrical conventions. In this spirit, for instance, dadaists and surrealists celebrated the cinema's "primitive" heritage, such as slapstick comedy with its anarchic physicality; American serials with their high speed and attention to material objects; trick films in the style of Méliès, Cohl, Bosetti, and Feuillade; or early nonfiction films on scientific subjects and defamiliarizing glimpses of the quotidian.[40]

By 1936, Benjamin's recourse to Soviet montage film, celebrated by leftist writers of the twenties as a model for realizing at once the cinema's aesthetic and political potential, was assuming a similar tactical belatedness.[41] In referring positively to Dziga Vertov's *Three Songs of Lenin* (1934), he must have been aware that Vertov, along with others, had been denounced as "formalist" and since 1930 was able to work only under massive constraints, having become, as Annette Michelson put it, "cinema's Trotsky."[42] (Of course, instead of *Three Songs of Lenin* Benjamin could have chosen *Man with a Movie Camera*, the film that earned Vertov the verdict of formalism and that, in important ways, provides a cinematic intertext for the artwork essay, in particular its earlier versions.)[43] The invocation of Vertov, especially—and *only*—in the third version of the essay that Benjamin was still hoping to get published in Moscow (at least until its rejection by *Das Wort* in 1937), had to be intended as a gesture of solidarity and an implicit critique of Stalinist cultural politics, just as the essay's overall argument put itself squarely against the official communist dogmas of cultural heritage and socialist realism.[44]

As for contemporary cinema in the West, Benjamin had no illusions that, instead of advancing a revolutionary culture by emancipating art from cult, the media of technological reproduction were lending themselves to reactionary political forces—first and foremost in the fascist restoration of myth through mass spectacles and newsreels. Likewise, he discerned attempts to resurrect the technologically extinguished aura in liberal-capitalist film production, whether in the cult of the movie star (which "preserves that magic of the personality which has long been no more than the putrid magic of its own commodity character") or in the art film's more elevated efforts at re-auratization, encapsulated in Max Reinhardt's *A Midsummer Night's Dream* (1935) and Franz Werfel's praise for the film.

In view of this situation, Benjamin readily conceded that "as a rule the only revolutionary merit that can be ascribed to today's cinema is the promotion of a revolutionary criticism of traditional concepts of art" (*SW* 4:261). While that in itself would have been no small feat, Benjamin knew well that the more far-reaching claims he invested in film—its potential for making human self-alienation apprehensible and productive, its enabling of a mimetic, playful innervation of technology—were not necessarily borne out by mainstream production. It is *because* Benjamin was so acutely aware of the politically and aesthetically retrograde and dangerous uses of the technological media, especially though not only in Germany, that he resumed the perspective of the 1920s avant-garde, as much for its emphasis on the cinema's past opportunities and unrealized promises as for its iconoclastic attacks on bourgeois art. Rather than a nostalgic reprise, however, such recourse was mandated by the twin objectives that a revolutionary art theory addressing the impasse of the present situation would have to accomplish: *first*, to throw into relief the link between the perpetuation of bourgeois concepts of art under capitalism and fascist strategies of mobilizing the masses; and *second*, to set forth an alternative contained in—and already demonstrated by—the aesthetic practices spawned by the technological media, yet held back by the political-economic conditions.

To that purpose, Benjamin forges his text into an arena of crisis. The essay does not *describe* a given crisis; it rather *stages* a crisis through the particular construction of the essay.[45] Like many of Benjamin's major texts, the artwork essay has its own method of exposition and argument, a stylistic and rhetorical design responding specifically to the logic of its subject matter. Framed by a preface and an epilogue, the essay (in its third version) consists of fifteen discrete sections or theses, which highlight, from distinct vantage points, different aspects of the problem posed in the title, the question of art under conditions of technological reproducibility. It could be argued that these sections are arranged to suggest alternating camera setups or, to use Benjamin's words, a "sequence of positional views" (*SW* 4:259). Thus, we might think of them as master shots taken from the

larger perspectives of, respectively, the institution of art and the aesthetic, includ-
ing film; reproduction technology and changes in human sense perception; and
the political formation of the masses. We could trace this design through more
detailed textual moves patterned on cinematic devices such as closer framing,
parallel editing, or superimposition—the whole essay could be considered an
example of modernist literary and artistic practices predicated on cinematic
montage. But above and beyond a New Objectivist desire to let "the facts" speak
for themselves, the model of cinematic montage offered Benjamin a mode of
representation or, more precisely, presentation that would yield meanings the
individual "views" did not have in themselves, that would allow him to project a
different, virtual reality.

It is well known that Benjamin himself advocated—and, from *One-Way Street*
through *The Arcades Project*, experimented with—"carry[ing] over the principle of
montage" into the field of writing, in particular historiography.[46] In the case of the
artwork essay, this practice does not simply result in, as it were, a theory film, but
translates into a performative method. Just as cinematic montage creates mean-
ings by juxtaposing elements that have neither a self-evident, intrinsic meaning
nor given, familiar relations among each other, the essay constitutes its object not
by way of a linear addition of individual propositions but rather in the interplay
of hitherto unconnected "positional views." By placing film at the intersection of
three different trajectories—the fate of art and the aesthetic under industrial capi-
talism; technology and sense perception; mass politics—the essay constructs the
significance of film in terms of the logics of each of these trajectories and makes it
the locus and medium in which they intersect. Thus, as both object and method,
film brings into visibility a larger political and historical force field.

Above all, the model of cinematic montage offered a *temporal* dynamic that
allowed Benjamin to think against and beyond the overwhelming facticity of the
present situation, to imagine an alternative to the all-but-certain catastrophe.
In the methodological preface to the essay (in all-German versions), Benjamin
invokes the Marxian axiom, from the 1859 preface to *A Contribution to the Critique
of Political Economy*, that the development of the productive forces under capital-
ist relations of production not only exacerbated the exploitation of the proletariat
but also created conditions that would make it possible for capitalism to abolish
itself. He complicates this axiom by shifting the contradiction between productive
forces and productive relations to the superstructure, specifically by pinpointing
the slowness of cultural production in catching up with changes in the material
conditions of production and reproduction. If the effects of these changes can be
assessed only now, more than half a century later, any such assessment must in
turn "meet certain prognostic requirements." What is called for, Benjamin makes
perfectly clear, are less theses on "the art of the proletariat after its seizure of power,
and still less . . . any on the art of the classless society," than "theses defining the

tendencies of development of art under the present conditions of production" (*SW* 3:101; *GS* 7:350). In other words, the essay seeks prognostic power by tracing long-term transformations that come into focus only in the present crisis; but this approach, he wagers, allows him to make predictions concerning the status of art in a technologically transformed environment that dart beyond the political and personal catastrophe to be borne out in future decades.

The essay enacts its temporal agenda by outlining major "tendencies of development" in distinct areas and intercutting them at increasingly closer range. This accelerated montage produces a heightened sense of "actuality" that pits the forgotten or marginalized futures of the new media against the catastrophic vision of the epilogue, the implicit point of departure from and against which the montage of developmental tendencies is mounted. To be sure, these tendencies are sketched with the broad brush of a philosophy of history (which has earned the essay numerous criticisms in detail).[47] But the point of Benjamin's theses is less to establish a historicist account of the past than to highlight, through a montage of these developments, possibilities "of creating an openness to the future."[48] At a more pragmatic level, Benjamin's procedure has to be seen as an attempt to produce an actuality equal to the present state of emergency—actuality understood, in Irving Wohlfarth's words, as "a matter of actualizing the specific potential of this particular now."[49]

The crisis staged by the essay is, first and foremost, a crisis of and within art. Its mise-en-scène targets intellectuals who refuse to recognize the impact of fundamental changes in the material conditions of production and reproduction on artistic practices and who perpetuate a cult of seemingly autonomous aesthetic effects or, worse, revive these effects in heroic and military contexts. This trajectory is explicitly spelled out in the essay's epilogue (and thus provides a lens for understanding the essay's retroactive structure), which reads fascism's monumentalist organization of the masses and glorification of war as a political culmination of the tradition of aestheticism. The introduction of aesthetics into politics, which denies the masses their right to changed property relations, is compounded with a similar "violation" or rape (*Vergewaltigung*) of the vastly expanded technology whose "natural," productive utilization is deflected into an "unnatural" one in militarization and war.[50] Thus contemporary history makes the crisis in art part and parcel of the political crisis.

The more comprehensive, anthropological or species-political development that links the two, however, is a world-historical crisis in perception—of *aisthesis* in the wider sense conceived by "the Greeks" and resumed by Baumgarten. To quote the famous passage in its entirety: "'*Fiat ars—pereat mundus*,' says fascism, expecting from war, as Marinetti admits, the artistic gratification of *a sense perception altered by technology* [emphasis added]. This is evidently the consummation of

'*l'art pour l'art.*' Humankind, which once, in Homer, was an object of spectacle for the Olympian gods, has now become one for itself. Its self-alienation has reached the point where it can experience [*erleben*] its own annihilation as a supreme aesthetic pleasure" (*SW* 3:122; *GS* 7:384).

The process that leads to this deadly miscognition on a cosmic scale is accounted for in terms of the changes that capitalist-industrial technology, metropolitan living, and phantasmagoric entertainment have inflicted on the human sensorium, the spiral of aesthetics and anaesthetics discussed above. In light of this etiology, the subsequent closing slogan cannot but appear inadequate to the task of disrupting that spiral. The assertion that communism responds to the fascist aestheticizing of politics by politicizing art rings hollow—at least, that is, without the anthropological-materialist elaboration, in the essay's 1936 version, of Benjamin's concept of politics[51]—and invites later readers to fill it with romantic notions of proletarian culture that he had explicitly omitted and implicitly opposed.

The leap of faith required to get from an argument about sensory-perceptual alienation to communist cultural politics encapsulates the disjunctive relationship between the main body of the essay's text and the epilogue. The rhetorical escalation of alternatives—either liquidation of the cultural heritage or (self-)liquidation of the human species—creates a hiatus that Gillian Rose has analyzed in terms of an incommensurability between the eschatological stakes of the epilogue and the endorsement of collective reception in distraction.[52] Whether or not, in view of the overwhelming facticity of fascism, imagining an alternative future would have depended on an apocalyptic break, the point is that the conditions for this alternative already exist, *virtual yet immanent,* in the possibilities evoked by Benjamin's theoretical montage. If the weak version of that futurity amounts to "a general and mild politics of distraction" (Rose), the stronger version, articulated in the essay's earlier incarnations, suggests a rather more bold and far-reaching politics of mimetic innervation (see below, chapter 5).

The rhetorical production of an actuality equal to the state of emergency comes at a cost. Pushing the developmental tendencies in art and aesthetics to the point of crisis, that is, the death-or-life choice between fascism and the revolution, it imposes a dichotomous structure upon the essay's argument. Having established the terms *aura* and *masses* as dichotomies, he groups other key categories around that opposition: distance versus nearness, uniqueness versus multiplicity and repeatability, image versus copy, cult versus exhibition value, individual versus simultaneous collective reception, contemplation versus distraction. (Significantly, the only terms that elude this dichotomous structure are the concepts of the optical unconscious and that of a simultaneously tactile and optical reception.) The accumulated force of these oppositions sets the reader up for the crisis spelled out in

the epilogue, leading to the either-or choice between communist political art and the phantasmagoria of fascism.

To be sure, this conceptual polarization is programmatic, and has been so for Benjamin beginning with his advocacy of a "new, positive concept of barbarism" in his essay "Experience and Poverty," published in Prague in December 1933; it has to be understood as a radical response to a near-hopeless polarization of political reality. But such polarization does not necessarily yield *polarities*, in the Goethean sense of (electromagnetic) opposites that require each other in order to produce a force field.[53] Rather, it divides the field into dichotomous—either-or—camps, if not antinomic positions (in the sense that a political meeting or public opinion may be polarized into factions that no longer speak the same language). As a result, the respective concepts assume a seemingly stable identity and clear-cut oppositional valences. If justified by what Benjamin recognized earlier than others as an extremely dangerous situation heading toward another war, we should still bear in mind that the artwork essay's dichotomous use of concepts contrasts with Benjamin's distinctive—and much commented upon—mode of theorizing in the larger body of his writings; more often than not, individual concepts tend to overlap, blend, and interact with other concepts, just as their meanings oscillate depending on the particular constellations in which they are deployed.

The major casualty of the artwork essay's rhetorical strategy is the concept of aura, particularly in its relation to the masses. Having proposed a connection between the withering of the aura and the emergence of the masses as historical subject in section two (three in the earlier versions), the essay stages a more systematic encounter between the two terms in section three (four in the earlier versions), concerned with long-range changes in the modality of human sense perception. Going beyond the formal-stylistic analyses of the Viennese School (Alois Riegl, Franz Wickhoff), which he invokes, Benjamin points to the social transformations that find their "expression" in these perceptual changes, troped as the decay of the aura. If the aura is defined as "the unique appearance [*Erscheinung*] of a distance, however near it may be," its decay is based in two circumstances, each related to the "increasing significance of the masses in contemporary life," namely: "*the urge of the present-day masses to 'get closer' to things spatially and humanly, and their equally passionate concern for overcoming each thing's uniqueness [Überwindung des Einmaligen jeder Gegebenheit] by appropriating it in the form of its reproduction*" (SW 4:255; GS 1:479).

Seeking to avoid the appearance of technological determinism, Benjamin ascribes the media's ability to mass-reproduce and circulate images and sounds previously confined to a unique existence in space and time to an urge or concern on the part of the masses. But the masses' subjecthood is in turn subsumed under the mode of perception he delineates by way of contrast with the aura. In other

words, he treats *aura* and *masses* as if they were parallel categories, standing for opposed, if not mutually exclusive, regimes of perception.

> Every day the urge grows more irrefutable to get hold of an object at close range in an image [*Bild*] or, rather, in a facsimile [*Abbild*], a reproduction. And the reproduction [*Reproduktion*], as offered by illustrated magazines and newsreels, differs unmistakably from the image. Uniqueness and permanence are as closely entwined in the latter as are transitoriness and repeatability in the former. The stripping of the veil from the object, the demolition of the aura, is the signature of a perception whose "sense for sameness in the world [*Sinn für das Gleichartige in der Welt*]" has so increased that, by means of reproduction, it extracts sameness even from what is unique. Thus is manifested in the field of perception what in the theoretical sphere is noticeable in the growing significance of statistics. (SW 4:255–56; GS 1:479–80)[54]

The passage elaborates the thesis of perceptual transformation along two distinct, if partly intersecting, axes: the first defined by spatial and temporal categories such as nearness versus farness as well as ephemerality and repeatability versus permanence; the second pertaining to the object's mode of being in relation to others, defined in such terms as sameness versus uniqueness, multiplicity or seriality versus singularity.

As we shall see, these two axes correspond to two distinct lines of argument in Benjamin's reflections on film and mass culture. Beginning with *One-Way Street* (1923–26; 1928), he attempts to track a new, physiologically experienced and tactile relationship with images, writing, and things—especially things modern (including "kitsch")—which film and advertising were articulating in particularly striking ways. In the 1929 essay on surrealism, he describes this phenomenon as an interpenetration of "body and image-space" (*SW* 2:217); in the artwork essay, he elaborates on how film's "interpenetration of reality with the apparatus" (*SW* 4:281; GS 1:503) effects new configurations of body- and image-space at the levels of both representation and reception. What is at stake here is nothing less than an assault on the regime of central perspective and, along with it, a reconfiguration of boundaries that had traditionally divided—and hierarchized—subject and object, vision and body, individual and collective, human and mechanical. The line of argument pertaining to repeatability, as we shall see, involves the idea of film as a form of play (*Spiel*) that allows for a nondestructive, mimetic innervation of technology.

The axis that pits sameness against uniqueness, on the other hand, involves transferring a quality of perception associated with technological reproduction—the seriality of mass-produced images, their ostensibly identical mode of exhibition and consumption—onto the masses, the collective subject of new modes of perception. In conflating the masses' "passionate concern" with a perceptual regime ascribed to the media of technological reproduction, Benjamin effectively elides the masses as a collective subject—with a class profile, psychosocial dynam-

ics, and publicness of their own—and turns them into a function or, to use his term, a "matrix" of historical tendencies in the field of perception (*SW* 4:267).

Sameness qua identity stands in implicit distinction from similitude or similarity (*Ähnlichkeit*), a key concept in Benjamin's theory of the mimetic faculty and related to his concept of experience.[55] Similitude is hardly ever manifest or overt; it is opaque, whether "distorted" (as in the 1929 essay on Proust and "A Berlin Childhood around 1900") or "nonsensuous" (as in the 1933 essays on the mimetic faculty).[56] One perceptual model of similitude is the process of dreaming, "in which everything that happens appears not in identical but in similar guise, opaquely similar to itself" (*SW* 2:239); another is the hashish experience.[57] Distorted similarity becomes a medium of cognitive experience, in the emphatic sense of memory. Benjamin thought of Proust as ceaselessly "emptying the dummy, his self," in order to keep garnering "the image which satisfied his curiosity or, more precisely, assuaged his homesickness . . . for the world distorted in the state of similarity, a world in which the true surrealist face of existence breaks through" (*SW* 2:240; *GS* 2:314). If the world itself is distorted—whether the reasons for this distortion are sought in Marxist or Jewish mystical terms—the only adequate mode of representation is one that displaces and destroys the obvious: a "distortion of distortion."[58]

Sameness is still dialectically entwined with similarity in "Hashish in Marseilles" (1932), in which the phrase "sense for sameness in the world" has a subject and an attribution: a sailor named Richard who appears in a novella by the Danish writer Johannes V. Jensen. "Richard was a young man with a sense for everything in the world that was the same" (*SW* 2:677; *GS* 4:414).[59] Benjamin contrasts the "rational-political" meaning of that phrase—its implied reference to thorough mechanization and rationalization—with the "individual-magic" meaning of his hashish experience, which had sharpened his sense for nuances, only to conjoin both in an apparent paradox: "For I saw only nuances, yet these were the same" (*SW* 2:677).

In the artwork essay, young Richard is replaced with the "contemporary masses" as the collective subject of the sense for sameness. Concomitantly, nonsensuous similarity as the perceptual condition for the mimetic faculty in modernity is submerged into the manifest iconicity of photographic representation. Deprived of its dialectical relation with similarity—and thus also of mnemonic and historical dimensions—the sense for sameness is now aligned with the "growing significance of statistics," polytechnical education, and popular expertise. With that move, however, Benjamin abandons the project he had been pursuing in the preceding decade: to reconceptualize the conditions of possibility for experience in modernity, in full awareness that experience had lost its practical value and congealed into an outdated bourgeois ideology. Nonetheless, a contemporary equivalent to experience was needed because the disabling of experiential facul-

ties was a crucial factor in the deepening political crisis. Crucial to this project was the effort to confront the challenge of technologically altered—and at any rate mediated—perception and, in the same move, to reimagine the conditions of individual experience for a collective subject.

MASSES, DISTRACTION

In my earlier discussion of Kracauer, I argue that Benjamin's concept of the masses, especially in the artwork essay, remains a philosophical if not aesthetic abstraction, a subjective correlative of changes in the organization of perception in modernity—a point elaborated above. In what follows, I complicate this assessment by tracing Benjamin's thinking about the masses as the locus of ambivalence that gives rise to a different, more productive line of argument.[60]

Like Kracauer, Benjamin sees the phenomenon of the modern mass manifest itself primarily in acts of consumption and reception, mediated by the fetish of the commodity (which he defines less from the perspective of production and exchange, as Marx did, than from one of desire, following Simmel).[61] But where Kracauer's analysis focuses on the present, Benjamin tracks the origins of mass culture in the nineteenth century, notably in his vast project on the Paris arcades. In this genealogy, he highlights the emergence of the metropolitan masses in the writings of Baudelaire, as well as Hugo, Poe, and others. Like Marx, Benjamin contrasts the urban masses depicted by the literati with the "iron [mass] of the proletariat": "They do not form any particular class or any structured collective; rather, they are nothing but the amorphous crowd of passers-by, the people in the street [Straßenpublikum]" (SW 4:320–21; GS 1:618). As is often noted, the ingenuity of Benjamin's reading is that he traces the presence of this urban crowd in Baudelaire's poetry as a "hidden figure," the "moving veil" through which the poems stage moments of "shock," as opposed to the literal depictions one finds in the poet's lesser contemporaries. As in Baudelaire, Benjamin sees the epochal turn toward the masses encoded in the architecture, fashions, events, and institutions of high-capitalist culture.

When confronting the more overt, precariously empowered reality of the masses in the twentieth century as a key factor in the ongoing political crisis, he still invokes the logic of the commodity, though in a more neutral, empirically inflected mode. In a draft note for the artwork essay, Benjamin asserts: "The mass reproduction of artworks is not only related to the mass production of industrial goods but also to the mass reproduction of human attitudes and activities" (GS 1:1042).[62] The mass circulation of images of human behavior in film and photography makes the consumers of these images themselves into objects of standardization and commodification. This observation could be read as anticipating Horkheimer and Adorno's point that the culture industry aims at repro-

ducing the consumers as consumers; yet it also resonates with the less apodic-
tic efforts on the part of writers such as Kracauer and Bloch to understand the
role of the mass media in new forms of fashioning personal and collective identity
and expression.[63]

The cinema audience as an empirical phenomenon confronts Benjamin with a
kind of collective—or rather, public—that clearly differs from the working-class
masses assumed by traditional leftist and labor politics, as well as from the amor-
phous mob demonized by turn-of-the-century crowd psychology. This problem
first emerges in his discussion of the screen actor, which is one of the sites of major
discrepancy between the 1936 and 1939 versions.[64] In both versions, the alienation
the screen actor experiences in the interaction with the apparatus is inseparable
from the awareness that his mirror image has become "detachable" from his person
and "transportable"; in the earlier version, it is transported "to a site in front of
the mass [die Masse]," the ultimate authority that tests the actor's performance or
artistic achievement (SW 3:113; GS 7:369–70). In the later version, however, Benja-
min replaces "the mass" with the more neutral term "audience [Publikum]," which
he now qualifies (probably in response to Adorno's criticism on that point) as "the
consumers who constitute the market." The capitalist entertainment market, where
the screen actor "offers not only his labor but his entire self, with skin and hair,
with heart and kidneys, is beyond his reach" (SW 4:261; GS 1:491–92); it makes him
a human commodity at the mercy of buyers who remain invisible to him. In the
earlier version, the screen actor's test performance or achievement (Testleistung)
had been defined as "asserting his humanity (or what appears to them as such)"
in the face of the apparatus and thus "placing that apparatus in the service of his
triumph"; thereby he takes "revenge" on behalf of the "masses," the "city-dwellers"
who, "throughout the workday in offices and factories, have to relinquish their
humanity in front of an apparatus" (SW 3:111). The idea that the actor is doing
vicarious battle with technology places the audience on the side of the performer;
by contrast, the later version's emphasis on the market assumes that viewers iden-
tify with the testing position of the camera (SW 4:260).

Notwithstanding the slippage between masses and consumers, Benjamin goes
on to generalize the notion of the audience as "examiner" and "quasi expert" into
an argument about the media's role in the democratization of culture, in particular
their advancing of a less axiomatic, more functional distinction between actor and
audience, author and reader. The politically progressive purchase of this argument
not only derives from a shift to Soviet cinema, where some of the performers
are not professional actors "but people who portray themselves"; it also accrues
from the assertion that "every person today can lay claim to being filmed." Citing
Three Songs of Lenin and Joris Ivens's Borinage—that is, examples of (marginalized)
Soviet and (marginal) Western European film practice that foreground everyday
life and labor—Benjamin asserts that this claim is legitimate, even as—and espe-

cially because—it is blocked by the capitalist film industry or, worse, diverted into its surrogate, the exploitation of star cult and fandom. The validity of this assertion, however, depends less (as it did for Kracauer) on the institutional conditions of mass participation, that is, the conditions of cinema culture, than on a medium-specific potential for the self-representation of the masses.[65] By appealing to an almost mystical egalitarianism inherent in cinematic technology, Benjamin rhetorically conflates semiotic and political registers of representation—thus reducing the problematic of each—and makes the latter vouch for the revolutionary potential of the former.

Yet Benjamin had no illusions regarding the contemporary masses; he knew all too well that class-conscious self-representation was not necessarily the direction in which dominant formations of collectivity were heading. On the contrary, the artwork essay proceeds from the assumption that the masses are not an intrinsically progressive productive force but a problem, if not *the* problem of modern politics—which the essay links to capitalist society's failed innervation of technology and the resulting alienation of collective sense perception. The capitalist film industry's "cult of the audience" (the consumerist complement to the star cult) merely enhances the "corrupt condition" of the contemporary masses, which in turn meets the objective of fascism to suppress their class consciousness (*SW* 3:113; *GS* 7:370).

It is at this point that Benjamin, in the "Urtext" of the essay, inserts a footnote that offers the most detailed discussion anywhere in his work on the question of the masses, particularly in relation to class and violence.[66] Excoriating the "ambiguous" concept of the masses in the German revolutionary press for fostering illusions with "disastrous consequences," he differentiates the proletarian masses from the "compact mass" of the petty bourgeoisie. With explicit reference to Le Bon and so-called mass psychology, he sees the petty bourgeois mass defined by "panic-prone" behavior such as war fever, anti-Semitism, and blind striving for self-preservation.[67] To the emotionality of the compact mass he opposes the "collective *Ratio*" guiding the revolutionary proletariat. The proletarian masses, while perceived by their oppressors as a compact mass, lose their ostensible compactness in the measure as they are disaggregated by class consciousness and solidarity; in fact, in the proletarian class struggle, "the dead, undialectical opposition of individual and mass is abolished." What is more, the shock (*Erschütterung*) of revolutionary action may cause an internal upheaval within the petty-bourgeois mass that "loosens" its composition and enables it to join "class-conscious cadres." This historic possibility is prevented by fascism, which mobilizes the masses by aestheticizing, racializing, and militarizing them, thus preserving their compact character and perpetuating their counterrevolutionary instincts. The proletariat, by contrast, "is preparing for a society in which neither the objective nor the subjective conditions for the formation of masses will exist any longer" (*SW* 3:129–30).

In a draft version of this note Benjamin engages the relationship between mass and class with regard to the cinema audience. Arguing that the concept of the mass cannot simply be folded into that of class because only the interrelation of these terms elucidates the process and dynamics by which classes are formed, he singles out the mass of moviegoers as a case in point. While not as "random" a mass as "the inhabitants of a town or the color-blind," he concedes that the cinema audience cannot be easily defined as to its class structure and therefore eludes political mobilization. Nonetheless, certain (fiction) films—not necessarily overt propaganda films—may work to either promote or suppress class consciousness of the various strata of the moviegoing public. It is therefore the task of "progressive film criticism" (Benjamin mentions Kracauer and the French critic Léon Moussinac) to draw attention to the damage done to proletarian class consciousness by bourgeois film production (GS 7.2:668).

This variant version does not appear in the second version of the essay, nor did the entire footnote on mass and class make it into the third version. In that text, there is no acknowledgment of the heterogeneity and institutionally based specificity of the moviegoing masses. What remains, though, is Benjamin's alarm over the compact mass, which troubles any assumption of an unequivocally progressive understanding of the relationship between the masses and the media of technological reproduction. In the epilogue, the masses, as the historical subject of "[modern man's] increasing proletarianization," figure as an object of "formation" (Formierung) on the part of fascism, which grants them an "expression" instead of their rights (SW 4:269). This strategy draws on the technological media, in particular film's ability to capture "assemblies of hundreds of thousands" by means of overhead shots. Taking Kracauer's ambivalence about the mass ornament to its radical conclusion, Benjamin observes that in the giant rallies and processions, mass sporting events, and above all war, "the mass looks itself in the face" (SW 4:282; GS 1:506). This technologically amplified mirror effect, however, is far from enabling the mass "to reason with itself" [sich mit sich selbst zu verständigen], as Benjamin postulates in a text of the same period.[68] The fascist phantasmagoria of national self-expression forecloses any reflection and discussion as to which end, in whose interest, and at whose cost these events are staged.

It is no coincidence that in 1936, the year Benjamin's essay was published in French translation, Jacques Lacan presented a paper to the International Psychoanalytic Association's meeting in Marienbad that first formulated his theory of the "mirror stage," the subject of his famous essay published in 1949. A day later, he traveled to the Olympics then being held in Berlin, where he would have seen his concept of the imaginary being enacted on a collective, national(ist) scale.[69] The specular experience of mastery and unity attributed by Lacan to the infant contrasts with an actual lack of motor-sensory coordination; the narcissistic identification to which it gives rise is based on a denial of lack and a repression of

the concomitant phantasm of the fragmented body. Benjamin observes a similar form of miscognition at work in fascist mass politics, a splitting of sensory (visual-specular) perception from cognition (of their own situation and objecthood) and from (their own) agency. In other words, fascism has perfected a method of mobilizing the masses that at once paralyzes their practical, moral, and political judgment and provides a collective imaginary that would overcome the experience—individual as well as national—of fragmentation, loss, and defeat. Thus, "no longer capable of telling . . . proven friend from . . . mortal enemy" (*SW* 4:335), the masses join their oppressors in "[experiencing their] own destruction as a supreme aesthetic pleasure." To be sure, in the epilogue the subject of this sentence is "humankind" rather than the masses, let alone a particular class. But Benjamin's attempt to situate the aporias of contemporary politics within a more global, anthropological-materialist perspective—that is, to frame the problem of the masses within a politics of the species—is precisely what makes the essay point beyond its tactical dichotomies toward the possibility of imagining another—different as well as other—history.[70]

In view of the success of fascist mass mobilization, Benjamin ascribed to contemporary cinema less a consciousness-raising than a therapeutic role. As a technologically based art form, the cinema offers the possibility that mass psychoses engendered by the industrial-capitalist misadaptation of technology might, at the very least, be diffused and neutralized. It does so with films that shake up the audience through viscerally experienced, collective laughter. In the earlier versions of the artwork essay, he develops this argument with reference to Mickey Mouse films, which he considered as an immunization against mass psychoses, sadistic fantasies, or masochistic delusions, inasmuch as they effect a preemptive release of destructive unconscious energies. Elsewhere, Benjamin refers to Chaplin (contrasting him with Hitler) as "the ploughshare that cuts through the masses; laughter loosens up the mass."[71] With stars like Chaplin and Mickey Mouse whose appeal is unusable for totalitarian purposes, Burkhardt Lindner observes, the cinema becomes "an institution of infection" or contagion, "in which the masses are alienated from their leaders."[72]

Whether in concession to Adorno's objection to the valorization of collective laughter or because of second thoughts of his own, Benjamin subsequently removed Mickey Mouse from the essay. However, the thesis concerning the cinema's potential for "loosening up" the masses still makes it into the third version, as an argument about the self-regulation of the masses in the public situation of reception. Benjamin contends that the form of reception specific to cinema, that is, simultaneous collective reception, changes the political dynamics of the masses' relation to art. "*An extremely backward attitude toward a Picasso painting turns into a highly progressive reaction vis-à-vis a Chaplin film*" (*SW* 4:264; *GS* 1:496–97). This reaction is characterized by "an immediate, intimate fusion of pleasure—pleasure

in seeing and experiencing—with an attitude of expert appraisal." Benjamin attributes the coincidence of critical and, to use the Brechtian term, "culinary" attitudes to the fact that, in the cinema, "the reactions of individuals, which together make up the massive reaction of the audience, [are] determined by the imminent massification of these reactions" (SW 4:264; GS 1:497). As he puts it elsewhere, not only do the "words, gestures, events registered by the masses differ from those perceived by individuals," but for the individual the "perceptual field" changes in the context of "stable large masses" (GS 2:1193–94). In the movie theater, this perceptual shift assumes mass-psychological and hence political dimensions: "By becoming manifest," the masses' reactions "regulate one another" (SW 4:264; GS 1:497). In other words, simultaneous collective reception allows for a public and reciprocal fine-tuning of audience reactions and thus works to disarm destructive tendencies in the masses.

Of course, processes of self-regulation and the loosening of psychopathological armors in the cinema are not limited to the comic register. They may be triggered by the viewers' mimetic identification with movement, rhythm, and metamorphic transformation; by sensory-perceptual shocks—or countershocks—staged by editing or montage; by music; or by diegetic intensities of emotion, including sentimentality. As Benjamin writes in One-Way Street, "People whom nothing moves or touches any longer learn to cry again in the cinema" (SW 1:476; GS 4:132). And in The Arcades Project, he attributes the "political significance" of film to the fact that it can absorb "kitsch"—the "'comfort of the heart'" that lends art a "100 percent, absolute and instantaneous availability for use [Gebrauchscharakter]"; it can thus meet the masses' desire for warmth and closeness, while dialectically, through its aesthetic procedures, transforming it (AP 395; GS 5:500).

Benjamin returns to cinematic reception in the final section before the epilogue. Here he asserts that the huge quantitative increase of "participants" (der Anteilnehmenden) in the cinema has given rise to a qualitatively different mode of reception—collective reception in distraction (Zerstreuung). Like Kracauer a decade earlier, he rehabilitates distraction—as opposed to Sammlung, or concentrated contemplation that traditional art demands of the beholder—against the age-old complaint about the masses' craving for entertainment and diversion. The question he poses is whether the "antithesis" of contemplation and distraction, understood as dichotomous perceptual regimes, is useful for an analysis of film. "A person who collects himself before a work of art is absorbed by it. . . . By contrast, the distracted masses absorb the work of art into themselves" (SW 4:268; GS 1:504). Benjamin complicates this antithesis with recourse to the "prototype" of an art form that entails collective reception in distraction—architecture. The way we absorb buildings in everyday life is itself defined by a twofold modality: "by use and by perception," that is, by bodies moving through space and simultaneously traversing that space through their sense of vision (and, we might add, hearing).

Benjamin describes this kind of embodied perception by way of another conceptual duality—"tactile and optical reception"—which partly overlaps, though, importantly, is not isomorphic with the dichotomy of distraction and contemplation. "On the tactile side, there is no counterpart to what contemplation is on the optical side" (SW 4:268). Unlike the traveler collecting himself before a famous building, the collective reception of buildings is simultaneously tactile and "casually" optical; like distraction, it is a matter of habit, of repetitive and not necessarily fully conscious practice.

With regard to cinema, we could understand the constellation of tactile and optical in terms of the dialectical entwinement of both these registers in its aesthetic *dispositif*. For cinema has the power to increase the haptic impact of material objects and events, to bring the viewer closer to them than possible in ordinary perception, but only on the condition of technological mediation, which affords the viewer distance and protection from the actual phenomena. Key to this paradoxical experience of mediated immediacy is the kinesthetic dimension of film, that is, the threefold movement of people and objects, the camera itself, and the rhythm of editing. Benjamin gets at this nexus of tactility and mobility in *One-Way Street* where he aligns advertisement, which "all but hits us between the eyes with things as a car, growing to gigantic proportions, careens at us out of a movie screen," with film, which "does not present furniture and facades in completed forms for inspection, their insistent, discontinuous nearness alone being sensational," and concludes that "the genuine advertisement hurls things at us with the tempo of a good film" (SW 1:476; GS 4:132).

In such dynamic invasion of "body-space" by "image-space," the haptic sense, suppressed since the Renaissance in favor of the distance senses of vision and hearing, is restored to a new, second-order tactility. This perceptual incorporation, though, depends on a simultaneous distancing, fracturing, and rendering strange of the object through technological and aesthetic mediation.[73] Cinema's social function for habituating human beings to the perceptual challenges presented by urban and industrial technology could thus be more specifically described as enabling them, among other things, to better negotiate the changed configurations of nearness and distance, and to do so across fundamentally transformed registers of duration, movement, and speed.

Whether we consider Benjamin's insight into an optically mediated tactility as a restoration of the polarity of distance and nearness (which had been sundered into a dichotomy earlier in the essay), or whether we extrapolate from it a model counter to the spiral of shock, anaesthetics, and aestheticization, suffice it to suggest that in view of the complexity of these questions the political claims made for distraction seem indeed "mild," if not inadequate. To be sure, Benjamin ascribes a progressive potential to distraction as a habitual—and habituating—mode of attention equal to the challenges of the modern environment, which finds

in film its "true training device" (SW 4:269; GS 1:505). But he retreats from the more far-reaching implications of an aesthetics of mediated tactility and instead resumes his earlier assumption of a testing, evaluating, quasi-expert disposition at work in cinematic representation and reception: "The audience is an examiner, but a distracted one."

As with the concept of the masses, Benjamin's attitude toward distraction is generally less sanguine than it appears in the artwork essay. In texts that discuss Brecht's notion of Epic Theater, in particular "Theater and Radio" (1932) and the lecture "The Author as Producer" (1934), he uses the term pejoratively when refer-ring to conventional theater with its bourgeois blend of cultivation (Bildung) and entertainment.[74] Against the practice of Zerstreuung qua Ablenkung, divertisse-ment or diversion, he endorses an aesthetics of montage exemplified by Brecht's principle of "gestus" and other devices of interruption and distanciation. Unlike the merely stimulating effect of distraction, these devices are taken to have a criti-cal, pedagogic function inasmuch as they "alienat[e] [the audience] in an enduring way, through thinking, from the condition in which it lives" (SW 2:779).

For the purposes of the artwork essay, however, Benjamin tries to square Kracauer's iconoclastic valorization of distraction with Brecht's montage aesthetics and its goal of generating critical distance and reflection. With its emphasis on the latter, the essay disavows the physiological, sensuous, and marvelous aspects of distraction that relate it to other types of decentered experience—Rausch or intoxication, trance, eccentric perception, temporary surrender of the conscious self—that is, modes of mimetic perception, ingestion, embodiment, and "profane illumination" that Benjamin had been exploring through his hashish experiments, surrealism, and such figures as the flâneur, the gambler, and the urban child.[75] This interest in forms of perceptual engagement drawing on unconscious or at the very least subconscious energies would have been at variance with the Brechtian tenor of the essay's final version; moreover, there were strong reasons, at this point in history, to refrain from validating those less-than-rational modes of behavior in a collective subject.[76] However, the emphasis on the critical, testing function of distraction overshadows the elements of play and humor that Benjamin had considered key to film's political task of redressing the pathological imbalance between humans and technology in the essay's earlier versions—key precisely to the imperative of diffusing and disarming destructive forms of intoxication within the masses.

An even greater inconsistency, if not antinomy, within Benjamin's politics of distraction opens up in relation to the 1935 exposé for the Arcades Project, "Paris, the Capital of the Nineteenth Century." In the section on world exhibitions, distrac-tion is explicitly linked to the Marxian category of self-alienation. Here the etiol-ogy of self-alienation is less the technologically altered sense perception (as in the artwork essay) than a Lukácsian logic of reification. The nineteenth-century world

exhibitions, with their enthronement of the commodity, inaugurate "a phantasma-goria which the human being enters in order to be distracted. The entertainment industry facilitates this by elevating [the spectator] to the level of the commodity. He surrenders to its manipulations while enjoying his alienation from himself and others" (*AP* 7; *GS* 5:50ff). In this context, capitalist mass culture, rather than the fascist spectacle of mass destruction, provides the dystopian vanishing point of self-alienation. As Benjamin elaborates in the 1938 exposé, the divertissements of the world exhibitions prepare the masses for the specular, vicarious consumption that in decades to come would make them flock to the movie theaters: "a school in which the masses, forcibly excluded from consumption, are imbued with the exchange value of commodities to the point of identifying with them" (*AP* 18). From here it is only a small step to Horkheimer and Adorno's analysis, written a few years later, of the "culture industry" as a system of miscognition, perverted mimesis, and self-commodification.

Reading the artwork essay, especially in its third, familiar version, against the grain of its rhetorical design reveals a culturally conservative strand in Benjamin's thinking, a segregation of the critical intellectual from the masses as object of formation. More specifically, it gives us a sense of the conceptual cost incurred within Benjamin's own thinking by the tactical dichotomization of the terms *aura* and *masses* with regard to the cinema. By conceiving of the relationship between cinema and masses primarily in terms of a structural affinity based in a nonauratic perceptual regime, and by muting the ambivalent and dialectical dimensions in his concept of the masses, Benjamin ends up placing the cinema on the side of "experiential poverty" (*Erfahrungsarmut*) and the "new, positive concept of barba-rism" he had espoused in his programmatic essay of 1933. The liquidationist agenda makes the distinction between *Bild* (auratic, aesthetic image) and *Abbild* (copy, facsimile, reproduction) congeal into an opposition. Relegated to the latter side of that opposition, a politically progressive cinema would thus offer a training ground for an enlightened barbarism, rather than—as in the second version—a medium for new kinds of mimetic experience, a "*Spiel-Raum*" or room-for-play for trying out an alternative innervation of technology. With the undialectical surrender of the auratic image in favor of reproduction, it could be argued, Benjamin denies the masses the possibility of aesthetic experience, in whatever form or medium (and thus, like the communist cultural politics he opposed, risks leaving sensory-affective needs to be exploited by the right). At the same time, the liquidationist gesture disavows a crucial impulse of his own thinking—his lifelong concern with the fate of experience in the age of its declining transmissibility, a concern in which the concept of the aura plays a central if precarious part.

4

Aura

The Appropriation of a Concept

Benjamin's first comment on the concept of aura can be found in an unpublished report on one of his hashish experiments, dated March 1930: "Everything I said on the subject [the nature of aura] was directed polemically against the theosophists, whose inexperience and ignorance I find highly repugnant. . . . First, genuine aura appears in all things, not just in certain things, as people imagine."[1] This assertion contrasts sharply with the common understanding of Benjamin's aura as a primarily aesthetic category—as shorthand for the particular qualities of traditional art that he observed waning in modernity, associated with the singular status of the artwork, its authority, authenticity, and unattainability, epitomized by the idea of beautiful semblance. On that understanding, aura is defined in antithetical relation to the productive forces that have been rendering it obsolete: technological reproducibility, epitomized by film, and the masses, the violently contested subject/object of political and military mobilization. Wherever aura or rather the simulation of auratic effects does appear on the side of technological media (as in the recycling of the classics, the Hollywood star cult, or fascist mass spectacle), it assumes an acutely negative valence, which turns the etiology of aura's decline into a call for its demolition.

The narrowly aesthetic understanding of aura rests on a reductive reading of Benjamin, even of the artwork essay, which seems to advance such circumscription most axiomatically. If we agree that Benjamin's writings, read through and against their historical contingencies, still hold actuality for film and media theory—and hence for questions of the aesthetic in the broadest sense—this notion of aura is not particularly helpful. I proceed from the suspicion, first expressed by Benjamin's antipodean friends Gershom Scholem and Bertolt Brecht, that the exemplary linkage of aura to the status of the artwork in Western tradition, whatever it may have accomplished for Benjamin's theory of modernity, was not least a tactical move designed to isolate and distance the concept from the at once more popular and more esoteric notions of aura that flourished in contemporary occultist discourse (and do to this day).[2] As Benjamin knew well, to corral the meanings of

aura into the privileged sphere of aesthetic tradition—and thus to historicize it as a phenomenon in decline—was the only way the term could be introduced into Marxist debates at all, in an intellectual and political gamble that would legitimate it as a philosophical category.

However, as I hope to show, Benjamin's deployment—and remarkably longtime avoidance—of the term *aura* is informed by the very field of discourse from which he sought to disassociate the term. And it is precisely the broader anthropological, perceptual-mnemonic, and visionary dimensions of aura that he wrests from that field that I take to be of interest for more current concerns. Restoring these dimensions to aura will highlight the conflicting roles the concept played in his lifelong endeavor to theorize the conditions of possibility for experience (in the emphatic sense of *Erfahrung*) in modernity.[3] For aura not only named the most precious facet among other types of experience he described as irrevocably in decline, to be grasped only through their historical erosion. Aura's epistemic structure, secularized and modernized (qua "profane illumination," Weimar *flânerie*, "mimetic faculty," and "optical unconscious"), can also be seen at work in Benjamin's efforts to reconceptualize experience through the very conditions of its *im*possibility, as the only chance to counter the "bungled" (capitalist-imperialist) adaptation of technology that first exploded in World War I and was advancing the fascist conquest of Europe. These efforts entailed exploring new modes of apperception and adaptation equal to a technologically changed and changing environment. At the same time, though, they revolved around the possibility that the new technological media could reactivate older potentials of perception and imagination that would enable human beings to engage productively, at a sensorial and collective level, with modern forms of self-alienation.

This chapter begins with glossing the range of meanings that aura acquires in Benjamin's writings of the 1930s, which happens substantially through his exploration of the technological media. Against the backdrop of these broader, experimental, and iridescent aspects of the concept, I revisit its more restrictive deployment in the artwork essay. My other project is to reexamine Benjamin's alleged ambivalence toward aura—his being torn between the extremes of revolutionary avant-gardism and elegiac mourning for beautiful semblance—in light of the notion's multiple, philosophically and politically incongruous genealogies. Rather than reviewing the sources he explicitly names (drawn from art history and literature) or those he polemically rejects (such as theosophy and anthroposophy), I turn to the less frequently discussed lineages of, on the one hand, the vitalist philosophy of Ludwig Klages and, on the other, Scholem's version of Jewish mysticism. The former lineage takes us through the Munich Kosmiker circle to Klages's theory of the image and a racialist notion of transgenerational memory; the latter involves the kabbalistic theory of the *tselem*—literally "image," interpreted by Scholem as visionary encounter with an other, alien self—and the

gnostically inflected notion (as read through Kafka) of productive self-alienation. By tracing these strangely crabbed and seemingly incompatible contexts, I hope to elucidate the extraordinary stakes entailed in Benjamin's appropriation of the concept of aura, not so as to revisit the more esoteric byways of Benjamin scholarship but in order to show how he transformed these theoretical impulses in his effort to reimagine (something like) experience under the conditions of technologically mediated culture.

AURA AT LARGE

Anything but a clearly delimited, stable concept, aura describes a cluster of meanings and relations that appear in Benjamin's writings in various configurations and not always under its own name; it is this conceptual fluidity that allows aura to become such a productive nodal point in Benjamin's thinking. However, since my goal is to defamiliarize the concept, let me first cite the two main definitions familiar from his work: (1) aura understood as "a strange weave of space and time: the unique appearance [*Erscheinung*, apparition, phenomenon] of a distance, however near it may be" (or "however close the thing that calls it forth"); and (2) aura understood as a form of perception that "invests" or endows a phenomenon with the "ability to look back at us," to open its eyes or raise its gaze.[4] When Benjamin develops the second definition in "On Some Motifs in Baudelaire," he refers the reader back to his earlier formulation in the artwork essay; the two are conjoined in *The Arcades Project* when he invokes his "definition of aura as the distance of the gaze that awakens in the object looked at [*Ferne des im Angeblickten erwachenden Blicks*]" (*AP* 314; *GS* 5:396).

I will begin, though, with a third usage of the term that, at first glance, appears distinct from both: the more common understanding (now as then) of aura as an elusive phenomenal substance, ether, or halo that surrounds a person or object of perception, encapsulating its individuality and authenticity. It is in this sense that Benjamin uses the term in his first set of "hashish impressions" (1927–28) and, more systematically, in his reflections on early photographs in "Little History of Photography" (1931).[5]

Before 1880, he argues in that essay, the photographer, still considered an advanced technician rather than an "artist," encountered in his client "a member of a rising class, endowed with an aura that had seeped into the very folds of the man's frock coat or floppy cravat" (*SW* 2:517; *GS* 2:376). The aura of objects such as clothing or furniture stands in a metonymic relation to the person who uses them or has been using them. Thus Schelling's coat will pass into immortality with the philosopher's image—"the shape it has borrowed from its wearer is not unworthy of the wrinkles in his face" (*SW* 2:514; *GS* 2:373). In other words, the aura of Schelling's coat does not derive, say, from its unique status as a handcrafted,

custom-made object but from a long-term material relationship with the wearer's physique or, rather, physiognomy. It thus seems to participate in—and figuratively instantiate—the logic of the trace, the indexical dimension or existential bond, in photographic signification.[6] Benjamin elsewhere refers to this type of aura as the "aura of the habitual" (*Gewöhnung*; AP 461; GS 5:576), or the "experience that inscribes itself as long practice" (*Übung*; SW 4:337; GS 1:644).

The indexical dimension of aura's relation to the past is not necessarily a matter of continuity or tradition; more often than not, it is a past whose ghostly apparition projects into the present and (to invoke Roland Barthes) "wounds" the beholder.[7] Benjamin's often-cited passage concerning the double portrait of the photographer Dauthendey and his fiancée—who was to slash her veins after the birth of their sixth child—evokes a complex temporality in which the past moment encrypted in the photograph speaks to the later beholder of the photo-graphed subject's future: "No matter how artful the photographer, no matter how carefully posed his subject, the beholder feels an irresistible urge to search such a picture for the tiny spark of contingency [*Zufall*], of the here and now, with which reality has (so to speak) seared the character of the image, to find the inconspicu-ous spot where in the thusness [*Sosein*] of that long-forgotten moment the future nests so eloquently that we, looking back, may rediscover it" (SW 2:510; GS 2:371).

The futurity that has seared the photographic image in the chance moment of exposure does not simply derive from circumstantial knowledge of its posthistory or that of its subject; it emerges in the field of the beholder's compulsively searching gaze. The spark that leaps across time is a profoundly unsettling and disjunctive one, triggered by the young woman's gaze into the off, past the camera and past her fiancé, absorbed in an "ominous distance." It speaks to the beholder, and to the later reader of the passage, not simply of photography's constitutive relation to death but more insistently of a particular form of death—suicide—that links the fate of the photographed subject to the writer's own future death.[8]

The notion of aura as a premonition of future catastrophe harks back to medical theories since antiquity that use the term to describe symptoms of anxiety and unease preceding and foreboding epileptic or hysterical attacks.[9] For Benjamin, the ominous aspect of aura belongs to the realm of the *daemonic*, in particular the phenomenon of self-alienating encounters with an older, other self. In a tech-nologically refracted, specifically modern form, this aspect of aura resurfaces in his notion of an optical unconscious, which he unfolds from the passage about the Dauthendey portrait quoted above and which, as we shall see, assumes acute political significance in the artwork essay's speculations on Mickey Mouse.

These few examples make it evident that the aura is not an inherent property of persons or objects but pertains to the *medium* of perception, naming a particular structure of vision (though one not limited to the visual). More precisely, aura is itself a medium that defines the gaze of the human beings portrayed: "There

was an aura about them, a medium that lent fullness and security to their gaze inasmuch as it penetrated that medium" (*SW* 2:515–17; *GS* 2:376). In other words, aura implies a phenomenal structure that enables the manifestation of the gaze, inevitably refracted and disjunctive, and shapes its potential meanings.

Benjamin's concept of medium in this context cannot be conflated with the post-McLuhan equation of the term with technological medium, let alone with a means of communication. Rather, it proceeds from an older philosophical usage (at the latest since Hegel and Herder) referring to an in-between substance or agency—such as language, writing, thinking, memory—that mediates and constitutes meaning; it resonates no less with esoteric and spiritualist connotations pivoting on an embodied medium's capacity of communing with the dead.[10] Significantly, however, Benjamin suggests that aura as a medium of perception, or "perceptibility," becomes visible only on the basis of technological reproduction. The gaze of the photographed subjects would not persist without its refraction by an apparatus, that is, a nonhuman lens and the particular conditions of setting and exposure; it already responds to another—and "other"—look that at once threatens and inscribes the subjects' authenticity and individuality. This element of contestation captured in the contingency of the long-forgotten moment, the oscillation, in Eduardo Cadava's words, "between a gaze that can return the gaze of an other and one that cannot," accounts for the aura of these early photographs ("beautiful and unapproachable" [*SW* 2:527]), *their* ability to look back at *us* across the distance of time, answering to the gaze of the later beholder.[11]

At this point we can see how the seemingly distinct sense of aura Benjamin develops in "Little History of Photography" folds into the later definition of aura as the experience of investing a phenomenon with the ability to return the gaze (whether actual or phantasmatic). "Experience of the aura . . . arises from the transposition of a response characteristic of human society to the relationship *of* the inanimate or nature *with* human beings. The person we look at, or who feels he is being looked at, looks at us in turn. To experience the aura of a phenomenon we look at means to invest it with the ability to look back at us" (*SW* 4:338; *GS* 1:646; [emphasis added]).

As we saw in connection with the Dauthendey portrait, the auratic return of the gaze does not depend on the photographic subject's direct look at the camera (or, for that matter, the later injunction against that direct look which voyeuristically solicits the viewer as buyer [*SW* 2:512]). What is more, in the above formulation and elsewhere Benjamin attributes the agency of the auratic gaze to the object being looked at, thereby echoing philosophical speculation from early romanticism through Bergson that the ability to return the gaze is already dormant in, if not constitutive of, the object.

If "Little History of Photography" discusses early photography as a historical threshold phenomenon, which has a late "pendant" in a poignant boyhood portrait

of Kafka (SW 2:515), the later writings mark it more decisively as a watershed.[12] Thus Benjamin writes in the artwork essay: "In the fleeting expression of a human face, the aura beckons from early photographs for a last time" (SW 3:108). In the second Baudelaire essay, he goes so far as to implicate even *early* photography in the "phenomenon of a 'decline of the aura.'" "What was inevitably felt to be inhuman—one might say deadly—in daguerreotypy was the (prolonged) looking into the camera [*Apparat*], since the camera records the human likeness without returning the gaze" (SW 4:338; GS 1:646). The early camera's indifference to the human gaze inaugurates the transformation of looking relations, both social and sexual, in metropolitan modernity. In Baudelaire's poetry, the image of eyes that have lost the ability to return the look ("the eye of the city dweller . . . overburdened with protective functions") becomes emblematic of the disintegration of the aura, its shattering in the "experience of shock," an experience as *Erlebnis* (SW 4:341, 343; GS 1:653).

If Benjamin sees the significance of Baudelaire in his having registered the shattering of aura and given it the weight of an irreversible historic experience (*Erfahrung*), he finds in Proust a contemporary whose writing seeks to artificially reproduce, as it were, in the "deadly game" that was his life, the ephemeral conditions of auratic perception.[13] As someone well versed in "the problem of aura," Proust intimates that the ability of objects to return the gaze hinges on a material trace: "'People who are fond of secrets occasionally flatter themselves that objects retain something of the gaze that has rested on them'" (SW 4:338–39). This mystical assumption is key to Proust's concept of *mémoire involontaire*, a sensorily and synesthetically triggered embodied memory that can be retrieved only through "actualization, not reflection" (SW 2:244, 246–47). In contrast with volitional remembering, or the recounting of an *Erlebnis*, the data of involuntary memory are "unique: they are lost to the memory that seeks to retain them" (SW 4:338–39). In this regard, Benjamin writes, they share the primary aspect of aura as "a unique apparition of a distance however near it may be," that is, an essential unapproachability and unavailability, related to an irrecuperable absence or loss.

The linkage of aura with *mémoire involontaire* not only suggests that the "unique distance" that appears to the beholder is of a *temporal* dimension, but also inscribes the entwinement of distance and closeness with the register of the unconscious. The fleeting moment of auratic perception actualizes a past not ordinarily accessible to the waking self; it entails a passivity in which something "takes possession of us" rather than vice versa (AP 447). Not surprisingly, Benjamin elaborates this aspect of auratic perception with recourse to the psychoperceptual experience of dreaming. But instead of turning to Freud, he invokes Valéry's observation that in dreams there is "'an equation between me and the object. . . . The things I look at see me just as much as I see them'" (SW 4:339). A decade earlier, he refers to Franz

Hessel's Berlin *flâneur* as a "dreamer" upon whom "things and people threaten to cast their bitter look," citing Hessel's axiomatic insistence on the priority of the object's gaze as a condition of physiognomic perception or reading: "We see only what looks at us."[14]

Images of the seer seen are a familiar topos in poetry and poetics in the wake of romanticism (for example, in Baudelaire, Valéry, Rilke, and Hofmannsthal) as well as phenomenological, psychoanalytic, and metapsychological thought (notably Merleau-Ponty, Sartre, and Lacan).[15] They suggest a vision that exceeds and destabilizes traditional scientific, practical, and representational concepts of vision, along with linear notions of time and space and clear-cut, hierarchical distinctions between subject and object. In this mode, the gaze of the object, however familiar, is experienced by the subject as other and prior, strange and heteronomous. Whether conceptualized in terms of a constitutive lack, split, or loss, this other gaze in turn confronts the subject with a fundamental strangeness within and of the self.

Rather than following the psychoanalytic route (which he was well aware of), Benjamin locates the unsettling force of the auratic return of the gaze in an anthropologically and mythopoetically conceived prehistory—Goethe's "Mothers," Bachofen's *Vorwelt*, Baudelaire's "*vie antérieure*." He cites Novalis to back up his definition of auratic experience as the expectation that the gaze will be returned; "perceptibility is an attentiveness," which implicitly extends to a prehistoric other. Already in his 1919 dissertation, Benjamin was fascinated with the ambiguity of that phrase—its deliberate blurring of the distinction between subject and object of perception—on which he elaborates by way of another quotation from the same text: "In all predicates in which we see the fossil, it sees us."[16] The reflexivity of this mode of perception, its reciprocity across eons, seems to both hinge upon and bring to fleeting consciousness an archaic element in our present selves, a forgotten trace of our material bond with nonhuman nature.[17]

What exactly may constitute this forgotten trace is the object of an exchange between Adorno and Benjamin concerning the latter's reliance, for both his etiology of the decline of experience in modernity and his elegiac evocation of aura in the second Baudelaire essay, on Proust's theory of *mémoire involontaire*. Finding fault with this theory's lack of an important element—*forgetting*—Adorno argues that a dialectical theory of forgetting needs to be grounded in a Marxist critique of reification.[18] Accordingly, he suggests that Benjamin's concept of aura might be more clearly elaborated along those lines as the "trace of a forgotten human [element] in the thing [*des vergessenen Menschlichen am Ding*]," that is, the trace of reified human labor (*CC* 322; *ABB* 418). In his reply, Benjamin insists that the "forgotten human element" actualized in auratic perception cannot be thus reduced. "The tree and the bush that are endowed [with an answering gaze] are not made by human hands. There must therefore be a human element in things that is *not*

founded on labor" (*CC* 327; *ABB* 425). Such emphasis, punctuated by Benjamin's explicit refusal to discuss the matter further, suggests, as Marleen Stoessel and others have argued, that the dialectic of forgetting and remembering involved in aura has more to do with a different kind of fetishism: the psychosexual economy of knowledge and belief first theorized by Freud.[19]

My interest here, however, is in the particular ways in which aura's defining elements of disjunctive temporality—its sudden and fleeting disruption of linear time, its uncanny linkage of past and future—and the concomitant dislocation of the subject are articulated through, rather than in mere opposition to, the technological media.[20] A case in point is the passage in "A Berlin Chronicle" (1932) that evokes the memory image of the six-year-old, already in bed, being told about the death of a distant cousin. Benjamin describes how this news (whose sexual implications he was to understand only much later) etched the room with all its details into the photographic "plate of remembrance," usually underexposed by the dimness of habit, "until one day the necessary light flashes up from strange sources as if fuelled by magnesium powder."[21] What is illuminated by the flash and thus photographically preserved in memory is neither the content of the message nor the child's room but an image of our "deeper self," separate from and outside our waking, everyday self, which "rests in another place and is touched by shock as is the little heap of magnesium powder by the flame of the match." And, Benjamin concludes suggestively, "it is to this immolation of our deepest self in shock that our memory owes its most indelible images" (*SW* 2:633).

In such formulations, the term *shock* acquires a valence quite different from, though no less in tension with, its more familiar sense of effecting, in its relentless proliferation in industrialist-capitalist labor and living, a defensive numbing of human sense perception. This other sense of shock also differs from the deliberate, avant-garde staging of countershock, designed to enhance the demolition of aura (as in the artwork essay's section on dada) or to undermine theatrical illusionism (as in Benjamin's account of Brecht's epic theater).[22] Rather, it relates to the idea of an involuntary confrontation of the subject with an external, alien image of the self.

When Benjamin unfolds this idea in "A Short Speech on Proust," delivered on his fortieth birthday, July 15, 1932 (the date of his intended, at the time not executed, suicide), he does so in language that expands the range of technological media beyond the paradigm of early photography.

Concerning the *mémoire involontaire*: not only do its images appear without being called up; rather, they are images we have never seen before we remember them. This is most clearly the case in those images in which—as in some dreams—we see ourselves. We stand in front of ourselves, the way we might have stood somewhere in a prehistoric past [*Urvergangenheit*], but never before our waking gaze. Yet these images, developed in the darkroom of the lived moment, are the most

important we shall ever see. One might say that our most profound moments have been equipped—like those cigarette packs—with a little image, a photograph of ourselves. And that "whole life" that, as they say, passes through the minds of people who are dying or confronting life-threatening danger is composed of such little images. They flash by in as rapid a sequence as the booklets of our childhood, precursors of the cinematograph, in which we admired a boxer, a swimmer, or a tennis player. (GS 2:1064)

In evoking a visionary encounter with an other, older self, this passage foregrounds the doubly disjunctive temporality of auratic experience qua *mémoire involontaire*—a memory at once "prehistoric" and ephemeral, flashing past, referentially unanchored. Instead of illustrating this type of memory with recourse to the olfactory and gustatory so central in Proust, Benjamin tropes it in terms of visual media. Describing the elusive epistemological status of such memory images, he moves from photography—"the darkroom of the lived moment," the little photograph of ourselves resembling those enclosed in cigarette packs—to protocinematic toys, the flipbooks of his childhood. The images imprinted on us in a prehistoric past are mobilized at moments of physical danger or imminent death, constituting the proverbial film that passes through a person's mind in life-threatening situations.[23]

Doubly disjunctive, the temporality of *mémoire involontaire* is thus overlaid with yet another temporality, that of the medium of photography in relation to film. This relationship should not be understood simply as a historical, let alone a teleological trajectory, in the sense of still photography being at once foundational to and superseded by film. Rather, in its reference to the flipbooks as precursors to cinema, Benjamin's conceit invokes the dialectical relation of still frames and moving image in the process of *défilement,* that is, the filmstrip's simultaneous production of and negation by the projected illusion of movement.[24] We might read this configuration as an appeal to cinema's forgotten future (SW 2:390)—a reminder that, notwithstanding the technologically based logic of *défilement* and the compulsorily narrativized temporality of mainstream cinema, film can be broken down again into still images, literally, through techniques of freeze-frame, slow motion, or step-printing, or in the direction of what Gilles Deleuze has theorized as "time-image." In other words, a medium-specific possibility could become a matter of aesthetic choice—which it actually does in a wide range of film practices—and there's no reason why such play with disjunctive temporalities should be limited to cinema based on celluloid film.

If we consider these reflections from the perspective of aura in the wider sense, the absolute boundary between photography and film dissolves. Instead, their relationship emerges as a crossing for larger questions of vital significance that Benjamin was wrestling with during the 1930s. Thus, we could reformulate the question he poses in one of his draft notes for the artwork essay, "If the aura is

in early photographs, why is it not in film?" (*GS* 1:1048), to ask: If technological reproducibility supplies imagery for rethinking forms of auratic self-encounter to the individual writer/beholder of photography, are there ways of translating aura's defining moments of disjunctive temporality and self-dislocating reflexivity into a potential for the *collective*, as the structural subject of cinema?[25]

This question, and the limits against which it pushes, pivots on the notion of the optical unconscious, which Benjamin hypothesizes for both photography and film in terms clearly differentiated along the axis of individual and collective. Howard Caygill has described the optical unconscious as "the possibility of creating an openness to the future," "a space free of consciousness . . . charged with contingency if it is open to the future and to becoming something other than itself."[26] The question, however, is what kind of future and for whom. When Benjamin speaks of the future in overtly or implicitly autobiographical writings—troping it as an "invisible stranger" or strangeness that has been forgotten or has left words or gestures "in our keeping"—or in his account of the Dauthendey photograph, this future is hardly open to change, but inscribed with preordained fate and violent death.[27] At the same time, the nexus of memory and futurity, the capacity to both remember and imagine a different kind of existence, is key to his effort of tracking at once the decline and the transformative possibilities of experience in modernity—in the face of a political crisis in which not only his personal fate but the survival of the human species seemed at stake. Whether or not Benjamin ultimately believed that the cinema, as a medium of collective "innervation" (*SW* 3:124), could ever actualize its utopian, surrealist potential ("the dream of a better nature")[28] or whether he considered the cinema revolutionary at best in the sense of "a purely preventive measure intended to avert the worst" (Wohlfarth),[29] what I wish to stress is that he was able to think salient features of auratic experience—temporal disjunction, the shocklike confrontation with an alien self—as asymmetrically entwined rather than simply incompatible with technological reproducibility and collective reception.

AURATIC ART, BEAUTIFUL SEMBLANCE

In light of the range of meanings and references the notion of aura acquires in Benjamin's writings, the definition we encounter in the artwork essay appears deliberately restrictive. The concept of aura is introduced to describe the mode of being of works of art as transmitted by tradition—that which "withers in the age of [their] technological reproducibility" (*SW* 3:104)—their singular existence and authenticity, historical testimony and authority. To be sure, this withering is "symptomatic" of a process whose "significance extends beyond the realm of art," a fundamental shift in the conditions of human sense perception that Benjamin in turn attributes to both the new technologies of reproduction and the increas-

ing importance of the masses in modern life. We remember, though, that a few years earlier Benjamin had insisted that "genuine aura appears in all things, not just in certain kinds of things" (*SW* 2:328), thus making it key to the possibility of experience in and of the modern everyday. But now aura pertains to the special status of the art object, a status bestowed upon it by the secular cult of beauty since the Renaissance, the tradition of Western culture. It is in that sense that Adorno sought to salvage aura as an aesthetic category, as the achieved semblance of autonomy in the work.[30]

One might object that Benjamin himself undermines this more narrowly aesthetic sense of aura in his famous gesture at a definition (which he borrows, with one elision, from "Little History of Photography"). Cutting from the transformations in the domain of *art* to the *social* determinants of large-scale changes in the organization of human perception, he poses the rhetorical question "What, actually [*eigentlich*], is the aura?" (*SW* 3:104, *GS* 7:355) and goes on to elaborate his general definition with an image relating to the experience of *nature*. "A strange weave [*Gespinst*] of space and time: the unique appearance of a distance, however near it may be. While resting on a summer afternoon, to trace a range of mountains on the horizon, or a branch that throws its shadow on the observer—this is what it means to breathe the aura of those mountains, that branch" (*SW* 3:104–5; *GS* 7:355). Benjamin's subsequent assertion that "in light of this description it is easy to grasp the social basis of the aura's present decay" begs the question, to say the least. I would argue that it rather functions as a sleight-of-hand that allows him to preserve, without having to explain, the esoteric nature of the concept.

Undeniably, the image of a meditative encounter with nature presents a configuration that resonates with the wider sense of aura discussed above. The perceiving subject engages in a form of *Belehnung* or endowment of the natural object with "the ability to look back at us." True to the etymological connotation of the word *aura* (Greek and Latin for "breath," "breeze," a subtle, fleeting *waft of air*, an atmospheric substance), the gazing subject is "breathing," not just seeing, "the aura of those mountains, that branch." Aura is a medium that envelops and physically connects—and thus blurs the boundaries between—subject and object, suggesting a sensorial, embodied mode of perception. One need only cursorily recall the biblical and mystical connotations of *breath* and *breathing* to understand that this mode of perception involves surrender to the object as other. An auratic quality that manifests itself in the object—"the unique appearance of a distance, no matter how close it may be"—cannot be produced at will; it appears *to* the subject, not *for* it.

In its specific elaboration, however, the scene squarely fits within the iconography of romantic poetry and landscape painting and is associated with the concepts of pathos and, to a certain extent, the sublime. When he resumes the discussion of aura in the second Baudelaire essay, Benjamin remarks that the endowment

of nature with an answering gaze "is a wellspring of poetry" (though he hastens to complicate the echo of early romanticism with a reference to Karl Kraus, a highly anti-romantic contemporary).[31] What is more, the artwork essay renders the poetic topos of auratic experience as a topos of poetry *tout court,* that is, of the Western tradition of lyric poetry. As if to underscore this point, Benjamin's "definition" of aura is the only passage in the artwork essay written in a rhythm approaching metric verse.[32]

The invocation of lyric poetry in Benjamin's account of auratic experience connects with a more general aesthetic motif: the description of art, and the effect of art on the perceiving subject, in terms of a phenomenal distance or farness (*Ferne*). One lineage of this motif, including the image of the meditative beholder in a mountain scene, has been traced in modern philosophy of art, particularly in the work of the Viennese art historian Alois Riegl, whom Benjamin read and repeatedly discussed.[33] As is often pointed out, Benjamin deploys Riegl's concepts, in particular the opposition of contemplative distance and haptic nearness, throughout the artwork essay, so as to throw into relief the tactile, haptic character of twentieth-century avant-garde art and film against the phenomenal distance of traditional, auratic art.[34]

Another lineage of the idea of distance as a constitutive condition of art (that is, autonomous art) connects the fate of aura in the artwork essay with the problematic of aesthetic semblance (*Schein*) and beauty's relation to truth, which had preoccupied Benjamin in his early work. The ingredients for this connection can be found in Georg Simmel's exemplary formulation "All art brings about a distancing from the immediacy of things: it allows the concreteness of stimuli to recede and stretches a veil between us and them just like the fine bluish haze that envelopes distant mountains."[35] If Benjamin frequently invokes the ancient topos of "blue distance" (mediated through Klages) as a shorthand for romantic longing, the similarly resonant term *veil* (*Schleier*), like the related term *husk* (*Hülle*), more specifically occurs in conjunction with the classical concept of beauty as "beautiful semblance" (*schöner Schein*).[36] This concept refers not just to any appearance—let alone mere illusion—but entails the inextricability of object and appearance. As Benjamin writes in his early essay on Goethe's *Elective Affinities:* "The beautiful is neither the veil [*Hülle*] nor the veiled object but rather the object *in* its veil" (*SW* 1:351; *GS* 1:195). In other words, the veil defines both the condition of beauty and its essential unavailability, a symbolic integrity predicated on "a distance however close the thing that calls it forth."[37]

It is not until the artwork essay that Benjamin explicitly laminates aura with the idea of beautiful semblance, a move that supports his insistence on the aura's irreversible decay, its historical index of pastness.[38] If, as Benjamin asserts in the essay's Urtext, Goethe's work is still imbued with "beautiful semblance . . . as an auratic reality," the concept of beautiful semblance in aesthetic theory, beginning

with Hegel, is no longer grounded in auratic experience (*SW* 3:127). But beautiful semblance is also branded with another kind of belatedness. As "the aporetic element in the beautiful," semblance marks the object as not just absent in the work but always already *lost*. The admiration that "is courting [the] identical object" is a retrospective one: it "gleans what earlier generations admired in it."[39] The assertion of an internal, structural belatedness of beautiful semblance ties in with and comes to support the thesis of the historical erosion of aura. Yet, if auratic art has lost its social basis with the decline of the bourgeoisie and is rendered anachronistic by the new realities of the masses and technological reproducibility, it gains a heuristic function in Benjamin's project to delineate, by contrast, a fundamentally different regime of perception. That is, by insisting on both the aura's internally retrospective structure and its irreversible historicity, he can deploy the concept to catalyze the ensemble of perceptual shifts that define the present—such as the ascendance of multiplicity and repeatability over singularity, nearness over farness, and a haptic engagement with things and space over a contemplative relation to images and time—and posit this ensemble as the signature of technological and social modernity.

However, the assimilation of aura to the grammar of beautiful semblance suppresses the broader senses of aura outlined above and thus restricts the concept's potential for theorizing the transformation of experience in modernity. One casualty of this operation is the daemonic aspect of aura that foregrounds the shock of self-recognition qua self-alienation that Benjamin shared with Scholem (see below). Another is the conception of distance and nearness as a *polarity* (in the Goethean sense of mutually imbricated opposites that generate a force field) rather than an antinomic opposition.[40] In his earlier writings, beginning with *One-Way Street* and his experiments with hashish, Benjamin had pursued the paradoxical entwinement of distance and nearness as a visionary mode epitomized by the psychophysiological state of *Rausch*, or ecstatic trance: "For it is in this experience alone that we gain certain knowledge of what is nearest to us and what is remotest from us, and never one without the other."[41] While still invoking the polarity of distance and nearness in the aura's paradoxical manifestation of a distance "however near it may be," the artwork essay's rhetorical design effectively severs and reduces distance and nearness to spatiotemporal categories that define antithetical perceptual regimes.

By assimilating aura to a regressive fetishistic cult of beautiful semblance (and, arguably, to a Kantian notion of distance vis-à-vis the sublime as the condition of aesthetic pleasure and individuation), the artwork essay makes a case not only for a recognition of the aura's irreversible decline but also for its active demolition. Conversely, by hailing film as a force in that "liquidation," it places the cinema on the side of a "new barbarism" and "poverty" of experience, rather than assigning it a historic function for negotiating the transformation of experience. The

essay thus jettisons what I take to be Benjamin's more productive reflections on the reconfiguration of distance and proximity in modernity, specifically as they revolve around new economies of "body and image-space" and the role of film in enabling a collective, playful innervation of technology.

It would be shortsighted to ignore the political crisis in which Benjamin sought to intervene—and the failure, if not complicity, of intellectuals from right to left in the face of it (see chapter 3, above). The problem was not simply that the decaying aura had come to prolong the cultural privilege of a bourgeoisie. As is often pointed out, Benjamin's call to demolition was aimed at the technologically enhanced fabrication, from the mid-nineteenth century on, of auratic effects on a mass scale. This was the thread that linked phenomena such as the phantasmagoria of spectacular entertainment and the commodity displays of the world fairs (up to the present, the 1930s); the creation of "atmosphere" in photographs of old Paris at the height of urban demolition; and the manufacturing of "personality" from portrait photography to the Hollywood cult of the star. Diverse practices of aura simulation converged and culminated, however, in supplying the means for resurrecting the aura's undead remains in the arena of national-populist and fascist politics. More precisely, this fatal resurrection was the heuristic vantage point that mandated, in the first place, Benjamin's genealogical tracking of the catastrophic concatenation of art, technology, and the masses.

It appears, then, that Benjamin distinguishes between a *genuine* aura, which is irrevocably in decay, and a *simulated* aura that prevents a different, utopian, or at the very least nondestructive interplay among those three terms—art, technology, the masses—from winning. It has been argued that it is only the simulated or "pseudo-aura" ("an already distorting reaction formation toward the historical 'decay of aura'") that is the object of the artwork essay's call for demolition.[42] But I believe that the violence of this call cannot but hit "genuine" aura as well; it rhetorically executes the same "destructive, cathartic" function that Benjamin ascribes to film in relation to traditional culture (*SW* 3:104). In that sense, the artwork essay would have to be seen as a desperate experiment, an existential wager comparable to the tabula rasa approach of "Experience and Poverty" three years earlier, the stakes exponentially raised with the darkening of the political—and Benjamin's personal—situation.

However, considering that aura as both medium of experience and epistemic model was essential to Benjamin's own mode of thinking (and resurfaced as such in his writings and letters as late as the second Baudelaire essay and his theses on the concept of history [1940]), the matter may be still more complex. For the "genuine" aura that Benjamin surrenders in the face of the overwhelming efficacy of aura simulation is, as I have tried to show, already a pocket version—circumscribed by the tradition of Western art and poetry, its range of temporalities foreshortened into a simple, irreversible pastness, an "*auréole*" or "halo," like the one in

Baudelaire's prose poem, that the poet would do well to be losing (SW 4:342). One might argue, therefore, that the self-denigrating reduction of aura in the artwork essay is not least an act of defense, a fetishistic deflection that would protect, as it were, the vital parts of the concept, inasmuch as they were indispensable to the project of reconceptualizing experience in modernity.

If there is such logic to the experiment, the violence deployed to carry it out should not be underestimated. Adorno famously invoked Anna Freud's notion of "identification with the aggressor" to criticize Benjamin's betrayal of aura (in the narrow sense of beautiful semblance and aesthetic autonomy) to the mass-cultural forms and forces of liquidation.[43] What eludes the psycho-analytic verdict, though, is the historical and political dilemma that Benjamin sought to confront—the extent to which "genuine" aura was compromised by the industrial and totalitarian simulation of auratic effects and yet, at the same time, contained structural elements indispensable to reimagining experience in a secularized, collective, and technologically mediated form. One strategy of preserving the potentiality of aura, of being able to introduce the concept in the first place, was to place it under erasure, to mark it as constitutively belated and irreversibly moribund; in other words, Benjamin had to kill the term, mortify and blast it to pieces, before he could use it at all. The other strategy was to abandon the term aura altogether and reconfigure the demolished fragments of auratic perception in other concepts, in particular the mimetic faculty and the optical unconscious.

AURA, PRIMAL IMAGE, DREAM CONSCIOUSNESS

This complex operation has obscured some of the more basic reasons that made it impossible for Benjamin—or any serious writer on the left—to use aura as an innocent, let alone positive, concept. Since the beginning of the century, the term *aura* had flourished in all kinds of occultist, spiritistic, and parapsychological discourses, especially theosophy and the only slightly more respectable anthro-posophy of Rudolf Steiner—with meanings and imagery not dissimilar from its more recent revival in the New Age cults. Benjamin made no secret of his contempt for Steiner and his school, attributing its success to the collapse of general education and comparing its rise to that of advertising.[44] It is therefore not surprising that Benjamin studiously avoids using the term *aura* for many years, although his thinking quite early on betrays an interest in the type of experience associated with it.[45] As Josef Fürnkäs points out, it took his turn to the avant-gardist exploration of capitalist modernity inaugurated with *One-Way Street* and his encounter with surrealism in 1925 before he could appropriate and redefine aura for his own purposes.[46]

He takes that step, not coincidentally, in an unpublished "protocol" of one of his hashish experiments. I resume the quotation that opened this chapter:

Everything I said on the subject [the nature of aura] was directed polemically against the theosophists, whose inexperience and ignorance I find highly repugnant. And I contrasted three aspects of genuine aura—though by no means schematically—with the conventional and banal ideas of the theosophists. First, genuine aura appears in all things, not just in certain things, as people imagine. Second, the aura undergoes changes, which can be quite fundamental, with every movement of the object whose aura it is. Third, genuine aura can in no sense be thought of as the spruced-up magic rays beloved of spiritualists which we find depicted and described in vulgar works of mysticism. On the contrary, the distinctive feature of genuine aura is ornament, an ornamental halo [*Umzirkung*], in which the object or being is enclosed as in a case [*Futteral*]. Perhaps nothing gives such a clear idea of aura as Van Gogh's late paintings, in which one could say the aura appears to have been painted along with the various objects.[47]

Just as he is experimenting with hashish and modes of writing about that experience, Benjamin is clearly experimenting with the concept of aura.

The insistence that "genuine aura appears in all things" suggests that he initially sought to reinvent aura as an exoteric and materialist concept capable of grasping the realities of the modern everyday. In this spirit he writes as early as 1925 (defending the illustrated magazine *Berliner Illustrirte Zeitung* against a conservative attack): "To show things in the *aura of their actuality* is worth more, is far more fruitful, albeit indirectly, than to trump them with ultimately petit-bourgeois ideas of popular education [*Volksbildung*]."[48] A thus secularized aura would correspond to, or at least overlap with, the seemingly paradoxical concept of profane illumination that Benjamin develops around the same time with regard to the surrealists, in particular Louis Aragon's explorations of Paris as modern myth. In fact, his cautioning of the surrealists against drifting into spiritism and mere intoxication seems to be fueled by the same animus that prompts him to reclaim the aura from the theosophists and Steinerites: "We penetrate the mystery only to the degree that we recognize it in the everyday world, by virtue of a dialectical optic that perceives the everyday as impenetrable, the impenetrable as everyday" (*SW* 2:216). Such exploration is aimed at the quotidian, the recognition of a collective *physis* transformed by modern technology and consumption. It takes shape not in the "aura of novelty" but rather in the encounter with *all* things, even and especially those that are no longer fashionable—in the "aura of the habitual. In memory, childhood, and dream" (*AP* 461 [N2a,1]).

Against an ontological use of *aura*, Benjamin emphasizes its unstable, metamorphic, and relational character, that is, its dependence on particular constellations and acts of reading and interpretation. This point ties in with his third

observation, the characterization of aura as *ornament*. (I am bracketing here an all-too-obvious comparison with Heidegger on the basis of their common, though I think quite different, invocation of Van Gogh.)[49] The characterization of aura as ornament or ornamental halo may sound odd in light of Benjamin's concurrent endorsement of Neue Sachlichkeit (New Objectivity), including Adolf Loos and his famous attack on the ornament in architecture and design.[50] However, the term names an important epistemological trope in other contexts.

For one thing, the notion of ornament is associated with the writings of Kracauer, who used linear figures such as ornament and arabesque to analyze the surface phenomena of contemporary commercial culture (notably in his discussion of Taylorist entertainment forms as "mass ornament"). For another, it plays a part in Benjamin's own theories of physiognomic reading, for which he repeatedly invokes Hugo von Hofmannsthal's phrase "to read what was never written."[51] In a later hashish protocol, he refers to the ornament as the "most hidden, generally most inaccessible world of surfaces," which reveals itself to the subject only under the influence, in a mode reminiscent of childhood games and feverish dreams. As an abstract configuration on a two-dimensional plane, the ornament (similar to the allegorical emblem) inevitably has multiple meanings; indeed, it represents the "Ur-phenomenon" of "manifold interpretability."[52] This observation situates aura, qua ornament, in the context of Benjamin's reflections on the mimetic faculty, the gift for seeing and producing similarities that unconsciously or imperceptibly permeate our lives.[53] If in modernity such similarities have withdrawn and become "nonsensuous" (as exemplified by language, in particular written language), already the phylogenetic prototype of mimetic reading—in particular the ancients' reading of celestial constellations—Benjamin speculates, entailed a degree of abstraction, or perception of similarities by way of ornamental figures. He concludes this thought with the heuristic question: "Are the stars with their gaze from the distance the Urphenomenon of aura?"[54]

Notwithstanding Benjamin's polemics against the theosophists and the disciples of Steiner, his notion of aura as ornamental halo is certainly no less mystical. But it is one thing to reclaim the aura from its "vulgar" currency by radically redefining it; it is another to appropriate the concept from sources even more fraught or, for that matter, too close to name. I am referring here, on the one hand, to the Munich Kosmiker circle, in particular Alfred Schuler and Ludwig Klages, with whom Stefan George, a regular and revered visitor, and Karl Wolfskehl, the only Jewish member of the group, broke because of their virulent anti-Semitism in 1904.[55] On the other, I am referring to the tradition of Jewish mysticism that captured Benjamin's interest early on, mediated primarily through his lifelong friendship with Scholem.

Benjamin came into contact with the Kosmiker through his friend Franz Hessel (and probably also Rilke) in 1915, when he went to study in Munich. He had sought

out Klages personally the year before, initially attracted to his work on graphology, a mode of physiognomic reading that fascinated Benjamin throughout his life and in which he himself had some expertise.[56] He also was familiar with Klages's radical ecological manifesto, "Mensch und Erde" ("Man and Earth," written for the Meissner meeting of the German youth movement in 1913), and wrote reverential letters to the philosopher on the publication of his essay on dream consciousness, "Vom Traumbewußtsein" (1913–14; expanded 1919), and his book *Vom Kosmogonischen Eros* (*On Cosmogonic Eros*, 1922).[57] He was almost as consistent, though even more secretive, in his fascination with Schuler, whom he described, in a text written in 1934–35 for publication in French, as a "highly peculiar figure."[58]

The Kosmiker subscribed to neopagan, hedonistic, and antipatriarchal theories inspired by Nietzsche and Johann Jakob Bachofen (in particular the latter's protofeminist work *Das Mutterrecht* [1861], or *Mother-Right*) and galvanized by the charismatic Schuler, their "oracular authority" (*SW* 3:18). In his dramatizations of late Roman antiquity, Schuler claimed to perceive the emanation of an "aura," an ephemeral breath, from the recently excavated ruins at Trier, which animated the "spirits" or "ghosts" (*Geister*) of prehistoric, primeval time.[59] Such emanation to him was the echo of an "open era" or "open life," defined by rituals of blood sacrifice and communion with the dead, which was slowly but irreversibly declining, giving way to a "closed life" defined by capitalist progress, logos, and patriarchy rooted in the monotheistic cult of "Jahwe—Moloch."[60] According to Schuler, the late Romans already sensed this decline: *"Es ist die Aura, die schwindet"* (that which is vanishing is the aura).[61]

The Kosmikers' aura may have entered Benjamin's dictionary more specifically through Wolfskehl, with whom he developed a sympathetic, if somewhat condescending, relationship beginning in 1927. Wolfskehl played the part of the cultural hermaphrodite in more than one sense: he referred to himself as "at once Jewish, Roman, and German" (as late as 1933) and during his Kosmiker days was variously dubbed "matriarch of Zion," "Dionysos of Schwabing," or, in Hessel's word, "Hermopan."[62] Benjamin seems to have treasured Wolfskehl primarily as a kind of medium, repeatedly emphasizing the visionary power of the poet's voice (reading the texts of others) and handwriting (an incomparable "hiding-place" and "world-historical refugium" in which, as in its author, "dwell images, wisdom, and [otherwise forgotten] phrases" [*GS* 3:368]). Among the texts actually written by the poet, Benjamin singles out the essay "Lebensluft" ("Air of Life"; 1929), which he links to his own ongoing work on surrealism and thus the notion of profane illumination. Wolfskehl's essay begins with the words "We may call it aura or use a less 'occult' term—every material being radiates it, has, as it were, its own specific atmosphere. Whether animate or inanimate . . . , created by human hand or unintentionally produced, everything thus pushes beyond itself, surrounds itself with itself, with a weightless fluidal husk."[63]

A more problematic intertext for Benjamin's aura—and notions surrounding that mode of experience—is the work of Klages, whose anthropological-psychological speculations he credits with having elevated the esoteric theories of the Bachofen revival to a level where they could "claim a place in philosophy" (SW 3:18).[64] Like Schuler, George, and, for that matter, Spengler, Klages engaged in powerful prophecies of decline, attributed to the hegemony of the intellect (Geist), the advance of science and technology in the pursuit of progress and property, and even labor itself (the result of the "Yahwist curse" that expelled Adam and Eve from Paradise). Against the self-destructive pursuits of "mechanical" civilization, he extolled archaic, mythical modes of experience based in a prehistoric unity of soul and body, which could be recaptured in states of dreaming and ecstatic trance (Rausch). In Klages's excoriation of technological modernity, the Kosmikers' neo-Nietzschean crusade against Judeo-Christian asceticism converged with anti-Semitic tendencies in (neo)romantic anticapitalism.[65]

Benjamin's admiration for Klages is an example of his antinomic mode of thinking, his professed tendency, discussed in the previous chapter, to move "by way of extreme positions."[66] This mode of thinking entailed, as Scholem observed in retrospect, his being "capable of perceiving the subterranean rumbling of the revolution even in authors whose world-view was reactionary."[67] To be sure, Benjamin had major differences with Klages on both political and philosophical grounds (to say nothing of the writer's paranoid anti-Semitism), increasingly so after the former's turn to Marxism in the mid-1920s. But his critique of Klages's lapsarian prophecies, in particular "his doomed attempt to reject the existing 'technical,' 'mechanized' state of the modern world," went beyond the standard Marxist verdict against Lebensphilosophie—that the vitalist opposition to machine technology was abstractly fixated on a means of production and thereby ignored the relations of production.[68] Rather, Benjamin considered Klages a "reactionary thinker" for setting up an "insipid and helpless antithesis . . . between the symbol-space of nature and that of technology," that is, for failing to recognize that technology, at bottom, is nothing but a "truly new configuration of nature" (AP 390; GS 5:493). However, as we shall see, the very notion of such a transgenerational "symbol-space"—and the ability, which Benjamin attributes to children, to "recognize the new once again" and to incorporate these new images "into the image stock of humanity" (ibid.)—testifies to how substantially he was thinking at once with, through, and against Klages.

Klages's writings, "properly fragmented" (Wohlfarth), provided Benjamin not only with a quarry of insights and motifs but also with a foil and catalyst that helped him formulate his own approach to technological modernity beginning with One-Way Street.[69] (Not least, this critical appropriation involved a modernization of Klages's language.) In Klages, Benjamin found elements of a theory of

experience that could be turned from its vitalist head onto modernist-materialist feet. Central to this theory of experience was Klages's concept of the image or *Bild*, epitomized by the so-called *Urbild*, a primal or archaic image, and his life-long insistence on the "actuality" or "reality of images."[70] "Aura" (or "nimbus") in Klages's parlance is the "fluidal shudder" or "veil" that constitutes and surrounds the *Urbild*, the "daimonically enchanted" image that transforms ordinary objects into visions or epiphanies.[71]

I will bypass the fairly well known debates on Benjamin's appropriation of Klages's primal image in the initial stages of his *Arcades Project*, that is, for an understanding of modernity through its mythical dream images that have to be translated into historical, dialectical images, inseparable from the political urgency of "waking up."[72] Nor will I go into Klages's significance for the cosmological and species-political strand in Benjamin's concept of history (which he was to develop under the heading of "anthropological materialism") or comment on the likelihood that he might have found in Klages a philosophical incentive, if not legitimation, for his drug experiments. The more interesting question in this context is what Benjamin sought in Klages that he could not have drawn—or did not acknowledge drawing, to the extent that he did—from the philosophy of Bergson (who, like Simmel, was part of the liberal-democratic wing of *Lebensphilosophie*). After all, Bergson had responded with more curiosity than Klages to the transformations of perception and memory entailed by modern imaging technologies, which accounts for the important impulses his work has harbored for theories of film and media to this day.[73]

One reason may be that Benjamin found in Klages a theory, not only of the memory image but of the *image memory* that lent itself to being historicized and politicized against the grain more readily—and perhaps more antagonistically—than Bergson's.[74] Klages's concept of the image partakes of the double and disjunctive temporality that fascinated Benjamin in Proust, as a medium at once ephemeral—irretrievable, flitting past—and enabling a self-dislocating encounter with the archaic. Unlike Proust's *mémoire involontaire*, though, Klages's *Urbild* derives its archaic dimension from the idea of a transgenerational species memory. "Primal images are appearing souls of the past [*erscheinende Vergangenheits-seelen*]."[75] In a gloss on *Vom Kosmogonischen Eros* (which takes up much of his 1926 review of C. A. Bernoulli's book on Bachofen), Benjamin singles out this particular trajectory, crediting Klages's studies in "natural mythology" with seeking to restore to human memory "from an oblivion of thousands of years" the "reality" of "actually existing and formative 'images.'" These penetrate "the mechanical world of the senses" through the "medium of the human being" in states of ecstasy or dreaming. "Images . . . are souls, be they of things or people; distant souls of the past form the world in which primitives, whose consciousness is comparable to

the dream consciousness of modern man, receive their perceptions" (*SW* 1:427; *GS* 3:44). For Klages, this mythical image memory has a physiological, specifically racial basis; the souls of the past appear and rematerialize thanks to the *Blutleuchte,* or lighting up of the blood, a notion Klages takes from Schuler. Nonetheless, conscious of this ideological baggage and thus of risking censure from his friends, in particular Adorno, Benjamin found in Klages an antithetical prompting for his own quest to theorize something like a transgenerational memory in modernity—a memory that would allow *new* images, that is, images of an industrially transformed collective *physis,* to be assimilated nondestructively "into the image stock of humanity."[76]

A no less important impulse of Klages's theory of images for Benjamin was his elaboration of the romantic polarity of farness and nearness, *Ferne* and *Nähe.* As an early fragment indebted to Klages shows, Benjamin's initial interest in this polarity was not concerned with the unique modality of works of art (as it might appear from the artwork essay) but with the "psychophysical problem" that linked questions of the body, eroticism, and dream consciousness within the more general project of a "theory of perception" (as opposed to a "theory of cognition" or epistemology).[77]

The conception of farness and nearness as "complementary poles," rather than binary opposites, is central to Klages's treatise on "cosmogonic eros." He asserts that this polarity extends to time as much as space; this temporal dimension imbricates the momentary "flashing-up" of the image with the past of cosmic nature (stellar constellations); generations of dead; and one's own forgotten youth.[78] Moreover, Benjamin aligns farness with *image* and nearness with *thing,* and stresses that farness and nearness are to be understood as *modes of perception* rather than measurable distances between subject and object.

> Compared to someone noticing a bug on his hand, the beholder of blue-veiled mountain ranges more substantially resembles . . . the "dreamer" or the "immersed." The observer seeking [cognitive] distinctions treats even the faraway as if it were something near . . . whereas the gaze of a person lost in contemplation of even an object close by is captivated by an *image* of the object. . . . It is not so much the actual distance of an object as the mode of contemplation that determines whether the object is characterized by nearness or farness; and no one will confuse the thingness of the quality of the near [*Nahcharakter*] with the imageness of that of the far [*Ferncharakter*].[79]

The image, as he emphasizes throughout, is characterized by a constitutive untouchability, or *Unantastbarkeit,* by a veil whose removal would rob the image of its essential character.[80] Benjamin may have replaced Klages's bug with a car or billboard and valorized proximity as a key parameter of modern experience, but he preserved Klages's fascination in the paradoxical conception of an apparition

or "appearance of a distance however close the thing that calls it forth," to say nothing of "blue-veiled mountain ranges."

If Benjamin preserved this fascination by marking the aura as irreversibly moribund, he did not simply invert Klages's antimodernist hierarchy by endorsing a sensibility of nearness, thingness, and shock as the perceptual dominant of technologically mediated mass modernity (though of course he did that, too). More important, he radicalized Klages's theory of perception—as grounded in the reality of images rather than in a subjective faculty—by historicizing it in relation to the technologically transformed *physis* of modernity. In particular, he appropriated Klages's elaboration of the polarity of farness and distance to theorize the epochal reconfiguration and interpenetration of "body and image-space" that he discerned in the mass-based media of advertising and cinema, the modern urban habitat, and the experiments of the surrealists (*SW* 2:217).

Benjamin is likely to have found more specific impulses for thinking about the historic reconfiguration of body and image-space in terms of the technological media in Klages's essay "On Dream Consciousness," which he seems to have read in both versions.[81] With its emphasis on the phenomenal-sensorial characteristics of dreaming, rather than the meaning and interpretation of dreams, this implicitly anti-Freudian treatise appealed to Benjamin's interest in eccentric states of consciousness. What is more, whether or not Benjamin was aware of it, Klages's essay offers a rich archive of observations relevant to film. Notwithstanding its author's rejection of technology (including the "metropolitan intoxication by distraction"[82]), the essay reads for long stretches like a theory of cinematic perception. Just substitute the word *film* for *dream,* and you have a text that sounds key motifs of film aesthetics and reflections on cinematic spectatorship as articulated by early writers on film such as Hugo Münsterberg, Jean Epstein, Louis Delluc, Germaine Dulac, and Kracauer.[83] Beyond the canon of classical film theory, I would submit, Klages's remarkable analysis of the "virtuality" of dream images and the dreamer's perception of these paradoxical "appearances" points to more recent efforts to make phenomenological thought productive for film.[84]

Against the psychoanalytic emphasis on the meaning of dreams for the individual subject, Klages aligns himself with antiquity's understanding of dream images as objective; he actually speaks of dreams as "apparitions," related to terms such as *phantasma* and *phantom* (171). Dreaming (and dreamlike) states of consciousness are characterized by a "pathic passivity," "subordination of the will," and "surrender" to impressions that are taken for reality; a sense of distance and elusiveness; and, in language resonating with Kracauer's writing on film of the early 1920s, a feeling of ephemerality and transience and at the same time fusion with the constant flux and metamorphosing of phenomena: "[The dreamer] turns into a leaf rippling in the wind, drifting smoke, disintegrating foam, wandering cloud, falling star" (164–65).[85] Dreaming, like cinematic reception, entails a mimetic

blending with such moving and morphing images and, accordingly, an erosion of the boundaries between subject and object. "What touches each other in the perfect dream should no longer even be called subject and object" (170).

The destabilization of the "I" goes along with a "de-objectification," or *Entgegenständlichung*, of space and time, in particular an unmooring of movement from spatiotemporal dimensions. Dream images are "virtual images that we see in the place-less space of a mirror" (217). They are not a representation or sign of actual objects but an *expression* of their imagistic qualities; that is, they work by referencing not things themselves but the experiential substance of things (213–14)—hence the paradoxical effect of sensory indifference (for instance, absence of pain) and visionary intensity, a synesthetic form of beholding or visioning (*Schauen*) (171; also 189, 205). Thus, despite its "quality of farness," oneiric perception involves a form of bodily experience in which one's "life is transferred to the place of appearance or apparition" (189).[86]

If images are perceived as material reality, and if bodies, for Klages (as for Bergson), are themselves defined as images, the valorization of their interpenetration as the only authentic form of vision harbors the risks of empiricopessimism and solipsism. Klages addresses this quandary—the dissociation of reality into an indeterminate plurality—by asserting a categorical difference between, on the one hand, the ordinary conditions of seeing and bodily being and, on the other, a higher form of vision that is a prerequisite to "accomplishing the spiritual act" of finding in the particularity and "peculiarity" (*Eigenheit*) of experienced reality "the universality of existences independent of [individual] life," that is, the universality of mythical, primal images. He supports that assertion, somewhat spuriously, with Heraclitus's famous phrase that "those who are awake have a single world in common, while each sleeper turns to a world of his own" (213).[87] When Benjamin cites the same phrase in the section on the optical unconscious of the 1936 artwork essay, he not only uses it to evoke the world-historical difference of film but, in the same move, modernizes and democratizes Klages: "The ancient truth expressed by Heraclitus . . . has been invalidated by film—and less by depicting the dream world itself than by creating figures of collective dream, such as the globe-encircling Mickey Mouse" (*SW* 3:118).

I am not claiming that Benjamin read Klages's essay on dream consciousness in terms of a theory of film or cinema. But it is evident that his critical appropriation of Klages went far beyond the concept of aura; it actually contributed to a perspective in which film could come to figure, in Benjamin's words, as "the most important subject matter, at present, for the theory of perception which the Greeks called aesthetics" (*SW* 3:120). This not only required an inversion of Klages's stance on technology and a valorization of nearness and tactility as a key experiential parameter of collective urban life. It also entailed Benjamin's insight that film, *because* of both its technological and its collective status, provided the

most significant perceptual and social matrix in which the wounds inflicted on human bodies and senses *by* technology—in its industrial-capitalist and imperialist usage—might yet be healed, in which the numbing of the sensorium in defense against shock and the concomitant splitting of experience could be reversed, if not prevented, in the mode of play.[88]

AURATIC SELF-ENCOUNTERS, PRODUCTIVE SELF-ALIENATION

There's one last twist in my tale. It involves another, equally important lineage for Benjamin's concept of aura: Jewish mysticism and psychotheology. On January 14, 1926, Benjamin wrote to Scholem about Bernoulli's book on Bachofen and the natural symbol (which, he says, "has a particular relevance for me—in a *fairytale*-like way"): "A confrontation with Bachofen and Klages is unavoidable; there is reason to assume, however, that it can be conducted compellingly only from the perspective of Jewish theology. It is no coincidence that these important scholars detect the archenemy precisely in this area, and not without cause" (*C* 288; *GB* 3:110). The battleground of this confrontation, I believe, is the cluster of phenomena Benjamin sought to name with the term *aura*.

Scholem must have taken it for granted that Benjamin derived his concept of aura from Jewish theology. This comes across not only in their correspondence but also in his sharply critical response to the artwork essay (reported in his memoir on Benjamin): "I attacked his use of the concept of aura, which he had employed in an entirely different sense for many years and was now placing in what I considered a pseudo-Marxist context. In my view, his new definition of this phenomenon constituted, logically speaking, a subreption [an improper or fallacious appropriation] that permitted him to sneak metaphysical insights into a framework unsuited to them."[89] It is telling that the archenemy for Scholem was not Klages but Benjamin's (and, by implication, Brecht's) Marxism.

Following scholars such as Giorgio Agamben and Harold Bloom, I share Scholem's assumption that Benjamin's understanding of aura is, partially at least, grounded in Jewish mysticism, in particular the kabbalistic theory of *tselem*, literally, image or *Bild*.[90] According to Scholem, the term is used in the *Zohar* and elsewhere to refer to "the unique, individual spiritual shape of each human being" or a person's "*principium individuationis*." He considers the *tselem* a version of the idea of an "astral body," a psychic "emanation of his own being made independent"—an idea that goes back to Neoplatonism and from there has migrated into both Jewish and non-Jewish mysticism.[91] (Klages and Steiner, for instance, refer to Paracelsus's analogous notion of a "sideric body.") Scholem highlights two aspects of the theory of *tselem* that have particular relevance for Benjamin's concept of aura. One is the understanding of the *tselem* as a "personal daemon"

that shadows and determines a person's being, less in the benign sense as the person's "perfected nature" than in the negative sense of an "antithetical self" or "adversary angel."[92] The other relates to the idea of *tselem* as a form of visionary self-encounter, for which he quotes at length a sixteenth-century kabbalistic text on prophecy: "The complete secret of prophecy to the prophet consists in that he suddenly sees the form of his self standing before him, and he forgets his own self and [is removed from it; *entrückt*] . . . and that form [of his self] speaks with him and tells him the future."[93]

The motif of a visionary, self-alienating self-encounter as described in this text is the topic of Scholem's 1930 article "Eine kabbalistische Erklärung der Prophetie als Selbst-begegnung" (A Kabbalist Account of Prophecy as Self-Encounter). Thanking his friend for an offprint of the article, Benjamin writes in November 1930: "You can hardly imagine how I feel watching you at work in this gold mine [*Goldbergwerke,* or 'Goldberg territory']. I read those few pages with true excitement."[94] It is exactly at this juncture in his life that Benjamin introduces the concept of aura into his writings, particularly in "Little History of Photography" and the hashish protocols and, implicitly, in the (semi)autobiographical texts discussed above, "Berlin Chronicle" and the "Short Speech on Proust."

One might wonder how mystical and psychotheological speculations revolving around the formation and fate of the individual can have any bearing on modern, historically immanent, and collectively experienced technological media such as film. Yet Benjamin himself did not treat these domains as separate or incompatible; on the contrary, the very intersection of cosmic and secular-historical registers is a recurring theme in his philosophy of history.[95] Traditions of Jewish messianism and gnosticism—in their relevance to modernity—were already available to him through writers such as Proust and, especially, Kafka.

The signal importance of Kafka in this context must not be underrated, although in Benjamin's writings on Kafka, including his great essay of 1934, the term *aura* does not appear. Its tenor clearly belongs to a different register than, say, the artwork essay's evocation of aura as beautiful semblance. Nonetheless, Benjamin finds in Kafka a number of motifs that overlap with elements of aura in the wider sense that are key to his theory of experience, including the very notion of experience as something haunting and destabilizing; "I have experience," Benjamin quotes from early Kafka, "and I am not joking when I say that it is a seasickness on dry land."[96] Suffice it here to mention the significance of *forgetting* in Kafka's work, linked to the motif of *Entstellung,* or distortion, which is "the form which things assume in oblivion" (*SW* 2:811) (this motif in turn relates to the notion of a "distorted similarity" that emerges in Benjamin's Proust essay and his autobiographical texts on Berlin childhood).[97] Moreover, the irruption of forgotten, distorted or misbegotten, strange things or beings into the quotidian world—such as Kafka's elusive Odradek or Benjamin's little hunchback of the opaque nursery

rhyme—instantiates a temporality in which the recent past evokes the archaic. It taps into a lost memory that "is never . . . purely individual. Everything forgotten mingles with what has been forgotten of the prehistoric world, forms countless uncertain and changing compounds, yielding a constant flow of new, strange products" (SW 2:809–10). Kafka offered Benjamin a pendant, and an alternative, to Klages's transgenerational, mythic image bank without the antimodernist and racial assumptions that compromised the Bachofen revival.

Probably the most important motif in Benjamin's reading of Kafka for his understanding of film is the concept of human *self-alienation*. "The invention of motion pictures and the phonograph came in an age of maximum alienation of men from one another, of immeasurably mediated relationships which have become their only ones. *Experiments have proved that a man does not recognize his own gait on film, or his own voice on the phonograph.* The situation of the subject in such experiments is Kafka's situation; this is what prompts his investigation, and what may enable him *to encounter fragments of his own existence*—fragments that are still within the context of the role" (SW 2:814; GS 2:436; emphasis added).

In the last section of the artwork essay, as in the second Baudelaire essay, Benjamin updates the Hegelian-Marxian category of self-alienation with an account of how the bungled reception of technology has blunted human beings' capability of experience and sense of self-preservation (SW 3:122; SW 4:335). In his work on Kafka, however, self-alienation is inflected with Scholem's kabbalistic assumption of a "primal and fundamental *Galut* [exile]" in which "all existence, including, 'as it were,' God, subsists," constituting "the state of creation after the breaking of the vessels."[98] That is, Benjamin's concept of self-alienation differs from the concept's currency in pessimistic and lapsarian critiques of modernity inasmuch as it does not entail the assumption of an originary, unalienated condition or a more identical, unitary self.

Conversely, the theological underpinnings of Benjamin's concept of self-alienation are bound up not only with "an irreparable condition of exile which is the (German-Jewish) tradition of modernity" (Anson Rabinbach) but, at least as crucially, with the experience of the capitalist-industrial everyday.[99] It is this "doubleness" of theological and immanent historical-political concerns— Benjamin stresses that the former have "no right" unless they engage the latter— that puts an important "key to the interpretation of Kafka" into the hands of Chaplin: "Just as there are situations in Chaplin that, in a unique manner, imbricate the condition of being expelled and disinherited, the eternal human woe, with the most specific conditions of today's existence—finance, the metropolis, the police—so every event in Kafka has a Janus face: immemorial and ahistorical, but then again charged with the latest, journalistic actuality."[100] Chaplin achieves this significance by mimicking technology's fragmenting effects on the human body: by dissecting "human expressive movement into a series of minute innervations"

and reconstituting his own movement as a "succession of staccato bits of movement" (*SW* 3:94), "he interprets himself allegorically" (*GS* 1:1047).

Self-alienation, after all, is one of the key concepts of the artwork essay, ostensibly unrelated to the concept of aura. *"In the representation of human beings by means of an apparatus their self-alienation has been put to a highly productive use"* (*SW* 3:113; *GS* 7:369). Chaplin is not the only witness for that claim. Benjamin elaborates this hypothesis more generally regarding the screen actor's confrontation with the apparatus, his or her instantiation of the "tests" that human beings are confronting in their work and everyday lives. Benjamin knows that the dialectics of productive self-alienation can prove itself only in the arena of reception, to the extent that the cinema—as a collective, public space—allows individuals "to encounter fragments of [their] own existence." Significantly, he discerns such a possibility in the appeal of early Mickey Mouse films and attributes their popularity to "the fact that the audience recognizes their own life in them" (*SW* 2:545; *GS* 6:144–45). This somewhat counterintuitive claim rests on the assumption, mentioned above and to be elaborated anon, that these films provoke a forced articulation of distorted, mass-psychotic responses to modernization and thus prematurely detonate, and neutralize their otherwise destructive potential (*SW* 3:118). It is here, in a wholly secularized, modern context, that Benjamin transposes onto a collective level his earlier linkage, in the photography essay's discussion of the Dauthendey portrait, of a daemonic, auratic self-encounter with the concept of an optical unconscious.

Again, I am not arguing that the theorization of cinema as the locus of productive self-alienation is the same as an individual auratic experience in the kabbalistic sense of a visionary encounter with an older, other self. But as I hope to have shown, if we consider Benjamin's concept of aura in its wider, anthropological, visionary, and psychotheological dimensions, rather than in the narrower sense it acquires in the artwork essay, the relationship between aura and technical reproduction, like that of aura and the masses, no longer reduces to an opposition of binary, mutually exclusive terms.

Benjamin's adaptation of the concept of aura in the last decade of his life entailed a forceful wresting away of the term from its contemporary theosophist and Steinerist currency—and at the same time involved a disavowal of his more specific esoteric sources. This critical appropriation could be accomplished only through a form of conceptual *apokatastasis,* "a resurrection, as it were, through [mortification and] dismemberment."[101] Even as Benjamin marked the phenomenon of the aura as historically belated and irreversibly moribund, he imported fragments of the concept—secularized and modernized—into his efforts to reimagine experience under the conditions of technically mediated culture. If Klages's theory of perception as mystical fusion with the image left its imprint on Benjamin's aura in the paradoxical entwinement of distance and nearness, it also resonates in his

notion of an interpenetration of body and image-space as a collective mimetic innervation of technology through film. And in Scholem's (re)construction of the kabbalistic theory of *tselem,* we can trace not only the elaboration of aura in terms of the return of the gaze and the daemonic vision of the self as other, but also Benjamin's notion of an optical unconscious and his understanding of film as a medium in which human "self-alienation can be put to a highly productive use."

The heterogeneity of sources and intertexts that resonate in Benjamin's aura goes a long way toward accounting for both the elusiveness and ambivalence that surrounds the concept in his work. More important, this heterogeneity testifies to Benjamin's revisionary ability—and intellectual courage—to appropriate and transform theoretical impulses from philosophically and politically incompatible, if not antagonistic, camps. I have traced some of these impulses to show aura's complex role in his efforts to reimagine the possibility of experience in mass-mediated modernity; I also hope to have elucidated the stakes of his experimental mode of theorizing—a mode of theorizing that I consider still, and in more than one sense, "open to the future."

Mistaking the Moon for a Ball

INNERVATION

Designating a mode of adaptation, assimilation, and incorporation of something external and alien to the subject, the neurophysiological concept of *innervation* seems to belong to a field of reference that couldn't be further removed from that of *aura*. And yet, like the latter, the term is essential to Benjamin's efforts to theorize the conditions of possibility of experience in modernity. As I argue in chapter 3, his engagement with the technological media was fueled by the insight that, notwithstanding the irrevocable decline and obsolescence of experience in its premodern and bourgeois forms, it was imperative to conceptualize some contemporary equivalent to that mode of knowledge. A reinvention of something like experience was needed above all to counter the already "bungled reception of technology" and with it the spiral of anaesthetics and aestheticization that, in Benjamin's analysis, was structurally accountable for the success of fascism.

In Benjamin's efforts to imagine a successful, nondestructive reception of technology, the concept of innervation plays a crucial role, particularly with regard to the perceptual, social, and political functions of film. As I elaborate in connection with the optical unconscious, the cinematic innervation of technology involves two levels: that of inscription—the technical refraction, through framing and montage, of an already technologically transformed environment, the incorporation of cinematic technique on the part of the screen actor—and the level of projection and reception, at which the film itself becomes an object of innervation for a spectating collective. As discussed earlier, Benjamin attributes to cinema a twofold role in the vital encounter between humans and technology. In an almost utilitarian sense, he considers it the "historical task" of film to train human beings in the forms of apperception and attention required in an increasingly machinic world—"to make the vast technical apparatus of our time an object of human innervation."[1] But in addition to this training function, he also imputed to cinema the therapeutic potential to counter, if not undo, the sensory alienation inflicted by industrial-capitalist modernity, to diffuse the pathological consequences of the failed reception of technology on a mass scale.

In Benjamin's dictionary, *innervation* broadly refers to a neurophysiological process that mediates between internal and external, psychic and motoric, human and machinic registers. These concerns—in particular the fate of the human sensorium in an environment altered by technology and capitalist commodity production—place the concept squarely in the framework of what Benjamin names the tradition of "anthropological materialism."[2] The term *innervation* enters his writings with a new "cycle of production" inaugurated with *One-Way Street* (written 1923–26; published 1928), following the literary-historical, "Germanist" cycle that had concluded with the book on the German *Trauerspiel*.[3] The concept is more fully developed in his 1929 essay on surrealism, particularly in the notion of a "collective bodily innervation," effected through the technologically enabled interpenetration of "body and image space" (*SW* 2:217–18). The notion of an imbrication of physiological with machinic structures becomes key in the artwork essay, in particular the sections on the screen actor and the observations on Chaplin and Mickey Mouse. The term *innervation* still appears in the 1935–36 versions of the essay (including the French translation by Pierre Klossowski), but is missing in the third, longtime-canonic version of 1939.

Following a brief sketch of innervation's psychoanalytic and neurophysiological genealogy, this chapter traces the concept primarily through *One-Way Street*, with excursions into the surrealism essay and the artwork essay. I will then move to Benjamin's notion of the *mimetic faculty*—as an anthropologically grounded yet historically determined mode of adaptation and appropriation that complements his politics of innervation. The chapter closes with a discussion of the *optical unconscious* as a form of mimetic innervation specifically available to photography and film. While these three terms—*innervation, mimetic faculty, optical unconscious*—are in no way synonymous, they hook into each other in ways highly relevant to a Benjaminian theory of film.

One-Way Street is commonly understood as documenting Benjamin's turn to Marxism beginning in 1924, under the influence of Asja Lacis, the "engineer" who, as he puts it in his dedication to her, "cut it [the street] through the author" (*SW* 1:444); in the same year, Benjamin read Georg Lukács's *History and Class Consciousness*. But *One-Way Street* is also part of a more general turn among critical intellectuals (discussed in chapter 1) from lapsarian critiques of modernity to a more curious and less anxious look at contemporary realities, in particular the marginalized, ephemeral phenomena of everyday life and a new leisure culture. The concern with "actuality," shared, though understood differently, by Benjamin, Kracauer, and Bloch, shaped their reception of Marx in idiosyncratic ways.[4] With the rapid transformation of German society from the chaos of the postwar years and hyperinflation through the subsequent period of stabilization (1924–29), history seemed to accelerate faster than ever. Like Kracauer and other Weimar intellectuals, Benjamin was acutely aware that social consciousness was

lagging behind actual developments; that what was most needed was a cognitive and aesthetic discourse equal to the new phenomena in their contradictory complexity. More than Kracauer, he focused on the question of technology and its impact on the history of human perception. In addition to Marx and early socialists such as Charles Fourier, he approached that question through selective recourse to psychoanalysis, including the neurological, anthropological, and surrealist fringes of Freud.[5]

Benjamin's turn to the material phenomena of modern life was catalyzed (even before his departure for Capri, where he met Lacis) by his contacts with avant-garde artists and architects from various countries then gathering in Berlin. He frequented meetings of the group that between 1923 and 1926 published the journal *G: Material zur elementaren Gestaltung* (material for elementary shaping, forming, or construction), founded by Hans Richter and edited by Werner Graeff. This group included, among others, architects Ludwig Mies van der Rohe and Ludwig Hilberseimer; filmmaker Viking Eggeling; international constructivists such as El Lissitzky, Naum Gabo, and Theo van Doesburg (founder of *de Stijl*); former or late dadaists such as Raoul Hausmann, Hans Arp, and Tristan Tzara (whose text on Man Ray's photograms Benjamin translated for the journal); emerging surrealists like Philippe Soupault; as well as Benjamin's wife, Dora Sophie Pollak; his close friend the composer and music theorist Ernst Schoen; photographer Sasha Stone (who was to create the cover of *One-Way Street*); and critic Adolf Behne.[6] The journal published articles on a wide range of topics—industrial architecture and design, urban planning, recording technology, film, photography, theater, poetry, painting, fashion—and featured visual material that both illustrated and counterpointed the stark typography of the text. If the "particular confluence in *G* of constructivism, late Dadaism, the new Americanism, and an awakening surrealism" fed into Benjamin's search for contemporaneous forms of expression, the graphic tension between image, script, and text not only echoed his early fascination with Mallarmé but also opened his eyes for similar styles of layout in mass-marketed illustrated magazines of the period such as the *Berliner Illustrirte Zeitung*.[7]

An impulse in the same direction came from the work of László Moholy-Nagy (briefly a member of the *G* group), whom Benjamin, in a review of 1928, hailed as "the pioneer of the new light-image," citing his well-known axiom "It is not the person ignorant of writing but the one ignorant of photography who will be the illiterate of the future."[8] In his important book *Malerei, Fotografie, Film* (1925; 1927), Moholy-Nagy had proposed a theory of modern visual form as part of the *Gestaltung* or "shaping of one's **own time** with means **appropriate to that time** [*zeitgemäß*]." As a collective enterprise, this project would enable human beings "to learn *again* how to react as much to the tiniest stirrings of [their] own being as to the laws of matter."[9] This agenda must have resonated with Benjamin's concern,

thematized in *One-Way Street*, that human beings' ability to perceive and comprehend their own material conditions was impaired, had atrophied, and therefore was not equal to dealing with their drastically changed environment. New art forms, such as modern photography, had to advance the ongoing transformation of perception, by inaugurating that "great stock-taking of the inventory of human perception that will alter our image of the world in as yet unforeseen ways."[10]

One-Way Street started out as a collection of "aphorisms, jokes, dreams" for friends in 1924,[11] but soon took on a more programmatic character. The challenge was to translate the actuality of avant-garde art and the popular print media into the medium of literature. In the opening section, "Filling Station" (*Tankstelle*), Benjamin stresses the paramount significance of "facts" (as opposed to "convictions") in "the construction of life at present"—facts, one might add, such as the mushrooming of the number of gas stations, which had been introduced in Germany only in 1924.[12] "Under these circumstances, true literary activity cannot aspire to take place within a literary framework. . . . Significant literary effectiveness can come into being only in a strict alternation between action and writing"; in the place of "the pretentious, universal gesture of the book," it must adopt the "prompt language" of inconspicuous forms such as "leaflets, pamphlets, articles, and placards" (*SW* 1:444; *GS* 4:85).

Benjamin's own text incorporates facts most directly in the section headings, originally printed in bold capital letters, that evoke quotidian objects, optical devices, and signs of the kind one might see walking down a modern street: a public clock, a stamp shop, stationers, "Enlargements," a stereoscope, toys, a war memorial, an arc lamp, a construction site, a fire alarm, "Post No Bills," and so forth.[13] But upon entering these sections, the reader is precipitated into a nonperspectival, multilayered space in which shards of discourse—proclamations, observations, adages, protocols of dreams and daydreams—convey something of the heterogeneous character of modern experience, "new aspects of [the] inner self opened by the text, that road cut through the interior jungle forever closing behind it" (*SW* 1:448). In other words, the constructivist conceit of the one-way street intersects with the nonlinear, vertiginous paths of feelings, desire, and the unconscious closer to the writings of the surrealists.[14] In rehearsing this crossing, the textual dynamic of *One-Way Street* enacts something like the neurophysiological process that Benjamin considered essential to a noncatastrophic adaptation of technology and that the book names with the concept of innervation.

If Jean Laplanche and J.-B. Pontalis feel compelled to say that "the term 'innervation' may pose a problem for the reader of Freud," one can only wonder what they would say about Benjamin's use of the term. According to Laplanche and Pontalis, in Freud's earliest writings the term refers to a "physiological process: the transmission, generally in an efferent direction, of energy along a nerve-pathway."[15] This definition by and large tallies with the term's usage in the discourse of physi-

ology since the 1830s, in which it denotes the process by which "nerve-force" is supplied to organs and muscles, or the "stimulation of some organ by its nerves."[16] In his (and Breuer's) work on hysteria, however, Freud uses *innervation* more specifically to describe the phenomenon of "conversion," the transformation of an unbearable, incompatible psychic excitation into "*something somatic.*" As in physiological discourse, this process is assumed to be unidirectional, which for Freud means an energy transfer from the psychic to the somatic. But instead of effecting a normal functioning of the organism, innervation in the hysteric facilitates a pathway related to the "traumatic experience" (which itself is repressed); excitation is "forced into a wrong channel (into somatic innervation)," which, as a "mnemic symbol," remains other and strange, lodged "in consciousness, like a sort of parasite."[17]

In *The Interpretation of Dreams* (1900), *innervation* appears in a more general sense, though with a significant twist. In his discussion of the "psychical apparatus" as a composite instrument comparable to various systems of lenses used in optical devices, Freud again asserts that the psychic apparatus has a definite direction: "All our psychical activity starts from stimuli (*whether internal or external*) and ends in innervations. Accordingly, we shall ascribe a sensory and a motor end to the apparatus. At the sensory end there lies a system which receives perceptions; at the motor end there lies another, which opens the gateway to motor activity. Psychical processes advance in general from the perceptual end to the motor end."[18]

Whereas in the context of the studies on hysteria, innervation represents a response to an *internal* excitation (whatever traumatic experience may have caused the excitation), here the sources of stimulation also include *external* ones. Freud resumes this distinction, along with the model of the psychic apparatus, in *Beyond the Pleasure Principle* (1920), when he discusses the case of traumatic neurosis caused by sensory overstimulation through mechanical violence (most acutely, in the recent war)—which returns us to Benjamin's account, in his second essay on Baudelaire, of the decay of experience under the urban-industrial-military proliferation of shock. In Freud's speculation, traumatic neurosis does not result simply from a thickening of the protective shield against excessive stimuli, but from an "extensive breach being made in the protective shield," to which the psyche responds by summoning massive amounts of "cathectic energy" around the area of the breach: "An 'anticathexis' [*Gegenbesetzung*] on a grand scale is set up, for whose benefit all the other psychical systems are impoverished, so that the remaining psychical functions are extensively paralysed or reduced."[19] The term *innervation* does *not* appear in this context, and for good reason, because it refers to the very process that is *blocked* in the configuration of shock-breach-anticathexis, the kind of discharge that alone could undo and counteract the anaesthetizing effects pinpointed by Benjamin.

Whether Benjamin borrowed the term from Freud or from the neurophysi-
ological and psychological discourse of the period, innervation comes to func-
tion as an antidote—and counterconcept—to technologically multiplied shock
and its anaesthetizing economy. In Susan Buck-Morss's words, "'innervation' is
Benjamin's term for a mimetic reception of the external world, one that is empow-
ering, in contrast to a defensive mimetic adaptation that protects at the price of
paralyzing the organism, robbing it of its capacity of imagination, and therefore
of active response."[20] To imagine such an enabling reception of technology, it
is essential that Benjamin, unlike Freud, understood innervation as a *two-way*
process or transfer, that is, not only a conversion of mental, affective energy into
somatic, motoric form but also the possibility of reconverting, and recovering,
split-off psychic energy through motoric stimulation (as distinct from the "talking
cure" advocated by Freud and Breuer).[21] This possibility implies that the protective
shield against stimuli, the precarious boundary or rind of the bodily ego, could
be imagined less as a carapace or armor than as a matrix—a porous interface
between the organism and the world that would allow for a greater mobility and
circulation of psychic energies.

Imagined as a two-way process, Benjamin's concept of innervation may have
less in common with Freudian psychoanalysis than with contemporary perceptual
and behaviorist psychology, physiological aesthetics, and acting theory, in par-
ticular the Soviet avant-garde discourse of biomechanics that must have reached
Benjamin via Lacis. A major reference point in this regard is Sergei Eisenstein,
who, drawing on and revising William James as well as Ludwig Klages, sought
to theorize the conditions of transmitting or, more precisely, generating emotion
in the beholder through the actor's bodily movement.[22] Seeking to adapt Klages's
metaphysically grounded concept of expressive movement (*Ausdrucksbewegung*)
for a materialist theory of signification and reception, Eisenstein, like his teacher
Vsevolod Meyerhold, returned to James's axiom that "emotion follows upon
the bodily expression" ("we feel sorry because we cry"), although he modified
James by insisting on the two-way character and indivisible unity of movement
and emotion.[23] Without going into detail here, what seems important regarding
Benjamin's concept of innervation and its implications for film theory is the notion
of a physiologically "contagious" or "infectious" movement that would trigger
emotional effects in the viewer, a form of mimetic identification based on the phe-
nomenon then known as Carpenter's Effect.[24] The recourse to neurophysiological
and reflex psychology may not be as sophisticated as the insights of psychoanalysis;
yet it may have been more in tune with new, technologically mediated forms of
aesthetic experience, predicated on mass production, unprecedented circulation
and mobility, and collective, public reception.

Even though in *One-Way Street* the term *innervation* appears only twice, the
idea pervades the text in a series of variations, culminating in the grand finale of

the book, "To the Planetarium." In the two places where the term is used explic-
itly—in one case referring to the practice of yoga meditation, in the other to the
typewriter—it involves different types of technology and stages of development. In
both cases, though, Benjamin is concerned with the gap between traditional means
of verbal language and the imagination, on the one hand, and the corresponding
quest for exact visual and graphic expression, on the other.

In the section labeled "Antiques," under the subheading "Prayer Wheel,"
Benjamin states axiomatically: "No imagination without innervation" (SW 1:466).
The preceding sentences, alluding to Schopenhauer, assert that "exact pictorial
imagination" (genaue bildliche Vorstellung) is essential to the vitality of "the will,"
in contrast with the "mere word," which at best inflames the will and leaves it
"smoldering, blasted." The following sentences exemplify the connection between
imagination and innervation in terms of an at once bodily and spiritual practice:
the discipline of breathing in yoga meditation. "Now breathing," Benjamin states,
is "[innervation's] most delicate regulator." And "the sound of formulas," he goes
on, is "a canon of such breathing." (In a fragment on gambling, Benjamin paren-
thetically equates the term motoric innervation with "inspiration," foregrounding
the etymological connection between inspiration and breathing.)[25] Inverting the
Western cliché that associates the Buddhist prayer wheel with mindless mechanic-
ity, Benjamin sees in the ascetic integration of external rhythm, physical posture,
and presence of mind a source of the imagination and, therefore, of power: "Hence
[the yogi's] omnipotence [Allmacht]."

The other passage in which innervation appears literally concerns the tools of
writing, in particular the typewriter, which had become a mass product during the
1920s as well as an emblem of (mostly female) labor in rationalized modernity.[26]
For the (male) literary intellectual this new writing tool was at once inferior to the
old-fashioned fountain pen and already obsolescent in view of future technological
possibilities. "The typewriter will alienate the hand of the man of letters from the
fountain pen only when the precision of typographic forms will enter directly into
the conception of his books. This will likely require new systems of more variable
typefaces. They will replace the pliancy of the hand with the innervation of the
commanding fingers" (SW 1:457; GS 4:105).

What Benjamin would like, obviously, is a computer, with a word-processing
program that operates in the graphic mode. Better yet, he wants to be wired or
have his thoughts transcoded wirelessly—provided the new systems of writing are
precise, flexible, and variable enough to play a productive role in the conception of
his books. Only then will he give up the beloved fountain pen, with its more inti-
mate, habitual relation to the writer's hand, a traditional mimetic bond that makes
him prefer the old-fashioned writing tool to the typewriter in its present form.

Both examples of innervation involve the body, but they do so in significantly
different ways. The difference between the ritualistic imbrication of physical and

spiritual energy in yoga meditation and modern mechanical tools of inscription seems to prefigure Benjamin's distinction, in the Urtext of the artwork essay, between "first" and "second technology" (*Technik*), which is predicated on, and entwined with, the Hegelian-Marxist concept of second nature. The distinction between first and second technology turns on the use of the human body and the degree of its implication: "Whereas the former made maximum use of human beings, the latter reduces their use to the minimum" (*SW* 3:107). The second technology originates "at the point where, with unconscious cunning, human beings first sought to gain distance from nature" (ibid.; *GS* 7:359). As Benjamin explains, "the greatest technical feat of the first technology is, as it were, the human sacrifice; that of the second excels along the lines of the remote-controlled aircraft which needs no human crew" (ibid.; *GS* 7:359). Yet, where a contemporary reader might associate the latter with the latest in electronic warfare (drones, cruise missiles), Benjamin makes an amazing turn. "In other words," he continues the speculation on the second technology's constitution through distance, "[its origin] lies in play [*Spiel*]" (*SW* 3:107). As we shall see in chapter 7, the notion of second technology is crucial to his understanding of film as a form of play.

The concept of play is central to how Benjamin understands the intersection of nature, technology, and humans. Unlike Frankfurt School critiques of technology from *Dialectic of Enlightenment* through Habermas, Benjamin does not assume an instrumentalist trajectory from mythical cunning to capitalist-industrialist modernity. The telos of the domination of nature defines the second technology only "from the standpoint of the first," which sought to master nature in existential seriousness, out of harsh necessity. By contrast, Benjamin asserts, the second technology "rather aims at the *interplay* between nature and humanity" (*SW* 3:107). And it is the *Einübung*, or training, practice of this interplay that Benjamin pinpoints as the decisive function of contemporary art, particularly film. Film, as I have been arguing, assumes this task not simply by way of a behaviorist adaptation of human perceptions and reactions to the regime of the apparatus but because film has the potential to reverse, in the form of play, the catastrophic consequences of an already failed reception of technology. For instead of providing humans with a "key to happiness," technology, in its capitalist-imperialist usage, had become a tool for the mastery over nature and thus of humanity's (self-)destruction; bourgeois culture had been complicit with that process by disavowing the political implications of technology, treating it as "second nature" while fetishizing an ostensibly pure and primary nature as object of individual contemplation.[27] Because of the technological nature of the filmic medium, as well as its collective mode of reception, film offers a chance—a second chance, a last chance—to bring the apparatus to social consciousness, to make it public. "To make the technical apparatus of our time, which is second nature to the individual, into first nature for the collective, is the historic task of film" (*GS* 7:688).

Innervation as a mode of regulating the interplay between humans and (second) technology can succeed (that is, escape the destructive vortex of defensive, numbing adaptation) only if it reconnects with the discarded powers of the first, with mimetic practices that involve the body, as the "preeminent instrument" of sensory perception and (moral, political) differentiation.[28] Where Ernst Jünger, for instance, turns his observations on the impact of technology into a paean to anaesthetization, self-alienation, and discipline (celebrating a "second and colder consciousness" capable of seeing its own body as object), Benjamin seeks to reactivate the abilities of the body as a medium in the service of imagining new forms of experience.[29] For Benjamin, negotiating the historical confrontation between human sensorium and technology as an alien, and alienating, regime requires learning from forms of bodily innervation that are no less technical but are to a greater extent self-regulated (which is clearly one of the motifs in Benjamin's auto-experiments with hashish, gambling, eroticism, running downhill).

The idea of a bodily innervation of technology raises the question of the fate of the individual, whose bodily, sensorial, psychosexual being was becoming more than ever an object, witting or unwitting, willing or unwilling, of transformation; this process coincides with the emergence of the collective as the subject of history. Benjamin condenses these motifs in a visionary tour de force at the end of his 1929 essay on surrealism. Observing in the surrealist experiments a radical interpenetration of "image-space" (*Bildraum*) with "body-space" (*Leibraum*) similar to the tendency he discerned in the modern urban media environment (a point to which I return), he describes this new space, "the world of universal and integral actualities," as one that challenges traditional boundaries, not only between subject and object, inside and outside, but more specifically between politics and creaturely life—"a space, in a word, in which political materialism and physical creatureliness share the inner man, the psyche, the individual . . . with dialectical justice, so that no limb remains untorn" (*SW* 2:217). Such morcelization, we might say, is paradigmatically performed on the screen actor; it advances the welding of his or her corporeal being into image-space.

The demolition of the autonomous, self-identical individual entails an analogous transformation of the collective. "The collective is a body, too. And the *physis* that is being organized for it in technology can, in all its factual and political reality, be generated only in that image-space to which profane illumination initiates us" (*SW* 2:217; *GS* 2:310). It is at this point that Benjamin formulates the notion of revolution as "innervation of the collective," which turns on the possibility of a collective innervation of technology. "Only when in technology body- and image-space so interpenetrate that all revolutionary tension becomes bodily collective innervation, and all the bodily innervations of the collective become revolutionary discharge, has reality transcended itself to the extent demanded by the *Communist*

Manifesto" (*SW* 2:217). And he concludes by "mimetically perform[ing]" the "leap into the apparatus," the revolutionary—and no less violent—crossing of human bodily sensorium with the new *physis* organized by technology.[30] "For the moment, only the Surrealists have understood its present commands. They exchange, to a man, the play of human features for the face of an alarm clock that in each minute rings for sixty seconds" (*SW* 2:218).

In this context Benjamin invokes the tradition of "anthropological material-ism" (Johann Peter Hebel, Georg Büchner, Nietzsche, Rimbaud, the surrealists) as an alternative to more orthodox Marxist, "metaphysical" versions of material-ism in the manner of Vogt and Bukharin. He further elaborates that perspective in the early layers of the Arcades Project, in particular in the convolute labeled "anthropological materialism" and in the sections on (particularly early) Marx, Fourier, and Saint-Simon. It is this perspective that still informs the Urtext of the artwork essay.[31] Adorno, writing to Benjamin in September 1936, singled out the term *anthropological materialism* to sum up all points on which he found himself disagreeing with Benjamin. The bone of contention was what Adorno considered Benjamin's "undialectical ontology of the body [*Leib*]."[32]

It is significant that Adorno, like Benjamin in the surrealism essay, uses the German word *Leib*, rather than the more contemporary word *Körper*. Benjamin takes up the distinction between *Leib*, the lived body, and *Körper*, the material, physiological body (famously elaborated, in different ways, by Edmund Husserl and Helmuth Plessner), in a fragment of 1922–23 that has important implications for his concept of the political up to and through the 1930s.[33] *Leib* there refers to the body as it belongs to and augments "the body of humankind" and as such is able, thanks to technology, to include even nature—the inanimate, plant, and animal—into a unity of life on earth. *Körper*, by contrast, refers to the individuated, sentient, and finite being whose "solitariness is nothing but the consciousness of its direct dependence on God" (SW 1:395; GS 6:80–81).

Benjamin's concept of the body no doubt has roots in theology and mysti-cism, but that does not necessarily make it undialectical or ahistorical, especially considering the distinction between *Körper* and *Leib*. For one thing, Benjamin situates the fate of the individual body and bodily sensorium in bourgeois-capi-talist society within a larger history of the human species, which entails thinking about humans in relation to all of creation and about human history in relation to that of the cosmos.[34] For another, the politics of innervation suggested in the surrealism essay interrelates the fragmentation of the individual temporal body (qua *Körper*) with the simultaneous constitution of a collective body (qua *Leib*) or bodily collective, which is both agent and object of the human interaction with nature. Within this anthropological-materialist framework, then, technology has endowed the collective with a new *physis* that demands to be understood and re/

appropriated, literally incorporated, in the interest of the collective; at the same time, technology (qua second technology) has provided the medium—film—in which such reappropriation can and should take place.

The utopian imagination at work here can be traced back in part to Benjamin's early messianic speculations on "Perception and Body." As Gertrud Koch argues, film would have supplied Benjamin with an answer to the perceptual limitations of the individual human body, in particular the old Machian problem that we cannot view our own body as an integral shape. In Benjamin's words, "It is very significant that our own body [Leib] is in so many respects inaccessible to us: we cannot see our face, our back, not even our whole head, that is, the most noble part of our body. . . . Hence the necessity that in the moment of pure perception the body transforms itself."[35] As a prosthetic extension of our perception, Koch interpolates, film gives us a more complete vision of ourselves (for instance, through variable framing and editing). The camera thus assumes "Messianic-prophetic power" for Benjamin, as it makes the cinema a "technical apparatus which permits one to forget anthropological lack."[36] Moreover, with its structural extension and inter-penetration of "body- and image-space," the cinema has the potential to project, at a profane and exoteric level, the "world of universal and integral actuality" sought by the surrealists, but in a way that is institutionally, qua mode of recep-tion, predicated on the sensorium of a collective.

When Benjamin resumes the idea of collective innervation in the artwork essay—in an important footnote appended to the passage on second technology—he links that idea with film's historic task of rehearsing the "interplay between nature and humanity" by (to repeat) training human beings in the "appercep-tions and reactions needed to deal with a vast apparatus whose role in their lives is expanding almost daily." In the footnote he asserts that it is the aim of revolutions "to accelerate this adaptation [to the new productive forces which the second technology has set free]":

> Revolutions are innervations of the collective—or, more precisely, efforts at inner-vation on the part of the new, historically unique collective which has its organs in the second technology. This second technology is a system in which the mastery of elementary social forces is a precondition for playing [das Spiel] with natural forces. Just as a child learns to grasp by stretching out his hand for the moon as it would for a ball, so humanity, in its efforts at innervation, sets its sights as much on presently still utopian goals as on goals within reach. (SW 3:124; GS 7:360; emphasis added)[37]

The utopian excess that Benjamin stresses here also marks a hiatus: "Because [second] technology aims at liberating human beings from drudgery, the indi-vidual suddenly sees his scope of play, or field of action [Spielraum], immeasurably expanded. He does not yet know his way around this space" (ibid.).[38] Benjamin

assigns film a central role both in opening up that room-for-play and in thus helping human beings to orient and to understand this vastly expanded *physis*.

Moreover, the *physis* opened up with second technology allows human beings to address existential concerns repressed by the goals imposed by the first. For as revolutions seek to resolve the problems of second nature through the systematic transformation of social, economic, and political conditions (as in the Soviet case), they also assert a "different," more species-oriented "utopian will" (*SW* 3:134). The utopian impulses that manifest themselves—qua excess—in historical revolutions articulate the still unresolved revolutionary demands "of the first, organic nature (primarily the bodily organism of the individual human being)"; they give voice to the "vital questions affecting the individual—questions of eros and death which had been buried by the first technology" (*SW* 3:135, 124; *GS* 7:360).[39]

The idea of a collective innervation of technology seems to have offered Benjamin a way to negotiate the disjunctive temporalities of the utopian imagination and actual conditions. The challenge is how to mobilize a species-historical politics to address a contemporary crisis that has its historical origins in the nineteenth century.[40] Here Benjamin, as so often, resorts to an image. The utopian aim of the second technology functions not unlike the moon for which the child reaches as if for a ball but nonetheless learns to grasp. In the layer of *The Arcades Project* written around the time of the artwork essay, Benjamin refers to "the idea of revolution as innervation of the technical organs of the collective (analogy with the child who learns to grasp by trying to get hold of the moon)" as one of "two articles of my 'politics'" (*AP* 631).[41] The child's gesture may be based in motor-perceptual miscognition; but for Benjamin (unlike Piaget or Lacan, for instance), this miscognition fuels creative and transformative energies, anticipating an alternative organization of perception that would be equal to the technologically changed environment. The child may not reach the moon, at least not in its own generation, but it nonetheless learns to grasp.

If the temporal index of innervation is oriented toward the future, it is motivated by a history that threatens the very possibility of a future: the failed—capitalist, imperialist—innervation of technology that had culminated in World War I and was headed toward another catastrophe of planetary dimensions. To return to *One-Way Street*, the philosophy of technology that subtends the idea of collective innervation in the artwork essay already emerges, in outline, in the book's famous concluding piece, "To the Planetarium."

Throughout the montage of *One-Way Street*, Benjamin interweaves his observations on the modern everyday with thematic strands concerning technology, the body, eroticism, and the changed parameters of perception (farness/nearness), as well as the possibility of divining and acting on the future. In "To the Planetarium," these motifs seem to coalesce and all but explode on the page. At stake is nothing less than the question of how human beings will appropriate the "new

body [*Leib*]," the new *physis* that is being organized for them in technology, and bring it under control. Benjamin seeks an answer with recourse to "antiquity," here in particular the "ancients' intercourse with the cosmos" experienced in ecstatic trance (*Rausch*). "For it is in this experience alone that we gain certain knowledge of what is nearest to us and what is remotest from us, and never of one without the other." It follows that the ecstatic contact with the cosmos could be experienced only communally. A major source here is obviously Klages's treatise *On Cosmogonic Eros* (1922).[42] This work provided Benjamin with the imagery to describe the last war as the modern instantiation of such cosmic experience, that is, as "an attempt at new and unprecedented mating [*Vermählung*] with the cosmic powers" (*SW* 1:486; *GS* 4:147).

Benjamin's mise-en-scène of World War I as an ecstatic, collective communion with the cosmos, albeit a fatally perverted one, has troubled commentators of various stripes.[43] In a language barely less pornographic than Klages's, Benjamin takes up the philosopher's cosmic mating fantasy, but he radicalizes and detonates it through the very term that Klages, like other proponents of *Lebensphilosophie,* had disavowed and opposed: *technology.* "Human multitudes, gases, electrical forces were hurled into the open country, high-frequency currents coursed through the landscape, new constellations rose in the sky, aerial space and ocean depths thundered with propellers, and everywhere sacrificial shafts were dug into Mother Earth. This immense wooing of the cosmos was enacted for the first time on a planetary scale—that is, in the spirit of technology" (*SW* 1:486–87). Yet technology, harnessed to the capitalist-imperialist purpose of mastering nature, "betrayed man and turned the bridal bed into a bloodbath" (*SW* 1:486).

From this graphic evocation, Benjamin appears to switch registers as he begins to sketch an alternative relationship with both nature and technology predicated on pedagogy (as a discipline ordering relations between generations rather than one of mastering children), which points to the politics/aesthetics of interplay and innervation elaborated in the artwork essay. As in that essay and elsewhere, his critique of capitalist-imperialist technology by and large elaborates the Marxian axiom that the productive relations that keep the productive forces fettered not only cause a "slave revolt on the part of technology" but also, by propelling the development of those forces, produce the conditions for their own abolition.[44] The subject of that process would be not "humans as a species" who have "completed their development thousands of years ago" but "humankind [*Menschheit*] as a species," which "is just beginning its development"—a collective that technology enables to organize its "contact with the cosmos" in social forms other than "nations and families" (*SW* 1:487; *GS* 4:147).

What is more astounding than this utopian thought, though, is that Benjamin phrases even this alternative reception of technology in the language of ecstasy, cosmic communion, and orgasmic convulsion, an affective terrain more typically

occupied by the German (and European) right. The "moderns" who dismiss this kind of experience as individual rapture commit a "dangerous error," he argues, and end up leaving these energies to the enemy. For the desire for ecstatic communion with the cosmos is not only real and powerful but also, above all, communal and ultimately therapeutic. "The 'Lunaparks' are a prefiguration of sanatoria" (*SW* 1:487). Bringing the new collective *physis* enabled and projected by technology under control may demand as violent a "paroxysm of genuine cosmic experience" as the mass destruction that brought it into recognition in all its extreme ("in the nights of annihilation of the last war, the frame of mankind was shaken by a feeling that resembled the bliss of the epileptic"). Having opened the Pandora's box of therapeutic violence, Benjamin tries to close it again by handing the key to the proletariat, whose power is "the measure of [the new body's] convalescence." It is no coincidence that the proletarian "discipline," which has to "grip" the new *physis* "to the very marrow," is cast in (hetero)sexual terms: "Living substance [*Lebendiges*] conquers the frenzy of destruction only in the ecstasy of procreation" (*SW* 1:487).

What does it mean that a mating with the cosmos that amounts to—and is clearly excoriated as—rape is rendered, in Irving Wohlfarth's observation, in "dithyrambic passages [that describe], in both constative and performative senses, the rhythmic climax of the sexual act"?[45] Wohlfarth argues that the sexualization of the experience of cosmic ecstasy allows Benjamin at once to account for the instinctual force with which the urge will assert itself again and again and to implicitly ascribe its deadly perversion to a collective Freudian "return of the repressed."[46] While this argument is compelling, it is worth noting that it also elides the question of gender. To be sure, it would be facile to criticize Benjamin for reproducing the masculinist discourse of his time (on the left as much as on the right). But neither does the performative mode exempt his language from attention to its traditional inscription of gender and sexual orientation.

It is hard to think of a smooth transition from this scene of Theweleitian male fantasy to the cultural politics of the late Weimar Republic. It is not surprising, then, that Benjamin went on to pursue the question of collective innervation by turning to French surrealism, a movement whose publications and activities he sums up as revolving around the project of "[winning] the energies of intoxication [or ecstatic trance, *Rausch*] for the revolution" (*SW* 2:215; *GS* 2:307).[47] To imagine a collective innervation of technology in the German context—and not as a "last," or latest, "snapshot of the European intelligentsia" (the subtitle of the surrealism essay) but on a wider social basis—was likely to be a more problematic proposition; there was no clear and direct path from that utopian snapshot to contemporary cinema. As Benjamin himself knew, the collective assembled in the movie theaters was hardly that of the heroic proletariat; rather, he considered the cinema audience in tendency part of the "compact mass"—the

blind, destructive and self-destructive formation of the masses that were the object of political organization by fascism.

From my discussion of technological innervation it should be evident that I am skeptical of attempts to assimilate Benjamin's speculations to contemporary media theory, especially teleological approaches that seek to demonstrate—celebrate or decry—the subject's inevitable abdication to the a priori regime of the apparatus.[48] Benjamin may have been a technophile (judging from his own letters as well as others' accounts), but his philosophy of technology is inseparable from his critique of the ideology of progress, his reflections on the nature of the political, and the history of nature in modernity.[49] Moreover, while he no doubt participates in the critique of Western bourgeois conceptions of the subject since Nietzsche, he would hardly have reduced subjectivity to an element in a loop that processes information and sensory signals. On the contrary, the very impulse to theorize technology is part of his project to reimagine experience—perhaps a generalizable version of "experience without a subject" (Martin Jay)[50]—in response to the technologically altered sensorium and environment; but he does so in a desperate effort to reassess, and redefine, the conditions of individual and collective agency, of affectivity, memory, and the imagination.

By the same token, however, we should guard against reading Benjamin too optimistically as assuming that the anaesthetization and alienation wreaked by technology on the human sensorium could be overcome, that "*the instinctual power of the human bodily senses*" could be "*restore[d]*" "*for the sake of humanity's self-preservation,*" and that this could be done, "not by avoiding the new technologies, but by *passing through* them."[51] For Benjamin there is no beyond or outside of technology, neither in immanent political practice nor even in his visions of messianic reconstitution. There is no way he would conceive of a restoration of the instinctual power of the senses and their integrity that would not take into account the extent to which technology has already become part of the human bodily sensorium; by the same token, there is no strategy for preventing humanity's self-destruction in which technology would not play an essential role. Because Benjamin so clearly recognizes the irreversibility of the historical process, the second fall that is modernity, he pursues a "politicization of art" in terms of a "collective innervation of technology" rather than a "restoration" of the sensorium to an instinctually intact, natural state: the issue is not how to reverse the historical process but how to mobilize, recirculate, and rechannel its effects.

MIMETIC FACULTY

The concept of innervation is bound up with Benjamin's speculations on the "mimetic faculty," in the sense that the mimetic describes a major modality under which collective innervation of technology could and would have to succeed. As

for Adorno, Benjamin's notion of mimesis differs substantially from traditional uses of the term beginning with Plato and Aristotle, from illusionist imitation to contemporary norms of literary-artistic realism, whether in Marxist theories of reflection (*Widerspiegelung*) or fascist aesthetics.[52] Benjamin draws on a wider range of anthropological, psychological, sociobiological (Roger Caillois's work on *mimicry*), and language-philosophical strands of mimesis, rather than the aesthetic more narrowly understood as pertaining to works of art and standards of verisimilitude. This is to say that the mimetic is not a category of representation, pertaining to a particular relationship with a referent, but a *relational* practice—a process, comportment, or activity of "producing similarities" (such as astrology, dance, and play); a mode of access to the world involving sensuous, somatic, and tactile, that is, embodied, forms of perception and cognition; a noncoercive engagement with the other that resists dualistic conceptions of subject and object; but also, in a darker vein, "a rudiment of the once powerful compulsion to become similar and to behave accordingly."[53] (Adorno and Horkheimer expand this negative connotation of mimesis when they consider fascism as "the organized manipulation of mimesis," just as they discern a perverted, unreflected form of mimesis toward reified and alienating conditions in the consumers' compulsive assimilation to the products of the culture industry.)[54]

Like the concept of aura, and equally central to Benjamin's theory of experience, the mimetic faculty is a category that comes into view only at the moment of its decay; one might say that its conceptualization depends on the withering away of that which it purports to capture. In both essays on the topic written in 1933, "Doctrine of the Similar" and "On the Mimetic Faculty," Benjamin emphasizes the historical character of mimesis and resists idealizing mimetic experience as a kind of prelapsarian merging. Since the "natural" or "magical correspondences" that stimulate mimetic responses in human beings have receded and have become dramatically less perceptible in our lives, the mimetic faculty in humans has declined, if not disappeared. The decisive question for Benjamin is, then, "whether we are concerned with the decay of this faculty or with its transformation" (*SW* 2:721). The question of what such a transformation might look like and in which areas it might be taking place implies, not least, the possibility of a resurgence of mimetic powers *within* the disenchanted modern world.

It is important to note that Benjamin considers the category of similarity or similitude (*Ähnlichkeit*) from the start, even in its phylogenetic trajectory, as marked by its "nonsensuous" quality, that is, as distinct from a resemblance that appears overt and self-evident. Similitude works on the order of affinity (*Verwandschaft*), rather than *sameness*, identity, copy, or reproduction (a distinction that matters for our reading of the artwork essay).[55] In addition to ancient practices of dance and reading from entrails, his major example of nonsensuous correspondences in the archaic past is astrology, the reading of stellar constellations

in relation to the instant of a newborn's birth. The actualization of this cosmic similitude thus hinges on a *temporal element*, a "flashing up" that "offers itself to the eye as fleetingly and transitorily as a constellation of stars" (*SW* 2:695–96); and it crucially depends on a third element, the astrologer as mimetically gifted reader. The "flashing up" of a past long since written resonates in Benjamin's work with the notion of the "dialectical image"—the historical moment of its coming into legibility—but also with the double temporality of auratic experience.

The example of astrology as an ancient practice of reading and writing (which evolves via the "ornament") leads Benjamin to a more contemporary "canon," "our most complete archive" of "nonsensuous similarities, of nonsensuous correspondences" (*SW* 2:722)—that is, language. This observation harks back to his early, theologically based theories of language ("On Language as Such and on the Language of Man" [1916] and "The Task of the Translator" [1921]), which have been the subject of extensive commentary. Suffice it here to say that the linkage of language and mimetic faculty ties in with his rejection, in the early essays, of a view of language as a system of arbitrary and conventional signs (a notion indebted to the somewhat reductive reception of the teachings of Ferdinand de Saussure) in favor of onomatopoeic models.[56] It should be noted, though, that Benjamin's concept of language was significantly complicated—and secularized—during the early 1930s, the time during which he wrote the essays on the mimetic faculty, by his intense occupation with anthropological and psychological debates on language origin, language acquisition, and the relationship between language and material culture (led by Karl Bühler, Lucien Lévy-Bruhl, Leo Weisgerber, Olivier Leroy, Piaget, L. S. Vygotsky); Marxist sociology of language; and the philosophy of Ernst Cassirer.[57]

More important from the perspective of film theory is Benjamin's emphasis on *script* and *writing*, hence *reading*, in language's archive of nonsensuous similitude. "The most recent graphology has taught us to recognize, in handwriting, images— or, more precisely, picture puzzles—that the unconscious of the writer conceals in his writing" (*SW* 2:697). This is to say that the mimetic qualities of script, even as they are propped onto the semiotic dimension of language and speech, are not obvious or coded in terms of conventional analogies; they are encrypted, hinging (as in astrology, as in psychoanalysis) on a hidden past conjuncture, an embodied form of the writer's unconscious.[58] At the same time, Benjamin concludes, the growing rapidity of writing and reading has also enhanced "the fusion of the semiotic and the mimetic in the sphere of language"—having absorbed "the earlier powers of mimetic production and comprehension . . . without residue, to the point where they have liquidated those of magic" (*SW* 2:722). Whether new technologies such as photography and film were bearing out this tendency, as new modes of inscription and reception that significantly expanded the terms under which the mimetic faculty could be actualized, is one of the questions, as we shall see, he sought to address with the concept of the *optical unconscious*.

Between astrology and graphology, though, Benjamin had been exploring other forms of mimetic reading, in particular forms of cultural physiognomy that circulated between 1910 and 1935.[59] "To read what was never written"—this phrase from Hugo von Hofmannsthal's 1894 play *Der Tor und der Tod* (*Death and the Fool*) appears in the essay on the mimetic faculty (without attribution) and among the epigrams of convolute M, "The *Flâneur*," in *The Arcades Project*. The motto extends the scope of physiognomic reading from human features and gestures via natural landscapes to the modern urban environment. In his review of Franz Hessel's *Spazieren in Berlin* (*Walking in Berlin*, 1929), "The Return of the *Flâneur*," Benjamin names the premise of such reading, citing Hessel: "'We see only what looks at us'" (*SW* 2:265). The *flâneur* makes the "stony eyes" of the pagan muses return the gaze; he is threatened by the "bitter look which both things and people cast on the dreamer" (*SW* 265; *GS* 3:198). Once again, the insistence on the reciprocity of the gaze, if not the priority of the alien gaze, recalls the structure of auratic experience. More specifically, the urban-literary genre calls attention to the physiognomic grounding of Hessel's reading—that is, the at once intuitive and staged projection, on the part of the perceiving subject, of expressive qualities of the animated human face onto nonhuman and inanimate phenomena. However, that very mode of reading is challenged by the epochal turn, or "*Zeitenwende*," that it registers, insofar as nineteenth-century forms of dwelling are being displaced by the more transitional, transparent spaces envisioned by modern architects (Benjamin mentions Sigfried Giedion, Erich Mendelsohn, Le Corbusier). If this makes the Weimar *flâneur* a historically belated figure, physiognomic vision has found a more contemporary medium in film—a theory first elaborated by Béla Balázs that, trimmed of its neo-romantic and vitalist language, echoes in Benjamin's notion of the optical unconscious.[60]

The other area in which Benjamin discerns at once the persistence and historical transformation of the mimetic faculty is childhood, in particular the ways in which children perceive, organize, and interact with their habitat. In their play and games, the "school of the mimetic faculty," children upset hierarchies of human and nonhuman, animate and inanimate: "The child plays at being not only a shopkeeper or teacher, but also a windmill and a train" (*SW* 2:720). Already in *One-Way Street* ("Enlargements"), Benjamin traces the manifold ways in which the child assimilates and transforms the gloomy parental apartment through his closeness and particular transactions with the material world (*SW* 1:465–66). When he expands on this theme in "Berlin Childhood around 1900" (1934, 1938), he borrows from "The Doctrine of the Similar" to describe how the "gift of perceiving similarities," the "weak remnant of the old compulsion to become similar and behave accordingly," acts through "words" as much as the "dwelling places, furniture, clothes" to which it makes the child assimilate (*SW* 3:390–91; *GS* 4:261). (Here, however, the similarity is not a nonsensuous but a "distorted"—and

distorting—one that forces the child to become similar to the alienating surroundings of a photographer's studio [392]).[61]

Importantly, the *physis* mimetically engaged by children is not that of an immutable organic nature, but the historically formed, constantly changing nature of urban-industrial capitalism, with its growing heap of ever-new—and increasingly obsolescent—commodities, gadgets, masks, and images. Children practice an inventive reception of this world of things in their modes of collecting and organizing objects, in particular discarded ones, thus producing a host of bewildering and hidden correspondences, tropes of creative miscognition: "Children . . . are irresistibly drawn by the detritus generated by building, gardening, housework, tailoring, or carpentry. In waste products they recognize the face that the world of things turns directly and solely to them. In using these things, they do not so much imitate the works of adults as bring together, in the artifact produced in play, materials of widely differing kinds in a new, disjunctive relationship."[62] In other words, by creating their own world of things within the larger one, children simultaneously transform material objects; they wrest them from their ostensibly linear, instrumental destination and reconfigure them according to a different logic—not unrelated to the aesthetics of bricolage, collage, and montage.

What interests Benjamin in such mimetic explorations is not only an alternative relationship with "things" but the tapping of a temporality that he considered key to capitalist modernity: the return of archaic, cyclical, mythical time in the accelerated succession of the new (fashion, technology), the mingling of the recently obsolescent "with what has been forgotten of the prehistoric world."[63] This temporal slippage attracted him to Kafka and to the surrealists' excursions through Paris, their fascination with "enslaved and enslaving objects" from which "the vogue has begun to ebb," in which they discovered "the revolutionary energies that appear in the 'outmoded.'"[64] Where adult society naturalizes the new as merely fashionable, children have the capacity to "discover the new anew," and thus to incorporate it into the collective archive of images and symbols.[65] Unlike the elegiac, belated figure of the Weimar *flâneur*, children pioneer a model of mimetic innervation on a par with modernity's destructive and liberating effects.

It was in *One-Way Street* that Benjamin began to think programmatically about the possibility of the mimetic (though not yet using that term) in urban modernity, discovering new possibilities of innervation and juxtaposing them with premodern examples. In most of these cases, the process of mimetic innervation entails dynamics that move in opposite, though complementary, directions: (1) a decentering and extension of the human sensorium beyond the limits of the individual body/subject, into the phenomena that stimulate and attract perception; and (2) an incorporation or ingestion of the object or device, be it an external rhythm, a long-forgotten madeleine, or an alien(ating) apparatus. The prototype of eccentric perception is the lover's gaze at the wrinkles in the beloved's face, an affectively

charged perception or sensation: "If the theory is correct that sensory perception [*Empfindung*] does not reside in the head, that we perceive a window, a cloud, a tree not in our brains but rather in the place where we see them, then we are, in looking at our beloved, too, outside ourselves" (*SW* 1:449; *GS* 4:92).[66] Whether or not Benjamin himself made the connection, we can imagine something of this affectively charged, eccentric perception at work, as well, in the dispersed subjectivity of the cinema experience.

The prototypical figures of the *incorporative* dynamic, on the other hand, are the child, the cannibal, the screen actor, the clown: "Suspension of inner impulses and the bodily center. New unity of dress, tattoo, and body. . . . Logical choice of deep expressivity: the man sitting on a chair will remain seated even after the chair has been removed."[67] In this image of extreme concentration the apparatus becomes part of the body; that is, the performance enacts, in an expressive, imaginative form, a process more commonly—and destructively—imposed on people in the modern everyday. This form of mimetic innervation is personified by the figure of the "eccentric," a precursor to Chaplin who, by "dissect[ing] human expressive movement [*Ausdrucksbewegung*] into a series of minute innervations," internalizes the law of the apparatus, whether conveyor belt or filmic montage, thus giving the encounter with technology an expression in the image world.[68] Benjamin finds another figure of mimetic innervation, one that embodies both incorporative and decentering dynamics, in Mickey Mouse.

If the essays on the mimetic faculty are concerned primarily with forms of physiognomic perception and reading, *One-Way Street* foregrounds the emergence of new methods, media, and sites of *inscription*. In a number of variations on his own craft, Benjamin sketches the principles, conditions, and rituals of successful writerly innervation, including the correct use of writing tools (see, for instance, "The Writer's Technique in Thirteen Theses" and "Teaching Aid"). This is the context for his reflection, cited earlier in this chapter, on the typewriter, in which the mimetic inadequacy of the latter leads him to imagine a literal form of, as it were, digital innervation—"the innervation of commanding fingers" (*SW* 1:457)— that anticipates ways in which contemporary technologies both interface with the bodily sensorium and extend it into and through the apparatus.

As new technologies of inscription emerge, there are indications that "the book in [its] traditional form is nearing its end" (*SW* 1:456). This observation resonates with the program of the contemporary avant-garde, in particular constructivists like Moholy-Nagy and Lissitzky whose new typographic practices sought to dynamize the "book-space" (Lissitzky) of traditional culture.[69] Benjamin saw the passing of the Gutenberg era signaled by poetic texts like Mallarmé's *Un Coup de dés*, which was "the first to incorporate the graphic tensions of the advertisement" into the "script-image" (*Schriftbild*) of the printed page. Poetic experiment joined the more profane media of film and advertisement ("a blizzard of changing, color-

ful, conflicting letters"), which have forced script from its quiet refuge, the book, into the "dictatorial perpendicular" of the street and the movie screen, just as the card index has expanded the flat space of the single page it into hypertextual three-dimensionality. Thus writing "advances ever more deeply into the graphic regions of its new eccentric figurativeness" or pictoriality (*Bildlichkeit*). And if poets are farsighted enough to collaborate in the development of this "picture-writing" (*Bilderschrift*), which includes learning from statistical and technical diagrams, they will renew their cultural authority in and through the medium of an international "*Wandelschrift*" (*GS* 4:104). More than simply a "moving script" (*SW* 1:457), *Wandelschrift* implies two senses in which writing has become at once more moving and more mobile: a new mutability and plasticity of script (*Wandel* in the sense of change), which heralds a resurgence of writing's imagistic, sensuous, and mimetic qualities; and the connotation of the verb *wandeln* (to walk, stroll, circulate), which suggests that writing's migration into three-dimensional, public space makes reading a more kinetic, haptic experience.

If the new graphicity that evolves with new media technologies and advertising hybridizes pictorial and scriptural qualities, it also makes writing part of a new economy of things and a changed phenomenology of nearness and distance.[70] It thus pertains to the phenomenon that Benjamin, in the 1929 surrealism essay, hails as an interpenetration of "body and image space" that I take to be another way of imagining innervation. The idea of spatial interpenetration, or *Durchdringung*, was key in discussions on modern architecture, in particular the work of Sigfried Giedion, which exerted considerable influence on Benjamin, especially for the conception of the Arcades Project.[71] In his account of nineteenth-century girder constructions such as the Eiffel Tower and the Pont Transbordeur in Marseille, for instance, Giedion describes the experience of moving—or being moved—through these structures as an "intermingling" of spaces, of exterior and interior, of structures and "things" ("ships, sea, houses, masts, landscape and harbor").[72] If the idea of *Durchdringung* comes to refer to an essential characteristic of modern architecture in various configurations (e.g., Le Corbusier, Gropius's Bauhaus, Mart Stam), it not only describes a new mode of spatial experience but also points toward an embodied, kinesthetic mode of seeing that defines the cinema experience.

Benjamin's notion of an interpenetration of "body- and image-space" implies yet another dimension. The spaces that intermingle and interrelate, the image-things that intrude into the psychophysiological space and presumed autonomy of the metropolitan subject, pertain to both actual and virtual registers; as discussed in chapter 3, we are dealing with a second-order tactility. In *One-Way Street*, this is most strikingly the case in "This Space for Rent" (*SW* 1:476; literally "these surfaces [*Flächen*] for rent"), a short piece that anticipates key concerns of the artwork essay. Instead of art and technological reproducibility, the terms of opposition are *criticism* (*Kritik*) and *advertisement* (*Reklame*); the latter is, in Benjamin's words,

"today the most real, mercantile gaze into the heart of things." While criticism used to be defined by a stable vantage point and "correct distancing" (just as art, as he writes elsewhere, used to begin "at a distance of two meters from the body"), advertising tears into the liberal space of contemplation and "all but hits us between the eyes with things," in the same way that "a car, growing to gigantic proportions, careens at us out of a film screen."[73] And as the cinema renders furniture and façades sensational by means of their insistent, discontinuous nearness, advertising "hurls things at us with the tempo of a good film." Advertising, like film, is a thing that both depicts the new world of things and, in its tactile, visceral appeal, significantly redramatizes our relation to things.

The emphasis on physicality, speed, and directness aligns Benjamin with the enthusiasm for Hollywood films and all things American that was pervasive among avant-garde artists and intellectuals of the period, whether German, French, Soviet, Chinese, or Japanese. What is less common, though, certainly among the technophile modernists of Neue Sachlichkeit, is the way Benjamin entwines the new relationship to things modern with dimensions of sensorial affect and sentimentality. Here is the passage from which I have quoted before: "Thereby [with advertisement's foreshortening of space and time in relation to things] 'matter-of-factness' [Sachlichkeit] is finally dismissed, and in the face of the huge images spread across the walls of buildings, where toothpaste and cosmetics ["Chlorodont" und "Sleipnir"] lie handy for giants, sentimentality is restored to health and liberated American style, just as people whom nothing moves or touches any longer are taught to cry again in the cinema" (SW 1:476; GS 4:132).

Skirting the critical cliché about moving the masses with clichés, Benjamin envisions a regeneration of affect by means of mechanically produced images, that is, the possibility of countering the alienation of the human sensorium with the same means and media that are part of the technological proliferation of shock-anaesthetics-aestheticization. The chance to engage the senses differently lies in the epochal reconfiguration of body- and image-space, in the emergence of new modes of imaging that refract the received organization of space, its forms and proportions, and articulate a new relation with the material world.

Benjamin's polemics against fictions of correct distancing and a singular, stable position in bourgeois criticism participates both in the modernist assault on the regime of central perspective and the ongoing critique of philosophical ontology and the traditional subject-object opposition. In this regard, it resonates with Heidegger's anti-Cartesian stance in Being and Time (1926), in particular his understanding of "being-in-the-world" in terms of our relation to things. These are not defined by their physical and optically accessible properties but manifest themselves in their practical usage, their constitutive "in-order-to" (Um-zu) and mode of being as "handiness" (Zuhandenheit, readiness-to-hand).[74] Thus they allow practical behavior and work, dealing with and taking care—activities that

enable our encounter with the phenomenal world, the discovery and "making available to everyone" of the "natural" *Umwelt,* or surrounding world. This everyday environment comprises not only the domestic workshop but also the *"public world,"* a world of urban nature (paths as much as streets, bridges, buildings, and railway platforms).[75]

Benjamin may have understood that world in more historical and class-conscious terms, but he similarly emphasizes practical use, contact, and embodied perception, even and precisely in relation to the commodified world of everyday capitalist modernity ("the most real, mercantile gaze into the heart of things"). In a fragment on the "political significance of film," he tactically and dialectically valorizes kitsch as meeting the masses' expectation of an artwork—"which, for them, belongs to the array of objects of use [*Gebrauchsgegenstände*]—to provide "'comfort to the heart'": "Kitsch . . . is nothing more than art with a 100 percent, absolute and instantaneous availability for use (*Gebrauchscharakter*)."[76] This concept of use has a pragmatic, if not Heideggerian, dimension that cuts across the Marxist distinction of use and exchange value. What's more, Benjamin links the transformed relationship with things (and among things, bodies, and images) to a notion of *Umwelt* that, like Heidegger's, is indebted to the vitalist theoretical biologist Jakob von Uexküll. According to Uexküll, every living being, whether human or animal, lives in a phenomenal world of its own—its *Umwelt.* Setting itself off against a Darwinist, deterministic concept of *milieu,* Uexküll's concept of *Umwelt* emphasizes the potential of living beings to create their environment in accordance with their physical and mental abilities (or with the aid of technologies, for that matter) and displaces an anthropocentric conception of the world with a multitude of interpenetrating, lived *Umwelten.*[77]

Benjamin's vignette not only assumes but also enacts this notion of *Umwelt.* Just as film (in the words of the artwork essay) "penetrates deeply into [the] tissue of reality" (*SW* 3:116), invading the viewer's space and absorbing him or her into its own, "This Space for Rent" systematically dislodges the writer/reader from a stable point of view. In a way similar to Kracauer's essay "Boredom" (1924), Benjamin evokes an experience in which the writer/reader becomes part of an urban environment in which the maps that clearly demarcate subject from object world no longer work. It is not the message of the advertisement that moves people, even if they are moved to buy (Benjamin never loses sight of the fact that it is money that "effects [this] close contact with things," that the means of inner-vation are subject to "the brutal heteronomies of economic chaos" [*SW* 1:456]). Rather, he is concerned, at a perceptual level, with the sensory-aesthetic effects of advertising. The blurring of the fixed lines of objects, spaces, and institutions is due not only to their montagelike refraction but, most dramatically, to a new imagination of *color.* Having deferred any mention of color up to this point, he closes with a coup de théâtre: "What, in the end, makes advertisement so superior

to criticism? Not what the moving red neon sign says—but the fiery red pool reflecting it in the asphalt."[78]

Profane illumination, indeed. Similar to Kracauer's vignettes on commercial lighting, this Blakean image of fire and water suggests an excess of sensation over the capitalist design, a mimetic connection with the afterlife of things.[79] At the same time, the red pool becomes a medium of reflection, one of the eponymic surfaces that are for rent—that ask to be used, reinscribed with a different message than the commercial one that generated it. The type of reflexivity exemplified here is anything but contemplative, granting a safe distance between observer and object; on the contrary, it implies a momentary fusion of vision and object, of body-space with image-space. True to Benjamin's roots in early romanticism, this reflexivity inheres in the material, in colors and things.[80] It is not to be found in traditional art, which "teaches us to look into [the inside of] things," but rather in "popular art" (Volkskunst) and "kitsch," which "allow us to look out from the inside of things."[81]

If Benjamin sought a structural equivalent to auratic experience (in the sense of investing the other with the ability to return the gaze) in the fast-accumulating rubble of modern history, he found one model in the psychopoetic experiments of the surrealists, whom he took to be on the trail "[less] of the psyche than on the track of things" (SW 2:4), in particular things that have recently become "outmoded." In other words, they (like Benjamin) were interested in things less as a means for experiencing "structures of frail intersubjectivity" (as Habermas suggests) than in innervating the "secret life of things," their different temporality, their nexus with an "other" history.[82]

OPTICAL UNCONSCIOUS

But what does it mean to look from the inside of things? How can things be made to look out of their own eyes? At this point the concept of mimetic innervation begs to be read through Benjamin's rather elusive notion of an *optical unconscious,* which adds a psychoanalytic dimension to the anthropological, language-philo-sophical, and mystical underpinnings of the mimetic faculty. With the optical unconscious, one might say, the mimetic faculty has migrated into the visual media and their aesthetic possibilities. This seems to me the only way we can speak of photography and film as "new mimetic technologies," at least in Benjamin's sense of the term *mimetic.*[83] For the mimetic capacity of the visual media rides less on their ability to resemble the real (in the traditional sense of mimesis or representational realism), and less on the principle of sameness (the capacity to generate an infinite number of identical copies), than on their ability to render the familiar strange, to store and reveal similarities that are "nonsensuous," not otherwise visible to the human eye.

To begin with, following Rosalind Krauss, we should be struck with the strangeness of the concept itself, particularly its definition by analogy.[84] "It is through photography that we first discover the existence of this optical unconscious, just as we discover the instinctual unconscious through psychoanalysis," Benjamin states in "Little History of Photography" (1931; *SW* 2:511–12). In the 1939 version of the artwork essay he elaborates this analogy with a reference to Freud's *Psychopathology of Everyday Life* (1901), which, he explains, illustrates the enrichment of our perceptual world with the advent of film. Just as Freud's book has "isolated and made analyzable things which had previously floated along unnoticed on the broad stream of perception," film has brought about a "similar deepening of apperception throughout the entire spectrum of optical—and now also auditory—impressions" (*SW* 4:265). Where Freud would clearly have differed with Benjamin, however, is in the latter's attempt to locate the dimension of the unconscious in the material world, that is, as much outside as inside the human subject.[85] As he asserts in "Little History" and repeats almost verbatim in both versions of the artwork essay, "It is another nature which speaks to the camera rather than to the eye: 'other' above all in the sense that a space informed by human consciousness gives way to a space informed by the unconscious" (*SW* 2:510; see *SW* 3:117; *SW* 4:266). While I think there is still purchase to Benjamin's claim, we should bear in mind that the optical unconscious is obviously not a philosophical concept but rather an experimental metaphor and, like all complex tropes, has multiple and shifting meanings.

When Benjamin introduces the notion of an optical unconscious in "Little History of Photography," it broadly refers to the idea that the apparatus is able to capture, store, and release aspects of reality previously inaccessible to the unarmed human eye. The mimetic, cognitive capacity of photographic inscription rests, to varying degrees, with the element of chance and contingency inherent in machinic vision, however carefully the image may be constructed. The camera's otherness— one might say its truck with the look of the other—translates into an affinity with the normally unseen and indeterminate, the unintended or repressed. Like Roland Barthes's *punctum,* such moments of contingency and alterity may act as a hook that arrests, attracts, and jolts the later beholder. The optical unconscious thus as much refers to the psychic projection and involuntary memory triggered in the beholder as it assumes something encrypted in the image that nobody was aware of at the time of exposure. In other words, the technological disjunction between storage and release entails an unconscious element at two levels: the (fixed) moment of inscription and the (variable) time of reception. While photographs may or may not require technological forms of display, cinematic reception is *necessarily* mediated, qua projection, by yet another apparatus, which doubles the chances for nonintentional and unconscious elements to intrude and refract the represented world; in the words of Jean Epstein, it is this transformation "raised to the power of two" that makes the cinema "psychic."[86]

Given Benjamin's invocation of Freud and indebtedness to Proust, the notion of the optical unconscious has been understood in terms of the logic of the trace (as we saw, a highly ambivalent concept for Benjamin)[87] and accordingly linked to the Peircean concept of indexicality. As noted in chapter 1, film theory adapted Peirce's concept of the index, designating a physical connection between sign and referent, primarily to describe the photochemical registration of light reflected off an object at a particular time and place, a connection that in turn subtends the iconic function of photographically-based images, their relation of resemblance to the objects they depict.[88] In this narrow sense the indexical sign came to be defined as an "imprint of a once-present and unique moment," in Mary Ann Doane's words, the "signature of temporality."[89] But not every indexical sign refers to pastness, be it a singular moment or a longtime habit (the sailor's bowed legs, Schelling's coat)—Peirce's own examples include the sundial and the weather vane. Moreover, Peirce also considers a type of index with a purely deictic function, such as the words *this* and *there,* that is, shifters that do not have a physical connection with a particular object, past or present, referring instead to specific but variable situations and depending, even more than the former, on the pragmatics of usage and interpretation.[90]

Benjamin's introduction of the optical unconscious in "Little History," with its disjunctive temporality of an elusive "flashing up" of a contingent moment long past, could be read in terms of photographic indexicality narrowly understood. Yet his account (discussed in chapter 4) of the portrait of the photographer Dauthendey and his fiancée, who was to slash her veins after the birth of their sixth child, significantly exceeds the semiotic framework by staging the encounter between image and beholder as an auratic, if not daemonic, experience. The beholder's compulsive search for the "tiny spark of contingency, of the here and now, with which reality has . . . seared the character of the image" is geared to the *future,* which "nests so eloquently" in the "particularity [*Sosein*] of that long-forgotten moment . . . that we, looking back, may rediscover it" (*SW* 2:510; *GS* 2:371). Rather than documenting a there and then, the photograph actualizes a here and now that bridges the gap between inscription and reception, speaking to the later beholder of both the subject's and his own future fate—suicide. This scene of recognition and mutual prescience makes one realize "to what extent opposites touch, here too: the most precise technology can give its products magical value, such as a painted picture can never again have for us" (ibid.)

Benjamin insists on the possibility of a productive (as opposed to phantasmagoric) linkage of technology and "magic"—in the sense of mimetic cognition—also regarding photographs in which temporality plays a weaker and different role. A case in point are images of a more scientific and quotidian nature: the way slow motion reveals the secret of the act of walking (he must be referring to film, and may have known of Étienne-Jules Marey's experiments), an example he extends

in the artwork essay to include a slow-motion rendering of "picking up a cigarette lighter or a spoon," which might tell us "what really goes on between hand and metal [and] how this varies with different moods" (SW 3:117). In "Little History," he singles out the possibilities of enlargement with recourse to Karl Blossfeldt's astonishing magnifications of plants and plant parts. In addition to matters of scientific interest—"details of structure, cellular tissue, with which technology and medicine are normally concerned"—Blossfeldt's plant photographs reveal "physiognomic aspects, image worlds, which dwell in the smallest things—meaningful yet covert enough to find a hiding place in waking dreams" (SW 2:512).[91] By stimulating the beholder's imagination and returning the daydreaming gaze, they confirm that "the difference between technology and magic [is] a thoroughly historical variable" (ibid.).

It is only after discussing the use of the close-up in photographs of nonhuman subjects that Benjamin considers the physiognomic potential of photographs of the human face and figure. For Balázs, whose physiognomic poetics of film must be the closest precursor to Benjamin's optical unconscious, the fulcrum of the camera's psychophysiognomic capability was the face: "The camera close-up aims at the uncontrolled small areas of the face; thus it is able to photograph the unconscious."[92] Benjamin pursues this line of thought in "Little History" with an at once more historical and political emphasis. The "salutary estrangement between the human being and his surroundings" inaugurated by Atget and surrealist photography, which gives the lie to the commercial, representative photographic portrait, has cleared the path for a new type of human imaging—the "tremendous physiognomic gallery" that he finds in the films of Eisenstein and Pudovkin and the photographs of August Sander. If the former capture the "anonymous appearance" in the features of "people who had no use for their own photographs," Sander's series of subjects through all social strata and occupations, in their observational precision and impartiality, provide a "training atlas" at a time like the present—1931—when sudden shifts of power "can make the development and acuity of physiognomic perception a matter of vital importance" (SW 2:519–20; GS 2:379–81).

When Benjamin resumes the notion of an optical unconscious in the artwork essay, his examples shift from the still to the moving image and even more decisively to the collective everyday shaped by capitalist-industrial modernity. If in photography the optical unconscious harbored a revelatory and cognitive function, in film the kinetic dimension—the ability to record movement, to mobilize the image through camera movement, variable framing, and rhythmic editing—augments this potential with a destructive, liberating, and transformative function in relation to the depicted world. Let me recall Howard Caygill's account of the optical unconscious as the "possibility of creating an openness to the future."[93] The political significance of this openness to the future, the possibility of things becoming something other than as what they are commonly perceived, is most

strongly expressed in the beautiful passage from the artwork essay that attributes to film the ability to explode, with its "dynamite of the split second," the "prison-world" of our urban-industrial environment (*SW* 3:117).

Benjamin first formulates this passage in his defense of Eisenstein's *Battleship Potemkin*, "Reply to Oscar A. H. Schmitz" (1927), which spells out in greater detail the stakes of this claim:

> We may truly say that with film a *new realm of consciousness* comes into being. To put it in a nutshell, film is the only prism in which the immediate environment—the spaces in which people live, pursue their avocations, and enjoy their leisure—are laid open before their eyes in a comprehensible, meaningful, and passionate way. In themselves these offices, furnished rooms, bars, big-city streets, stations, and factories are ugly, incomprehensible, and hopelessly sad. Or rather, they were and seemed to be, until the advent of film. The cinema then exploded this prison-world with the dynamite of its fractions of a second, so that now we can set off calmly on journeys of adventure among its scattered ruins. (*SW* 2:18)[94]

The "prismatic work" that film performs by "acting on that milieu" (*SW* 2:18) assumes a *twofold* process of innervation, inasmuch as it refracts a world that has already, historically, been shaped by technological, economic, and social structures that have become second nature to us. "In themselves these offices, furnished rooms, bars, big-city streets, stations, and factories are ugly, incomprehensible, and hopelessly sad. Or, rather, they *were and seemed to be,* until the advent of film" (emphasis added). By enabling human beings to bring into visibility, represent *to* themselves, their technologically altered *physis*, film creates a "*new realm of consciousness*"—or, as he was to put it in the artwork essay, it opens up a new "field of action [*Spielraum*]" or room-for-play (*SW* 3:117). By refracting the modern *physis*, film simultaneously transforms it: "With the dynamite of the split second," it denaturalizes the entire "prison-world," undoes its semblance of immutability, and makes its scattered ruins available for mimetic transformation and reconfiguration.

Two assumptions seem to be at work in this—one might say, classically modernist, nominalist—claim. First, Benjamin speaks of a "conspiratorial relationship between film technique and milieu," which he calls the "most intrinsic project [*Vorwurf*]" of film (*SW* 2:18; *GS* 2:753). Film's mimetic capacity for capturing and mobilizing traces of social experience in the ostensibly dead world of things draws on both the referential qualities of photography (including indexically registered contingency) and the refracting, defamiliarizing procedures available to film (camera movement, fast and slow motion, variable framing, and montage). Second, the complicity between film and milieu entails a partisan perspective: it is "incompatible with the glorification of the bourgeoisie" (*SW* 2:18). The adventurous spaces Benjamin explores in his defense of *Potemkin* are spaces of the collec-

tive, and they apprise the bourgeois intellectual of the passing of his own class: "The proletariat is the hero of those spaces to whose adventures, heart pounding, the bourgeois gives himself over in the cinema, because he must enjoy the 'beautiful' precisely where it speaks to him of the destruction of his own class" (SW 2:18; GS 2:753). In other words, the prismatic work of film creates a temporal dynamic of historical transition and revolutionary transformation—it transforms the past forgotten in the hopeless present into the possibility of a future.

But the cinema's most important collective space is, or at least used to be, its site of exhibition and reception—the movie theater as a public space, moviegoing as a specifically modern, technologically mediated form of collective sensory experience that most clearly distinguishes the reception of a film from that of literature, theater, and the fine arts. The cinema experience would therefore be central for thinking through the possibility of a "bodily collective innervation," as the condition of an alternative interaction with technology and the commodity world. For the optical unconscious, as the medium of a transformed mimetic capacity, to become effective as—and in—collective innervation, the psychodynamically inflected temporality of individual experience vis-à-vis photography would have to be imagined as being available to a collective subject. Only then would the technologically enabled extension and decentering of the sensorium at the level of the filmic text translate into an imaginative, empowering incorporation of the apparatus on the part of the audience. Benjamin seems to suggest as much when he asserts that it is only with the "human collective that film can complete the prismatic work that it began with milieu," though he subsequently limits his discussion to the moving masses depicted in Eisenstein's film, the collectivity on, rather than in front of, the screen.

Benjamin attempts to extend the optical unconscious to the spectating collective in the early versions of the artwork essay, specifically in his remarks on the "globe-encircling" Mickey Mouse (whose name heads the entire section on the optical unconscious in the first, handwritten version; see GS 1:433). As I elaborate in the following chapter, Benjamin's reading of Mickey Mouse as a "figure of the collective dream" retains a sense of disjunctive temporality, the mnemonic and psychoanalytic aspects of the optical unconscious. But his investment in the therapeutic potential of the early Disney films, their ability to trigger a "preemptive and healing outbreak" of dangerous mass psychoses (SW 3:118), rests at least as much with the physiological, biomechanical effects he imputed to collective laughter. By propelling the audience into laughter through the kinetic transfer of visual-acoustic shocks or, rather, countershocks, these films, he was hoping against hope, had the capacity to perforate collective psychopathological armors and thus effect a reconversion of neurotic energy into sensory affect.

The politics of innervation I have tried to delineate in Benjamin involves an understanding of cinema as a form of aesthetic, sensory and psychosomatic expe-

rience relating to the challenges and casualties of capitalist-industrial modernity. For the promise the cinema held out was that it might give the technologically altered sensorium access to a contemporary, materially based, and collective form of reflexivity that would not have to surrender the mimetic and temporal dimensions of (historically individualized) experience. At this juncture, the cinema appeared as the only institution capable of linking the antinomic trajectories of modernity and thus wresting them from their catastrophic course; that is, rather than thriving on and exacerbating the spiral of shock, anaesthetics, and aestheticization, the cinema could work to diffuse the deadly violence unleashed by capitalist technology, could yet be revolutionary if only in the sense of "a purely preventive measure intended to avert the worst."[95] If the Medusan gaze of the camera is affiliated with the backward-flying angel of history, then Mickey Mouse embodies the possibility of meeting that gaze and countering it—with apotropaic games of innervation.

But Mickey disappeared from the 1939 version of the artwork essay, and with him the term *innervation*. In that version, the section on the optical unconscious opens with the reference to Freud's *Psychopathology of Everyday Life* cited above, which seeks to define the optical unconscious in analogy with the psychoanalytic notion of the unconscious. Throughout the section, the optical unconscious is lodged at the level of inscription and individual reception; even when Benjamin allows us to "set off calmly on journeys of adventures among [the] far-flung debris" (SW 4:265) created by film's detonation of the naturalized capitalist-industrial everyday, that collective action resembles more a surrealist excursion through Paris than the dynamics specific to the cinema experience, in particular its sensory-somatic immediacy, anonymous collectivity, and unpredictability. When Benjamin does address collective reception in the preceding section (already in the 1936 version), the potentially sadistic mob reaction to a Disney film is sanitized into the *"highly progressive reaction to a Chaplin film"* by a simultaneously critical and enjoying audience. Of the high-stakes therapeutic claim regarding Mickey Mouse remains the generalized and more benign—though no less important—assertion that the cinema makes individual reactions both contingent on and mutually regulative of the reactions of the assembled masses. What's more, with the disappearance of Mickey Mouse and the concept of collective innervation of technology, cinema spectatorship ends up subsumed under the notion of distraction, reduced to a Brechtian attitude of critical testing and thus robbed of its mimetic, eccentric, psychosomatic dimensions.

Why did Benjamin give up on innervation? It has become a cliché to blame Adorno for the mutilation of the artwork essay, but we should not overlook Benjamin's own ambivalence, not least regarding the figure of Mickey Mouse, and his suspicion of the "usability of the Disney method for fascism" (*GS* 1:1045). Nor can we ignore the problems that Benjamin might have had with the actual

collective assembled in urban movie theaters, a collective whose demographic profile was not predominantly and simply working class, let alone consciously proletarian. The heterogeneous mass public that congregated in, and was catalyzed by, the cinema of the Weimar period, as we saw in connection with Kracauer, consisted largely of people who bore the brunt of modernization—women, white-collar workers of both sexes, along with traditional working-class people. And as a new social formation, this mass public was just as unpredictable and politically volatile as German society at large. It would have been conceivable to think of the moviegoing collective as made up of individual viewers, with the kinds of mimetic engagement Benjamin found in the surrealists, the child, the beholder of old photographs, or, for that matter, Proust. But it is also historically understandable why Benjamin, unlike Kracauer, did not make that leap of faith—why he submerged the imaginative, mnemonic possibilities of the medium into an enlightened politics of distraction, renouncing the cinematic play with otherness in view of the increasingly threatening otherness of actual mass publics.

Collective innervation, the apotropaic play with technology that would prevent and reverse the spiral of shock-anaesthetics-aestheticization, seems to have failed, at least in Benjamin's lifetime; the cosmic mating fantasy in the spirit of technology as which he described the First World War at the end of *One-Way Street* returned in the Second as a bloodbath of exponentially vaster scope and efficiency. But we have to admire Benjamin for having taken on the gamble, the *"vabanque* game" with technology. For if anything was *not* an antinomy for Benjamin, nor even cause for ambivalence, it was the insight that the fate of the "beautiful" in modernity was inseparable from the transformation of the human sensorium under capitalist-industrial conditions; and that the fate of the human senses, pertaining to the very possibility of the species' self-preservation, was a political question of utmost urgency.

Micky-Maus

Benjamin's reflections on film and mass culture repeatedly revolved around Disney, in particular early Mickey Mouse cartoons and Silly Symphonies.[1] Adorno took issue with Benjamin's investment in Disney, both in direct correspondence and, implicitly, in his writings on jazz and, after his friend's death, in the analysis of the Culture Industry in his and Horkheimer's *Dialectic of Enlightenment*. These scattered references to Disney engaged central questions concerning the politics of mass culture, the historical relations with technology and nature, the body and sexuality. They demonstrate, in an exemplary way, a mode of thinking that sought to crystallize observations on mass-cultural phenomena into a critical theory of culture and history.

In this chapter, I reconstruct Benjamin's arguments on Disney—and Adorno's response—as a debate on these larger questions. I do not intend to reiterate the familiar pattern of adjudicating between the two writers—dismissing one as mandarin and pessimist while claiming the other for a progressive canon of film and media theory. To a degree, Adorno's reservations about Disney highlight ambivalences in Benjamin's own thoughts—ambivalences that speak to our own unresolved relations with technology. What is more, Benjamin himself considered their opposing views as a sign of "deep" and "spontaneous communication." As he wrote to Adorno in June 1936, referring to the latter's essay on jazz and his own artwork essay, "It seems to me that our respective investigations, like two searchlights trained upon the same object from opposite directions, make the contours and dimension of contemporary art recognizable in a definitely innovative and much more significant manner than anything hitherto attempted."[2] Maintaining these conflicting perspectives in a stereoscopic view seems to me a more productive way of engaging problems and possibilities of mass culture and modernity in general and, for that matter, of contemporary media culture.

Nor is the point here to measure Benjamin and Adorno's remarks on Mickey Mouse and Donald Duck in terms of their critical adequacy or inadequacy toward Disney as a textual and industrial phenomenon. Rather, I am interested in the way that Disney films became emblematic of the juncture of art, politics, and technology debated at the time. The key question for Critical Theory in the interwar years

was which role the technological media were playing in the historic restructuring of subjectivity: whether they were giving rise to new forms of imagination, expression, and collectivity, or whether they were merely perfecting techniques of subjection and domination. In the face of fascism, Stalinism, and American-style capitalism, theorizing mass culture was a highly political effort to come to terms with new, bewildering, and contradictory forces, to map possibilities of change and prospects of survival. In this situation, the Disney films catalyzed discussions on the psychopolitics of mass-cultural reception, specifically the linkage of laughter and violence with the sadomasochistic slant of spectatorial pleasure. But to Benjamin they also suggested alternative visions of technology and the body, prefiguring a utopian mobilization of the "collective *physis*" and a different organization of the relations between humans and their environment.

The questions that Benjamin and Adorno raised in connection with Disney point not only beyond the films but also beyond the historical context of Critical Theory. In the age of the global and digital proliferation of images and sounds, the issue of technologically generated and enhanced violence is still of paramount importance and remains one of the unresolved legacies of modernity. Now as then, the industrial-technological media constitute as much part of the problem as they do the primary public horizon through which solutions can be envisioned and fought for. Now as then, the issue pertains to the organization and politics of sensory perception, of aesthetics in the wider, etymological sense of *aesthesis* that Benjamin explicitly resumes.

COLLECTIVE LAUGHTER: THERAPY AND TERROR

In the handwritten, first draft of the artwork essay, the entire section devoted to the notion of an optical unconscious is entitled "Micky-Maus." Where the third, familiar version meanders through a reference to Freud's *Psychopathology of Everyday Life*, the earlier versions (including the French) open with the epigrammatic thesis "The most important among the social functions of film is to establish equilibrium between human beings and the apparatus." To that effect, Benjamin stresses the importance of film not only for the manner in which human beings present themselves to the apparatus but also for their effort to represent, "to themselves," their industrially changed environment (*SW* 3:117; *GS* 7:375). As I elaborate in the previous chapter with regard to Benjamin's troping of film as the "dynamite of the split second" that explodes the "prison-world" of the urban-industrial environment, this implies an aesthetics of film that utilizes the camera's exploratory, cognitive, and liberating possibilities.

In the passage that follows in the earlier versions of the artwork essay, however, the analogy between film and psychoanalysis takes a somewhat different turn. Film not only makes visible formations hitherto invisible to the human eye, but

registers configurations of psychoperceptual reality that emerged, historically, only with modern technology. If, as Benjamin observes elsewhere, film gives rise to "*a new realm of consciousness*" (*SW* 2:17), it also brings into sensory perception new configurations of the unconscious that are not necessarily all liberating. Benjamin locates the latter largely "outside the *normal* spectrum of sense perceptions," in the region of "psychoses, hallucinations, and dreams." Thus, "many of the deformations and stereotypes, transformations and catastrophes which can affect the optical world in films" provide an unconscious lens for the borderline experience that comes with the pressures of urban-industrial modernity (*SW* 3:118; *GS* 7:376–77).

The point of the psychoanalytic analogy here is not merely the revelation or "prismatic" analysis of latent structures. Rather, Benjamin is concerned with film's *therapeutic* function, based on its ability to translate individually experienced borderline states, such as the psychoses and nightmares engendered by industrial and military technology, into *collective* perception. These coordinates mark the cue for the entrance of Mickey Mouse. "The ancient truth expressed by Heraclitus, that those who are awake have a world in common while each sleeper has a world of his own, has been breached by film—and less by depicting the dream world itself than by creating figures of the collective dream such as the globe-encircling Mickey Mouse" (*SW* 3:118; *GS* 7:377).

As an antidote to the violent return of modern civilization's repressed, effecting "a therapeutic detonation of the unconscious," the image of the frantic Mouse is brought to a standstill at the crossroads between fascism and the possibility of its prevention: "*If one considers the dangerous tensions which technologization [Technisierung] and its consequences have engendered in the masses at large—tensions which at critical stages take on a psychotic character—one also has to recognize that this same technologization has created the possibility of psychic immunization against such mass psychosis. It does so by means of certain films in which the forced development of sadistic fantasies or masochistic delusions can prevent their natural and dangerous maturation in the masses.* Collective laughter is one such preemptive and healing outbreak of mass psychoses" (*SW* 3:118; *GS* 7:377; emphasis in original).

By articulating the repressed pathologies of technological modernity, this speculation suggests, the Disney films, like American slapstick comedies, could work to preemptively diffuse, through collective laughter, an otherwise destructive potential. In other words, by activating individually based mass-psychotic tendencies in the space of collective sensory experience and, above all, in the mode of play, the cinema might prevent them from being acted out in reality, in the form of organized mob violence, genocidal persecution, or war.

In his response to the artwork essay, Adorno was clearly troubled by this passage: "Your attack on *Werfel* gave me great joy; but if you take the Mickey

Mouse instead, things are far more complex, and the serious question arises as to whether the reproduction of every human being really does constitute the a priori of film you claim it to be, or whether it belongs instead to precisely that 'naive realism' on the bourgeois nature of which we so found ourselves in complete agreement in Paris" (*CC* 130–31; *ABB* 172).[3] Whether elision or non sequitur, Adorno's phrasing displaces his main objection to Benjamin's Mickey Mouse—the endorsement of the collective laughter that the films provoke—onto the political claims made for film in the name of representational realism; it may also register a certain contradiction between those claims and Benjamin's choice of a creature of cel animation.

Adorno's objections to Benjamin's political investment in collectivity (such as the concept of the "dreaming collective" in *The Arcades Project*) are well known: besides straying into the vicinity of C. G. Jung's "collective unconscious," Benjamin, according to Adorno, seriously underrated the extent to which any existing collective today was imbricated with the commodity character (whereas Benjamin's more immediate concern seems to have been its complicity with fascism). The more specific point of disagreement, however, was the sadistic—and, in Adorno's analysis, effectively masochistic—slant of the collective laughter. In the letter quoted above, Adorno cautions Benjamin emphatically against romanticizing the barbarism manifested in mass-cultural reception: "The laughter of a cinema audience . . . is anything but salutary and revolutionary; it is full of the worst bourgeois sadism instead" (*CC* 130). He extends this verdict even to Chaplin, who had been a political good object, after all, not just for Kracauer but generally in leftist-intellectual and avant-garde circles of the time. Instead of elaborating on the point, Adorno refers Benjamin to his soon-to-be-completed essay on jazz, in particular his reflections on the figure of the eccentric.

Like the 1938 essay "The Fetish Character of Music and the Regression of Listening," Adorno's writings on jazz represent a running argument with Benjamin's artwork essay. In a postscript written in Oxford in 1937, Adorno delineates the "jazz subject," the listener's position in the musical text, in terms of sadomasochistic pleasures short-circuited in the service of social integration. Like its precursor, the eccentric, the jazz subject is marked by a pseudo-individuality that Adorno pinpoints as the root of the jazz ritual's "curiously affirmative character." Instead of real autonomy, the "individual traits [of the jazz subject] by which it protests against social authority are in truth the very stigmata of mutilation inflicted upon him by society." This makes for a form of identification in which the subject takes pleasure in his or her own mutilation, yet without consciousness of the masochistic slant of that pleasure, identifying instead with the sadistic principle and internalizing the threat of castration. In the dancers' relation to the music, this submission corresponds to a stubborn refusal to really dance the "break" (English in the original), the syncope which is jazz's futile assertion to difference. This is

the place where Adorno ambiguously situates the Disney mascot: "It is key to the success of Mickey Mouse that he/she/it [*sie*] alone translates all the breaks into precise visual equivalents."[4]

The association of Mickey Mouse and jazz was a commonplace in Weimar and Nazi Germany, perhaps more so than in the United States. The connection was not only a literal one, suggested by a synchronization of the figure's movements with the rhythms of the music (which was hardly ever, one should add, authentic jazz); but both Mickey and jazz figured prominently in the German discourse of Americanism, that is, a modernism predicated on industrial-capitalist rationalization, on Taylorized labor and a Fordist organization of production and consumption. Like Chaplin and American slapstick comedy, jazz and cartoons represented, as it were, the other side of Americanism, a branch of consumer culture that seemed to subvert the economically imposed discipline through orgies of destruction, magic, and parody.[5] Walt Disney's relation to Fordism was anything but critical, to be sure, and he espoused Fordist-Taylorist principles of efficiency and management in both his creative products and business strategies.[6] Still, Mickey's enormous success in Germany from the late 1920s through the 1930s no doubt owed much to the figure's anarchic, exuberant appeal, which was, in a more exoticized vein, what people expected from jazz.

It is not surprising that the National Socialists early on included Mickey Mouse in their campaign against the "*Verniggerung*" (negroization) of German popular culture.[7] The ideological conflation of Mickey and jazz throws into relief the question of the figure's blackness and thus inserts it into the long history of white projections of African American culture. In a 1991 exhibition on the reception of Disney in Germany, 1927–1945, a number of vernacular depictions (caricatures, mugs, figurines) show Mickey with protruding white teeth and Africanized features, while others make him look like an inversion of blackface, that is, a black figure wearing a white face and white gloves.[8] Whether Benjamin and Adorno were aware of this racialized subtext is unclear; that Adorno, by placing Mickey Mouse in the context of white projection—for which he took jazz—came closer than Benjamin to spelling out the figure's racial and racist connotations might also account for Adorno's greater ambivalence.

For Mickey, in Adorno's reading, is not simply an embodiment of the jazz subject (as Lawrence Rickels would have it), but rather one element in a configuration of desire: the bait of difference, the fantasy of a break.[9] It is no coincidence that Adorno subsequently, in a kind of substitution trick, switched his polemic against Disney from Mickey to Donald Duck, a cartoon character that fits the authoritarian profile much more smoothly. Thus we read in Adorno and Horkheimer's chapter on the culture industry in *Dialectic of Enlightenment*: "Donald Duck in the cartoons, like the unfortunate ones in real life, receives his beatings so that the viewers can accustom themselves to theirs."[10] Sadistic pleasures are

mobilized not to challenge the regime of heterosexual genitality but to rehearse the internalization of terror. The "medicinal bath of fun" administered by the culture industry does not inspire a conciliatory laughter that would "echo the escape from power," but a Schadenfreude, a terrible laughter that "copes with fear by defecting to the forces that are to be feared."[11] Humor provides the glue that prevents the subject from recognizing him- or herself as the actual object of mutilation. These ideological effects of the Disney humor are at once revealed and sanctioned in the locus classicus of "laughter betrayed" (Kracauer): the climax of Preston Sturges's *Sullivan's Travels* (1942) in which the screening of a rather violent Mickey Mouse cartoon to an audience of chain-gang prisoners persuades the eponymic director-in-disguise that cathartic laughter is a better gift to humanity than any realist critique of social conditions.[12]

Benjamin, writing in the mid-1930s, was no less aware of the direction in which the Disney films were heading. In a footnote to the section cited above, following the therapeutic reclamation of the collective laughter inspired by these films, he concedes that their comic aspects are often indistinguishable from horror. In particular the most recent Mickey Mouse films, he observes, manifest a tendency already latent in the earlier films: "the cozy acceptance of bestiality and violence as inevitable concomitants of existence." By doing so, they resume an "old tradition which is far from reassuring—the tradition inaugurated by the dancing hooligans to be found in medieval depictions of pogroms, of whom the 'riff-raff' in Grimm's fairy tale of that title are a pale, indistinct rear-guard" (*SW* 3:130; *GS* 7:377).

The affinity of comedy and cruelty is an old story, though it clearly assumed an acute meaning in the face of the more systematic, totalizing manifestations of anti-Semitic terror after 1933. The psychoperceptual structure described by Adorno resonates with Benjamin's image of "humankind" experiencing "its own annihilation as a supreme aesthetic pleasure," an image that spells out the trajectory of the fascist spectacularization of politics (*SW* 3:122).[13] This catastrophic escalation of human self-alienation seems only the most extreme instance of the miscognition Adorno sees operating in capitalist mass culture, the identification with the aggressor by which the consumers unwittingly assent to their own mutilation and subjection.

Obviously, there is a difference between the fascist aestheticization of politics and the ideological mechanisms that Adorno imputes to Hollywood cartoons and jazz. But the structural similarity between the forms of miscognition that Benjamin and Adorno see at work in the respective syndromes is nonetheless striking. In each case, there is a complicity of historical subjects with their particular mode of subjection; for Benjamin, this complicity is linked to a defensive numbing of perception, a splitting of experience that prevents spectating social subjects from

recognizing the mechanisms that make them both objects and agents of violence.[14] The disagreement between Adorno and Benjamin lies less in the diagnosis than in the assessment of whether and by whom that complicity could be undone, whether and how the integrity of the human senses could be restored.

These questions crucially entail the problem of how we distinguish between a film practice that "breaks through the numbing shield of consciousness" and one that "merely provides a 'drill' for the strength of its defenses."[15] Can we—at a theoretical level—draw a clear line between a defensive adaptation to technology and a mimetic, cognitive incorporation of technology? As I elaborate in chapter 5, Benjamin sought to imagine the possibility of the latter through the concept of innervation. Like the notion of shock, he thought of innervation in neurophysi- ological, energetic terms. In that sense, the paralyzing and destructive effects of technology are only the flipside of tensions, currents, and forces that, under differ- ent relations of production and reception, could have a mobilizing and empower- ing effect, that could even at this point in history be imagined to undo the damage inflicted on the human sensorium by the former.

To return to Mickey Mouse, the therapeutic diffusion of violent mass psychoses that Benjamin attributes to the films is accomplished through a process of twofold innervation—at the level of graphic inscription, in the cartoon figure's parodistic incorporation of technology (on which more below); and at the level of recep- tion on the part of a viewing collective—whereby individual alienation can leap into public release. The stimulation of involuntary and collective laughter takes place not only in the visual register; it also relies significantly on both acoustically and visually structured movement—that is, rhythm. "A Mickey Mouse film may still be incomprehensible today to [this or that] individual, but not to an entire audience [*Publikum*]. And a Mickey Mouse film can govern an entire audience through rhythm" (*GS* 2:962). What Benjamin seems to have in mind here is the precise synchronization of acoustic and visual rhythm, a technique for which Hol- lywood parlance has coined the term "Mickey Mousing" (and which Adorno and Eisenstein understood perhaps more clearly than Benjamin as Disney's particular aesthetic innovation).[16]

More generally speaking, this rhythmic "loosening" of the "compact mass" (*SW* 3:129) could be seen as an instance of conscious staging of shock, or rather coun- tershock, which Benjamin discerned in phenomena such as dada happenings and Brecht's epic theater. At any rate, we are clearly dealing with a different concept of reception than the one Benjamin assumes in "On Some Motifs in Baudelaire" (1939–40), in which he claims that film had established the "perception condi- tioned by shock" epitomized by the assembly line as its "formal principle": "What determines the rhythm of production on a conveyer belt is the same thing that underlies the rhythm of reception in film" (*SW* 4:328; *GS* 1:631).

A MODERNIST FAIRY TALE

Mickey Mouse first enters Benjamin's work in a series of notes he composed following a conversation with his friend Gustav Glück and the composer Kurt Weill in 1931.[17] From this fragment it seems that he was fascinated with the phenomenon as a figure of "manifold interpretability."[18] The guiding question—how to explain the "huge popularity" of the Mickey Mouse cartoons—produces observations in a number of registers. These lead Benjamin to the conclusion that the films' popularity cannot be accounted for in terms of "'mechanization' or their 'formal' construction, nor as a 'misunderstanding'"; rather, "it is simply the fact that the audience [*Publikum*] recognizes its own life in them" (*SW* 2:544; *GS* 6:145). If this somewhat counterintuitive conclusion is to make sense, it has to be understood not as a matter of representational verisimilitude but rather as referring to the films' lending expression to salient aspects of modern experience through hyperbolic humor, kinetic rhythms, and plasmatic fantasy.

The two observations that open the fragment come closest to supporting the claim to the cartoons' connection with the audience's "own life." The first pertains to their graphic play with "property relations": "Here we see for the first time that it is possible to have one's own arm, even one's own body, stolen." Whether we take this form of expropriation to resonate with the experience of mutilation and fragmentation in World War I or with the effects of rationalized labor—"mechanization" after all?—it seems related to the category of human self-alienation discussed earlier. The second observation further complicates any direct analogy between the cartoons and principles of rationalized labor such as goal-determined functionality, efficiency, and seriality. "The route taken by a file in an office has more resemblance with the course covered by Mickey Mouse than that of a marathon runner" (*SW* 2:545; *GS* 6:144). In other words, the frantic movements of the animated creature bare the irrational flipside of the regime of rationalization and trace the contours of a logic of play that resists that regime. This is but one sense in which Mickey Mouse provided Benjamin with a dynamic figure of *disruption*—in his search for an emergency break that might yet derail the catastrophic continuum of history, the catastrophe of things going on the way they are.

The connotation of disruptiveness tallies with another characteristic of Mickey Mouse cartoons—their anti-empirical exuberance, their nonreliance on what can be expected, their defiance of gravity and perspective. "These films disavow experience more radically than ever before. In such a world, it is not worthwhile to have experiences" (*SW* 2:545; *GS* 6:144). Herein Benjamin discerns a similarity between Mickey Mouse cartoons and fairy tales: "Not since fairy tales have the most important and most vital events been evoked more unsymbolically and more unatmospherically," that is, uncluttered by any recourse to past associations. And he invokes one particular fairy tale by the Brothers Grimm, "Von Einem, der

auszog das Fürchten zu lernen": "All Mickey Mouse films are founded on the motif of leaving home in order to learn the meaning of fear" (SW 2:545). "Young and cheerful" like the "destructive character" of Benjamin's article by that title, the figure is imagined as a small, physically inferior, yet fearless and plucky hero who leaves his family in order to undertake adventures and learn about life.[19] As an instance of tabula rasa mentality, Mickey Mouse later joins the representatives of a "new, positive concept of barbarism" in Benjamin's essay "Experience and Poverty" (1933), which documents a programmatic, if belated, endorsement of Neue Sachlichkeit (New Objectivity). However, Mickey Mouse does so with a twist that distinguishes the early Disney fantasy from the more sober, presentist, and constructivist tendencies of Neue Sachlichkeit.

In the 1931 fragment, Benjamin further anticipates the "new barbarian" tenor of the later essay by asserting that in the Disney films "mankind makes preparations to survive civilization." He pursues this thought in a cosmological and utopian vein: "Mickey Mouse proves that the creature [die Kreatur] can still survive even when it has thrown off all resemblance to a human being." An allegedly nonanthropomorphic creature endowed with agency and subjectivity, the figure challenges any anthropocentric worldview: "[He/she/it] disrupts the entire hierarchy of creatures that is supposed to culminate in mankind" (SW 2:545; GS 6:144). This kind of disruption aligns Mickey Mouse with the utopian socialist Charles Fourier, in particular the idea of "cracking open the teleology of nature" that Benjamin in The Arcades Project names as one of "two articles of [his] 'politics'" (AP 631; GS 5:777).[20]

In "Experience and Poverty," Benjamin situates the reception of Mickey Mouse in a rather more specific political force field. The currents that electrified Mickey's German audience have one pole in the cataclysm of World War I and another in the world-economic crisis and, behind it, the "shadow of the coming war" that Benjamin discerned in the Nazis' rise to power (SW 2:736; GS 2:219). The shattering effect that World War I had on Benjamin—as on so many Weimar intellectuals—emerged, in retrospect, as an epistemic watershed. The war had exploded nineteenth-century dreams of technology and progress and the fantasies of imperialist nationalism; it had also catalyzed an unprecedented crisis of "experience," in Benjamin's emphatic sense.[21] Technologically facilitated mass destruction had changed all familiar coordinates of experience; and it had expelled the private individual from the soft shell of bourgeois interiority. Benjamin encapsulates this displacement in an often-cited image or a lap dissolve: "A generation that had gone to school in horse-drawn streetcars now stood in the open air, amid a landscape in which nothing was the same except the clouds, and, at its center, in a force field of destructive torrents and explosions, the tiny, fragile human body" (SW 2:732).[22]

The monstrous fruition of technology not only had blunted the faculty of experience, the capability of individuals to remember, grasp, and communicate their

experience but had also revealed the bankruptcy of existing discourses of experience, in particular those predicated on classical humanist notions of culture and individual *Bildung*, or cultivation. The inadequacy of the latter—and the myriad sectarian offshoots seeking to fill the vacuum—for dealing with the psychosocial consequences of the war and hyperinflation only show up the "poverty of experience" that Benjamin observes on a large scale, "a new kind of barbarism." Instead of condemning this barbarism on moral grounds, however, he advocates a "new, positive concept of barbarism," an attitude he sees exemplified in constructivist architecture (the Bauhaus, Adolf Loos, Le Corbusier), the painting of Paul Klee, and the work of writers such as Brecht and Paul Scheerbart. This new culture—or anticulture—is a "culture of glass," a phrase Benjamin borrows from Scheerbart: a culture that rejects the privacy of the bourgeois interior, the *Etui* (case) and the overstuffed armchair, the personal trace, symbolism, the aura. Mickey Mouse is a younger cousin of these new barbarians, herald of an imagination that does not rely on experience, instantiating a subjectivity that, like the " 'people' [*Leute*]" in Scheerbart's science fiction novels, has shed all "humanlikeness" and thus a key principle of bourgeois humanism.[23] If in the buildings, pictures, and stories of this new sensibility "mankind is preparing to outlive culture," it does so, and here Benjamin sounds a key motif of his later argument about Mickey Mouse, "with a laugh" (*SW* 2:735). "This laughter may sound somewhat inhuman, but perhaps the individual has to have something inhuman about him so that the totality, which hitherto has so often been inhuman, may become human."[24]

With Benjamin's programmatic attack on experience, we return to one of the major antinomies in his work. Throughout his life, Benjamin was concerned with the problem of how to conceptualize the possibility of a cognitive discourse vis-à-vis the transformations of modernity when those same transformations were eroding the very capacities that would enable such a discourse on a collective and public scale—capacities of sensory perception and reflection, of seeing similarities and making connections (compare Kracauer's insistence on relationality), of recognizing danger and acting on it, of remembering the past and imagining a different future. The problem was compounded by the fact that the very concept of experience was held hostage by a bourgeois-humanist culture that had tied it to authority, privilege, and individual cultivation. In view of this dilemma, Benjamin opts for a desperate leap forward, into the "purgatory of New Objectivity."[25] The decline of experience presents an opportunity to liquidate it; the "new barbarism" of experiential poverty appears as the proletarian alternative to a moribund bourgeois culture. We can find this stance as well in Benjamin's work on Brecht, his essay on Karl Kraus (1931), and the already-mentioned essay "The Destructive Character."

At the same time, as I have emphasized, Benjamin never abandoned his efforts to reconceptualize the conditions of possibility for experience in modernity. In an

unpublished note of 1929, he writes that "the word [*experience*] has now become a fundamental term in many of my projects" (*GS* 2:902). The contours of a new theory of experience emerge in, for instance, *One-Way Street* and his essays on surrealism, Proust, Kafka, and the mimetic faculty—that is, in writings *concurrent* with the liquidationist stance of "Experience and Poverty" and related essays. If the essay "The Storyteller" (1936) appears to revert to lapsarian mourning for the loss of experience (though only if we disregard the essay's connection with Benjamin's exploration of a new "epic" culture in Döblin and Brecht), the work on Baudelaire and respective sections in *The Arcades Project* attempt more systematically to keep in view both the irrevocable decline of experience and the need for a contemporary equivalent—as does, I've been arguing, the artwork essay. For by this time, fascism had brought home the vulnerability and danger of a collective lacking a discourse on technological modernization, lacking a public horizon that would enable human beings to recognize and negotiate the effects of historical fragmentation, rupture, and loss, of collective yet privatized self-alienation.

Even in Benjamin's programmatic endorsement of a "poverty of experience," Mickey Mouse does not fully merge with the "destructive character," but retains some of the fairy tale appeal that Benjamin had noted in the fragment of 1931. To people "tired" of experience, "fed up" with "*Kultur*" and "the human being," the existence of Mickey Mouse is "a dream that compensates for the sadness and discouragement of the day" and shows them that "simple but quite magnificent existence for which energy is lacking in waking life" (SW 2:734; GS 2:218). But unlike the aesthetics of Neue Sachlichkeit, this dream is not modeled on the forms and functions of technology; it seems closer to surrealist fantasy and cheerful parody than to the functionalist sobriety of the Bauhaus or the didactic rationalism of Brecht. The existence of Mickey Mouse "is full of miracles—miracles that not only surpass the wonders of technology but make fun of them."

> For the most curious thing about them is that they all appear, quite without any machinery, to have been improvised out of the body of Mickey Mouse, out of her/his/its partisans and persecutors, and out of the most ordinary pieces of furniture as well as from trees, clouds or a lake. Nature and technology, primitiveness and comfort, have completely merged, and before the eyes of people who have grown weary of the endless complications of everyday living and to whom the purpose of existence seems to have been reduced to the most distant vanishing point on an endless horizon of means, there appears as a redemption a way of life which at every turn is self-sufficient in the simplest and simultaneously most comfortable way, in which a car is no heavier than a straw-hat and the fruit on the tree grows round as quickly as a hot-air balloon. (SW 2:735; GS 2:218–19)

The miracles in a film like *Plane Crazy* (Disney/Ub Iwerks, 1928), while produced by a version of the constructivist engineer, defy expectations of gravity and con-

ventional senses of speed and perspective; they destroy familiar correlations and oppositions and play with their liberated elements.[26]

Like Eisenstein, Benjamin was impressed with the metamorphoses staged by the Disney films, with what Eisenstein called their "plasmaticness": "a displacement, an upheaval, a unique protest against the metaphysical immobility of the once-and-forever given."[27] Like Benjamin, Eisenstein attributed political significance to this plasmaticness in that the cartoons presented a challenge, if not an antidote, to the regimentation of American/ized labor and living.[28] But where Eisenstein, writing at the height of World War II, curiously elides the role of technology in these metamorphic games, Benjamin reads them as forms of innervation, stimulating an emancipatory incorporation of technology. As he stresses in the 1931 fragment, the Mickey Mouse films engage technology not as an external force, in a literal or formal rendering of "mechanization," but as a hidden figure: they hyperbolize the historical imbrication of nature and technology through humor and parody. While mechanically produced, the miracles of the animated cartoon seem improvised out of the bodies and objects on the screen, in a freewheeling exchange between animate and inanimate worlds. This aesthetic self-sublation of technology not only suggests a supplementary, homoeopathic relation between film and other technologies but also prefigures the utopian potential of technology for reorganizing the relations between human beings and nature.

The notion of an aesthetically sublated technology points toward Benjamin's difficult remarks, in the artwork essay, concerning film's ability to make its own technology disappear. There he observes that the thorough penetration of reality by means of editing makes "*the foreign body of equipment*" disappear and lends film an illusory nature "of the second degree." "The equipment-free aspect of reality has here become the height of artifice, and the vision of immediate reality the Blue Flower in the land of technology" (*SW* 3:115, 4:263). Invoking this highly auratic emblem of the romantic imagination (Novalis) appears puzzling, especially in light of the later critique of the ideal of an "equipment-free aspect of reality" on the part of poststructuralist film theory. Pinpointing that ideal as one of the principles by which the Hollywood continuity system worked to mask the apparatus and thus the material conditions of production, writers such as Christian Metz, Jean-Louis Baudry, Stephen Heath, and Peter Wollen took it to be an essential aspect of the basic ideological effect of classical narrative cinema; the fiction of a preexisting diegesis that afforded the spectator privileged access simultaneously advanced his identification with the position of a transcendental subject. Benjamin, by contrast, rather than dismissing the fiction of a seamless diegesis for perpetuating reality as an illusion, sees the cinematic crossing of supreme artificiality with physiological immediacy as a chance—a chance to rehearse technological innervation in the medium of the optical unconscious.

The comparison between Mickey Mouse and the cinematic Blue Flower effect urges us finally to address the difference between animation and live-action film. By invoking an example from animated film—that is, graphic cinema that does not require, or need to pretend to, a preexisting, stable referent—Benjamin bypasses the hierarchy of live-action over animated film fostered by Hollywood. Whether or not we agree with the polemical claim that digital technology has made live-action cinema a subset of animated film (since all photographic images can in principle be computer-generated), this claim redresses the long-standing marginalization of animated film.[29] In the ideological division of labor between the two modes of film, animation had served the role of exemplifying the "mechanical magic" of the cinematic apparatus as a whole—to children, to regressive adults—so as to complement and uphold mainstream narrative films' claim to "realism."[30] To be sure, cartoons also imitated live-action films, not necessarily all in the parodistic spirit famously cultivated by Warner Brothers' animation branch at Termite Terrace (by directors such as Tex Avery, Bob Clampett, Fritz Freleng, Chuck Jones, and Frank Tashlin). Disney in particular began to develop a naturalistic look patterned on the Hollywood continuity style: while the pulsating rhythm of the Disney cartoons prior to the mid-1930s destabilizes just about everything within the frame, most of the subsequent productions, especially the features, show an increased concern for a stable animated diegesis.[31] But, if the degree of verisimilitude in animation was a matter of stylistic choice, comparable options for live-action film were restricted in advance due to the institutional investment in the medium's photographic iconicity. With regard to Benjamin, this is particularly relevant for conventions of representing the human being, that is, in classical cinema, the fictional self-identity of character embodied by the actor.

As a prototype of innervation, Benjamin's Mickey Mouse competes with the figure of the screen actor. In the artwork essay, especially in the earlier versions, Benjamin elaborates at great length on the profound changes that the mediation through the apparatus has visited upon the phenomenology of performance. In contrast with the stage actor, the performer on screen forgoes the aura of "his presence in the here and now"; his performance or accomplishment (*Leistung*) is to a much greater degree determined by heteronomous agents, from the director and cinematographer to the sound engineer and editor. Thus fragmented and remote-controlled, he or she no longer dominates the scene by psychologically identifying with a role but, in tendency at least, functions like a prop—"a thing among things," as Kracauer was wont to put it—a moving object that interacts with and is acted upon by other objects, animate or inanimate, in a scenic space constituted by the apparatus. "Film is thus the first artistic medium which is able to show how matter plays havoc with human beings [*wie die Materie dem Menschen mitspielt*]." This makes film "an excellent means of materialist exposition"

(*SW* 3:126, 4:277). Whether this causes the audience to side with the actor—who takes "revenge on their behalf" in their own daily battle with technology (as in the second version)—or whether they are thought to assume the testing, critical, impersonal attitude of the camera (as in the third version), the actor's confrontation with the camera, microphones, and klieg lights redefines his or her role as a performance of human self-alienation: "In the representation of human beings through the apparatus their self-alienation has found a most productive realization [*Verwertung*]" (*SW* 3:113; *GS* 7:369).

In the historic task of making self-alienation aesthetically productive, Mickey Mouse has certain advantages over the screen actor. While the actor by and large remains tied to a realistic imaging of the human shape and can thus be naturalized and fetishized in the cult of the star, the cartoon figure does not lend itself to such false restoration of the aura; or so it seems, at least, in theory.[32] The appeal of the small and versatile animated creature—and this claim goes beyond Mickey—owes much to its hybrid status, its blurring of human and animal, two-dimensional and three-dimensional, corporeal and machinic energies. It could well be said that, as a figure of technologically generated, artificial subjectivity, Benjamin's Mickey Mouse points toward the general imbrication of physiological impulses with cybernetic structures that, no longer confined to the domain of cyberfiction, has become standard practice in science and medicine, architecture and design, and a host of other areas. This cyborgian quality brings Mickey Mouse into the purview of Benjamin's reflections on the body: the problematic of the psychophysiological boundaries supposed not only to contain the subject "within" but also to distinguish the human species from the rest of creation.

HYBRID CREATURE: "CRACKING THE TELEOLOGY OF NATURE"

The transformations of second nature accelerated with twentieth-century modernity could not have left human beings' "primary" nature untouched: they have changed the meaning of sexuality and death; they have pervaded the boundaries of the human body and endowed it with prosthetic extensions; they have initiated, as Kracauer put it in his essay on the "mass ornament," the human figure's "*exodus* from lush organic splendor" and individual form "toward the realm of anonymity" (*MO* 83). Indeed, the technically induced mutations of "our historical metabolism" have called into question the very distinction between first and second nature.[33]

. In the 1931 fragment, Benjamin noted that the Mickey Mouse figure visualizes the effect of "property relations" in the assault on the subject's physical integrity: "Here we see for the first time that it is possible to have one's own arm, even one's own body, stolen." This bodily fragmentation, actually quite rare in Mickey Mouse, is more typical in figures of radical animation such as Felix the Cat, Koko

the Clown, or even Disney's own Oswald the Lucky Rabbit. I suggest above that Benjamin might have associated the playful dismembering of the cartoon figure's body with the historical experience of mutilation and fragmentation in technological warfare and industrial production. More specifically, however, in the context of the German 1920s the playful fragmentation of cartoon bodies enters a constellation with dadaist depictions of the body as a dysfunctional automaton or a dismembered mannequin. As Hal Foster has observed with respect to works by Max Ernst and Hans Bellmer, such depictions do not just respond to physical violations of the human shape but incite psychosocial and political reactions that seek to reimagine the body as an invulnerable whole. They deconstruct the defensive transmutation of military-industrial trauma into the prosthetic fantasy of the male body as armor.[34]

In Benjamin's work, the antithesis to the phantasmatic wholeness of the "metallized" male body is the embodiment of the alien in the writings of Kafka. In his great essay on Kafka, he delineates another etiology of self-alienation (in addition to commodification and the misadaptation of technology) in the human relationship with the body, "one's own body," which he calls the "most forgotten alien territory [*die vergessenste Fremde*]" (*SW* 2:810; *GS* 2:431). The strangeness and distortion that characterizes the inhabitants of Kafka's world is the result of a primal "forgetting," a forgetting in which modern psychic repression mingles with prehistoric forces, reverberations from a gnostic abyss. The forgotten alien that is part of oneself extends beyond the human body to the strange and simultaneously familiar creatures that populate Kafka's tales, hybrid or imaginary creatures like the Cat Lamb or Odradek that challenge the taxonomies of an anthropocentric creation.

This psychotheological perspective should make it sufficiently clear that Benjamin's concept of self-alienation does not imply an alienation from an ostensibly originary, authentic, identical self. Rather, Kafka's figurations of the forgotten alien point to a constitutive split, an anthropological condition that merely culminates, historically, in the effects of modern technology and commodification. The answer is therefore not a return to an unalienated, undivided, natural state but, as we have already seen in the case of the screen actor, a productive transformation of self-alienation in the medium of technological reproduction. In a passage discussed in chapter 4, Benjamin compares Kafka's situation with that of experimental subjects who, watching themselves on film or hearing themselves speak on a gramophone, do not recognize their own walk or their own voice. But this moment of trompe l'oeil (and its acoustic equivalent), this salutary miscognition, guides his inquiry in a direction "where he may encounter fragments of his own existence" (*SW* 2:814).[35]

If we recall Benjamin's early speculations (discussed in the previous chapter) on the fundamental, species-specific discrepancy between the human body (espe-

cially the face) and sensory perception, the task of the technological media vis-à-vis human self-alienation could be said to be twofold: *allegorical*, in the sense of making this condition visible, readable in materialist terms (which includes ways in which technology itself compounds sensory alienation); and *utopian*, in the sense of compensating for anthropological lack by rehearsing a collective inner-vation of technology. As I argue above, Benjamin read Chaplin as exemplary of film's allegorical function, the embodiment of self-alienation in the spirit of Kafka. As an animated creature, Mickey Mouse comes closer to prefiguring the utopian interpenetration of body- and image-space that Benjamin delineates at the end of his 1929 essay on surrealism. What the surrealists, according to Benjamin, have understood as a movement of individuals Mickey accomplishes in the arena of mass reception—by generating in the sphere of the image (and matching sounds) the reality of a "collective *physis*" (*Kollektivleib*). Where image space and collec-tive *physis* interpenetrate, there is no place for armored bodies. The leap into the apparatus opens up the dimension of the optical unconscious and makes it public and redemptive; hence Benjamin's initial choice of the title "Micky-Maus" for the entire section devoted to the optical unconscious in the artwork essay.

As an animated, artificial subjectivity, Mickey Mouse not only unfetters the human sensorium from its confinement to the human shape but also projects the demise of the human species in an anthropomorphic and anthropocentric sense. In *The Arcades Project*, Mickey Mouse is cited for carrying out Fourier's utopian project of the "moral mobilization of nature," a connection that for Benjamin confirms Marx's designation of the latter as a "great humorist." "The cracking open of natural teleology proceeds in accordance with the plan of humor" (*AP* 635). Like the surrealists, Benjamin was thrilled with Fourier's hilarious visions that allocated technology a playful role in the cosmic reorganization of nature. When the ocean turns to lemonade; when human beings are able to live like fish in the water and fly like birds in the air; when they can turn themselves into amphibians at will by closing the hole in the cardiac chamber; when oranges blossom in Siberia and the most dangerous beasts are configured into their opposites (anti-lions will deliver the mail and anti-whales will help human beings tug boats); when new stars come into existence that replace the old, which, as we speak, are rotting anyway . . . It is evident why Benjamin perceived an afterglow of the Fourierist imagination when he saw films in which trees court and marry, bloomers turn into a parachute, cars into monsters, pigs into accordions, fish into tigers, and octopuses into elephants.[36]

Benjamin's anthropological materialism, which links his reading of Kafka with his interest in Fourier and early Marx, superimposes the historical-political trajectory of modernity—from the Second Empire to fascism—with an alterna-tive temporality, closer to the messianically inflected theses in "On the Concept of History."[37] Even in the context of the artwork essay, as we saw, he defined

the problem of revolution by the disjunction between "the utopia of the second nature," concerned with society and technology (the Soviet experiment), and "the utopia of the first," concerned with the human body, with "eros and death" (*SW* 3:134–35). If the utopia of second nature takes on the legacy of one or more centuries, the utopia of a changed *physis* refers itself to the grand scheme of "natural history"; like Kafka, it thinks "in terms of cosmic epochs [*in Weltaltern*]" (*SW* 2:795; *GS* 2:410).[38] Inasmuch as the concept of collective innervation bridges first and second nature, it also telescopes anthropological, global-ecological, and messianic temporalities with Benjamin's analysis of modernity and the politics of perception mandated by the contemporary crisis. Mickey Mouse becomes a dialectical image for Benjamin because he/she/it embodies the disjunctive temporalities of human and natural history.

EXCESS AND DOMESTICATION

Benjamin was of course not the only writer who discerned in Mickey Mouse an instance of the utopian imagination.[39] And the earliest Mickey Mouse films (such as *Steamboat Willie* and *Plane Crazy* [both 1928]), like some of the Silly Symphonies of the early 1930s, indeed contain glimpses of a playfully transformed nature, nature liberated from anthropocentric and phallocentric oppositions and hierarchies, a nature in which the boundaries between humans and animals, mechanical and organic, living and inanimate objects, master and slave, labor and play become fluid. Is Mickey a mouse? An android or cyborg? Is the creature woman, man, or child?

If such blurring of boundaries had a utopian appeal, it also involved an encounter with the uncanny. For Mickey's otherness was not that of an easily recognizable difference (like his "blackness"), but one of hybridity, the fantastic blend of strange and familiar elements that animated film encourages. Contemporary responses to Mickey, including Disney's own, tend to register the creature's uncanny fallout, but only to domesticate it in various ways.

Fritz Moellenhoff, for instance, in the first major psychoanalytic attempt to come to terms with Mickey Mouse, relates the figure to "doubts and anxieties" caused by the "overpoweringly rapid development" of technology. Drawing on an important essay by Hanns Sachs, "The Delay of the Machine Age" (1933), Moellenhoff sees Mickey as a "playful inversion of the machine age," inasmuch as the Mouse "ridicules" the "goddess" that technology has become.[40] If the historical imbrication of organic and mechanical, "living and lifeless," breeds anxiety under conditions of reality, Mickey's artificial, dreamlike existence allays those fears by appealing to our narcissism and fantasies of omnipotence. In a similar gesture, Moellenhoff enumerates other aspects that combine at once transgressive and reassuring appeals: Mickey's inversion of the mouse character, the fearless pluckiness

of the tiny, weak creature; his hybrid gender or "hermaphroditism" (especially after Disney gave the creature the voice of a eunuch or prepubescent child, which was, incidentally, his own); Mickey's acting out of polymorphous perversions, in particular sadism and orality, without guilt or punishment; and the absence of castration symbolism and of Oedipal conflicts and confrontations. Moellenhoff concludes by venturing that the key to Mickey's Mouse's success is his symbolic significance of "a phallus but a desexualized one." Lacking genital interest—and thus refusing heterosexual reproduction—"he does not stir up wishes which have to be suppressed and consequently he does not arouse anxiety."[41]

The psychoanalytic discourse on Mickey Mouse evokes, once more, Adorno's association of the Disney figure with the "jazz subject." If jazz has a socially non-conformist, resistant element, Adorno grants, it may lie in its gender hybridity. For even as the sound approximates the human voice, the timbre of the jazz instruments refuses to be characterized in terms of sexual difference: it is "impossible to diagnose the muted trumpet as masculine-heroic; or to define the anthropoid sound of the saxophone as the voice of a noble virgin in the manner in which Berlioz still used the related clarinet." To be sure, the partial drives released in the moment of regression are soon repressed, are falsely integrated, and become detrimental in their particular social configuration that turns "sadism into terror," "homosexuality into a conspiratorial collective." Nonetheless, Adorno discerns in jazz's momentary rebellion "against patriarchal genitality" an affinity with the most advanced esoteric music (Berg, Schönberg) in which "the partial drives are called up one by one." The timbres in which this naming takes place are the same ones that in jazz appear as "parodistic."[42]

Whatever radical edge the first Disney cartoons might have had, most historians agree, disappeared sometime during the mid-1930s. Perhaps Disney had his own or, rather, his corporation's, second thoughts on the uncanny hybrid that some of his viewers discovered in his creation. Mickey's perverse streaks were sanitized, his rodent features domesticated into neotenic cuteness; the playful, anarchic engagement with machinery was functionalized to align with the Fordist work ethic; and surreal fantasy gave way to an idealized, sentimentalized world. And despite—and perhaps through—this process of normalization, violence and terror became a staple of the Disney films, including the features.[43]

Benjamin's fascination with Mickey Mouse no doubt responded to certain traits present in the films that were also perceived by his contemporaries. But there is a moment of excess in this investment (an excess comparable to Eisenstein's obsession with Disney's fire imagery in *The Moth and the Flame*) that has at least as much to do with the writer's unconscious as with that of the spectating collective whose reactions are claimed as evidence. Compared with Benjamin's gnostic science fiction fantasy of the Disney Mouse, the psychoanalytic efforts at explanation or critique (including Adorno's) invariably sound tame and normalizing.

Benjamin's own effort to rationalize Mickey as part of a presentist "culture of glass" suggests that the utopian overvaluations of the figure not least betray a formidable fear, unleashed by thinking the demise of the bourgeois-humanist subject. The fear that Mickey "sets out to learn" in Benjamin's technological fairy tale is that of the reactions that it might catalyze in the mass audience, the "inhuman laughter" that may be therapeutic discharge or prelude to a pogrom.

Mickey Mouse appealed to Benjamin as a cosmic, transnational, post-human(ist), and perhaps transsexual fantasy. But unlike the cataclysmic scene evoked at the end of *One-Way Street* ("To the Planetarium"), the encounters with technology staged by the cartoons provided a model for a benign, imaginative innervation at the level of the films' inscription. However, when in the artwork essay Benjamin tried to make that model productive at the level of collective reception, he must have realized that the dynamics of the laughter unleashed were unpredictable and uncontrollable. Nonetheless, he took the gamble to valorize its potential violence as therapeutic and preemptive.

By the time he was writing the artwork essay, he was well aware of how close the Disney subject could come to the spirit of fascism. In a fragment accompanying the essay's early versions, he considers the "usability of the Disney method for fascism" (*GS* 1:1045), a remark he elaborates in the footnote cited above. The "gloomy and sinister fire-magic [of the more recent—color—Mickey Mouse films] highlight a feature which up to now has been present only covertly"—that is, the condonation of violence as an inevitable aspect of life—and thus "shows how easily fascism appropriates 'revolutionary' innovations in this field as well" (*SW* 3:130; *GS* 7:377). Research on the German reception of Disney confirms Benjamin's suspicions. Contrary to Disney publicity, Hitler was a great fan of Mickey Mouse and Disney films and the respective comics continued to circulate even after and against the official prohibition; Mickey appeared as a mascot on German fighter planes well into the war.[44]

For Benjamin, the thin line that separated the Fourierist Disney dream of a transformed nature from the nightmare of fascism was that of humor: only in a playful, parodistic form can the revolution counter the "beastly seriousness" of fascism, its retrenchment of the contradictions of second nature into the literalist, essentialist myth of blood and soil (*GS* 1:1045). This strategy may well have worked in theory; and the observation no doubt captures a salient feature of fascism. But in the context of the reception of the Disney films, Benjamin's insistence on the therapeutic, redemptive role of humor suggests a rhetorical emergency break similar to the anticapitalist afterthought in his war-as-cosmic-mating fantasy in *One-Way Street*. His own sense—and concept—of humor was not exactly in tune with what mass audiences at the time might have considered to be "fun" (in the sense that Adorno would use the word in German texts, leaving it in the original English).[45] Besides, making humor the primary criterion for the possibility of a

nondestructive innervation of technology sends us back to the unresolved issue between Benjamin and Adorno—the politics of the collective laughter.

It may well be that Benjamin had maneuvered himself into a genuine aporia, and the fact that he expelled Mickey Mouse from the third version of the artwork essay suggests as much. Adorno may have had a more acute assessment of the sadomasochistic mechanisms operating in mass-cultural reception; and his individualist mode of critique put him at a safe distance from fascism. For both Benjamin and Adorno, the Disney syndrome was perched on the threshold of fascism: for Benjamin, a dialectical image of the utopian possibilities of technology in the age of technological warfare; for Adorno, a sociogram of the psychic deformations that linked liberal-capitalist culture to its *völkisch* counterpart. Unlike Adorno, Benjamin invested in both technology and mass-cultural reception as productive forces, and his rhetoric came close to getting caught in their destructive reality. Yet even in these aporetic and ambivalent moments, the price of a tendency to think through extremes, he might have understood something about the success of fascism that Adorno did not.

What remains, however, is the image of the globe-encircling Mickey Mouse as a being who sets out to leave "home in order to learn what fear is" and who engages with the technologically transformed *physis*—the life that Benjamin claims the audience recognizes in the films—in the form of *play*. Even in the artwork essay (both early versions), the passage on the optical unconscious does not end with the emphasis on the therapeutic detonation of pathological energies through collective laughter. The more comprehensive category, as I argue in the following chapter, is the notion of *Spiel-Raum*, or room-for-play, which historically opened up with film and that aligns Mickey Mouse with Chaplin and American slapstick comedy. These new rooms-for-play or "fields of action" provide the perceptual-aesthetic, exploratory, and public arena for both a successful, mimetic innervation of technology and a preemptive disarming of its already deadening and destructive effects.

Play-Form of Second Nature

What is lost in the withering of semblance [Schein], or decay of the aura, in
works of art is matched by a huge gain in room-for-play [Spielraum]. This
space for play is widest in film.
—WALTER BENJAMIN, "THE WORK OF ART IN THE AGE OF ITS
TECHNOLOGICAL REPRODUCIBILITY: SECOND VERSION"

The artwork essay's rhetorical staging of a crisis that culminates in the epilogue,
I argue in chapter 3, imposes a dichotomous structure upon the essay's argu-
ment.[1] It does so by pitting aura and the masses, as the subject of technological
reproducibility, against each other in a binary opposition, and by aligning key
concepts, such as distance and nearness, uniqueness and multiplicity/repeatability,
and contemplation and distraction, with that opposition. However, just as other
important concepts, in particular the optical unconscious and the notion of a
simultaneously tactile and optical reception, elude this dichotomization, even the
concept of aura is not entirely determined by the opposition of the masses and
technology. Rather, it is complicated by a different conceptual trajectory, spelled
out in the essay's earlier versions, that makes aura part of the polarity of *semblance*
and *play* [*Schein und Spiel*].

In this last chapter on Benjamin, I revisit the artwork essay from the perspective
of *Spiel*, understood in its multiple German meanings as "play," "game," "perfor-
mance," and "gamble." *Spiel* is a term and concept, I argue, that allows Benjamin
to imagine an alternative mode of aesthetics on a par with modern, collective
experience, an aesthetics that could counteract, at the level of sense perception,
the political consequences of the failed—capitalist and imperialist, destructive
and self-destructive—reception of technology. Not least, his investment in the
category of *Spiel* helps us better to understand why and how film came to play
such a crucial role in that project. I trace this connection with the goal of explor-
ing the possibilities of a Benjaminian theory of cinema as "play-form of second
nature" (*Spielform der zweiten Natur*).[2]

SPIEL AND PLAY THEORY

In Benjamin's writings, the term *Spiel* appears in a variety of contexts, which span the range of meanings attached to the German word. His theoretical interest in *Spiel* in the sense of "play" is most explicit in his book reviews and exhibition reports on children's toys (1928). In these articles he argues for a shift in focus from the toy as object (*Spielzeug*) to *playing* (*Spielen*) as an activity, a process in which, one might say, the toy functions as a medium.[3] He develops such a notion of playing—whether the child uses toys or improvises games with material objects, detritus, and environments—in several vignettes in *One-Way Street* (e.g., "Child Hiding") and "Berlin Childhood" (e.g., "The Sock," "The *Mummerehlen*," "Hiding Places"), as well as in the texts on the "mimetic faculty." In the latter, the emphasis is on the child's penchant for creative simulation, for pretending to be somebody or something else: "The child plays at being not only a shopkeeper or teacher, but also a windmill and a train" (*SW* 2:720).

In the playful osmosis of an other, in this case a world shot through with "traces of an older generation" (*SW* 2:118), the child engages with an "alien . . . agenda imposed by adults" (as Jeffrey Mehlman paraphrases Benjamin), though not necessarily in ways intended or understood by them.[4] However, since the child's mimetic reception of the world of things centrally includes technology, children's play not only speaks of generational conflict. More significantly, it elucidates the way in which "each truly new configuration of nature—and, at bottom, technology is just such a configuration"—is incorporated "into the image stock of humanity." The cognitive experience of childhood undercuts the ideological abuse of technological progress by investing the discoveries of modernity with mythic yet potentially utopian meanings: "By the interest it takes in technological phenomena, its curiosity for all sorts of inventions and machinery, every childhood binds the accomplishments of technology to the old worlds of symbols."[5]

Benjamin complicates the mimetic, fictional dimension of play ("doing as if") with an interest, following Freud, in the "dark compulsion to repeat," the insatiable urge to do "the same thing over and over again" (*SW* 2:120; *GS* 3:131). Referring explicitly to an "impulse 'beyond the pleasure principle,'" Benjamin attributes to repetition in play an at once therapeutic and pedagogic function: "The transformation of a shattering experience into habit" (*SW* 2:120). He thus modifies Freud's pessimistic slant somewhat by imputing to repetition in play an existential quest for happiness and, as we shall see with regard to cinema, a liberating and apotropaic function.

The notion of play as creative simulation shades into a second meaning of the German word: *Spielen* as *Schauspielen*, that is, performing or acting a part before a specially assembled audience. (This slippage touches on Roger Caillois's distinction between *paidia*, the improvisational, inventive, and open-ended type of play pursued by children, and *ludus*, a rule-bound, formalized, and institutionalized

type of play more properly associated with the English term *games,* though, as we shall see, Benjamin seems to be programmatically interested in preserving the continuum between those terms.)[6] Both senses of play are evocatively conjoined in Benjamin's "Program for a Proletarian Children's Theater" (1928–29). In this text, Benjamin intervenes in ongoing debates on "proletarian education" by giving unequivocal priority to the child's imagination and improvisation, declaring the child's gesture a "signal," not so much of the unconscious, but "from another world, in which the child lives and commands" (*SW* 2:203–4). While he grants that an instructor is needed to "release children's signals from the hazardous magical world of sheer fantasy and apply them to materials," Benjamin foregrounds the child's gesture as a model of "creative innervation," one in which receptivity and creativity are in exact correlation. Grounding the performance in a "radical unleashing of play—something the adult can only wonder at" (205)—children's theater could become "truly revolutionary," as "the *secret signal* of what is to come that speaks from the gesture of the child" (206).

At first sight, this vision of acting appears different from Benjamin's notions of adult acting within a rule-governed artistic institution, be it the traditional stage, experimental and epic theater, or the cinema.[7] As discussed earlier, the artwork essay elaborates at length on the screen actor, who faces his or her audience ("the masses") in its absence, performing instead before an apparatus and a group of specialists. The discussion of the actor's performance before the camera foregrounds the connotation the word has in English, that is, performance as an achievement, or *Leistung,* that is being "tested" at both the level of production and that of reception; in other words, it becomes an object of controlled exhibition or, one might say, dis-play. Yet in the earlier versions of the essay, Benjamin still links the success of that performance to the actor's transformative ability to turn his confrontation of the apparatus into a victory, or revenge, on behalf of an audience dehumanized in its members' own daily battles with mechanized labor—"by asserting *his* humanity (or whatever appears to them as such)" and to do so "by placing that apparatus in the service of his triumph" (*SW* 3:111). Not only does this assumption link screen acting with the imaginative and apotropaic dimensions of children's play, but it also extends the concept of play to the behavior of the spectating collective in front of the screen.

The third meaning in the complex of *Spiel* is that of gambling, the game of chance or, to use Benjamin's preferred term, *Hasardspiel,* that is, a more properly ludic activity structured by rules and concerned with winning and losing. His reflections on the figure of the *Spieler,* or gambler, are familiar primarily from his essay "On Some Motifs in Baudelaire" (1939–40), in which they conform to that essay's generally pessimistic tenor regarding the decline of experience in capitalist-industrial modernity. As a symptom of that decline, the gambler exemplifies a mode of attention ever ready to parry mechanical shocks, similar to the reflex reaction required of the worker on the assembly line and, like the latter, no

longer relying on experience in the sense of accumulated wisdom, memory, and tradition.

Conceptually, however, Benjamin's interest in gambling also belongs to a series of earlier efforts, beginning with *One-Way Street* and continuing into *The Arcades Project*, to theorize alternative modes of apperception, assimilation, and agency that would be equal to the technologically changed and changing environment, as well as open to chance and a different future. In that sense, the gambler is less one of the constructivist new barbarians who do not rely on experience than one of the "types" pursuing "profane illumination," like the "reader, the thinker, the loiterer, the *flâneur*," along with the "opium eater, the dreamer, the ecstatic" (*SW* 2:216). In that company, the gambler becomes part of Benjamin's project to reconceptualize the conditions of possibility for experience in modernity.

In this project, the multiple meanings of *Spiel* are entwined with the concept of innervation discussed above, broadly referring to a nondestructive, mimetic mode of apperception and incorporation. In an unpublished fragment written in 1929 or 1930, "Notes on a Theory of Gambling" (*des Spiels*), Benjamin states that the decisive factor in gambling is "the level of motor innervation" (*SW* 2:297). The successful contact of the gambler's motor stimuli with "fate" requires, before all else, a "correct physical predisposition" (*SW* 2:298), a heightened receptivity that allows "the spark [to leap] within the body from one point to the next, imparting movement now to this organ, now to that one, concentrating the whole of existence and delimiting it. It is condensed to the time allowed to the right hand before the ball has fallen into the slot."[8] Benjamin insists on the neurophysiological character of such innervation, which is all the more decisive "the more emancipated it is from optical perception" (*SW* 2:297).

In other words, rather than relying on the master sense of vision, say, by means of "reading" the table, let alone an "'interpretation' of chance" (*AP* 513), gambling turns on a "*bodily* presence of mind," a faculty that Benjamin attributes to "the ancients."[9] In marginal cases of gambling, this presence of mind becomes "divination—that is to say, one of the highest, rarest moments in life" (*SW* 2:298). The ability to commune with cosmic forces, however, is mobilized in the register of play, of experimental simulation: "Gambling generates by way of experiment the lightning-quick process of stimulation at the moment of danger" (*SW* 2:298); it is, as it were, "a blasphemous test of our presence of mind."[10] The moment of accelerated danger, a topos in Benjamin's epistemology and theory of history, is defined in the realm of roulette by a specific temporality: "the tendency of gamblers to place their bets . . . at the very last moment" (*AP* 513). Accordingly, the danger is not so much one of *losing* than one of "*not winning*," of "missing [one's] chance" or arriving 'too late'" (*SW* 2:297, 298).[11]

With a view to Benjamin's concept of cinema, it is significant that he seems less interested in pursuing analogies with assembly line work or the stock market—as

he does in his later work on Baudelaire—than in linking the game of chance to the gambler's ability to seize the current of fate, related to ancient practices of divination that involve the human being in his or her material entirety. Whether or not we are persuaded by this linkage, it represents one of Benjamin's more daring (and, as history would have it, most desperate) efforts to trace an archaic, species-based faculty within a modern, industrial-capitalist context in which mimetic relations seem to have receded into "nonsensuous similarity."[12] The rare gift of proper gambling, pursued—and misused—by individuals in a hermetically isolated manner and for private gain, becomes a model of mimetic innervation for a collective that seems to have all but lost, literally, its senses, that lacks that bodily presence of mind that could yet "turn the threatening future into a fulfilled 'now'" (*SW* 1:483). At this point in history, with traditional political organizations on the left failing to mobilize the masses in their own interest (that is, against fascism and war), Benjamin wagers that the only chance for a collective, nondestructive, playful innervation of technology rests with the new mimetic technologies of film and photography, despite and because of their ongoing uses to the contrary—a wager in the spirit of Kracauer's 1927 declaration of the turn to the photographic media as the "*go-for-broke game* [*Vabanque-Spiel*] of history." By 1936, the political crisis had forced the literary intellectual himself into the role of a gambler, making his play, as it were, in the face of imminent catastrophe.

Benjamin's reflections on *Spiel* belong to a genealogy of which he was clearly aware. In one of his articles on children's toys, for instance, he makes a plea "to revive discussion of the theory of play," which had its last major contribution in Karl Groos's 1899 work *Die Spiele der Menschen* (*The Play of Man*).[13] For a recent contribution to such a revival, he cites the "*Gestalt* theory of play gestures" by Willy Haas, founding editor of the journal *Die literarische Welt*, in which Benjamin's own article was published. The far more significant touchstone for him, as we shall see, is Freud's 1920 essay *Beyond the Pleasure Principle*.[14]

Freud's essay discusses infantile play, famously the "*fort/da* game," in the context of traumatic neurosis as precipitated by mechanically caused, life-threatening accidents, an illness that considerably increased due to the barely concluded "terrible war"; accordingly, his more general speculations on the repetition compulsion and his assumption of a death drive are often read in light of that recent catastrophe and its legacy.[15] Two of the most widely known theories of play, in Johan Huizinga's *Homo Ludens* and in Caillois's *Man, Play, and Games*, were written in the shadow of the following war, shortly after the French publication of Benjamin's artwork essay.[16] Since the configuration of play, technology, and war has some bearing on our understanding of the latter, let me briefly sketch the relevant positions of the former.

For Huizinga, World War II merely consummates the decline of the "play-element" in contemporary civilization. "Until quite recently"—that is, in pre-

industrial, pre-mass society in which play was linked to the sacred—"war was conceived as a noble game—the sport of kings," an agonistic ritual in which fighting was bound by rules and international law. Without these limitations, warfare deteriorates into "barbaric," "criminal violence": "It remained for the theory of 'total war' to banish war's cultural function and extinguish the last vestige of the play-element."[17] In other words, the fascist war is cast as both symptom and executor of the decline of the ludic dimension in modern culture. Caillois goes along with Huizinga's narrative of decline to some extent, but draws a clearer line between earlier forms of ritualized agon and modern, unbounded war: "War is far removed from the tournament or duel, i.e. from regulated combat in an enclosure, and now finds fulfillment in massive destruction and the massacre of entire populations."[18] More than Huizinga, Caillois stresses a causal link between the decline of play—which he describes as a "corruption of games"—and the emergence of total and genocidal war.

Huizinga, following Schiller, defines play as a free activity and a source of freedom—a voluntary occupation executed "according to rules freely accepted but absolutely binding, having its aim in itself and accompanied by a feeling of tension, joy and the consciousness that it is 'different' from 'ordinary life,'" that is, diametrically opposed to work and necessity and historically associated with leisure and luxury.[19] He stresses the "disinterested character" of play, its lack of material purpose, which he considers necessary for play to fulfill its civilizing function. Not surprisingly, he accounts for play's tendency to create a perfect order and "to [be] order" in the language of idealist aesthetics—"terms with which we try to describe the effects of beauty: tension, poise, balance, contrast, variation, solution, resolution, etc."[20] Again, Caillois follows Huizinga up to a point, but takes him to task for viewing play "as action denuded of all material interest," which effectively excludes bets and games of chance.[21] He amends this omission by offering a detailed discussion of gambling and lotteries and their function in Western societies; he also situates gambling within a typology of games, in which chance, *alea,* figures in relation to—and partial combination with—forms of *agon* (competition, test), *mimicry* (simulation), and *ilinx* (vertigo).

Unlike Huizinga, Caillois admits economic and social factors into the discussion of play, yet ultimately he too blames them for the "corruption of games." The professionalization of sports, the pathological, obsessive character of gambling that deteriorates into speculation on the stock market, and the overall commercialization of leisure represent an intrusion into the closed universe of play—its "[contamination] by the real world."[22] Still, if Callois to some extent shares Huizinga's elitism and idealism, he resists the latter's techno-pessimism. In a passage echoing Benjamin, he observes that "industrial civilization has given birth to a special form of *ludus,* the hobby." He classifies the hobby with a number of other occupations that function primarily as "a compensation for the injury to personality caused by bondage to work of an automatic and picayune character." By

engaging machinery in playful ways (by building models, collecting, inventing gadgets, etc.), "the worker-turned-artisan . . . avenges himself upon reality, but in a positive and creative way." The hobby thus responds to "one of the highest functions of the play instinct." "It is not surprising," Caillois concludes, "that a technical civilization contributes to its development, even to providing compensations for its more brutal aspects."[23]

The imbrication of play with technology, along with the large-scale industrialization of leisure and entertainment (in the West) since the mid-nineteenth century, complicates any clear-cut opposition between play and work or, rather, (alienated) labor. As play became an object of mass production and consumption, as sports and other recreational forms grew into technologically mediated spectacles (not unlike war), the ideal of play as nonpurposive and nonproductive frequently came to serve, in Bill Brown's words, as an ideological cover for its "material correlative, commodified amusement." At the same time, this development produced "conflicting economies of play, conflicting circuits through which play attains new value"—in which the transgressive, transformative potential of play and the transformation of such excess into surplus value cannot always be easily distinguished.[24]

For Benjamin (and, for that matter, Kracauer), that very ambiguity presented a point of departure rather than an index of decline—a chance (to paraphrase Kracauer) to determine the place of the present in the historical process.[25] In the Urtext of the artwork essay, Benjamin transposes his reflections on *Spiel* from the children's room and gambling hall to the public arena of history. More precisely, the essay spells out the political and cultural constellation that motivated his interest in the category of play in the first place—a constellation defined, on the one hand, by the rise of fascism and the renewed threat of a technologically enhanced military catastrophe and, on the other, the false resurrections of the decaying aura in the sphere of art, the liberal-capitalist media, and the spectacularization of political life.

ROOM-FOR-PLAY, SECOND TECHNOLOGY, REPEATABILITY

The category of *Spiel* figures in the second version of the artwork essay as an aesthetic counterpoint to *Schein*, or semblance, in particular the concept of "beautiful semblance" (*schöner Schein*), which finds its fullest elaboration in Hegel. However, Benjamin argues, the German idealist version of "beautiful semblance" already had some "derivative qualities," having relinquished the "experiential basis" it had in classical antiquity—the aura. He proposes a genealogy of both terms, "semblance and play," by projecting them back, past Hegel, past Goethe and Schiller (and even past classical antiquity), onto ancient practices of mimesis, the "*Ur*-phenomenon of all artistic activity" (*SW* 3:137, 127; *GS* 7:368).[26]

In mimetic practice, semblance and play were two sides of the same process, still folded into one another: "The mime presents what he mimes merely as semblance [*Der Nachmachende macht, was er macht, nur scheinbar*]," which is to say he evokes the presence of something that is itself absent (a key aspect of later concepts of representation). But since the oldest forms of imitation, "dance and language, gestures of body and lips," "had only a single material to work with: the body of the mime himself," he does not merely evoke an absent other but also enacts, embodies what he mimes: "The mime presents his subject as a semblance [*Der Nachmachende macht seine Sache scheinbar*]. One could also say, he plays," simulates and performs, his subject matter (*die Sache*). "Thus we encounter the polarity informing mimesis." In mimesis, he sums up, "tightly interfolded like cotyledons, slumber the two aspects of art: semblance and play" (*SW* 3:127).[27]

In a related fragment, Benjamin observes that in traditional art and aesthetics, semblance and play continue to be entwined in varying proportions; he even postulates that the polarity of semblance and play is indispensable to *any* definition of art: "Art (the definition might run) is a suggested improvement on nature [*Verbesserungsvorschlag an die Natur*]: an imitation [*Nachmachen*] which is, in its hidden core, a demonstration [*Vormachen*], a model or instruction to the original. "In other words, art is a perfecting mimesis [*vollendende Mimesis*]" (*SW* 3:137; *GS* 7:667–68). Yet to the dialectician, Benjamin asserts, the polarity of semblance and play is of interest only if historicized. In his genealogy of Western art, this polarity has been tipped toward semblance, autonomized and segregated in the aesthetics of beautiful semblance that has dead-ended in aestheticism (phantasmagoria, false resurrections of the aura). By the same token, however, he discerns an increase of "elements of play in recent art: futurism, atonal music, *poésie pure*, detective novel, film" (*GS* 1:1048; Marcel Duchamp might be added to that list, see ibid., 1045–46).[28] Benjamin correlates these two developments through an economy of loss and gain: "What is lost in the withering of semblance, or decay of the aura, in works of art is matched by a huge gain in the scope for play [*Spiel-Raum*]. This room for play is widest in film. In film, the element of semblance has been entirely displaced by the element of play" (*SW* 3:127; *GS* 7:369).

Of course there is a rather basic, and perhaps trivial, association between film and play in the period's German term for cinema—*Lichtspiele*, or "games of light"—and one should not underestimate Benjamin's penchant for literalizing abstract compound nouns into their elements. But there is clearly more at stake in his decision to situate film on the side of play, rather than the cult of illusion. In view of major tendencies in actual film practice of the early 1930s, whether fascist, liberal-capitalist, socialist-realist (or, for that matter, poetic-realist), this move appears, at the very least, counterintuitive. However, the argument begins to make sense in the context of the artwork essay (which, at any rate, refers to

early cinema and other forms of nonclassical film practice) if we consider it as part of Benjamin's larger effort to theorize the relationship between art and technology.

In the essay's third, familiar version, technology primarily figures in its destructive, "liquidating" effect on traditional art, summed up in the erosion of the aura, and its concomitant potential for democratizing culture, based on a structural affinity between the new reproduction technologies and the masses. In the Urtext, however, the concept of technology is grounded more fully in the framework of Benjamin's "anthropological materialism" and a broader sense of aesthetics as pertaining to sensory perception. Within this framework, technology endows the collective with a new *physis* that demands to be understood and re/appropriated, literally incorporated, in the interest of both individual and collective; at the same time, technology provides the very medium in which such reappropriation can and must take place. Such a reflexive understanding of technology makes visible a different logic—a logic of play—in Benjamin's conception of the historic role of film.

This role is determined by what he calls "the world-historical conflict between the first and second technologies" (*SW* 3:127). As we have seen, the distinction between first and second technology turns on the degree of involvement of the human body, with the first culminating in human sacrifice and the second in remote-controlled aircraft. This distinction entails another, equally existential one. If the first technology is defined by the temporal modality of "once and for all" (*Ein für allemal*), "the irreparable lapse or sacrificial death," the second technology, with its origin in play, operates in the register of "once is as good as never" (*Einmal ist keinmal*) since it works "by means of experiments and endlessly varied test procedures" (*SW* 3:107; *GS* 7:359).[29] In Benjamin's historico-philosophical construction, then, semblance is "the most abstract [*das abgezogenste*]—but therefore the most durable—schema of all the magical procedures of the first technology," whereas play gives rise to "the inexhaustible reservoir of all the experimenting procedures of the second" (*SW* 3:127; *GS* 7:368). Thus, play is related to experimental repetition, in particular a concept of repetition that, as I argue below, significantly diverges from Freud.

Like the polarity of semblance and play, the relationship of art vis-à-vis first and second technology is historically variable. "Seriousness and play, rigor and license, are mingled in every work of art, though in very different proportions." The increase of the element of play in contemporary art is linked, in Benjamin's construction, to the degree that the chief goal of the first technology—to master nature—has given way to the second technology's objective of "interplay (*Zusammenspiel*) between nature and humanity"; or rather, one should say, the technologically feasible and politically imperative possibility of such interplay. "To rehearse that interplay," he contends, is "the primary function of art today," in particular

film (*SW* 3:107). And he caps this argument with the thesis quoted earlier: "*The function of film is to train human beings in the apperceptions and reactions needed to deal with a vast apparatus whose role in their lives is expanding almost daily*" (*SW* 3:108).

Taken by itself, we could easily read this statement as a behaviorist conception of adapting the human sensorium to the regime of the apparatus in the tradition of play theory, as a version of training theory, or *Einübungs-Theorie* (Groos).[30] And there is no reason not to, considering Benjamin's interest, thanks in part to Asja Lacis, in the Soviet avant-garde discourse of biomechanics and his tactically belated endorsement of Productivism and Operativism (Tretyakov).[31] But it would be a mistake to read the statement as simply an inversion of an idealist or aristocratic hierarchy of play and work (such as Huizinga's), to the effect, say, that film, as a "play-form" of technology, would be instrumental to the goal of increasing industrial productivity, albeit on behalf of socialist society. Notwithstanding Benjamin's advocacy of positioning art in the relations of production of its time, he was interested in *labor* primarily within the larger, anthropological-materialist frame of humanity's interaction with nature, negotiated in the medium of technology. If he understands (children's) play as "the canon of a labor no longer rooted in exploitation," this notion is less indebted to Lenin than to (early) Marx and Fourier. The Fourierist notion of "work inspirited by play," Benjamin asserts, does not aim at the "production of values" but at a more radical goal: "the amelioration of nature" (*AP* 361; *GS* 5:456). And lest we think here of gradual improvement, let alone progress, the idea of a "better nature" for Benjamin is linked with the Fourierist project of the "cracking open of natural teleology" and doing so by way of humor (*AP* 631, 635).

Throughout the second version of the artwork essay, Benjamin uses the term *Spielraum* in both figurative and literal senses; he himself suggests this double reading when he hyphenates the word *Spiel-Raum* (literally, "play-room" or "-space") in the note on semblance and play.[32] As a "dead metaphor," as Emerson would call it, *Spielraum* in common usage refers to scope or field of action, leeway, margin, room to move or maneuver. It names an intermediary zone not yet fully determined in which things oscillate among different meanings, functions, and possible directions. As such, it harbors an open-ended, dynamic temporality, an interval for chance, imagination, and agency. "Because [second] technology aims at liberating human beings from drudgery," Benjamin asserts, "the individual suddenly sees his scope for play, his field of action [*Spielraum*], immeasurably expanded." In this new space, "he does not yet know his way around" (*SW* 3:124). Film performs a twofold function in this regard: with cinematic techniques such as camera movement and close-ups exploring the common "milieux" of ordinary life, it not only "assures us of a vast and unsuspected field of action [*Spielraum*]" (*SW* 3:117) but simultaneously offers human beings a sensory-perceptual matrix to

comprehend and reconceive their environment in the mode of play. In this mode, mistakes are not—at least not immediately—fatal. What's more, just as the child learns to grasp by stretching out its hand for the moon as it would for a ball, even moments of motor-perceptual miscognition can yield transformative energies, can dart beyond what is given and imaginable.

We have seen how Benjamin, beginning with *One-Way Street*, sought to theorize the transformation and reconfiguration of space in modernity—from the dynamization of book space into three-dimensionality and the urban environment; to the kinetic interpenetration of optical and tactile registers in advertisement, architecture, and cinema; to the surrealists' project of intersecting image-space with body-space, that is, joining representational and imaginary percepts with physical and physiological realities. The "one hundred percent image space" that, in Benjamin's reading, the surrealists discover in the "space of political action" is at once actual and virtual, historical and utopian. In opposition to the cultural politics of the organized left—and the prevalence of "moral metaphor" in left-liberal politics—they had understood that the space of political action, qua collective space, was being crucially redefined by the expanding image-space (no less, one might add, a space of sounds, scripts, and things) that emerged with modern technologies of reproduction. At the same time, in their artistic and living experiments, the surrealists sought to project a radical transformation of that space in which image and action would coincide: "Where an action puts forth its own image and exists, devouring and consuming it, where nearness looks at itself with its own eyes, this long-sought image space opens up, the world of universal and integral actuality" (*SW* 2:217; *GS* 2:309).

If this evocation of a utopian image- or action-space assimilates the surrealists to a messianic temporality, the notion of *Spielraum* in the artwork essay belongs to the more secular concept of second technology, with its connotations of experiment, virtual action, and an indefatigable modification of tests. It is no coincidence that Benjamin associates the image/play-space opened up by cinema qua second technology with the genre of comedy, in particular Disney cartoons, American slapstick film, and of course Chaplin. As a descendant of the figure of the eccentric, Chaplin ranks as one of the first "provisional dwellers [*Trockenwohner*]" in the "new fields of action [*Spielräumen*] that emerged with film" (*SW* 3:118; *GS* 7:377–78). This observation frames Benjamin's reading of the Chaplin figure—in terms of his comedic performance of self-alienation and therapeutic mobilization and disaggregation of the compact mass through laughter—within his theory of play and playing, with its emphasis on mimetic transformation, innervation, and productive repetition.[33]

While clearly distinct terms, *comedy* and *play* are linked through their antonym—*Ernst*, in its double meaning of both seriousness and earnestness.[34] *Ernst* corresponds to the logic of once-and-for-all (the irreversible human sacri-

fice, the discus or shot that kills, tragedy, fascism). *Spiel,* on the other hand, works
on the logic of "*Einmal ist keinmal,*" drawing on the "inexhaustible reservoir of
all the experimental procedures" of second technology. One of the most obvious
instantiations of the ludic in film comedy (not limited to silent film; take the Marx
Brothers or Jacques Tati) is the device of the gag, the serially structured, at once
rule-bound and rule-inverting type of action that anarchically disrupts the narra-
tive causality and semblance it is propped onto and deceptively conforms to.[35] Not
only do gags play games with the order of things and meaning of words, but their
logic of open-ended seriality also defies the once-and-for-all of narrative closure.
Whereas in noncomedic genres the destruction of objects and people is meant to
be understood as irreversible, in principle at least, comedies tend to hyperbolize
the fictionality and performative nature of cinematic action and narrative fate.

Comedy and play have in common the principle of repetition. As many writers
have pointed out, comic modes—irony, parody, satire, sight gags—involve struc-
tures of citationality: they work through quotation and reiteration. Benjamin con-
siders it essential for a new theory of play "to explore the great law that presides
over the rules and rhythms of the entire world of play: the law of repetition." For
the child, "repetition is the soul of play"; nothing makes him happier than "'doing
the same thing over and over again.'" Benjamin invokes Freud—only to depart
from him in a crucial way. Comparing the child's compulsion to repeat with the
sexual drive in erotic passion, both "powerful" and "cunning," he agrees with
Freud's claim that there is indeed an "impulse 'beyond the pleasure principle.'"
But he proceeds to read that "beyond" rather more ambiguously through Goethe.
"In fact, every profound experience longs to be insatiable, longs for repetition
and return until the end of time, and for the restitution of an original condi-
tion from which it sprang." Repetition thus understood is more than an effort to
domesticate trauma; "it also means enjoying one's victories and triumphs over and
over again, with total intensity" (*SW* 2:120). Freud dismisses repetition in pursuit
of the pleasure principle as infantile (adults don't laugh at a joke the second time
around) and attributes the neurotic compulsion to repeat in the adult to the drive
inherent in the living organism to restore a prior state of equilibrium, in other
words, the death drive.[36] While Benjamin retains the linkage of repetition and
trauma—play as "the transformation of a shattering experience into habit"—he
reconfigures it in terms of a utopian notion of repetition as difference, one that
does not privilege traumatic experience as a primal event but makes it productive
of a future. Whether fueled by trauma or triumph, the emphasis is on the nexus of
play and habits, but habits understood as "petrified forms of our first happiness,
or our first dread, deformed to the point of being unrecognizable" (*SW* 2:120;
GS 3:131).

In Benjamin's philosophy of history, repetition belongs to those ambivalent, if
not antinomic, categories that he nursed so stubbornly, and it is inseparable from

his politics of happiness and historical redemption.[37] Broadly speaking, Benjamin's concept of repetition oscillates between two extremes: one, Nietzsche's eternal return congealed in the law of the commodity, with fashion as both disguise and perpetuation of the ever-same (Baudelaire); the other, dialectically embedded in the first, repetition as the striving for a past happiness that Proust pursued to the point of asphyxiation—a repetition that Deleuze has taught us to read as the *production* of that past in the very movement of repetition.[38] The second sense of repetition, turning on similitude and hence difference, also recalls Kierkegaard's notion of repetition as a memory in the direction of the future ("*Erinnerung in Richtung nach vorn*").[39] In Benjaminian terms, repetition in the mode of the "yet-once-again" (it might work this time) is linked to the messianic idea of repairing a history gone to pieces.

When we turn to cinema as a medium of repetition, we find both poles of the antinomy present, though not elaborated in the assumption of a transformation of quantity (sameness, seriality) into quality (similitude, difference). In a quite basic sense, Benjamin regarded film as the medium of repetition par excellence on account of its technological structure: mechanical reproduction as replication that lacks an original; infinite reiterability and improvability at the level of production (numerous takes) as well as the level of reception, that is, the seemingly unlimited distribution and exhibition of prints of the same film (an argument that, we would contend today, ignores the variability of both exhibition practices and demographically diverse, public events of reception). At the same time, and *because* of both its technological and collective status, he invested the cinema with the hope that it could yet heal the wounds inflicted on human bodies and senses by technologies predicated on the mastery of nature; the hope that film, as a sensory-reflexive medium of second technology, offers a second—though perhaps last—chance for reversing sensory alienation, the numbing of the human sensorium in defense against shock and the concomitant splitting of experience. To repeat the line from *One-Way Street*, "In the cinema, people who are no longer moved or touched by anything learn to cry again" (*SW* 1:476; *GS* 4:132). In the artwork essay, as we have seen, Benjamin resumes this motif in the figure of Mickey Mouse, making a case that film, in the form of play, could reanimate, prematurely detonate, and thus neutralize—on a mass basis—the psychopathological effects of the failed adaptation of technology.

ANTINOMIES OF PLAY

The rest is history: the term *Spiel* disappeared from the final version of the artwork essay, along with the concept of innervation and Mickey Mouse. Benjamin may have dropped the term not only at Adorno's insistence that the collective laughter at the cartoons was nothing but petit-bourgeois sadism; he also might have lost

the courage of his convictions in the face of an increasingly grim reality. Still, even if for understandable reasons he withdrew from imagining film as a play-form of second nature and cinema as a site for collective and homeopathic innervation, he was willing to wager the possibility of a technologically mediated aesthetics of play capable of diverting the destructive, catastrophic course of history.

The significance of Benjamin's wager is thrown into relief by the intensity and persistence with which Adorno responded to it.[40] Throughout his work, he again and again returned—explicitly or implicitly—to the artwork essay, that is, the original version (rather than the 1939 version he himself published in *Illuminationen*). In his posthumously published *Aesthetic Theory*, Adorno takes up Benjamin's argument on the historical differentiation of semblance and play, in particular the contention that the "withering" of semblance, or aura, is accompanied by an increase of play elements in contemporary avant-garde art and film. "The rebellion against semblance did not . . . take place in favor of play, as Benjamin supposed, though there is no mistaking the playful quality of the permutations, for instance, that have replaced fictional development. The crisis of semblance may engulf play as well, for the harmlessness of play deserves the same fate as does harmony, which originates in semblance. Art that seeks to redeem itself from semblance through play becomes sport."[41]

Adorno in no way denies the basic affinity of art and play, that "element of play without which there is no more possibility of art than of theory" (*AT* 39). Nor does he contest Benjamin's observation concerning the increase of the play element in modern art, whether in self-referential permutations or in the greater emphasis of art on its own agency, from Debussy to Beckett (*AT* 198). It is rather that Adorno turns the "powerful lesson," which, as Martin Jay rightly insists, he had learned from Benjamin's essay—"a lesson about the impossibility of reversing the decline of . . . 'aura'"—against Benjamin himself.[42] Insofar as art qua play abdicates its responsibility to engage with an antagonistic, heteronomous reality, it merely sidesteps the crisis of semblance that "engulfs" all Western art. In rejecting semblance in the same breath as instrumental rationality, it either regresses into harmlessness (*"fun"*) or degenerates into sport.

Within the framework of his aesthetic theory, Adorno assimilates Benjamin's concept of play to a tradition of experimental art and, more generally, to art that, qua play, "seeks to absolve itself of the guilt of its semblance" yet, by doing so, results in a "neutralization of praxis" (*AT* 39, 317). To be sure, semblance, for Adorno (and no less for Benjamin), does not reduce to referential illusionism; he considers most striking the extent to which the crisis of semblance, qua harmony, has affected music, the most nonrepresentational of arts. Still, semblance is the very condition of possibility for art to engage with reality at all. "The difference of artworks from the empirical world, their semblance character, is constituted out of the empirical world and in opposition to it" (*AT* 103).

Crucially, for Adorno, this dialectics of semblance turns on the mediation of the material through the internal organization of the autonomous work of art, its claim to totality, however conscious the work may be of the historical impossibility of that claim. Hence, he sees the weakness of an aesthetics of play not only in its alleged refusal to engage with reality but also in its regressive evasion of formal closure in favor of repetition.[43] In one of the paralipomena of *Aesthetic Theory*, largely a commentary on Huizinga's *Homo Ludens* (and to some extent on Schiller), Adorno spells out the psychoanalytic reservation against the notion of art as play. Looking back toward childhood, "if not animality," art conceived as play can only be regressive; it "inevitably stands in the service of restorative and archaizing social tendencies." The mark of ludic forms in art is repetition, inseparable from the (internal) compulsion to repeat, which Adorno reads unequivocally as the (internalized) "compulsion toward the ever-same" and which, more literally true to Freud than Benjamin, he associates with the death drive and surrender to reification (*AT* 317).

The earliest published reference to Benjamin's thesis on play and semblance appears in Adorno's essay "On the Fetish Character in Music and the Regression of Listening" (1938), his polemical response to the artwork essay. Although he rejects the idea that there might be " 'new possibilities' " in regressive listening, he still accepts (albeit in the subjunctive mood) Benjamin's basic claim that "one might be tempted to redeem [regressive listening] if it were something in which the 'auratic' character of the work of art, its elements of semblance [*Schein*], gave way to the playful ones." While he allows at least for the possibility that this might be the case in film, he hastens to add that nothing of the sort has happened in music: "Today's mass music shows little of such progress in disenchantment. Nothing survives in it more steadfastly than illusion, nothing is more illusory than its objectivity." Nonetheless, Adorno shares Benjamin's basic valorization of play (in the sense of *paidia*) by insisting that the "infantile play" of mass music "has scarcely more than the name in common with the productivity of children." What is more, he pits genuine play against the bourgeois business of sport, which, in its "bestial seriousness," surrenders the "dream of freedom"—that is, the dream of "getting away from purposiveness"—to the treatment of "play as a duty."[44]

Four years later, in the context of the "culture industry" chapter in *Dialectic of Enlightenment,* Adorno has entrenched himself in the position he was to take in *Aesthetic Theory,* that is, a critique of Benjamin's aesthetics of play as an evasion of the problematic of semblance—and, worse, as a degradation of art to a form of sport (a position not shared by Horkheimer).[45] In the unpublished continuation of the culture industry chapter, "The Schema of Mass Culture" (completed in October 1942), Adorno compares the mechanisms of mass culture to sporting events, from which it borrows certain features, in particular its emphasis on virtuosity of perfor-

mance (*Leistung*) and its ostensible abstention from meaning. "Thus sportification plays its part in the dissolution of semblance. Sport is the imageless counterpart to practical life, and aesthetic images increasingly partake of such imagelessness the more they turn into a form of sport themselves. One might well perceive in this the anticipation of a kind of play which, in classless society, would sublate semblance along with the principle of utility whose complement it is."[46]

Again, although Adorno does not mention Benjamin by name, he clearly responds to claims made in the artwork essay. After all, Benjamin himself links sports and film repeatedly, most memorably when he evokes the "newspaper boys leaning on their bicycles and discussing the outcome of a bicycle race" to illustrate the way in which film technology makes everyone in the audience a semi-expert (*SW* 3:114). Given Adorno's animus against sport under whatever political flag or economic system it might be propagated, Benjamin's admittedly somewhat uncharacteristic nod to sportivity was just one more of those "Brechtian motifs" that Adorno had recommended for "total elimination."[47]

Adorno here distorts Benjamin's larger argument about film as a "play-form" of technology in two ways. First, he reduces Benjamin's concept of play, resonating with the latter's theories on children's play, the mimetic faculty, gambling, and technology, to one aspect—that of performance under the conditions of a test, developed in relation to the figure of the screen actor. Then he implicitly takes up Benjamin's argument about the cinema as a site of actually *ongoing* collective innervation—and a highly contested innervation of collectivity—but transposes this argument into a utopian vision of the role of play in classless society, in which aesthetic semblance would be sublated along with the principle of utility to which it historically responded.

It is only in a utopian key that Adorno can imagine his friend's view of technology's actual reconfiguration and reconstitution of collectivity. Whereas Benjamin (and, for that matter, Kracauer) traced signs of change in the present and sought to extrapolate from them the possibility of a different future, Adorno dichotomizes that temporality into one of utopia and the present as hell. Thus, he dismisses any potential of alterity within the notion of play, first by reducing it to sport, and then by reducing both sport and mass culture to their ideological function in monopoly capitalism: "Sport is actually not play, but a ritual in which the subjected celebrate their subjection. They parody freedom in the voluntary character of the service which the individual forcibly exacts from its own body a second time."[48] Preserving the "joy of movement, the thought of bodily liberation, the suspension of practical ends" only in extremely distorted form, spectator sports erode the last traces of spontaneity and mimetic aspiration in favor of crude curiosity: "Mass culture is not interested in turning its consumers into athletes but only into screaming fans in the stands." By conflating life with a "system of open or covert sportive competition, it . . . even eliminates the tension between the Sunday devoted to sports

and the wretchedness of the working week that used to make up the better part of real sport." This, Adorno concludes, is how mass culture enacts the "liquidation of aesthetic semblance."[49]

To be sure, Adorno's conception of semblance and play, especially with regard to experimental art and modern music, is more complex.[50] What is curious, however, is that he treats Benjamin's argument as if the polarity of semblance and play were a binary opposition of the kind that dominates the artwork essay's later version (aura versus masses, distance versus nearness, etc.)—which it precisely is *not*. When, in his famous epistolary response, Adorno takes Benjamin to task for claiming a dialectical dimension for play while denying it to semblance, he reads the two terms as conceptually independent of each other.[51] He thus ignores Benjamin's insistence on a dialectical relation between play and semblance—a tension in the polarity that persists, notwithstanding the historical crisis and polemical erasure of aura, in a Benjaminian aesthetics of film.

Adorno's critique of Benjamin's theses, skewed as it may be, reveals differences in their conceptions of both play and film. It urges us to take a closer look at how a theory of film as play might translate not only into general assumptions about the medium but also into particular kinds of film aesthetics, critical concepts, and analytic tools. This discussion leads into the question of what bearing Benjamin's ideas on play and second technology might have for contemporary media practice and, conversely, how new technologies and practices may furnish a test for these reflections.

Whether in avant-garde art or film, play for Benjamin remains linked to the mimetic faculty, key to his effort to theorize a nondestructive, imaginative innervation of the ever more rapidly changing, technological environment. As we saw earlier, he is careful to locate the origin of both play and semblance in mimesis, the "*Ur*-phenomenon of all artistic activity," emphasizing their interdependence as much as their polarity (*SW* 3:127; *GS* 7:368). This genealogy significantly departs from accounts that place the concept of play, in both its idealist and modernist versions, in an antithetical relation to mimesis, more narrowly understood as illusionist imitation or representational realism.[52] Conversely, the inflection of Benjamin's concept of the mimetic capacity with the category of play is further evidence of his effort to subvert representational concepts of mimesis at a time when these concepts flourished—in reductive and literalist form—in fascist aesthetics and, for that matter, socialist realism. Thus, if we assume that Benjamin considered film, like other modern media (including radio and "the electronic television of our own day" [SW 2:108]), as evidence of the "transformation" rather than "the decay of the [mimetic] faculty" (*SW* 2:721), this argument cannot simply rest on the (audio)visual media's ability to record and represent reality—at least not in the sense in which this ability came to subtend ideological truth claims in mainstream cinema and media practices.

The question of how film engages with the empirical world within the paradigm of play leads us back to the optical unconscious, in particular the famous passage hailing film for "exploding," with the "dynamite of the split second," the prison-world of the urban-industrial environment and allowing us "journeys of adventure among its far-flung debris." If the "prismatic" work of film is to destroy the semblance (in the sense of illusory appearance) of naturalness and immutable continuity of the capitalist everyday, it matters that the photographic medium capture and make recognizable the familiar surface of that environment; the idea is not only to defamiliarize and rupture its apparent coherence and continuity (along with classical stylistic conventions designed to maintain that appearance) but also to allow for mimetic explorations and imaginative reconfigurations of city life. In other words, Benjamin advocates an avant-gardist film aesthetics that is less constructivist than citational, iconoclastic, and transformative, closer to Vertov and Vigo than, say, Richter, Eggeling, or even Léger and Murphy; it also recalls Kracauer's vision of film suspending "every habitual relationship among the elements of nature" and "playing with the pieces" of photographic debris, thus making palpable the experience of historical contingency and the possibility of radical change. While this type of film practice clearly involves formal construction, it does not operate on the model of negation—that is, the aesthetic semblance, however problematic, achieved by the closed work of art—that Adorno attributes to, and mandates for, autonomous modern art. Rather, it suggests an open-ended dynamics of exploration and transformation that enlists the viewer in its game, seeking to turn acceptance of things as they are into mobility and agency.

The imaginary city film evoked in Benjamin's passage would probably have involved stylistic devices common in 1920s avant-garde filmmaking, from French Impressionism to Soviet experimental cinema, in particular montage (that is, discontinuous and rhythmic editing), nonconventional and expressive framing, and camera movement. While he shares a modernist investment in montage as creating meanings that individual shots do not have on their own, and thus as being capable of presenting a world different from empirical reality, there remains the question of how he conceived of reference, the semiotic relationship between image and object, at the level of the individual shot. When the optical unconscious involves photochemically based film, indexicality obviously plays an important part, though what that part may be depends on the particular constellation. Thus, in the above example, it matters that the iconic resemblance between film and urban environment be underpinned by the physical connection of the photographic process, because that same process—not just montage but the discontinuous temporality of exposure (fractions of seconds), its unconscious element—makes it possible to explode that world, as it were, to destroy it in effigy, and to make its scattered fragments available for transformative play.

By contrast, in the other instances of the optical unconscious, discussed in chapter 5, specifically concerning photographs (the Dauthenday portrait and Blossfeldt's magnifications of plants), the magic of modern technology turns on an indexical relationship that underpins a "nonsensuous," not immediately intelligible or nonintelligible similarity. As in the semiotic example of the bowlegged sailor—and we might add the grooves of a phonograph record—the meaning of this kind of indexical bond hinges on an interpretant or reader, requiring experience and decipherment.[53] However, when Benjamin meditates on the "tiny spark of contingency" captured in the mechanical mediation of the long-past moment, he takes this requirement a Freudian step further. His interest is not in a hermeneutic understanding of a given trace, let alone in authenticating the correspondence between the image and the person portrayed. Rather, if the encrypted moment speaks to the future beholder, it is through the latter's unconscious (or not so unconscious) projection.

From the Dauthendey portrait to Mickey Mouse, Benjamin's notion of the optical unconscious is not concerned with an ontological, initially invisible or hidden relationship between image and referent, but with particular dynamics of representation and reception. If, as he claims, the success of the Mickey Mouse films is due to "the fact that the audience recognizes its own life in them," this has as much to do with the graphic evocation of recognizable elements of modern experience as with the films' playful—comedic, metamorphic, rhythmic—animation and mobilization of these elements.[54] With the biomechanical model, Benjamin stressed the neurophysiological effects of kinesthesia, the mimetic transfer that would mobilize the audience, whether energizing them with utopian dreams of transformation or preemptively detonating the psychopathologies of capitalist-industrial modernity through collective laughter, thus reconverting split-off psychic energies into nondestructive affect. The idea of cinema as a "play-form of second nature" crucially entailed the interplay both between film and audience—activating and depending on their experience and memory, their mimetic, cognitive, and self-regulatory capabilities—and *among* viewers as members of a heterogeneous, volatile social collective in the public space of the theater.

The vision of Mickey Mouse as a cheerful barbarian countering the violence unleashed by capitalist-imperialist regimes of technology with apotropaic games of innervation fell prey to the all-too-realistic fear that the therapy, for now, had failed, that the collective laughter of the mass audience might indeed turn out, as Adorno had warned, to be a prelude to genocide. But, as a creature of animation and figure of cinematic play, Mickey Mouse also points to a future beyond Benjamin's time. Here we return to the question of Benjamin's "actuality," in particular the dismissive argument that his prognostications on film, art, and politics have been proven wrong, at the latest with the rise of digital technology and the global

consolidation of capitalism. I hope to have complicated that argument—along with the assumption that his positions on these matters can be easily pinpointed—by situating them within a larger field of his theories of aesthetics, experience, and technology, and his efforts to think beyond both the historic catastrophe and the regimes of anthropocentric, national Western culture.

In this wider context, Benjamin's un/timely speculations seem in a number of ways more pertinent to new and emergent media than they were to cinema at a time when film and other "old" media were still considered new. It is not unlikely that he would have welcomed digital technology for its potential to open up for human beings a further, globally enlarged *Spielraum,* a virtual space that dramatically advances and reconfigures the interpenetration of body- and image-space, of perceptual embodiment, disembodiment, and reembodiment; and that offers hitherto unimaginable modes of playful innervation. Such an argument, which has been made in some form or other, could claim that the notion of technological reproducibility, framed within his theories of play and second technology—and thus associated with infinite repeatability, experimental modifiability, and improvability (art as perfecting mimesis, a model to nature)—would be better served by algorithmic procedures than by the practice of striking a large number of prints from a degenerative negative. In a similar vein, following Lev Manovich's installation of Vertov as a precursor of digital moving-image culture, we could consider Benjamin's imaginary city film in terms of a database aesthetics of sampling, recombining, and repurposing.[55] Moreover, if the masses' desire to have things closer, as it were, ready-to-hand, is epitomized today by the practice of watching a film on a mobile phone, the phenomenology of cinematic spectatorship—watching a film projected on a big screen in the darkened theater space, being absorbed into something larger than yourself—increasingly bears affinity with auratic experience (in the wider sense discussed in chapter 4). And Benjamin's claims to the effect that the technological media blur traditional dividing lines between authors and readers, as between actors and viewers, thus enabling a democratization of culture, would be more than borne out by digital media that make us users and agents in simulated situations rather than spectators of prerecorded representations.

The ascendancy of an aesthetics of play over one of semblance that Benjamin discerned in film and contemporary avant-garde art is of course nowhere more evident than in the meteoric rise of video games—a medium that in its four decades of commercial existence has evolved into a *dispositif* of diverse forms, styles, and genres and that, as an industry, has been outperforming the motion picture business (in the United States since 2005 and globally since 2008), including DVD and Blu-ray sales. Within the field of video game studies, the term *ludology* (already used for nonelectronic games) was introduced to counter and complicate approaches that view games as an extension of narrative and its cin-

ematic and representational legacy. Scholars expanding on this position discuss concepts of play and game in the theoretical lineage of Huizinga and Caillois, supplemented by Derrida, though not Benjamin.[56]

Without elaborating this line of argument further, I would caution against a reductive, applicationist version. We can no less assimilate Benjamin's prescient speculations to a naive digital utopianism (such as flourished during the 1990s) than to an understanding of cinema as intrinsically progressive. He would more likely have shared the concerns of critical media theorists regarding global systems of surveillance, information, and control; the vastly increased imbrication of play, labor, and consumption; and an unproblematic valorization of social networks as an egalitarian, democratic, alternative public sphere.

Benjamin's speculations offer chances to think about the possibilities and effects of new media in less binary ways. Specifically, his reflections on the role of tech-nological media qua second technology to at once innervate and counter the anaesthetizing, destructive effects of new technologies might help complicate the tedious yet unresolved controversy surrounding types of video games that reward the virtual killing of other human beings and survival at any cost (a highly popular genre), rather than divorcing the issue from the (no less urgent) formal analysis of rules, rhetorics of user involvement and perspective, types of environmental design, genre conventions, and so forth.[57] Not least, his reflections resonate with a number of games, commercial or experimentally modified and designed, that put the player in morally and politically conflicting situations vis-à-vis violent action, especially games that test our affective, cognitive, and ethical capabilities by scrambling the boundaries between playing subject, avatar, and targets, as between human, nonhuman, and machine.[58] By the same token, however, new media forms such as gaming are bound to put Benjamin's theories to the test (for instance, an all-too-innocent view of second technology's achievements in distancing human beings from nature), and thereby illuminate at once seismic shifts in and conti-nuities with the age of cinema and mass modernity.

In the end, the actuality of Benjamin's thinking on film and other media may not hinge on the validity of particular concepts and prognostications but on his efforts to theorize the technological media's supplementary and recursive func-tion for the vital—economic, social, political, ecological—contest over the uses of technology on a global, cosmic scale. As we have seen, this entails two interrelated assumptions. One is that film, more effectively than the traditional arts, provides the most advanced medium of experience to engage in this contest or struggle, as a technological medium that has an at once metonymic and sensory-reflective relation to technology at large. The other assumption concerns the compounded temporality of film's historic task—its present and future-oriented role in advanc-ing the mimetic, nondestructive innervation of new technologies and, at the same time, its belated, therapeutic and apotropaic potential to diffuse the pathological

effects of an already failed, and continuing-to-fail, capitalist-imperialist adaptation of technology.

Benjamin's ability to imagine both vast possibilities and deadly risks in technological media practices—and to gamble on particular combinations and constellations—makes his thinking more productive than critical approaches that ultimately come down on either techno-utopian or media-pessimistic sides. His legacy for film and media theory today may consist, not least, in the ways in which the structure of his thinking, his habit of thinking antithetical positions through in their most extreme implications, highlights contradictions in media culture itself, now more than ever. If he shared Gramsci's call for a "pessimism of the intellect," he did not link it, like the latter, with an "optimism of the will," but rather with an experimental will to explore and keep in view conflicting, if not antinomic, perspectives.

Adorno

The Question of Film Aesthetics

Adorno's stance on mass culture, in particular technologically produced and circulated media such as film, has often enough been dismissed as mandarin, conservative, and myopic. From the new left to cultural studies, he came to figure as a bad object in theory canons that enthroned Benjamin as a bourgeois intellectual who could nonetheless envision progressive, utopian dimensions of such media. This dismissal was largely based on the theory of the "culture industry," as it was articulated in his and Horkheimer's *Dialectic of Enlightenment* (1947), written in American exile between 1941 and 1944.[1] There, to recall, the authors excoriated the culture industry as a system of secondary exploitation, domination, and integration by which advanced capitalism subordinates any cultural practice, low or high, to a single purpose: to reproduce the spectator/listener as consumer. If the culture industry voraciously commodified human experience and reduced all art to advertisement, any attempt to make a difference was doomed to be assimilated and to validate the system as a whole; no alternative practice of film (or any other technologically based mass medium) seemed conceivable.

The limitations of Adorno's critique of the culture industry—such as the problems inherited with Lukács's theory of reification and its Hegelian concept of totality, the tacit equation of American capitalist mass culture and its Nazi counterpart, particular assumptions about film—have been widely discussed, qualified, and historicized. I do not intend to reiterate these debates. Instead, I will focus on Adorno's contributions on the question of film aesthetics, reflections that pop up in the margins and fissures of the dichotomy of mass culture and modern art.[2] As Andreas Huyssen noted early on, Adorno was one of the few critics to insist that one couldn't speak of one without the other. He had learned Benjamin's lesson that, in Huyssen's words, "ever since their simultaneous emergence in the mid-19th century, modernism and mass culture have been engaged in a compulsive *pas-de-deux*."[3] But against Benjamin, Adorno also insisted on the continued importance of autonomous art, even if aura could be grasped only in its irreversible decay (or, for that matter, resisted in its false resurrections). As he famously wrote in his response to the artwork essay, "Both [the highest and the lowest] bear the stigmata of capitalism, both contain elements of change (but never, of course, the middle-

term between Schönberg and the American film); both are the torn halves of an integral freedom, to which however they do not add up."[4]

If it is impossible to speak of Adorno's reflections on film aesthetics independently of his analysis of the social, economic, and ideological functions of film within the culture industry, these reflections are also inseparable from his philosophy of modern art. The very question of film aesthetics—which for Adorno is not least the question of whether there could be an aesthetics of film at all—is articulated in terms of standards developed in and by the most advanced autonomous art, especially music. Indeed, one of the blind spots of the theory of the culture industry has been discerned in precisely that normative stance, all the more since Adorno's canon of modernism, ranging from Schönberg and cubism through Beckett, was not exactly broad. By the same token, however, he considered both the aporias and possibilities of film as an implicit challenge to modern art, in particular the relationship between aesthetic technique and industrial technology. In the dialectical constellation of mass culture and modernism, film primarily fell under the verdict against the culture industry; it also figured as a *pharmakon* vis-à-vis modernist aesthetics.

To be sure, film—like visual media in general—occupied a rather marginal position in Adorno's work. Unlike music, in which he was involved as a critic, performer, and composer, film remained for the most part a theoretical concern. Nonetheless, as more recent studies have elaborated, his engagement with film—either directly or indirectly, through reflections on other technologically based media—was more comprehensive and complex than commonly assumed. These efforts could be grouped according to three distinct phases. The first consists of early writings—mostly for the Viennese journal *Musikblätter des Anbruch,* in which he published from 1925 on and whose editorial board he joined in 1929—concerning popular culture in the form of "light music" and "kitsch," such as the European operetta, popular hits, and jazz, as well as "mechanical music," which included gramophone records, the radio, and "the musical problems of the cinema," both silent and sound.[5] Also part of this phase are occasional remarks in Adorno's reviews of Frankfurt opera productions of the early 1930s, in which film is cited as a positive contrast in a related genre.[6]

The second phase takes us via Oxford, where Adorno wrote "On Jazz" (1936) and "On the Fetish-Character of Music and the Regression of Listening" (1936, published in 1938), to his exile in the United States from 1938 to 1949. This phase comprises his most intense, at once theoretical, empirical, and political engagement with film and other technological and market-based media, especially radio.[7] At the same time as he was elaborating his critique of the culture industry—from *Dialectic of Enlightenment* to *Minima Moralia* (1944–47)—he was involved with Hollywood and the filmmaking community on a more pragmatic level. A case in point, brought to light, respectively, by Gertrud Koch and David Jenemann, is

the experimental film project first described in the anonymously published article "Research Project on Anti-Semitism" (1941), written by Adorno in collaboration with Horkheimer and other members of the Institute for Social Research.[8] Conceived in the larger context of the Studies in Prejudice project under the auspices of the American Jewish Congress, *Below the Surface* (working title "The Accident") was an experimental film designed to test discriminatory attitudes toward Jews. Although it never materialized beyond the script stage, Adorno pursued the project through several detailed treatment versions from 1943 to 1946, with input from Kracauer and Hans Richter. Pitched to several Hollywood producers, the project gained support from left-liberal screenwriter-director-producer Dore Schary, during that time (off and on) at the helm of MGM, who also contributed a treatment version.

The other, more widely known project that made Adorno consider film in both aesthetic and creative terms was *Composing for the Films,* written in collaboration with composer Hanns Eisler in 1944.[9] In the trajectory of Adorno's thinking, the book's critical analysis of Hollywood film music practices resumed arguments from his essay *In Search of Wagner* (1938; first published in 1952), such as the critique of amalgamation of materials and primacy of effect in the aesthetic program of the Gesamtkunstwerk. His idea of alternative music for film was shaped by the Second Viennese School, in particular Schönberg (whose *Begleitmusik zu einer Lichtspielszene,* op. 34, is discussed in the book) and Alban Berg, a composer intensely interested in film and film music who experimented with musical equivalents to cinematic techniques, most overtly in the music to accompany the film projection envisioned for his opera *Lulu.* Eisler on his part contributed both practical experience in composing for cinema—from Weimar films such as *Kuhle Wampe* (Slatan Dudow, 1932) to Hollywood films such as *Hangmen Also Die* (Fritz Lang, 1943)—as well as an aesthetics of montage indebted to Brecht and Eisenstein.[10] When *Composing for the Films* was first published in English translation in 1947, it appeared under Eisler's name alone (because Adorno did not wish to be drawn into the McCarthyist attacks against Eisler's brother Gerhart and Eisler himself). Eisler published a streamlined (East) German version in 1949, but the most comprehensive and detailed version of the text, with a new preface by Adorno and bearing the unmistakable marks of his stylistic idiosyncrasies over long stretches, appeared only in 1969, shortly before his death, when he finally claimed co-authorship.[11]

The decision to (re)publish *Komposition für den Film* culminates the third phase of Adorno's engagement with film and technological mass media, which I take to begin with his return to Germany after World War II. This phase comprises writings that reiterate and adapt the critique of the culture industry, such as his essays on television (based on research in the United States in 1952–53) and "Culture Industry Reconsidered" (1963), which extends that critique to the administrative

culture of the Federal Republic. But it also includes efforts to understand film in the context of modern art and modernist aesthetics, of which we find Adorno's fullest account in *Aesthetic Theory* (1970). His most extensive statement on the question of film aesthetics remains the essay "Transparencies on Film" (1966). As I've elaborated elsewhere, "Transparencies on Film" was written in solidarity with Young German Cinema, emerging in the wake of the Oberhausen manifesto (1962). The essay is also testimony to Adorno's friendship with the spokesman of that group, writer-filmmaker Alexander Kluge, with whom Adorno was hoping to resume his work on film music, with a particular view to international new wave cinema.[12] No less important, though, are scattered remarks on film in other texts, including *Aesthetic Theory* and his writings on music.

Revolving around "Transparencies on Film," this chapter begins by addressing the problem Adorno considered key to the question of an aesthetics of film—the relationship between technology and technique—a problem that, in new configurations, is still haunting today's debates on cinema in the age of digital moving-image culture. In Adorno's view, film's dependency on industrial technology, as a means of mechanical reproduction and circulation, has dominated and impeded the development of artistic technique, understood as the internal organization of the aesthetic material. A central aspect of this problem (though not the only one) is film's photographically based claim to immediacy and verisimilitude, its inherent pull toward iconic representation, which circumscribes the possibilities of absolute construction (even in abstract film). In what follows, I discuss the strategies he imagined to counteract this representational pull, in particular the idea of film as a form of "writing," which would negate the ostensible self-identity of the image flow and provide film with the essential aesthetic polarity of the mimetic and the constructive. The notion of film as writing takes us back, via an excursus on his theory of mass culture as hieroglyphic writing, to his critique of film in the context of the culture industry. The chapter concludes by tracing alternative impulses in Adorno's thinking on film, especially through concepts of natural beauty, temporality, and movement, mediated in part by his writings on music. These are impulses in which the moving image is not so much negated as seen to be yielding less absolute practices and a more productive understanding of film as aesthetic experience.

TECHNIQUE, TECHNOLOGY

Adorno's thinking about the intersection of artistic technique and industrial technology is not limited to film. If this intersection poses a particular problem in film, as a primarily dependent art, it is no less relevant to autonomous art, in particular modern art beginning in the first half of the nineteenth century. In *Aesthetic Theory*, he addresses the relationship between inner-aesthetic technique and

extra-aesthetic technology as historically and dialectically mediated, considering it at once a site of the artwork's power of negation and a source of complicity that neutralizes that power. These reflections provide the horizon on which Adorno could have thought—and occasionally did think—that film had a privileged role to play in discussions on modern art.

The German terms *Technik* and *Technologie*, at least as they were used during the time Adorno was writing, do not correspond exactly to the English terms of *technique* and *technology*—if we take the former to refer to artistic mastery of the formal aspects of a work, or any artisanal method and skill, and the latter to denote an ensemble of mechanical and industrial tools and procedures. In both languages *technology* retains its distinction as the "branch of knowledge" that comprises individual techniques.[13] But the German word *Technik* far exceeds the term *technique*; it refers to both artistic and extra-artistic, industrial and preindustrial practices. Thus, throughout *Dialectic of Enlightenment* the term *Technik* denotes the principles and means of controlling and mastering nature, be they industrial-capitalist, artisanal, or archaic-magical; this includes, in the chapter on the culture industry (and its unpublished sequel, "Schema of Mass Culture"), the mechanically based techniques of popular genres and the fetishized virtuosity that assures the cultural commodity's mass circulation. Yet, in *Aesthetic Theory* and Adorno's writings on music, the term *Technik* primarily names artistic technique, "mastery over material," or "innervation" of and reflection on the "*métier*," that is, the formal procedures and conventions the artist both works with and rebels against, in dialectical tension with the work's expressive-mimetic *Gehalt* (which is not quite the same as "content").[14] In those works, when *Technik* is used to indicate industrial technology, the term is either modified by the adjective *extra-artistic* or defined by the context; conversely, the term *Technologie* is occasionally coupled with the adjective *artistic* (*künstlerisch*) or *aesthetic*.[15]

In *Aesthetic Theory*, the fluidity of meanings associated with the term *Technik* is programmatic. "The antagonism in the concept of technique as something determined inner-aesthetically and as something developed externally to artworks, should not be conceived as absolute" (*AT* 33). Adorno insists on the conceptual unity of technique and technology because the development of inner-aesthetic technique, qua productive force, is bound up with the progress of the extra-aesthetic technological forces; the dynamics of that relationship, however, are historically variable. The antagonism *within* the concept of *Technik* "originated historically and can pass. In electronics it is already possible to produce artistically by manipulating means that originated extra-aesthetically" (ibid.).

Adorno's assertion of the historical mutability of the concept, especially in relation to contemporary electronic music, responds to the familiar point about the common origin of both senses of *Technik* in (Greek) antiquity, which counted artistic among other artisanal techniques.[16] The differentiation of artistic technique

from the more practical crafts, Adorno speculates, can be discerned as early as the cave drawing, which marks an "objectivation . . . vis-à-vis what is immediately seen," thus containing "the potential of the technical procedure that effects the separation of what is seen from the subjective act of seeing." Here, the question of aesthetic technique is linked to the issue of *reproduction*, the realization of a work to be perceived by a plural subject. "Each work, insofar as it is intended for many, is already its own reproduction" (*AT* 33). This argument is part of a running objection to Benjamin's pinpointing of technological reproducibility as the historic watershed between auratic and mechanically based art. Adorno's point is more typically unfolded with regard to musical reproduction, the realization of a work in performance: "It is obvious that [Benjamin's] theory cannot be directly applied to music because there is no conceivable music, except perhaps improvisations and they do not count [*sic*], which is not based upon the idea of reproducibility."[17]

In Adorno's theorization of the relation between artistic technique and industrial technology, another genealogy seems similarly important. In a section in *Aesthetic Theory* headed "'*Technik*'" (in quotation marks, referring to the journalistic slogan "art in the age of technology"), he reflects on the affinity of artistic procedures with "the artisanal praxis of the medieval production of goods, a praxis from which art, resisting integration into capitalism, never completely diverged." This anachronistic affinity of artistic technique with craft ordains both modern art's difference from and its dialectical relationship with technology. "In art the threshold between craft and technique is not, as in material production, a strict quantification of procedures, which is incompatible with art's qualitative telos; nor is it the introduction of machines; rather, it is the predominance of conscious free control [*Verfügung*] over the aesthetic means, in contrast to traditionalism, under the cover of which this control matured" (*AT* 213; *ÄT* 316).

The differentiation of art from artisanal practices in the course of capitalist division of labor gives rise to artistic technique in the sense of "conscious free control over the aesthetic means," that is, a mastery over the aesthetic material that excludes exhausted and obsolete procedures. At the same time, art's continued individual mode of production, its alienated artisanal sediment, puts it in conflict with the prevailing conditions of production, determined by the more advanced industrial-capitalist deployment of technology.

Adorno observes that the *concept* of artistic technique emerges relatively late, in the wake of the French Revolution, and is associated with the insistence on the "primacy of making." He describes the "emphatic opposition to the illusion of the organic nature of art" as an element of modernism from Mallarmé and Valéry through cubism and constructivism in whatever medium or genre (*AT* 60, 34). "Technification" (*Technifizierung*) establishes "free control over the material as a principle" (*AT* 59; *ÄT* 94). The modernist foregrounding of artistic technique,

however, raises the stakes of aesthetic autonomy. On the one hand, the artwork's immanent formal logic—its Kantian "purposiveness without purpose"—remains the condition of its autonomy, and thus its antithetical relation to empirical existence.[18] On the other, modeled on technological mastery of nature in material production as defined by instrumental rationality, modern artworks "come into contradiction with their purposelessness" (*AT* 217). To the extent that modern artworks aspire to the functional forms of nonartistic technology, the Kantian paradox is exacerbated to the point of an antinomy; that is, the artworks' adaptation of industrial standards of rationality eliminates their difference from empirical existence, from the world of commodities. This antinomy lies at the basis of Adorno's polemics against applied art (*Kunstgewerbe*) as well as the functionalist aesthetics of Neue Sachlichkeit.

Like Benjamin and Kracauer, Adorno insists that modern art must "prove itself equal to high industrialism." The modern, though, is not a chronological concept, but "the Rimbaudean postulate of an art of the most advanced consciousness, an art in which the most advanced and differentiated technical procedures are saturated with the most advanced and differentiated experiences" (*AT* 33; *ÄT* 57). This postulate is realized neither at the level of subject matter, least of all through realist representation of the industrialized world, nor through the "pseudomorphism" of machine art in the form of aesthetic functionalism, or by mimicking the rhythms of industrial technology.[19] Rather, it is a matter of art's engagement with irrevocably changed modes of experience (*Erfahrung*) that are marked as much by the social relations of production as by the advance of the productive forces. The issue, as he puts it, "is not so much the adequacy of art to technological development as the transformation of constitutive modes of experience that are sedimented in artworks. The question is that of the aesthetic world of images [*Bilderwelt*]: preindustrial imagery irretrievably had to go" (*AT* 218; *ÄT* 324).[20] This injunction concerns especially the experience of nature, in particular the impossibility of artistic celebrations of untouched nature as an idyllic preserve that lay claim to a lost immediacy; hence, for Adorno, the anachronism of nature poetry.[21]

The question of *how* modern art negotiates the historical dialectic of artistic technique and (industrial-urban-military) technology is thus mediated by two terms: *experience* and *world of images*. These terms involve a dimension of subjectivity that differs from the subject's assertion of control in both inner- and extra-aesthetic spheres. The subject of experience is one of suffering and loss in the double sense we encountered in Benjamin: referring at once to the ravages wrought by industrial capitalism on the conditions of human living and to the threatening loss of the very ability to perceive and comprehend those changes, that is, at once to a specific historical experience and to experience as a constitutive medium irrevocably in decline. In Adorno's words, "Art is modern when,

by its mode of experience and as the expression of the crisis of experience, it absorbs what industrialization has called forth under the given relations of production" (*AT* 34; *ÄT* 57). Here aesthetic technique is accorded something like the homoeopathic function in relation to technology that we observed in Benjamin's conceptualization of film in terms of second technology and play. As Adorno put it elsewhere, "Technological progress in art is motivated not least by the dialectic of technique repairing the damages wrought by technology [*durch Technik gutzu-machen, was Technik frevelte*]."[22]

Like the category of experience, the correlating notion of a "world of images" has a collective substratum and a material grounding in unconscious and preconscious states, in dreams and daydreams. Adorno defines the status of such images, whether pre-aesthetic *imagines* or aesthetic *imagerie,* in opposition to Klages and Jung and their conception of collective unconscious images as an invariant, archaic reality (*AT* 85). Rather, he argues that images have their reality in the historical processes sedimented in them, refracted at the experiential level. In this modality they constitute the material of art. "Art is mimesis toward [*an*] the world of images and at the same time its enlightenment through forms of control" (*AT* 218; *ÄT* 324). Mimesis in this context names an archaic and pre-individual affinity with the other, disparate and nonidentical receptiveness toward the unconscious, indeterminate, and evanescent.[23]

It is important to understand that Adorno's concept of mimesis, while anthropologically grounded, is not an ahistorical category; indeed, its very historicity is the condition for art's ability to respond to the industrially transformed world. Invoking Marx's preface to *A Contribution to the Critique of Political Economy,* Adorno asserts that the differentiation of subjectivity essential to modern art is part of the development of the productive forces, in both aesthetic and nonaesthetic realms. Irreducible to advanced consciousness in art is the element of spontaneity; in it, the "spirit of the age" assumes a particularity that goes beyond the mere reproduction of the status quo. But aesthetic spontaneity, the mimetic impulse that poses a "determinate resistance to reality by way of adaptation to it," is just as historically produced as the aesthetic procedures and extra-aesthetic reality it opposes. If, according to Marx, "each epoch solves the tasks that are posed to it," it also yields "talents" that, "as if by second nature, respond to the level of technology [*Technik*] and by a sort of *secondary mimesis* drive it further. Thus, the categories that are held to be extratemporal, natural endowments are temporally mediated: *the cinematographic gaze becomes an innate faculty*" (*AT* 193; *ÄT* 287; emphasis added). Like Benjamin and Kracauer, Adorno observes a transformation of sensory perception and subjectivity in modernity. But where the former stress the collective nature of this transformation, Adorno insists on the mediation of collective experience by the idiosyncratic individual in whose art pre-individual mimetic impulses take refuge.[24]

Adorno's theorization of the relationship between artistic technique and industrial technology is challenged—if not prompted in the first place—by the unprecedented proliferation of industrial-technological procedures within the very domain of art and culture. Mass reproduction, Adorno argues against Benjamin, has not given rise to a new immanent formal law; its technologies remain external to its artistic organization, the inner logic of the work. "[In] film, industrial and aesthetic-craftsmanlike elements diverge under socioeconomic pressure" (*AT* 217). In "Culture Industry Reconsidered" (1963), he even denies the status of artistic technique to those "craftsmanlike" elements: "The technology [*Technik*] of the culture industry is, from the beginning, one of distribution and mechanical reproduction, and therefore always remains external to its object."[25] The primacy of (industrial) technology prevents, or at the very least seriously restricts, the development of technique in the aesthetic sense, understood as "conscious free control over the aesthetic means."

Adorno's complaint about film pivots on the assumption that reproduction technology forecloses the autonomous development of cinematic technique, rather than, as he observed with regard to electronic music, artistic technique being liberated by technological possibilities. The question here—and it is part of the problem critics have had with his argument on film—is whether he attributes this aporia to the dominant practice of film within the culture industry or whether he locates it in the mechanical grounding of the cinematic medium as such. In other words, is he making an argument about forms of practice under particular institutional and economic conditions, or one about medium specificity? The stakes are considerable: they are about how we understand the terms of Adorno's thinking about film, and whether it is even possible to derive an aesthetics of film from his writings in the first place. The threat is that the technological predetermination of cinematic technique would be an a priori circumscription of the aesthetic possibilities of what he calls the "emancipated film." To get around that worry, we need to look for moments in which alternative forms of practice become imaginable.

Even within the critique of the culture industry, Adorno grants a degree of alterity to film's technologically based procedures when he remarks that the culture industry preserves its ideological stability precisely by "carefully shield[ing] itself from the full potential of the techniques contained in its products."[26] (The obvious example would be the containment of montage in favor of continuity editing.) The proposition that reproduction technologies harbor a radical potential denied by industrial practices is linked to the acknowledgment that technology sets a standard that cannot be reversed or ignored. Such thinking, not unfamiliar to avant-garde critical discourse on cinema from the interwar years, is more clearly articulated in Adorno's writings on music, in particular his reflections on the radio and gramophone. In the 1938 text "Music in Radio," he echoes Kracauer's essay on

the mass ornament, asserting "that there is in principle no way out of mechanical reproduction and that any progressive tendencies can only be realized by going right through it [*durch sie hindurch*]."[27] In a similar vein, he and Eisler argue in *Composing for the Films* that "technology as such [should not] be held responsible for the barbarism of the cultural industry." As they put it, "Technology opens up unlimited opportunities for art in the future, and even in the poorest motion pictures there are moments when such opportunities are strikingly apparent." Still, they hasten to add, "the same principle that has opened up these opportunities also ties them to big business" (*CF* lii–liii).

Given that Adorno's thinking on the nexus of technology and technique is most developed with regard to music, it is no coincidence that his first major project on film is dedicated to film music. In *Composing for the Films*, the problem of a technologically based aesthetics is complicated by the relationship between film and music, which the authors consider fundamentally antithetical. At a basic level, this relationship combines a visual medium founded on mechanical (re)production with an acoustic medium that has a pre-industrial past; the sensuous elements resonating from that past compensate for the constitutive muteness, the lifelessness and ghostly character even of the talking film (*CF* 75–77). If, according to Adorno and Eisler, the synchronized recording of moving images and sounds as such is nothing but a technological invention comparable to that of the pneumatic break, music—in particular New Music in the Schönberg tradition—can provide a dialectical model that opens up aesthetic possibilities for film (*CF* 9–10, 64). Thus, they propose a practice of scoring on the model of contrapuntal relations between music and image track that effect dissonance and rupture, irony and defamiliarization—effects that sabotage the affirmative character of the narrativized image flow. In short, they advocate applying the principle of montage to the relationship between sound and image tracks.

When Adorno and Eisler discuss existing efforts to create aesthetics specific to film, they engage in an all-around attack on synesthesia, in particular the assumption of sensory, especially visual-acoustic equivalents. This critique is aimed above all at the use of music to generate mood or atmosphere (*Stimmung*) that neutralizes music and allegedly makes it unheard; combined with chiaroscuro lighting or picturesque tableaux, such practice is nothing but an attempt to resurrect the declining aura through technologically enhanced magic (*CF* 69, 72–73).[28] They even take on Eisenstein for drawing an unreflected analogy between cinematic and musical *movement*, which they consider problematic because the term has different and multiple meanings in the respective media. While they agree with Eisenstein on the significance of *rhythm* as common denominator for regulating movement in both (a concept to which we will return), they criticize his assumption of aesthetic equivalents between moving image and score as at once too formalist and too vague (*CF* 66–69).[29]

In a similar vein, Adorno and Eisler also reject abstract film that seeks to derive compositional laws from a presumed perceptual-psychological relation between the optical (color and nonrepresentational forms and movements) and the sonic qualities of the media "as such"; the result, they argue, is "ornamental applied-art" that mistakes itself for avant-garde. The main point of their critique is that such experiments ignore the divergence of the aesthetic vectors of music and film, the antithetical qualities that mandate combining them not according to some presumed ontological correspondence but on the constructivist model of montage—a model already advocated in Eisenstein, Pudovkin, and Alexandrov's 1928 manifesto on sound.[30]

Adorno and Eisler's reservations about abstract film might seem to contrast with Adorno's valorization of abstraction in other media. For instance, in *Aesthetic Theory* abstraction figures as the mimetic response to the abstractness of the "administered" world—"new art is as abstract as social relations have in truth become" (*AT* 31)—and as the radical challenge of "the new" to the social compromise afforded by representational art. But the reservation vis-à-vis abstract film derives rather from Adorno's critique of Benjamin's elevation of play over an aesthetics of semblance—the claim that "no picture, not even an abstract painting is completely emancipated from the world of objects." Because of the eye's perceptual relation to the object world, "even the purely geometric figures of abstract painting appear like broken-off fragments of the visible reality" (*CF* 70–71). Abstract film's experimental play with purely geometric figures thus merely sidesteps the crisis of semblance that modern art must confront; in Adorno's view, it risks regressing into harmlessness. Most important, though, the verdict against abstract *film* seems motivated by a contradiction between, on the one hand, modernist norms that mandate nonrepresentationalism, anti-organicism, and absolute construction and, on the other, a significant aspect of what Adorno took to be the medium-specificity of film. Seeking to translate modernist norms into the medium of film, abstract film ends up disavowing the (photographic) character of its material and the immanent aesthetic principles that might be derived from it.

The other horn of this contradiction would seem to revolve around the issue of film's unprecedented ability to convey sensory immediacy that, in the context of the culture industry, has itself become a master ideology. Yet Adorno is explicit that there is a different kind of immediacy to which cinematic technology lends itself—a "radical naturalism" that would dissolve any surface coherence of meaning and thus present an antithesis to the pseudo-realism of the culture industry. As he writes in *Minima Moralia*, "If film were to give itself over to the blind representation of everyday life . . . as would indeed be feasible with the means of moving-image photography and sound-recording, the result would be a creation alien to the visual habits of the audience, diffuse, and outwardly unarticulated." This kind of film would blend with the "associative stream of images" and derive its form

from their "pure, immanent construction."[31] He resumes and modifies this argument in "Transparencies on Film."

TRANSPARENCIES

In "Transparencies"—which is less an essay than a series of discontinuous reflections—Adorno reconsiders the problem of the relationship between technology and technique primarily as one of film aesthetics, specifically with a view to the emerging independent cinema in West Germany and the other European countries. This entails a shift from a view of film as invariably trapped in the system of the culture industry to a more pragmatic stance willing to think about it as a genre of modern art. Rather than denying film the possibility of intrinsic artistic technique, as he still does in "Culture Industry Reconsidered," Adorno acknowledges that it is difficult to distinguish between filmic technique, pertaining to the internal organization of the work, and technology, the means of (re)production. Pondering this problem from various angles, he not only grants film an equal, if exceptional, status among the arts but also attributes to it a leading role in modern art's rebellion against its very status as art.

First off, because independent film practice, even if subsidized, can escape neither the pressures of the market (Hollywood and its West German counterparts) nor the aesthetic problematic of a mechanically mediated art, Adorno seems willing to modify the imperative that modern art must operate on the most advanced, differentiated level of technique. Defending the relative awkwardness and lack of professionalism of the work of Young German filmmakers (Volker Schlöndorff, Edgar Reitz, Kluge, et al.), he elevates these shortcomings to a trace of "hope that the so-called mass media might eventually become something different." "While in autonomous art anything lagging behind the already established technical standard does not rate, vis-à-vis the culture industry—whose standard excludes everything but the predigested and already integrated, just as the cosmetic trade eliminates facial wrinkles—works that have not completely mastered their technique, conveying as a result something *consolingly uncontrolled and accidental,* have a liberating quality. In them the flaws of a pretty girl's complexion become the corrective to the immaculate face of the professional star". (emphasis added).[32]

The fetishistic perfection of the products of the culture industry is of a stylistic kind, yielding "nuances so fine as to be almost as subtle as the devices used in a work of the avant-garde" (which, unlike the former, "serves truth") (*DE* 102). By contrast, the *lack* of a virtuoso mastery of means and thorough planning is taken to allow independent film to develop "other means of conveying immediacy." These prominently involve improvisation, or "the planned surrender to unguided chance" (TF 200).

Adorno's valorization of improvisation and chance in the constellation of independent film vis-à-vis the culture industry marks a clear departure from his writings on jazz, in particular his dismissal of improvisation as prescripted and clichéd. It also diverges from the more traditional aesthetic vocabulary of *Composing for the Films*—correspondence and counterpoint, question and answer, affirmation and negation, imitation and irony—and its closed notion of montage that leaves little room for indeterminacy and unpredictable effects. In Adorno's writings on music, the admission of chance as an aesthetic principle aligns with his efforts to come to terms with postserialism, in particular the aleatoric aesthetics of John Cage.[33] If the musical paradigm behind *Composing for the Films* is twelve-tone music in the tradition of Schönberg ("classical" serialism), one might say that "Transparencies on Film" benefited from Adorno's confrontation with the "aging of New Music" and the emergence of new modes of experimental music—including electronic, total (or integral) serial, as well as aserial—in the work of composers such as Pierre Boulez, Karlheinz Stockhausen, Cage, György Ligeti, and others.[34]

Unlike music that, at least up to the electronic period, allowed for a clear distinction between notation and reproduction (in the sense of performance), film has no original from which copies would then be reproduced on a mass scale: "The mass product is the thing itself" (TF 200). If Adorno agrees with this Benjaminian insight, he cautions against inferring from it an equation of cinematic technology and film technique, let alone aesthetic norms. A case in point is Chaplin, in particular the common complaint that he underutilizes cinematic technique, "being content with the photographic rendering of sketches, slapstick routines, or other performances." Nonetheless, Adorno argues, nowhere but in film "could this enigmatic figure—reminiscent of old-fashioned photographs right from the start—have developed its concept." This observation of a tension within Chaplin's films between heterogeneous, nonsynchronous media materials is elaborated in an earlier text in which he speaks of Chaplin as "a ghostly [or haunting] photograph in the live film [*eine geisternde Photographie im lebendigen Film*]."[35] Another example Adorno points to is Michelangelo Antonioni's *La Notte* (1961), a film whose static character "provocatively" negates the medium-specific focus on moving objects and simultaneously preserves it qua negation. "Whatever is anti-cinematic in this film gives it the power to express, as if with hollow eyes, the emptiness of time" (TF 201; FT 355).[36]

The flipside to these cinematic examples can be seen in specific techniques such as soft focus, superimpositions, and flashbacks that, Adorno argues, intend to counteract the medium's compulsory linear temporality, along with its photographically subtended claim to realism, but that are grounded in convention rather than the internal necessities of the work. The discrepancy between their sheer conventionality and the expressive values, albeit deteriorated ones, these clichéd devices nonetheless convey makes them appear as kitsch. "The lesson to

be learned from this phenomenon is dialectical: [aesthetic] technology in isolation, which disregards film's language character [*Sprachcharakter*], may end up in contradiction with its own internal logic" (TF 204; FT 359). While this is clearly an argument about film practice, Adorno's criticism is that the use of such devices is disconnected not only from the internal logic of individual films but also from a more medium-specific dimension that he calls film's language character (a term I discuss below).

The heart of the problem that Adorno confronts for a film aesthetics appears to be that the photographic basis of the moving image privileges the representational object over aesthetically autonomous procedures. (Considering his reservations against abstract film, to say nothing of his indictment of animation—Disney as opposed to Betty Boop—in the critique of the culture industry, his reflections on film aesthetics are clearly aimed at live-action film, obviously prior to the use of digital technology.) "Even where film dissolves and modifies its object as much as it can, the disintegration is never complete" (TF 202; FT 357). The implications of this limitation—or more precisely, contradiction—are twofold. Not only does film not permit absolute construction, but, because of this irreducibility of objects in film, "society juts into film quite differently," with greater immediacy, "than into advanced painting or literature." Hence, "there can be no aesthetics of film, not even a purely technical one, that would not include its sociology" (TF 202; FT 357). It is important to recognize that Adorno here is not concerned with the ideological effects of film's duplication and naturalization of the world, effects that he had denounced in the chapter on the culture industry. Rather, he considers the photographic irreducibility of objects as a question of *aesthetics,* relating it to modern art's assault on meaning and intentionality and its negation of its own status as art.

Adorno provides these reflections in a critique of Kracauer's *Theory of Film* (1960). While relying on Kracauer's assumption that film is concerned with the "intentionlessness of mere existence [*des bloßen Daseins*]" (AT 154; ÄT 232), he points out that, beginning with the selection of motifs, the ostensible renunciation of subjective meaning endows "the object with exactly that meaning [it is] trying to resist." Thus Kracauer's program "to celebrate film as the discoverer of the beauties of everyday life," like "those films which let wandering clouds and murky ponds speak for themselves," runs the risk of relapsing into art nouveau, that is, applied art, rather than giving expression to the historical experience of material reality (TF 202).

He elaborates this critique in his important essay "Kunst und die Künste" (Art and the Arts, 1966), written shortly before "Transparencies on Film." There, he situates Kracauer's project in the wider context of modern art's utopian rebellion against the very concept of art, against the separation of art and ordinary life. The "latest" among the arts, film instantiates this dynamic, one beyond the "helpless"

question as to whether or not film is art. Adorno invokes Benjamin's assertion that film is "closest to itself" where it radically eliminates "aura," "the semblance of transcendence" warranted by the internal organization of autonomous art (that explanatory clause being Adorno's adaptation of Benjamin's *aura*.) Thus film is capable, in ways undreamt of by painting and literature, of foregoing elements that infuse the material with subjective meaning and symbolic significance. "Siegfried Kracauer inferred from this [potential] that film, as a kind of redemption of the extra-aesthetic world of things, was aesthetically possible only if it renounced the principle of stylization, through the camera's intentionless immersion into the raw state of being before all subjectivity."[37]

Whether or not this is an adequate representation of *Theory of Film*, Adorno needs Kracauer's hyperbole to formulate a contradiction in modern art's negation of its status as art. For Adorno, the refusal of artistic intervention is itself just another aesthetic principle of stylization. Even in a film that seeks to abstain from auratic effects and subjective intention, the basic parameters of cinematic technique—script, mise-en-scène, framing, editing—inevitably infuse the material with meaning. The point here is not the obviousness of Adorno's argument (as if Kracauer hadn't been aware of the inevitably formative role of these techniques), but his insistence that film comes to instantiate a contradiction that runs through modern art. "While film, by its immanent logic, tries to rid itself of its artistic character—almost as if the latter violated its aesthetic principle—in this rebellion it is still art and expands the notion of art. Such a contradiction, which film is prevented from acting out in pure form because of its dependency on profit, is the vital element of all genuinely modern art."[38] How can film act out this contradiction, avoiding the pitfalls of what one might call the fallacy of intentionlessness of which Adorno accuses Kracauer?

"The obvious answer today, as forty years ago," he writes in "Transparencies on Film," is that of "montage, which does not interfere with things but arranges them in a constellation akin to writing [*Schrift*]" (TF 203). Yet if Adorno clearly valorizes montage, favoring discontinuous editing over Hollywood-style continuity editing, he raises doubts vis-à-vis montage on two grounds. For one, he calls into question the viability of a procedure based on the principle of shock, the attack on a presumed organic unity by means of juxtaposing discontinuous, if not heterogeneous, elements; once the surprise is inured, the tension between the elements is neutralized. For the other, the juxtaposition of discontinuous shots merely reproduces the problem of intentionlessness already present at the level of the filmic image. "It seems illusory to claim that through the renunciation of all meaning, especially the cinematically appropriate [*materialgerechten*] renunciation of psychology, meaning will emerge from the reproduced material itself." As with Kracauer's faith in film's rendering of an unstylized material reality, montage that refuses "to interpret, to add subjective ingredients, is in itself a subjective act

and as such a priori significant" (TF 203; FT 358). Such refusal could hardly be imputed to Soviet montage in the tradition of Kuleshov, Pudovkin, Eisenstein, and Vertov, which openly embraced the constructivist project of creating a new reality. Rather, Adorno seems to address this insight to young German filmmakers "ostracized for being too intellectual" (the filmmaker who comes to mind here is Kluge), with an injunction to absorb it into their working methods.

In *Aesthetic Theory*, Adorno offers a more detailed discussion of montage, not only in cinema but as an aesthetic principle in the other arts, beginning with the "heroic" period of cubism and, one might add, continuing through dada and surrealism. The larger context here is art's negation of meaning in the face of an increasingly meaningless world (exemplified for him by the work of Beckett and Cage). Montage effects this negation by disrupting the organic unity of artworks; it "disavows unity through the demonstrative disparateness of the parts at the same time that, as a principle of form, it reaffirms unity" (*AT* 154; *ÄT* 231–32). In this vein, montage has its "appropriate place" in film—in the "jolting, discontinuous juxtaposition of sequences, editing employed as an artistic means, [which] wants to serve intentions without damaging the intentionlessness of mere existence," supposedly film's main concern (*AT* 154; *ÄT* 232). Montage enables film to push beyond photography's limiting dependence on empirical reality: rather than integrating photography for pseudo-artistic effects, it can become "photography's self-correction" (ibid.).

In Adorno's aesthetic genealogy, montage emerged as an antithesis to all art charged with atmosphere (*Stimmung*), in particular impressionism. Impressionism sought to assimilate objects—"primarily drawn from the sphere of technological civilization or its amalgams with nature"—by dissolving them "into their smallest elements in order to synthesize them gaplessly into the dynamic continuum" (*AT* 154–55). In such subjectification of objective reality, the attempt to "aesthetically redeem the alienated and heterogeneous qua replica" in the end relapsed into romanticism. In protest, avant-garde artists inserted newspaper clippings and other fragments of quotidian objects (including photographs)—"literal, illusionless ruins of empirical reality"—into their works, thereby rupturing the semblance provided by art with which "through the [creative] fashioning of the heterogeneously empirical it was reconciled." Montage, Adorno argues, acknowledges the fissure and refunctions it for aesthetic effect. By doing so, art seeks to admit its powerlessness vis-à-vis late-capitalist totality so as to initiate the latter's abolition. "Montage is the inner-aesthetic capitulation of art to what stands heterogeneously opposed to it" (*AT* 155; *ÄT* 232).

This genealogy of montage takes us back to the relationship between inner-aesthetic technique and industrial-capitalist technology. To recall, Adorno insists on modern art's obligation to engage not only with the most advanced and dif-

ferentiated techniques but also with historically transformed modes of experience. Kracauer and Benjamin had also formulated similar arguments for film—Kracauer for slapstick comedy and individual films like *The Street* and *Battleship Potemkin,* Benjamin for the ways in which technological modernity constitutes a hidden figure in Mickey Mouse and Chaplin.

Adorno comes closest to granting film the ability of conveying, on the basis of its internal organization of mimetic movement, the transformation of experience in modernity in an often-cited (though nonetheless opaque) passage. What is striking is that he does so by suggesting an aesthetic orientation that is "indifferent" (*gleichgültig*) toward—neither guided by nor ignorant of—the medium's technological, photographic base.

> The aesthetics of film will do better to resort to a subjective mode of experience that film, indifferent toward its technological origin, resembles and that constitutes its artistic character. For instance, a person who, after a year in the city, spends a few weeks in the mountains abstaining from all work may unexpectedly experience colorful images of landscape consolingly coming over or moving through him or her in dreams or daydreams.... Such movement of [interior] images may be to film what the visible world is to painting or the acoustic world to music. Film could be art as the objectivating re-creation of this mode of experience. The technical medium par excellence is intimately related to natural beauty [*tief verwandt dem Naturschönen*]. (TF 201; FT 355; translation slightly altered)

The choice of example is no coincidence. The mode of experience expressed in the movement of images is one of displacement, transience, and loss. The colorful images that appear without being called up are not of a timeless idyllic nature but of a nature segregated as refuge from urban living and labor. Adorno's example may seem privileged and harmless, but it also calls to mind examples drawn from a worldwide history of rural flight, migration, and exile.

The movement of interior—and anterior—images Adorno proposes as the raw material for film is not simply a psychologically defined stream of associations but feeds on the "pre-artistic comportment that approaches art most closely and ultimately leads to it." This comportment "transforms experience into the experience of images; as Kierkegaard expressed it: 'my booty is images' [*was ich erbeute, sind Bilder*]" (AT 287). Images that impose themselves on the dreaming or daydreaming subject are images of the imagination, even as they refer to a nonimaginary historical reality. In the passage from "Transparencies" above, what matters as much as the experiential content of individual images is the complex modality of their appearance—spatiotemporal displacement, ephemerality and elusiveness, involuntary and embodied perception—a process that itself constitutes a subjective mode of experience that, Adorno suggests, film is capable of re-creating. If

modern art objectivates the irreversibly transformed world of images, film is particularly suited to capturing the world of images in flux—as an unstable, transitory, and open-ended process.

There are two major conceptual pivots in this passage. One is the seemingly paradoxical claim that "the technical medium par excellence is intimately related to natural beauty"; the other is the notion that in its phenomenal unfolding the movement of interior images resembles writing—written language. I'll return to the former below; the latter becomes evident in the sentences elided in my previous citation of the passage. "These images do not merge into one another in a continuous flow, but are rather set off against each other in the course of their appearance, much like the magic lantern slides of our childhood. It is in the discontinuity of their movement that the images of the interior monologue resemble the phenomenon of writing [*Schrift*]: the latter similarly moving before our eyes while fixed in its discrete signs" (TF 201). As we saw earlier, Adorno describes montage as arranging things "in a constellation akin to writing." But just as his attitude toward montage entailed some serious reservations, his notion of writing at work in film is by no means neutral or unequivocal. In the following sections, I discuss the ambivalence of Adorno's concept of writing in relation to the moving image, a discussion that requires a brief detour through his earlier notion of mass culture as a form of hieroglyphic writing.

IMAGE/WRITING

As Gertrud Koch has argued, the problem of film aesthetics for Adorno is more fundamental than the issues spelled out in "Transparencies on Film." In its most basic definition as a medium that depicts a moving object in front of the camera, photographically based live-action film conflicts with the *Bilderverbot*, the Biblical ban on graven images that Koch and other scholars have discerned as a regulative idea in Adorno's *Aesthetic Theory*.[39] The prohibition against likeness—from prehistoric taboos to the monotheistic verdict on idolatry and its gnostic radicalizations—is one of the lineages in the development of aesthetic autonomy. Adorno's insistence that artworks are "imageless images [*bilderlose Bilder*]," images that are not replicas or representations *of* something in the sense of iconic resemblance (*AT* 283, 287), is founded on the view that such representational duplication is in the strict sense impossible. The problem is that it robs that which "appears" in nature of its "being-in-itself," which is what we seek in the experience of nature (*AT* 67); it lacks the "block" that makes artworks enigmatic, "images of being-in-itself" (*AT* 126). In *Dialectic of Enlightenment*, Adorno and Horkheimer take up the problem of the *Bilderverbot* in philosophical terms: "The right of the image is rescued in the faithful observance of its prohibition." They pinpoint the possibility of such observance in the Hegelian concept of "determinate nega-

tion," the immanent assertion of difference. Dialectic, via determinate nega-
tion, "discloses each image as writing," teaching us to "read from its features the
admission of falseness which cancels its power and hands it over to truth" (*DE*
18; *AGS* 3:41).

In the effort to redeem Adorno's position on film, critics have emphasized
the trope of writing—with or without poststructuralist, in particular Derridean,
connotations—in his attempts to delineate an aesthetics of film against its tech-
nical and economic aporias. Koch locates film's possibility of determinate nega-
tion, of rendering the seemingly self-identical image flow as "writing," in avant-
garde practice and theories of montage from Eisenstein through Kluge. Montage
thus understood seeks not only to fracture the fetishistic illusionism of narrative
cinema, along with the fiction of diegetic continuity and closure, but also to shift
the production of meaning from the relationship between image and referent to
the cut—the space between shots, the space of difference and heterogeneity. Latent
in the cut is a third image that is immaterial, which for Kluge marks the entry
point for the "film in the viewer's head."[40]

From a different angle, Tom Levin mounts an argument for Adorno's valoriza-
tion of writing vis-à-vis mass-cultural technology by shifting the discussion to
Adorno's writings on the gramophone record. Adorno could display a remarkably
open, even enthusiastic attitude toward this particular medium of technological
reproduction, Levin argues, because he saw in it an indexical, that is, a materially
motivated, form of inscription (acoustic waves etched into a vinyl plate) that was
not hitched, as was film, to iconic resemblance and thus to false immediacy and
facile intelligibility. While lacking the (authentic) immediacy of live performance,
the gramophone record replaces the arbitrary conventions of musical notation
with a form of nonsubjective writing at once motivated and unintelligible, a lan-
guage of "determined yet encrypted expressions." Adorno links this kind of writing
to Benjamin's hope, in *The Origin of German Tragic Drama*, "that once fixed in that
way, it will some day become readable as the 'last remaining universal language
since the construction of the tower.'"[41]

In this context, *writing* clearly means something different from the notation
systems of phonetic languages. Like equivalent words in other languages, the
German word *Schrift*—writing, script, scripture—has rich resonances in theology,
philosophy, and aesthetic theory. At the time Adorno wrote his second essay on
the phonograph record, he had just published his *Habil*-dissertation on Kierke-
gaard, in which the philosopher's preoccupation with *Schrift* emerges as one of
the elements in the "construction of the aesthetic."[42] Yet this was also the peak of
the period in which writing in a more literal sense, in its material graphicity as
letters, words, and slogans, had entered the image world of avant-garde art, from
cubism through futurism, dada, and constructivism, from Brecht's epic theater
through Hannah Höch's and John Heartfield's photomontages. Written language

had also taken up residence in the urban skies and movie theaters, and it is worth recalling here Benjamin's observations on the transmigration and transformation of writing in *One-Way Street* (see above, chapter 5), which for him stood in no contradiction with the esoteric reflections on writing in his recently completed treatise on the baroque tragic drama.

When Adorno resumes the concept of writing in his later aesthetic theory, he uses the term *écriture,* which he explicitly adopts from the French art dealer and art historian Daniel-Henry Kahnweiler. As the nonsubjective, indirect language of modern painting and music, *écriture* is a sign of the temporality and history congealed in it, "seismographic" in its registration of subcutaneous, mimetic impulses and tremors of distant catastrophes. Yet, because this writing is veiled and not immediately readable, it assumes a "broken-off, hieroglyphic character" (as in the drawings of Paul Klee).[43] In *Aesthetic Theory,* Adorno links this (Kierkegaardian, Benjaminian) understanding of writing to the status of artworks as enigmatic, arguing that the concept of *écriture* in modern art "illumines the art of the past" inasmuch as "all artworks are writing, not just those that are obviously such; they are hieroglyphs for which the code has been lost, a loss that plays into their content" (*AT* 124). If this is the case, any "reading" of artworks is more adequately described as an aesthetic, mimetic experience that encompasses at once the effort of deciphering and its futility.

If the concept of writing Adorno uses in "Transparencies"—when he suggests that an aesthetics of film should model itself on the discontinuous movement of the interior flow of images—were anything close to the one he assumes in the context of modern art, this might indeed be a productive route to pursue. Alas, the only film-related instance in which he uses the trope of writing in an unequivocally positive sense occurs in his observations on Chaplin, which he hopes will "contribute to a descriptive account of his image [*zur écriture seines Bildes*]."[44] Instead, Adorno uses the concept of writing in a very different sense. The description of the scriptural appearance of film and film viewing as a form of reading in fact has its precursor in his 1953 essay, "Prologue to Television," which links the image-writing connection to a psychoanalytic critique of mass-cultural consumption. Adorno argues that the "language of images," "pictographic writing," or "hieroglyphic writing" dispensed by television lends itself to the "will of those in charge," all the more so as it wants to "pass itself off as the language of those whom it supplies":

> By awakening and representing in the form of images what slumbers preconceptually in people, it also shows them how they should behave. Whereas the images of film and television strive to evoke those that lie buried in the viewer and indeed resemble them, they also, by flashing up and slipping away, approach the effect of writing. They are grasped, but not contemplated. The eye is pulled along by the film as it is by the

line of a text, and in the gentle jolt of a scene change a page is turned. As image, the image-writing is the medium of regression in which producer and consumer meet; as writing, it makes the archaic images available to modernity.[45]

For the notion of film as hieroglyphic writing, Adorno footnotes an article by two Italian psychoanalysts who elaborate the affinity between image and writing mainly in terms of Freud's *Interpretation of Dreams*.[46] But where these authors celebrate the pictographic and pre-logical quality of filmic images as the idea of "pure cinema," Adorno discerns a powerful mechanism of ideology, reminiscent of Leo Löwenthal's quip about the culture industry as "psychoanalysis in reverse." By mimicking the figurations of unconscious or preconscious fantasy, Adorno argues, mass-cultural hieroglyphics actually spell out a behavioral *script*. Disguising the very fact that they were written, and with it their heteronomous origin, they produce the illusion that they speak the viewer's desire.

The main purpose of Adorno's note is to refer the reader to his (and Horkheimer's) analysis of film as hieroglyphic writing in the longtime apocryphal sequel to the chapter on the culture industry in *Dialectic of Enlightenment*, "Schema of Mass Culture" (written in 1942, but not published until 1981), which contains some of the same language and critical argument as in "Prologue to Television."[47] The notion of mass culture as hieroglyphics ties in with key themes of *Dialectic of Enlightenment*: the reversion of Enlightenment into myth and the resurfacing of the archaic in the modern; the dissociation of image and sign and the instrumentalization of language and reification of aesthetic expression; and the false identity of individual and social totality enhanced by a cultural economy of commodification, repetition, and regression. Like the fascist resurrection of archetypes, Hollywood's dream production is seen as a manufacturing of archaic symbols on an industrial scale; they function as masked allegories of domination: "In the rulers' dream of [the] mummifying of the world, mass culture represents a priestly hieroglyphic script which addresses its images to those subjugated, not in order to be enjoyed but to be read." This form of reading is enhanced by the technologically conditioned way in which the images in the cinema—"flashing up and slipping past"—even optically approximate the appearance of writing (an observation that leads into the above statement about the eye being pulled by the film). Trained in the hermeneutic skills required and encouraged by Hollywood conventions of narration, the viewer is compelled to translate moving images into scripts of social identity—ways of being, smiling, and mating, the injunction of the star image "to be like her."[48]

In the context of *Dialectic of Enlightenment*, the mechanism of identification via hieroglyphic reading is analyzed not in psychoanalytic terms but rather through the nexus between reification and mimesis. Reification is at work at the levels of

both representation and reception. Given the universality of the commodity and of advertisement in the culture industry, the image of an animated, speaking human being merely naturalizes that condition; it functions as a mask that captures everything living about the human face, especially laughter: "As far as mass culture is concerned, reification is no metaphor: it makes the human beings it reproduces resemble things, even where their teeth do not signify toothpaste and their care-worn wrinkles do not conjure up a laxative."[49] Adorno and Horkheimer speculate that it is the well-concealed hope that one day this spell might be broken that draws people to the cinema. (This speculation ties in with their observation that silent film, in its alternation between images and actual writing in the intertitles, still presented some alterity to the tendency toward the hieroglyphic because, they argue, its material heterogeneity allowed the images to retain some of their aesthetic quality qua images.) Once in the cinema, however, the viewers obey and assimilate to what is dead. Adorno and Horkheimer account for such self-reifying behavior with one of the key concepts of the book—mimesis. "Mimesis explains the mysteriously empty ecstasy of the fans of mass culture."[50]

Much has been written about Adorno's concept of mimesis and the different, if not antithetical, meanings it assumes depending on the constellations in which it is used.[51] Earlier, I touched on the concept in relation to Benjamin's notion of the "mimetic faculty" and Adorno's Aesthetic Theory. In Dialectic of Enlightenment, Adorno and Horkheimer take up the anthropological connotations of mimesis that underpin Benjamin's texts on the mimetic faculty, but, writing a decade later and with an exponentially growing sense of the devastations being wrought by fascism, they also resort to the zoological concept of mimicry as developed by Roger Caillois. In the anthropological context, mimesis draws on archaic divinatory and magical practices, referring to efforts to make oneself similar to the environment, to assuage nature by imitating and learning from it—an "organic adaptation to otherness" (DE 148). Within the unfolding of the historical process they designate as Enlightenment, the development of instrumental, classificatory, and objectifying reason, mimesis comes to name a mode of experience and interaction between humans and nature that cannot be imagined in anything but a utopian register, linked to the metaphysical promise of reconciliation with nature. (Adorno will abandon this paradigm in his aesthetic theory, where mimesis survives as the promesse de bonheur of works of art.) In the historical present of Dialectic of Enlightenment, however, mimesis persists only in repressed, perverted forms—in the "false projection" that fuels anti-Semitism as well as the unreflected mimicry or camouflage of pretending to be dead for the sake of self-preservation, a freezing or numbing of the human in "petrified terror" (DE 154, 148). When such individual reactions are organized and manipulated as collective behavior, amplified by people's imitation of each other, they manifest in the fascist horde, the lynch mob, and the cinema audience (see DE 149).

It is in the sense of mimesis as "deadly reification compulsion" (Michael Cahn) that Adorno and Horkheimer elaborate on the ideological mechanism they see operating in cinema as hieroglyphic writing.[52] But there are other possibilities, too. One might object that, despite the resonances with these earlier texts, there remains a significant difference between the analysis of this mechanism in a dominant practice of cinema and Adorno's suggestion, in "Transparencies," that an aesthetics of film should model itself on a subjective mode of experience—namely, on the discontinuous movement of the images of the interior monologue. One might even argue that, rather than seeing his observation of the writing-reading character of film as contaminated by its earlier uses, Adorno actually was conceding the possibility that film might actually correspond to—not merely mimic to assimilate—something about the way the human mind organizes the flow of interior images.[53] To take this one step further, we could imagine a mutual and historically mutable relationship between film and mind on the model of his already cited speculation (in *Aesthetic Theory*) about a form of secondary mimesis by which the artist's mind spontaneously responds to technology: "The cinematographic gaze becomes an innate faculty" (*AT* 193; *ÄT* 287). The advantage of this kind of argument is that we don't have to mount it on a privileged notion of writing as such—as a mode of negating the ostensible self-identity of the image flow—all the more since the term's relationship with the *écriture* of autonomous art remains ultimately undefined in Adorno's work.

In the following section, I am interested in shifting the emphasis in Adorno's reflections on film aesthetics from the iconophobic implications of the *Bilderverbot* to the kinds of mimetic experience that, according to Koch, the observance of the prohibition enables. This will take us through a discussion of the other salient concept in the passage from "Transparencies," natural beauty, and the possibilities some of its key aspects may hold for an aesthetics of film. The section will end on the related category of the "language character" of art, which involves questions of expression, mimetic experience, the inherent collectivity of the visual arts' mode of address, and the primacy of the object world.

NATURAL BEAUTY, LANGUAGE CHARACTER

I begin with Adorno's assertion in "Transparencies on Film" that as an "objectivating re-creation" of a subjective mode of experience, the "technological medium par excellence is intimately related to natural beauty." The provocatively oxymoronic phrase clearly echoes Benjamin's evocation, in the artwork essay, of cinema as "the Blue Flower in the land of technology" (*SW* 3:115, 4:263; cf. above, chapter 6). But Adorno is doing something different, and trying to fathom the implications of this phrase once more requires recourse to *Aesthetic Theory*. There, Adorno famously seeks to vindicate the category of natural beauty from its repression in the German

idealist tradition of art and aesthetics beginning with Hegel. He indicts the ideal-
ization of the spirit and the spiritualization of art—along with the transplantation
of ideals of freedom and human dignity into the realm of aesthetics (Schiller)—as
a usurpation by the subject and the degradation to mere material of qualities that
elude subordination. As he sees it, the expulsion of the experience of nature in
idealist aesthetics is tied to the progressive mastery and devastation of nature in
the name of Enlightenment and instrumental rationality. Thus, the category of
natural beauty is as profoundly historical as nature itself, even (and especially)
where it seeks to escape the logic of mastery and reification.[54]

With the universalization of the principle of exchange, the idea of a pure,
untouched, ostensibly ahistorical nature emerges as the subjective counterpart
of increasingly reified social conditions that in turn masquerade as nature: "The
subject's powerlessness in a society petrified into a second nature becomes the
motor of the flight into a purportedly first nature" (*AT* 65). What appears as natural
beauty in nature becomes itself the object of appropriation—whether as raw mate-
rial for (a certain kind of) artistic naturalism, locus of sentimentalist projection,
or, at the low end, fodder for the tourism industry. As mere contrast to the sphere
of labor and exchange, the experience of immediacy promised by natural beauty
becomes part of what it opposes: "Natural beauty is ideology where it appropriates
immediacy on behalf of mediatedness [*als Subreption von Unmittelbarkeit durchs
Vermittelte*]" (*AT* 68; *ÄT* 107). Nonetheless, in Adorno's reconceptualization of the
category in relation to history as well as art, natural beauty—as an instantiation of
being-in-itself—offers the possibility of determinate negation: "Natural beauty is
the trace of the nonidentical under the spell of universal identity" (*AT* 73). As such,
nature—a site of possible happiness—holds out the promise that art seeks to keep.[55]

Adorno's understanding of film in terms of natural beauty is elucidated by
his critique of the "vulgar antithesis of technology and nature" implied by Rous-
seauian calls for the return to nature. The fallacy of this antithesis, he argues, "is
obvious in the fact that precisely nature that has not been pacified by human
cultivation, nature over which no human hand has passed—alpine moraines and
taluses—resembles those mountains of industrial debris from which the socially
accepted aesthetic need for nature flees" (*AT* 68; *ÄT* 106–7). There is a complex
argument here. The terror inspired by untamed nature lends natural beauty an
archaic, mythical ambiguity that makes it border on the sublime; at the same time,
untamed nature's resemblance to modern industrial wasteland places it within
the history of nature's subjection.[56] Adorno rejects the gendered topos, redolent
of bourgeois sexual morality, of technology having "ravished" (*geschändet*) nature
and points instead to the potential of technology, albeit under transformed rela-
tions of production, to develop a mimetic solidarity with nature. Short of that,
he argues, "consciousness does justice to the experience of nature only when, like
impressionist art, it incorporates nature's stigmata [*Wundmale*]" (*AT* 68; *ÄT* 107).

Accordingly, "art holds true to appearing nature only where it makes landscape present in the expression of its own negativity" (*AT* 67–68).

Here is where film seems relevant. As a technological art, film is capable of filling this role in ways that avoid the pitfalls Adorno discerns in some impressionist painting (poeticization of industry, subjectification of objective reality)—inasmuch as cinematic technique can convey, with sensory immediacy, the presence of the apparatus without representing it. One example would be early travelogues shot from a moving vehicle—mostly a train, though sometimes a car or boat—a technique popular well into the 1910s. Participating in the genre of "phantom rides," such films offered the viewer the thrill of an embodied perception that exceeded the hitherto natural limits of human vision in both speed and vantage point (see, for instance, the dizzying overhead shots taken from an elevated train in *A Bird's-Eye View of the Islands of Hawaii* [Lyman H. Howe, 1916]). This technique, doubly grounded in mechanical technology, makes the historical intersection of nature and technology palpable in a nonrepresentational mode; it maintains a tension between natural beauty with its potentially regressive appeal to an Edenic past and the presence of modern instruments of perception, which are in turn implicated in a history of colonization and tourism.[57] Another use of nonnarratively motivated and character-independent, mechanically based yet autonomous camera movement emerges in experimental films that show landscapes without visible traces of human activity and history; these include Michael Snow's *La Région Centrale* (1971), Jean-Marie Straub and Danièle Huillet's *Fortini/Cani* (1976) and *Too Early, Too Late* (1982), and Claude Lanzmann's *Shoah* (1985).[58] Such films evoke a sense of dissonance even if and where they show a seemingly idyllic nature. The path to nature, seen as the mute record of the stigmata of history, leads *through* technology, aesthetically instantiated by cinematic technique.

From there, we can see Adorno's ambition to reinstate the dialectic of natural beauty and art beauty that was disrupted after Kant by casting their mutual trajectories within a historical-materialist framework. As autonomous artifact, the artwork seems opposed to nature as the incarnation of what is not made by human hand. "As pure antitheses, however, each refers to the other: nature to the experience of a mediated and objectified world, the artwork to nature as the mediated plenipotentiary [*Statthalter*] of immediacy" (*AT* 62). They are imbricated above all by the mode of experience they have in common. Where nature is perceived in the mode of the beautiful, it is never an object of action—neither for labor and the reproduction of life nor for scientific and instrumental knowledge. Adorno marks this mode of experience as one of images: "Like the experience of art, the aesthetic experience of nature is one of images" (*AT* 65; *ÄT* 103).

The rhetoric of images is significant. As discussed earlier, Adorno conceives of images as nonrepresentational, not limited to the visual, and not fixable in space and time. He writes, "Artworks are images as *apparition,* as appearance, and not

as copy [*Abbild*]" (*AT* 83). The word *apparition* appears in the German text in the (French or English) original, combining connotations of epiphany and haunting.[59] As both illumination and spectral manifestation of an unredeemed past, it also refers to the complex temporality that links the experience of natural beauty to that of artworks. Natural beauty flashes up momentarily, suddenly, ephemerally—in the register of Bergson's *temps durée*—and is accessible only to unconscious, involuntary apperception; it eludes intentional observation. The artwork, qua image, "is the paradoxical effort to transfix this most evanescent instant"; to objectify the apparition and "summon [it] to duration" (*AT* 84, 73). If involuntary perception and memory, almost a kind of blindness, are essential to the aesthetic experience of nature, they are also "archaic vestiges incompatible with the increasing maturation of reason"; the artwork makes it possible to experience archaic impulses nonregressively by enjoining them to concentrating consciousness and analytic reflection (*AT* 69).

Rather than a mere source of inspiration or object of contemplation, natural beauty provides a *model* for art in its elusive appearance and indeterminateness. For Adorno, the aporia of natural beauty—its flashing-up only to disappear before the effort to transfix it, make it graspable—names the aporia of aesthetics as a whole. In his definition, "art does not imitate nature, not even individual instances of natural beauty, but natural beauty as such" (*AT* 72). Natural beauty assumes this allegorical status for art inasmuch as it refers, despite its social mediation, to a dimension beyond that mediation. Adorno locates the difference between natural beauty and the artistic artifact in the "degree to which something not made by human beings speaks: in its expression [*Ausdruck*] (*AT* 70; *ÄT* 111). This quality, however, involves a mimetic reciprocity on the part of the beholder: "What is beautiful in nature is what appears to be more than what is literally there." Adorno acknowledges the role of the beholder's imagination even as he immediately circumscribes it, writing, "Without receptivity there would be no such objective expression, but it is not reducible to the subject; natural beauty points to the primacy of the object in subjective experience" (*AT* 71). The primacy of the object endows the perception of natural beauty with both a compelling authority and an incomprehensibility that awaits resolution, a double character that has been transferred to art. Still, when Adorno elaborates on the fluidity and metamorphic quality of meanings in the aesthetic experience of nature, he describes a process that is not—and can never be—entirely controlled by the authority of art. "A stand of trees distinguishes itself as beautiful, as more beautiful than the others, because it bears, however vaguely, the mark of a past event; a rock appears for an instant as a primeval animal, while in the next instant the similarity slips away" (*AT* 71; *ÄT* 111). (Adorno here in fact performs what he describes. Although he draws this account from Hölderlin's "Winkel von Hardt," a poem in which natural beauty is bound up with history and the idea of an allegorical history of nature, his own

paraphrase exceeds "what is literally there," the rock being part of a later philo-
logical commentary on the poem, while its flashing similarity with a prehistoric
animal is reminiscent of Benjamin—and, in that case, Novalis.)[60]

If natural beauty provides a model for art in both its particular mode of appear-
ance and experience on the part of the beholder, art beauty nevertheless has an
ability that natural beauty on its own lacks: "What nature strives for in vain,
artworks achieve: they open their eyes" (*AT* 66; *ÄT* 104). The romantic meta-
phor of nature opening its eyes, here marked as a longing that can be fulfilled
only by the artwork, suggests a connection between Adorno's concept of natural
beauty and Benjamin's theory of aura, which resonates as well in the temporality
of natural beauty, its momentary and unpremeditated appearance and its truck
with the prehistoric and archaic. Adorno acknowledges this connection in an
important paralipomenon of *Aesthetic Theory* that takes on the category of *Stim-
mung*, or atmosphere. There he cites in full Benjamin's famous "definition" of aura
in the artwork essay, illustrating the concept by way of the experience of aura in
natural objects as the "unique appearance [*Erscheinung*, "apparition"] of a distance,
however near it may be" (*AT* 274; *ÄT* 408). Reading Benjamin's account of auratic
experience as requiring a recognition in nature of "what it is that essentially makes
an artwork an artwork," Adorno emphasizes in the paradoxical compounding of
distance and nearness the objectivity of an artwork's expression, its "innervations
of the objective language of objects" as opposed to the prevailing mechanisms of
projection and identification on the part of the beholder (*AT* 275). The element
of distance or farness has, as we saw in chapter 4, a distinctly temporal, archaic,
and psychotheological dimension for Benjamin. What this suggests to Adorno,
however, is rather an aesthetic distancing of natural objects from their subjection
to practical aims and intentions, their being-in-itself; in other words, he channels
Benjamin's mystical temporality into a conception of history indebted to *Dialectic
of Enlightenment*.[61]

Yet Adorno himself invokes that "other" history when he links the priority of
the alien gaze—Benjamin's admiration of Rilke's line "for there is no place / without
eyes to see you"—to another concept indebted to his friend: that of art's *Sprachcha-
rakter*, the mimetic aspect of art that resembles language or speech, as the quintes-
sence of "expression" (*Ausdruck*). It is through this concept that expression can be
defined as "the gaze of artworks" (*AT* 112; *ÄT* 171–72). Although we might speak
here of a conceptual catachresis, the theoretical crossing of the disparate registers
of the gaze and speech implies a more principled recourse, in Adorno's effort to
wrest the category of expression away from Klages and other neo-romantics, to
Benjamin's early, theologically grounded philosophy of language.[62] Since much
has been written about the latter, suffice it here to recall Benjamin's theorization
of language as a medium distinct from arbitrary and conventional signification
and, in particular, his reflections on nature's "muteness" and on the languages of

sculpture, painting, and poetry.[63] Alluding to these reflections (and the kabbalist tradition subtending them), Adorno associates natural beauty with the expression of nature's "mute language" and art's desperate effort to lend speech to that muteness, caught in the irresolvable contradiction between that effort and the idea of making something speak that by definition cannot be willed (*AT* 69, 78; *ÄT* 121). The language character of art is therefore defined by a tension—both incommensurability and inevitable engagement—with communicative language.[64] Adorno sees this tension at work, for instance, in the attempt of modern prose since Joyce "to put discursive language out of action, or at least to subordinate it to formal categories of construction to the point of unrecognizability." By means of such artistic technique, "the new art tries to bring about the transformation of communicative into mimetic language" (*AT* 112).

For Benjamin, at least in his essays on the mimetic faculty, the notion of a mimetic language leads to the thesis that "nonsensuous similarities" and "correspondences" have their modern, "most complete archive" in language, in particular written language (*SW* 2:722); inasmuch as mimetic qualities are propped onto the semiotic dimensions of writing and speech, they mandate a particular kind of reading. But Adorno takes the relationship between mimesis and language in a somewhat different direction, closer to Benjamin's earlier speculations about "certain kinds of thing-languages" that the languages of the plastic arts are founded on—"nameless, non-acoustic languages, languages issuing from matter" (*SW* 1:73). Attributing a language character to premodern and nonverbal artifacts such as the Etruscan vases in Villa Giulia (and natural beings like "the rhinoceros" as well), Adorno endows these objects with expressive agency. He ventures that the aspect that comes closest to making such objects resemble language, their mute speech, is most likely their sense of "*Here I am* or *This is what I am*"—a form of selfhood "not first excised by identificatory thought from the interdependence of all existence [*des Seienden*]" (*AT* 112; *ÄT* 171–72). If mimetic language enables the expression of nonidentificatory forms of selfhood in nonhuman entities—artifactual and natural alike—it both requires and allows for a similar disposition in the perceiving subject, an openness to the experience of what is nonidentical, alien, and alienated.[65] In such return of the gaze (to mix metaphors again), Adorno locates the language character of art, the expressiveness of artworks—"not where they communicate the subject, but rather where they reverberate with the Ur-history of subjectivity, that of ensoulment [*Beseelung*]" or animation (*AT* 112–13; *ÄT* 172).

The question of what it is that "speaks" in art, its actual subject—"not the individual who makes it or the one who receives it" (*AT* 167)—points toward the nexus between the language character of art and its collective dimension. To be sure, this collectivity is mediated at the level of the production of artworks by the empirical, "private I" as a function of the historical division of labor. But, "by entrusting itself fully to its material, production results in something general born out of utmost

individuation." The "force with which the private I divests itself and enters into the object or matter (*Sache*)" lends it collective resonance—"it constitutes the language character of works" (*AT* 167; *ÄT* 250). The collectivity that speaks in art is thus located at the intersection of the archaic—mimesis as the animistic Urhistory of subjectivity—and the modern, the rationality of the most differentiated and dense techniques that alone can summon up the mimetic residue of art.

Adorno maps the nexus of language character and collectivity with reference to various media and genres, including, along with music and poetry, the visual or plastic arts (*bildende Kunst*). As he remarks with a grand gesture, "The plastic arts could be said to speak through the How of apperception. Their We is nothing short of the sensorium in its historical condition, [radicalized] to the point that it fractures the relation to the changed representational object [*Gegenständlichkeit*] by means of the development of its formal language." By virtue of their grounding in the human sensorium, including the experience of a historically transformed world of images, the visual arts address themselves to a plural beholder: "What images say is a Look Here! [*Seht einmal*]." The collective subject of images is appealed to in this deictic gesture toward an external object, however mediated and refracted it may be: "in what they point to, which is outward, not inward as with music" (*AT* 168; *ÄT* 251).

We are left, then, with a complex array of concepts: natural beauty and art, mimesis and experience, expression and identity, language and collectivity. It is this constellation that is in play, along with the language character of other arts— Adorno was well aware of the heterogeneity of materials and aesthetic traditions that cinema combines—when, in "Transparencies," he refers to the "language character of film" (TF 204; FT 359).

Given this constellation, it seems safe to say that Adorno's notion of the language character of film has little in common with discussions of film as language in structuralist-semiotic film theory (though there may be interesting resonances with Christian Metz's early, phenomenologically inspired reflections on that relationship).[66] Neither, however, can it be simply equated with his own comparison of film to writing. The conceptual imbrication of art's language character with Benjamin's metaphor of investing things with the ability to return the gaze suggests, rather, a particular tradition in the international aesthetics of silent cinema: the foregrounding of material objects through close-ups, camera movement, editing, lighting, and mise-en-scène in the work of filmmakers as diverse as Germaine Dulac, Dziga Vertov, G. W. Pabst, and Ozu Yasujirō and its theorization in the writings of, among many others, Béla Balázs, Kracauer, Jean Epstein, and Tanizaki Jun'ichiro. As was recognized early on, film's ability to animate and foreground inanimate objects enabled it to dramatize the changed and changing economy of things, be it to explore their fetishistic power and objectification of human relations and conditions; to "reveal" them in their essence by countering the abstrac-

tion of commodity capitalism with physiognomic expressiveness; or to enhance their thingness, their physical opacity and alterity.[67]

Adorno may well have assimilated some of that tradition, especially its emphasis on the primacy of the object in subjective experience. However, not only would he have rejected the neo-romantic legacy of physiognomy—and, for that matter, the concept of *photogénie*—he would probably have been suspicious of any hermeneutic understanding of a cinematic "language of things" (*AT* 60). In Adorno's modernist canon, after all, art is emphatically modern where it engages things in their negativity, in their primacy over human meaning and intention; this "mimesis toward the deadly" (*Mimesis ans Tödliche*), the "hardened and alienated," is the "admixture of poison" without which art would remain "impotent comfort" (*AT* 133, 21; *ÄT* 201).[68] It is important to bear in mind that for Adorno the central experience of his time was the historic catastrophe named by the word *Auschwitz*—"the horror that the object threatens to annihilate the subject without leaving a trace."[69] Inasmuch as artworks mimetically absorb elements of the lifeless, reified world, while also working to displace, dissolve, and reconstruct them according to a new logic, they are able "to negate the negativity in the primacy of the object, to negate what is heteronomous and unreconciled in it"—as long as that negativity persists even in the "semblance of reconciliation" achieved by the works (*AT* 259).

For Adorno, film comes closest to such a negative aesthetics in a "radical naturalism" suggested by its technology, thereby "giv[ing] itself over to the blind representation of everyday life." By renouncing intentionality, such an experiment would result in a diffuse and outwardly inarticulate creation alien to the visual and acoustic habits of the audience; it would amount to something like a secondary mimesis toward a reified world that does not return the gaze. Yet it would at once negate and preserve that negativity by constructing its images according to the immanent logic of the "associative stream of images," the subjective mode of experience that film "resembles and that constitutes its artistic character."

MOVEMENT, TIME, MUSIC

Having taken a detour through Adorno's concepts of writing, natural beauty, and language character, we can now circle back to "Transparencies on Film" and take another look at the passage in which he develops the idea that film should model its aesthetics on the movement of internal images. These "images of the interior monologue" move "through" us without being consciously called up. In trying to characterize the perceptual quality of that "*Zug*"—train, flight, pull, or procession—of images, at once moving and set off against each other, he resorts to the comparison, discussed above, with the phenomenal appearance of writing before the reader's eyes, at once moving and fixed in its discrete signs; at the same time,

he invokes the discontinuous sequentiality of the "magic lantern slides of our childhood." Both comparisons beg to be considered in terms of the interrelated mechanisms that generate the psychophysiological impression of motion in film. These include the breakdown of movement in the camera into discrete frames, each minimally but crucially different from each other, registered on a continuous filmstrip. After the intervention of a printer, movement is reconstituted in the projector, a kind of inverted camera, that drives the film strip past a light source at a speed equaling the shooting speed (normally at twenty-four frames per second). Just as essential is the projector's shutter action, which disrupts the stream of light twice for each frame so as to eliminate the flicker effect (critical flicker fusion); this means that, unperceived by the spectator, the screen is dark for almost half the film's running time. In film theory, in particular apparatus theory of the 1970s and '80s, the analysis of these basic mechanisms has often been coupled with a claim that the constitutive gap between frames and simultaneous denial of difference is reinscribed at the level of editing and narrative.[70] Closer to Adorno, Kluge has suggested that the fact that we spend about half the time in the movie theater in the dark means that our eyes, trained to look outward, have a chance to look inward during that time.[71]

Adorno was obviously aware of the basic mechanism that generates the impression of motion on the basis of slightly differentiated, static frames; he actually extolled this "dynamic" effect of film over (early) radio's "constantly moving hearstripe," which "makes music appear to stand still" and dissociate "itself into 'pictures,'" that is, into spatial form.[72] Yet, while he alludes to the striplike quality of radio music in "Transparencies on Film," he also insists that the argument for film's grounding in a subjective mode of experience is indifferent with regard to the technology on which it is based. In particular, the comparison with the discontinuous succession of the "magic lantern slides of our childhood" might take us further. Not only does it evoke a sense of wonder filtered through the memory of images of a lost world and a pre-adult mimetic receptivity, but it also implies a palpable darkness surrounding the luminous images that invite the viewer's imagination to see "more than is literally there."

The question of cinematic movement returns us to the problem of time and temporality.[73] As we have seen, Adorno's understanding of the temporality of natural beauty is bound up with the dialectical entwinement of nature and history. "Natural beauty is suspended [sistierte] history, a moment of becoming at a standstill [innehaltendes Werden]" (AT 71; ÄT 111).[74] This sense is particularly strong in artworks "justly said to have a feeling for nature," a feeling that is "fleeting to the point of déjà vu and is no doubt all the more compelling for its ephemeralness" (ibid.). Adorno's thesis that art "is not the imitation of nature but the imitation of natural beauty" has its temporal significance in the Sisyphean effort to lend duration to the most ephemeral and evanescent, to something that "flashes up

. . . only to disappear in the instant one tries to grasp it" (*AT* 72). At one level, the objectivation of this aporia, the paradoxical unity of the vanishing and the pre- served, constitutes the "temporal nucleus" of artworks and lends their experience a "processual" character (*AT* 177). It also endows artworks with an anamnestic archaic dimension: inasmuch as they strike the beholder as a momentary, sudden apparition of an other, they are "truly afterimages of the primordial shudder in the age of reification; the terror of that age is recapitulated vis-à-vis reified objects" (*AT* 79).

The conception of art as enabling the duration of the transient reaches back, of course, into primeval times and is related to art's mimetic heritage and the ritual functions of imaging. Adorno cites practices of mummification and substitution— the "reification of the formerly living"—as a model of art, at once a revolt against death and magical thinking caught up in nature (*AT* 281), using rhetoric that is also found in the work of André Bazin.[75] Closer to modern times, the aesthetic tension between instantaneity and objectification recalls Lessing's notion of the "pregnant moment" in painting. Yet, while Adorno himself makes reference to the latter, his concern belongs to another paradigm. The issue is not the representa- tion of the most significant, essential, or "privileged" instant, but the experience of something new and emerging, "the not-yet-existing, the possible" (*AT* 73)—a script or *écriture* "that flashes up, vanishes, yet cannot be read for its meaning" (*AT* 81; *ÄT* 125).[76] Such formulations hark back to a modernist concept of time fueled by a messianic desire for disruption, the exploding of an instant (Benjamin's "*Nu*," or Now) that would arrest the catastrophic course of historical time. Yet they also gesture toward a more immanent sort of modernism, one open to chance and contingency and to the coexistence of multiple and conflicting temporalities, an aesthetic on a par with the challenges of modern everyday life.

For Bazin, cinema promised to provide a solution to the conflict between instantaneity and objectification. Unlike photography that, by seeking to preserve the object ("enshrouded as it were in an instant"), simply "embalms time," cinema "is objectivity in time." To recall his famous statement: "Now, for the first time, the image of things is likewise the image of their duration, change mummified, as it were."[77] In quite a different spirit, Adorno might have taken the phrase "change mummified" to be an apt description of what film was doing to time in the context of the culture industry (elaborated in "The Schema of Mass Culture"). Just as the hieroglyphic quality of the filmic image epitomizes reification by freezing what is most alive in human expression, classical narrative abstracts time into a "temporal relation of before and after" and regulates a film's duration "as if by stopwatch."[78]

It is not only the subordination of time to narrative action and character move- ment that comes in for critique. Adorno's argument about the fate of time in the culture industry even concerns the *varieté,* variety or vaudeville, whose bur-

lesque residue is actually valorized in the chapter on the culture industry. With its programming of short, sensational acts or attractions, the variety format—which shaped film exhibition and programming until the advent of the feature film and beyond—"cheats" the viewer out of time inasmuch as what is perceived as preparation turns out to be the event itself. Adorno reads variety as a conjuring up of industrial procedures, mechanical repetition, and the temporality of the ever-same, an allegory of high capitalism tamed by "appropriating its necessity and turning it into the freedom of play." Variety's refusal to grant the semblance of historical development or progress at a time when history seems at a standstill or caught in cyclical repetition—"a semblance to which the bourgeois work of art still clung even in the advanced industrial age"—may have inspired praise on the part of modern artists such as Wedekind, Cocteau, Apollinaire, and Kafka (*CI* 61; *AGS* 3:308–9). And yet, in line with his critique of Benjamin's aesthetics of play, Adorno is more troubled by what repetition, the "curse of predetermination" or the transmutation of conflict into "pre-ordained fate," does to the possibility of experiencing time in the emphatic sense (*CI* 62, 64; *AGS* 3:312).

Adorno's critique of the neutralization and abstraction of time in mass culture—and his advocacy of an aesthetics that seeks, as it were, to retemporalize time—invite comparison with Gilles Deleuze's concept of the "time-image." Deleuze characterizes "modern" (post–World War II) cinema—from Italian neo-realism through Ozu and Welles, Antonioni, Resnais, Marker, Godard, Rivette, Straub, and Huillet—as an effort to carry out "a temporalization of the image."[79] For Deleuze, the time-image of modern cinema "liberates" cinematic time from movement as defined by sensory-motor schemata (as in classical Hollywood cinema's emphasis on character and action), which implies a "beyond of movement" that enables film to become "pure optical, sound (and tactile) image."[80] Redefined in optical-sound situations of everyday banality, movement in turn assumes different functions at the level of performance, narration, and montage, revealing "connections of a new type, which are no longer sensory-motor and which bring the emancipated senses into a direct relation with time and thought."[81]

The difference between these two kinds of temporalization may have to do with the fact that Adorno's conception of time and movement is crucially shaped by his engagement with music, arguably his paradigmatic art. While he might not have disagreed with Deleuze's account of modern film's time-image, the musical inflection of his concept of time entails a different conception of movement. Less burdened with the subordination to character action prevalent in narratively integrated moving images, movement in music—"the motion and tempi of sounding events through time and space, along with the horizontal and vertical structures provided by rhythm and counterpoint"[82]—does not have to surrender sensory-motor links to become modern. On the contrary, the kinesthetic dimension remains essential for most of what Adorno canonized as modern music;

it is a major relay for the mimetic impulses that stir our senses by way of the ear, memory, and imagination. If the mimetic impulses of music have an archaic lineage in dance, the historical trajectory of music in modernity, as part of a broader history of time and temporality, has infinitely complicated, though not abrogated, the possibility of such mimetic embodiment.

Before I continue with this argument, let me make clear that I am not trying to give an account of Adorno's musical aesthetics (which is not my expertise), but instead to draw out certain strands from it that might fill in the gaps in his insufficiently articulated aesthetics of film. This does not mean that Adorno's reflections on time and movement in music can simply be translated into film aesthetics. While both share salient features as essentially temporal arts, if we ignore the obvious material differences between the two media, we might easily end up with a version of the ontology of synesthetic equivalences that Adorno and Eisler had criticized in *Composing for the Films*. As is well known, the idea of film as visual music was widespread during the silent period—for example, in French Impressionist film of the 1920s, experiments in abstract film, the genre of city symphonies, and the writings and films of Eisenstein. Notions of cinematic musicality—rhythmic montage, motivic patterns, the interplay of formal systems—were often coupled with the ideal of "pure cinema," the aim to subordinate all representational, especially narrative, content to the formal unity of principles of musical composition. (The musical analogy was taken in a direction closer to Adorno by Noël Burch's audacious effort to mobilize the principles of total serial music, in particular that of Pierre Boulez, for a theory of parametric form in film, elaborated in terms of oppositions and permutations at all levels of cinematic signification. Burch considers Tati's *Playtime* as one of the main models of such parametric filmmaking, but his project also deserves revisiting in light of the algorithmic logic of digital media.[83]) David Bordwell calls the musical analogy "necessary even if troublesome," because it "crystallizes the drive of film form toward multiple systems." Yet what allows the analogy to persist is not the common denominator of ostensible purity, but precisely the tension with "cinema as a *mixed* representational mode, its unyielding impurity."[84] As I argue below, the possibility of making some of Adorno's thinking on music productive for film is bound up with the fundamental heterogeneity and impurity of cinema. By this I mean not only its promiscuous borrowing from other arts and entertainment forms but also its constitutive combination of heterogeneous visual, graphic, and acoustic materials of expression, each with its own registers of temporality and mobility, organized to varying degrees of integration, continuity, balance, and closure or, conversely, tension, dissonance, disjunction, and openness.[85]

Of course, a major difference between the temporality of film and that of music involves the issue of reproduction that was at the core of Adorno's objections to Benjamin's artwork essay. The relations between the time and movement inscribed

on film, the static filmstrip, and the dynamics of projection differ substantially from the relations between the notation of a musical piece and its actualization—"reproduction," interpretation—in performance. In technological terms, the more pertinent analogy might be that between film and recorded music (or between live transmission in television and in broadcast music).[86] To be sure, the vagaries of time's effect on musical notation—material corrosion, copying technologies, censorship, the interplay between performance practices and editorial changes—have put into question assumptions of a stable musical source text as much as comparable assumptions of a singular, original, integral, authoritative film print (and not just for the silent era).[87] It is also the case that the electronic and digital availability of films has given viewers a greater freedom in performing and interpreting the film, although this does not make it the same thing as musical practices of improvisation and aleatory processes in performance. Indeed, it may be that the only level at which aspects of musical and cinematic time and movement can be usefully compared is that of the listening/viewing experience.

As a temporal art, Adorno writes, music not merely unfolds in time; "it has time as its problem."[88] Inasmuch as musical form creates temporal relationships among its constituent parts and thus a temporal order of its own, it negates empirical time, in the sense of chronometric duration. Adorno insists, however, that empirical time returns in the inner historicity of the work, its internal temporal form, which "reflects real, external time."[89] If autonomous music "binds itself to time" and simultaneously "sets itself against it, antithetically," this tension is exacerbated in modern music. It is here that music engages the experience of abstract, spatialized, commodified time by at once demonstrating what time has historically become and rupturing this naturalized regime; in its internal structure, modern music projects the possibility—as well as the memory—of different temporalities.[90]

One of the central concerns in Adorno's writings on Western musical form, from Bach and Beethoven through Wagner, Schönberg and Webern, is how the intratemporal organization of musical time varies both historically and from one type of music to the next. Broadly speaking, he discerns a trajectory from the developmental logic of classical form exemplified by Beethoven's middle period—the successive, irreversible unfolding of musical events from the parts to the whole in parallel "with the pure flow of time"—to the disintegration of "big forms" in late Beethoven and romanticism, leading to fragmentary, microcellular, episodic complexes that "temporalize" the relationships from within, "from below to above, not the other way around."[91] This tendency advances to a new level with Expressionism and the Second Viennese School. Contemporary experimental music (that is, from the 1950s through the 1960s), in particular the seemingly opposed schools of total or integrated serialism and aleatory music, rebels against the very principle of temporal succession and thus, in Adorno's view, collapses the dialectic of freedom and necessity.

The dissolution of conventional musical forms also entailed an increasing dissociation of rhythm from metrical time. Initiated by romanticism, in particular Schubert, it was pushed further, in different ways, by Mahler, Berg, Bartok, and Stravinsky and radicalized by contemporary experimental music. This dissociation entailed both a greater independence of rhythm from chronometric structures and a transformation of its role and quality. Since Adorno takes the historical differentiation of musical materials to be irreversible, he levels the charge of regression against any type of modern music he takes to be relapsing into metrical rhythms, be it commercial jazz or Stravinsky. Thus, even as he credits jazz with having inspired and provided a broader acceptance for an "emancipation of the rhythmic emphasis from metrical time," he denounces practices of syncopation and improvisation as pseudo-spontaneity and illusory self-expression, contained as they are within a "metrically conventional, banal architecture."[92] Most important, he argues that the "archaic stance" of jazz, its demonstrative appeal to primordial rhythm and vitality, is as "modern as the 'primitives' who fabricate it." Rather than an opposition to the repetitive, abstract, commodified temporality of capitalist modernity, the standardized beats of jazz signal a return of the archaic in modern structures of domination.[93]

Problematic as it may be, Adorno's critique of a regressive or illusory emancipation of rhythm from metronomic—chronometric, mechanical—time bears on film aesthetics in the context of a broader debate on rhythm, the body, and technology that emerged in Europe in the early twentieth century.[94] In that debate, the conception of rhythm in terms of the accelerated speed of industrial-urban modernity competed with the advocacy of a different kind of rhythm—a physiological, organic sense of rhythm attuned to the cyclical processes of nature and preindustrial modes of collective labor and linked to fantasies of community. In his influential book *Das Wesen des Rhythmus* (*The Nature of Rhythm*, 1923), Ludwig Klages expounded on the irreconcilable opposition between the flow of "primal rhythm" (heartbeat, breath, planets, tides, waves)—movement expressing the essence of life—and *Takt*, the staccato measures of clocks and metronomes imposed by the "rational, ordering, and segmenting activity of the intellect" (*Geist*).[95] Suppressed and disrupted by the regime of machinic civilization—the serialized, punctualized, fragmenting logic of the assembly line, the shocks of metropolitan traffic—organic rhythm was hailed as a panacea against the pathologies of modern living in a whole range of movements from body culture and expressive dance, through theosophy and anthroposophy (eurhythmic gymnastics), and vitalist philosophy.

It is not surprising that these competing discourses on rhythm played an important part in the work and writings of the cinematic avant-garde of the 1920s—Blaise Cendrars, Epstein, Dulac, Léger, Richter, Ruttmann, Vertov, and Eisenstein—in particular the fascination with accelerated montage in the wake of Griffith's *Intolerance* (1916) and Abel Gance's *La Roue* (1922). The temporal deployment of

montage, that is, the manipulation of tempo through rhythmic editing, served to articulate the experience of modern life in terms of an overcoming of natural by mechanical rhythms, whether that was a cause for celebration or ambivalence. Yet, as Michael Cowan has compellingly shown, these antithetically conceived senses of rhythm more often than not overlapped and entwined, in both individual filmmakers (cf. Richter's *Rhythm* films) and film aesthetics (notably Eisenstein's).[96] Reading Fritz Lang's *Metropolis* (1927) in terms of the rhythm debate—flooding waters versus structures of machinic oppression, both mediated by the image of the heart—Cowan credits the film with trying to imagine cinema as "a forum for mediating between technological and organic rhythms."[97] We could discern a more radical version of that project developed around the same time, and probably in awareness of the rhythm debate, in Benjamin's notion of the cinema as a medium of collective mimetic innervation and play-form of technology.

On both Freudian and Marxist grounds, Adorno perceived the relationship between organic and mechanical rhythms not as an essential dualism but as a historical convergence of equally regressive and repressive structures. Beyond his polemics against jazz and Stravinsky, his writings on music of the 1960s gesture toward a different kind of temporality, a dynamic no longer containable in dualistic terms—he envisions "limitless possibilities," already latent in free atonality, "of something organic that did not let itself be seduced into imitating organic life that in reality only disguises reification."[98]

In his remarkably empathetic, evocative "musical physiognomy" of Mahler (1960), Adorno links the loosening of traditional temporal structures in the composer's symphonies to their inclusion of metrical material in citational form, fragments of "vulgar music" including marches, waltzes, popular hits—that is, "kitsch." As the refuse of a musical culture debased to ideology, not only do these scraps of secondhand music import anamnestic and collective dimensions, but, resituated in and simultaneously shoring up a "second" totality, they also reflect the historical dissociation of serious and light music, while expressing a utopian yearning that subtends both. "Not despite the kitsch to which it is drawn is Mahler's music great, but because its construction unties the tongue of kitsch, unfetters the longing that is merely exploited by the commerce that the kitsch serves."[99]

Adorno's writing on contemporary music takes a similar form, though with a different emphasis. He sought to theorize the possibility of a different experience of time in music through the antagonistic tendencies in contemporary music, notably the controversies between proponents of integrated or total serialism (early Boulez and early Stockhausen) and those of post- or nonserial music, associated with the aleatory aesthetics of Cage and the emphasis on chance, indeterminacy, and open form. For Adorno, the complete rationalization and domination of musical material in total serialism, which had radicalized the principle of twelve-tone music—that of a series in which no note can be repeated until all elements of the

series have been used—by extending it to rhythmic-metrical and dynamic parameters, suppresses the distinction between "objective" time and the "living temporal experience of the phenomenon." It thus turns the freedom of total technical control into a listening experience of automatism and arbitrariness.[100] Adorno approvingly cites the Hungarian composer Ligeti's observation that, in its effect on the listener, the absolute determinism of total-serial music coincides with the principle of absolute chance advocated by Cage and his disciples.[101] While he acclaims Cage for breaking through the aporias of total serialism (and even admits to being moved, for reasons he cannot explain, by one of his pieces), he argues that this most recent rebellion against semblance—the reduction of the fictive dynamics of the temporal unfolding of music to the point at which successive sounds can become interchangeable—remains merely "abstract negation."[102]

Nonetheless, Adorno's efforts to imagine what he calls *"musique informelle"* seem closer in spirit to principles of openness and chance than to any strict forms of seriality. If *musique informelle* were "to take up anew the challenge posed by the idea of unrevised, uncompromised freedom," he thinks it could gain a "hitherto undreamt-of flexibility of rhythm." It would allow for an autonomous stringency of partial, simultaneous configurations (e.g., Stockhausen's "note clusters [*Tontrauben*]"); it would recognize sounds in their physical existence and otherness (rather than merely structural function); and it would entail an experimental element of surprise, unpredictability, the emphatically new, the contingent and incomplete.[103] In the tension between what is imagined by the composer and what cannot be foreseen, "something not fully imagined," *musique informelle* would amount to the "real, concrete possibility" that characterizes "every artistic utopia today—to make things of which we do not know what they are."[104]

Adorno locates this dimension of unpredictability and openness in the compositional subject, the "ear that can hear live from the musical material what has become of it," the ear that entwines critically reflective control over the material with the logic of dreams, associations, and the imagination.[105] It goes without saying that, for Adorno, the notion of the musical subject refers to the subjectivity objectivated in the music itself; "it has absolutely nothing to do with potential listeners, and everything to do with the human right to what Hegel termed 'being there' [*Dabeisein*] . . . the right of subjectivity to be present in the music itself, as the power of immediate performance."[106] However, it seems clear that the perception of the subjectivity present in music would have to depend on the ear of actual listeners, *their* associations, memory, imagination, and curiosity, in more active and less structurally unified ways, at once sensorial-affective and reflective. After all—and Adorno would definitely *not* have agreed with me here—the "power of immediate performance" rests in no small measure with the assembled public responding to it, and this does not reduce to the mechanisms of consumer solicitation endemic to the culture industry.

Another tack Adorno could have pursued, and to some extent did, has to do with a redefined relationship of music with the other arts, which I take to have implications for an aesthetics of impure cinema and questions of cinematic temporality and mobility. If the idea of informal music describes a utopian trajectory in contemporary music, it had, he asserts, been a "real possibility" once before, around 1910—in works of free atonality such as Schönberg's *Erwartung* and Stravinsky's *Three Poems from the Japanese*.[107] Adorno explicitly relates such "scenic" works to the age of synthetic cubism, yet this was also the time when writers, among them Lukács and Bloch, began to formulate an aesthetics of cinema both in relation to and in distinction from traditional art forms. In his 1966 essay "Art and the Arts," Adorno describes a more recent tendency of what he calls the "interfraying" (*Verfransung*) of the arts, a tendency that lives on in installation and performance art to this day. He not only valorizes the unabashed embrace of generic hybridity against ideologically fraught standards of purity, but also clearly sets it off against the models of the Wagnerian *Gesamtkunstwerk* and "neo-romantic" synesthesia. He considers all of Stockhausen's work—including his electronic music—to be exemplary of the project to explore free possibilities of "musical relationality [*Zusammenhang*] in a multidimensional continuum." "Such sovereignty, which permits an immeasurable multiplicity of dimensions to create relationality, develops, as it were, from within, the association of music with the visual, with architecture, sculpture, and painting."[108]

An echo of this line of thought can be found in "Transparencies," where Adorno suggests that the most promising potential for film practice "lies in its interaction with other media, which on their part merge into film, as certain kinds of music" (TF 85; FT 358). He may have been thinking of possible relations between film and electronic music, a question well worth pursuing (though I cannot do it here). In the overall context of the dynamization of intermedial relations, film comes to exemplify art's rebellion against art and the reach toward extra-aesthetic reality that Adorno considers part of such intermediality (he reads action art and happenings as a clownesque parody of "real life," including the mass media). Ultimately, Adorno concludes, the interfraying or "mutual cannibalization" of the arts, by unwittingly surrendering to a historical reality that has itself compromised all artistic imaging and nonetheless requires it, makes for a "false demise" of art.[109]

It is in his efforts to situate film in relation to developments in contemporary art and music that Adorno suggests aesthetic possibilities that go well beyond the model of *Composing for the Films*, with its advocacy of "planned" music and attendant assumptions of structural unity. The category of rhythm, central to the dynamic configuration of visual and acoustic movement (and key to the authors' critique of Eisenstein), is elaborated there in rather conventional ways. The antithetical deployment of musical and cinematic materials happens largely at the level

of tonality; the possibilities of free rhythm and multiple mobilities—differential and irregular pacing and durations, disruptions, silences, polyrhythmic configurations that contest both chronometric and developmental time—are not yet on the horizon.[110] While Adorno and Eisler assert that a concept of cinematic movement would have to go beyond the "tangible, measurable rhythm of optical structures in animated cartoons and ballets" and the "unbearable monotony" of an incessant simultaneity of image and sound track, their effort to imagine an equivalent to the traditional musical notion of *Großrhythmus* or higher rhythm (e.g., the "dramatic" form of *The Little Foxes;* the "epic," episodic form of *Citizen Kane*) remains at the level of narrative structure and editing.[111] Even as they praise the musical (whose "potentialities are wasted only because of their standardization, spurious romanticism, and stupidly super-imposed career plots"), the grounds for this praise is that these films "come closest to the ideal of montage."[112] Not only does *Composing for the Films* rely on a rather closed concept of montage, one in which meaning is unequivocally predetermined by that of its constituent elements, but there is also no sense of the possibilities of additional techniques—especially camera movement—in shaping cinematic mobility and temporality.

In his 1965 commentary on the opening pages of Bloch's *Spirit of Utopia* (1918), Adorno extols in the honoree's "gestural" style a faster pace (as compared to Simmel) that indicates, "philosophically, . . . a change of position toward the object. It can no longer be contemplated calmly, with composure. As in emancipated film, thought uses a mobile camera."[113] In "Transparencies," camera movement does not receive any special attention. It does, however, make an implicit appearance when Adorno cites, as a powerful example of the possibilities of film's interaction with other media, the Argentinian composer Mauricio Kagel's television film *Antithèse*—which, as he enthusiastically reports in a letter to Kracauer in September 1966, he had seen projected (presumably in its original 35 mm version) at the Darmstadt summer courses.[114] *Antithèse* tracks the psychic meltdown of a sound engineer haunted by an unruly soundscape ostensibly emanating from an array of old and new recording, mixing, and amplifying equipment that combines "electronic and public," directional and ambient sounds, including music and birdsong; the film systematically blurs the distinction between diegetic and nondiegetic sources, and prompts a corresponding breakdown of coherent space and continuous movement, initially doubled on a TV monitor within the studio. On the image track, the process of spatial disorientation is initiated by slow tracking shots to the left that keep refinding the engineer in diegetically improbable locations and accelerates in a combination of independent and character-guided camera movement, quickly repeated zooms from an overhead position, and an opening up of multiple diegetic spaces in the frame through matted shots (the trickling of water the engineer tries to stop turns into a flood; the entangled mass of magnetic tape, into a monstrous web).

From Adorno's late writings on music we can extrapolate a model of think-ing about cinematic mobility that would complement phenomenological, vital-ist, gestaltist, and neuropsychological approaches currently in discussion with an aesthetic perspective capable of historicizing and analyzing particular instances of film practice. We might imagine cinematic mobility as a striated dynamics governed by distinct and sometimes disparate temporalities—a multisensorial "moving carpet" (as Bloch wrote in 1914) made up of internally dynamic chunks, knots, or clusters of time and the relations among them, in tension with irre-versible linear time and the forward movement of narrative or other principles of organization.[115] The multiple mobilities available to film would include four (if not more) registers at the level of the image track: the movement of people and objects within the frame (performance, gesture, gravity, and other aspects of mise-en-scène); the manipulation of the quality of that movement by changes in focal length and focus, slow and fast motion, time-lapse cinematography, lighting, and color; camera movement of varying speeds and durations and diverse linear or figural trajectories and spatial relations with moving figures; and the sense of motion generated by the rhythm of editing. To this we can add graphic materials in intertitles, subtitles, and credit sequences that can function as disruption to the visual flow but can also on their own assume a plastic mobility and rhythmic pacing.[116] And all the elements of the soundtrack—speech, noise, music, and their overlaps—contain possibilities of differential and dynamic temporalities, both on their own and in interaction with the mobile texture of the image track. Obvi-ously, at all these levels, the concept of mobility also includes its polar opposite: rest, breaks, slowness, stillness, silence. Just as obviously, microcellular clusters of cinematic mobility are imbricated, to a greater or lesser degree depending on the type of film, with structures of narrational and narrated time.

Examples of such layered dynamics are prominent within experimental film, but they are also present in canonical films such as Orson Welles's *Touch of Evil* (1958), known for its alternation of long takes with fast-paced montages. Yet just as significant as its choreography of camera movement and character/object move-ment (especially in the opening sequence) is the film's remarkable sound design, in which wafts of pre-used popular music from both sides of the border (rumba, fox-trot, jazz, country and western) hover between diegetic and nondiegetic sources—that very undecidability foregrounded in shots of loudspeaker, car radios, and Marlene Dietrich/Tanya's pervasive pianola—while ambient noises and mechani-cal sounds (such as the tape recorder that traps Welles/Quinlan) rub against the de-dramatized yet almost self-parodistic voices of both these faded stars. A similar dynamic density can be observed in the films of Max Ophuls, in their sometimes harmonious, sometimes jarring interplay of fluid camera movement and that of characters (famously in dance and suicide sequences; cf. *Liebelei, Le Plaisir, Madame de . . . , Lola Montes*), and in their staging of musical performances and

recordings that range across a spectrum of "high" and "low" (cf. *Letter from an Unknown Women, La Signora di Tutti*). (In the latter case, Adorno's discussion of Mahler comes to mind.) We could prolong this list with examples from Kubrick, Antonioni, and a great variety of other and more recent work.

In "Transparencies," Adorno does not fully develop any of these possibilities of cinematic temporalization and mobility, except implicitly with his praise for *Antithèse*. On the contrary, he himself seems to fall back on a problematic blend of organic and mechanical rhythm when he invokes the analogy between music and film as temporal arts to describe the "a priori collectivity" of the cinematic subject, one that is based in the formal characteristics of film. "The movements that film presents are mimetic impulses. Prior to all content and concept, they incite [*animieren*] the viewer and listener to move along as if in a procession [*Zug*]. . . . As the eye is swept along, it joins the current of all those who are responding to the same roll-call [*Appell*]" (TF 203; FT 358–59).

One need hardly comment on the mixture of military and vitalist imagery to anticipate the critical argument that follows about the "ideological misuse" facilitated by this formal and vague collective appeal. By contrast, Adorno proclaims, "the emancipated film would have to wrest its a priori collectivity from the mechanisms of unconscious and irrational influence and enlist this collectivity in the service of enlightening intention" (TF 203–4; FT 359), that is, of self-reflexive reason.[117]

But how is the "emancipated" film to accomplish such refunctioning of cinematic collectivity without surrendering the possibilities of sensory immediacy and multisensorial dynamics available to film? For one thing, "mimetic impulses" are not necessarily the same as mechanically mediated physiological rhythm, and so a conception of cinematic temporalization on a par with contemporary music would precisely allow for imagining polyphonic and polyrhythmic processes that could make selective and reflexive use of both organic and mechanical rhythms. For another, Adorno himself suggests a different model of mobility when he proposes that film aesthetics should base itself on the subjective mode of experience he specifies as interior monologue or stream of associations, the sub- or semiconscious logic by which images (and thoughts) move "through" the subject. (In the following chapter, I show that this implies, to use Kracauer's idiomatic phrase, a subject with "skin and hair.") The mimetic impulses and collective dimension of the film experience would rest neither with the representation of an individual, particular stream of associations nor with the assumption of a universal, anthropologically invariable structure. Rather, they depend on the conscious, experimental inclusion of gaps, blank spaces, contingency, and slow time, that is, the construction of a filmic texture loose and porous enough to move viewers to mobilize their own associations, memories, and expectations. One could argue that if anything constitutes film's language character (in Adorno's sense of the term), it would be

this interplay between film and viewer, between the film on screen and what Kluge calls the "film in the spectator's head." The experience of having one's experience mobilized, given presence and presentness, would thus be the basis of film's a priori collectivity or, rather, in Kluge's sense of the word, its publicness.

This means, as I have already indicated, parting ways with Adorno on the question of reception, in particular his mistrust of that category as compromised by the culture industry and quantitative social science research methods. As Adorno resolutely maintained, "Artworks are the objectivations of images, of mimesis, schemata of experience that assimilate *to* themselves the experiencing subject" (*AT* 287; *ÄT* 427; emphasis added).[118] Kluge responds to this hypostatization of the artwork's autonomy and authority with a Marxian hyperbole: "The media are standing on their head"—they are merely the auteurist and corporate forms and conditions that feed on the labors of spectators and nonspectators alike. "It is *their* imagination that animates the screen." Less constrained by the differentiation and refinement of the traditional arts, "film takes recourse to the spontaneous workings of the imaginative faculty which has existed" approximately "since the Ice Age." These include "streams of images, so-called associations [that] have moved through the human mind, prompted to some extent by an anti-realistic attitude, by the protest against an unbearable reality"; their order is spawned by spontaneity, fantasy punctuated with laughter, memory and intuition. In a species-political variant of Bazin's "myth of total cinema," Kluge refers to this raw material of associations as "the more-than-ten-thousand-year-old cinema to which the invention of the film strip, projector and screen only provided a technological response."[119]

This "utopia of cinema" is not exactly what new media discourse frequently refers to as interactivity. The emphasis on film's affinity with experience—with everyday life, historical rupture, and people's efforts to reinvent themselves in the face of disjunctive and contradictory realities—is a pervasive concern in both postwar and new wave cinemas, and it places Kluge in closer vicinity with Kracauer's *Theory of Film*. By the same token, I have been suggesting that we can read Kluge's filmmaking and writings on cinema as an ongoing conversation with Adorno. This conversation can be traced in his persistent, idiosyncratic modernist stance, his citational use of secondhand music and popular illustrations, intellectual-affective montage clusters, "impure" crossings of fiction and documentary, professional and nonprofessional as well as improvisational modes of performance, differential speeds and rhythms, and the foregrounding of questions of temporality and history.[120] Nor would it be far-fetched to say that Kluge's thinking about cinema as a public sphere, and as a space in which different and multiple temporalities can be articulated and experienced, was dialectically prompted by the critique of the culture industry.[121] Likewise, Kluge's political, organizational, and institutional savvy—which was instrumental in fostering independent West

German cinema and which propelled him, from the mid-1980s on, to pursue the project of cinema through his prolific and idiosyncratic video work for television—translated into cultural praxis critical questions that Adorno had resolutely reserved for theory.

However, the point is not to install Kluge as the proof text for the fruitfulness of Adorno's aesthetics of film. The latter does not amount to a coherent theory, in the sense in which the different layers and ambivalent positions of Kracauer's writings on film—and even Benjamin's radical antinomies on technological reproduction and experience in modernity—can be construed to constitute a larger set of interconnected propositions. For Adorno, the aesthetic possibilities of and for film have to be gleaned from elsewhere, from his writings on art in general and music in particular. Through this recuperative project, his thinking about film in relation to larger questions of technology and artistic technique, the historic transformation of experience, image and writing, mimesis, natural beauty, time and movement, intermediality, collectivity, and reception still contains valuable impulses for film theory, critical analysis, and creative practice.

Kracauer in Exile

9

Theory of Film

MARSEILLE-NEW YORK

Theory of Film: The Redemption of Physical Reality (1960) could not place itself more squarely within the paradigm that seeks to derive the salient features of film from its being grounded in photographic, analog representation. In the preface to that book, Kracauer famously sums up the guiding assumption of his *"material* aesthetics" of film: "that film is essentially an extension of photography and therefore shares with this medium a marked affinity with the visible world around us" (*T* xlix).[1] This assumption not only circumscribes the nature of photography; it also delimits the medium of film by its dependence on photochemical processes—which, as Kracauer acknowledges up front, leaves out animation. If the "basic properties" of film are identical with those of photography, it follows that film "is uniquely equipped to record and reveal physical reality and hence gravitates toward it" (*T* 28). Therefore, "films come into their own" when they utilize this potential (*T* xlix).[2]

As clear and consistent as this proposition may appear, its key terms beg the questions, What does Kracauer mean by *affinity*? And how are we to understand the term *reality*? He defines the visible world he is concerned with as that of "actually existing physical reality—the transitory world we live in," but then goes on to list presumably synonymous terms: "'material reality,' or 'physical existence,' or 'actuality,' or loosely just 'nature.' Another fitting term might be 'camera-reality'" (related to "cinematic" or "filmic reality" and "camera-life") and, alternately, just "life," (*T* 28) or the "flow of life" (*T* 71–72). Yet film's affinity with the physical world—"nature in the raw"—also constitutes, because of its relative indeterminacy of meaning, a membrane for a range of cultural and subjective meanings. It thus gives rise to a fringe of "psychophysical correspondences," the "more or less fluid interrelations between the physical world and the psychological dimension" (*T* 68–69). As more recent commentaries on the book have argued, such conceptual slippages are not coincidental;[3] they are part of Kracauer's programmatic effort to describe the mixed, category-crossing, at once differential and indifferent experience that he thought film, more than any other medium, was able to convey.

253

Within cinema studies, *Theory of Film* ranks as a canonical work, one of the last, of so-called classical film theory, the body of writings on film ranging from Hugo Münsterberg in the 1910s through Balázs, Eisenstein, Epstein, Arnheim, and others during the 1920s and '30s, to Bazin in the 1940s–50s. This tradition is often taken to be primarily concerned with questions of ontology and medium specificity: What is the "essence" or "nature" of film? What can film do that other art forms cannot? And what kind of film practice succeeds best in utilizing the possibilities of the cinematic medium? More specifically, Kracauer's book is usually discussed in the context of postwar theories of cinematic realism, notably the work of Bazin and writings surrounding Italian neo-realism. Yet, unlike nineteenth-century concepts of realism centering on referential verisimilitude and formal closure that were invoked (more wrongly than rightly) by semiotic critiques of realist film theory, Kracauer's realism has a distinctly modernist inflection, emphasizing film's truck with contingency, indeterminacy, and endlessness, with the fortuitous, fragmentary, ephemeral, and ordinary.[4]

This version of cinematic realism resonates with germane strands in high Cold War culture, a period that saw new stirrings in various artistic media. Hence, it might be productive to think of *Theory of Film* as contemporaneous with the magazine *Film Culture* (which published two sections of the book in advance), the New American Cinema group (like *Film Culture*, cofounded by Jonas Mekas), and the emergence of independent venues of film production and exhibition with the breakup of the Hollywood studio system as well as the beginnings of academic cinematology;[5] with existentialism in philosophy and lifestyle, abstract expressionism and minimalism in the visual arts, and the aleatory music of John Cage; with Susan Sontag's essay "Against Interpretation," Miles Davis's *Kind of Blue,* and Lawrence Ferlinghetti's *A Coney Island of the Mind.* Beyond this habitat, Kracauer's book, like Bazin's writings, has to be considered as part of an international cineaste culture that inspired and supported new wave movements in France, Germany, Italy, Eastern Europe, Japan, India, and other parts of the world.

Whatever its subterranean resonances and impact may have been, *Theory of Film* became the object of critical demolition early on, long before digital technology presented a major challenge to what appeared to be its basic assumptions. Intellectual attacks on the book assumed an unusually condescending tone, from Pauline Kael's smug polemics against the author's Germanic pedantry (1962) and Andrew Tudor's labeling the book a "teutonic epic" (1974); through Dudley Andrew's indictment of *Theory of Film* for its normative ontology (1976) and "naive realism" (1984), and similar charges raised from a semiotic perspective in the pages of the British magazine *Screen;* to the German new-left/Critical Theory argument that, with the shift in emphasis to "physical reality," Kracauer had abandoned his earlier preoccupation with the cinema's relation to social and political reality.[6]

First off, let me stress that the book is anything but "utterly transparent" or "direct," as Andrew asserts, nor is it "a huge homogeneous block of realist theory."[7] On the contrary, much as *Theory of Film* strives toward transparency and systematicity, the text remains tantalizingly slippery and opaque, defying any attempt to deduce from it a clear-cut and univocal position.[8] If, as I believe, it still yields important insights, they do not depend on its status as logically consistent theory or, for that matter, on claims to transhistorical and transcultural validity. Rather, the book itself has something of the palimpsestic quality that Kracauer attributes, via Proust's famous passage likening the narrator's terrifying sight of his grandmother through the eyes of a stranger to photographic vision, to the "mental make-up" of the exile, shaped by rupture and the "near-vacuum of extra-territoriality," the fluid superimposition of responses to "the challenges of an alien environment" and older "loyalties, expectations, and aspirations" (*H* 83).

What *Theory of Film* offers us today, I contend, is not a theory of cinematic realism, but a theory of film experience and, more generally, of cinema as a sensory-perceptual matrix of experience—a project that links Kracauer on this side of the Atlantic with Robert Warshow and Stanley Cavell.[9] His concept of experience, though, is still inflected with the debate surrounding the category in the German context, in particular in the writings of Benjamin and Adorno. It may not be as radically ambivalent as Benjamin's, yet it is just as deeply bound up with the history—and barely overcome crisis—of modernity. What is more, the book seeks to theorize film as a paradigmatic mode of experiencing, of encountering and discovering, the world in the wake of *and beyond* that historic crisis. We therefore need to understand Kracauer's concept of realism within the larger framework of this heuristic and, broadly understood, phenomenological project.

In the following, I try to delineate this project through its historical and conceptual metamorphoses, its continuities and ruptures. In addition to situating *Theory of Film* in relation to Kracauer's Weimar writings, I touch on the book's early versions beginning in 1940–41, notably the Marseille Notebooks.[10] While this intermediate body of texts resonates with motifs of his early film aesthetics, in particular the strand I have described as gnostic-modernist-materialist, and at the same time points forward to the way these motifs are reframed and recast in the final version of the book, it has to be seen less as an evolutionary bridge than as a pivot, if not a territory of its own. Thus it helps us understand the distinctly different key of the book as published in 1960, which points in the direction of the posthumously published *History: The Last Things before the Last* (1969).[11] Read in the context of this late work, *Theory of Film* operates at a remarkable distance from, among other things, the critique of the culture industry associated with the Frankfurt School, for which Kracauer's own Weimar writings had been an important influence.

Kracauer's early writings on film are bound up with the dense and volatile history of the Weimar Republic, and the acute sense, shared by intellectuals on the left, that the outcome of the mounting political and economic crisis would prove exemplary of the fate of modernity. Even as his earlier lapsarian stance gave way to a greater openness toward the cultural phenomena associated with Americanism and simultaneously a more principled critique of ideology, the eschatologically tinged notion of *Weltzerfall*, or disintegration of the world, continued to structure Kracauer's thinking about film and photography—as media capable of advancing and registering disintegration in a material, sensorily graspable form, of archiving the disintegrated particles, and of reconfiguring them toward a different, as yet unknowable order. As this historic chance was systematically betrayed by dominant cinema and other mass media institutions, film and photography emerged as the crucial site at which the battle not only for a democratic Germany but over the direction of modernity, the "go-for-broke game of history," was being fought.

Theory of Film was published at a fundamentally different point in history: the all-out gamble of the historical process had been lost on an unprecedented scale, the catastrophe had happened, but the messiah did not come. With the triumph of fascism, brute nature did, to use an image from Kracauer's photography essay, "sit down at the very table that consciousness had abandoned" (*MO* 61). But fascism was eventually defeated, and Kracauer, in contrast with millions of others (including his mother and aunt), survived, though at the price of permanent exile. In the wake of postwar affluence and Cold War stability, the catastrophic features of capitalist-industrial modernity appeared increasingly regularized and containable (at least in the West). The view of history that arises from the pages of *Theory of Film* no longer ticks to the countdown of a self-destructing, self-sublating modernity, but keeps time with an "open-ended limitless world" and the apostrophized "flow of life." The subject that finds refuge in the movie theater no longer seeks an experience tantamount to the modernist assault on the subject, but has become the stoically cool, postapocalyptic "subject of survival."[12] Kracauer's attempt, in the in/famous "epilogue" to the book, to sketch "modern man's intellectual landscape" as littered with "ruins of ancient beliefs" (Durkheim) (*T* 287–88), could easily be construed as anticipating the postmodern, neoconservative topos of "the end of ideology" and related proclamations of *posthistoire*.[13]

It could be argued that history disappears from *Theory of Film* in a double repression: both at the level of theory, inasmuch as the specifically modern and modernist moment of film and cinema is transmuted into a medium-specific affinity with visible, physical, or external reality; and, in the same move, at the level of intellectual biography, in that Kracauer seems to have cut himself off completely from his Weimar persona and the radical "love of cinema" that inspired him then.[14] (With a few minor exceptions, there are no references at all to his earlier

texts, even in places, especially those concerning the "photographic approach," that clearly echo these texts, in particular the 1927 photography essay.)[15] This double repression has been linked to Kracauer's near-elision of the trauma around which his "psychological history of German film," *From Caligari to Hitler* (1947), still revolved more explicitly: the unimaginable, systematic mass annihilation of European Jewry. In *Theory of Film*, there are only a few explicit references to the Shoah, notably in the section entitled "The Head of the Medusa," which cites films made of the Nazi death camps as an example of how film, like Perseus's shield, could mirror unspeakable horrors "and thus incorporate into [the spectator's] memory the real face of things too dreadful to behold in reality" (*T* 306).[16] Proceeding from this passage, commentators have argued that the impossibility of representing man-made mass death—and yet the stubborn hope that film might be the medium to register that horror—constitutes the epistemic and ethical vanishing point of *Theory of Film*; thus the elided historical object of the book is not film as a phenomenon of late capitalism but, more specifically, the question of film after Auschwitz.[17]

The effort to restore this dimension of history in and to the book is supported by a look at the history *of* the book. For the project that was to become *Theory of Film* was actually conceived in the midst of the catastrophe, in extreme poverty and the shadow of certain death—"during those months [1940–41]," as Kracauer told Adorno in a later letter, "that we spent in anguish and misery in Marseille."[18] Like many other refugees, Kracauer and his wife, Lili, were stranded in the French port city waiting for papers allowing them to escape extradition by the Vichy government and to emigrate to the United States. Benjamin, whom Kracauer had known since 1924 and seen regularly during their years of exile in Paris, arrived in Marseille in mid-August and stayed through the end of September, up to his by now legendary premature suicide in the attempt to cross the Spanish border. During that summer, as Kracauer wrote to Adorno, he began taking "copious notes" toward a "book on film aesthetics" (*AKB* 445, 444), which Benjamin, shrewdly if a bit ungenerously, interpreted as a single-minded strategy of survival. Soma Morgenstern, novelist and former Vienna correspondent of the *Frankfurter Zeitung*, describes how he and Benjamin, on their way to the Préfecture, ran into Kracauer, seated in front of a café eagerly scribbling. At the end of the daily desperate conversation about expired transit visas and the never-arriving French exit visa, Morgenstern recalls, she asked Kracauer, "What will become of us, Krac?" To which the latter replied, without thinking twice, "Soma, we will all have to kill ourselves here"—and quickly returned to his notes. As they reached the Préfecture, Benjamin turned to Morgenstern and remarked: "What will happen to us cannot be easily predicted. But of one thing I'm sure: if anyone will *not* kill himself, it's our friend Kracauer. After all, he has to finish writing his encyclopedia of film. And for that you need a long life."[19]

If Benjamin (on Morgenstern's account) was right, and Kracauer's immersion in such a project at this moment of mortal danger represents an act of self-preservation, the strategy of disavowal involved was a rather curious one. For the gesture of disavowal that averts the gaze from the threat of annihilation onto the precious object that was to become a major book paradoxically embraces, in its conception of cinematic experience, the very undoing of fetishistic wholeness, perfection, and control. Kracauer incorporates the threat of annihilation, disintegration, and mortal fear into his film aesthetics as a fundamental historical experience. He also incorporates his by then dead friend's memory and legacy in the first major outline for the book, consisting of three fat notebooks begun on November 16, 1940, that is, after Benjamin's suicide and before Kracauer's own rescue. These notes take up Benjamin's vision of modernity at its bleakest, harking back to his early treatise *Origin of German Tragic Drama* and its aesthetics of allegorical mortification. This vision is adapted, however, not only to the medium of film but also to the prospect of confronting life after the apocalypse.

Kracauer did not return to the project until November 1948, after his narrow escape to the United States, after difficult years of settling in New York, after starting to write and publish articles in English as well as the *Caligari* book, which established his American reputation. Sources relating to this phase of the project include a "Preliminary Statement on a Study of Film Aesthetics" in English (November 6, 1948), a mixed English-German excerpt from the Marseille Notebooks (May 8–12, 1949), and a "Tentative Outline" dated September 8, 1949, typed with marginalia recording critical comments by Adorno, Rudolf Arnheim, and Robert Warshow, which also became the basis for influential suggestions by Erwin Panofsky and his "glowing letter" to Oxford University Press.[20] The first full-length draft of the book, 192 typed pages in English, was probably written in 1954, when Kracauer received another grant. While this lengthy essay contains some of the basic arguments of the later book, it does not yet forge them into generalizing oppositions (such as the "realistic" versus "formative tendency"). Kracauer did not try to systematize in this manner until 1955, in response to readings from film historian Arthur Knight and Eric Larrabee, his editor. Only then did he begin to organize and reorganize the material in what he referred to as his "syllabus," of which there are three draft versions and several schematic synopses. During this last phase, the process of revision assumes an anxious, if not obsessive quality that contrasts with the final text's aspiration to a detached, Olympian vision and its display of the well-turned, idiomatic phrase.

Had it been completed at a time closer to the stage of its conception, Kracauer's virtual book on film aesthetics—to the extent that it can be extrapolated from a wealth of heterogeneous and fragmentary notes[21]—would have gone a long way toward restoring the history that seems to have disappeared in the later book. Short of that, though, the way in which the virtual book both preserves and revises

the defeated, lost perspective of the Weimar essays allows us to reconsider key concepts of the book as published, in particular material reality, camera reality, and realism.

In the first section of the Marseille Notebooks, Kracauer appears to assert an unmistakable break with the concerns of his earlier writings on film and mass culture: "The dimension which really defines the phenomenon of film lies below the dimension in which political and social events take place" (*W* 3:529, 527). In a letter of October 1950, Adorno encourages Kracauer in this direction, stressing the supreme importance of theorizing film in terms other than the "conventional sociological sense," because in film we find "sedimented the most basic layers of the transformation of experience, all the way into [the sphere of] perception" (*AKB* 453). Since Adorno brings up Benjamin's "Little History of Photography" in the preceding sentence, we may assume that he is thinking of that transformation in Benjaminian terms, focused on technology and the masses. Kracauer, too, repeatedly emphasizes the function of film in relation to both these terms, in particular the role of cinematic movement, speed, and multiple and rapidly changing viewpoints in updating human consciousness and the sensorium to the level of technology; as well as film's affinity with the scale and movement of huge crowds and the experience of chance (as opposed to fate and providence), which gains significance with the "entry of the masses into history" (*W* 3:694).

However, the dimension "below" that of political and social events that Kracauer sees as defining the phenomenon of film takes that claim in a different direction. At the end of the introductory section, he ventures the following propositions: "Film brings the whole material world into play; reaching beyond theater and painting, it for the first time sets that which exists into motion. It does not aim upward, toward intention, but pushes toward the bottom, to gather and carry along even the dregs. It is interested in refuse, in what is just there—both in and outside the human being. The face counts for nothing in film unless it includes the *death's-head* beneath. 'Danse macabre.' To which end? That remains to be seen" (*W* 3:531).

To be sure, there are echoes of Kracauer's earlier writings: the imperative to register the seemingly insignificant and ephemeral, to archive the detritus of history; the iconoclastic penchant to deflate high-cultural pretensions and bourgeois-idealist values, social conventions and hierarchies, along with humanist fictions of the sovereign individual; the insistence on the photographic media's potential—and obligation—to enable, instead of disavowing, an awareness of mortality, otherness, and contingency. And yet the underlying concept of materiality gestures beyond the allegorical death's head toward a broader cognitive interest, which includes, however ambivalently in the later book, the realm of the physical and life sciences. The claim that film is the first medium to "set into motion" the material world in all its phenomenal manifestations—"that which exists," "what is just there—

both in and outside the human being"—is demonstratively indifferent to categorical distinctions between subject and object, between human and nonhuman, physical, physiological, and psychological, living and mechanical. Moreover, if, despite the taboo against positive utopian imagining, the Weimar writings still betray a yearning for an *Umschlag*, a radical turn, and occasionally even intimations of a "right order" (*MO* 62), the future projected in the Marseille Notebooks may be bleak, but it is remarkably open and unpredictable and "remains to be seen."

Kracauer's theorizing in the Marseille Notebooks has a different status from his effort, in *Theory of Film*, to define the essential "properties of the medium." The declared purpose is not to distill an ontology of film, but to "*grasp the phenomenon of film*" in its historical development and aesthetic multiplicity (*W* 3:527). In a letter responding to Panofsky's crucial suggestion to locate the constitutive antinomies of film in the medium of photography, Kracauer discusses the methodological problem involved in the analysis of "historical phenomena" (such as photographs), that is, the difficulty of "having to systematically foreground their inherent tendencies" as if they were "natural objects" rather than historical ones. Criticizing philosophical phenomenology for forgetting, in its concern with "timeless essences [*Wesenheiten*]," their historical quality, he sets himself the task "to blend the 'historical approach' with the 'phenomenological' one."[22]

If that effort eventually resulted in front-loading the book with a systematizing genealogy of photography, the introduction drafted in the Marseille Notebooks puts greater emphasis on the "historical approach" and reflects on the very project of *film history*—questions of collecting and archiving (the novelty of "*cinémathèques*"), the methodological difficulty of dealing with ongoing developments, the issue of film as art as well as canon formation. In the first three chapters, Kracauer was planning to explore the characteristics of film with recourse to early film history (in his demarcation, 1885–1918) and with preliminary remarks on the early sound film (1928–30), as periods in which cinema displays its most inventive impulses and enduring motifs. The way early cinema figures in this context differs strikingly from the analogous move, in *Theory of Film*, to derive "basic concepts" from the "two main tendencies"—"realistic" versus "formative"—respectively exemplified by Lumière and Méliès. It also elucidates the extent to which the question of film's referential relation to reality is still bound up, as in Kracauer's Weimar essays, with the historic restructuration of subjectivity—as part of an ongoing transformation and reconfiguration of social relations—and the increasingly problematic status of the autonomous subject.

Already the chapter headings—"Horses Galloping," "Archaic Panorama," and "Film d'Art"—signal a more inclusive and empirical approach. The example of animal locomotion films (he alludes to the experiments of Marey and Muybridge) serves Kracauer to highlight the cognitive and gnoseophilic dimension of film, its

ability to "penetrate the *material* dynamic world" beyond the range of the human eye and thus to register and inventory the "holdings" of that world (*W* 3:533–35). His fascination with early cinema's interest in "material movement" ("for its own sake," before any particular meaning) forecasts the more differentiating observations, in *Theory of Film*, on types of movement (the chase, the dance) and the role of nascent motion and the contrast between motion and stillness. In addition, he highlights the nonanthropocentric tendency of early cinema, its relative indifference to hierarchies between human and nonhuman, people and things. For Kracauer, the very diversity of genres, styles, and appeals—the mixture of actualities, scenics, reenactments, popular science films, magic and trick films, passion plays, acrobatic acts, pornographic views, broad-based physical farce, and chase films—conveyed a vision that treated the human figure as one attraction among a variety of sights, a "jumble" of animals, children, crowds, streets, natural disasters, and historic events, of inanimate objects come to life (like the pumpkins in *La course aux potirons* [Feuillade, Bosetti, 1907]). He singles out animated films, especially the work of Emile Cohl, for metamorphosing lines into human figures and spaces, of objects into people and vice versa, as a genre in which material movement and species- and category-crossing are aesthetically entwined (*W* 3:539, 541).

Kracauer's account of early cinema complicates the concept of the kind of reality that film is capable of engaging. The notion of the "material dimension"— the "material world" or "material existence"—is clearly more comprehensive than the concept of "physical reality" (indebted to Panofsky) that seems to govern the published book.[23] It does not reduce to the "visible world around us" (*T* xlix) but also involves other senses and media. Kracauer aligns the virtually limitless range of filmable world with the multiplicity and heterogeneity of basic cinematic materials: "the whole world in every sense: from the beginning film strove toward sound, speech, color" (*W* 3:559). (Some of his early notes on sound—noise, speech, music—have made it into the final book, in particular the remarkably prescient chapter on "dialogue and sound.")[24] Moreover, he understands cinematic materiality to include creations of fantasy: unlike the theater, "film mixes the *whole world* into play, be that world real or imagined." In addition to lighting effects, décor, and montage, he considers tricks and fast and slow motion as techniques by which film can materialize imagined worlds as well as real ones (exemplified by a genealogy from Méliès and Cohl to Mickey Mouse and *The Little Match Girl;* see *W* 3:569, 645–47).

Even when he addresses genres traditionally associated with photographic realism, Kracauer's concern is less with representational verisimilitude for its own sake than with film's ability to discover and articulate materiality, to enact "*the process of materialization*" (*W* 3:647). With regard to the use of décor in the fiction film, for instance, he rejects the naively realistic assumption that authentic props and settings alone guarantee a film's "conquest of the material dimension."

"It is not the authenticity of objects that matters, but the impression of authentic objects," an effect obviously enhanced by their photographic representation (*W* 3:643–45). Such formulations suggest that film's ability to create the "impression" of authenticity is as much a matter of stylistic choice on the part of the filmmaker as of the properties of the medium. At the same time, they shift the focus from questions of representation toward reception, to the question of how films engage the viewer in the "process of materialization."

Like other writers on film during the 1920s, Kracauer discerned in cinema a new mode of encountering the world, a perceptual experience that affected and mobilized the viewer in unprecedented ways. The materiality to which the cinema gave access was, first off, that of the historically transformed urban-industrial environment, a world in which, by the end of the nineteenth century, "dynamics" had become an "essential factor of the everyday" (*W* 3:555). While most palpable in particular areas, such as ordinary life in its uneven layers and speeds, materiality more generally refers to a realm of being that constitutes at once the object and the limit of intention, calculation, action, and control. It is thus associated with "the increasing impact of the contingencies of life" that Kracauer considered one of the features of "our historical situation"—contingency understood both as the uncertainty and dispensability of individual existence, and as equally unpredictable moments of chance and possibility.[25]

Film "enacts the historical turn to materiality," Kracauer asserts throughout the Marseille Notebooks, inasmuch as, like hardly any other art form, it confronts "intention with being." He sees the anti-idealist and intrinsically "class-conscious" impulse explicitly at work in early films that debunk social conventions and pretensions and that show aspects of life excluded from refined culture ("film looks *under* the table, which one is not supposed to do in better circles" [*W* 532]), a penchant for which Kracauer uses the shorthand *dégonflage*.[26] Above all, he discerns this impulse in the way in which the film experience undercuts the still revenant ideology of the sovereign, self-identical subject.[27] For the materiality film engages is not least that of the spectator—the human being "with skin and hair [*mit Haut und Haar*]." In contrast to the "referential subject of the theater," the spiritually defined and psychologically integrated individual, film involves its viewer as a corporeal being. "The material elements that present themselves in film directly stimulate the *material layers* of the human being: his nerves, his senses, his entire *physiological substance*." While traditional bourgeois theater maintains perspectival unity and tends to mediate emotional responses with consciousness, the cinema assaults the viewer with sensational, physical immediacy and multiple viewpoints, shattering the integrity of individual identity: "The 'ego' [*Ich*] of the human being assigned to film is subject to *permanent dissolution*, is incessantly exploded by material phenomena" (*W* 3:575–77).

Such formulations echo—and radicalize—similar ones in Kracauer's Weimar essays, for example in "Boredom," and resonate with the masochistic sensibility of his novels, in particular *Ginster*. From the perspective of later film theory, they could not be further from efforts, in psychoanalytic-semiotic film theory of the 1970s, to conceptualize cinematic spectatorship in terms of perceptual—imaginary, disembodied—mastery, identification, and subject effect (or, for that matter, from cognitivist conceptions of film viewing as an operation of "scanning," of processing hypotheses relevant for the construction of a story from the film's representational materials).[28] Rather, Kracauer ranks in an alternative tradition that situates the film experience in psychosomatic regions that elude symptomatic and symbolic analysis, a tradition that includes contemporaries such as Epstein; overlaps to some degree with biomechanical approaches (discussed in connection with Benjamin); plays a part in the conceptualization of early cinema as "cinema of attractions"; and more recently has resurfaced in film theory drawing on, among others, Deleuze, Guattari, Blanchot, and Merleau-Ponty.[29] For Kracauer, the valorization of self-shattering shock and sensation in the film experience was fueled by the hope, even in darkest times, that the cinema could stage, in an institutionally bounded form of play, encounters with a historical experience marked by rupture and displace-ment, fragmentation and reification, but also by the possibilities of self-alienation and alternative modes of engaging with the material world.

While Kracauer sought to ground his conception of spectatorship in early cinema, he was well aware that the materialist, sensationist, nonanthropocentric, and subject-demolitionist tendency was only one impulse among a wide range of genres and appeals (though he rightly took this very diversity to be contributing to that tendency). Within the spectrum of early films, he delineates a paradigmatic opposition between, on the one hand, slapstick comedy and, on the other, the *film d'art*, promoted by the production company of the same name and exemplified for Kracauer by (most likely a bad print of) its most famous example, *The Assas-sination of the Duke de Guise* (France, 1908). In the chapter on *film d'art* sketched in the Marseille Notebooks, the genre figures as the prototype of everything the Weimar critic had polemicized against, and everything he still considers antitheti-cal to the materialist capacities of film. This starts with the misplaced ambition, in the bid for the "privileged" and "educated strata," to legitimize film as art. Kra-cauer objects less vehemently to the choice of historical and literary subject matter than to the effort to impose on film the aesthetics of bourgeois drama (as distinct from the popular stage, vaudeville, and experimental theater), in particular the ideal of "classical tragedy" and its implication of a closed, purposefully organized, and meaningful world or cosmos, sealed by the law of fate (*W* 3:545, 547). Not coincidentally, the aesthetic principles he ascribes to *film d'art*—action centering on individualized characters and their goals, intelligibility, closure—overlap (and

were influential for) classical narrative cinema as it was being elaborated during that period in the United States and elsewhere.[30]

Kracauer's critique of *film d'art* concerns more than the stylistic incompatibility of filmic and theatrical registers on which it is narrowly focused in the final book (*T* 216–18). In the Marseille Notebooks, the genre functions as a metaphor for a historically obsolete, static, and anthropocentric regime of perception and experience. Kracauer characterizes the theatrical regime as wedded to the subject position of the "*TOTALE*" (capitalized in the original), playing on both the German term for long shot and the double meaning of *Einstellung* as both framing and attitude. In a literal sense, this refers to the tableau style of *film d'art*, which keeps the viewer at a fixed distance instead of dynamizing perception by means of camera movement and editing and expanding the scope of experience by ranging across extremes of scale (*W* 3:565–67). In a figurative sense, Kracauer's characterization of the "referential subject" of *film d'art* as the "human being in long shot" targets the ideology of an intentionally defined individual subject, unified by consciousness and representative of social—and human—totality (*W* 3:575, 555).

By contrast, the exemplary genre that allows for the "breakthrough of material events," and thus belongs to film's "basic layer" (*Grundschicht*), is slapstick comedy (*Groteske*), in particular the "primitive" variety that includes Max Linder and Mack Sennett and a few early Chaplin films (*W* 3:609). As we saw in Kracauer's Weimar reviews, slapstick comedy, with its clashes between human beings turned into things and objects assuming a life of their own, had ranked high in Kracauer's effort to theorize film as a discourse of modernity; it earned particular praise for offering a practical critique of, and relief from, the discipline of capitalist rationalization. When he resumes his discussion of slapstick in the Marseille Notebooks, he is no longer concerned with allegorical meanings, let alone critical ones. What matters now is the genre's systematic confrontation of intentionality with "material life at its crudest," "the shock troops of unconquered nature." The sole purpose of the slapstick genre is "to perform games in the material dimension" (*W* 3:613). With its "shocklike," "discontinuous" sequence of gags, which Kracauer compares to the "sputtering of a machine gun," slapstick comedy not only affects the viewer "with skin and hair," riddling idealist notions of subjecthood with the bodily mechanics of laughter, but also counters the protocols of narrative development and closure with patterns of seriality and potentially "endless action" (*W* 3:629–33).

The games slapstick comedy performs between people and things take place "on the brink of the abyss"; the genre engages, in ludic form, the threat of annihilation. "The leitmotif of slapstick comedy is the *play with danger, with catastrophe, and its prevention in the nick of time*" (*W* 3:609). The last-minute rescue in slapstick comedy, as Kracauer points out, is not brought about by divine predestination or

melodramatic coincidence, but simply by *chance,* by sheer accident—the same principle that sets into play the anarchic transactions between people and things in the first place. Like shock, chance is a historical category, one of the signatures of modernity; it arises with the exponentially increased significance of the masses, their circulation in urban spaces and new entertainment venues—the street, movie theaters—and the emergence of a new type of public sphere that is unpredictable and volatile (see *W* 3:694–99). Kracauer's notion of chance, which affiliates him with the surrealists, abstract expressionism, and the aleatoric aesthetics of John Cage, is part of (and only part of) his concept of contingency, which names unforeseeable possibility as well as uncertainty and lack of control ("accidents superseded destiny; unpredictable circumstances now foreshadowed doom, now jelled into propitious constellations for no visible reason" [*T* 62]). Chance alone provides the tiny window of survival, both hope and the obligation to continue living after the catastrophe, after the grand metaphysical stakes have been lost along with everything else.

It is important to note that, as in his Weimar writings on Chaplin, Kracauer links the comic rescue in the nick of time to the rescue in the fairy tale, the hero's escape against all odds, the counterfactual victory of the weak and powerless over brute force (David versus Goliath). In both genres, the rescue is a happy ending under erasure, containing both the image of utopia and its impossibility, but also the realization that the world "could be different and still continues to exist."[31] In the Marseille Notebooks, Kracauer reads the happy endings of Chaplin's films as an injunction saying "we must go on living" (*W* 3:707), an injunction that entails rethinking the conditions of existence and experience.

While the emphasis on chance and Kracauer's defense of happy endings under erasure have survived in *Theory of Film* (as has the David-versus-Goliath motif), slapstick comedy no longer commands the paradigmatic significance it had in the Marseille Notebooks. The fact that the genre seemed to have come to an end with the silent era—a point Kracauer dwells on in relation to the question of sound—is not the only reason for this shift. Rather, the genre's gamble with catastrophe, like the idea of the turn to the photographic media as the "go-for-broke game of history," could no longer be thought through to the end, much less imagined on the level of aesthetics. What is marginalized along with slapstick comedy is Kracauer's earlier preoccupation with death, with film's ability to stage encounters with mortality and otherness. The mandate for film to "include the death's head beneath the face," the allegorical legacy of Benjamin's *Trauerspiel* book, had presided over the Marseille project as an epigraph and had persisted in later outlines as a never-realized final chapter—to be called, variously, "Kermesse fune`bre," "Danse macabre," or "The death's head" and centering on Eisenstein's Mexican material—that would "not only summarize the whole of the book but formulate certain ultimate conclusions."[32] But by January 1955, Kracauer's contents page has

replaced this chapter with the now familiar "Epilogue," subtitled "The redemption of physical existence."

CINEMA AS HISTORY'S ANTEROOM

The historic event of the Shoah had irrevocably changed the terms under which film could still be theorized as a publicly available medium for experiencing and reflecting on the obsolescence of bourgeois ideals of autonomous subjectivity. If the death of the subject, heralded by radical modernists, still referred to a nineteenth-century conception of the individual, the industrially planned extermination of a collective subject, an entire genus, made such thinking, at the very least, seem incommensurate. Where Adorno insisted vis-à-vis Kracauer on the fundamental unrepresentability, in the register of the image, of "the complex instantiated by the word *Auschwitz*" (*AKB* 688) and famously made the question of the possibility of poetry after Auschwitz central to his aesthetics of negativity, Kracauer sought to reimagine the conditions of possibility of experience for the "shrinking self" (*T* 170) through the specific encounter with concrete physical reality enabled by film.[33] However, this turn to the object world was motivated as much by the need to ascertain its continuing existence as by the photographic media's potential to transform and render it strange, so as to allow us to perceive that world as both "given and yet ungiven" (*T* 298).

By devoting the entire introduction to *Theory of Film* to photography, that is, still (and presumably black-and-white) photography, Kracauer seems to be taking a step beyond and away from the Marseille project, with its emphasis on movement and the process of materialization.[34] At the same time, he returns—up to a point and, as he claims in *History*, unwittingly—to his 1927 essay "Photography." As we saw in chapter 1, that essay links its critique of photographic positivism in contemporary media culture with an argument in which the very negativity at the core of the medium, the problematic indexicality eternalizing the random moment of exposure, turns into a countervailing potential with the aging of photographs. The dissociation of the photograph from the living, remembered referent and from validating contexts of display, which Kracauer traces in the domestic sphere through the portrait of a/the grandmother as a young woman, provokes in the beholder/writer a self-alienating confrontation with his own contingency and mortality. In the panoramic view of history's vast assemblage of outdated photographs, this dissociation has spawned a general archive of nature alienated from meaning—an archive that can be mobilized, repurposed, and reconfigured by film.

Kracauer resumes the argument about photography's alienating and disfiguring effects in *Theory of Film* by way of another grandmother, already mentioned—the narrator's grandmother in Proust's *Recherche*. (This is part of an extended con-

versation with Proust that continues through *History*.) To illustrate his notion of the "photographic approach," he quotes a passage from Proust's *The Guermantes Way*, in which the narrator, after a long absence, enters the drawing room of his grandmother unannounced. Instead of the beloved person, he sees "sitting on the sofa, beneath the lamp, red-faced, heavy and common, sick, lost in thought, following the lines of a book with eyes that seemed hardly sane, a dejected old woman whom I did not know" (*T* 14). Proust's narrator refers to this terrifying sight of his grandmother as a photograph, the opposite of a vision charged with love, intimacy, and memory. The arbitrary, split-second exposure of the photographic apparatus epitomizes the view of an "impersonal stranger" (*H* 83); it momentarily displaces the "unseeing lover" with the photographer's "indiscriminating mirror" (*T* 15).

Kracauer considers Proust's account "one-sided" for a number of reasons. He objects to the notion that photographs "mirror" nature, given the metamorphoses involved in framing, the transfer of three-dimensional phenomena to the plane, of color to black-and-white, and so forth. More important, he argues, Proust ignores the extent of spontaneous and unconscious structuring at work in the photographer's no less than our own ordinary cognizance of visible reality, a function that in the case of "almost automatically" obtained photographs—the limit case being aerial reconnaissance photos—is assumed by the spectator (*T* 15). Nonetheless, Kracauer stresses Proust's insight into the disjunctive, alienating moment of photography, the blind spot of machinic recording that unsettles and defies our habitual modes of seeing or, rather, not-seeing. And he links the alienating effect of the photographic approach to a psychic disposition of melancholy and self-estrangement (an observation that Rudolf Arnheim, in his review, took to be the key to—and problem with—*Theory of Film*).[35] This disposition combines the photographer's emotional detachment from himself and others with a receptivity that advances "identification with all kinds of objects": it makes the individual "lose himself in the incidental configurations of his environment, absorbing them with a disinterested intensity no longer determined by his previous preferences" (*T* 17).

However, when Kracauer invokes the same passage in *History*, he differs from Proust on yet another count. He refers to the narrator's re-entry of the scene as the "loving Marcel"—the "reinstated complete" self that resumes control by falling "back on ideas which he entertained of his grandmother prior to her transformation into a photograph"—to throw into relief, by contrast, the historian's effort to assimilate "to himself the very reality which was concealed from him by his ideas of it" (*H* 92–93). The point is not to adjudicate between the truths of either habitual or estranged vision but to allow them to become "superimposed," to make one's mind a "palimpsest" (*H* 83). This is to say that the "near-vacuum of extraterritoriality," the exilic experience of nonbelonging that Kracauer projects onto Marcel's momentary sense of estrangement, makes the spatial threshold of

displacement simultaneously one of temporal discontinuity, granting the histo-
rian—and, I would add, the film viewer—the possibility of keeping "his identity
. . . in a state of flux" and moving between different layers of time "without a fixed
abode" (H 93).[36] (It should be added, though, that elsewhere in History Kracauer
recognizes the Recherche precisely for "grappl[ing] with the perplexities of time"
[H 160] and for floating between the narrated pasts and the time of narration in
ways that often leave the temporal location of the narrator's observations open [H
78], an undecidability he links to the writer's professed inconsistency or "incoher-
ence" of mind and multiplicity of selves [H 147, 160]).

The concept of alienation—Entfremdung here sliding into Verfremdung,
estrangement or defamiliarization—was, of course, a staple of modernist thinking
in the 1920s, notably in the work of Brecht and the Russian formalists and often
coupled with the political project of confronting the reader/spectator with actual
conditions of alienation and reification. Likewise, artistic devices of disruption and
estrangement were strongly indebted to the principle of montage as epitomized in
Soviet avant-garde cinema. Kracauer, too, in the photography essay, had pinned
his hope on the potential of film to radicalize photographic negativity by means
of constructive and syntactic procedures, in particular fragmentizing framing and
discontinuous editing.

In Theory of Film, however, he foregrounds the opportunities or "chances for
alienation" at the level of the shot.[37] Unlike Eisenstein, who is the subject of a
running argument in the book, Kracauer does not consider this montage effect
within the shot as a compositional device (such as, for Eisenstein, the creation of a
graphic conflict within the frame),[38] but as an effect of de-composition—of a fissure
between psyche and physis that is made visible by the photographic apparatus and
that is key to what Kracauer means by "camera reality." The difference that erupts
within the image is not one between minimal units within an oppositional system
of signs (as in semiotics), but one between the realm of discourse and that of mate-
rial contingency, between the implied horizon of our "habits of seeing"—shaped
by language and circulation, by social, cultural, and representational regimes—and
that which momentarily eludes and confounds such structures.

The photographic qualities that bring such disjunctures into play register at
the level of the film experience, in the embodied perception of the viewer. In
the 1960 book, the Marseille Notebooks' extensive reflections on the "referential
subject" of film are distilled into a single chapter, "The Spectator," and the notion
of the "basic layer," which in the 1940s included the human being with "skin and
hair," is ontologized into "basic properties of the medium." Still, when Kracauer
lists one aspect and example after another of film's affinity with "physical existence"
or "physical reality," he more often than not describes these qualities in terms
of their effect on the viewer, that is, the empirical instance of the fractured,
"shrinking" subject.

In the chapter "The Spectator," Kracauer continues to stress the physiological impact of film, including moments of shock, panic, and suspense, and kinesthetically induced muscular reflexes. Whether through the "compulsory attractiveness" of movement, the impact of material phenomena never seen before or never seen this way, or the "sheer presence" of images that urge the viewer "to assimilate their indeterminate and often amorphous patterns," the film experience involves "not so much his power of reasoning as his visceral faculties," his "sense organs" (not just vision and hearing), as well as "his innate curiosity" (*T* 158–59). Like drug addicts, the "habitués" who frequent the cinema do so "out of an all but physiological urge," less the desire to see a particular film or be entertained than a craving "for once to be released from the grip of consciousness, lose their identity in the dark, and let sink in, with their senses ready to absorb, the images as they happen to follow each other on the screen" (*T* 159–60)—cinephilia at its most minimalist, though no doubt part of Kracauer's own "incoherent," palimpsestic self. This kind of film experience is hardly one of identification with individual characters and the narrating gaze of the camera but describes, in a more bodily pre- or subconscious register, a form of mimetic identification that pulls the viewer into the film and dissociates rather than integrates the spectatorial self. "In the theater I am always I," Kracauer quotes an anonymous French woman saying, "but in the cinema I dissolve into all things and beings."[39]

Analyzing the pervasive trope of the film experience as a dream (had he been as experimentally inclined as Benjamin, he might have added the hashish experience), Kracauer distinguishes two directions of dreaming. The viewer's self-abandonment, dissolution into and incorporation of "camera-reality" also encourages a perceptual movement away from the film, for instance, when a material detail assumes a life of its own—as in Blaise Cendrars's account of seeing an ordinary cap turn into a leopard " 'all set to jump' "—and triggers in the viewer associations, "memories of the senses" that return the "absentee dreamer" to forgotten layers of the self (*T* 165–66). The interplay between these two dream processes— "cataracts of indistinct fantasies and inchoate thoughts"—makes for a "stream of consciousness," in which the images on the screen mingle with the viewer's private associations and the shared historical "image worlds," to use Adorno's (Warburgian) term. Structurally, Kracauer argues in a somewhat circular fashion, the spectator's stream of consciousness "in a measure parallels the 'flow of life,' one of the main concerns of the medium." It thus follows that "films featuring that flow are more likely to initiate both movements of dreaming" (*T* 166).

The private stream of associations that the spectator interweaves with the film exceeds—yet has its basis in—the more objective, intersubjective dimension of "psychophysical correspondences" that Kracauer considers an essential part of the material world that film "assists us in discovering" (*T* 300). He attributes these correspondences to factors that encompass the object depicted, its forgotten history,

as well as cinematic techniques of framing, lighting, and editing. First off, there is the photographic concern with natural objects ("nature in the raw") that, alienated from their pragmatic context, are "surrounded with a fringe of indistinct, multiple meanings" and thus import an inevitable degree of indeterminacy into the image (T 20). (It seems useful here to recall Adorno's discussion of "natural beauty" and the "radical naturalism" available to film; cf. chapter 8, above.) Kracauer goes on to speculate that some psychophysical correspondences may have a foundation in the traces that the mind, habit, events, and experiences may leave in faces and objects, a mysticist-physiognomic line of thought echoing Proust (T 68–69).

For both Kracauer and Benjamin, the only viable method of adapting the magic of Proust's madeleine for postbourgeois society is through the alienating intervention of technology. The gaze that material objects—furniture, clothes, architecture—are capable of returning in certain films may "spirit" the viewer "away into the lumber room of his private self" (T 56), but this room is a historical space and thus part of a collective memory space. The return of the gaze is enabled by cinematic techniques that lead us "through the thicket of material life"; they disclose "hidden aspects of the world about us" and, by the same token, "alienate our environment by exposing it" (T 48, 55). In a passage that explicitly invokes Benjamin's "optical unconscious," Kracauer singles out the metamorphosing power of extreme close-ups: "Any huge close-up reveals new and unsuspected formations of matter; skin textures are reminiscent of aerial photographs, eyes turn into lakes or volcanic craters." Such shots, however, do not reveal to the viewer hidden aspects of the depicted person's character (as they would for Balázs); instead, they affectively superimpose upon the face a larger, alien, nonanthropocentric world, "opening up expanses which we have explored at best in dreams before" (T 48). In other words, the viewer's imagination becomes an important part of the projection, rather than simply a function of representation.[40]

If Kracauer's notion of "psychophysical correspondences" gravitates toward the melancholy and haunting side of the historical experience resonating in them, this no longer entails a sense of crisis, as do the instances of demonic self-confrontation one finds in his Weimar writings and, for that matter, Benjamin's emphasis on the element of self-alienation in auratic experience. The alien *physis* may still return the gaze and may jolt the viewer by way of a long-forgotten past, but the wounding, unsettling effect no longer translates into allegorical meaning. Kracauer repeatedly invokes Proust's image of the "ghostly trees that seem to impart a message to him," an image he adduces to distinguish the "material continuum" of life that film is able to convey from the mental and language-bound continuum of the novel: "[Proust's] affinity for the cinema makes him sensitive to transient impressions, such as the trees which look familiar to him; but when he identifies the trees as yet undeciphered phantoms of the past 'appealing to me to take them with me, to bring them back to life[,]' he exchanges the world of cinema for dimensions

alien to it" (*T* 238–39).[41] Kracauer wants those trees to remain trees, rather than "rebuses" or decipherable messages. Cinema, like no other medium, can register material phenomena in their otherness, their opaque singularity. "Snatched from transient life, [these ideograms] not only challenge the spectator to penetrate their secret but, perhaps even more insistently, request him to preserve them as the irreplaceable images they are" (*T* 257). Preserving such images for memory comes closest to what I take Kracauer to mean by *redemption*.

During the Weimar period, his attention to the surface, as the site where contemporary reality appeared in an iridescent and contradictory multiplicity, was still coupled with the ideal of "transparency" (a term as much of psychotheological as hermeneutical valence); accordingly, the project of registering and transcribing the surface phenomena of quotidian life was often linked to allegorizing readings aimed at deciphering the historico-philosophical direction of modernity or a critique of ideology, or both. In *Theory of Film*, Kracauer is concerned with surface reality—reality that "cling[s] to the epidermis of things" (*T* 206)—for its own material qualities and experiential possibilities. The notion of the "flow of life" evokes not only the multiplicity, mobility, and mutability of things but also a degree of indifference to sense and legibility. Yet, to use Friedrich Kittler's words, this "return of an opaque thisness" enabled by technological recording should not be taken for a romantic "nostalgia for life as such" (*T* 169); nor is it, as Adorno imputes, a yearning for "things" in a "state of innocence."[42] The fringe of indeterminacy that surrounds "camera reality" is as much a product of overdetermination as it is one of underexposure: it is the aura of history's vast archive of debris, the snowy air reflecting the perpetual "blizzard" of media images and sounds.

Commenting on the photography essay, Mary Ann Doane links Kracauer's alarm over "photography's and film's inscription of a spatial and temporal continuum without gap, of a 'blizzard' or 'flood' of images," to widespread "anxieties of total representation generated by the new technological media." This may or may not have been the case for Kracauer in 1927, but in the 1960 book, (early) cinema's assumed penchant for what Doane calls "hyperindexicality," its striving "for the status of total record" and "refusal of a distinction or differentiation that would insure legibility," provokes anything *but* anxiety.[43] The late Kracauer's anti-hermeneutic stance is linked to a remarkable stoicism, a disposition that Heidegger around the same time referred to as "Gelassenheit."[44] This disposition makes him confront with equanimity the "cooling process" of the world, which joins him to what Helmut Lethen has described as "ice-age folklore," referring to the topos of coldness in avant-garde intellectual discourse on modernity from the 1920s on.[45] The second law of thermodynamics, which Kracauer invokes in the book's epilogue, is irreversible; the blizzard will never cease; but occasionally, the snow will melt, or reconfigure itself, and may reveal random coincidences and "unforeseeable possibilities" (*T* 295, 170).

This anti-hermeneutic and stoic stance is only one of the implications of the "flow of life," as Kracauer deploys the metaphor. Indirectly, through the early French film theorists he has read and cites, *Theory of Film* is inflected with Bergsonian thinking (just as his early writings owe much to Simmel), though I would hesitate to call his stance vitalist.[46] Kracauer's insistence on the concreteness of camera reality versus the abstractness inflicted on our perception by modern science may echo the old vitalist complaint about the mechanist reduction of life, but his notion of the flow of life does not hinge on that opposition; besides, he links the possibility of seeing and experiencing life in its concreteness to its refraction through the cinematic apparatus. The flow of life contains the ripple of leaves stirred by the wind as much as the ever-changing patterns of anonymous crowds in the street, the circulation of urban traffic, people-mobilizing machines such as roller coasters, the "thicket of things" both natural and mass-produced, "the ordinary business of living" (*T* 304) along with the dread of the "normally hidden whirlpool of crude existence" (*H* 108).

In *History,* the flow of life seems largely synonymous with Husserl's concept of *Lebenswelt,* or life world, the given world that subjects inhabit and may experience together (that is, neither the world of the physical sciences nor the phenomenal environment immanent to consciousness).[47] Kracauer explicitly—if idiosyncratically—adapts Husserl's concept in his effort to sketch the elusive qualities of historical reality through the parallel with "camera reality," and the methodological problems of historiography with recourse to the "photographic approach." Camera reality, he declares, "has all the earmarks of the *Lebenswelt,*" the "practically endless, fortuitous, and indeterminate" world of daily life "as we commonly experience it" (*H* 58, 194). The parallel between historical reality and camera reality pertains not merely to its virtually infinite contents—which include the subjects and practices of having a world and experiencing, analyzing, and conceptualizing it—but also to its general constitution and structure: "It is partly patterned, partly amorphous—a consequence . . . of the half-cooked state of our everyday world" (*H* 58).

Thinking about flow of life in terms of *Lebenswelt* helps us to better understand several important strands in Kracauer's film theory. In addition to the crucial inclusion of the embodied subject in his concept of material reality discussed earlier, the account of camera reality in terms of the structural constitution of the life world throws into relief its "nonhomogeneous," unevenly textured, both over- and undercoded, multiperspectival make-up; it places film in the "intermediary," "inherently provisional" area he designates as "anteroom," which "eludes the grasp of systematic thought" as much as the pressure to become art (*H* 191–92). I would argue that the "side-by-side" (*H* 216) existence and interpenetration of natural objects with mechanically produced and historically inscribed ones; of indeterminate shapes and movements, unauthored processes, and transient patterns with intentional actions, discursive utterances, and formulaic gestures; of

THEORY OF FILM 273

the strange with the familiar, the accidental and provisional with the planned and choreographed must have played a more significant role in Kracauer's fascination with the filmic medium than photochemical indexicality (problematic for him at any rate), to say nothing about evidentiary truth claims made for "pictures taken on the spot" (*T* 161). This seems to me the gist, elaborated only in *History*, of his revision of Proust's passage on seeing his grandmother as a photograph in terms of a superimposition or palimpsest—rather than a dichotomy—of habitual with photographically alienated vision in which the line between these states remains in flux. As in that example, the conception of camera reality in terms of the non-homogeneous texture of the life world crucially includes a temporal dimension; it assumes the coexistence of different and competing speeds and layers of time, encompassing both the "zone of inertia" (*H* 22–23) in the ordinary life of groups and institutions and the "cataract of times" (*H* 199) in which we live, due to the accelerated pace of circulation and the dynamics of technological innovation. (Not least, Kracauer was interested in the imbrication of different speeds and temporalities, of natural history and human history, as a point where the projects of the life sciences and the *sciences humaines et sociales* intersect.)[48]

It is not surprising, then, that Kracauer foregrounds the ecological and collective implications in the concept of *Lebenswelt* (the world that is "our" world, a world "for all," by the practice of "living together"[49]), in particular when he quotes the French philosopher Gabriel Marcel as attributing to film "the power of deepening and rendering more intimate 'our relation to this Earth which is our habitat'" (*T* 304).[50] The capital spelling of *Earth* (also in the French original), stresses the at once natural and cultural, historical and global dimensions of this habitat. Not unlike Brecht, who writes of "this star" besides which "there is nothing" and which, in all its devastation, is nonetheless "our shelter," Kracauer clearly distinguishes this attitude from one that considers the earth homey or "comfortable."[51] Visualizing, imagining, cognizing, and acknowledging this universe—in its profound unevenness as well as material interconnectedness—is at once an impossible desire, an epistemological challenge, and a necessity.

In *History*, Kracauer links this insight to the methodological problem of the traffic between micro and macro levels of historiography—Toynbee's idea of a "merger of the bird's eye and the fly-eye view"—a difficulty that he takes to be *insurmountable* given the nonhomogeneous structure of the historical universe qua *Lebenswelt* and the constitutive incommensurability of these levels (*H* 126–27). Again drawing on *Theory of Film*, he seeks to illustrate the "law of levels" in terms of the phenomenon of cinematic scale, the "paradoxical relation," in narrative films, between close-ups and long shots, between extreme close-ups and (panoramic, aerial, static or traveling) extreme long shots. There is no single stable vantage point from which different distances can be grasped: "The big can be adequately rendered only by a permanent movement from the whole to some detail, then

back to the whole" (*H* 122). Above and beyond the "recording" and "revealing functions" of such shots, Kracauer's emphasis on film's ability to establish physical reality by means of extreme scales—to lend the isolated object or detail a life of its own or to show the vastness of landscapes and enormity of catastrophes both elemental and man-made—suggests that he valorized the cinematic imbrication of scalar extremes as a mode of vision that exceeds "normal" human, phenomenal vision. It thus allows us to move through, concretely experience, and confront a heteronymous material world, a world that is as open-ended and unknown as it is deeply scarred.[52]

Finally, Kracauer's conception of film in terms of its affinity with the uneven, nonhomogeneous texture of the life world also helps to elucidate his stance on narrative. He is undoubtedly one of the major theorists of the nonnarrative aspects of cinema, a tradition that runs from the phenomenological and physiognomic, vitalist and surrealist approaches of the interwar period, often entwined with the notion of *photogénie*, through later work by writers as diverse as Gilles Deleuze and Tom Gunning. Since the 1970s, the relationship between narrative and its other—be it spectacle, performance, attraction, gag, or excess—has been discussed in a number of constellations, with a focus on questions of how and to which extent nonnarrative elements are integrated by the narrative or suggest a conception of cinematic pleasure different from the narrative economy of classical films. (More recently, similar questions have resurfaced in connection with the immersive and impact aesthetic of digital films and, for a different *dispositif*, in video game theory; thus, proponents of ludology have been challenging and modifying narratological approaches and are seeking to develop alternative concepts—worldmaking, experience-design, and the like—that set aside the binary structure of earlier arguments.)[53]

From the Marseille Notebooks to the published book, Kracauer complicates the understanding of narrative and nonnarrative as binary opposition. The narrative fiction film (*Spielfilm*) is a "problematic genre" inasmuch as it is caught in a "genuine antinomy." On the one hand, its action tends toward "endlessness," the expectation that the world, actual or implied, continues beyond the frame, not just spatially but also in a temporal sense (as in the case of performance that draws on the actor's accumulated life history, his "nature"). On the other hand, qua "theatrical" or dramatic narrative, it is guided by the principle of a finite, purposively organized totality, a "cosmos."[54] If the latter, by imposing a closed structure on the open-ended flow of life, overwhelms the former, "material phenomena lose their function as bearers of action"; film no longer reaches into the "basic layer" of material reality (like the mythical giant Antaios, who kept drawing invincible strength from touching earth until Hercules lifted him off the ground), and thus fails to meet its basic obligation "to take along" that which exists, material being (*W* 3:621, 673, 675, 822).[55]

Yet Kracauer can hardly be said to advocate narrative abstinence; he recognizes, and acknowledges, the phenomenal multiplicity and necessity of storytelling, of structures organizing time and space, affect, thought, and action. For one thing, even the films he considers "cinematic" do not exhaust themselves in capturing "small material phenomena," nor does he think that fleeting impressions, overwhelming sights, or the alienation of sights too familiar can "be expected to fill the bill" (T 271). For another, any film literalizing the medium's "chimerical desire to establish the continuum of physical existence"—Kracauer cites Fernand Léger's idea of a "monster film . . . record[ing] painstakingly the life of a man and a woman during twenty-four consecutive hours"[56]—would expose everyday life's "widely ramified roots in crude existence" and send us into a state of horror and panic (T 63–64).

The opposition of narrative and nonnarrative constitutes a polarity, as Philippe Despoix and Nia Perivolaropoulou have pointed out with regard to the more familiar conceptual pair of the "formative" versus "realistic tendency," though that polarity is an asymmetrical one.[57] While clearly invested in having the balance tipped toward the pole of realism, what interests Kracauer is how narrative films engage with the dialectical tension generated by its antinomies, how they seek to resolve a "dilemma" that is by definition irresoluble. He praises D. W. Griffith for his "admirable nonsolution," in particular the insertion of "huge images of small material phenomena [that] are not only integral components of the narrative but disclosures of new aspects of physical reality" (T 231, 48). He repeatedly invokes the close-up of Mae Marsh's hands in Intolerance, which makes us "forget that they are just ordinary hands": "isolated from the rest of the body and greatly enlarged, the hands we know will change into unknown organisms quivering with a life of their own" (T 48). What such semi-autonomous details succeed in summoning is not exhausted by a functionalist concept of "motivation," whether realistic, artistic, or compositional.[58] Their "intoxicating effect" derives from moments of indeterminacy and contingency, a material dynamics that exceeds narrative and diegetic motivation. "Street and face . . . open up a dimension much wider than the plots which they sustain" (T 303). In a similar vein, and with an enthusiasm that echoes his 1926 review, Kracauer praises Battleship Potemkin for "breath[ing an] allusive indeterminacy" in many shots—the rising mists in the harbor, the sleeping sailors, the moonlit waves—and, of course, the "suggestive rendering of physical events" on the Odessa Steps that evoke fragmentary micronarratives, haunting images that do not care whether Eisenstein thought of them as elements in a five-act tragedy (T 226–27; also see 208).[59]

If physical events and details are essential to make narrative films "breathe," narrative structures are in turn part of camera reality qua Lebenswelt. "Since this contingent and indeterminate reality is partly patterned, . . . stories, or fragments of them, can easily be discovered in it" (H 181). Accordingly, Kracauer extols

loosely composed, "porous," "permeable," open-ended forms such as the episode film and the found story, types of narrative that leave "gaps into which environmental life may stream" (*T* 255); and he gives qualified approval to the convention of "happy" or, more precisely, "nontragic," "provisional" endings (*T* 268–70). In addition to canonic examples from Italian neo-realism, he cites the situational and serial gag structure of comedy and the "sensational incidents" of melodrama that allow films to preserve a "relative autonomy of [their] parts" (*T* 272). But he singles out the genre of the musical, with its alternation of narrative and numbers and its improvisational effects (e.g., Astaire's bricolage numbers), for "materializ[ing]" the conflict between film's antinomic vectors in its "very form," offering a "fragmentized whole" rather than a "false unity" (an argument that includes examples from integrated musicals such as *The Band Wagon*). In an almost Greenbergian gesture, Kracauer observes that musicals "reflect tensions at the core of the cinema" (*T* 148), in particular, "the dialectic tension between the story film and the nonstory film without ever trying to resolve it."[60] "Penelope fashion, they eternally dissolve the plot they are weaving. The songs and dances they sport form part of the intrigue and at the same time enhance with their glitter its decomposition" (*T* 213).

In Kracauer's example from *Intolerance,* such decomposition already happens at the level of the shot—a point I discussed earlier with regard to Kracauer's notion of photographic alienation. In terms of narrative and character psychology, Mae Marsh's quivering clasped hands belong to a character fearing for her husband's life; stylistically, they join a host of emblematic close-ups, often discontinuous with diegetic space and time, that I take to be a salient feature of *Intolerance*.[61] But in Kracauer's reading they come to designate a dynamic that runs alongside the narrative, an associative concatenation of photographically alienated things or beings—"the procession of environmental phenomena flowing across the screen"[62]—that opens out on a stranger, nonanthropocentric landscape; it is no coincidence that Kracauer cites this shot in *History* to illustrate the basic incongruity of micro and macro levels (see *H* 126). The disjuncture in play is as much temporal as spatial: summoned by a close-up or heterogeneous fragments, "strange shapes shine forth from the abyss of timelessness" (*T* 235).

Indifferent to the narrative design of Griffith's film (a precarious one to begin with), this "action below the action" (*W* 3:522) has a centrifugal dynamic. Much as the film—and, to different degrees, any film—seeks to direct our attention, it simultaneously allows the viewer to get sidetracked by details or wander to the margins and corners of the screen, or to commit to memory transient, contingent images.[63] For Kracauer, this spectatorial mobility is the condition for a centrifugal movement in yet another direction: away from the film, into the labyrinths of the viewer's imagination, memories, and dreams, that is, "the film in the viewer's head."[64] This process takes the viewer into a dimension beyond, or below, the

illusory depth of diegetic space, beyond/below the "intersubjective protocols" and particular kinds of knowledge that govern our understanding of narratives,[65] into the at once singular and historical-collective realm of experience, the striated, heterogeneously aggregated, partly frozen, partly fluid *Lebenswelt*. It is in Kracauer's insistence on the possibility of such openings that we can hear an echo, albeit muted, of his earlier vision of cinema as an alternative public sphere, a sensory and collective horizon for people trying to live a life in the interstices of modernity.

It would be as misleading, though, to assimilate Kracauer's celebration of such disjunctive moments to an epiphantic or "revelationist" tradition as it would be to reduce contingency to its "crucial ideological role" in the thoroughly rationalized systems world of modernity—as a utopian idealization that appears to "offer a vast reservoir of freedom and free play, irreducible to the systematic structuring of 'leisure time.'"[66] Kracauer's notion of contingency, as we have seen, is not even one of ambivalence: it designates the antinomic condition of modern existence, which has dramatically exacerbated the tension within the Aristotelian definition of the contingent as anything that is neither necessary nor impossible. In his Weimar essays, contingency was the allegorical message underlying the subject's encounters with the uncertainty and disposable finitude of individual and social existence, coupled with the cautious hope that, if things could be this way or another, different configurations of reality might be possible or, rather, not impossible; hence the valorization of chance, improvisation, the in-between, and provisional. While this valorization continues into *Theory of Film*, contingency and indeterminacy come to function as an almost formal condition of the possibility of cognition.[67] His insistence, criticized by Warshow, that the photographically alienated phenomena crossing the screen are, "if only for a split-second, meaningless,"[68] marks the blind spot that temporarily derails, yet remains superimposed on, our routinized perception. Film thus offers a heuristic model for new modes of seeing, comprehending, and remembering—of experiencing the world in ways that historically, more than any other art, the cinema has first made possible.

Once we make *Theory of Film* resonate between the Marseille Notebooks at one end and *History* on the other, its concept of realism becomes a more interesting project than any narrow notion of representational verisimilitude. As we have seen, Kracauer's investment in film's affinity with the material world rests as much on its ability to decompose that world and render it strange as on its ability to resemble it, and to let us experience both alienation and similitude at the same time, in a side-by-side or anteroom register. Inasmuch as film, on Kracauer's account, can be said to "mirror" anything, it does so through an assemblage of shards and fragments that only problematically add up to a whole. It does not transfigure what it depicts into an ideal, aesthetically objectified version of reality; even Perseus's blank shield anamorphically distorts what it captures—"the real face of things too

dreadful to be beheld in reality" (*T* 305–6)—and captures only what it distorts. But it still beckons the spectator to commit those images to memory and keeps us, in Kracauer's words, "from shutting our eyes to the 'blind drive of things'" (*T* 58).[69] In the end, it is this complex intertwining of the material reality of the viewer—as embodied subject of perception, memory, experience—with the life world that the term *camera reality* designates.

Kracauer's faith in happy endings under erasure made him considerably more open to possibilities within commercial media culture than his Frankfurt School interlocutors, especially Horkheimer and Adorno. True to 1920s avant-garde iconoclasm, he is still more likely to be irritated by the falsity of "cultural aspi-rations" than by the commercialization of art per se: "Many a commercial film or television production is a genuine achievement besides being a commodity. Germs of new beginnings may develop within a thoroughly alienated environ-ment" (*T* 217–18). In a nondiscriminatory fashion, he draws his examples from international art cinema as well as Hollywood films. When he addresses the issue of mass entertainment and Hollywood as "dream factory," he does not balk at the idea that film producers go some way toward meeting their patrons' needs, their "leanings and longings"—a permanent interaction that is "necessarily elusive" and admits of "diverse interpretations" (*T* 163). But then he does a dialectical turn on the familiar argument: "Each popular film corresponds to popular wants; yet in conforming to them it inevitably does away with their inherent ambiguity. . . . Through their very definiteness films thus define the nature of the inarticulate from which they emerge" (*T* 164).

While we can still hear in this passage a faint echo of his analysis of the ideologi-cal loop effect of film and reality and the status of films as "daydreams of society" in the 1927 essay "The Little Shopgirls Go to the Movies," his stance has clearly changed (even compared to a number of later essays published in English).[70] Sure enough, Adorno writes to Kracauer after the publication of the German translation of *Theory of Film* in early 1965 that his major problem with the book is its failure to address that "against which, after all, the resistance to film on the part of serious human beings is directed"—that, since it is "much more immediately harnessed into the commercial system than any other form of expression, [film] has not evolved an immanent [aesthetic] logic of its own" (*AKB* 688). To which Kracauer coolly replies that the peculiar characteristics of film that he had discovered and analyzed "throughout its history have been realized again and again—regardless of all economic and social obstacles"; that it had been his "strategic-polemical interest" to trace, from within the material, aesthetic possibilities that film has developed under various conditions and will be developing from time to time anew (*AKB* 691–92).

In a similar vein, Kracauer does not panic over the drop in attendance that pre-occupied Hollywood during the 1950s, but takes the very fact that both films and

audiences have migrated to television as a sign of cinema's survival capacities: "The cinema may well weather the crisis. Its potentialities are far from being exhausted, and the social conditions which favored its rise have not yet changed substantially" (*T* 167). The conditions, needs, and pressures that shaped the cinema, not only in Western Europe and the United States, were those of modern mass society. And Kracauer's penchant for terms like *anonymity, isolation, alienation,* and *dissociation,* but also *receptivity, flexibility, improvisation,* and *openness toward strangers,* is no doubt indebted to modern mass sociology, in particular David Riesman's *The Lonely Crowd* (1950), a study that fleshes out, for a different context, the contours of new forms of subjectivity and interaction that Kracauer saw emerging in Weimar employee culture.[71]

"What is the good of film experience" (*T* 285) today, in a moving image culture transformed by new media? The dynamics of self-alienation and self-absorption, the viewer's simultaneous abandonment to the world on screen and to its centrifugal impulses, would seem to belong to a cinema *dispositif* centering on projection in a darkened theater space. The proliferation of films across smaller and smallest platforms and the hybridization of cinematic forms in many video games and digital art installations have made the boundaries of this *dispositif* porous and precarious. There is no way of second-guessing how Kracauer would have responded to these changes, though his appreciation of the survival of film by way of television, like his repeated references to computers in *History,* suggest that he would have explored the expanded possibilities of cinema and film viewing with curiosity and lack of alarm. After all, the commitment to responding to changes in the media environment that we see at work in his Weimar writings remained part of the luggage of "loyalties, expectations, and aspirations" that the exile brought to a new and challenging environment.

It is remarkable how little Kracauer's theorization of the salient features of the film experience depends on the logic of the trace and the indexical temporality of photographic exposure that has been taken to be the centerpiece of classical theories of cinematic realism. One could argue that since the photographic approach in Kracauer's theory of film is less a matter of representational authenticity than a condition of a particular mode of experiencing and encountering the world, it is already understood rhetorically, as a translation of the principle of photographic alienation—qua superimposition or side-by-side coexistence of unevenly coded materials and kinds of vision—into another medium, that is, a matter of stylistic practice rather than a matter of medium ontology. Whether *Theory of Film* can provide impulses to identify and envision comparable "chances of alienation" in the new media and in digital cinema, whatever hybridized forms and formats it may assume, "remains to be seen."

NOTES

PREFACE

1. Fredric Jameson, *Late Marxism: Adorno; or, The Persistence of the Dialectic* (London and New York: Verso, 1990), 7.

2. Witte's second seminar became the basis for his influential collection, *Theorie des Kinos: Ideologiekritik der Traumfabrik* (Frankfurt a.M.: Suhrkamp, 1972). American Studies, with its programmatic interdisciplinarity and broader, anthropologically based concept of culture, was generally more open to the study of film. My first article, coauthored with Martin Christadler, was on the relationship between film and concepts of history in Griffith's *Intolerance* (1976), previously presented at an American Studies conference with a special focus on the Progressive Era. When I taught my first film courses in 1975–76, together with Heide Schlüpmann, on realism in the fiction film and on postwar youth rebellion films, they were held at the Frankfurt Volkshochschule, an institution of continuing education.

3. See Adorno's important analysis of this notion, "The Meaning of Working through the Past" (1959), in *Critical Models: Interventions and Catchwords*, trans. Henry W. Pickford (New York: Columbia University Press, 1998), 89–103.

4. See Rolf Wiggershaus, *The Frankfurt School: Its History, Theories, and Political Significance*, trans. Michael Robertson (Cambridge, Mass.: MIT Press, 1994), and Martin Jay, *The Dialectical Imagination: A History of the Frankfurt School and the Institute of Social Research, 1923–1950* (Boston and Toronto: Little, Brown, 1973). The problem with these labels in English-language academic and publishing contexts was twofold: one, the largely retrospective term *Frankfurt School* became all-inclusive, extending to writers such as Bloch and Benjamin who, despite their more or less informal associations with—or even financial dependency on—the institute, could not by any stretch of the imagination be thus

subsumed; second, the term *critical theory*, in lowercase, by the 1980s had come to name varieties of poststructuralist thought.

5. The Auschwitz trials were mounted, against much resistance, by Fritz Bauer, attorney general of the state of Hesse and part of the social circle around Adorno and Horkheimer. Kluge pays homage to Bauer in his first feature, *Yesterday Girl* (*Abschied von Gestern*, 1966), in which the attorney general appears playing himself.

6. See Gertrud Koch, "Chassidische Mystik und *popular culture*: Erste Eindrücke vom wiederentdeckten jiddischen Film," *Frankfurter Rundschau*, 5 July 1980; *Das jiddische Kino*, ed. Ronny Loewy (Frankfurt a.M.: Deutsches Filmmuseum, 1982); and *New German Critique* 38, *Special Issue on the German-Jewish Controversy* (Spring–Summer 1986).

7. See Michael Geyer and Miriam Hansen, "German-Jewish Memory and National Consciousness," in *Holocaust Remembrance: The Shapes of Memory*, ed. Geoffrey Hartmann (Cambridge, Mass., and Oxford: Basil Blackwell, 1994).

8. See Adorno, "Culture Industry Reconsidered" (1963), trans. Anson G. Rabinbach, intr. Andreas Huyssen, *New German Critique* 6 (Fall 1975): 3–19; repr. in Adorno, *The Culture Industry: Selected Essays on Mass Culture* (*CI*), trans. Nicholas Walker, ed. J.M. Bernstein (London: Routledge, 1991), 98–106.

9. See Hans Magnus Enzensberger, "Constituents of a Theory of the Media" (1970), in Enzensberger, *The Consciousness Industry: On Literature, Politics, and the Media*, trans. Stuart Hood (New York: Continuum, 1974).

10. In addition to Witte's work on and with Kracauer, the pathbreaking scholarly study was Inka Mülder-Bach, *Siegfried Kracauer—Grenzgänger zwischen Theorie und Literatur: Seine frühen Schriften, 1913–1933* (Stuttgart: J.B. Metzler, 1985). While Kracauer was never invited to any even semipublic event at Frankfurt University, he did participate— thanks to the endeavors of Hans Robert Jauss—in two meetings of the legendary working group Poetik und Hermeneutik in 1964 and 1966. The designation of his work as "journalism," which Kracauer considered offensive as a label for his work, occurs most recently in Dudley Andrew, "The Core and the Flow of Film Studies," *Critical Inquiry* 35.4 (Summer 2009): 908.

11. "Über die Aufgabe des Filmkritikers," *Frankfurter Zeitung* (hereinafter *FZ*), 23 May 1932, repr. in Kracauer, *Kino: Essays, Studien, Glossen zum Film*, ed. Karsten Witte (Frankfurt a.M.: Suhrkamp, 1974), 11; "The Task of the Film Critic," trans. Don Reneau, in *The Weimar Republic Sourcebook*, ed. Anton Kaes, Martin Jay, and Edward Dimendberg (Berkeley: University of California Press, 1994), 635; trans. modified.

12. See Michael Rutschky, *Erfahrungshunger: Ein Essay über die siebziger Jahre* (Frankfurt a.M.: Fischer, 1982), in particular "Allegorese des Kinos," 167–92; 184, 171, 181. For an example of Wenders's assimilation of Kracauer, see his remarkable review of Werner Nekes's film *Kelek* (1969), in *West German Filmmakers on Film: Visions and Voices*, ed. Eric Rentschler (New York and London: Holmes & Meier, 1988), 61–62. Also see Volker Schlöndorff's redemptive rereading of Kracauer's *From Caligari to Hitler* (1980), in ibid., 104–11.

13. See, in particular, Gertrud Koch, "Exchanging the Gaze: Revisioning Feminist Film Theory," *New German Critique* 34 (Winter 1985): 139–53 (this essay contains large sections published earlier in *Frauen und Film*), and Koch, "Why Women Go to the Movies [*Männerkino*]," trans. Marc Silberman, *Jump Cut* 27 (July 1982): 51–53. Also see Heide Schlüp-

mann's essay on Kracauer and Emilie Altenloh, "Kinosucht," *Frauen und Film* 33 (1982): 45–52.

14. See Oskar Negt and Alexander Kluge, *Public Sphere and Experience: Toward an Analysis of the Bourgeois and Proletarian Public Sphere* (1972), trans. Peter Labanyi and Jamie Owen Daniel (Minneapolis: University of Minnesota Press, 1993). Also see my foreword to this edition.

15. A notable exception was Philip Rosen's essay, "Adorno and Film Music: Theoretical Notes on *Composing for the Films,*" *Yale French Studies* 60, *Cinema/Sound* (1980): 157–82.

16. See Fredric Jameson, *Marxism and Form* (Princeton: Princeton University Press, 1971); Jay, *Dialectical Imagination*; Susan Buck-Morss, *On the Origins of Negative Dialectics: Theodor W. Adorno, Walter Benjamin, and The Frankfurt Institute* (New York: Free Press, 1977); and *Aesthetics and Politics*, with an afterword by F. Jameson (London: Verso, 1977). Also see Thomas Wheatland, *The Frankfurt School in Exile* (Minneapolis and London: University of Minnesota Press, 2009), in particular chs. 7 and 8.

17. See, for instance, Tom Gunning, "An Aesthetic of Astonishment: Early Film and The (In)Credulous Spectator" (1989), repr. in *Viewing Positions: Ways of Seeing Film*, ed. Linda Williams (New Brunswick, N.J.: Rutgers University Press, 1994), 114–33; and Anne Friedberg, *Window Shopping: Cinema and the Postmodern* (Berkeley: University of California Press, 1993). The reception of Benjamin has undergone considerable changes over the years, in particular with the publication of the more adequately translated scholarly edition of his *Selected Writings* beginning in 1996 and *The Arcades Project* in 1999.

18. See David Jenemann, *Adorno in America* (Minneapolis: University of Minnesota Press, 2007), chs. 1 and 2.

19. Benjamin, "Mickey Mouse" (1931), in *Selected Writings*, vol. 2, ed. Michael W. Jennings, Howard Eiland, and Gary Smith (Cambridge, Mass.: Harvard University Press, 1999), 545; trans. modified.

20. Klaus Eder and Alexander Kluge, *Ulmer Dramaturgien: Reibungsverluste* (Munich: Hanser, 1981), 48.

CHAPTER 1

1. For a complete annotated listing of these writings, see Thomas Y. Levin, *Siegfried Kracauer: Eine Bibliographie seiner Schriften* (Marbach a.N.: Deutsche Schillergesellschaft, 1989). The bulk of Kracauer's articles from the *Frankfurter Zeitung,* many of which were published under pseudonyms (Kr., raca., rac., er.) or anonymously, can be found in his own scrapbooks, Kracauer Papers, Deutsches Literaturarchiv, Marbach am Neckar. A large selection of these articles is reprinted in Kracauer, *Schriften* (hereinafter *S*) 5.1–3, ed. Inka Mülder-Bach (Frankfurt a.M.: Suhrkamp, 1990); see additional articles in *Frankfurter Turmhäuser: Ausgewählte Feuilletons, 1906–30* (hereinafter *FT*), ed. Andreas Volk (Zurich: Edition Epoca, 1997), and *Berliner Nebeneinander: Ausgewählte Feuilletons, 1930–33* (*BN*), ed. A. Volk (Zurich: Edition Epoca, 1996). The first collection of Kracauer's film criticism was edited by Karsten Witte under the title *Kino* (Frankfurt a.M.: Suhrkamp, 1974). Since 2004, a new critical edition of Kracauer's writings has been appearing under the title of

Werke (W), ed. Mülder-Bach and Ingrid Belke, of which volume 6.1–3 reprints his reviews and articles on film. So far, the only English translations of Kracauer's early writings are his own selections published shortly before his death, *Das Ornament der Masse* (Frankfurt a.M.: Suhrkamp, 1963), and *The Mass Ornament: Weimar Essays (MO)*, trans., ed., and intr. Thomas Y. Levin (Cambridge, Mass.: Harvard University Press, 1995); his book-length study *Die Angestellten: Aus dem neuesten Deutschland* (1929–1930), in *S* 1 (1978), *W* 1 (2006); *The Salaried Masses: Duty and Distraction in Weimar Germany (SM)*, trans. Quintin Hoare, intr. Mülder-Bach (London and New York: Verso, 1998); "Loitering: Four Encounters in Berlin," *Qui Parle* 5.2 (Spring–Summer 1992): 51–60; and various texts in *The Weimar Republic Sourcebook*, ed. Anton Kaes, Martin Jay, and Edward Dimendberg (Berkeley: University of California Press, 1994).

2. On Kracauer's position at the *Frankfurter Zeitung*, see Levin, foreword to Kracauer, in *MO* 6–9; also see Ingrid Belke and Irina Renz, eds., "Siegfried Kracauer, 1889–1966," *Marbacher Magazin* 47 (1988): 37–74. On the 1929 sellout of the paper to IG Farben and its political consequences, see Wolfgang Schivelbusch, *Intellektuellendämmerung: Zur Lage der Frankfurter Intelligenz in den zwanziger Jahren* (Frankfurt a.M.: Suhrkamp, 1985), 55–76. On the conception of the *Feuilleton* as a critical, "enlightening" address to the Weimar public, see Almut Todorov, *Das Feuilleton der Frankfurter Zeitung während der Weimarer Republik: Zur Rhetorik einer publizistischen Institution* (Tübingen: Max Niemeyer Verlag, 1995).

3. On Kracauer and Simmel, see David Frisby, *Fragments of Modernity: Theories of Modernity in the Work of Simmel, Kracauer, and Benjamin* (Cambridge, Mass.: MIT Press, 1986), ch. 3.

4. Kracauer, "The Mass Ornament," *FZ*, 9 & 10 June 1927; *MO* 75.

5. In the years in which Kracauer developed his theoretical approach to film, a number of film-theoretical treatises were pursuing this well-worn line of argument; for example, Georg Otto Stindt, *Das Lichtspiel als Kunstform* (1924); Otto Foulon, *Die Kunst des Lichtspiels* (1924); Rudolf Kurtz, *Expressionismus und Film* (1926); and, especially, Rudolf Harms, *Philosophie des Films* (1926). On literary intellectuals and the cinema, see Anton Kaes, ed. and intr., *Kino-Debatte: Texte zum Verhältnis von Literatur und Film, 1909–1929* (Tübingen: Max Niemeyer, 1978); Kaes, "The Debate about Cinema: Charting a Controversy (1909–1929)," *New German Critique* 40 (Winter 1987): 7–34; Heinz-B. Heller, *Literarische Intelligenz und Film* (Tübingen: Max Niemeyer, 1985); and Heide Schlüpmann, *The Uncanny Gaze: The Drama of Early German Cinema* (1990), trans. Inga Pollmann (Champaign: University of Illinois Press, 2010), part 2. On Kracauer in the context of Weimar film criticism, see Karsten Witte, "Nachwort," in Kracauer, *Kino*, 265–81; and Sabine Hake, *The Cinema's Third Machine: Writing on Film in Germany, 1907–1933* (Lincoln: University of Nebraska Press, 1993).

6. See, for instance, Andrew Tudor, *Theories of Film* (London: Secker and Warburg; British Film Institute, 1974), 79; J. Dudley Andrew, *The Major Film Theories* (London and New York: Oxford University Press, 1976), ch. 5; Andrew, *Concepts in Film Theory* (Oxford and New York: Oxford University Press, 1984), 19; Vivian Sobchack, *The Address of the Eye: A Phenomenology of Film Experience* (Princeton: Princeton University Press, 1992), 183.

7. On Kracauer's philosophical-antiphilosophical turn, see Eckhardt Köhn, *Straßen-rausch: Flanerie und kleine Form: Versuch zur Literaturgeschichte des Flaneurs bis 1933* (Berlin: Arsenal, 1989), 225–30; Uwe Pralle, "Philosophie in Bruchstücken: Siegfried Kra-cauers Feuilletons," in *Siegfried Kracauer: Zum Werk des Romanciers, Architekten, Film-wissenschaftlers und Soziologen,* ed. Andreas Volk (Zurich: Seismo Verlag, 1996), 63–79; and Gertrud Koch, *Siegfried Kracauer: An Introduction,* trans. Jeremy Gaines (Princeton: Princeton University Press, 2000), ch. 2. The rejection of systematic philosophy, pioneered by Nietzsche and Kierkegaard, was pervasive among German intellectuals during the postwar period. For Benjamin, see particularly "On the Program of the Coming Philoso-phy" (1918), in *SW* 1:100–110.

8. *FZ,* 4 Feb. 1924, *W* 6.1:56. Kracauer's earliest film reviews date back to May and June 1921, the year he began working for the *Frankfurter Zeitung.*

9. On this phase of Kracauer's writing, see Inka Mülder's pioneering study, *Siegfried Kracauer—Grenzgänger zwischen Theorie und Literatur: Seine frühen Schriften, 1913–1933* (Stuttgart: Metzler, 1985), part 1; Michael Schröter, "Weltzerfall und Rekonstruktion: Zur Physiognomik Siegfried Kracauers," *Text + Kritik* 68 (1980): 18–40; and Koch, *Kracauer,* chs. 1 and 2.

10. The first phrase is from Kracauer, *Soziologie als Wissenschaft: Eine erkenntnistheo-retische Untersuchung* (1922), *W* 1:12; the second from Georg Lukács, *Theory of the Novel: A Historico-philosophical Essay on the Forms of Great Epic Literature* (German orig., 1920), trans. Anna Bostock (Cambridge, Mass.: MIT Press, 1971), 41. Kracauer reviewed *Theory of the Novel* twice with enthusiasm; see, in particular, "Georg von Lukács' Romantheorie" (1921), *S* 5.1: 117–23. Written during the war years, Lukács's treatise on the novel became a "cult book" for Kracauer's generation; see Leo Löwenthal, "As I Remember Friedel," *New German Critique* 54 (Fall 1991): 8.

11. The opposition of *"Gemeinschaft"* and *"Gesellschaft,"* famously coined by Ferdinand Tönnies in 1886 (corresponding to oppositions such as "culture" versus "civilization," "unity" versus "distraction" [*Zerstreuung*], "organic" versus "mechanical"), was still highly popular after World War I and part of the antimodernist and anti-Americanist repertoire.

12. Kracauer, *Ginster: Von ihm selbst geschrieben* (Berlin: S. Fischer, 1928), *S* 7, *W* 7.

13. Kracauer's treatise, *Der Detektiv-Roman,* was written between 1922 and 1925 but not published until 1971, *W* 1 (2006), 103–209. Kracauer included an excerpt, "The Hotel Lobby," in the German original of *The Mass Ornament* (1963). See Koch, *Kracauer,* 15–25; Heide Schlüpmann, *Ein Detektiv des Kinos: Studien zu Siegfried Kracauers Filmtheorie* (Basel and Frankfurt: Stroemfeld/Nexus, 1998), 18–24; David Frisby, "Between the Spheres: Siegfried Kracauer and the Detective Novel," *Theory, Culture & Society* 9 (1992): 1–22; and Frisby, *Fragments of Modernity,* 126–34.

14. "Im Zirkus," *FZ,* 8 June 1923, in *FT* 76.

15. Walter Benjamin, *The Origin of German Tragic Drama* (1928), trans. John Osborne (London: NLB, 1977); on the return of allegory in modernity, particularly in and around Baudelaire, see Benjamin, "Central Park" (1939), trans. E. Jephcott and H. Eiland, in *SW* 4:161–199. A similar version of this logic, though in a different key, can be found in Benja-min's later discussion of Proust where he speaks of the writer's "homesickness for the world

distorted in the state of resemblance, a world in which the true surrealist face of existence breaks through." Benjamin "The Image of Proust" (1929), in *SW* 2:240.

16. In his letter to Benjamin of 29 Feb. 1940, Adorno goes so far as to speak of a "distinction between good and bad reification"; see Theodor W. Adorno and Walter Benjamin, *The Complete Correspondence, 1928–1940 (CC)*, ed. Henri Lonitz, trans. Nicholas Walker (Cambridge, Mass.: Harvard University Press, 1999), 321.

17. "Hochstaplerfilme," *FZ*, 17 Nov. 1923, in *W* 6.1:37.

18. "Die Straße," *FZ*, 3 Feb. 1924; Kracauer, "[Ein Film.]," *FZ*, 4 Feb. 1924, in *W* 6.1:54–58.

19. "Der Künstler in dieser Zeit," *Der Morgen* 1.1 (April 1925), in *S* 5.1: 300–308. The section on *Die Straße* was reprinted, under the title "Filmbild und Prophetenrede," in *FZ*, 5 May 1925, in *W* 6.1:138–40.

20. "Waterloo," *FZ*, 16 March 1929, in *W* 6.2:226. In his review of "Die Brüder Schellenberg," *FZ*, 1 May 1926, Kracauer calls *Die Straße* "one of the most beautiful German films" (*W* 6.1:229).

21. This shift can already be seen in his important article series entitled "Re-encountering Old Films," which Kracauer wrote in Paris and published in a Swiss newspaper; "Wiedersehen mit alten Filmen: V: Der expressionistische Film," *Basler National-Zeitung,* 97.198 (2 May 1939), in *W* 6.3:268.

22. Kracauer's emphasis on the superficiality and the lack of presence, substance, and soul, in film resonates with Georg Lukács's important 1913 essay, "Thoughts on an Aesthetics of Cinema," trans. Lance W. Garmer, in *German Essays on Film,* ed. Richard W. McCormick and Alison Guenther-Pal (New York and London: Continuum, 2004), 11–16.

23. See Edward Dimendberg, *Film Noir and the Spaces of Modernity* (Cambridge, Mass.: Harvard University Press, 2004), 130–48. On Weimar *flânerie,* associated with the work of Franz Hessel yet also relevant to Benjamin, Kracauer, Joseph Roth, Egon Erwin Kisch, and a number of other Weimar writers, see Anke Gleber, *The Art of Taking a Walk: Flanerie, Literature, and Film in Weimar Culture* (Princeton: Princeton University Press, 1999); Köhn, *Straßenrausch,* ch. 4; David Frisby, "Deciphering the Hieroglyphics of Weimar Berlin: Siegfried Kracauer," in *Berlin: Culture and Metropolis,* eds. Charles W. Haxthausen and Heidrun Suhr (Minneapolis and Oxford: University of Minnesota Press, 1991), 152–65; and Helmut Stalder's critique of the *flâneur* paradigm, "Hieroglyphen-Entzifferung und Traumdeutung der Großstadt: Zur Darstellungsmethode in den 'Städtebildern' Siegfried Kracauers," in *Siegfried Kracauer,* ed. Volk, 131–55.

24. As a number of critics have noted, Kracauer's exile did not begin in 1933, and his later plea for a personal "extraterritoriality" (letter to Adorno, 8 Nov. 1963) merely made explicit a persistent motif in his writings from the beginning. See Martin Jay, "The Extraterritorial Life of Siegfried Kracauer," in *Permanent Exiles* (New York: Columbia University Press, 1986), 152–97; Inka Mülder-Bach, "'Mancherlei Fremde': Paris, Berlin und die Extraterritorialität Siegfried Kracauers," *Juni: Magazin für Kultur & Politik* (Mönchengladbach) 3.1 (1989): 61–72; and Ingrid Belke, "Identitätsprobleme Siegfried Kracauers (1889–1966)," in *Deutsch-jüdisches Exil: Das Ende der Assimilation?* (Berlin: Metropol, 1994), 45–65. Also see M. Hansen, "Decentric Perspectives: Kracauer's Early Writings on Film and Mass Culture," *New German Critique* 54 (Fall 1991): 47–76.

25. Kracauer, *From Caligari to Hitler: A Psychological History of the German Film* (1947), revised and expanded, ed. Leonardo Quaresima (Princeton: Princeton University Press, 2004), 119, 120. Also see Kracauer, *Theory of Film: The Redemption of Physical Reality* (*T*) (1960), repr., with an introduction by Miriam Hansen (Princeton: Princeton University Press, 1997), 72–73.

26. See Lukács, "Thoughts," 14.

27. "Zwischen Flammen und Bestien," *FZ*, 4 Nov. 1923, in *W* 6.1:36.

28. "Artistisches und Amerikanisches," *FZ*, 29 Jan. 1926, in *W* 6.1:198.

29. "Wetter und Retter," *FZ*, 16 Dec. 1923, in *W* 6.1:43. The notion of an "ironic bracket" is used in his review of the fairy tale film *Der verlorene Schuh* (Ludwig Berger, 1923), *FZ*, 20 Jan. 1924, in *W* 6.1:52.

30. "Der verlorene Schuh," *FZ*, 20 Jan. 1924, in *W* 6.1:51. Also see "Niddy Impekoven im Film," *FZ*, 29 Nov. 1924, in *W* 6.1:104–6. Ernst Bloch, too, emphasized the utopian aspect of modern fairy tales; see *The Utopian Function of Art and Literature*, trans. Jack Zipes and Frank Mecklenburg (Cambridge, Mass.: MIT Press, 1987), 163–85.

31. Alexander Kluge, *Die Macht der Gefühle* (*The Power of Emotion*, 1983); see the script of this film published under the same title (Frankfurt a.M.: Zweitausendeins, 1984).

32. "Der letzte Mann," *FZ*, 11 Feb. 1925, in *W* 6.1:120–21. On the hotel lobby as privileged locus of the modern "phantom world," see Kracauer, "The Hotel Lobby," in *MO* 173–85.

33. *From Caligari to Hitler*, 100–101.

34. "Der Kaufmann von Venedig," *FZ*, 24 Nov. 1923, in *W* 6.1:38. For examples of other genres, see "Der Mythos im Großfilm," *FZ*, 7 May 1924, in *W* 6.1:79–81; and "Edles aus Welt und Halbwelt," *FZ*, 3 Oct. 1925, in *W* 6.1:161–62.

35. David Bordwell, Janet Staiger, and Kristin Thompson, *The Classical Hollywood Cinema: Film Style and Mode of Production to 1960* (New York: Columbia University Press, 1985). On German cinema's alternative trajectory, see Thomas Elsaesser, ed. and intr., *A Second Life: German Cinema's First Decades* (Amsterdam: Amsterdam University Press, 1996), esp. sec. 3.

36. "Schünzel als dummer Hans," *FZ*, 7 Nov. 1925, in *W* 6.1:170; "Großstadtplanzen," *FZ*, 28 March 1925, in *W* 6.1:131; and "Aus der Gesellschaft," *FZ*, 2 Dec. 1925, in *W* 6.1:174. This preference points forward to Kracauer's valorization of episodic form and the "found story" in *Theory of Film*.

37. See, in particular, "Cult of Distraction," *FZ*, 4 March 1926, in *MO* 323–28; for an elaboration of this argument, see "An der Grenze des Gestern [On the Border of Yesterday]: Zur Berliner Film- und Photo-Schau," *FZ*, 12 July 1932, in *W* 6.3:76–82. Likewise, Kracauer consistently defends the practice of mixed programming (live performances, shorts, and features), just as he sees in live music an invaluable source of improvisation and unpredictability; see, for example, "Ufa-Beiprogramm," *FZ*, 11 March 1928, in *W* 6.2:45–46. In a wonderful passage from his unpublished novel, *Georg* (1934), Kracauer unfolds the anecdote of the piano player who cannot see the screen and thus creates an aleatory and epiphanous relation between image and music (*S* 7:428–29).

38. "Kaliko-Welt," *FZ*, 28 Jan. 1926 (broadcast earlier as a radio feature), in *MO* 281–88.

39. "Der Demütige und die Sängerin," *FZ*, 25 April 1925, in *W* 6.1:135.

40. The former effects are attributed to classical cinema by psychoanalytic-semiotic film theory of the 1970s, notably by Jean-Louis Comolli, Jean-Louis Baudry, Christian Metz, Noël Burch, Stephen Heath, and others; see Philip Rosen, ed., *Narrative, Apparatus, Ideology: A Film Theory Reader* (New York: Columbia University Press, 1986). The emphasis on optimal attention guiding and hypothesis formation grounds itself in cognitive psychology and neoformalist poetics; see, for instance, Bordwell, Staiger, and Thompson, *Classical Hollywood Cinema*, 7–9, 58–59; Bordwell, *Narration in the Fiction Film* (Madison: University of Wisconsin Press, 1985); and Noel Carroll, *Theorizing the Moving Image* (Cambridge: Cambridge University Press, 1996).

41. The trope is pervasive in Kluge's writings, interviews, and films; see, for instance, interview by Ulrich Gregor, in *Herzog, Kluge, Straub*, ed. Peter W. Jensen and Wolfram Schütte (Munich: Hanser, 1976), 158; also see Kluge, "On Film and the Public Sphere," ed. and trans. Miriam B. Hansen and Thomas Y. Levin, *New German Critique* 24–25 (Fall–Winter 1981–82): 206–20, esp. 208–10.

42. Gunning, "An Aesthetic of Astonishment; also see Gunning, "The Cinema of Attractions: Early Film, Its Spectator, and the Avant-Garde," *Wide Angle* 8.3–4 (1986): 63–70.

43. See, for example, "Filmvorführung im Polizeipräsidium," *FZ*, 16 May 1925, in *W* 6.1:142–43. On early nonfiction film (in particular the "rocks and waves" phenomenon), see Daan Hertogs and Nico de Klerk, eds., *Nonfiction Films from the Teens* (Amsterdam: Netherlands Filmmuseum, 1994), and Tom Gunning, "Before Documentary: Early Nonfiction Films and the 'View' Aesthetic," in *Uncharted Territory: Essays on Early Nonfiction Film*, eds. Hertogs and de Klerk (Amsterdam: Netherlands Filmmuseum, 1997); also see Jennifer Peterson, *Education in the School of Dreams: Travelogues and Early Non-fiction Film* (Durham, N.C.: Duke University Press, 2010).

44. "Der Kaufmann von Venedig"; for other examples, see "Ägypten im Film," *FZ*, 27 Sept. 1924, in *W* 6.1:91; "Helden des Sports und der Liebe," *FZ*, 25 Oct. 1924, in *W* 6.1:99; "Ein Hochgebirgsfilm," *FZ*, 20 March 1926, in *W* 6.1:219–21.

45. *From Caligari to Hitler*, 112. On the genre of the mountain film, see Eric Rentschler, "Mountains and Modernity: Relocating the *Bergfilm*," *New German Critique* 51 (Fall 1990): 137–61.

46. "Berge, Wolken, Menschen," *FZ*, 9 April 1925, in *W* 6.1:132–33. In the same category, see Kracauer's enthusiasm for slow-motion shots of body movements ("marvelous configuration of limbs unveil themselves in this snail's walk through time") in *Wege zur Kraft und Schönheit* (*FZ*, 21 May 1925, in *W* 6.1:143–46), a film he was to pan sarcastically a year later (*FZ*, 5 Aug. 1926, in *W* 6.1:253–55).

47. On the distinction—and dialectic—between things and objects, see Bill Brown, "Thing Theory," intr. to *Things*, ed. Brown (Chicago: University of Chicago Press, 2004), 1–22. On Kracauer and things, see Lesley Stern, " 'Paths That Wind through the Thicket of Things,'" in ibid., 317–54.

48. Kracauer's evocative ekphrases of the appearance of things in films echo Hofmannsthal's poetic account of the ordinary things and environments of childhood memory and waking dreams that cinema conjures up from its "chest with magical junk." Hugo von Hofmannsthal, "The Substitute for Dreams" (1921), trans. Lance W. Garmer, in McCormick and Guenther-Pal, *German Essays on Film*, 55.

49. "Niddy Impekoven im Film," see above, n. 30.

50. "Thérèse Raquin," *FZ*, 29 March 1928, in *W* 6.2:54.

51. Walter Benjamin, "Reply to Oscar A. H. Schmitz" (1927), in *SW* 2:18; *GS* 2:753. Benjamin praises Kracauer's own writings for their "great inventorying of the petty bourgeois [*mittelständischen*] world" in its demise through an "'affectionate' description" of the things that are its legacy. See letters to Kracauer, 20 April and 17 June 1926, in Walter Benjamin, *Briefe an Siegfried Kracauer: Mit vier Briefen von Siegfried Kracauer an Walter Benjamin,* ed. Theodor W. Adorno Archiv (Marbach a.N.: DLA, 1987), 17, 24.

52. See Béla Balázs, *Early Film Theory: Visible Man and the Spirit of Film,* trans. Rodney Livingstone (Oxford and New York: Berghahn, 2010); also see Gertrud Koch, "Béla Balázs: The Physiognomy of Things," *New German Critique* 40 (Winter 1987): 167–77; Jean Epstein, "Magnification," and other writings, trans. Stuart Liebman, in *French Film Theory and Criticism, 1907–1939,* vol. 1, ed. Richard Abel (Princeton: Princeton University Press, 1988); also see Liebman, "Jean Epstein's Early Film Theory, 1920–1922" (PhD dissertation, New York University, 1980).

53. In his essay on Rodin, Simmel speaks of modern art as an "animated mirror"; see Georg Simmel, "Rodin," in *Philosophische Kultur: Über das Abenteuer; die Geschlechter und die Krise der Moderne* (1911, 1923; Berlin: Wagenbach, 1983), 151–65; also see Koch, "Balázs," 170, 174.

54. Kracauer and Adorno's friendship, with all its intensities and ambivalences, is documented in their remarkable lifelong correspondence; see Theodor W. Adorno and Siegfried Kracauer, *Briefwechsel, 1923–1966 (AKB),* ed. Wolfgang Schopf (Frankfurt a.M.: Suhrkamp, 2008). Also see Martin Jay, "Adorno and Kracauer: Notes on a Troubled Friendship," in *Permanent Exiles,* 217–36.

55. Theodor W. Adorno, "The Curious Realist: On Siegfried Kracauer" (1964), in *Notes to Literature,* trans. Shierry Weber Nicholsen, vol. 2 (New York: Columbia University Press, 1992), 75; *GS* 11:408.

56. On the changed status of "things" in modernity, see Bill Brown, "The Secret Life of Things (Virginia Woolf and the Matter of Modernism)," *Modernism/Modernity* 6 (April 1999): 1–28.

57. Georges Duhamel, *Scènes de la vie future* (Paris, 1930), 52, quoted in Benjamin, "The Work of Art in the Age of Its Technological Reproducibility: Third Version," in *SW* 4:119.

58. Named after the British physiologist Dr. William Carpenter (1813–85); see his *Principles of Mental Physiology, with Their Applications to the Training and Discipline of the Mind, and the Study of Morbid Conditions* (New York: Appleton & Co., 1878). Also see below, ch. 5, in connection with Benjamin's concept of "innervation."

59. Martin Jay, "Experience without a Subject: Walter Benjamin and the Novel" (1993), in *Cultural Semantics: Keywords of Our Time* (Amherst: University of Massachusetts Press, 1998), 47–61.

60. For another, strong example of the shift to the second person singular, see "Der verbotene Blick" ("The Forbidden Gaze"), *FZ*, 9 April 1925, in *S* 5.1:298–99.

61. Kracauer's reservations against *History and Class Consciousness* had to do with, among other things, the way that any empirical analysis of capitalist modernization was

preempted by a Hegelian concept of totality; see his letter to Ernst Bloch, 27 May 1926, in Bloch, *Briefe, 1903–1975*, ed. Karola Bloch et al. (Frankfurt a.M.: Suhrkamp, 1985), 1:273; also see below, ch. 2. On the relation between reification and totality, see Martin Jay, *Marxism and Totality: The Adventures of a Concept from Lukács to Habermas* (Berkeley and Los Angeles: University of California Press, 1984).

62. Georg Lukács, *History and Class Consciousness: Studies in Marxist Dialectics*, trans. Rodney Livingstone (Cambridge, Mass.: MIT Press, 1997), especially 83–110.

63. See Anson Rabinbach, "Between Enlightenment and the Apocalypse: Benjamin, Bloch, and Modern German Jewish Messianism," *New German Critique* 34 (Winter 1985): 78–124; and Michael Löwy, *Redemption and Utopia: Jewish Libertarian Thought in Central Europe; a Study in Elective Affinity*, trans. Hope Heaney (London: Athlone Press, 1992). My understanding of Jewish messianism is indebted to Gershom Scholem's influential essay, "The Messianic Idea in Judaism," in *The Messianic Idea in Judaism and Other Essays on Jewish Spirituality* (New York: Schocken, 1972).

64. On the history and significance of the Lehrhaus, see Nahum N. Glatzer, "The Frankfort Lehrhaus," *Leo Baeck Institute Yearbook* 1 (1956); and Erich Ahrens, "Reminiscences of the Men of the Frankfurt Lehrhaus," *Leo Baeck Institute Yearbook* 19 (1974). Also see Raimund Sesterhenn, ed., *Das Freie Jüdische Lehrhaus—Eine andere Frankfurter Schule* (Munich and Zurich: Schnell & Steiner, 1987). On Kracauer's Jewish background (his uncle, Isidor Kracauer, was the author of a standard work on the history of Jews in Frankfurt), see Belke and Renz, *Kracauer*, ch. 1.

65. "Those Who Wait," *FZ*, 12 March 1922, in *MO* 133. Also see Kracauer's hilarious review "Prophetentum" (on Bloch's *Thomas Münzer als Theologe der Revolution*), *FZ*, 27 Aug. 1922, in *S* 5.1:196–204, and various letters to Löwenthal, repr. in Leo Löwenthal and Siegfried Kracauer, *In steter Freundschaft: Briefwechsel, 1921–1966*, ed. Peter-Erwin Jansen and Christian Schmidt (Springe: zu Klampen Verlag, 2003), partially quoted and translated in Löwenthal, "As I Remember Friedel," *New German Critique* 54 (Fall 1991): 5–17. Kracauer also resented Benjamin's version of messianism, though he responded to it less ferociously than to Bloch's; see letter to Löwenthal, 6 Jan. 1957, commenting on the recently published collection of Benjamin's essays, *Illuminationen*: "Much has paled and suffers from a messianic dogmatism which on the level at which I dwell appears abstruse and arbitrary" (*In steter Freundschaft*, 186). Also see Mülder-Bach, *Kracauer*, 45ff.

66. Paradoxically, this battle cry resonates strongly with Rosenzweig's influential major work, *The Star of Redemption* (1921, 1930), trans. William W. Hallo (Notre Dame, Ind.: Notre Dame University Press, 1985). See Eric L. Santner, *On the Psychotheology of Everyday Life: Reflections on Freud and Rosenzweig* (Chicago: University of Chicago Press, 2001), which throws into relief remarkable resonances between Rosenzweig and Kracauer's writings of this period. Also see Benjamin's letter to Kracauer, 3 June 1926, in which he expresses his lasting respect for Rosenzweig's *Star* and regret for the damage inflicted on its author by the "fraternity" (with Buber and the storm of indignation at Kracauer's review); *Briefe an Siegfried Kracauer*, 21.

67. Schröter, "Weltzerfall und Rekonstruktion," 25, 28.

68. Kracauer to Löwenthal, 12 April 1924, trans. in Löwenthal, "As I Remember Friedel," 9.

69. Kracauer, "Zwei Arten der Mitteilung," undated typescript, ca. 1929, in S 5.2:166. Cf. Benjamin's endorsement of "revolutionary nihilism" and "pessimism" in his essay of the same year, "Surrealism: The Last Snapshot of the European Intelligentsia," in SW 2:210, 216–17.

70. "Künstler in dieser Zeit," 304–5.

71. Ernst Bloch, for instance, elaborates on Kracauer's statement in "The Anxiety of the Engineer" (1929), in Literary Essays, trans. Andrew Joron et al. (Stanford: Stanford University Press, 1998), 304–14.

72. Scholem, "Messianic Idea," 4. The motif of redemption runs through Kracauer's entire work and becomes eponymic in the subtitle of Theory of Film: The Redemption of Physical Reality. Discussing the German translation of that subtitle with Rudolf Arnheim (who had proposed "Rückgewinnung"), Kracauer writes: "I still think 'Erlösung' would not be bad, precisely because of its theological connotation" (letter to Arnheim, 30 Nov. 1960, Kracauer Papers, Deutsches Literaturarchiv, Marbach a.N.). On the concept of tikkun, see Gershom Scholem, Major Trends in Jewish Mysticism (New York: Schocken, 1954), 245–48.

73. Kracauer, History: The Last Things Before the Last (1969; repr., Princeton: Markus Wiener, 1995), 4.

74. On Jewish gnosticism, see Gershom Scholem, "Redemption through Sin," in Messianic Idea in Judaism, 78–141, and other works by Scholem; also see Harold Bloom, "Scholem: Unhistorical or Jewish Gnosticism," in Gershom Scholem, ed. Bloom (New York, New Haven, and Philadelphia: Chelsea House, 1987), 207–20. I am indebted to Bloom for the concept of literary gnosticism; see Bloom, The Strong Light of the Canonical: Kafka, Freud, and Scholem as Revisionists of Jewish Culture and Thought (New York: City College, 1987), 1–25.

75. In his 1931 inaugural lecture, Adorno uses similar imagery when he approvingly quotes Freud and the epistemological turn to the "'refuse of the physical world' (Abhub der Erscheinungswelt)"; "The Actuality of Philosophy," trans. Benjamin Snow, The Adorno Reader, ed. Brian O'Connor (Malden, Mass., and Oxford: Blackwell, 2000), 32.

76. "Gestalt und Zerfall," FZ, 21 Aug. 1925, in S 5.1:328.

77. Kracauer to Bloch, 29 June 1926, in Bloch, Briefe, 1:281.

78. In "Der Künstler in dieser Zeit," Kracauer mentions, among others, Max Beckmann (in contrast to the "ideologically overdetermined verism" of George Grosz), Archipenko, Stravinsky, and Schönberg (307–8).

79. Benjamin, "An Outsider Makes His Mark" (1930), in SW 2:310.

80. "Farewell to the Linden Arcade" (1930), in MO 340. This text begs comparison with the section on the Passage de l'Opéra in Louis Aragon's Paysan de Paris (1926); Paris Peasant, trans. and intr. Simon Watson Taylor (Boston: Exact Exchange, 1994). Köhn goes so far as to call Kracauer's prose pieces on Berlin "documents of a German surrealism whose history has yet to be written" (Straßenrausch, 245).

81. Kracauer, "Ansichtspostkarte" (Picture Postcard), FZ, 26 May 1930; S 5.2:184–85.

82. In his discussion of urban Denkbilder in Kracauer and Benjamin, Andreas Huyssen links this modernist genre to the architectural concept of "Durchdringung" (Sigfried Giedion), the dynamic interpenetration of hitherto separate and unequal spaces; see "Mod-

ernist Miniatures: Literary Snapshots of Urban Spaces," *PMLA* 122.1 (2007): 27–42. On the genre of the *Denkbild*, see Gerhard Richter, *Thought-Images: Frankfurt School Writers' Reflections from Damaged Life* (Stanford: Stanford University Press, 2007).

83. See Inka Mülder-Bach, "Der Umschlag der Negativität: Zur Verschränkung von Phänomenologie, Geschichtsphilosophie und Filmästhetik in Siegfried Kracauers Metaphorik der 'Oberfläche,'" *Deutsche Vierteljahresschrift* 61.2 (1987): 359–73; Mülder-Bach, *Kracauer*, 86–95; and Koch, *Kracauer*, 11, 28–31. Also see John Allen, "The Cultural Spaces of Siegfried Kracauer: The Many Surfaces of Berlin," *New Formations*, 61, special issue on Kracauer, ed. Jan Campbell (Summer 2007): 20–33.

84. The term *Denkfläche* appears in Kracauer's review of Paul Oppenheim's book on a comparatist, interdisciplinary approach to the sciences: "Die Denkfläche: Eine neue Wissenschaftslehre," *FZ*, 7 July 1926, in *S* 5.1:368–71.

85. This is not to say that Kracauer altogether abandons the distinction between surface and that which may be hidden from view (a distinction that has been problematized by postmodern and poststructuralist thought), but the relationship between the two terms becomes more dialectical and political. See especially his articles on Berlin in the early 1930s, in the wake of the world economic crisis and the rise of the National Socialists; e.g., "Unter der Oberfläche" (below the surface), *FZ*, 12 July 1931, in *BN* 26–28.

86. See Janet Ward, *Weimar Surfaces: Urban Visual Culture in 1920s Germany* (Berkeley: University of California Press, 2001), ch. 4, esp. 196–98. Ward reminds us that these modern surfaces of the 1920s are still "street-based," as opposed to the contemporary surface culture of the "simulacrum" and the "hyperreal" (121).

87. Jeremiads against distraction (diversion, divertissement) are as old as Pascal's rejoinder to Montaigne and proliferated with the emergence of mass culture; see Leo Löwenthal, "Historical Perspectives of Popular Culture" (1950), repr. in *Mass Culture: The Popular Arts in America*, ed. Bernhard Rosenberg and David Manning White (New York: Free Press, 1957), 46–58. For a contemporary example, see Martin Heidegger, *Being and Time* (1927), trans. John Macquarrie and Edward Robinson (New York and Evanston, Ill.: Harper & Row, 1962), §36, pp. 214–17, in which *Zerstreuung* is linked to curiosity and the "lust of the eyes" (216). Also see Kracauer's early pessimistic account of the public addiction to summery pleasures, "Sommerlicher Vergnügungstaumel," *FZ*, 2 Aug. 1923, in *FT* 49–52.

88. See, for instance, the epigraph to Adorno, *Minima Moralia: Reflections from Damaged Life* (1951), part one [1944], trans. E. F. N. Jephcott (London: Verso, 1978), 19. The phrase is from Kürnberger's novel *Der Amerikamüde* (1855; repr., Frankfurt a.M.: Insel Verlag, 1986), 451; thanks to Lydia Goehr for locating the citation.

89. Kracauer, "Photography," *FZ*, 28 Oct. 1927, in *MO* 62. The notion of "forms of living" being increasingly "perforated" appears in Kracauer's letter to Bloch, 29 June 1926, in which he refers to himself as "ultimately an anarchist," albeit a skeptical one (Bloch, *Briefe*, 1:280). See Helmut Lethen, *Cool Conduct: The Culture of Distance in Weimar Germany*, trans. Don Reneau (Berkeley: University of California Press, 2002), ch. 5.

90. See, for instance, Mülder-Bach, *Kracauer*, 97–102, and Christine Mehring, "Siegfried Kracauer's Theories of Photography: From Weimar to New York," *History of Photography* 21.2 (Summer 1997): 129–36. Benjamin H. D. Buchloh reiterates this emphasis, citing the photography essay as evidence of Kracauer's "extreme media pessimism"; see

Buchloh, "Gerhard Richter's *Atlas:* The Anomic Archive," *October* 88 (Spring 1999): 117–47, esp. 129–34.

91. For a critique of a narrow adaptation of Charles Sanders Peirce's concept of the index in film theory, see Tom Gunning, "What's the Point of an Index? Or Faking Photographs," in *Still Moving: Between Cinema and Photography*, ed. Karen Beckman and Jean Ma (Durham, N.C.: Duke University Press, 2008), 23–40, and "Moving Away from the Index: Cinema and the Impression of Reality," *differences: A Journal of Feminist Cultural Studies* 18.1 (2007): 29–52. Also see Mary Ann Doane, "The Indexical and the Concept of Medium Specificity," ibid., 128–52, and Doane's introduction to this special issue of *differences*.

92. For a critique of a high-modernist, Greenbergian notion of medium specificity, see Rosalind Krauss, *"A Voyage on the North Sea": Art in the Age of the Post-Medium Condition* (London: Thames & Hudson, 1999); also see Ji-Hoon Kim, "The Post-Medium Condition and the Explosion of Cinema," *Screen* 50.1 (Spring 2009): 114–23.

93. Kracauer had repeatedly written on the Tiller Girls from May 1925 on, most notably in his 1926 essay "The Mass Ornament," *MO* 75–86.

94. The reprographic halftone process reproduces images by means of dots varying in size and spacing. Digital pixels, by contrast, are homogeneous in size and relation to each other; what varies is their color value. Both involve a perceptual shift from discrete to continuous appearance.

95. Hermann Ullstein, *The Rise and Fall of the House Ullstein* (New York: Simon & Schuster, 1943), 85, cited in Mila Ganeva, *Women in Weimar Fashion: Discourses and Displays in German Culture, 1918–1933* (Rochester, N.Y.: Camden House, 2008), 53. Also see Kurt Korff, "Die 'Berliner Illustrirte,'" in *Fünfzig Jahre Ullstein, 1877–1927* (Berlin: Ullstein, 1927), 297–302.

96. Kracauer expands this argument—in language anticipating Bazin—in his first analysis of the sound film: "The sound film is so far the final link in the chain of a series of powerful inventions that, with blind certainty and as if guided by a secret will, push toward the complete representation of human reality. This would make it possible, in principle, to wrest the totality of life from its transitoriness and transmit it in the eternity of the image." "Tonbildfilm: Zur Aufführung im Frankfurter Gloria-Palast," *FZ*, 12 Oct. 1928, in *W* 6.2:124.

97. Martin Heidegger, "The Age of the World Picture" (1938), in *The Question of Technology and Other Essays,* trans. William Lovitt (New York: Harper & Row, 1977), 129.

98. I borrow the term *psychotheological* from Eric Santner's book on Franz Rosenzweig, *On the Psychotheology of Everyday Life,* cited above, n. 66.

99. See Frederic J. Schwartz, *Blind Spots: Critical Theory and the History of Art in Twentieth-Century Germany* (New Haven and London: Yale University Press, 2005), 39–62. Also see below, ch. 5.

100. Walter Benjamin, "Nichts gegen die 'Illustrirte'" (1925), *GS* 4:448–49.

101. See Kracauer's remarkable review of a newsreel showing the fatal crash of an aviator that he contrasts with Dziga Vertov's ability, in *Man with a Movie Camera* (1929), to bring death to collective and public consciousness: "Todessturz eines Fliegers," *FZ*, 5 Feb. 1932, in *W* 6.3:14–27.

102. Kracauer refers to Bergson's critique of "measurable, chronological time" in "Tonbildfilm," 124. Also see his critique of the architectural politics of the Berlin Kurfürstendamm

as the "embodiment of the empty flow of time," in "Straße ohne Erinnerung" (Street without Memory), *FZ*, 16 Dec. 1932, in *S* 5.3:170. He aligns photography with "historicist thinking" in section 2 of the photography essay, a comparison to which he returns in *History*, 4, 49–51.

103. Benjamin, "On Some Motifs in Baudelaire" (1940), in *SW* 4:316, 337.

104. Phenomenological media theory, for instance, conceives of technologically produced images as "tertiary memory." Defined as "experience that has been recorded and is available to consciousness without ever having been lived by that consciousness," tertiary memory significantly affects the perceptual dynamics of secondary (individual) memory and primary retention. See Mark B. N. Hansen, *New Philosophy for New Media* (Cambridge, Mass., and London: MIT Press, 2004), 255. Also see Alison Landsberg, *Prosthetic Memory: The Transformation of American Remembrance in the Age of Mass Culture* (New York: Columbia University Press, 2004).

105. In his review of Benjamin's *Origin of German Tragic Drama* and *One-Way Street* (both 1928), Kracauer asserts that its "method of dissociating immediately experienced unities," the laying-in-ruins of the seemingly live and organic, "must take on a meaning which, if not revolutionary, is nonetheless explosive when applied to the present" (*MO* 263).

106. On the affinity of *Moderne* and *Mode*, see Jürgen Habermas, *Der philosophische Diskurs der Moderne* (Frankfurt a.M.: Suhrkamp, 1985), 18. On the cultural-conservative inscription of the term "fashion," particularly in opposition to the category of "style," see Schwartz, *Blind Spots*, ch. 1; also see Ganeva, *Women in Weimar Fashion*.

107. Benjamin's reflections on fashion can be found in *The Arcades Project* (hereinafter *AP*), trans. Howard Eiland and Kevin McLaughlin (Cambridge, Mass.: Harvard University Press, 1999), Konvolut B, 62–81, and his exposés for that project, *AP* 8, 18–19. On the temporality instantiated by fashion, see Peter Osborne, *The Politics of Time: Modernity and the Avant-Garde* (London: Verso, 1995), 134–50 and passim.

108. Benjamin, "Little History of Photography" (1931), trans. Edmund Jephcott and Kingsley Shorter, in *SW* 2:510.

109. Kracauer elaborates this point in "An der Grenze des Gestern," *FZ*, 12 July 1932, in *W* 6.3:77, but does so to contrast early with contemporary photography.

110. Benjamin, "The Work of Art in the Age of Its Technological Reproducibility," in *SW* 3:108; 4:258.

111. On the distinction between index as a trace and index as deixis and its implications for cinema, see Doane, "The Indexical." Also see Philip Rosen, *Change Mummified: Cinema, Historicity, Theory* (Minneapolis: University of Minnesota Press, 2001), ch. 8.

112. Kracauer's understanding of "second nature" is indebted to Lukács's *Theory of the Novel* and *History and Class Consciousness*. See Steven Vogel, *Against Nature: The Concept of Nature in Critical Theory* (Albany: State University of New York Press, 1996), 17 and passim. The term goes back to Hegel's *Philosophy of Right*, paragraph 151.

113. In that sense, the concept of the archive here is actually more an-archic than both institutional archives and the counterarchival projects of the Weimar period cited by Buchloh in "Gerhard Richter's *Atlas*," esp. 118–34; while ultimately cognitive, its mnemonic function is less didactic (as in Hannah Höch and Aby Warburg) than it is buried

in virtuality. On the problematic of the archive in general, see Jacques Derrida, *Archive Fever: A Freudian Impression* (1995), trans. Eric Prenowitz (Chicago: University of Chicago Press, 1996).

114. A similar argument can be found in André Bazin, "The Ontology of the Photographic Image" (1945), in *What Is Cinema?* ed. and trans. Hugh Gray (Berkeley: University of California Press, 1967), vol. 1, esp. 14–16.

115. Heidegger, "Das Ding" (1950), in *Vorträge und Aufsätze* (Pfullingen: Neske, 1954), 157–75; "The Thing," in *Poetry, Language, Thought*, trans. Albert Hofstadter (New York: Harper & Row, 1971), 165–86, esp. 165–66. Heidegger's notion of "the thing" (as opposed to the object [*Gegenstand*] and its idealist corollaries, the subject and representation) appears appropriate here, despite the fact that Heidegger himself specifically excluded the technological media from such consideration as the very agents that eradicated all distances and any sense of distance, both farness and nearness, and were thus antithetical to the condition under which things can said to be "thinging" (*dingen*).

116. "Das Schloß: Zu Franz Kafkas Nachlaßroman," *FZ*, 28 Nov. 1926, in *S* 5.1:390–93. On the significance of this review for Kracauer's early film theory and its affinity with secular-Jewish literary gnosticism, see Hansen, "Decentric Perspectives," 56–57.

117. See Heide Schlüpmann, "Phenomenology of Film: On Siegfried Kracauer's Writings of the 1920s," trans. Thomas Y. Levin, *New German Critique* 40 (Winter 1987): 97–114.

118. I am trying to complicate an argument made in Jay David Bolter and Richard Grusin, *Remediation: Understanding New Media* (Cambridge, Mass.: MIT Press, 2000).

119. We might take this possibility to have found its most inventive realization in more recent artistic practices, for example, the analytic, dissociating, and transformative engagement with film and film history in electronic and digital video, interactive storage modes, and multimedia installations—in work as diverse as that of Ken Jacobs, Douglas Gordon, Zoe Beloff, and Harun Farocki, to mention only a few. See, most recently, Christa Blümlinger, *Kino aus zweiter Hand: Zur Ästhetik materieller Aneignung im Film und der Medienkunst* (Berlin: Vorwerk 8, 2009).

120. See Hansen, "Of Lightning Rods, Prisms, and Forgotten Scissors: *Potemkin* and German Film Theory," *New German Critique* 95 (Spring–Summer 2005): 162–79, and sources cited therein.

121. Kracauer, "Die Jupiterlampen brennen weiter: Zur Frankfurter Aufführung des Potemkin-Films," *FZ*, 16 May 1926, in *W* 6.1:234–37, partially translated in my essay "Of Lightning Rods," 172–74.

122. See, for instance, "The Little Shop Girls Go to the Movies" (1927), "Film 1928" (1928), both in *MO*, and "The Task of the Film Critic" (1932), trans. Don Reneau, in *Weimar Republic Sourcebook*, 634–35.

CHAPTER 2

1. This chapter modifies and expands my essay "America, Paris, the Alps: Kracauer (and Benjamin) on Cinema and Modernity," in *Cinema and the Invention of Modern Life*, ed. Leo Charney and Vanessa Schwartz (Berkeley: University of California Press, 1995), 362–402.

2. Kracauer, "Berliner Nebeneinander: Kara-Iki—Scala-Ball im Savoy—Menschen im Hotel," *FZ*, 17 Feb. 1933, in *BN* 32.

3. For a sample of Weimar texts on Americanism, see *The Weimar Republic Sourcebook*, ed. Anton Kaes, Martin Jay, and Edward Dimendberg (Berkeley: University of California Press, 1994), ch. 15. Also see Frank Trommler, "The Rise and Fall of Americanism in Germany," in *America and the Germans: An Assessment of a Three-Hundred-Year History*, eds. Trommler and Joseph McVeigh (Philadelphia: University of Pennsylvania Press, 1985), 2: 332–42, and Alf Lüdtke, Inge Marßolek, and Adelheid von Saldern, eds., *Amerikanisierung: Traum und Alptraum im Deutschland des 20. Jahrhunderts* (Stuttgart: Franz Steiner, 1996). On "white socialism," see Helmut Lethen, *Neue Sachlichkeit, 1924–1932: Studien zur Literatur des 'Weißen Sozialismus* (Stuttgart: Metzler, 1970); and Detlev J. K. Peukert, *The Weimar Republic: The Crisis of Classical Modernity* (New York: Hill & Wang, 1992), 178–90. On "left Fordism," in particular Gramsci, see Peter Wollen, "Cinema/Americanism/The Robot," in *Raiding the Icebox: Reflections on Twentieth-Century Culture* (Bloomington: University of Indiana Press, 1993), 35–71.

4. On the distinction and relation between "Americanization" and "Americanism," see Victoria de Grazia, *Irresistible Empire: America's Advance through Twentieth-Century Europe* (Cambridge, Mass.: Harvard University Press, 2005), 552–56 and passim.

5. Charles S. Maier, "Between Taylorism and Technocracy: European Ideologies and the Vision of Industrial Productivity in the 1920s," *Journal of Contemporary History* 5.2 (1970): 27–61; Mary Nolan, *Visions of Modernity: American Business and the Modernization of Germany* (New York: Oxford University Press, 1994), 42–50. On Taylorism and Fordism in the United States, see David A. Hounshell, *From the American System to Mass Production, 1800–1932* (Baltimore: Johns Hopkins University Press, 1984), chs. 6 and 8; and Terry Smith, *Making the Modern: Industry, Art, and Design in America* (Chicago: University of Chicago Press, 1993), part 1.

6. See Alf Lüdtke, *Eigen-Sinn: Fabrikalltag, Arbeitererfahrung und Politik vom Kaiserreich bis in den Faschismus* (Hamburg: Ergebnisse-Verlag, 1993), 244–54.

7. Kracauer, "Der Künstler in dieser Zeit," *Der Morgen*, 1.1 (April 1925), in *S* 5.1:305. Kracauer returns to the metaphor of "discovering America" in his novel *Ginster*, in *S* 7:34.

8. On the juncture of cinema and Americanism, see Thomas J. Saunders, *Hollywood in Berlin: American Cinema and Weimar Germany* (Berkeley: University of California Press, 1994); Kristin Thompson, *Exporting Entertainment* (London: British Film Institute, 1985); Ian Jarvie, *Hollywood's Overseas Campaign: The North Atlantic Movie Trade, 1920–1950* (Cambridge and New York: Cambridge University Press, 1992); David W. Ellwood and Rob Kroes, eds., *Hollywood in Europe: Experiences of a Cultural Hegemony* (Amsterdam: VU University Press, 1994); and Ruth Vasey, *The World According to Hollywood, 1918–1939* (Madison: University of Wisconsin Press, 1997).

9. Kr. [Kracauer], "Die Tagung des Deutschen Werkbunds," *FZ*, 29 July 1924. On the Werkbund, see Frederic J. Schwartz, *The Werkbund: Design Theory and Mass Culture before the First World War* (New Haven and London: Yale University Press, 1996).

10. See ch. 1, nn. 84 and 85.

11. "The Mass Ornament," *FZ*, 9 June 1927, in *MO* 75.

12. See ch. 1, n. 7.

13. "Der Künstler," 304.

14. Already in *Soziologie als Wissenschaft* he had criticized social theory's abstract conceptualizations for failing to grasp the "immediately experienced reality, that is, the life reality of socialized human beings" (*W* 1:62).

15. On Lukács's concept of totality in *History and Class Consciousness*, see Jay, *Marxism and Totality*, ch. 2, esp. 102–27.

16. Kracauer to Ernst Bloch, 27 May 1926, in Bloch, *Briefe*, 1:273. On Kracauer's relation to Marxist theory, especially in Lukács, see Jay, "The Extraterritorial Life of Siegfried Kracauer," *Permanent Exiles*, 162–64.

17. Georg Simmel, "The Metropolis and Mental Life" (1903), in *On Individuality and Social Forms*, ed. Donald Levine (Chicago: University of Chicago Press, 1971), 119.

18. *Georg Simmel: Ein Beitrag zur Deutung des geistigen Lebens unserer Zeit* (1919), in *W* 9.2:269. Only the introductory chapter of this monograph was published: "Georg Simmel," *Logos* 9.3 (1920), in *MO* 225–57. On Simmel and Kracauer, see Frisby, *Fragments of Modernity*, ch. 3; also see David Frisby, *Simmel and Since: Essays on Georg Simmel's Social Theory* (London and New York: Routledge, 1992). On Kracauer's radicalization of Simmel and *Lebensphilosophie*, see Rolf Wiggershaus, "Ein abgrundtiefer Realist: Siegfried Kracauer, die Aktualisierung des Marxismus und das Institut für Sozialforschung," in *Siegfried Kracauer: Neue Interpretationen*, ed. Michael Kessler and Thomas Y. Levin (Tübingen: Stauffenburg Verlag, 1990), 284–95.

19. "Schumann-Theater," *FZ*, 5 March 1925, in *FT* 93.

20. The Tiller Girls were actually a British troupe. On American "girl" dance troupes in Germany, see Reinhard Klooss and Thomas Reuter, *Körperbilder: Menschenornamente in Revuetheater und Revuefilm* (Frankfurt a.M.: Syndikat, 1980); also see Doremy Vernon, *Tiller's Girls* (London: Robson, 1988), and Derek Parker and Julia Parker, *The Natural History of the Chorus Girl* (Indianapolis: Bobbs-Merrill, 1975), 102–11. On the linkage between Taylorist principles of efficiency and the aesthetics of the chorus line, see Ramsay Burt, *Alien Bodies: Representation of Modernity, "Race," and Nation in Early Modern Dance* (London and New York: Routledge, 1998), 84–100, and Susan A. Glenn, *Female Spectacle: The Theatrical Roots of Modern Feminism* (Cambridge, Mass., and London: Harvard University Press, 2000), 174–84.

21. "Die Revue im Schumann-Theater," *FZ*, 19 May 1925, in *FT* 97.

22. On Kracauer's gender politics, see Schlüpmann, *Detektiv des Kinos*, 91–102, and "The Return of the Repressed: Reflections on a Philosophy of Film History from a Feminist Perspective," *Film History* 6.1 (Spring 1994): 80–93; Patrice Petro, *Joyless Streets: Women and Melodramatic Representation in Weimar Germany* (Princeton: Princeton University Press, 1989), 63–70; Sabine Hake, "Girls and Crisis: The Other Side of Diversion," *New German Critique* 40 (Winter 1987): 147–64. On the Tiller Girls in the context of Weimar androgyny and sexual politics, see Maud Lavin, *Cut with a Kitchen Knife: The Weimar Photomontages of Hannah Höch* (New Haven and London: Yale University Press, 1993), and Kirsten Beuth, "Die wilde Zeit der schönen Beine: Die inszenierte Frau als Körper-Masse," and other essays in *Die Neue Frau: Herausforderung für die Bildmedien der Zwanziger Jahre*, ed. Katharina Sykora et al. (Marburg: Jonas Verlag, 1993). Also see Nolan, *Visions of Modernity*, 120–27,

and Eve Rosenhaft, "Lesewut, Kinosucht, Radiotismus: Zur (geschlechter-)politischen Relevanz neuer Massenmedien in den 1920er Jahren," in Lüdtke, Marßolek, and Von Saldern, *Amerikanisierung*, 119–43.

23. "Exzentriktänzer in den Ufa-Lichtspielen," *FZ*, 16 Oct. 1928, in *FT* 122. On the protofascist imagination of the male body as armor, see Klaus Theweleit, *Male Fantasies*, 2 vols. (1977, 1978), trans. Stephen Conway (Minneapolis: University of Minnesota Press, 1987, 1989).

24. See Hal Foster, "Armor Fou," *October* 56 (Spring 1991): 64–97.

25. See, for instance, "Boredom," *MO* 331–34; and "Der verbotene Blick," *FZ*, 9 April 1925, in *S* 5.1:296–300.

26. "Mass Ornament," section 5. Ernst Bloch, too, valorizes the revue as a form that "by virtue of consummate nonsense, dissolves the unity of the person"; see *Heritage of Our Times* (1935), trans. Neville and Stephen Plaice (Berkeley: University of California Press, 1991), 203 (translation modified).

27. "Die Revuen," *FZ*, 11 Dec. 1925, in *S* 5.1:338–42.

28. While the circus is an Enlightenment invention and belongs to a manufactural mode of production, Kracauer notes the pervasiveness of rationalization even in an institution that was rapidly being pushed aside, and subsumed, by deterritorialized forms of media culture such as cinema. An awareness of this interstitial status inflects his numerous reviews of circus films, one of his favorite genres.

29. "Zirkus Hagenbeck," *FZ*, 19 June 1926, in *FT* 108. The difference that rationalization made for Kracauer's perception of the circus, if not for circus aesthetics itself, can be seen in comparison with his earlier essay, "Im Zirkus," *FZ*, 8 June 1923, *FT* in 73–78.

30. Also see "Geh'n wir mal zu Hagenbeck," *FZ*, 20 June 1926, in *FT* 113; and "Akrobat—schöön," *FZ*, 25 Oct. 1932, in *S* 5.3:127–31.

31. See, for instance, "Stehbars im Süden," *FZ*, 8 Oct. 1926, in *S* 5.1:383: "The value of cities is measured by the number of sites that they give over to improvisation." Also see "Zirkus Sarrasani," *FZ*, 13 Nov. 1929, in *FT* 128. On the significance of the category of chance in Kracauer's later work, see ch. 9, below.

32. "Artistisches und Amerikanisches," *FZ*, 29 Jan. 1926, in *W* 6.1:199. On the centrality of slapstick comedy in the drafts and outlines for *Theory of Film*, see ch. 9, below.

33. Georg Simmel, *The Philosophy of Money* (1900; rev. ed. 1907), trans. Tom Bottomore and David Frisby (London and New York: Routledge, 1990), 483.

34. In his review of *The General*, Kracauer hails Keaton as "the allegory of absentmindedness"; "Buster Keaton im Krieg," *FZ*, 5 May 1927, in *W* 6.1:338.

35. "Chaplin," *FZ*, 6 Nov. 1926, in *W* 6.1:269.

36. See, for instance, texts collected in Wilfried Wiegand, ed., *Über Chaplin* (Zürich: Diogenes, 1978); Klaus Kreimeier, ed., *Zeitgenosse Chaplin* (Berlin: Oberbaumverlag, 1978); and Richard Schickel, ed. *The Essential Chaplin* (Chicago: Ivan R. Dee, 2006). Also see Witte, "Nachwort"; Sabine Hake, "Chaplin Reception in Weimar Germany," *New German Critique* 51 (1990): 87–111.

37. Joseph Roth, review of *Ginster*, *FZ*, 25 Nov. 1928, in Belke and Renz, *Siegfried Kracauer*, 52. The phrase was subsequently used by the novel's publisher, S. Fischer, on the cover of the paperback and in publicity material. On Ginster as a *Lochmensch* (hole-person),

see Jörg Lau, "'Ginsterismus': Komik und Ichlosigkeit: Über filmische Komik in Siegfried Kracauers ersten Roman 'Ginster,'" in Volk, *Siegfried Kracauer*, 13–42; also see Hildegard Hogen, *Die Modernisierung des Ich: Individualitätskonzepte bei Siegfried Kracauer, Robert Musil and Elias Canetti* (Würzburg: Königshausen/Neumann, 2000), esp. 82–84.

38. "Chaplins Triumph," *Neue Rundschau* 42.1 (April 1931), in *W* 6.2:495; also see "Chaplin: Zu seinem Film 'Zirkus,'" *FZ*, 15 Feb. 1928, in *W* 6.2:32–35.

39. The David-versus-Goliath metaphor, which first appears in Kracauer's review of *The Pilgrim* ("Chaplin als Prediger," *FZ*, 23 Dec. 1929, in *W* 6.2:314), would become a recurrent motif in Kracauer's *Theory of Film*, where it is linked to cinematic techniques such as the close-up and the capacity of film to give representation to "the small world of things," as opposed to the grand schemes of narrative and history.

40. On the messianic connotations of Kracauer's Chaplin, see Mülder-Bach, *Kracauer*, 100.

41. Also see "Chaplin kommt an!," *FZ*, 11 March 1931, in *W* 6.2:468–70, and "Lichter der Großstadt: Zur deutschen Uraufführung des Chaplinfilms," *FZ*, 29 March 1931, in *W* 6.2:472. Benjamin too comments on the nationally varying reception of Chaplin ("in Germany, people are interested in the theoretical implications of his comedies"); "Chaplin in Retrospect," in *SW* 2:223.

42. Le Bon conflates the terms *mass* and *crowd*; see J. S. McClelland, *The Crowd and the Mob: From Plato to Canetti* (London: Unwin Hyman, 1989), ch. 7. Also see Markus Bernauer, *Die Ästhetik der Masse* (Basel: Wiese Verlag, 1990), ch. 2.

43. Among commentaries on this essay, see Karsten Witte, "Introduction to Siegfried Kracauer's 'The Mass Ornament,'" *New German Critique* 5 (Spring 1975): 59–66; Levin, "Introduction" to *MO* 15–20; and Koch, *Kracauer*, ch. 3.

44. "The Revolt of the Middle Classes: An Examination of the *Tat* Circle," *FZ*, 10 & 11 Dec. 1931, in *MO* 112.

45. See, for instance, Klooss and Reuter, *Körperbilder*, 71–72; and Hake, "Girls and Crisis," 156. In a perceptive reading of Kracauer's essay, Ramsay Burt points out that the Tiller Girls' performance style was actually still patterned on military precision rather than an aesthetics of the assembly line (*Alien Bodies*, 99).

46. Fritz Giese, *Girlkultur: Vergleiche zwischen amerikanischem und europäischem Rhythmus und Lebensgefühl* (Munich: Delphin Verlag, 1925).

47. Ibid., 35; Stefan Zweig, "The Monotonization of the World" (1925), in *Weimar Republic Sourcebook*, 398. For an anti-American(ist) and antifeminist response to Giese's book, see Richard Huelsenbeck, "Girlkultur," *Die Literarische Welt* 2.16 (1926): 3.

48. "Hundreds of thousands of salaried employees daily throng the streets of Berlin, yet their life is more unknown than that of the primitive tribes at whose customs those same employees marvel in the films." *Die Angestellten*, in *W* 1:217–18; *SM* 29.

49. See "Berliner Landschaft," *FZ*, 8 Nov. 1931, repr. under the title "Aus dem Fenster gesehen," in *S* 5.2:401: "The knowledge of cities hinges upon the deciphering of their dream-like images [*ihrer traumhaft hingesagten Bilder*]."

50. The term *hieroglyph* appears significantly in "Über Arbeitsnachweise: Konstruktion eines Raumes," a material analysis of the sociospatial reality of unemployment; *FZ*, 17 June 1930, in *S* 5.2:186. On Kracauer's trope of "dream image/hieroglyphics/deciphering,"

see Helmut Stalder, "Hieroglyphen-Entzifferung und Traumdeutung der Großstadt: Zur Darstellungsmethode in den 'Städtebildern' Siegfried Kracauers," in Volk, *Siegfried Kracauer*, 131–55.

51. For Kracauer's polemics against "body culture" and sports, see, for example, "Sie sporten," *FZ*, 13 Jan. 1927, in *S* 5.2:14–18; also see his review of *Wege zu Kraft und Schönheit* (revised version), *FZ*, 5 Aug. 1926, in *W* 6.1:253–55; "Mass Ornament," section 5; and *SM* 78–80. On the body culture movement, see Karl Toepfer, *Empire of Ecstasy: Nudity and Movement in German Body Culture, 1910–1935* (Berkeley: University of California Press, 1997), and Maren Möhring, *Marmorleiber: Körperbildung in der deutschen Nacktkultur (1890–1930)* (Köln: Böhlau, 2004). For examples of an alternative—though always, for Kracauer, problematic—physicality, see "Die Eisenbahn," *FZ*, 30 March 1930, in *S* 5.2:175–79; "Farewell to the Linden Arcade," *FZ*, 21 Dec. 1930, in *MO* 337–42; and "Heißer Abend," *FZ*, 15 June 1932, in *S* 5.3:82–83.

52. The decentered space of Chinese landscape painting is a topos in the modernist critique of traditional representational systems based on Renaissance perspective from Brecht through Barthes. See, for instance, Stephen Heath, "Lessons from Brecht," *Screen* 15.2 (Summer 1974): 104–5.

53. *From Caligari to Hitler*, 302–3, 94–95.

54. The parallel is further developed in Kracauer's exposé for a "study on fascist propaganda," solicited by Adorno for the Institute for Social Research in New York; "Masse und Propaganda (Eine Untersuchung über die faschistische Propaganda)," Dec. 1936, unpublished manuscript, in Belke and Renz, *Siegfried Kracauer*, 85–90, esp. section 4, "Ansatz der fascistischen Scheinlösung." Also see Witte, "Introduction to 'Mass Ornament,'" 62.

55. Max Horkheimer and Theodor W. Adorno, "Das Schema der Massenkultur: Kulturindustrie (Fortsetzung)" (1942), in Adorno, *Gesammelte Schriften* (*AGS*), vol. 3, ed. Rolf Tiedemann (Frankfurt a.M.: Suhrkamp, 1981), 332. For a not entirely reliable translation, see *CI* 81.

56. Also see Kracauer's discussion of the gap between mass formations (as object of organization and surveillance) and mass democracy (as the condition of social and economic justice) in his essay on unemployment agencies, "Über Arbeitsnachweise," 190–91.

57. See, for instance, Kracauer's obituary "Edgar Wallace," *FZ*, 13 Feb. 1932; "'Berlin-Alexanderplatz' als Film" (comparison with Sternberg, *An American Tragedy*), *FZ*, 13 Oct. 1931, in *W* 6.2:549; "Film 1928": "It is not the standardization [*Typisierung*] of film that is reprehensible. On the contrary . . ." (*W* 6.2:152; *MO* 308).

58. See "Not und Zerstreuung: Zur Ufa-Produktion 1931/32," *FZ*, 15 July 1931, in *W* 6.2:519–23; "Gepflegte Zerstreuung: Eine grundsätzliche Erwägung," *FZ*, 3 Aug. 1931, in *W* 6.2:528–30; "Ablenkung oder Aufbau? Zum neuen Ufa-Programm," *FZ*, 28 July 1932, in *W* 6:3:90–94. Also see "The Task of the Film Critic" (1932), trans. Don Reneau, in *Weimar Republic Sourcebook*, 634–35.

59. For examples of apparatus theory, see Rosen, *Narrative, Apparatus, Ideology*. Also see Roland Barthes, "Upon Leaving the Movie Theater" (1975), in *The Rustle of Language*, trans. Richard Howard (New York: Hill & Wang, 1986), 345–49.

60. "Philosophie der Gemeinschaft," in S 5.1:269–70.

61. Heide Schlüpmann, "Der Gang ins Kino—Ein Ausgang aus selbstverschuldeter Unmündigkeit: Zum Begriff des Publikums in Kracauers Essayistik der Zwanziger Jahre," in Kessler and Levin, Siegfried Kracauer, 276. Oskar Negt and Alexander Kluge distinguish different types of publicness—bourgeois, proletarian, and commercial-industrial; partial, alternative, oppositional—in Public Sphere and Experience.

62. Michel Foucault, "Of Other Spaces," Diacritics 16.1 (Spring 1986): 23–24.

63. See Hansen, Babel and Babylon: Spectatorship in American Silent Film (Cambridge, Mass.: Harvard University Press, 1991), ch. 3.

64. See, for instance, Lethen, Neue Sachlichkeit, 102–4, and Erhard Schütz, Romane der Weimarer Republik (München: W. Fink, 1986), 32–33.

65. See Michael Hardt and Antonio Negri, Multitude: War and Democracy in the Age of Empire (New York: Penguin, 2004). This trajectory makes sense if we extend Hardt and Negri's limited, primarily legal notion of the public (202–4) to one grounded in their concept of the common (which overlaps in important ways with Negt and Kluge).

66. Kracauer, "Einer, der nichts zu tun hat," FZ, 9 Nov. 1929, S 5.2:155.

67. See Alon Confino and Rudy Koshar, "Regimes of Consumer Culture: New Narratives in Twentieth-Century German History," German History 19.2 (2001): 135–61; and Konrad H. Jarausch and Michael Geyer, Shattered Past: Reconstructing German Histories (Princeton: Princeton University Press, 2003), ch. 10, "In Pursuit of Happiness: Consumption, Mass Culture, and Consumerism."

68. Peukert, Weimar Republic, 174–77.

69. See, for instance, "Farewell to the Linden Arcade," in MO 342; "Roller Coaster," trans. Thomas Y. Levin, Qui Parle 5.2 (1992): 58–60; and "Proletarische Schnellbahn," FZ, 24 April 1930, in S 5.2:179–80.

70. The distinction between the terms tends to get lost in translation; thus, Emil Lederer and Jakob Marshak, "Der neue Mittelstand," in Grundriß der Sozialökonomik, vol. 9, part 1 (Tübingen: Mohr, 1926): 120–41, appeared in English under the title "The New Middle Class," trans. S. Ellison (New York: Department of Social Science, Columbia University, 1937).

71. The term Stehkragen-Proletarier appears in the German edition of From Caligari to Hitler, S 2:199; the American version simply refers to "white-collar workers" (189).

72. Mülder-Bach, "Introduction" to SM 5, 6.

73. See ibid., 19, n. 8. Also see Weimar Republic Sourcebook, ch. 7.

74. Citing Egon Erwin Kisch, one of the prime representatives of Weimar reportage, Henri Band points out that Kracauer's distanciation from that genre is a strategic one, underplaying similarities in approach; see "Siegfried Kracauers Expedition in die Alltagswelt der Berliner Angestellten," in Volk, Siegfried Kracauer, 213–31.

75. See Bertolt Brecht, "The Threepenny Lawsuit," in Bertolt Brecht on Film and Radio, ed. and trans. Marc Silberman (London: Methuen, 2000), 164. "The situation has become so complicated because the simple 'reproduction of reality' says less than ever about that reality. A photograph of the Krupp works or the AEG reveals almost nothing about these institutions. Reality as such has slipped into the domain of the functional."

76. Koch, Kracauer, 62, 64.

77. The method of participant observation was developed around the same time by Robert and Helen Lynd in their famous studies of Muncie, Indiana, *Middletown: A Study in American Culture* (1929) and *Middletown in Transition* (1937). On Kracauer's status as employee and his increasingly precarious position with the *Frankfurter Zeitung*, see his semiautobiographical novel, *Georg*, in *W* 7, and references in ch. 1, n. 2.

78. Kracauer wrote a number of articles focusing on female employees: for instance, "Mädchen im Beruf," *Der Querschnitt* 12.4 (April 1932), in *S* 5.3:60–65; (abridged) trans. in *Weimar Republic Sourcebook*, 216–18. On the precarious status of female employees see, among others, Atina Grossmann, "*Girlkultur* or Thoroughly Rationalized Female: A New Woman in Weimar Germany?" in *Women in Culture and Politics*, ed. Judith Friedlander et al. (Bloomington: Indiana University Press, 1986).

79. Kracauer, "Berliner Nebeneinander," in *BN* 31.

80. The inversion of exotic and familiar, of distance and closeness, is a pervasive theme in Kracauer's writings of that period, especially on the genre of the *Wochenschau* (weekly news and scenics accompanying the feature film); see, for instance, "Exotische Filme," *FZ*, 28 May 1929, in *W* 6.2:251–54; "Mischmasch," *FZ*, 22 Sept. 1931, in *W* 6.2:540–41; "Die Filmwochenschau," *Die Neue Rundschau* 42.2 (1931): 573–75, in *W* 6.2:553–56; and "Reisen, nüchtern," *FZ*, 10 July 1932, in *S* 5.3:87–90. This theme ties in with the methodological metaphor of "Unknown Territory" in chapter 1 of *Die Angestellten*, as well as his critique of the illustrated magazines in "Photography," *MO* 58.

81. Review of Balázs, *Der Geist des Films*, "Ein neues Filmbuch," *FZ*, 2 Nov. 1930, in *S* 6.2:412–15; also see Kracauer's review of *Der sichtbare Mensch*, "Bücher vom Film," *FZ*, 10 July 1927, in *S* 6.1:370–72.

82. Emilie Altenloh, *Zur Soziologie des Kino: Die Kino-Unternehmung und die sozialen Schichten ihrer Besucher* (Leipzig: Spamer, 1914).

83. For the latter argument, see Henri Band, "Massenkultur versus Angestelltenkultur: Siegfried Kracauers Auseinandersetzung mit Phänomenen der modernen Kultur in der Weimarer Republik," in *Zwischen Angstmetapher und Terminus: Theorien der Massenkultur seit Nietzsche*, ed. Norbert Krenzlin (Berlin: Akademie Verlag, 1992), 73–101; also see Band, "Kracauers Expedition," where he reverses his earlier position, now defending employee culture as a subcultural formation against Kracauer's sarcasm. Also see Hans G. Helms, "Der wunderliche Kracauer" (1971), repr. in Volk, *Siegfried Kracauer*, 256.

84. "Über den Schauspieler" (1930), in *S* 5.2:232.

85. In a letter to Kracauer of 13 April 1926, Benjamin praises this insight as a "sociological discovery"; *Briefe an Siegfried Kracauer*, 41.

86. "Zwei Arten der Mitteilung" (1929), in *S* 5.2:167.

87. "Über Arbeitsnachweise," in *S* 5.2:189.

88. Benjamin, "An Outsider Makes His Mark" (1930), in *SW* 2:308.

89. By "poststructuralist film theory," I refer to such influential texts as Christian Metz, *The Imaginary Signifier: Psychoanalysis and the Cinema* (1975), trans. Celia Britton et al. (Bloomington: Indiana University Press, 1982), and related positions advanced in the journals *Screen* and *Camera Obscura*; see Rosen, *Narrative, Apparatus, Ideology*, part 2.

90. Kracauer, "Der Mörder Dimitrij Karamasoff: Einige grundsätzliche Überlegungen zum Tonfilm," *FZ*, 12 Feb. 1931, in *W* 6.2:453.

91. For Negt and Kluge, writing at a more advanced stage of the media industries' development, this tendency of voracious inclusiveness is a salient distinction between the commercial public spheres and the traditional bourgeois type. See *Public Sphere and Experience*, chs. 4–6, and Hansen, "Foreword," in ibid., xxix–xxx.

92. "Girls and Crisis," *FZ*, 26 May 1931, trans. Courtney Federle, *Qui Parle* 5.2 (Spring–Summer 1992): 52. Also see Kracauer, "Renovierter Jazz," *FZ*, 25 Oct. 1931, in *S* 5.2:390–92.

93. Ernst Bloch, "Bezeichnender Wandel in Kinofabeln" (1932), in *Gesamtausgabe* (Frankfurt a.M.: Suhrkamp, 1965), 9:77; "prosperity" in the original.

94. "Das neue Bauen: Zur Stuttgarter Werkbundausstellung: 'Die Wohnung,'" *FZ*, 31 July 1927, in *S* 5.2:68–74, 74. For Benjamin, see especially his 1933 essay "Experience and Poverty," in *SW* 2:731–36. Also see Hilde Heynen, *Architecture and Modernity* (Cambridge, Mass.: MIT Press, 1999).

95. "Ein paar Tage Paris," *FZ*, 5 April 1931, in *S* 5.2:301.

96. "Die Wiederholung: Auf der Durchreise in München," *FZ*, 29 May 1932, in *S* 5.3:71–72.

97. "Straße ohne Erinnerung," *FZ*, 16 Dec. 1932, *S* 5.3:173. This article and other "urban miniatures" (Huyssen) were collected by Kracauer himself in *Straßen in Berlin und anderswo* (Frankfurt a.M.: Suhrkamp, 1964). See Andreas Huyssen, "Modernist Miniatures: Literary Snapshots of Urban Spaces," *PMLA* 122.1 (2007): 27–42; also see Mülder-Bach, "'Mancherlei Fremde': Paris, Berlin und die Extraterritorialität Siegfried Kracauers," *Juni: Magazin für Kultur und Politik* 3.1 (1989) 61–72; Anthony Vidler, "Agoraphobia: Spatial Estrangement in Simmel and Kracauer," *New German Critique* 54 (Fall 1991): 31–45; and references in ch. 1, n. 23.

98. The term *Straßenrausch* appears in Kracauer's essay "Erinnerung an eine Pariser Straße," *FZ*, 9 Nov. 1930, in *S* 5.2:243.

99. Ibid., 248.

100. "Pariser Beobachtungen," *FZ*, 13 Feb. 1927, in *S* 5.2:25–36; "Das Straßenvolk in Paris," *FZ*, 12 April 1927, in *S* 5.2:39–43. Also see "Analysis of a City Map," in *MO* 41–42; and "Die Berührung," *FZ*, 18 Nov, 1928, in *S* 5.2:129–36.

101. "Negerball in Paris," *FZ*, 2 Nov. 1928, in *S* 5.2:127–29. On Kracauer's parochial relation to race and simultaneous rejection of primitivism (and the hypothetical challenge of Josephine Baker), see James Donald, "Kracauer and the Dancing Girls," *New Formations* 61 (Summer 2007): 49–63.

102. Kracauer, "Lichtreklame," *FZ*, 15 Jan. 1927, in *S* 5.2:19. This image belongs to Kracauer's pervasive play with tropes of illumination and reflection; see "Ansichtspostkarte," *FZ*, 26 May 1930, in *S* 5.2:184–85, discussed in ch. 1. Benjamin makes a similar gesture in *One-Way Street* (1928): "Not what the moving red neon sign says—but the fiery pool reflecting it in the asphalt" (*SW* 1:476).

103. On Clair's *Sous les toits de Paris* (1930), see "Neue Tonfilme: Einige grundsätzliche Bemerkungen," *FZ*, 16 Aug. 1930, in *W* 6.2:392–95; on Feyder, see "Thérèse Raquin," *FZ*, 29 March 1928, in *W* 6.2:53–55, and "Wiedersehen mit alten Filmen: VI. Jean Vigo," *Basler National-Zeitung*, 1 Feb. 1940, in *W* 6.3:299–303.

104. "Man with a Movie Camera," *FZ*, 19 May 1929, trans. Stuart Liebman, in *Lines of Resistance: Dziga Vertov and the Twenties*, ed. and intr. Yuri Tsivian (Pordenone: Le Giornate

del Cinema Muto, 2004), 358; W 6.2:249. In this remarkable review, Kracauer foregrounds the film's affinity with states of dreaming and waking and its evocation of death as a fundamental question concerning individual and collective existence.

105. "Idyll, Volkserhebung und Charakter" (on Clair's *Quatorze Juillet*) FZ, 24 Jan. 1933, in W 6.3:132; Benjamin, "Surrealism," in SW 2:216.

106. "Neue Filme" (on *Le Million* [1931]), FZ, 18 May 1931, in W 6.2:510–11; "Rationalisierung und Unterwelt" (on *À nous la liberté*), FZ, 27 Jan. 1932, in W 6.3:21–23; "Idyll, Volkserhebung und Charakter."

107. See Kracauer to Adorno, 24 Aug. 1930: "The situation in Germany is more than serious. . . . We will have three to four million unemployed and I can see no way out. A disaster is hanging over this country and I am certain that it's not just capitalism. That capitalism may be bestial is not due to economic causes alone. . . . I simply keep noticing in France, even though there's much to criticize there too, all the things that have been destroyed here: the basic decency, much good nature and with it people's trust in one another." (*AKB* 246–47).

108. "Rationalisierung und Unterwelt," 22. On the historical context of France's resistance to "mechanization," see Richard F. Kuisel, *Seducing the French: The Dilemma of Americanization* (Berkeley and Los Angeles: University of California Press, 1993).

109. "Pariser Beobachtungen," 25, 35.

110. "La ville de Malakoff," FZ, 30 Jan. 1927, in S 5.2:22–24.

111. "Ein paar Tage Paris," FZ, 5 April 1931, in S 5.2:301. For a similar turn, see "Die Wiederholung," which contrasts Berlin's presentist modernity with Munich's dreamlike evocation of the past yet culminates in a veritable flight back to Berlin.

112. "Berliner Landschaft," FZ, 8 Nov. 1931, in S 5.2:401; also see "Unfertig in Berlin," FZ, 13 Sept. 1931, in S 5.2:375.

113. "Roller Coaster," 59.

114. "Organisiertes Glück: Zur Wiedereröffnung des Lunapark," FZ, 8 May 1930, in BN 73.

115. "Zirkus Sarrasani," FZ, 13 Nov. 1929, in FT 128. This piece relates to his earlier articles on the circus, e.g., "Zirkus Hagenbeck" (see n. 29 above), in a similar way as "Organized Happiness" does to "Roller Coaster." In fact, Kracauer's writings on the circus could be taken as something of a barometer indicating his stance on the ability of mass-cultural entertainment forms to provide a reflexive matrix for the experience of rationalization.

116. "Girldämmerung," FZ, 22 June 1928, in W 6.2:95–97. The review concludes with the statement "American miracles happen in Hollywood."

117. Kracauer, "Worte von der Straße," FZ, 7 July 1930, in S 5.2:201. For an attempt to rescue the Alps from the discourse of reactionary kitsch, see Bloch, "Alpen ohne Photographie" (1930), in *Gesamtausgabe* 9:488–98.

CHAPTER 3

1. "Benjamin hat Konjunktur, aber ist er auch aktuell?" Norbert Bolz, "Walter Benjamins Ästhetik," in *Walter Benjamin, 1892–1940, zum 100. Geburtstag*, ed. Uwe Steiner (Bern: Peter Lang, 1992), 11. A shorter version of this essay appears under the title "Aesthetics of Media:

NOTES TO CHAPTER 3 305

What Is the Cost of Keeping Benjamin Current?" in *Mapping Benjamin: The Work of Art in the Digital Age,* ed. Hans Ulrich Gumbrecht and Michael Marrinan (Stanford: Stanford University Press, 2003), 24. In that version, the translator makes a point of rendering *Aktualität* as "currency," which it precisely does *not* mean in Benjamin's usage.

2. Also see Gumbrecht and Marrinan, "Editors' Preface," in *Mapping Benjamin,* xiii–xvi.

3. The notion of actuality was a shared concern between Kracauer and Bloch and other Weimar intellectuals, signaling the epistemological and political imperative to engage with modernity and its contradictions. The term was revived, and applied to Benjamin himself, in a volume commemorating his eightieth birthday, *Die Aktualität Walter Benjamins,* ed. Siegfried Unseld (Frankfurt a.M.: Suhrkamp, 1972), and in celebrations of his centennial in 1992. See Irving Wohlfarth, "The Measure of the Possible, the Weight of the Real and the Heat of the Moment: Benjamin's Actuality Today," in *The Actuality of Walter Benjamin,* ed. Laura Marcus and Lynda Nead (London: Lawrence & Wishart, 1998), 13–39.

4. Kracauer, "The Mass Ornament," in *MO* 75. Benjamin's critique of the nineteenth-century ideology of progress runs though his early to late work, from *The Origin of German Tragic Drama* through *The Arcades Project,* and finds its most concise form in his theses "On the Concept of History" (1940).

5. Benjamin to Werner Kraft, 27 Dec. 1935, in *The Correspondence of Walter Benjamin, 1910–1940* (hereinafter *CWB*), ed. and annot. Gershom Scholem and Theodor W. Adorno, trans. Manfred R. Jacobson and Evelyn M. Jacobson (Chicago: University of Chicago Press, 1994), 517. The metaphor of the telescope does not suggest optical objectivity but a special, at once critical and utopian, optics: "As for me, I am busy pointing my telescope through the bloody mist at a mirage of the nineteenth century that I am attempting to depict according to the features that it will manifest in a future state of the world liberated from magic. Of course I first have to build this telescope myself and, in making this effort, I am the first to have discovered some fundamental principles of materialist art theory. I am currently in the process of explicating them in a short programmatic essay." Benjamin to Werner Kraft, 28 Oct. 1935, in *CWB* 516; Benjamin, *Gesammelte Briefe* (*GB*), 6 vols., ed. Christoph Gödde and Henri Lonitz (Frankfurt a.M.: Suhrkamp, 1999–2000), 5:193.

6. Benjamin to Max Horkheimer, 16 Oct. 1935, in *CWB* 509; *GB* 5:179.

7. On Benjamin's complex relation to historicism, see H. D. Kittsteiner, "Walter Benjamin's Historicism," trans. Jonathan Monroe and Irving Wohlfarth, *New German Critique* 39 (Fall 1986): 179–215. Also see Michael Steinberg, ed., *Walter Benjamin and the Demands of History* (Ithaca, N.Y.: Cornell University Press, 1996).

8. Benjamin to Horkheimer, 16 Oct. 1935, in *CWB* 509; *GB* 5:179.

9. Benjamin to Gretel Karplus, 9 Oct. 1935, *GB* 5:171.

10. Max Horkheimer to Benjamin, 18 March 1936, in Benjamin, *Gesammelte Schriften* (*GS*), ed. Rolf Tiedemann, Hermann Schweppenhäuser, et al. (Frankfurt a.M.: Suhrkamp, 1974): 1:997–99. The list of cuts and changes enclosed with the letter includes, for example, replacing "Le fascisme" with "L'état totalitaire," the word "impérialiste" with "moderne," and "Le communisme" with "Les forces constructives de l'humanité" (ibid., 1000). On the altercations surrounding the translation, see Chryssoula Kambas, *Walter Benjamin im Exil: Zum Verhältnis von Literaturpolitik und Ästhetik* (Tübingen: Niemeyer, 1983), 158–62.

11. On Benjamin's relation to communist cultural politics in the context of the Popular Front, see Philippe Ivornel, "Paris, Capital of the Popular Front or the Posthumous Life of the 19th Century?" trans. Valerie Budig, *New German Critique* 39 (Fall 1986): 61–84.

12. See Kambas, *Benjamin im Exil*, 153–57, 163–70. Also see Maria Gough, "Paris, Capital of the Soviet Avant-Garde," *October* 101 (2002): 53–83; and Burkhardt Lindner, "Technische Reproduzierbarkeit und Kulturindustrie: Benjamins 'Positives Barbarentum' im Kontext," in *Walter Benjamin im Kontext,* ed. Lindner (1978; Königstein/Ts.: Athenäum, 1985), 187–88.

13. Benjamin, "Surrealism: The Last Snapshot of the European Intelligentsia" (1929), in *SW* 2:217; on anthropological materialism, see below, ch. 5.

14. Pierre Klossowski, who translated the artwork essay into French, emphasizes the esoteric and early-socialist context, especially Fourier, in which Benjamin developed his theses; see "Lettre sur Walter Benjamin," *Mercure de France* 315 (1952): 456–57.

15. On Benjamin and temporality, see Peter Osborne, "Small-Scale Victories, Large-Scale Defeats: Walter Benjamin's Politics of Time," in *Walter Benjamin's Philosophy: Destruction and Experience,* ed. Andrew Benjamin and Peter Osborne (London and New York: Routledge, 1994), 59–109. Also see Osborne, *The Politics of Time: Modernity and Avant-Garde* (New York: Verso, 1995).

16. Benjamin to Werner Kraft, 28 Oct. 1935, in *CWB* 516; *GB* 5:193.

17. "Das Kunstwerk im Zeitalter seiner technischen Reproduzierbarkeit (Zweite Fassung)," in *GS* 7.1:381; "The Work of Art in the Age of Its Technological Reproducibility: Second Version," in *SW* 120. On Benjamin's intervention in the idealist tradition of aesthetics, see Alexander Gelley, "Contexts of the Aesthetic in Walter Benjamin," *Modern Language Notes* 114 (1999): 933–61.

18. The German term *Erfahrung*—with its etymological connotations of *fahren* (riding, journeying, cruising) and *Gefahr* (peril, which is also present, if submerged, via the Latin root *periri,* to perish, in *experience*)—does not have as much of an empiricist connotation as its English counterpart, which also contains the German term *Erlebnis* (immediate but isolated experience); Benjamin famously historicized and reconstellated the two terms in his 1939–40 essay on Baudelaire. He emphatically set off the mnemonic, mimetic, and collective conception of *Erfahrung* against models of experience based on the exact natural sciences; see, for instance, the fragment "Experience" (1931 or 1932), in *SW* 2:553. There is a vast literature on Benjamin's concept of experience; see, among others, Martin Jay, *Songs of Experience: Modern American and European Variations on a Universal Theme* (Berkeley and Los Angeles: University of California Press, 2005), esp. ch. 8. Also see Marleen Stoessel, *Aura: Das Vergessene Menschliche: Zu Sprache und Erfahrung bei Walter Benjamin* (Munich: Carl Hanser, 1983); Martin Jay, "Experience without a Subject: Walter Benjamin and the Novel" (1993), in *Cultural Semantics: Keywords of Our Time* (Amherst: University of Massachusetts Press, 1998); and Howard Caygill, *Walter Benjamin: The Colour of Experience* (London and New York: Routledge, 1998).

19. Eduard Fuchs, "Collector and Historian" (1937), in *SW* 3:266; *GS* 2:475.

20. Benjamin, "Theories of German Fascism" (1930), trans. Jerolf Wikoff, in *SW* 2:321; also see "Pariser Brief 1: André Gide und sein neuer Gegner" (1936), in *GS* 3:482–95, esp. 490–92.

21. Susan Buck-Morss, "Aesthetics and Anaesthetics: Walter Benjamin's Artwork Essay Reconsidered," *October* 62 (Fall 1992): 3–41. Also see Lieven de Cauter, "The Panoramic Ecstasy: On World Exhibitions and the Disintegration of Experience," *Theory, Culture & Society* 10 (1993): 1–23.

22. Benjamin to Gretel Karplus, early June 1934, in *GB* 4:441. The passage continues: "The scope that [my thinking] thus claims, the freedom to juggle on parallel tracks things and thoughts that are considered incompatible, assumes a face only at the time of danger" (*CWB* 300). Also see his letter to Gershom Scholem of 29 May 1926, in which he characterizes his attitude in all things that really matter as "always radical, never consistent" (*CWB* 300; *GB* 3:159). On the antinomic structure of Benjamin's thinking, see Anson Rabinbach, "Between Enlightenment and Apocalypse: Benjamin, Bloch, and Modern German Jewish Messianism," *New German Critique* 34 (1985): 78–124; Irving Wohlfarth, " 'No-Man's Land': On Walter Benjamin's 'Destructive Character,' " in *Walter Benjamin* and Osborne, *Benjamin's Philosophy*, 155–82; and John McCole, *Walter Benjamin and the Antinomies of Tradition* (Ithaca, N.Y.: Cornell University Press, 1993).

23. McCole, *Benjamin and the Antinomies*, 3, 21–30; Wohlfarth, "Measure," 16.

24. In his elegiac essay on Nicolai Leskov, "The Storyteller" (1936), he repeats verbatim the memorable passage on World War I's rupturing of traditional experience ("A generation that had gone to school in horse-drawn streetcars . . .") from his essay "Experience and Poverty" (1933), which had sought to derive from the unreliability of experience the virtue of a "new, positive concept of barbarism." See "Experience and Poverty," in *SW* 2:732, and "The Storyteller: Observations on the Work of Nicolai Leskov," in *SW* 3:144.

25. "On Some Motifs in Baudelaire" (1939–40), in *SW* 4:343; *GS* 1:653.

26. Benjamin unfolds the trope of a forgotten future in "A Berlin Chronicle," in *SW* 2:634–35.

27. McCole, *Benjamin and the Antinomies*, 9 and passim; Gillian Rose, "Walter Benjamin—Out of the Sources of Modern Judaism," in Marcus and Nead, *The Actuality of Walter Benjamin*, 104.

28. The controversies surrounding the essay during Benjamin's lifetime were not public. On the contrary, the degree of its untimely actuality can be inferred from a remarkable lack of response, both to Benjamin's attempt to generate discussion by presenting his theses to the Paris branch of the Schutzverband deutscher Schriftsteller (Defense League of German Authors) and even among his friends and allies (especially in Moscow); notable exceptions include the efforts of film historian Jay Leyda to obtain an English translation for the Museum of Modern Art Film Library (and the offer by *Close-Up* co-editor Bryher [Annie Winifred Ellerman], to pay for such a translation), as well as the conservative appropriation of Benjamin's theses by André Malraux. See editors' notes in *GS* 1:982–1035 and *GS* 7:661–88; editors' "Chronology, 1935–1938," in *SW* 3:426–29; and Detlev Schöttker, "Kommentar," in Walter Benjamin, *Das Kunstwerk im Zeitalter seiner technischen Reproduzierbarkeit*, ed. Schöttker (Frankfurt a.M.: Suhrkamp, 2007), 118–64, as well as letters reprinted there.

The French version of the essay, "L'oeuvre d'art à l'époque de sa reproduction mécanisée," is reprinted in GS 1:709–39; on the politically motivated cuts, see editorial notes, GS 1:999–1000. The first German, handwritten version of "Das Kunstwerk im Zeitalter seiner tech-

nischen Reproduzierbarkeit" can be found in *GS* 1:431–69, and the "third" (actually fourth), 1939 version of the essay in *GS* 1:471–508. It is the latter that was published, in a rather unreliable translation, in the first English-language collection of Benjamin's writings, *Illuminations,* ed. and intr. Hannah Arendt, trans. Harry Zohn (New York: Schocken, 1969); for a thoroughly revised translation, see "The Work of Art in the Age of Its Technological Reproducibility," in *SW* 4:251–83. The second, first typewritten version, to which Benjamin referred as his "Urtext" (*GS* 1:991) and of which he circulated copies, was rediscovered and published only in 1989 in *GS* 7: 350–84; trans. *SW* 3:101–33.

29. See Helmuth Lethen, "Zur materialistischen Kunsttheorie Benjamins," *Alternative* 10.56–57 (1967): 225–34; and Hans Magnus Enzensberger, "Constituents of a Theory of the Media" (1970), in *The Consciousness Industry: On Literature, Politics and the Media,* trans. Stuart Hood (New York: Continuum, 1974).

30. On Benjamin's reception in Germany, see Thomas Küpper and Timo Skrandies, "Rezeptionsgeschichte," in *Benjamin-Handbuch: Leben—Werk—Wirkung,* ed. Burkhardt Lindner (Stuttgart and Weimar: J.B. Metzler, 2006), esp. 22–29; and Klaus Garber, *Rezeption und Rettung: Drei Studien zu Walter Benjamin* (Tübingen: Max Niemeyer Verlag, 1987), part 3.

31. The first English version of the essay—"The Work of Art in the Epoch of Mechanical Reproduction," trans. H.H. Gerth and Don Martindale—was actually published in the American journal *Studies on the Left* 1.2 (Winter 1960): 28–46. In addition to Hannah Arendt's introduction and edition of *Illuminations,* the initial English-language reception of Benjamin owes much to Fredric Jameson, *Marxism and Form* (Princeton: Princeton University Press, 1971); Jay, *Dialectical Imagination;* and Buck-Morss, *Origins of Negative Dialectics,* as well as to journals such as *New German Critique* and *Telos.*

32. See D.N. Rodowick, *The Crisis of Political Modernism: Criticism and Ideology in Contemporary Film Theory* (Urbana and Chicago: University of Illinois Press, 1988).

33. See, for instance, Tom Gunning, "The Cinema of Attractions: Early Film, Its Spectator, and the Avant-Garde" (1986), repr. in *The Cinema of Attractions Reloaded,* ed. Wanda Strauven (Amsterdam: Amsterdam University Press, 2006); Leo Charney and Vanessa R. Schwartz, eds., *Cinema and the Invention of Modern Life* (Berkeley: University of California Press, 1995); and Lynne Kirby, *Parallel Tracks: The Railroad and Silent Cinema* (Durham, N.C.: Duke University Press, 1997).

34. See David Bordwell, *On the History of Film Style* (Cambridge, Mass.: Harvard University Press, 1997), 141–46; Ben Singer, *Melodrama and Modernity* (New York: Columbia University Press, 2001), 9–10, ch. 4; and Tom Gunning, "Modernity and Cinema: A Culture of Shocks and Flows," in *Cinema and Modernity,* ed. Murray Pomerance (New Brunswick, N.J.: Rutgers University Press, 2006), esp. 302–15.

35. On the concept of "force field" in Benjamin (and Adorno), see Martin Jay, *Force Fields: Between Intellectual History and Cultural Critique* (New York and London: Routledge, 1993), esp. 1–3, 8–9.

36. One of the most remarkable examples of such international practice, most likely unknown to Benjamin, can be found in the Mitchell and Kenyon collection preserved and restored by the British Film Institute. Active roughly between 1899 and 1913 in the North West of England, the firm of Mitchell and Kenyon shot hundreds of actuality films

of workers leaving a factory, the opening of soccer games, and fairground scenes that, advertised as "local films for local people," were subsequently exhibited in traveling cinematograph shows at country fairs. See *The Lost World of Mitchell and Kenyon: Edwardian Britain on Film*, ed. Vanessa Toulmin, Simon Popple, and Patrick Russell (London: British Film Institute, 2004).

37. See Bordwell, Staiger, and Thompson, *The Classical Hollywood Cinema*, 214–21; 157–73.

38. Benjamin (together with stage director Bernhard Reich) had developed an analogous principle for the theater in "Revue oder Theater," *Der Querschnitt* (1925), in *GS* 4:802.

39. See, for instance, Richard Koszarski, *An Evening's Entertainment: The Age of the Silent Feature Picture, 1915–1928* (New York: Charles Scribner's Sons, 1990), ch. 2; and Hansen, *Babel and Babylon*, ch. 3.

40. See Paul Hammond, ed., *The Shadow and Its Shadow: Surrealist Writings on the Cinema* (London: British Film Institute, 1978), and Abel, *French Film Theory and Criticism*, vol. 1.

41. Benjamin had already practiced such tactical belatedness in his invocation of Sergei Tretyakov (whose experimental, modernist aesthetics was anathema to the champions of proletarian art and cultural heritage and who was to perish in the Gulag) in "The Author as Producer" (1934). On the significance of this essay in relation to both the Soviet and German politics of socialist realism (made official doctrine in 1934) and the (communist-front) Paris Institute for the Study of Fascism (INFA), to which it was originally addressed, see Gough, "Paris," 76–83.

42. Annette Michelson, "Introduction" to *Kino-Eye: The Writings of Dziga Vertov*, trans. Kevin O'Brien (Berkeley: University of California Press, 1984), lxi.

43. I have not been able to ascertain if Benjamin saw *Man with a Movie Camera*, but it is more than likely that he had read Kracauer's enthusiastic review of that film, *FZ*, 19 May 1929, in Tsivian, *Lines of Resistance*, 355–59. Benjamin refers to Vertov in only one other place: his 1927 article "On the Present Situation of Russian Film" (*SW* 2:13), which contains observations on montage sequences in Vertov's *The Soviet Sixth of the Earth* prefiguring similar ones in the later film.

44. See, for instance, Willi Bredel's letter of rejection of 28 March 1937, repr. in Schöttker, *Kunstwerk*, 92–93. *Das Wort* was a German-exile Popular Front literary journal of which Brecht served as a principal, though ambivalent, editor. See David Pike, *German Writers in Soviet Exile, 1933–45* (Chapel Hill: University of North Carolina Press, 1982), ch. 8.

45. See Eva Geulen, "Under Construction: Walter Benjamin's 'The Work of Art in the Age of Mechanical Reproduction,'" trans. Eric Baker, in *Benjamin's Ghosts*, ed. Gerhard Richter (Stanford: Stanford University Press, 2002), 121–41.

46. *AP* 461 (N2,6).

47. See, most recently, Antoine Hennion and Bruno Latour, "How to Make Mistakes on So Many Things at Once—and Become Famous for It," in Gumbrecht and Marrinan, *Mapping Benjamin*, 91–97. Also see Horst Bredekamp, "Der simulierte Benjamin: Mittelalterliche Bemerkungen zu seiner Aktualität," in *Frankfurter Schule und Kunstgeschichte*, ed. Andreas Berndt, Peter Kaiser, Angela Rosenberg, and Diana Trinkner (Berlin: Dietrich Reimer Verlag, 1992), 117–40.

48. Caygill, *Walter Benjamin*, 94.

49. Wohlfarth, "Measure," 14.

50. See Benjamin's critique of Ernst Jünger, "Theories of German Fascism" (1930), in *SW* 2:318–19, and of Thierry Maulnier, "Pariser Brief 1: André Gide und sein neuer Gegner" (1936), in *GS* 3:490–92.

51. See Uwe Steiner, "The True Politician: Walter Benjamin's Concept of the Political," *New German Critique* 83 (Spring–Summer 2001): 43–88.

52. Rose, "Walter Benjamin," 104.

53. See below, ch. 4, n. 40. The only opposition in the artwork essay for which Benjamin actually uses the term *polarity* is that between semblance (*Schein*) and play (*Spiel*); see *SW* 3:127, n. 22.

54. Except for the last sentence the passage already appears verbatim in the German original of Benjamin's "Little History of Photography" (1931), in SW 2:519; GS 2:379.

55. In the fragment "Experience" (1931 or 1932), Benjamin defines experiences as "lived similarities" (*SW* 2:553).

56. On Benjamin's notion of "distorted similitude" (and its distinction from "nonsensuous" similitude), see Sigrid Weigel, *Entstellte Ähnlichkeit: Walter Benjamins theoretische Schreibweise* (Frankfurt a.M.: Fischer, 1997); also see Weigel, *Body- and Image-Space: Rereading Walter Benjamin*, trans. Georgina Born (London and New York: Routledge, 1996); and Michael Opitz, "Ähnlichkeit," in *Benjamins Begriffe*, ed. Opitz and Erdmut Wizisla (Frankfurt a.M.: Suhrkamp, 2000), 1:48.

57. In *The Arcades Project* (*AP* 418), Benjamin links the centrality of the concept of similitude to the way that, in the hashish experience, everything appears as or, rather, "is face," has a "degree of bodily presence that allows it to be scanned—as one scans a face"—which amounts to a physiognomic mode of perception.

58. Irving Wohlfarth, "Walter Benjamin's Image of Interpretation," *New German Critique* 17 (1979): 80. A similar logic can be seen at work in Kracauer's early film aesthetics.

59. See Johannes V. Jensen, "Arabella," in *Exotic Novellas* (1919). Benjamin's complete texts on hashish are collected in *On Hashish*, ed. and trans. Howard Eiland, intr. Marcus Boon (Cambridge, Mass.: Harvard University Press, 2006).

60. For a discussion of Benjamin's concept of the masses in relation to intellectual-political antipodes such as Heidegger and Jünger, see Norbert Bolz, "Prostituiertes Sein," in *Antike und Moderne: Zu Walter Benjamins "Passagen,"* eds. Bolz and Richard Faber (Würzburg: Königshausen + Neumann, 1986), 191–213.

61. See, in particular, Simmel's *Philosophy of Money* (1900; 1907). Yet, where Simmel sees the desire that produces value leading to greater social distance and isolation, Benjamin discerns in the commodity a utopian dimension, linked to the collective dream of a better life, if not a "better nature."

62. In another draft note, Benjamin formulates the mimetic aspect of the formation of the masses in a striking metaphor: "At all times, the life of the masses has been decisive for the face of history. But that the masses, as it were, the muscles of this face, give conscious expression to this mimic relation [*Mimik*]—that is an altogether novel phenomenon. This phenomenon manifests itself in many areas, but in a particularly drastic way in art" (*GS* 1:1041).

63. See, for instance, Bloch, "The Dazzling Film Star," in *Heritage of Our Times,* 27–28.

64. In the earlier versions of the essay (*GS* 7:365–70, *GS* 1:449–55), the question of screen acting is treated in greater detail, which throws into clearer relief the significance of Benjamin's concepts of "shock," "self-alienation," and "play" for the political function of cinema.

65. A weaker and more compelling version of this claim can be found in Benjamin's defense of *Battleship Potemkin,* in which he speaks of "the complicity of film technique with the milieu" (*SW* 2:18).

66. In his letter responding to the artwork essay, Adorno singles out this discussion for particular praise: "I find your few sentences concerning the disintegration of the proletariat into 'masses' through the revolution, to be amongst the most profound and most powerful statements of political theory I have encountered since I read [Lenin's] State and Revolution" (*CC*, 132–33).

67. This account resonates with Benjamin's pessimistic description of "the mass" in terms of an "instinctual," animal-like yet blindly self-destructive behavior in *One-Way Street,* section "Imperial Panorama," *SW* 1:451.

68. "Pariser Brief I: André Gide und sein neuer Gegner" (1936), in *GS* 3:488.

69. See David Macey, *Lacan in Contexts* (New York: Verso, 1988). For a more detailed analysis of this connection, see Buck-Morss, "Aesthetics and Anaesthetics," 37–38.

70. See Beatrice Hanssen, *Walter Benjamin's Other History: Of Stones, Animals, Human Beings, and Angels* (Berkeley: University of California Press, 1998).

71. "Hitler's Diminished Masculinity," fragment written ca. Aug. 1934, in *SW* 2:792. Also see Benjamin, "Chaplin Retrospect" (1929), in *SW* 2:224, where he praises Chaplin for appealing to "the most international and the most revolutionary emotion of the masses: their laughter."

72. Burckhardt Lindner, "Das Kunstwerk im Zeitalter seiner technischen Reproduzierbarkeit," in Lindner, *Benjamin-Handbuch,* 247.

73. See Nicolas Pethes, "Die Ferne der Berührung: Taktilität und mediale Repräsentation nach 1900: David Katz, Walter Benjamin," *Zeitschrift für Literaturwissenschaft und Linguistik* 30.117 (2000): 33–57. Pethes relates this new tactility to *Lebensphilosophie* and other efforts, during the late nineteenth and early twentieth century, to revive the significance of the haptic sense, from art history and the philosophy of art (Riegl, Wilhelm Worringer, Carl Linfert) to the psychology of perception and psychotechnology (David Katz, Hugo Münsterberg). Also see Antonia Lant, "Haptical Cinema," *October* 75 (Fall 1995): 111–27.

74. Benjamin, "Theater and Radio," in *SW* 2:584–85; "The Author as Producer," in *SW* 2: 777–9. For a more detailed discussion, see Howard Eiland, "Reception in Distraction," *boundary 2* 30.1 (Spring 2003): 51–66.

75. In a fragment associated with the artwork essay, "Theory of Distraction," Benjamin notes: "Distraction, like catharsis, should be conceived as a physiological phenomenon. . . . The relation of distraction to ingestion must be examined" (*SW* 3:141; *GS* 7:678).

76. In *One-Way Street,* written a decade earlier, Benjamin still makes a case for reappropriating collective intoxication; see "To the Planetarium," in *SW* 1:486–87. Also see below, ch. 5.

CHAPTER 4

1. Benjamin, *On Hashish*, 58; *SW* 2:327–28. The following chapter is based on my essay, "Benjamin's Aura," *Critical Inquiry* 34.2 (Winter 2008): 336–75.

2. Bertolt Brecht, entry for 25 July 1938, *Journals*, ed. John Willett and Ralph Manheim, trans. Hugh Rorrison (London: Methuen, 1993), 10: "a load of mysticism, although his attitude is against mysticism."

3. In a note written ca. 1929, he refers to his early critique of the (bourgeois) category of experience ("Experience" [1913–14], in *SW* 1:3–5) as a "rebellious" act of youth with which, given the centrality of a theory of experience in his ongoing work (one may think of the essays on surrealism and the mimetic faculty, Proust, and Kafka), he had nonetheless remained faithful to himself: "For my attack punctured the word without annihilating it" (*GS* 2:902). Also see above, ch. 3, n. 18.

4. The first definition appears in Benjamin's "Little History of Photography" (1931), in *SW* 2:518; *GS* 2:378. It is resumed almost verbatim in the artwork essay, *SW* 3:104ff; *GS* 7:355. The parenthetical phrase is from Benjamin's *Arcades Project*, in *AP* 447; *GS* 5:560. The second definition is elaborated in "On Some Motifs in Baudelaire" (1940), *SW* 4:338; *GS* 1:646–47.

5. See, for instance, his first "impression of hashish," written 18 Dec. 1927, at 3:30 A.M.: "The sphere of 'character' opens up. . . . One's aura interpenetrates with that of the others" (*On Hashish*, 19; *GS* 6:558). Writing about his second experiment with hashish on 15 Jan. 1928, 3:30 P.M., Benjamin complains that Ernst Bloch gently tried to touch his knee: "I sensed the contact long before it actually reached me. I felt it as a highly repugnant violation of my aura" (*On Hashish*, 27; *GS* 6:563). Something of this psychophysiological sense of aura survives into the artwork essay's comparison of the screen actor to the live actor on stage. On the relation of aura and body, see, among others, Guy Hocquenhem and René Schérer, "Formen und Metamorphosen der Aura," in *Das Schwinden der Sinne*, ed. Dietmar Kamper and Christoph Wulf (Frankfurt a.M.: Suhrkamp, 1984), 75–86.

6. Trace (*Spur*) is one of those terms in Benjamin's writings that have antithetical meanings depending on the constellation in which they are used. It is dismissed qua the fetishizing signature of the bourgeois interior in his advocacy of the new "culture of glass" in "Experience and Poverty" (quoting Brecht, "Erase the traces!" in *SW* 2:734), but is valorized as a mark of an epic culture (see "The Storyteller") that he, like Brecht, saw renewed in modern literature and film and that linked art with material production and tactical, habitual perception (*SW* 3:149). While in some contexts aura and trace are overlapping terms, in both negative and positive senses, a late entry in *The Arcades Project* puts them in stark opposition: "Trace and aura. The trace is the appearance of a nearness, however far removed the thing that left it behind may be. The aura is the appearance of a distance, however close the thing that calls it forth. In the trace, we gain possession of the thing; in the aura, it takes possession of us" (*AP* 447 [M16a,4]). See Hans Robert Jauss, "Spur und Aura (Bemerkungen zu Walter Benjamins 'Passagen-Werk')," in *Art social und Art industriel: Funktionen der Kunst im Zeitalter des Industrialismus*, ed. Helmut Pfeiffer, H. R. Jauss, Françoise Gaillard (Munich: Wilhelm Fink Verlag, 1987), 19–38; Karl Stierle, "Aura, Spur und Benjamins Vergegenwärtigung des 19. Jahrhunderts," in ibid., 39–47; and Mika

Elo, "Die Wiederkehr der Aura," in *Walter Benjamins Medientheorie,* ed. Christian Schulte (Konstanz: UVK, 2005), 130–31.

7. I am using Roland Barthes's language here deliberately, since so many of his observations on photography echo Benjamin (in addition to Kracauer). See, in particular, the notion of the "punctum," the accidental mark or detail of the photograph that "pricks," stings, wounds the beholder; *Camera Lucida: Reflections on Photography,* trans. Richard Howard (New York: Hill & Wang, 1981), 26–27.

8. As is evident from diary notes and his correspondence of May 1931 through July 1932, Benjamin was actually contemplating taking his own life when he wrote "Little History of Photography," which is to say that the forgotten future of the woman who was to become Mrs. Dauthendey speaks to him less through an uncanny premonition than through a rather conscious and detailed preoccupation with this mode of death. See "Diary from August 7, 1931, to the Day of My Death," in *SW* 2:501, and farewell letters to Franz Hessel, Jula Radt-Cohn, Ernst Schoen, and Egon and Gert Wissing (including Benjamin's will), all dated 27 July 1932, in *GB* 4:115–22. Also see Gershom Scholem, *Walter Benjamin: The Story of a Friendship,* trans. Harry Zohn (1981; New York: New York Review of Books, 2003), 225–37; Bernd Witte, *Walter Benjamin* (Reinbek bei Hamburg: Rowohlt, 1985), 97–100; and the editors' "Chronology," in *SW* 2:842–43.

9. See Peter M. Spangenberg, "Aura," in *Ästhetische Grundbegriffe: Historisches Wörterbuch in sieben Bänden,* ed. Karlheinz Barck et al. (Stuttgart and Weimar: J. B. Metzler, 2000), 1:402–4. The nineteenth-century positivist psychiatrist Hippolyte Baraduc tried to document these symptoms by means of photographs; see Georges Didi-Huberman, *Invention of Hysteria: Charcot and the Photographic Iconography of the Salpetrière,* trans. Alisa Hartz (Cambridge, Mass.: MIT Press, 2003).

10. See Markus Bauer, "Die Mitte der Mitteilung: Walter Benjamin's Begriff des Mediums," in Schulte, *Walter Benjamins Medientheorie,* 39–48. For a different approach, see Sam Weber, *Mass Mediauras—Form, Technics, Media* (Stanford: Stanford University Press, 1996), 76–106, and Hanno Reisch, *Das Archiv und die Erfahrung: Walter Benjamins Essays im medientheoretischen Kontext* (Würzburg: Königshausen & Neumann, 1992), 98–108.

11. Eduardo Cadava, *Words of Light: Theses on the Photography of History* (Princeton: Princeton University Press, 1997), 120.

12. On the place of the Kafka portrait in "Little History," especially its superimposition with Benjamin's own visit to a photographer's studio as a highly allegorical scene of "distorted similarity" ("Berlin Childhood around 1900" [1934], in *SW* 3:391–92), see Cadava, *Words of Light,* 106–27.

13. "A Berlin Chronicle" (1932), in *SW* 2:597. Benjamin's writings on Proust range from his 1929 essay "On the Image of Proust" (*SW* 2:237–47) through his late reflections on the writer in the second Baudelaire essay (*SW* 4: 332–33, 337–39). Also see fragments relating to the 1929 essay in *GS* 2:1048–69.

14. "The Return of the *Flâneur*" (1929), in *SW* 2:265; *GS* 3:198.

15. Also see Georges Didi-Huberman, *Ce que nous voyons, ce qui nous regarde* (Paris: Éditions de Minuit, 1992), which makes extensive reference to Benjamin.

16. Novalis, quoted in Benjamin's doctoral dissertation (1920), "The Concept of Criticism in German Romanticism," in *SW* 1:145. The entire section IV, "The Early Romantic

Theory of the Knowledge of Nature," is relevant to the complex that he will later refer to by the term *aura*.

17. See Stoessel, *Aura*, 75–76 and passim; Weigel, *Body- and Image-Space*, ch. 2; and Hanssen, *Walter Benjamin's Other History*.

18. Letter to Benjamin, 29 Feb. 1940, *CC* 320–21. Adorno proposes a distinction between "epical forgetting" (essential to hatching *Erfahrung*) and "reflex forgetting" (characteristic of *Erlebnis*)—which would amount to formulating a "distinction between good and bad reification"—to reconcile ostensible inconsistencies in Benjamin's account of experience and aura. What Adorno himself seems to have forgotten is that Benjamin, in his 1929 essay on Proust, had already commented upon *mémoire involontaire* as a dialectic of remembering and forgetting—calling the author's "weaving of his memory . . . a Penelope work of forgetting" (*SW* 2:238). See also the fragment relating to his Proust essay, *GS* 2:1066.

19. Stoessel, *Aura*, 61–62, 72–77, and ch. 5, esp. 130–40; also see Christine Buci-Glucksmann, *Baroque Reason: The Aesthetics of Modernity*, trans. Patrick Camiller (Thousand Oaks, Calif.: Sage, 1994). This argument goes some way toward accounting for the gendered oscillation between Benjamin's semi-reflective fetishization of aura and his masculinist insistence on the necessity of its critical destruction, its allegorical mortification. However, the disjunctive temporality of auratic experience—the glimpse of a prehistoric past at once familiar and strange—suggests that the logic of fetishism is crucially inflected with the register of the Freudian uncanny, a point I elaborate in my earlier essay, "Benjamin, Cinema and Experience: 'The Blue Flower in the Land of Technology,'" *New German Critique* 40 (Winter 1987): 212–17. Also see Helga Geyer-Ryan, "Abjection in the Texts of Walter Benjamin," in *Fables of Desire* (Cambridge: Polity, 1994), ch. 6.

20. Giorgio Agamben suggests that Benjamin found an important contemporary source for thinking of photography and cinema as "transmitters of aura" (including the definition of Baudelaire as "poet of the aura") in the writer-physician Léon Daudet's book *Mélancholia* (1928); see Agamben, *Stanzas*, trans. Ronald L. Martinez (Minneapolis: University of Minnesota Press, 1993), 44–45. (Daudet was also at the time editor of *L'Action Française*, organ of the right-wing, ultranationalist and monarchist movement founded by Charles Maurras.) The notion of technological media as transmitters of supernatural phenomena was of course pervasive in occultist practices (e.g., spirit photography, telegraphy). The point here is that Benjamin not only historicized and dialecticized that conjuncture but also sought through it to theorize the possibility of temporally disjunctive experience in modernity.

21. "A Berlin Chronicle," in *SW* 2:632; *GS* 6:516. The part of the news that the father "forgot" to convey to the child was that the man had died of syphilis (*SW* 2:635); also see "News of a Death," in the 1934 version of "Berlin Childhood around 1900," *SW* 2:389–90.

22. Benjamin, "What Is Epic Theater (II)?" (1939), in *SW* 4:306.

23. Also see Benjamin, "Storyteller," in *SW* 3:151.

24. See Thierry Kuntzel, "Le Défilement: A View in Closeup," and Bertrand Augst, "Le Défilement into the Look . . . ," both in *Apparatus: Cinematographic Apparatus: Selected Writings*, ed. Theresa Hak Kyung Cha (New York: Tanam Press, 1980), 233–47, 249–59.

25. Benjamin himself formulates a version of this question—and a partisan response to it—in his essay on Eisenstein's *Battleship Potemkin*, "Reply to Oskar A. H. Schmitz"

(1927), in *SW* 2:16–19, which anticipates the artwork essay's section on the optical unconscious.

26. Caygill, *Walter Benjamin*, 94. For Caygill, this understanding of the optical unconscious encapsulates Benjamin's concept of experience, "where the future subsists in the present as a contingency which, if realized, will retrospectively change the present." Contrary to my argument here, Caygill asserts that "the weave of space and time captured by the photograph is characterized by contingency and *is anything but auratic*" (emphasis added).

27. "Berlin Chronicle," in *SW* 2:634–35. The troping of the future as an invisible stranger or alien land (*jene unsichtbare Fremde*) is the counterpart to the déjà vu, the "shock" with which "moments enter consciousness as if already lived," in which—here Benjamin emphasizes the acoustical dimension of the phenomenon—"a word, a tapping, or a rustling" may transport "us into the cool tomb of long ago, from the vault of which the present seems to return only as an echo." The linkage of auratic experience, futurity, and death already appears in one of Benjamin's earliest surviving texts, "The Metaphysics of Youth" (1913–14), in *SW* 1:6–17, esp. 12–14. Also see Roberta Malagoli, "'Vergiß das Beste nicht!' *Déjà vu*, memoria e oblio in Walter Benjamin," *Annali di Ca' Foscari* 27.1–2 (1988): 247–79.

28. In *The Arcades Project*, Benjamin repeatedly links the decline of aura to the waning of the "dream of a better nature" (362, J76, 1), and the waning of the utopian imagination in turn to impotence, both sexual and political (342, J63a, 1; 361, J75, 2).

29. Wohlfarth, "Measure of the Possible," 28.

30. See Birgit Recki, *Aura und Autonomie: Zur Subjektivität der Kunst bei Walter Benjamin und Theodor W. Adorno* (Würzburg: Königshausen & Neumann, 1988). For a critique of the effort to conserve aura qua aesthetic autonomy, see Ansgar Hillach, "Man muß die Aura feiern, wenn sie fällt: Überlegungen zu Walter Benjamins anarchistischem Konservatismus," in *Konservatismus in Geschichte und Gegenwart*, ed. Richard Faber (Würzburg: Königshausen & Neumann, 1991): 167–82, esp. 171, 176–78.

31. "Whenever a human being, an animal, or an inanimate object thus endowed by the poet lifts up its eyes, it draws him into the distance. The gaze of nature, when thus awakened, dreams and pulls him after its dream" (*SW* 4:354). If this account of poetic inspiration itself culminates in a lyrical image, the subsequent reference to Kraus ("words, too, can have an aura. . . . 'The closer one looks at a word, the greater the distance from which it looks back'") pertains to a different type of language, written language or script, and thus to Benjamin's concern with physiognomic reading (including graphology) as a modern practice of the mimetic faculty.

32. "Ein sonderbares Gespinst aus Raum und Zeit: / Einmalige Erscheinung einer Ferne, so nah sie sein mag. / An einem Sommernachmittage ruhend / Einem Gebirgszug am Horizont oder einem Zweig folgen[d], / Der seinen Schatten auf den Ruhenden wirft— / Das heißt die Aura dieser Berge, dieses Zweiges atmen" (*GS* 7:355, 1:479). See Dietrich Thierkopf, "Nähe und Ferne: Kommentare zu Benjamins Denkverfahren," *Text und Kritik* 31–32 (Oct. 1971): 3–18. On the relationship of aura and the lyric in modernity, see Robert Kaufman, "Aura, Still," *October* 99 (Winter 2002): 45–80.

33. See Alois Riegl, "Die Stimmung als Inhalt der modernen Kunst" (Atmosphere as the Content of Modern Art, 1899), repr. in *Gesammelte Aufsätze* (Augsburg and Wien: Dr.

Benno Filser Verlag, 1929), 28–39. Also see Wolfgang Kemp, "Fernbilder: Benjamin und die Kunstwissenschaft," in *"Links hätte noch alles sich zu enträtseln . . .": Walter Benjamin im Kontext,* ed. Burckhardt Lindner (Frankfurt: Syndikat, 1978), 224–57; and Michael W. Jennings, "Walter Benjamin and the Theory of Art History," in Steiner, *Walter Benjamin, 1892–1940,* 77–102.

34. At least as important a source for this opposition was Wilhelm Worringer's ideologically charged popularization of Riegl's categories in *Abstraction and Empathy* (1908), which had its aesthetic counterpart less (as is often claimed) in German expressionism than in cubism following Cezanne (see Jennings, "Walter Benjamin and the Theory of Art History," 83, 89–100) and in British vorticism, mediated by T. E. Hulme, and "reactionary modernists" such as T. S. Eliot and Ezra Pound. Also see Antonia Lant, "Haptical Cinema," *October* 75 (Fall 1995): 111–27.

35. Simmel, *Philosophy of Money,* 473. Also see Simmel's book on Goethe (1912), *Gesamtausgabe,* ed. Otthein Rammstedt, vol. 15 (Frankfurt a.M.: Suhrkamp, 2003), 74–76 and passim.

36. It is no coincidence that expressions like "blue distance," or *"Fernblick ins Blau"* (literally, "the far-gaze into the blue"), appear epigrammatically in Benjamin's first avowedly modernist work, *One-Way Street* (1928), in *SW* 1:468, 470; *GS* 4:120, 123.

37. Also see the fragment "On Semblance," in *SW* 1:223–25. In the essay on Goethe (1919–22, published 1924–25), the term *aura* is used only in passing and, actually, in an antithetical sense to beauty (*SW* 1:348).

38. Gary Smith notes that the artwork essay's conflation of aura with the idea of beautiful semblance reflects a "less than seamless transfer of the grammar of beauty's relation to truth and the sublime onto the specifically modern category of aura." Smith, "A Genealogy of 'Aura': Walter Benjamin's Idea of Beauty," in *Artifacts, Representations, and Social Practice,* ed. Carol C. Gould and Robert S. Cohen (Dordrecht, The Netherlands: Kluwer, 1994), 115.

39. "On Some Motifs in Baudelaire," *SW* 4:352. Benjamin distinguishes beauty defined by its relationship to history from beauty in its relationship to nature. "On the basis of its *historical* existence, beauty is an appeal to join those who admired it in an earlier age," that is, to join the majority of those who are dead (*"ad plures ire,* as the Romans called dying"). It is significant, especially in the context of his reception of Klages (see below), that Benjamin does not use the term *tradition* here, but speaks of generations and the majority of the dead.

40. For Goethe's notion of polarity, see his *Theory of Colors,* trans. Charles Lock Eastlake (Cambridge, Mass.: MIT Press, 1970), 293–303, paragraphs 739–57. Contemporary versions of the polarity of farness and nearness can be found in *Lebensphilosophie,* in particular Klages, as well as Heidegger; see, for example, Heidegger, "The Thing" (1950), 165–66.

41. *One-Way Street,* in *SW* 1:486. Situated in the Klages-inspired closing section of *One-Way Street,* "To the Planetarium," this statement refers to the conditions of possibility—and the high stakes—of attaining this kind of experience, predicated on "the ancients' intercourse with the cosmos," in modernity and doing so in a collective mode; see ch. 5, below.

42. Josef Fürnkäs, "Aura," in Opitz and Wizisla, *Benjamins Begriffe,* 1:141–42.

43. Adorno, "Benjamin's *Einbahnstrasse*" (1955), in Nicholsen, *Notes to Literature*, 2:326; also see *Aesthetic Theory*, newly trans., ed., and intr. Robert Hullot-Kentor (Minneapolis: University of Minnesota Press, 1997), 311.

44. "Light from Obscurantists" (1932), in *SW* 2:653–75: "If one [advertising] has mastered the art of transforming the commodity into an arcanum, the other [occult science] is able to sell the arcanum as a commodity."

45. See, for instance, "Metaphysics of Youth," in *SW* 1:13.

46. Fürnkäs, "Aura," 105–6.

47. *On Hashish*, 58; *SW* 2:327–28; *GS* 6:588.

48. "Nichts gegen die 'Illustrierte,'" in *GS* 4:448–49, 449 (emphasis added).

49. See Martin Heidegger, "The Origin of the Work of Art" (1935), in *Poetry, Language, Thought*, 32–37 and passim. While Heidegger's famous invocation of Van Gogh's painting of a pair of peasant shoes depends on the three-dimensional depth of the shoes that makes for their essential thingness, Benjamin's reference turns on the ornamental flatness of Van Gogh's later paintings. See Michael P. Steinberg, "The Collector as Allegorist: Goods, Gods, and the Object of History," in Steinberg, *Benjamin and the Demands of History*, 96–106; also see Christopher P. Long, "Art's Fateful Hour: Benjamin, Heidegger, Art, and Politics," *New German Critique* 83 (Spring–Summer 2001): 99–101.

50. See, in particular, "Experience and Poverty," in *SW* 2:733–34. Also see Adolf Loos, "Ornament and Crime" (1908), in *Programs and Manifestoes on 20th-Century Architecture* (Cambridge, Mass: MIT Press, 1970).

51. Epigraph, convolute M ("The Flaneur") of *AP*, 416. The phrase is from Hofmannsthal's play *Der Tor und der Tod* (*Death and the Fool*, 1894). On Benjamin's theory of reading, see Wohlfarth, "'Was nie geschrieben wurde, lesen,'" in Steiner *Walter Benjamin, 1892–1940*, 297–344. On Benjamin (and Kracauer) as part of the boom in cultural physiognomy between 1910 and 1935, see Heiko Christians, "Gesicht, Gestalt, Ornament: Überlegungen zum epistemologischen Ort der Physiognomik zwischen Hermeneutik und Mediengeschichte," *Deutsche Vierteljahresschrift für Literaturwissenschaft und Geistesgeschichte* 74.1 (2000): 84–110. On the history and theory of physiognomy, see Claudia Schmölders, *Das Vorurteil im Leibe: Eine Einführung in die Physiognomik* (Berlin: Akademie Verlag, 1995).

52. "Crock Notes" (ca. June 1933), in *On Hashish*, 81–82; *GS* 6:603–4.

53. See "Doctrine of the Similar" and "On the Mimetic Faculty" (1933), *SW* 2:694–98, 720–22. Also see Burckhardt Lindner, "Benjamins Aurakonzeption: Anthropologie und Technik, Bild und Text," in Steiner, *Walter Benjamin, 1892–1940*, 218–24.

54. Draft note relating to his essays on the mimetic faculty, in *GS* 2:958.

55. See Richard Faber, *Männerrunde mit Gräfin: Die "Kosmiker" Derleth, George, Klages, Schuler, Wolfskehl und Franziska von Reventlow* (Frankfurt a.M. and Berlin: Peter Lang, 1994); Irene Gammel, *Baroness Elsa: Gender, Dada, and Everyday Modernity—A Cultural Biography* (Cambridge, Mass.: MIT Press, 2002), esp. ch. 4, "Munich's Dionysian Avant-Garde in 1900"; Gerd-Klaus Kaltenbrunner, "Zwischen Rilke und Hitler—Alfred Schuler," *Zeitschrift für Religions- und Geistesgeschichte* 19.4 (1967), 333–47; Werner Fuld, "Die Aura: Zur Geschichte eines Begriffs bei Benjamin," *Akzente* 26 (1979), esp. 360–69; and Manfred Schlösser, ed., *Karl Wolfskehl, 1869–1969: Leben und Werk in Dokumenten* (Darmstadt: Agora Verlag, 1969), 138–39.

56. Benjamin, on behalf of the "Freie Studentenschaft," had invited Klages to give a lecture on graphology that took place in Munich in July 1914; see letter to Ernst Schoen, 23 June 1914, in *CWB* 69, as well as letters to Klages himself, 10 Dec. 1920 (*GB* 2:114) and 28 Feb. 1923 (*GB* 2:319). Benjamin discusses Klages's books *Prinzipien der Charakterologie* (1910) and *Handschrift und Charakter* (1917)—both of which were to enjoy a wave of reprints during the Nazi period—in his review article "Graphology Old and New" (1930), in *SW* 2:398–400; also see "Review of the Mendelssohns' *Der Mensch in der Handschrift*" (1928), in *SW* 2:131–34, and the fragment "Zur Graphologie" (1922 or 1928), in *GS* 6:185. Also see Schmölders, *Vorurteil im Leibe*, 99–108.

57. In his letter to Klages of 10 Dec. 1920, Benjamin inquires about the announced sequel to the essay on dream consciousness, "which revealed to me extraordinary and, if I may say so, longed-for perspectives" (*GB* 2:114). In a letter of 28 Feb. 1923, he writes: "I permit myself . . . to convey to you how much joy and confirmation of my own thoughts I gratefully took away from your text on the cosmogonic eros" (*GB* 2:319). Also see his fragment of 1922–23, "Outline of the Psychophysical Problem," esp. section VI, in *SW* 1:397–401.

58. "Johann Jakob Bachofen," in *SW* 3:18. As late as 1933, however, he manages to mention Schuler positively in print (not coincidentally in a "thought-image" entitled "Secret Signs"), attributing to him the insight that authentic cognition had to contain "a dash of nonsense [*Widersinn*]": "what is decisive is not the progression from one cognition to the next, but the or leap [or crack, *Sprung*] within any single cognition" (*SW* 2:699; *GS* 4:425). His letter to Scholem of 15 August 1930 suggests not only his enduring interest in Schuler ("admittedly on the basis of very special constellations") but also an awareness of the untimeliness of that connection: "I also had ordered a slim volume of posthumously published fragments that I can marvel at in secret" (*CWB* 367; *GB* 3:538).

59. Alfred Schuler, *Fragmente und Vorträge aus dem Nachlaß*, ed. Ludwig Klages (Leipzig: Ambrosius Barth, 1940); and Klages's introduction to this volume, 1–119, 7. Also see Kaltenbrunner, "Zwischen Rilke und Hitler," 336–37.

60. Schuler, *Fragmente und Vorträge*, 151.

61. Ibid., 262.

62. See Richard Faber, "Karl Wolfskehl, ein deutsch-jüdischer Antiintellektueller," in *"Verkannte Brüder": Stefan George und das deutsch-jüdische Bürgertum zwischen Jahrhundertwende und Emigration*, ed. Gert Mattenklott, Michael Philipp, and Julius H. Schoeps (Hildesheim: Georg Olms Verlag, 2001), 117–33. On Benjamin's interactions with Wolfkehl see *GB*, 3:312, 326, 348, 454, 460, 474–75, as well as his homage to the poet, "Karl Wolfskehl zum sechzigsten Geburtstag: Eine Erinnerung," *FZ*, 17 Sept. 1929, in *GS* 4:366–68. Benjamin dissociates Wolfskehl from the spiritists (and even the Steinerites, who claimed him as one of their own) in a remarkable review of 1932, "Erleuchtung durch Dunkelmänner: Zu Hans Liebstoeckl, 'Die Geheimwissenschaften im Lichte unserer Zeit,'" in *GS* 3:356–60, 357.

63. Karl Wolfskehl, "Lebensluft" (1929), repr. in Wolfskehl, *Gesammelte Werke*, vol. 2 (Hamburg: Claassen, 1960): 419. Benjamin also mentions "Die neue Stoa," ibid., 380–83, which sounds the cosmic key words of "*Urwelt*" and "*Fernen der Ferne*" (distances of distance) in a critique of instrumental reason and scientific progress. Benjamin is likely to have read another of Wolfskehl's articles in the *Frankfurter Zeitung*: "Spielraum" ("Room-

for-Play"; 1929), ibid., 430–33, which employs a term that Wolfskehl deploys *against* the technological transformation of space and time in modernity that Benjamin, in turn, was to appropriate to describe film's enabling and therapeutic role vis-à-vis that very transformation; see below, ch. 7.

64. On Klages and Benjamin, see, among others, McCole, *Benjamin and the Antinomies*, 178–80, 236–40, 242–52; Irving Wohlfarth, "Walter Benjamin and the Idea of a Technological Eros: A Tentative Reading of *Zum Planetarium*," in *Benjamin Studies/Studien 1: Perception and Experience in Modernity*, eds. Helga Geyer-Ryan, Paul Koopman, and Klaas Yntema (Amsterdam: Rodolpi, 2002), 65–109; Richard Block, "Selective Affinities: Walter Benjamin and Ludwig Klages," *Arcadia* 35 (2000): 117–35; Michael Pauen, "Eros der Ferne: Walter Benjamin and Ludwig Klages," in *Global Benjamin: Internationaler Walter-Benjamin-Kongreß 1992* (Munich: Wilhelm Fink, 1992), 2:706–11. For attempts to revive Klages from the perspective of Critical Theory, including Horkheimer and Adorno's *Dialectic of Enlightenment*, ecology, phenomenology, and poststructuralism, see M. Pauen, "Wahlverwandschaft wider Willen? Rezeptionsgeschichte und Modernität von Ludwig Klages," in *Perspektiven der Lebensphilosophie: Zum 125. Geburtstag von Ludwig Klages*, ed. Michael Großheim (Bonn: Bouvier, 1999), 21–43; and M. Großheim, "'Die namenlose Dummheit, die das Resultat des Fortschritts ist'—Lebensphilosophie und dialektische Kritik der Moderne," *Logos*, N. F. 3 (1996), 97–133.

65. See, in particular, Klages's introduction to Schuler's writings (1940) in *Fragmente und Vorträge*, 1–119. On Klages's (and Schuler's) anti-Semitism, see Faber, *Männerrunde*, 69–91.

66. Letter to Gretel Karplus, early June 1934, in *GB* 4:441. In his letter to Scholem, 15 August 1930, Benjamin calls Klages's major new publication, *Der Geist als Widersacher der Seele* (*The Intellect as Adversary of the Soul*) "without doubt a great philosophical work" that he intended to study closely. "I would never have imagined that the kind of preposterous metaphysical dualism that forms the basis of Klages's work could ever be associated with really new and far-reaching conceptions" (*CWB* 366; *GB* 3:537).

67. Scholem, "Walter Benjamin" (1965), trans. Lux Furtmüller, *Yearbook of the Leo Baeck Institute* 10 (1968).

68. Benjamin, "Review of Bernoulli's *Bachofen*" (1926), in *SW* 1:427. For a Marxist critique of Klages, Jung, and Bergson, see, for instance, Bloch, *Heritage of Our Times*, 304–24.

69. Wohlfarth, "Benjamin and Technological Eros," 76.

70. Adorno acknowledged that Klages's "doctrine of 'phantoms'" in the section "'The Actuality of Images" ("*Wirklichkeit der Bilder*") from his *Geist als Widersacher der Seele* (vol. 3 [Leipzig: J. A. Barth, 1922]: 1223–37) "lies closest of all, relatively speaking, to our own concerns" (Adorno to Benjamin, 5 Dec. 1934, in *CC* 61).

71. See, for instance, Klages, *Geist*, 3:1103; *Vom Wesen des Bewusstseins*, in Ludwig Klages, *Sämtliche Werke*, vol. 3 of *Philosophische Schriften*, ed. Ernst Frauchiger et al. (Bonn: Bouvier, 1974), 293–94; and *Vom kosmogonischen Eros*, ibid., 422–23.

72. See, in particular, Adorno's (and Gretel Karplus's) response to the first *Exposé* of *The Arcades Project* in the letter of 2–4 and 5 Aug. 1935, in *CC* 104–16. Also see Susan Buck-Morss, *The Dialectics of Seeing: Walter Benjamin and the Arcades Project* (Cambridge, Mass.: MIT Press, 1989).

73. Benjamin read *Matière et mémoire* during his student years but seems to have reserved any more systematic reflections until his "On Some Motifs in Baudelaure," in *SW* 4:314–15, 336 and passim. The revival of Bergson in film and media theory has almost entirely been channeled through Gilles Deleuze, *Cinéma 1: L'Image-mouvement*, and *Cinéma 2: L'Image-temps* (1983). See, among others, Paul Douglass, "Deleuze's Bergson: Bergson Redux," in *The Crisis in Modernism: Bergson and the Vitalist Controversy*, ed. Frederick Burwick and P. Douglass (Cambridge: Cambridge University Press, 1992), 368–88; and Douglass, "Bergson and Cinema: Friends or Foes?" in *The New Bergson*, ed. John Mullarkey (Manchester: Manchester University Press, 1999), 209–28. For a return to Bergson through different routes, see, for instance, Paula Amad, *Counter-Archive: Film, the Everyday, and Albert Kahn's Archives de la Planète* (New York: Columbia University Press, 2010), ch. 3 and passim; and Mark B. N. Hansen, *New Philosophy for New Media* (Cambridge, Mass.: MIT Press, 2004).

74. The term *image memory* had a less controversial lineage in the "new art studies," in particular the Warburg School. See Aby Warburg's *Der Bilderatlas Mnemosyne*, on which Warburg began to work in 1924; also see Fritz Saxl and Erwin Panofsky, *Melencolia 1* (1923), to which Benjamin refers in his treatise *The Origin of German Tragic Drama*. However, the lineage through art history is only one, if a privileged, case of Benjamin's interest in the historical transmissibility of images—as much in the medium of perception and experience as in and across particular artistic and technological media. On Benjamin's unreciprocated "elective affinity" with the Warburg School, see Sigrid Weigel, "Bildwissenschaft aus dem 'Geiste wahrer Philologie': Benjamins Wahlverwandtschaft mit der neuen Kunstwissenschaft und der Warburg Schule," in *Schrift Bilder Denken: Walter Benjamin und die Künste*, ed. Detlev Schöttker (Frankfurt a.M.: Suhrkamp; Berlin: Haus am Waldsee, 2004), 112–27.

75. Klages, *Vom kosmogonischen Eros*, 470.

76. To Adorno, the mythic-oneiric premises of Benjamin's image memory (in his initial concept of the "dialectical image") were of course at least as suspect because of their propinquity with C. G. Jung's archetypes and the attendant notion of a collective unconscious; see letter to Benjamin, 2–4, 5 Aug. 1935, in *CC* 106–7.

77. "Outline of the Psychophysical Problem," fragment written 1922–23, in *SW* 1:393–401, esp. section VI: "Nearness and Distance (Continued)," 397–400. Under the heading of "literature," Benjamin lists five works by Klages, 398.

78. Klages, *Vom kosmogischen Eros*, 432–33.

79. Ibid., 428–29.

80. See ibid., appendix 1, "Warum bringt es Verderben, den Schleier des Isisbildes zu heben?" 474–82, esp. 481–82.

81. In the following, I refer to the 1919 version, which expands the 1913–14 version by a second chapter, titled "Das Wachbewußtsein im Traume." See Klages, *Sämtliche Werke*, 3:155–238; parenthetical page numbers refer to this edition.

82. Klages, "Mensch und Erde," in *Sämtliche Werke*, 3:623.

83. See Hugo Münsterberg, *The Photoplay: A Psychological Study* (1916), ed. Allan Langdale (New York and London: Routledge, 2002), and texts by Epstein, Delluc, Dulac, and others in Abel, ed. *French Film Theory and Criticism*, vol. 1. The more direct and better-known lineage between Klages and classical film theory runs through Sergei Eisenstein, who, like Vsevolod Meyerhold and other biomechanical acting theorists, found in Klages's

study on "expressive movement," *Ausdrucksbewegung und Gestaltungskraft* (Leipzig: Johann Ambrosius Barth, 1923), a confirmation of the theory, derived from William James, that bodily movement both manifests and generates affective reflexes.

84. See, among others, Vivian Sobchack, *The Address of the Eye: A Phenomenology of Film Experience* (Princeton: Princeton University Press, 1992), and "The Passion of the Material: Toward a Phenomenology of Interobjectivity," in Sobchack, *Carnal Thoughts: Embodiment and Moving Image Culture* (Berkeley, Los Angeles: University of California Press, 2004).

85. The double movement of the dreamer's mimetic fusion with the phenomena perceived and, in the flux of their displacement, a sense of embodied metamorphosing is reminiscent of Kracauer's account of the subject of "boredom" in his eponymous essay of 1924, in *MO* 332; see ch. 1, above. The image of leaves rippling in the wind has been a topos since the Lumière brothers first showed their films in 1895, famously invoked by Kracauer in the preface to his *Theory of Film*.

86. Benjamin borrows the latter idea, without attribution, in *One-Way Street*, in SW 1:449.

87. Heraklitus [of Ephesus], *The Cosmic Fragments*, ed. G. S. Kirk (Cambridge: Cambridge University Press, 1954), 57–64.

88. Benjamin's investment in technology—and in film as "second technology"—is reminiscent of the logic of *Parsifal:* "Only the spear that struck it heals the wound" (Die Wunde schliesst der Speer nur, der sie schlug.)

89. Scholem, *Walter Benjamin*, 207.

90. See Agamben, "Walter Benjamin and the Demonic: Happiness and Historical Redemption" (1982), in *Potentialities*, ed. and trans. Daniel Heller-Roazen (Stanford: Stanford University Press, 1999), 138–59, esp. 145–48, and Harold Bloom, "Ring around the Scholar" (review of *The Correspondence of Walter Benjamin, 1910–1940*), *Artforum* 32 (Nov. 1994): 3, 31. In the Hebrew Bible, the word *tselem* refers to the creation of man in the *image* of God (Gen. 1:26).

91. Scholem, *On the Mystical Shape of the Godhead: Basic Concepts in the Kabbalah*, trans. Joachim Neugroschel, ed. Jonathan Chipman (New York: Schocken, 1991), ch. 6 ("*Tselem:* The Concept of the Astral Body"), 251, 270, 254, 255.

92. Bloom, "Ring," 31. This reading relies on Scholem's interpretation of Benjamin's angel as satanic; see "Walter Benjamin and His Angel" (1972), in Scholem, *On Jews and Judaism in Crisis* (New York: Schocken, 1976), 198–236. Agamben calls Scholem's interpretation into question by emphasizing the eudaemonist side of Benjamin's angel, associated with his politics of happiness.

93. Scholem, *Mystical Shape*, 253. The text in brackets quotes the same passage, from the 1509 compilation *Shushan Sodot*, that Scholem first discusses in "Eine kabbalistische Erklärung der Prophetie als Selbstbegegnung," *Monatsschrift für Geschichte und Wissenschaft des Judentums* 74 (1930): 288.

94. *CWB* 369; *GB* 3:548. Benjamin puns on the name of the Judaic scholar Oskar Goldberg, to whom both had an ambivalent relationship.

95. See, in particular, "On the Concept of History," in *SW* 4:389–400, esp. thesis XVIII. The entwinement of these registers is programmatic to the surrealist-inspired, "anthropo-

logical materialist" first layer of *The Arcades Project*. Also see Hanssen, *Walter Benjamin's Other History*.

96. "Franz Kafka: On the Tenth Anniversary of His Death" (1934), in *SW* 2:809.

97. See "Franz Kafka: *Beim Bau der Chinesischen Mauer*," in *SW* 2:497–99; "On the Image of Proust," in *SW* 2:240; and "Berlin Childhood around 1900," in *SW* 3:374–75. On Benjamin's notion of "distorted similitude" (and its distinction from "nonsensuous similitude"), see Weigel, *Entstellte Ähnlichkeit*, and above, ch. 3.

98. Scholem, *Messianic Idea in Judaism*, 45.

99. Anson Rabinbach, "Introduction" to *The Correspondence of Walter Benjamin and Gershom Scholem, 1932–1940*, ed. Scholem, trans. Gary Smith and Andre Lefevere (Cambridge, Mass.: Harvard University Press, 1992), xxxii.

100. *GS* 2:1198. Also see Benjamin to Scholem, 12 June 1938: "What is actually and in a very precise sense *folly* [*das Tolle*; crazy, mad, or great] in Kafka is that this, the most recent of experiential worlds, was conveyed to him precisely by the mystical tradition" (Scholem, *Correspondence of Benjamin and Scholem*, 224).

101. Wohlfarth, "Benjamin and Technological Eros," 68.

CHAPTER 5

1. The sentence appears in the first (handwritten) version of the artwork essay, in *GS* 1.2:445.

2. See below, at n. 32.

3. Benjamin to Gershom Scholem, 30 Jan. 1928, in *CWB* 322; *GB* 3:322. As a number of commentators have pointed out, there are nonetheless substantive links between the *Trauerspiel* book and *One-Way Street*; see, most recently, Michael Jennings, "Script, Image, Script-Image," introduction to section 2 of Benjamin, *The Work of Art in the Age of Its Technological Reproducibility and Other Writings on Media*, ed. Jennings, Brigid Doherty, and Thomas Y. Levin (Cambridge, Mass.: Harvard University Press, 2008), 167–70.

4. See, for instance, the exchange of letters between Bloch and Kracauer in 1926, in Bloch, *Briefe, 1903–1975*, 1:269–75.

5. For an overview, see Sarah Ley Roff, "Benjamin and Psychoanalysis," in *The Cambridge Companion to Walter Benjamin*, ed. David Ferris (Cambridge: Cambridge University Press, 2004), 115–33.

6. On the G group and Benjamin's relations to the constructivist avant-garde, see Schwartz, *Blind Spots*, 39–62. Also see Eckhardt Köhn, "'Nichts gegen die Illustrierte!': Benjamin, der Berliner Konstruktivismus und das avantgardistische Objekt," in Schöttker, *Schrift Bilder Denken*, 48–69; as well as Raoul Hausmann, "More on Group 'G'," *Art Journal* 24.4 (Summer 1965): 350, 352; and Hans Richter, *Köpfe und Hinterköpfe* (Zürich: Arche Verlag, 1967), 67–69, 87–88. The journal, with critical essays, has been reprinted as *G: An Avant-Garde Journal of Art, Architecture, Design, and Film, 1923–1926*, ed. Detlef Mertins and Michael William Jennings (Los Angeles: Getty Research Institute, 2010).

7. The quotation is from Michael Jennings, "Walter Benjamin and the European Avant-Garde," in Ferris, *Cambridge Companion to Walter Benjamin*, 22. Köhn (see n. 6) refers to this crossover between avant-garde and commercial publicity as "applied constructiv-

ism." For Benjamin's defense of contemporary illustrated magazines, see his polemical gloss "Nichts gegen die 'Illustrierte'" (1925), in *GS* 4:448–49. Benjamin also contributed to the Dutch journal *i10* (no. 2, 1927), edited by Arthur Lehning, with Moholy-Nagy as layout editor, which further developed the constructivist design of *G*; his essay, "Duitch Verval," like a number of pieces previously published in the press, appeared the following year in *One-Way Street*.

8. Review of Karl Blossfeldt's book, *Urformen der Kunst: Photographische Pflanzenbilder* (1928), "News about Flowers," in *SW* 2:155–56. The quotation is repeated, without attribution, toward the end of Benjamin's "Little History of Photography" (1931), in *SW* 2:527. Moholy-Nagy's atelier was an important meeting place for the *G* group, though it is unclear whether Benjamin met him this early. On Benjamin and Moholy-Nagy, see Schwartz, *Blind Spots*, 42–50 and passim. Also see Edward Dimendberg, "Transfiguring the Urban Gray: László Moholy-Nagy and the 'Dynamic of the Metropolis,'" in *Camera Obscura, Camera Lucida: Essays in Honor of Annette Michelson*, ed. Richard Allen and Malcolm Turvey (Amsterdam: Amsterdam University Press, 2003), 109–26.

9. László Moholy-Nagy, *Malerei, Fotografie, Film* (1925), facsimile of the revised edition of 1927 (Mainz and Berlin: Florian Kupferberg, 1967), 8, 16; boldfacing in original; italics added.

10. "News about Flowers," in *SW* 2:155. This formulation both echoes and varies on Kracauer's 1927 essay, "Photography"; see ch. 1, above.

11. Benjamin to Scholem, 22 Dec. 1924, in *GB* 2:510.

12. See Detlev Schöttker, *Konstruktiver Fragmentarismus: Form und Rezeption der Schriften Walter Benjamins* (Frankfurt a.M.: Suhrkamp, 1999), 187.

13. In his review of *One-Way Street*, Ernst Bloch tropes the discontinuous sequence of the sections in terms of the variety format: "Revue Form in Philosophy" (1928), in *Heritage of Our Times*, 334–37.

14. The latter strand has led commentators to read *One-Way Street* in light of surrealism, in particular Louis Aragon's *Paysan de Paris* (1926). See Josef Fürnkäs, *Surrealismus als Erkenntnis: Walter Benjamin—Weimarer Einbahnstraße und Pariser Passagen* (Stuttgart: J. B. Metzler, 1988). The case for the text's greater affinity with German constructivism is made by Schwartz, *Blind Spots*, 51–55; Eckhardt Köhn, "Konstruktion des Lebens: Zum Urbanismus der Berliner Avantgarde," *Avant-Garde: Revue interdisciplinaire et internationale* 1 (1988): 33–72; and Schöttker, *Konstruktiver Fragmentarismus*, 181–93.

15. Jean Laplanche and J. B. Pontalis, *The Language of Psychoanalysis*, trans. D. Nicholson-Smith (New York: W. W. Norton, 1973), 213. Also see editors' note to Freud's *The Interpretation of Dreams*: "'Innervation' is a highly ambiguous term [*keineswegs eindeutig*]. It is very frequently used in a structural sense, to mean the anatomical distribution of nerves in some organism or bodily region. Freud uses it . . . often (though not invariably) to mean the transmission of energy into a system of nerves, or . . . specifically into an *efferent* system—to indicate, that is to say, a process tending towards discharge." *The Standard Edition of the Complete Psychological Works of Sigmund Freud*, ed. and trans. James Strachey (London: Hogarth Press, 1953–74), 5:537; Sigmund Freud, *Studienausgabe*, ed. Alexander Mitscherlich, Angela Richards, and Strachey (Frankfurt a.M.: Fischer, 1982) 2:513.

16. *Oxford English Dictionary*, s.v. "innervation."

17. Sigmund Freud, "The Neuro-Psychoses of Defence (I)" (1894), in *Standard Edition* 3:49, 51, 55; also see Freud, "Further Remarks on the Neuropsychoses of Defence" (1896), ibid., 3:175.

18. Freud, *Standard Edition*, 5:537; emphasis added.

19. Ibid., 18:31, 30; Freud, *Studienausgabe* 3:241, 240.

20. Buck-Morss, "Aesthetics and Anaesthetics," 17, n. 54. As will become evident from my discussion of both innervation and mimetic faculty, I want to maintain a clearer distinction between the two terms than does Buck-Morss, who tends to make the former a subcategory of the latter. While the concepts no doubt overlap and interact, innervation implies a greater degree of violence and danger, considering its function of incorporating and integrating heterogeneous, machinic, alien elements into a human *physis* traditionally understood as organic.

21. Freud, too, speaks of a "conversion in the opposite direction," but assumes that such a conversion, as pursued by Breuer, would be effected "by means of thought-activity and a discharge of the excitation by talking"; see "Neuropsychoses of Defence," 3:49, 51.

22. In an early article written with Sergei Tretyakov, "Expressive Movement" (1923), Eisenstein writes: "It is precisely expressive movement, built on an organically correct foundation, that is solely capable of evoking this emotion in the spectator, who in turn reflexively repeats in weakened form the entire system of the actor's movements; as a result of the produced movements, the spectator's incipient muscular tensions are released in the desired emotion"; *Millennium Film Journal*, no. 3 (Winter–Spring 1979): 36–37. Eisenstein repeatedly uses the term *innervation* in "The Montage of Attractions" (1923) and "The Montage of Film Attractions" (1924), in S. M. Eisenstein, *Selected Works*, vol. 1, *Writings, 1922–34,* ed. and trans. Richard Taylor (London: British Film Institute; Bloomington and Indianapolis: Indiana University Press, 1988), 33–38, 39–58. On Eisenstein and Klages, see Oksana Bulgakowa, "Sergej Eisenstein und die deutschen Psychologen: Sergej Eisenstein und sein 'psychologisches' Berlin—zwischen Psychoanalyse und Gestaltpsychologie," in *Herausforderung Eisenstein,* ed. Bulgakowa (Berlin: Akademie der Künste der DDR, 1989), 80–91. On Benjamin and Klages, see above, ch. 4.

23. William James, *The Principles of Psychology* (Cambridge, Mass.: Harvard University Press, 1983), 1065–66. James's critique of Wundt's category of "Innervationsgefühl" (1880) is directed not against the concept of innervation as such but against the idealist notion of innervation being coupled with, and depending on, a sentient, conscious "feeling" rather than the physiological fact of "discharge into the motor nerves" (1105). On Eisenstein's and Meyerhold's reception of James, see Alma Law and Mel Gordon, *Meyerhold, Eisenstein, and Biomechanics: Actor Training in Revolutionary Russia* (Jefferson, N.C., and London: McFarland, 1996), 36–37, 207, and passim.

24. See above, ch. 1, n. 58. Also see James on "ideo-motor action," in *Principles*, 1130–35. Another genealogy for the idea of unconscious imitation that Benjamin may have been aware of can be found in French late-nineteenth-century physiological aesthetics as enacted in cabaret and early cinema; see Rae Beth Gordon, "From Charcot to Charlot: Unconscious Imitation and Spectatorship in French Cabaret and Early Cinema," *Critical Inquiry* 27.3 (Spring 2001), esp. 518–24.

25. "Notes on a Theory of Gambling" (1929–1930), in *SW* 2:297–98.

26. See Friedrich A. Kittler, *Gramophone, Film, Typewriter*, trans. Geoffrey Winthrop-Young and Michael Wutz (Stanford: Stanford University Press, 1999), pt. 3. Also see Kracauer's erotized vignette on his first typewriter, "Das Schreibmaschinchen," *FZ*, 1 May 1927, in *S* 2:48–52; and Heidegger's essay on "Hand and Typewriter" (1942–43), repr. in Kittler, *Gramophone*, which makes an interesting counterpart to Benjamin's reflections.

27. "Theories of German Fascism" (1930), in *SW*, 2:321; on the upsurge of the "German feeling for nature" in the context of World War I, see ibid., 318–19.

28. "Outline of the Psychophysical Problem" (1922–23), in *SW* 1:396; also see "Madame Ariane: Second Courtyard on the Left," in *One-Way Street*, *SW* 1:483.

29. Ernst Jünger, "Über den Schmerz" (1934), in *Sämtliche Werke, Zweite Abteilung: Essays*, vol. 7 (Stuttgart: Klett-Cotta, 1980), 181. On Jünger's aesthetics/politics of technology, see Andreas Huyssen, "Fortifying the Heart—Totally: Ernst Jünger's Armored Texts," *New German Critique* 59 (Summer 1993): 3–23; and, for a different approach, Lethen, *Cool Conduct*, 147–70.

30. Sigrid Weigel, *Body- and Image-Space: Re-reading Walter Benjamin*, trans. Georgina Born (London and New York: Routledge, 1996), 16; also see Weigel, "Passagen und Spuren," in *Leib- und Bildraum: Lektüren nach Benjamin*, ed. Weigel (Köln, Weimar, and Wien: Böhlau, 1992), 52.

31. Also see *The Arcades Project*, Convolute p [Anthropological Materialism, History of Sects], 807–17, and the discussion of French and German versions of that tradition, ibid., 633; W8, 1. On the significance of "anthropological materialism" in Benjamin's work, see Norbert Bolz and Willem van Reijen, *Walter Benjamin* (New York: Campus, 1991), ch. 6; also see Lindner, "Benjamins Aurakonzeption"; and Lindner, "Zeit und Glück: Phantasmagorien des Spielraums," in *Benjamin Studies*, vol. 1, *Perception and Experience in Modernity*, ed. Helga Geyer-Ryan et al. (Amsterdam and New York: Editions Rodopi, 2002): 127–44.

32. Adorno to Benjamin, 6 Sept. 1936, in *CC* 147.

33. "Outline of the Psychophysical Problem" (1922–23), in *SW* 1:395. On the significance of the distinction between *Leib* and *Körper*, particularly in conjunction with technology, for Benjamin's understanding of the political, see Steiner, "True Politician." Husserl mobilizes the *Leib/Körper* distinction in the fifth of his *Cartesian Meditations* (based on his 1929 lecture), trans. Dorion Cairns (Dordrecht, Boston, and London: Kluwer, 1995). For Plessner, see his *Die Stufen des Organischen und der Mensch: Einleitung in die philosophische Anthropologie* (1928; 2nd ed., Frankfurt a.M.: Suhrkamp, 1981), 297–98, 303–4, 367–68; also see Plessner, *Laughing and Crying: A Study of the Limits of Human Behavior* (1941), trans. James Spencer Churchill and Marjorie Grene (Evanston: Northwestern University Press, 1970), ch. 1.

34. The most striking example of this juncture—or, at this point in time, disjuncture—between human and cosmic history can be found in the eighteenth and last of his theses "On the Concept of History," in *SW* 4:396. The idea appears in other contexts as well; see especially his essay on Franz Kafka (*SW* 2:794–818), and work relating to Fourier (*Arcades Project*, convolute W & passim).

35. Benjamin, "Wahrnehmung und Leib" (probably early 1920s), in *GS* 6:76.

36. Gertrud Koch, "Cosmos in Film: On the Concept of Space in Walter Benjamin's 'Work of Art' Essay," trans. Nancy Nenno, in A. Benjamin and P. Osborne, *Walter*

Benjamin's Philosophy, 209–10. For a contemporary reflection similar to Benjamin's, see Freud's famous pronouncement that, thanks to modern technology, "man has, as it were, become a kind of prosthetic God," in *Civilization and Its Discontents*, in *Standard Edition*, 21:91–92; *Studienausgabe*, 221–22.

37. On the "doctrine of revolutions as innervations of the collective," see also Benjamin's excerpt from early Marx in *AP* 652 (X1a,2).

38. Kracauer makes a similar observation in "'Travel and Dance" (1925): "Technology has taken us by surprise, and the regions that it has opened up are still glaringly empty." (*MO* 73).

39. Since Benjamin, in a related fragment, cites de Sade along with Fourier as instantiating these impulses (see *SW* 3:134), I suggest translating the word *Liebe* here as "eros," if not "sexuality."

40. Much has been written about Benjamin's concept(s) of history and temporality; particularly relevant here are discussions of Benjamin's experimental intersecting of modern (social, political, cultural) history with "other" histories, be they mythical (Urhistory), "natural," cosmic, and/or messianic: see, for instance, Buck-Morss, *Dialectics of Seeing*, esp. chs. 5 and 8; Irving Wohlfarth, "Re-fusing Theology: Some First Responses to Walter Benjamin's Arcades Project," *New German Critique* 39 (Fall 1986): 3–24; and Osborne, "Small-scale Victories, Large-scale Defeats."

41. The other being "[Fourier's] idea of the 'cracking open of the teleology of nature'" (*AP* 631). On Benjamin's interest in cognitive development, especially in comparison with the theories of Jean Piaget, see Buck-Morss, *Dialectics of Seeing*, 262–64.

42. Klages, *Vom kosmogonischen Eros*, 353–497. See above, ch. 4.

43. See, for instance, Irving Wohlfarth's magisterial essay, "Walter Benjamin and the Idea of a Technological Eros."

44. This argument appears in the methodological introduction of all versions of the artwork essay. Also see Benjamin, "Theories of German Fascism," in *SW* 2:312, and "Pariser Brief I: André Gide und sein neuer Gegner" (1936), in *GS* 3:482–95.

45. Wohlfarth, "Benjamin and Technological Eros," 78.

46. Ibid., 83.

47. In fact, where "'To the Planetarium" goes beyond the vitalistic bombast reminiscent of Klages—as in its reference to Lunaparks or its joining of the "nights of annihilation" with the "bliss of the epileptic"—Benjamin's language seems closer to the archive of surrealism, in particular Bataille and Artaud.

48. I am thinking here, for example, of writings by Paul Virilio and Friedrich Kittler, as well as Norbert Bolz, *Theorie der neuen Medien* (Munich: Raben Verlag, 1990), and Mark B. Hansen, *Embodying Technesis: Technology beyond Writing* (Ann Arbor: University of Michigan Press, 2000).

49. On Benjamin's technophilia, see Pierre Missac, *Walter Benjamin's Passages*, trans. Shierry Weber Nicholsen (Cambridge, Mass.: MIT Press, 1995), 90–91.

50. Jay, "Experience without a Subject."

51. Buck-Morss, "Aesthetics and Anaesthetics," 5.

52. For a historical survey situating Benjamin and Adorno in relation to other revivals of the concept of mimesis (notably Erich Auerbach's), see Gunter Gebauer and Christoph Wulf, *Mimesis: Culture, Art, Society*, trans. Don Reneau (Berkeley and Los Angeles: Uni-

versity of California Press, 1995); also see Martin Jay, "Mimesis and Mimetology: Adorno and Lacoue-Labarthe," in *Cultural Semantics*, 120–37; Michael Cahn, "Subversive Mimesis: T. W. Adorno and the Modern Impasse of Critique," in *Mimesis in Contemporary Theory*, ed. Mihai Spariosu (Philadelphia and Amsterdam: John Benjamins, 1984), 27–64; Josef Früchtl, *Mimesis: Konstellation eines Zentralbegriffs bei Adorno* (Würzburg: Königshausen + Neumann, 1986), esp. 17–29. For a reanimation of Benjamin's concern with the mimetic from an anthropological perspective, see Michael Taussig, *Mimesis and Alterity: A Particular History of the Senses* (New York and London: Routledge, 1993), and *The Nervous System* (New York and London: Routledge, 1992); also see Martin Jay's review, "Unsympathetic Magic," *Visual Anthropology Review* 9.2 (Fall 1993): 79–82, along with Taussig's reply and Jay's counterreply, ibid. 10.1 (Spring 1994): 154, 163–64.

53. "On the Mimetic Faculty" (1933), in *SW* 2: 720; *GS* 2:210. Also see the first, longer version, "Doctrine of the Similar" (1933), in *SW* 2:694–98. For the darker implications of the mimetic gift, see almost the same phrase in "Berlin Childhood around 1900: 1934 Version" (*SW* 3:390–91; *GS* 4:261), where Benjamin recalls the impossibility of resemblance with oneself in the alienating nineteenth-century environment of the photographer's studio: "I am distorted by similarity to all that surrounds me here" (*SW* 3:392).

54. Max Horkheimer and Theodor W. Adorno, *Dialectic of Enlightenment* (1944, 1947), trans. Edmund Jephcott, ed. Gunzelin Schmid Noerr (Stanford: Stanford University Press, 2002), 148.

55. Opitz, "Ähnlichkeit"; Weigel, *Entstellte Ähnlichkeit*. On the slippage between similitude and sameness in the artwork essay, see ch. 3, above.

56. On Benjamin's essays on the mimetic faculty in relation to his early theory of language, see Beatrice Hanssen, "Language and Mimesis in Walter Benjamin's Work," in *Cambridge Companion to Walter Benjamin*, 54–72. Also see Winfried Menninghaus, *Walter Benjamins Theorie der Sprachmagie* (Frankfurt a.M.: Suhrkamp, 1980), 60–77; and Christian J. Emden, *Walter Benjamins Archäologie der Moderne: Kulturwissenschaft um 1930* (München: Wilhelm Fink Verlag, 2006), 113–17.

57. See Benjamin, "Problems in the Sociology of Language: An Overview" (1935), in *SW* 3:68–93, as well as well as numerous reviews of related works.

58. See Benjamin's essay on different directions in graphology, among which he singles out Anja and Georg Mendelssohn's psychoanalytic approach against earlier positions, in particular Klages: "Graphology Old and New" (1930), in *SW* 2:398–400; as well as "Review of the Mendelssohns' *Der Mensch in der Handschrift*" (1928), in *SW* 2:130–34. "Graphology is concerned with the bodily aspect of the language of handwriting and with the expressive aspect of the body of handwriting" (ibid., 133).

59. On Benjamin's concept of physiognomic reading in this context (which includes Simmel, Kracauer, Joseph Roth, and Ernst Jünger), see n. 51, ch. 4.

60. See Béla Balázs, *Schriften zum Film*, ed. Helmut H. Diederichs and Wolfgang Gersch (München: Carl Hanser, 1984); *Béla Balázs: Early Film Theory; Visible Man and The Spirit of Film*, ed. Erica Carter, trans. Rodney Livingstone (New York: Berghahn Books, 2010). Also see Koch, "Béla Balázs."

61. The element of distortion relates to the mnemonic status of childhood experience; it marks both memory traces and the forgotten/remembered moment of similitude. It is

no coincidence that Benjamin develops the notion of a "distorted similitude" in his essay on Proust, "On the Image of Proust" (1929), in *SW* 2:240. On the concept of "distorted similitude" and its distinction from "nonsensuous similitude," see Weigel, *Body- and Image-Space*, xvii, chs. 8 and 9; Weigel, *Entstellte Ähnlichkeit*, 9–11, 27–51.

62. "Construction Site," in *One-Way Street*, in *SW* 1:449–450; *GS* 4:93. The passage already appears in Benjamin's review of Karl Hobrecker's book, "Old Forgotten Children's Books" (1924), *SW* 1:408, leading into interesting remarks on children's similar play with fairy tales as "waste product."

63. "Franz Kafka" (1934), in *SW* 2: 810.

64. "Surrealism," in *SW* 2: 210; see also *AP* (K1a,8), in *GS* 5.1:494, and *AP*, in *GS* 5.2:1045–46. Benjamin's vision of modernity as Urhistory, combined with the notion of capitalism as a "dreamsleep" and the political project of "awakening" the collective from that dream while preserving its utopian energies, is central to his work on the Paris arcades, especially in its early stages; see, in particular, *AP*, convolute K (Dream City and Dream House, Dreams of the Future, Anthropological Nihilism, Jung). Also see Buck-Morss, *Dialectics of Seeing*, chs. 5 and 8.

65. *AP* (K1a,3); *AP* 390; interpretive translation in Buck-Morss, *Dialectics of Seeing*, 274. On Benjamin's insistence on the historicity—and historiographic significance—of childhood, especially children's experience of technology, see ibid., 261–65, 273–79.

66. The theory Benjamin refers to is Ludwig Klages's; see ch. 4, above.

67. "Negativer Expressionismus" (ca. 1921), in *GS* 4:132.

68. *SW* 3:94; *GS* 1:1040. Also see Benjamin, "Chaplin" (1928–29; on *The Circus*), in *SW* 2:199–200; "Chaplin in Retrospect," in *SW* 2: 222–24; and the fragment in which he compares Chaplin and Hitler (in 1934, six years before *The Great Dictator*), "Hitler's Diminished Masculinity," in *SW* 2: 792–93.

69. See Schwartz, *Blind Spots*, 46–55.

70. The alignment of nearness with "things" (and, implicitly, of distance with the "image") can be found in Klages's *On Cosmogonic Eros* (416ff.), a text whose generally antimodernist, anti-technological pathos provided a contrasting foil for *One-Way Street* (see ch. 4, above). On the question of a particular modern(ist) sense of "things," I am indebted to Bill Brown; see above, ch. 1, n. 56.

71. See, in particular, Sigfried Giedion, *Building in France, Building in Iron, Building in Ferro-Concrete*, trans. J. Duncan Berry (1928; repr., Santa Monica, Calif.: Getty Center for the History of Art and the Humanities, 1995). Also see Hilde Heynen, *Architecture and Modernity* (Cambridge, Mass.: MIT Press, 1999), 30–38; and Andreas Huyssen, "Modernist Miniatures: Literary Snapshots of Urban Spaces," *PMLA* 122.1 (Jan. 2007): 27–42.

72. "They lose their delimited form: as one descends, they circle into each other and intermingle simultaneously." *Building in France*, 91, quoted in Heynen, *Architecture and Modernity*, 30.

73. The quotation in parentheses is from "Dream Kitsch: Gloss on Surrealism" (1927), in *SW* 2:4.

74. Martin Heidegger, *Sein und Zeit* (Tübingen: Niemeyer, 1993), 66–69; Heidegger, *Being and Time*, trans. Joan Stambaugh (Albany: State University of New York Press, 1996), 62–65.

75. Heidegger, *Being and Time*, 66.

76. *AP* 396; *GS* 5:500. The translation of *Gebrauch* as "consumption" misses the Heideggerian resonance in Benjamin's argument. For Benjamin's revisionist approach to kitsch, also see his gloss on surrealism, "Dream Kitsch," in *SW* 2:3–5, and "Some Remarks on Folk Art" (ca. 1929), in *SW* 2:278–80. Kitsch was not only a preferred objet trouvé for the surrealists; it was also a topic in the journal *G* ("Kitsch ist nahrhaft" [Kitsch is nutritious], *G* 5–6 [1926]) and for the programmatically germane journal *Der Querschnitt* 3 (1929), which featured a "Kitschmuseum." Also see Bloch, "Hieroglyphs of the Nineteenth Century," in *Heritage of Our Times*, 346–51.

77. On Uexküll and Benjamin, see Inga Pollmann, "Unseen Worlds: Uexküll's *Umwelt* Theory at the Movies," ch. 3 of "Cinematic Life—Vitalism and the Moving Image," dissertation in progress, University of Chicago.

78. This "speculative image," to use Caygill's term, resonates with Benjamin's early reflections on the philosophy of color, which Caygill (*Walter Benjamin*, 9–13, 82–88, 150–52) has shown to be central to his concept of experience; see "Der Regenbogen: Gespräch über die Phantasie" (1915), in *GS* 7.1:19–26; "Aphorisms on Imagination and Color" (1914–15), "A Child's View of Color" (1914–15), and "Notes for a Study of the Beauty of Colored Illustrations in Children's Books" (1918–21), in *SW* 1:48–51, 264–66; *GS* 6:109–12, 123–25; and other fragments in the section "Zur Ästhetik" in *GS* 6:109–29. Specifically, the image of the "fiery pool" reflecting, and dissolving, the actual neon sign recalls qualities of "chromatic fantasy" or imagination that Benjamin discerns in children, their fascination with rainbows, soap bubbles, and pictures produced by decals and magic lanterns—color's fluidity ("moistness"), its freedom from contours and substance (color in opposition to form), its intensive infinity of nuances, its availability for shifting patterns and transformations. These qualities may also have played a part in Benjamin's adult fascination with animated film, in particular the metamorphoses of objects and characters, the freewheeling interchange between the animate and inanimate world, in early Disney films (see "Experience and Poverty," in *SW* 2:735). Also see Heinz Brüggemann, "Fragmente zur Ästhetik/Phantasie und Farbe," in Lindner, *Benjamin-Handbuch*, 124–33.

79. For examples of Kracauer's play with the trope of commercial lighting, see "Boredom" (1924), in *MO* 331–34; "Lichtreklame" (1927), in *S*5.2:19–21; "Ansichtspostkarte" (1930), ibid. 184–85. Benjamin appreciated Kracauer's mimetic sensibility for the afterlife of things, characterizing him as a ragpicker (Baudelaire's *chiffonnier*); see his review of *Die Angestellten*, "An Outsider Makes His Mark" (1930), in *SW* 2:305–11, 310. The phrase "profane illumination" appears in Benjamin's 1929 essay on surrealism, *SW* 2:216.

80. See Benjamin's fragment, "Die Reflexion in der Kunst und in der Farbe" (1914–15), in *GS* 6:117–18, in which he claims that color has an inherent reflexivity: "The look of the colors is the equivalent of their being seen / This is to say: *the colors see themselves*" (118).

81. Benjamin, "Some Remarks on Folk Art" (1929), in *SW* 2:279; *GS* 6:187. This seems to be a less hyperbolic version of the condition Benjamin refers to in the surrealism essay as a "nearness that looks out of its own eyes" (*wo die Nähe sich selbst aus den Augen sieht*; *SW* 2:217; *GS* 2:309).

82. Jürgen Habermas, "Consciousness-Raising or Redemptive Criticism: The Contemporaneity of Walter Benjamin" (1972), trans. P. Brewster and C. H. Buchner, *New German Critique* 17 (Spring 1979): 45–46. For a related attempt to think "things" in terms other than

the philosophical subject-object relation, see Adorno, *Negative Dialectics*, trans. E. B. Ashton (1966; repr., New York: Continuum, 1997), pt. 2; also see Bill Brown, "The Secret Life of Things: Virginia Woolf and the Matter of Modernism," in *Aesthetic Subjects*, ed. Pamela R. Matthews and David McWhirter (Minneapolis: University of Minnesota Press, 2003).

83. Buck-Morss, *Dialectics of Seeing*, 267; Taussig, *Nervous System*, 143–48; and Taussig, *Mimesis and Alterity*, ch. 2.

84. See Rosalind E. Krauss, *The Optical Unconscious* (Cambridge, Mass., and London: MIT Press, 1993), 178.

85. Ibid., 179.

86. Jean Epstein, "The Senses 1 (b)," from *Bonjour cinéma* (1921), trans. Tom Milne, in Abel, *French Film Theory and Criticism*, 1:244; also see Epstein, "Magnification" (1921), trans. Stuart Liebman, ibid., 235–41.

87. See above, ch. 4, n. 6.

88. Peirce himself uses the example of the photograph to illustrate the mixed nature of sign functions; see Charles Sanders Peirce, *The Essential Peirce: Selected Philosophical Writings*, ed. Nathan Houser (Bloomington: Indiana University Press, 1998), 5–6 and passim. Peirce's distinction among three types of sign—icon, index, and symbol (referring to an arbitrary, conventional mode of signifying)—entered film theory largely through Peter Wollen's essay "The Semiology of the Cinema," in *Signs and Meaning in the Cinema* (Bloomington: Indiana University Press, 1969), 116–54; another lineage of Peircean semiotics in film theory goes through Umberto Eco, *A Theory of Semiotics* (Bloomington: Indiana University Press, 1976); and Teresa de Lauretis, *Alice Doesn't: Feminism, Semiotics, Cinema* (Bloomington: Indiana University Press, 1984). Also see above, ch. 1, n. 91.

89. Mary Ann Doane, *The Emergence of Cinematic Time: Modernity, Contingency, the Archive* (Cambridge, Mass.: Harvard University Press, 2002), 16.

90. See Doane, "The Indexical and the Concept of Medium Specificity," *differences: A Journal of Feminist Cultural Studies* 18.1 (2007): 128–52; also see Doane's introduction to this special issue.

91. *GS* 2:371. This sentence resonates with Aby Warburg's adage, "Der liebe Gott steckt im Detail" (God resides in the detail), invoked to support micrological approaches in various disciplines. The notion of a "geyser of new image-worlds" that hisses up from the magnification of the most minute detail already appears in Benjamin's earlier review of Blossfeldt's book, "News about Flowers" (1928), in *SW* 2:156.

92. Balázs, *Schriften zum Film*, 2:60.

93. Caygill, *Walter Benjamin*, 94.

94. I situate this essay in the wider context of debates triggered by Eisenstein's film in my essay "Of Lightning Rods, Prisms, and Forgotten Scissors."

95. Wohlfarth, "Measure," 14; also see the section "Fire Alarm" in *One-Way Street*, in *SW* 1:469–70; *GS* 4.1:122.

CHAPTER 6

1. This chapter has its roots in my article "Of Mice and Ducks: Benjamin and Adorno on Disney," *South Atlantic Quarterly* 92.1 (Jan. 1993): 27–61.

2. Benjamin to Theodor Wiesengrund Adorno, 30 June 1936, in *CC* 144; *ABB* 190. Adorno echoes and refines this perception in his letter to Benjamin of 1 Feb. 1939, in *CC* 305. On the relationship between Adorno's essay "On Jazz" and the artwork essay, see Jamie Owen Daniel, "Introduction to Adorno's 'On Jazz,'" *Discourse* 12.1 (Fall–Winter 1989–90): 39–44.

3. I am aware that the literal translation of the definite article (*die* Micky-Maus) is unidiomatic, but wish to convey the vernacular, more concrete and physical sense of the creature in Benjamin and Adorno's style. Likewise, in the following, I will preserve the sexual ambiguity of the figure resulting from the grammatically feminine gender of the German *Maus*.

4. Adorno, "Oxforder Nachträge," in *AGS* 17:101, 105. Also see "On Jazz" (1936), in Adorno, *Essays on Music*, selected, with intr., commentary, and notes, Richard Leppert, new trans. Susan H. Gillespie (Berkeley and Los Angeles: University of California Press, 2002), 470–95; "Farewell to Jazz" (1933), in ibid., trans. Susan H. Gillespie, 496–500; and "Perennial Fashion: Jazz," in *Prisms*, trans. Samuel and Shierry Weber (Cambridge, Mass.: MIT Press, 1981). For a critical account of the debates surrounding Adorno's writings on jazz and a compelling reevaluation, see James Buhler, "Frankfurt School Blues: Rethinking Adorno's Critique of Jazz," in *Apparitions: New Perspectives on Adorno and Twentieth-Century Music*, ed. Berthold Hoeckner (New York and London: Routledge, 2006), 103–30. Also see Leppert, "Commentary," in Adorno, *Essays on Music*, 349–60.

5. See above, ch. 2. On the reception of jazz in Weimar Germany, see J. Bradford Robinson, "The Jazz Essays of Theodor Adorno: Some Thoughts on Jazz Reception in Weimar Germany," *Popular Music* 13.1 (Jan. 1994): 1–25; and Robinson, "Jazz Reception in Weimar Germany: In Search of a Shimmy Figure," in *Music and Performance during the Weimar Republic*, ed. Bryan Gilliam (Cambridge: Cambridge University Press, 1994), 107–34.

6. See Richard Schickel, *The Disney Version* (1968; repr., New York: Avon, 1971), 208–9, 107 and passim. Also see *Father Noah's Ark* (1933), Disney's paean to Fordist-Taylorist methods of production. Disney's business strategies of the 1920s and '30s appear innocuous compared to his labor practices and anticommunist activities of the 1940s, to say nothing of the corporation's global economic control to this day. See *Rethinking Disney: Private Control, Public Dimensions*, eds. Mike Budd and Max H. Kirsch (Middletown, Conn.: Wesleyan University Press, 2005); Douglas Gomery, "Disney's Business History: A Reinterpretation," in *Disney Discourse: Producing the Magic Kingdom*, ed. Eric Smoodin (New York and London: Routledge, 1994), 71–86; and Smoodin, *Animating Culture: Hollywood Cartoons from the Sound Era* (New Brunswick, NJ: Rutgers University Press, 1993), chs. 4 and 5. On Disney's contribution to American ideologies of efficiency and management, see Nicholas Sammond, *Babes in Tomorrowland: Walt Disney and the Making of the American Child, 1930–1960* (Durham, N.C.: Duke University Press, 2005), 162–85.

7. See J. P. Storm and M. Dressler, *Im Reiche der Micky Maus: Walt Disney in Deutschland, 1927–1945*, Filmmuseum Potsdam (Berlin: Henschel, 1991), 61. An article in the Nazi party paper of the Gau Pommern of 1931 calls Mickey Mouse "the most miserable ideal ever revealed," a "dirty and filth-covered vermin, the greatest bacteria carrier in the animal kingdom," another instance of the "Jewish brutalization of the people" (ibid.). Art Spiegelman uses this quotation as an epigraph in the second volume of *Maus: A Survivor's Tale* (New York:

Pantheon, 1991). Also see Esther Leslie, *Hollywood Flatlands: Animation, Critical Theory and the Avant-Garde* (London: Verso, 2002), 80–81.

8. Storm and Dressler, *Im Reiche der Micky Maus* 55, 56, 156 and passim.

9. Lawrence A. Rickels, *The Case of California* (Baltimore and London: Johns Hopkins University Press, 1991), 59.

10. Horkheimer and Adorno, *Dialectic of Enlightenment,* 110; *AGS* 3:160. I attribute this analysis primarily to Adorno, since Horkheimer, in "Art and Mass Culture," *Studies in Philosophy and Social Science* 9.2 (1941): 296, describes a somewhat different structure in the response to Donald Duck: "Misanthropic, spiteful creatures, who secretly know themselves as such, like to be taken for the pure, childish souls who applaud with innocent approval when Donald Duck gets a cuffing." The sadomasochistic structure described by Adorno is of course not limited to Disney; it is actually quite pervasive and can be found as well in Warner Brothers cartoons of the period, such as *You Ought to Be in Pictures* (Porky Pig/Freleng, 1940) or *Hiawatha's Rabbit Hunt* (Bugs Bunny/Freleng, 1941), to name just two examples.

11. *Dialectic of Enlightenment,* 112; *AGS* 3:162. "The collective of those who laugh parodies humanity. . . . Their harmony presents a caricature of solidarity" (ibid.).

12. Siegfried Kracauer, "Sturges or Laughter Betrayed," *Films in Review* 1.1 (Feb. 1950): 11–13, 43–47.

13. Adorno actually alludes to this passage from the artwork essay in "On Jazz" (473–74), though he substitutes "the bourgeoisie" for "humankind."

14. See Buck-Morss, "Aesthetics and Anaesthetics."

15. Ibid., 18, n. 62.

16. Eisenstein was particularly interested in Disney's synesthetic matching of sound and image tracks in conjunction with his own collaboration with Prokofiev on *Alexander Nevsky* (1938): see S. M. Eisenstein, "Vertical Montage" (1940), in *Selected Works,* vol. 2, *Towards a Theory of Montage,* ed. Michael Glenny and Richard Talyor (London: BFI, 1991), 327–99.

17. "Mickey Mouse," in *SW* 2:545–46; "Zu Micky-Maus," in *GS* 6:144–45. Benjamin collected newspaper articles on Mickey Mouse and Disney, mostly in French, throughout the early 1930s (see Benjamin papers, Theodor W. Adorno Archiv, Frankfurt a.M.).

18. Benjamin, "Crock Notes" (1932), 82.

19. "The Destructive Character" (1931), in *SW* 2:541.

20. The other article that his "politics" subscribes to is "the idea of revolution as innervation of the technical organs of the collective (analogy with the child who learns to grasp by trying to get hold of the moon)" (*AP* 631). Mickey Mouse and Fourier are linked in *The Arcades Project*'s convolute on the latter, *AP* 635 (W8a,5). On Benjamin's understanding of "politics," see Steiner, "True Politician."

21. As Martin Jay rightly points out, "experience" in Benjamin's sense has always been in crisis compared to some indeterminate time in the past; see "Is Experience Still in Crisis? Reflections on a Frankfurt School Lament," in *The Cambridge Companion to Adorno,* ed. Tom Huhn (Cambridge: Cambridge University Press, 2004), 129–47. Also see above, ch. 3, n. 18, and ch. 4, n. 3.

22. The same passage reappears three years later in Benjamin's essay on Nikolai Leskov, "The Storyteller," in *SW* 3:144, where it serves to set up a position diametrically opposed to that of the earlier essay.

23. Benjamin was fascinated with Scheerbart throughout his life, having been "converted" to the writer by Scholem. He wrote a review of Scheerbart's 1913 novel *Lesabendio* between spring 1917 and fall 1919, assumed to be the unpublished text "Paul Scheerbart: Lesabéndio," *GS* 2:618–20. His second, major text on Scheerbart, planned as the conclusion to a large-scale work on politics (beginning with two sections respectively entitled "The True Politician" and "The True Politics"), is lost; see Steiner, "Benjamin's Politics," 61, 75–77. Benjamin returned to Scheerbart, who had also written a book on glass architecture (*Glasarchitektur*, 1914) and worked with Bauhaus architect Bruno Taut, in the 1930s; see "Short Shadows (II): To Live without Leaving Traces" (1933), *SW* 2:701–2; and his celebration of the new "culture of glass" in "Experience and Poverty." In a late text written in French, Benjamin resumed Scheerbart's utopian politics of technology, aligning him with Fourier's cosmic fantasies and mockery of contemporary humanity; see "On Scheerbart" (late 1930s or 1940), *SW* 4:386–88.

24. Variant, in *GS* 2:962–63.

25. Norbert Bolz, *Auszug aus der entzauberten Welt: Philosophischer Extremismus zwischen den Weltkriegen* (Munich: Wilhelm Fink, 1989), 95. Also see Lindner, "Technische Reproduzierbarkeit und Kulturindustrie."

26. A similar analysis can be found in Kracauer's review of *Dumbo*, *The Nation*, 8 Nov. 1941.

27. *Eisenstein on Disney*, ed. Jay Leyda, trans. Alan Upchurch (London, New York, and Calcutta: Methuen, 1988), 5, 33.

28. Ibid., 3–4, 21, 22. Kracauer makes a similar point with reference to slapstick comedy; see above, ch. 2.

29. See Lev Manovich, *The Language of New Media* (Cambridge, Mass.: MIT Press, 2002), 295.

30. See Kristin Thompson, "Implications of the Cel Animation Technique," in *The Cinematic Apparatus*, eds. Teresa de Lauretis and Stephen Heath (New York: St. Martin's Press, 1980), 108–12.

31. See Kracauer's review of *Dumbo*, 463, and Eisenstein's critical remarks about "the crude naturalism" of the landscapes in *Bambi* in *Eisenstein on Disney*, 99. Also see Schickel, *Disney Version*, ch. 21 and passim. I am indebted to Hank Sartin for alerting me to the fact that, contrary to received opinion, Disney's move toward "realism" already began prior to the features, with the stabilization and standardization of the background drawings that were thus distinguished from the throbbing, rhythmic movement of the figures.

32. Cartoon figures, Mickey Mouse in particular, did of course assume star status and were billed as such, with the attendant phenomena of fan mail, fan clubs, and copyright exploitation; to the extent that the name Disney increasingly referred to a giant corporation of anonymous employees, however, the star aura was transferred to Walt the inventor, artist, American genius (see Smoodin, *Animating Culture*, 63–67 and ch. 4). A considerable number of Warner Brothers cartoons, by contrast, present parodies of the star cult and of particular stars.

33. Jameson, *Late Marxism*, 95.

34. See Hal Foster, "Armor Fou," *October* 56 (Spring 1991): 65–97. The classic argument on this fantasy can be found in Klaus Theweleit, *Male Fantasies* (1977–78), 2 vols., trans.

S. Conway, E. Carter, and C. Turner (Minneapolis: University of Minnesota Press, 1987–89).

35. I am using the term *trompe l'oeil* here in the sense developed by Mary Ann Doane, in "'When the Direction of the Force Acting on the Body Is Changed': The Moving Image," *Wide Angle* 7.1–2 (1985): 45–49.

36. The last example is actually from *Merbabies* (1938), one of Eisenstein's favorite Silly Symphonies, in which he perceived a similar play with evolutionist teleology; see *Eisenstein on Disney*, 4, 10, 33.

37. See, in particular, thesis XVIII, in which Benjamin cites a contemporary biologist on the minute fracture that human history represents in relation to the history of all organic life on earth ("'the paltry fifty millennia history of *homo sapiens* equates to something like two seconds at the close of a twenty-four hour day'"); the "figure" that human history "describes in the universe" is recursively related to "Now-time" (*Jetztzeit*), "which, as a model of messianic time, comprises the entire history of mankind in a tremendous abbreviation" (*SW* 4:396).

38. On the concept of "natural history" (*Naturgeschichte*) in Benjamin (and Adorno), see Buck-Morss, *Origin of Negative Dialectics* (New York: Free Press, 1977), ch. 3, and Hanssen, *Walter Benjamin's Other History*, 94 & passim; also see Buck-Morss, *Dialectics of Seeing*, chs. 3 and 6.

39. See Leslie, *Hollywood Flatlands*, on the reception of Disney among European avant-garde artists and intellectuals. For an overview of Disney's changing critical currency, see Mike Budd, "Introduction: Private Disney, Public Disney," in Budd and Kirsch, *Rethinking Disney*, 7–15.

40. Fritz Moellenhoff, M. D., "Remarks on the Popularity of Mickey Mouse," *American Imago* (June 1940), repr. in *American Imago* 46.2–3 (Summer–Fall 1989): 115–16. Hanns Sachs's essay first appeared in *Psychoanalytic Quarterly* 2 (1933): 404–24.

41. Moellenhoff, "Remarks," 117. Ariel Dorfman and Armand Mattelart take the Disney characters' refusal to reproduce—and thus evade "natural" motherhood—as part of the cartoons' authoritarian structure; *How to Read Donald Duck: Imperialist Ideology in the Disney Comic* (1971), trans. David Kunzle (New York: International General, 1975). Also see Sammonds, *Babes in Tomorrowland*, ch. 5.

42. Adorno, "Oxforder Nachträge," in *AGS*, 17:106–7.

43. Robert Sklar, "The Making of Cultural Myths: Walt Disney," in *The American Animated Cartoon*, ed. Gerald Peary and Danny Peary (New York: Dutton, 1980), 58–65. Also see Schickel, *Disney Version*, on the films' reputation for terrifying children (most impressively, Benjamin Spock's allegation that Nelson Rockefeller told his wife "that they had to reupholster the seats in Radio City Music Hall because they were wet so often by frightened children" [185]).

44. Storm and Dressler, in *Im Reiche der Micky Maus*, for instance, cite the following entry from Goebbels's diary, 20 Dec. 1937: "I present the Führer with thirty of the last four years' top films and eighteen Mickey Mouse films . . . for Christmas. He is very pleased and totally happy about this treasure which I hope will bring him much joy and recreation" (11). When Leni Riefenstahl visited the United States in the winter of 1938–39, she was boycotted by the industry; the only producer who gave her a warm welcome was Disney (see Leslie, "Leni

and Walt: Deutsch-Amerikanische Freundschaft," in *Hollywood Flatlands*, 123–57). Also see Carsten Laqua, *Wie Micky unter die Nazis fiel* (Reinbek bei Hamburg: Rowohlt Taschenbuch Verlag, 1992).

45. On Benjamin's concept of humor, see Marleen Stoessel, "*Löwenpastete:* Humor und Geistesgegenwart im Werk von Walter Benjamin," *Lettre International* 79 (Winter 2007): 85–88; and Stoessel, *Lob des Lachens: Eine Schelmengeschichte des Humors* (Frankfurt a.M. and Leipzig: Insel Verlag, 2008), 145–50.

CHAPTER 7

1. This chapter is a shortened and modified version of my essay "Room-for-Play: Benjamin's Gamble with Cinema," *October* 109 (Summer 2004): 3–45.

2. Fragment relating to artwork essay, in *GS* 1:1045.

3. "The Cultural History of Toys," in *SW* 2:113–16; "Toys and Play: Marginal Notes on a Monumental Work," in *SW* 2:117–21. Also see "'Old Forgotten Children's Books'" (1924), in *SW* 1:408.

4. Jeffrey Mehlman, *Benjamin for Children: An Essay on His Radio Years* (Chicago: University of Chicago Press, 1993), 5. For Benjamin's antifunctionalist and antinaturalist position on toys, see "Cultural History of Toys," 115–16. Also see Adorno's remarks on children's play, obviously inspired by Benjamin, in *Minima Moralia: Reflections from Damaged Life* (1951), trans. E. F. N. Jephcott (London: Verso, 1978), 228.

5. *AP* 390 (K1a,3), 461 (N2a,1) [*GS* 5:576], and 855 (M°,20). On the significance of children's play for Benjamin's theory of cognition and approach to history, see Buck-Morss, *Dialectics of Seeing,* 261–75.

6. Roger Caillois, *Man, Play, and Games*, trans. Meyer Barash (New York: Schocken, 1979), 12–13.

7. I am bracketing here another sense of *Spiel* associated with dramatic art, the noun that forms part of the composite term *Trauerspiel*, literally "play of mourning," which is the subject of Benjamin's treatise *The Origin of German Tragic Drama* (1928). Martin Jay reads Benjamin's "saturnine attraction to *Trauerspiel*, the endless, repetitive 'play' of mourning (or more precisely, melancholy)" as a rejection of *Trauerarbeit*, the "allegedly 'healthy' 'working through' of grief." See Jay, "Against Consolation: Walter Benjamin and the Refusal to Mourn," in *War and Remembrance in the Twentieth Century*, eds. Jay Winter and Emmanuel Sivan (Berkeley: California University Press, 2001), 228. Benjamin's antitherapeutic insistence on repetition in the endless play of melancholia has a structural counterpart, as we shall see, in his antithetical efforts to redeem repetition as an aesthetic, comedic, and utopian modality.

8. Benjamin, "Short Shadows (II)" (1933), in *SW* 2:700.

9. Benjamin, "Madame Ariane: Second Courtyard on the Left," in *One-Way Street*, in *SW* 1:483 (emphasis added). The isolation of the successful gambler from the other gamblers as prerequisite to a telepathic contact with the ball is emphasized—and illustrated with a drawing—in the fragment "Telepathie" (1927–28), in *GS* 6:187–88.

10. "Die glückliche Hand: Eine Unterhaltung über das Spiel" (1935), in *GS* 4:771–77, 776. Also see *AP* 513 (O13,3).

11. This temporality, Benjamin speculates in *The Arcades Project*, is a crucial dimension of what constitutes the "authentic 'intoxication' [*Rausch*]" of the gambler (*AP* 512), a state of passion, of delirious trance, an obsession not unrelated to eroticism. He compares the winner's happiness in having "seized control of destiny" to a man's receiving the "expression of love by a woman who has been truly satisfied by [him]" (*SW* 2:298); by the same token, the gambler's *Rausch* can also substitute for that experience: "Isn't Don Juan a gambler?" (*AP* 513). In the same context, Benjamin justifies the pairing of prostitution and gambling with the claim that casino and bordello have in common "the most sinful delight: to challenge fate in lust" *(AP* 489). Also see "In Parallel with My Actual Diary" (1929–31), trans. Rodney Livingstone, in *SW* 2:413–14.

12. This does not mean that the category of "nonsensuous similarity" is a lapsarian one; on the contrary, it allows Benjamin to link the "earlier powers of mimetic production and comprehension" to his own medium—language and writing. "Language may be seen as the highest level of mimetic behavior and the most complete archive of nonsensuous similarity" (*SW* 2:722, also 721).

13. I will not attempt to relate Benjamin's concept of play to the wider canon of play theory of both earlier and later provenance, but touch only on sources roughly within Benjamin's intellectual habitat. For the revalorization of "play" from the 1950s on, see, for instance, David Riesman, *The Lonely Crowd* (New Haven: Yale University Press, 1950); Eugen Fink, *Oase des Glücks: Gedanken zu einer Ontologie des Spiels* (Freiburg and Munich: Karl Alber, 1957); Herbert Marcuse, *Eros and Civilization: A Philosophical Inquiry into Freud* (1955; repr., Boston: Beacon Press, 1966); and, in particular, Jacques Ehrman, ed., *Games, Play, Literature*, a special issue of *Yale French Studies*, no. 41 (1968), which introduced European concepts of play, particularly in Bakhtin and Caillois, to an American audience. Subsequent theorizing of play received major impulses from Derrida's reinscription of the term, especially in *Writing and Difference* (Chicago: University of Chicago Press, 1978) and *Dissemination* (Chicago: University of Chicago Press, 1981). For an attempt to introduce Derrida's concept of play into film theory, see Peter Brunette and David Wills, *Screen/Play Derrida and Film Theory* (Princeton: Princeton University Press, 1989). Finally, for a brilliant interrelation of sociological, philosophical, literary, and aesthetic perspectives on play, see Bill Brown, *The Material Unconscious: American Amusement, Stephen Crane, and the Economies of Play* (Cambridge, Mass.: Harvard University Press, 1996).

14. *Beyond the Pleasure Principle* famously figures in Benjamin's "On Some Motifs in Baudelaire," in which he reads Freud's hypothesis on traumatic shock through Theodor Reik's and Proust's concepts of memory, generalizing it into an etiology of the decline of experience in industrial-capitalist modernity (*SW* 4:316–18).

15. Sigmund Freud, *Beyond the Pleasure Principle* (1920), in *Standard Edition*, vol. 18, trans. & ed. James Strachey in collaboration with Anna Freud, 12. Also see Cathy Caruth, *Unclaimed Experience: Trauma, Narrative, and History* (Baltimore: Johns Hopkins University Press, 1996), ch. 3; and the critique of Caruth's reading of Freud in Ruth Leys, *Trauma: A Genealogy* (Chicago: University of Chicago Press, 2000), ch. 7.

16. Johan Huizinga, *Homo Ludens: A Study of the Play Element in Culture* (1950; repr., Boston: Beacon Press, 1955). The Dutch original appeared in 1938; the English edition is based on a German version published in Switzerland, 1944, and the author's own transla-

tion of 1945. Caillois's study, which responds to Huizinga's, began as an essay written in 1946 and was published in book form by Gallimard in 1958; the English version, *Man, Play, and Games,* did not appear until more than two decades later. Benjamin repeatedly quotes Huizinga's magnum opus, *The Waning of the Middle Ages* (1928), in *The Arcades Project.* On the revival of Huizinga and Caillois in contemporary video game theory, see below, n. 56.

17. Huizinga, *Homo Ludens,* 208, 90; the whole chapter 5 is devoted to "play and war."

18. Caillois, *Man, Play, and Games,* 55.

19. Huizinga, *Homo Ludens,* 19. Also see Friedrich Schiller, *On the Aesthetic Education of Man, in a Series of Letters,* ed. & trans. Elizabeth M. Wilkinson and L. A. Willoughby (Oxford: Clarendon Press, 1967), in particular letters 14 and 15. Within the tradition of the Frankfurt School, Herbert Marcuse in particular took up Schiller's concept of play, especially in *Eros and Civilization*; also see Fredric Jameson, *Marxism and Form: Twentieth-Century Dialectical Theories of Literature* (Princeton: Princeton University Press, 1972), 83–116.

20. Huizinga, *Homo Ludens,* 7–10.

21. Caillois, *Man, Play, and Games,* 5.

22. Ibid., 44–45.

23. Ibid., 32; also see Caillois's positive remarks about vertigo-inducing technological contraptions at amusement parks and traveling carnivals (50) and his inclusion of the cinema among legitimate forms of mimicry to be found at the margins of the social order (54). These are not the only affinities between Benjamin's and Caillois's theories of play. Indeed, it is striking how Benjamin's elaboration of the various meanings of *Spiel* parallels Caillois's fourfold classification of games in terms of agon, *alea,* mimicry, and *ilinx,* just as he seeks to renegotiate the distinction between *ludus* and *paidia.* From his correspondence, we know that Benjamin was familiar with, and felt ambivalent about, Caillois's work on mimicry or *mimétisme*; conversely, it is more than likely that Caillois had first- or second-hand knowledge of Benjamin's artwork essay. (The French translation of the artwork essay, though, does not contain the footnote in which Benjamin develops his concept of play in relation to semblance, and the term *Spielraum* is translated as *champ d'action.*) Benjamin and Caillois were introduced by Pierre Klossowski, the essay's translator and member of the Collège de Sociologie, organized by Georges Bataille, Michel Leiris, and Callois from 1937 to 1939. According to Klossowski, Benjamin "assiduously" attended meetings of the *collège* and was scheduled to present a lecture on Baudelaire (or, as Hans Maier claims, on "fashion") in the fall of 1939 that was preempted by the outbreak of the war. See Klossowski, "Entre Marx and Fourier," *Le Monde,* 31 May 1969, repr. in *The College of Sociology (1937–39),* ed. and intr. Denis Hollier, trans. Betsy Wing (Minneapolis: University of Minnesota Press, 1988), 388–89; Hollier's "Foreword: Collage," in ibid., 21; and Hans Maier, *Der Zeitgenosse Walter Benjamin* (Frankfurt a.M.: Jüdischer Verlag, 1992), 66. Also see Michael Weingrad, "The College of Sociology and the Institute of Social Research," *New German Critique* 84 (Fall 2001): 129–61. For an introduction to Caillois, see Claudine Frank, "Introduction" to *The Edge of Surrealism: A Roger Caillois Reader* (Durham, N.C.: Duke University Press, 2003), 1–53.

24. Brown, *Material Unconscious,* 11–12; also see 106–8.

25. Kracauer, "The Mass Ornament" (1927), in *MO* 75. For a discussion of Kracauer's writings on commercialized forms of play and leisure, see above, ch. 2. While these texts treat new forms of amusement and play with dialectically staged ambivalence, Kracauer was unequivocally critical of the contemporary cult of sports; see, in particular, his deadpan satire "Sie sporten," *FZ*, 13 Jan. 1927, in *S* 5.2:14–18; and his more straightforward critique of the ideological function of sports in *SM*, 76–80.

26. Also see draft notes for the second version in *GS* 7.2:667–68, partly translated in *SW* 3:137–38. The concept of *Schein* is central to Benjamin's major essay on Goethe's *Elective Affinities* (1919–22; 1924–25), in *SW* 1:297–360, a novel that, unlike idealist aesthetic theory, "is still entirely imbued with beautiful semblance as an auratic reality" (*SW* 3:127). Also see the fragments "On Semblance," in *SW* 1:223–25, and "Beauty and Semblance," in *SW* 1:283.

27. The translation includes the German phrases in brackets.

28. Benjamin elsewhere emphasizes the "dimension of play" as the bridge between "art" and the so-called practical and mechanically mediated arts, ranging "from early techniques of the observer [magic lantern shows, dioramas] right down to the electronic television of our own day" ("Moonlit Nights on the Rue La Boétie" [1928], in *SW* 2:108).

29. I have retained a literal translation of the German proverb *Einmal ist keinmal*, not only because of its pairing with *Ein für allemal* but also because of Benjamin's fascination with the phrase; see his short piece "Einmal ist Keinmal" (1932), in *GS* 4:433–34.

30. Karl Groos, *Die Spiele der Menschen* (Jena: Gustav Fischer, 1899), v.

31. On Benjamin's reception of biomechanics, see above, ch. 5. For his endorsement of Tretyakov, see "The Author as Producer" (1934), in *SW* 2:768–82.

32. A similarly self-conscious use of the term can be found in a techno-pessimistic piece by Karl Wolfskehl, member of the George circle and the Munich Kosmiker group, whom Benjamin admired notwithstanding ideological differences; see Wolfskehl, "Spielraum" (1929), in *Gesammelte Werke*, 2:431–33. Also see Karl Kraus's 1912 statement that the ability to distinguish "between an urn and a chamber pot" is what provides culture with "*Spielraum*"; lacking this distinction, contemporary culture is "divided into those who use the urn as a chamber pot and those who use the chamber pot as an urn," that is, in Hal Foster's reading, "Art Nouveau designers who want to infuse art (the urn) into the utilitarian object (the chamber pot)" and, conversely, "functionalist modernists who want to elevate the utilitarian object into art." Foster, *Design and Crime* (London and New York: Verso, 2002), 16–17. This is precisely why Marcel Duchamp, "trump[ing] both sides with his dysfunctional urinal" (Foster), provides a case in point for Benjamin's observation of an increase of "elements of play in recent art."

33. For a different reading of Chaplin, see Tom McCall, "'The Dynamite of a Tenth of a Second': Benjamin's Revolutionary Messianism in Silent Film Comedy," in Richter, *Benjamin's Ghosts*, 74–94, esp. 85.

34. See Huizinga, *Homo Ludens*, 5–6, 8, 44–45, for an extended reflection on the relations between seriousness or earnestness and play.

35. See Donald Crafton, "Pie and Chase: Gag, Spectacle and Narrative in Slapstick Comedy," repr. in *Classical Hollywood Comedy*, ed. Kristine Brunovska Karnick and Henry Jenkins (New York and London: Routledge, 1995), 106–19, as well as Tom Gunning, "Response to 'Pie and Chase,'" in ibid., 120–22.

36. Freud, *Beyond the Pleasure Principle*, 35–36, 38–41.

37. See Agamben, "Walter Benjamin and the Demonic," esp. 155–56.

38. In addition to *The Arcades Project*, especially convolutes B, D, and J, see the condensed version of Benjamin's late reflections on repetition in "Central Park" (1939), in *SW* 4:161–99, esp. 184. In his earlier essay on Proust, Benjamin links "eternal repetition" to the "eternal restoration of the original, first happiness" and the writer's pursuit of *mémoire involontaire* as an "impassioned cult of similarity," his "homesickness . . . for the world distorted in the state of similarity, a world in which the true surrealist face of existence breaks through"; significantly, Benjamin illustrates this quest with the image of children's repetitive play with a rolled-up stocking. "On the Image of Proust" (1929), in *SW* 2:239–40 (cf. the reprise of that image in "Berlin Childhood around 1900: 1934 Version," in *SW* 3:401). On that passage in particular, see Wohlfarth, "Walter Benjamin's Image of Interpretation," esp. 79–82. Also see Buck-Morss, *Dialectics of Seeing*, 97–109; Osborne, "Small-Scale Victories," 83–84; and Lindner, "Zeit und Glück." Gilles Deleuze develops his concept of repetition with recourse to Proust in *Difference and Repetition* (1968), trans. Paul Patton (New York: Columbia University Press, 1994), 17, 84–85, 122–26 and passim.

39. On Kierkegaard, see Heike Klippel, "Wiederholung, Reproduktion und Kino," *Frauen und Film* 63 (2002): 84–94; 86. Also see Klippel, *Gedächtnis und Kino* (Basel and Frankfurt a.M.: Stroemfeld, 1997).

40. In an earlier article revised for this chapter, I also compare Benjamin's argument about play and semblance in relation to technology to the ways these terms are configured in Herbert Marcuse; see Hansen, "Room-for-Play: Benjamin's Gamble with Cinema," *October* 109 (Summer 2004): 30–33.

41. Theodor W. Adorno, *Aesthetic Theory* (*AT*) (1970), ed. Gretel Adorno and Rolf Tiedemann; newly trans., ed., and intr. Robert Hullot-Kentor (Minneapolis: University of Minnesota Press, 1997), 100.

42. Martin Jay, "Taking on the Stigma of Inauthenticity: Adorno's Critique of Genuineness," *New German Critique* 97 (Winter 2006): 18.

43. See, for instance, his remarks on Proust's attempt to "outwit art's illusoriness" by evading the appearance of closure (*AT* 102).

44. Adorno, "On the Fetish Character in Music and the Regression of Listening," in *Essays on Music*, 312; *AGS* 14:46.

45. In their discussions surrounding *Dialectic of Enlightenment* (written up by Gretel Adorno), Max Horkheimer notably dissents from Adorno's indictment of sport for its tendency to lapse into manifest brutality: "In sport, there is something of play, and in play there is something of the dream. Athletic accomplishment and gambling. Mass culture has grasped [or taken up, *erfaßt*] play. Play has something of unrepressed mimesis.—Your concept of mimesis is probably incorrect since real regression is repressed. . . . Repressed mimesis is identical with controlled regression." Max Horkheimer, *Gesammelte Schriften, Band 12: Nachgelassene Schriften, 1931–1949*, ed. Gunzelin Schmid Noerr (Frankfurt a.M.: Suhrkamp, 1985), 592.

46. [Max Horkheimer and] Theodor W. Adorno, "The Schema of Mass Culture," trans. Nicholas Walker, in *CI* 77; *AGS* 3:328.

47. Adorno, letter of 18 March 1936, in *CC* 131.

48. Adorno, "Schema of Mass Culture," 77; *AGS* 3:328. The passage continues by linking this self-subjection to the unrecognized sadomasochistic structure of mass-cultural subjectivity and to repetition compulsion: "One can play the master by inflicting the original pain upon oneself and others at a symbolic level, through compulsive repetition."

49. Adorno, "Schema of Mass Culture," 78; *AGS* 3:329. As for the "screaming fans in the stands," also see the already cited fragment in *AT*: "The putative play drive has ever been fused with the primacy of blind collectivity" (317).

50. See, for instance, Adorno's chapter on Schönberg in *Philosophie der neuen Musik* (1949; written between 1940 and 1948), in particular the section "Schönberg's critique of semblance and play"; in the same chapter, he invokes Benjamin's argument to address twelve-tone music's relation to gambling and fate. See *Philosophy of Modern Music*, trans. Anne G. Mitchell and Wesley V. Blomster (New York and London: Continuum, 2003), 37–41, 66.

51. "I cannot see why play should be dialectical, while semblance—the semblance you once salvaged in the figure of Ottilie [in Goethe's *Elective Affinities*] . . .—is supposed not to be" (*CC* 129).

52. Mihai Spariosu, for instance, reads the restoration-of *play* "to its pre-Platonic high cultural status," beginning with Kant and German idealism, as a process of divorcing it from and opposing it to *mimesis*; see Spariosu, *Literature, Play, Mimesis* (Tübingen: Narr, 1982), 9.

53. Thomas Y. Levin discusses Adorno's writings on the phonograph record as a form of highly encrypted indexicality in "For the Record: Adorno on Music in the Age of Its Technological Reproducibility," *October* 55 (Winter 1990): 23–47, esp. 33–39.

54. Criticizing the overemphasis on a narrowly understood, photochemically defined, notion of indexicality in film theory (and, for that matter, in triumphalist versions of new media theory), Tom Gunning has drawn attention to the centrality of cinematic motion, exemplified in discussions of the 1920s; see "Moving Away from the Index: Cinema and the Impression of Reality," *differences: A Journal of Feminist Cultural Studies* 18.1 (2007): 29–52.

55. Lev Manovich, *The Language of New Media* (Cambridge, Mass.: MIT Press, 2001), xiv–xxxvi, 239–43.

56. See, in particular, Gonzalo Frasca, "Simulation versus Narrative: Introduction to Ludology," in *The Video Game Theory Reader*, ed. Mark J. P. Wolf and Bernard Perron (New York and London: Routledge, 2003), 221–35; B. Perron, "From Gamers to Players and Gameplayers," in ibid., 237–58; and Alexander R. Galloway, *Gaming: Essays on Algorithmic Culture* (Minneapolis and London: University of Minnesota Press, 2006), 19–31. Also see Henry Jenkins, "Game Design as Narrative Architecture," in *First Person: New Media as Story, Performance, and Game*, ed. Noah Wardrip-Fruin and Pat Harrigan (Cambridge, Mass.: MIT Press, 2004), 118–30.

57. See, for instance, Frasca, "Simulation," 221–22, and Galloway, "Origins of the First-Person Shooter," ch. 2 of *Gaming*, esp. 69.

58. See, for instance, *Arcanum* (Troika Games/Sierra Entertainment, 2001), *Fallout 3* (Bethesda Games Studios/ZeniMax Media, 2008), and, especially, *Portal* (Valve Corporation/Microsoft Game Studios, 2007).

CHAPTER 8

1. In his essay "Art and Mass Culture," *Studies in Philosophy and Social Science* 9.2 (1941), Horkheimer uses the term in the plural, "cultural industries" (303). In a late essay based on a 1963 radio speech, Adorno claims that he and Horkheimer first used the term *culture industry* in *Dialectic of Enlightenment*, substituting it for *mass culture* so as to avoid any suggestion, promoted by its advocates, that "it is a matter of something like a culture that arises spontaneously from the masses themselves, a contemporary form of popular art." See "Culture Industry Reconsidered," trans. Anson G. Rabinbach, *New German Critique* 6 (1975): 12; repr. in *CI* 85.

2. For related efforts, see Gertrud Koch, "Mimesis and *Bilderverbot,*" trans. Jeremy Gaines, *Screen* 34.3 (Autumn 1993): 211–22, and Martin Seel, "Adornos Apologie des Kinos," in *Adornos Philosophie der Kontemplation* (Frankfurt a.M.: Suhrkamp, 2004), 77–95.

3. Andreas Huyssen, *After the Great Divide: Modernism, Mass Culture, Postmodernism* (Bloomington: Indiana University Press, 1986), 24.

4. Adorno to Benjamin, 18 March 1936, trans. Harry Zohn, in *Aesthetics and Politics* (London: New Left Books, 1977), 123; Adorno and Benjamin, *Briefwechsel, 1928–1940* (Frankfurt a.M.: Suhrkamp 1994), 171.

5. Adorno, "Zum 'Anbruch': Exposé" (1928), *AGS* 19:595–604, 601–2, cited and trans. Thomas Y. Levin, "For the Record: Adorno on Music in the Age of Its Technological Reproducibility," *October* 55 (Winter 1990): 27–28. This text introduces two essays by Adorno translated by Levin, "The Curves of the Needle" (1927–28) and "The Form of the Phonograph Record" (1934), repr. in Leppert, *Essays on Music,* 271–82. Also see Leppert, "Commentary," in *Essays on Music,* 230–36.

6. See, for instance, "Frankfurter Opern- und Konzertkritiken," *AGS* 19:232, 243.

7. On Adorno's radio research, see David Jenemann, *Adorno in America* (Minneapolis: University of Minnesota Press, 2007), chs. 1 and 2; Leppert, "Commentary," 213–30; and Thomas Y. Levin, with Michael von der Linn, "Elements of a Radio Theory: Adorno and the Princeton Radio Research Project," *Musical Quarterly* 78.2 (Summer 1994): 316–24. Of particular interest to this chapter's concerns are Adorno's unpublished writings collected in Adorno, *Nachgelassene Schriften,* Abteilung 1, vol. 3, of *Current of Music: Elements of a Radio Theory,* ed. and intr. Robert Hullot-Kentor (Frankfurt a.M.: Suhrkamp, 2006); for a shorter English version of Hullot-Kentor's introduction, see "Second Salvage: Prolegomenon to a Reconstruction of *Current of Music,*" in Hullot-Kentor, *Things beyond Resemblance: Collected Essays on Theodor W. Adorno* (New York: Columbia University Press, 2006), 94–124.

8. See Gertrud Koch, "Kritische Theorie in Hollywood," in *Die Einstellung ist die Einstellung: Visuelle Konstruktionen des Judentums* (Frankfurt a.M.: Suhrkamp, 1992), esp. 57–94; and Jenemann, *Adorno in America,* ch. 3. "Research Project on Anti-Semitism" was first published in *Studies in Philosophy and Social Science* 9 (1941), repr. Adorno, *The Stars Down to Earth and Other Essays on the Irrational in Culture,* ed. and intr. Stephen Crook (London and New York: Routledge, 1994), 135–61; see esp. 158–60.

9. Theodor Adorno and Hanns Eisler, *Composing for the Films* (*CF*) (1947), with a new introduction by Graham McCann (London and Atlantic Highlands, N.J.: Athlone Press,

1994). See Philip Rosen, "Adorno and Film Music: Theoretical Notes on Composing for the Films," *Yale French Studies* 60 (1980): 157–82; Thomas Y. Levin, "The Acoustic Dimension: Notes on Cinema Sound," *Screen* 25.3 (May–June 1984): 55–68; Claudia Gorbman, *Unheard Melodies: Narrative Film Music* (Bloomington: Indiana University Press, 1987), 106–8; Lisa Parkes, "Adorno and Schoenberg in Hollywood," *New German Review* 19 (2003): 90–102; and Lydia Goehr, *Elective Affinities: Musical Essays on the History of Aesthetic Theory* (New York: Columbia University Press, 2008), ch. 7.

10. In addition to musicological studies on Eisler, see Claudia Gorbman, "Hanns Eisler in Hollywood," *Screen* 32.3 (Fall 1991): 272–85.

11. Hanns Eisler, *Komposition für den Film* (Berlin: Henschel, 1949); Adorno and Eisler, *Komposition für den Film* (München: Rogner and Bernhard, 1969); Adorno, "Zum Erstdruck der Originalfassung," in *AGS* 15:144–46; Rolf Tiedemann, "Editorische Nachbemerkung," in *GS* 15:405–6; McCann, "New Introduction," in *Composing for the Films*, xxxvii–xxxix; and Leppert, "Commentary," in *Essays on Music*, 365.

12. Adorno, "Zum Erstdruck," in *AGS* 15:145. See Hansen, "Introduction to Adorno's 'Transparencies on Film' (1966)," *New German Critique* 24–25 (Fall–Winter 1981–82): 193–98. Also see Adorno to Kracauer, 22 Oct. 1962, on the Oberhausen group and his own participation—probably with his "close friend" Alexander Kluge—in a discussion on "film questions" at the Mannheim festival of "modern film"; in *AKB* 552–53. On Kluge, also see ibid., 557–58, 577, 717.

13. See *Oxford English Dictionary*, s.v. "technology," 1a & b. Also see sense 2, referring to "the mechanical arts or applied sciences" collectively or individually.

14. *AT* 212, 214. Lambert Zuidervaart, *Adorno's Aesthetic Theory: The Redemption of Illusion* (Cambridge, Mass., and London: MIT Press, 1991), translates *Gehalt* as "import" (38, 41 and passim); the word also shares aspects of *substance*.

15. See *AT* 35, 59. Adorno also speaks of "musical" technology, for instance in "The Dialectical Composer" (1934), trans. S. H. Gillespie, in Leppert, *Essays on Music*, 207. In his letter responding to Benjamin's artwork essay, he links his insistence on the "primacy of technology" in music to Benjamin's concept of "second technology" (*CC* 128; *ABB* 168). On the latter, see above, ch. 5. Throughout the letter, the distinction between *Technik* and *Technologie* (or the respective adjectives) remains fluid. When Adorno summarizes his objection to the artwork essay—"You underestimate the technical character [*Technizität*] of autonomous art and overestimate that of dependent art" (131, 173)—the word *technicity* refers to aesthetic technique in the first part of the sentence and to technology in the second, or rather, as we shall see, to both at once.

16. *AT* 212. Also see "Music and Technique" (1958), in *Sound Figures*, trans. Rodney Livingstone (Stanford: Stanford University Press, 1999), 197–214; 197.

17. Hullot-Kentor, *Current of Music*, 140. Adorno had been thinking about the question of reproduction, as a key problem of modern music, from an essay of 1925 through the 1950s and, as early as 1935, was planning to write a book on the topic with the violinist Rudolf Kolisch, a member of the Schönberg circle and leader of string quartets. The material relating to the project is collected in Adorno, *Towards a Theory of Musical Reproduction: Notes, a Draft and Two Schemata*, ed. Henri Lonitz, trans. Wieland Honban (Cambridge: Polity Press, 2006).

18. On the juncture of technique and Kant's "purposiveness without purpose," see *AT* 217–18. Also see Tom Huhn, "Kant, Adorno, and the Social Opacity of the Aesthetic," in *The Semblance of Subjectivity: Essays in Adorno's Aesthetic Theory*, ed. Huhn and Lambert Zuidervaart (Cambridge, Mass., and London: MIT Press, 1997), 250–56.

19. *AT* 34; also see 217, 272.

20. To underline this point, Adorno invokes Benjamin's statement "'It no longer feels right to dream of the Blue Flower'" (*AT* 218). See Benjamin, "Dream Kitsch: A Gloss on Surrealism" (1927), in *SW* 2:3; *AGS* 2:620. The passage continues: "Dreaming has a share in history. The statistics on dreaming would stretch beyond the loveliness of the anecdotal landscape into the barrenness of a battlefield. Dreams have started wars, and wars, from the very earliest times, have determined the propriety and impropriety—indeed, the range— of dreams."

21. By the same token, Adorno criticizes the poeticization of industry by which impressionist painting "contributes its part to making peace with an unpeaceful world." "Art, as an anticipatory form of reaction, is no longer able—if it ever was—to embody pristine nature or the industry that has scorched it; the impossibility of both is probably the hidden law of aesthetic nonrepresentationalism." As proof texts of a poetic stance that does not yearn for either nature or industry, he adduces the works of Beckett and Celan, stressing their "anorganic" quality (*AT* 219).

22. Adorno, "Der getreue Korrepetitor," in *AGS* 15:371. In *Aesthetic Theory*, Adorno attributes the power of artworks to reconcile to "the fact that, in accord with the ancient topos, they heal the wound with the spear that inflicted it" (134).

23. On Adorno's concept of mimesis in its various constellations, see Früchtl, *Mimesis*. Also see Jay, "Mimesis and Mimetology," and other references in ch. 5, above, n. 52.

24. See, for instance, *AT* 41–42, 131, 166–168, and passim. Also see the conclusion to "Fetish-Character in Music and the Regression of Listening" (1938), in Leppert, *Essays on Music*: "In music, too, collective powers are liquidating an individuality past saving, but against them only individuals are capable of consciously representing the aims of collectivity" (315).

25. Adorno, "Culture Industry Reconsidered," 87–88; "Résumé über Kulturindustrie," in *AGS* 10.1:340.

26. "Culture Industry Reconsidered," 88.

27. Adorno, "Musik im Rundfunk" (1938), *Frankfurter Adorno Blätter* 7 (München, 2001): 107. Translation mine.

28. Adorno and Eisler invoke Benjamin's critique of Franz Werfel's celebration of Max Reinhardt's *A Midsummer Night's Dream*.

29. Also see their critique of Eisenstein's collaboration with Prokofiev—and his commentary on the correspondence of mobile shots and score—in *Alexander Nevsky*, in *CF* 152–57.

30. Eisenstein, Vsevolod Pudovkin, and Grigori Alexandrov, "Statement on Sound," in Eisenstein, *Selected Works*, 1:113–14.

31. Adorno, "Intention and Reproduction" (1945), *Minima Moralia: Reflections from Damaged Life*, trans. E. F. N. Jephcott (London: Verso, 1974), 142; *AGS* 4:159.

NOTES TO CHAPTER 8

. Adorno, "Transparencies on Film" (TF) (1966), trans. Thomas Y. Levin, *New German Critique* 24–25 (Fall–Winter 1981–82): 199; "Filmtransparente" (FT), in *Ohne Leitbild* (1967), in *AGS* 10.1:353.

33. See Adorno, "Vers une musique informelle" (1961; 1963), in *Quasi una Fantasia: Essays on Modern Music,* trans. Rodney Livingstone (London and New York: Verso, 1992), 269–322; and "Difficulties" (1964; 1966), trans. Susan H. Gillespie, in Leppert, *Essays on Music,* 644–79, esp. 658–59. Also see Ian Pepper, "From the 'Aesthetics of Indifference' to 'Negative Aesthetics': John Cage and Germany, 1958–1972," *October* 82 (1997): 31–47.

34. This shift found a catalyst in the Darmstadt International Vacation Courses on New Music, in which Adorno actively participated between 1950 and 1966. See "The Aging of the New Music" (1955), trans. Susan H. Gillespie, in Leppert, *Essays on Music,* 181–209. Also see Adorno's essays listed in the preceding note.

35. Adorno, "Chaplin Times Two" (1: 1930; 2: 1964), *The Essential Chaplin: Perspectives on the Life and Art of the Great Comedian,* ed. Richard Schickel (Chicago: Ivan R. Dee, 2006), 268; *AGS* 10:362.

36. Martin Seel discusses Adorno's observation in relation to Antonioni's film, elaborating on the complex cinematic production involved in creating this effect. In addition to camera and editing techniques that combine with the near-static character of the mise-en-scène and narrative, he stresses the role of the sound track—sparse and laconic dialogue, nonphonetic urban noise, and diegetic music featuring the cool jazz of the Gaslini Quartet. See Seel, "Adornos Apologie des Kinos," 93–95.

37. "Die Kunst und die Künste" (1966–67), in *Ohne Leitbild,* in *AGS* 10:451.

38. Ibid., 10:452.

39. Koch, "Mimesis and *Bilderverbot.*"

40. Ibid., 221; Kluge, "On Film and the Public Sphere."

41. Adorno, "The Form of the Phonograph Record," 279; Levin, "For the Record," 59.

42. Adorno, *Kierkegaard: Construction of the Aesthetic* (1929–30; 1933), trans., ed., and intr. Robert Hullot-Kentor (Minneapolis: University of Minnesota Press, 1989).

43. Adorno, "On Some Relationships between Music and Painting" (1965), trans. Susan Gillespie, *Musical Quarterly* 79.1 (Spring 1995): 73, 72. This essay is dedicated to Kahnweiler on his eightieth birthday.

44. Adorno, "Chaplin Times Two," 270.

45. "Prologue to Television," in Adorno, *Critical Models,* 54–55; Adorno, "Prolog zum Fernsehen," in *AGS* 10.2:513–14.

46. Angelo Montani and Giulio Pietranera, "First Contribution to the Psycho-analysis and Aesthetics of Motion Picture," *Psychoanalytic Review* 33 (1946): 177–92.

47. The analogy between film and hieroglyphic writing has of course a much longer history, from Vachel Lindsay through the Freudian adaptation of the Russian formalist notion of "inner speech" (see below, n. 53) to Derridean film theory. I elaborate on the problems with this analogy in my essay "Mass Culture as Hieroglyphic Writing: Adorno, Derrida, Kracauer," *New German Critique* 56 (Spring–Summer 1992): 43–73.

48. Adorno, "Schema of Mass Culture," 80–81; *AGS* 3:332–33.

49. Adorno, "Schema of Mass Culture," 82; *AGS* 3:334.

50. Ibid. This account confirms the importance of the concept (elided in the translation) in the last sentence of the chapter on the culture industry: "That is the triumph of advertising in the culture industry: the compulsive mimesis of consumers toward the cultural commodities even as they see through them." *DE* 136; *AGS* 3:191.

51. See n. 23 in this chapter and n. 52 in chapter 5.

52. Cahn, "Subversive Mimesis," 32–33.

53. Adorno's argument here recalls the idea of "inner speech" developed by Eisenstein and the Russian formalists. See, for example, Eisenstein, *Selected Works*, 1:236; Boris Eikhenbaum, "Problems of Cinema Stylistics," in *Russian Formalist Film Theory*, ed. Herbert Eagle (Ann Arbor: University of Michigan Press, 1981), 55–79; David Bordwell, "Eisenstein's Epistemological Shift," *Screen* 15.4 (Winter 1974–75): 32–46; Paul Willemen, "Cinematic Discourse: The Problem of Inner Speech" in *Looks and Frictions* (Bloomington: Indiana University Press, 1994), 27–55.

54. This account of the historical marking of the natural world is distinct from Adorno's earlier interest in the history of nature and its relation to human history, an interest that springs more directly from Benjamin's work. The key text here is Adorno, "The Idea of Natural-History," trans. R. Hullot-Kentor, in Hullot-Kentor, *Things beyond Resemblance*, 252–69. See Hanssen, *Walter Benjamin's Other History*, 81, and Buck-Morss, *Origin of Negative Dialectics*, 54. Also see Heinz Paetzold, "On Adorno's Notion of Natural Beauty: A Reconsideration," chap. 8 of Huhn and Zuidervaart, *Semblance of Subjectivity*.

55. I am deliberately downplaying the messianic-utopian trajectory of Adorno's aesthetics of nature, that is, its imbrication with a philosophy of reconciliation implicit in *Dialectic of Enlightenment*. Albrecht Wellmer points up the limitations incurred by this metaphysical horizon. See Wellmer, "Truth, Semblance, Reconciliation: Adorno's Aesthetic Redemption of Modernity," in *The Persistence of Modernity: Essays on Aesthetics, Ethics, and Postmodernism*, trans. David Midgley (Cambridge, Mass., and London: MIT Press, 1991), ch. 1.

56. On Adorno's concept of the sublime in modern art and its relation to natural beauty, see Albrecht Wellmer, "Adorno, Modernity, and the Sublime" (1991), in *Endgames: The Irreconcilable Nature of Modernity*, trans. D. Midgley (Cambridge, Mass., and London: MIT Press, 1998), ch. 6.

57. The counterexample would be travelogues compositionally weighted toward the picturesque, especially in their depiction of premodern pockets of Europe, for example, *Die schönsten Wasserfälle der Ostalpen* (*The Most Beautiful Waterfalls of the Eastern Alps*, Germany: Emelka-Kultur-Film, 1905–10) or *L'Auvergne pittoresque* (*Picturesque Auvergne*; France: Lux, 1912), both beautifully hand-colored. Such films participate in the enlargement, in the course of the nineteenth century, of the concept of natural beauty to include the domain of the "cultural landscape," associated with preindustrial built environments that relate organically to their geographical setting; beginning with the romantic cult of the ruin, images of cultural landscapes became a "memento," filled with the promises, however spurious and regressive, of a more humane past (*AT* 64–65).

58. On natural beauty, history, and cinematic technique, see Daniel Morgan, "The Place of Nature in Godard's Late Films," *Critical Quarterly* 51.3 (Fall 2009): 1–24. The historicization of natural beauty by means of cinematic technique is of course not limited to camera movement. In *Children of the Beehive* (1948), by Japanese director Shimizu Hiroshi, known

for his moving landscapes, an extreme overhead long shot of a logging site in a beautiful forest creates the momentary perception of the felled tree trunks as skeletal and thus condenses the film's unrepresented yet ever-present subtext of Hiroshima and Nagasaki (one of the orphans working at the logging site is dying of radiation sickness).

59. For a more detailed discussion of this concept see Berthold Hoeckner, "Preface: On Apparition," in Hoeckner, *Apparitions*.

60. Adorno discusses "Winkel von Hardt"—and the editor's commentary—in his essay "Parataxis: On Hölderlin's Late Poetry," in *Notes to Literature*, trans. Shierry Weber Nicholson (New York: Columbia University Press, 1992), 2:111–12; this edition includes Richard Sieburth's translation of the poem. On Benjamin and Novalis, see above, ch. 4.

61. This attempt to historicize and rationalize the mystical substratum of Benjamin's theory of aura echoes their earlier exchange—in letters of 1940—occasioned by Benjamin's second essay on Baudelaire; see above, ch. 4, near n. 18.

62. Adorno directly relates the term *Sprachcharakter* to Benjamin's essay "On Language as Such and on the Language of Man" (1916) in "On Some Relationships between Music and Painting," 71; *AGS* 16:633–34. In *Aesthetic Theory*, Robert Hullot-Kentor translates *Sprachcharakter* as "eloquence," explaining in a note the difficulty of a literal translation yet also the inadequacy of his substitution. What gets lost in this translation is, among other things, precisely the implicit link with Benjamin's philosophy of language. (In a later section, Hullot-Kentor resorts to "linguistic quality"; see *AT* 166–67.) I prefer the somewhat awkward literal translation as "language character" to preserve the metaphoric—and, in the case of literature, metonymic and dialectical—relation with verbal language that Adorno describes.

63. Benjamin, "On Language as Such and on the Language of Man" (1916), in *SW* 1:62–74, esp. 72–74.

64. Albrecht Wellmer argues that Adorno's conceptualization of mimesis in *Dialectic of Enlightenment* as antithetical to instrumental reason makes it "extraterritorial to the sphere of conceptual thought"; it thus fails to recognize "that there is a communicative-mimetic dimension *at the heart* of discursive reason" (as, for Wellmer, linguistic philosophy has shown)—"which is always more than just formal logic, instrumental reason, or a compulsion to systematize" (*The Persistence of Modernity*, 83). The question is whether and to what extent Adorno's understanding of mimesis in *Aesthetic Theory* can be uncoupled from his and Horkheimer's historico-philosophical critique of conceptual thought per se. The notion of art's language character seems to me one relay to alternative modes of discursive reason, reflection, and self-revision.

65. Vivian Sobchack describes a similar interrelation within the framework of phenomenological thought; see "The Passion of the Material," 286–318.

66. Christian Metz, *Film Language: A Semiotics of Cinema* (1968), trans. Michael Taylor (New York: Oxford University Press, 1974). Also see Stephen Heath and Patricia Mellencamp, eds., *Cinema and Language* (Los Angeles: American Film Institute, 1983).

67. Film's affinity with the "secret life of things" (Virginia Woolf) is a key topos of film aesthetics in interwar Europe, informed in part by a turn to the object in avant-garde movements such as dada and surrealism and Soviet artists such as Boris Arvatov and Alexander Rodchenko, as well as the Japanese school of New Sensationism and its Shang-

hai counterpart. See Brown, "Thing Theory," and Stern, "'Paths That Wind,'" and other essays in the collection *Things*, ed. Brown. Also see Tanizaki Jun'ichiro's early writings on film and modernity, of which only his essay *In Praise of Shadows* (1933) and his novel *Naomi* (1924–25) are widely known in English; see Thomas LaMarre, *Shadows on the Screen: Tanizaki Jun'ichiro on Cinema and "Oriental" Aesthetics* (Ann Arbor: Center for Japanese Studies, University of Michigan, 2005).

68. On the "primacy of the object," see *AT* 258–59 and Adorno, *Negative Dialectics*.

69. Michael Rutschky, *Erfahrungshunger: Ein Essay über die siebziger Jahre* (Frankfurt a.M.: Fischer, 1982), 65, 64.

70. See, for instance, Kuntzel, "Le Défilement," and August, "The Défilement into the Look"; Jean-Louis Baudry, "Ideological Effects of the Basic Cinematographic Apparatus," in Rosen, *Narrative, Apparatus, Ideology*, esp. 290–91; and, most recently, Garrett Stewart, *Between Film and Screen: Modernism's Photosynthesis* (Chicago: University of Chicago Press, 1999), 7–8 and passim.

71. Alexander Kluge, "The Assault of the Present on the Rest of Time" (1985), trans. Stuart Liebman, *New German Critique* 49 (Winter 1990): 16. Chris Marker, Raymond Bellour, and Babette Mangolte, among others, have made a similar point.

72. Adorno, "Radio Physiognomics" (written in 1939), in Hullot-Kentor, *Current of Music*, 176–77.

73. On the relationship between time and movement, see Doane, *Emergence of Cinematic Time*, esp. ch. 6. Also see D. N. Rodowick, *Gilles Deleuze's Time Machine* (Durham, N.C.: Duke University Press, 1997), esp. ch. 4.

74. Adorno invokes Benjamin's formulation of "dialectic at a standstill" in the context of his conception of the "dialectical image" (*AT* 84).

75. Also see Koch, "Mimesis and *Bilderverbot*," 215–17. André Bazin famously speaks of the "mummy complex" in his essay "The Ontology of the Photographic Image" (1945), 9.

76. Adorno refers here to fireworks, as a prototype of artistic apparition.

77. Bazin, "Ontology of the Photographic Image," 14–15. This quotation in no way exhausts Bazin's reflections on cinematic temporality.

78. Adorno, "Schema of Mass Culture," 62, 74. See ibid., 60–65 (*AGS* 3: 307–14) for an extensive discussion of the fate of time in the culture industry. Also relevant here is Adorno's critique of the spatialization of music in his radio theory in *Currents of Music*.

79. Gilles Deleuze, *Cinéma 2: The Time Image*, trans. Hugh Tomlinson and Robert Galeta (Minneapolis: University of Minnesota Press, 1989), 39. Also see Rodowick, *Gilles Deleuze's Time Machine*, esp. ch. 4.

80. Deleuze, *Cinema 2*, 22–23.

81. Ibid., 17.

82. Goehr, *Elective Affinities*, 4.

83. See Noël Burch, *Theory of Film Practice* (1969), trans. Helen R. Lane (Princeton: Princeton University Press, 1981). David Bordwell discusses and adapts Burch's notion of parametric form in *Narration in the Fiction Film*, ch. 12.

84. David Bordwell, "The Musical Analogy," *Yale French Studies* 60, *Cinema/Sound* (1980): 155–56.

85. I am borrowing the term *materials of expression* from Christian Metz (who in turn borrows it from linguist Louis Hjelmslev), though my argument goes in a different direction. See Metz, *Language and Cinema,* trans. Donna Jean Umiker-Sebeok (The Hague and Paris: Mouton, 1974), 16, 24–25, 208–11.

86. See n. 17, above, as well as Adorno's essays on the gramophone record, "The Curves of the Needle" (1927–28) and "The Form of the Phonograph Record" (1934).

87. See, for example, Philip Gossett, *Divas and Scholars: Performing Italian Opera* (Chicago: University of Chicago Press, 2006), and Paolo Cherchi Usai, *The Death of Cinema: History, Cultural Memory and the Digital Dark Age* (London: British Film Institute, 2001).

88. Adorno, "On Some Relationships between Music and Painting," 66.

89. Adorno, "On the Contemporary Relationship of Philosophy and Music" (1953), in Leppert, *Essays on Music,* 144.

90. Adorno, "On Some Relationships between Music and Painting," 66.

91. Adorno, "Form in der neuen Musik" (1966), in *AGS* 16:619, 624. Also see Max Paddison, *Adorno's Aesthetics of Music* (Cambridge: Cambridge University Press, 1993), 179–80.

92. Adorno, "Farewell to Jazz" (1933), trans. Susan H. Gillespie, in Leppert, *Essays on Music,* 499, 498.

93. Adorno, "On Jazz" (1936), 477–78; also see Adorno, "Perennial Fashion—Jazz," esp. sec. 2. In his polemics against Stravinsky, in particular the imbrication of archaic, cultic elements with mechanical, shocklike rhythmical beats in *Sacre du printemps,* Adorno repeatedly links this problematic of rhythm to jazz. See *Philosophy of New Music* (1949), trans., ed., and intr. Robert Hullot-Kentor (Minneapolis: University of Minnesota Press, 2006), 115–20; and "Stravinsky: A Dialectical Portrait" (1962), in Adorno, *Quasi una Fantasia,* 145–75; also see "On Jazz," 488–89.

94. See Michael Cowan, "The Heart Machine: 'Rhythm' and Body in Weimar Cinema and Fritz Lang's *Metropolis,*" *Modernism/modernity* 14.2 (April 2007): 225–48.

95. Ibid., 231. Also see Christine Lubkoll, "Rhythmus: Zum Komplex von Lebensphilosophie und ästhetischer Moderne," in *Das Imaginäre des Fin de siècle: Ein Symposium für Gerhard Neumann,* ed. Lubkoll (Freiburg: Rombach, 2002), 83–110. Klages's opposition of *Rhythmus* and *Takt* corresponds to a whole set of dualisms in both his own work (e.g., *Der Geist als Widersacher der Seele* [1934]) and the antimodernist ideology of the period (see above, chs. 4 and 2).

96. Cowan, "The Heart Machine," 234. See Eisenstein's discussion of rhythm in montage as dynamic "conflict" between metric measures and "the irregularity of the particular" in "The Dramaturgy of Film Form," in Eisenstein, *Selected Works,* 1:162–63.

97. Cowan, "The Heart Machine," 239.

98. Adorno, "Vers une musique informelle," in *Quasi una fantasia,* 311; *AGS* 16:530–31.

99. Adorno, *Mahler: A Musical Physiognomy,* trans. Edmund Jephcott (Chicago: University of Chicago Press, 1992), 39; see 34–37. Also see "Kitsch" (1932), trans. Gillespie, in Leppert, *Essays on Music,* 501–5.

100. Adorno, "Vers une musique informelle," 312; *AGS* 16:531. This argument goes back to his critique of twelve-tone music, in particular Schönberg's, in *Philosophy of New Music.*

101. Adorno, "Difficulties," 658. Also see "Form in der neuen Musik," 619.

102. Adorno, "Vers une musique informelle," 296. An example of the abstract negation Cage and his disciples content themselves with are their "séances" that recall Rudolf "Steiner, eurhythmics, and healthy-living [*lebensreformerische*] sects" (ibid., 315; *AGS* 16:534).

103. Ibid., 272, 275, 304, 322; *AGS* 16:498, 524, 540.

104. Ibid., 303, 322; *AGS* 16:540. This last sentence of the essay echoes the essay's epigraph from Beckett's *L'Innommable:* "Dire cela, sans savoir quoi" (269).

105. Ibid., 319; cf. 301.

106. Ibid., 320.

107. Ibid., 273–74; *GS* 16:497. At the same time, he criticizes compromises attendant on the "scenic" element of music in this vein (e.g., *Pierrot lunaire*). Also see his approving comments on Schönberg's *Begleitmusik zu einer Lichtspielszene*, ibid., 290, and elsewhere.

108. Adorno, "Die Kunst und die Künste," 438–39.

109. Ibid., 452–53.

110. Except, very cautiously, in Eisler's scoring of two films by Joris Ivens, *La Nouvelle Terre* (*New Earth*, 1933) and *Fourteen Ways of Describing the Rain* (1941); see *CF* 26; appendix, 158–65.

111. *CF* 68; *AGS* 15:69. The word *symmetrical* does not occur in the original German version. *Großrhythmus:* "the proportion between the parts and their dynamic relationship, the progression or stopping of the whole, the breath pattern [*Ein- und Ausatmen*], so to speak, of the total form" (68).

112. *CF* 75; *AGS* 15:74. "They [musicals] may be remembered once the sound film is emancipated from present-day conventions."

113. Adorno, "The Handle, the Pot, and Early Experience," in Nicholsen, *Notes to Literature* [IV], 2:216; *AGS* 11:562.

114. Adorno to Kracauer, 28 Sept. 1966, in *AKB* 717.

115. Ernst Bloch, "Die Melodie im Kino oder immanente und transzendentale Musik" (1914), repr. in *Prolog vor dem Film: Nachdenken über ein neues Medium, 1909–1914*, ed. Jörg Schweinitz (Leipzig: Reclam, 1992), 326–34. On the utopian connotations of the syncretistic celebration of motion in and surrounding early cinema, see Tom Gunning, "Loïe Fuller and the Art of Motion: Body, Electricity, and the Origins of Cinema," in Allen and Turvey, *Camera Obscura, Camera Lucida*, 75–89. On the tension between chunks of time and the forward movement of narrative time, see Laura Mulvey, "Passing Time: Reflections on Cinema from a New Technological Age," *Screen* 45.2 (Summer 2004): 142–55.

116. The plastic and rhythmic mobilization of written text can be found from the 1920s on in the work of filmmakers as diverse as Richter, Murnau, Vertov, Len Lye, and Godard, as well as Kluge's television and video work, in particular his recent DVD *Nachrichten aus der ideologischen Antike: Marx—Eisenstein—Das Kapital* (Frankfurt a.M.: Filmedition Suhrkamp, 2008).

117. In his observation that Mahler's music "makes itself the theater [*Schauplatz*] of collective energies," Adorno links this dream of collectivity with film: "In Mahler, there resounds something collective, the movement of the masses, just as for seconds, in even the most wretched film, does the force of the millions who identify with it" (*Mahler*, 33; also see 34; *AGS* 13:182).

118. He distinguishes between projective, narcissistic "identification" and "the innervations of the objective language of objects," the latter being linked to the disposition Hegel called "freedom toward the object," which Adorno in turn took to be related to the paradoxical entwinement of distance and closeness in Benjamin's concept of aura (*AT* 275).

119. Kluge, "On Film and the Public Sphere," 208–9.

120. See Peter C. Lutze, *Alexander Kluge: The Last Modernist* (Detroit: Wayne State University Press, 1998). Among my essays on Kluge, see for instance Hansen, "Space of History, Language of Time: Kluge's *Yesterday Girl* (1966)," in *German Film and Literature: Adaptations and Transformations*, ed. Eric Rentschler (London and New York: Methuen, 1986), 193–216.

121. See Kluge, "The Assault of the Present on the Rest of Time."

CHAPTER 9

1. In the following, page numbers in parentheses will refer to the 1960/1997 edition of *Theory of Film* cited in the list of abbreviations. This chapter is a substantially revised version of my introduction to the reprint, reflecting changes in my thinking about the book.

2. As has often been pointed out, this logic involves a potential methodological circularity—assumptions about the ontological qualities of the medium derived from viewing particular films become the basis for aesthetic norms and critical judgments—a problem that Kracauer is not unaware of and actually cautions against (*T* 12).

3. See, for instance, Janet Harbord, "Contingency's Work: Kracauer's *Theory of Film* and the Trope of the Accidental," *New Formations* 61 (Summer 2007): 90–103.

4. See Ivone Margulies, ed., *Rites of Realism: Essays on Corporeal Cinema* (Durham, N.C.: Duke University Press, 2003).

5. A version of chapter 14 of *Theory of Film*, "The Found Story and the Episode," appeared in *Film Culture* 2.1 (1956), 1–5, with a portrait of the author; also "Opera on Screen" (from chapter 8) appeared in *Film Culture* 1.2 (1955): 19–21. Kracauer was a member of the Society of Cinematologists (the precursor of today's Society for Cinema and Media Studies) from its beginnings in 1960. See Johannes von Moltke, "Manhattan Crossroads: *Theory of Film* between the Frankfurt School and the New York Intellectuals," forthcoming in *Culture in the Anteroom: The Legacies of Siegfried Kracauer*, ed. Gerd Gemunden and J. von Moltke (Ann Arbor: University of Michigan Press, 2011). Also see Lee Grieveson and Haidee Wasson, eds., *Inventing Film Studies* (Durham, N.C.: Duke University Press, 2008).

6. Pauline Kael, "Is There a Cure for Film Criticism? Or: Some Unhappy Thoughts on Siegfried Kracauer's *Nature of Film* [*sic*]," *Sight and Sound* 31.2 (Spring 1962): 56–64; Tudor, *Theories of Film*, 79; Andrew, *The Major Film Theories*, ch. 5, and Andrew, *Concepts in Film Theory*, 19. On the immediate German reception of *Theory of Film*, see Helmut Lethen, "Sichtbarkeit: Kracauers Liebeslehre," in Kessler and Levin, *Siegfried Kracauer*, 197. *Theory of Film* was to gain a second life in the 1970s when it was assimilated by the Munich Sensibilists, in particular Wim Wenders; see Rutschky, *Erfahrungshunger*, in particular "Allegorese des Kinos," 167–92.

7. Andrew, *Major Film Theories*, 106.

8. See Noël Carroll, "Kracauer's *Theory of Film*," in *Defining Cinema*, ed. Peter Lehman (London: Athlone Press, 1997), 111–31.

9. See Robert Warshow, *The Immediate Experience: Movies, Comics, Theatre & Other Aspects of Popular Culture* (1962; enl. ed. Cambridge, Mass.: Harvard University Press, 2001); and Stanley Cavell, *The World Viewed* (1971; enl. ed. Cambridge, Mass.: Harvard University Press, 1979). Kracauer knew and was in frequent conversation with Warshow until the latter's premature death in 1955. See Von Moltke, "Manhattan Crossroads."

10. The complete Marseille Notebooks, along with a number of later outlines in English (part of Kracauer's papers at Deutsches Literatur-Archiv, Marbach a.N.), have recently been published, with careful annotations, as an appendix to the book's German translation, *Theorie des Films*, in *W* vol. 3 (2005): 515–845. For a comprehensive account of the book's genesis, see Mülder-Bach's editorial postscript, ibid., 847–74. Also see Hansen, "'With Skin and Hair': Kracauer's Theory of Film, Marseille 1940," *Critical Inquiry* 19 (Spring 1993): 437–69.

11. *History: The Last Things Before the Last* (hereinafter *H*), ed. Paul Oskar Kristeller (New York: Oxford University Press, 1969); also see the revised German translation in *W* vol. 4, ed. Ingrid Belke, with Sabine Biebl (2009), which contains a substantive editorial postscript (435–627) and a host of useful annotations. On the relationship between *History* and Kracauer's film theory, see, among others, D. N. Rodowick, "The Last Things before the Last: Kracauer and History," *New German Critique* 41 (Spring–Summer 1987): 109–37, and Jean-Louis Leutrat, "Le diptyque de Kracauer, ou comment être présent à sa propre absence," in *Siegfried Kracauer: Penseur de l'histoire*, ed. Philippe Despoix and Peter Schöttler, with Nia Perivolaropoulou (Sainte-Foy, Quebec: Les Presses de l'Université Laval, 2006), 209–28.

12. Heide Schlüpmann, "The Subject of Survival: On Kracauer's *Theory of Film*," trans. Jeremy Gaines, *New German Critique* 54 (Fall 1991): 111–26.

13. Long before such postmodernist associations, Adorno urged Kracauer to eliminate the term *Ideologieverlust* (loss of ideology) from the German version of the book. See his letter of 17 Dec. 1963, *AKB* 629.

14. Heide Schlüpmann develops the notion of "love of cinema," as distinct from cinephilia, to capture the intellectual-erotic investment in theorizing the cinema in analogy with the root meaning of philosophy (or love of wisdom), after, against, and with Nietzsche. See Schlüpmann, *Abendröthe der Subjektphilosophie: Eine Ästhetik des Kinos* (Frankfurt a.M. and Basel: Stroemfeld, 1998), ch. 1.

15. There are echoes of the photography essay throughout the book; see, for instance, 56–57; also 21. An explicit reference to the essay surfaces only in Kracauer's introduction to *History*, where he notes with amazement that he had already observed "parallels between history and the photographic media," in particular between the rise of photography and that of historicism, in an article of the 1920s. He marvels whether his previous "blindness" was effected by the "strange power of the subconscious," but finds that his (re)discovery of the essay justified, "after the event," all the years he had spent on *Theory of Film* (*H* 3–4).

16. The book actually references another film relating to the Shoah, *The Last Stop* (*Ostnani Etap*, 1948), a Polish film made by former deportees. Less overtly, Kracauer speaks

of Luis Buñuel's *Land without Bread/Las Hurdes* (1933) as a "terrifying documentary [which] bared the depth of human misery, prefiguring the near future with its unspeakable horrors and sufferings" (*T* 181). In the epilogue, he resumes the argument through a discussion of Georges Franju's film about a Paris slaughterhouse, *Le Sang des bêtes* (1949). See Nia Perivolaropoulou, "Le Travail de la mémoire dans *Theory of Film* de Siegfried Kracauer," *Protée* 32.1 (2004): 39–48. For a perceptive commentary on the Medusa passage in the context of debates surrounding the imaging of the Shoah, see Georges Didi-Huberman, *Images in Spite of All: Four Photographs from Auschwitz*, trans. Shane B. Lilllis (Chicago: University of Chicago Press, 2008), 176–79.

17. See Gertrud Koch, "'Not yet accepted anywhere': Exile, Memory, and Image in Kracauer's Conception of History," trans. Jeremy Gaines, *New German Critique* 54 (Fall 1991): 95–109. Also see Schlüpmann, "The Subject of Survival."

18. Kracauer to Adorno, 12 Feb. 1949, in *AKB* 445.

19. Soma Morgenstern to Gershom Scholem, 21 Dec. 1972, excerpts in *Benjaminiana*, ed. Hans Puttnies and Gary Smith (Gießen: Anabas, 1991), 202–3. Also see Klaus Michael, "Vor dem Café: Walter Benjamin und Siegfried Kracauer in Marseille," in *"Aber ein Sturm weht vom Paradise her": Texte zu Walter Benjamin*, ed. Michael Opitz and Erdmut Wizisla (Leipzig: Reclam, 1992), 203–21. Kracauer mentions his and his wife's own plans for suicide in a letter to Max Horkheimer, 11 June 1941, Kracauer Papers, Deutsches Literaturarchiv, Marbach a.N.

20. See Erwin Panofsky's letter to Philip Vaudrin, Oxford University Press, 17 Oct. 1949, and Kracauer's letter to Panofsky, 6 Nov. 1949, in *Siegfried Kracauer-Erwin Panofsky Briefwechsel, 1941–1966*, ed. Volker Breidecker (Berlin: Akademie Verlag, 1996), 52–55. This collection includes Kracauer's "Tentative Outline of a Book on Film Aesthetics" (1949), 83–92.

21. It would be misleading to refer to the Marseille Notebooks as a book. Not only are its entries fragmentary, but they are dispersed over parallel columns entitled WHERETO? / REMARKS / EXAMPLES / CATCHWORDS / COMPOSITION / TO DO that include quotations and paraphrases (a running dialogue with cinematographer Eugen Schüfftan), cross-references, tangential notes, and polemical asides (frequently against Balázs).

22. Letter to Panofsky, 6 Nov. 1949, in Breidecker, *Kracauer-Panofsky Briefwechsel*, 55. The apostrophized terms appear in English in the original.

23. See Erwin Panofsky, "Style and Medium in the Motion Pictures" (1947), in *Three Essays on Style* (Cambridge, Mass.: MIT Press, 1995): "The medium of the movies is physical reality as such." It should be added that Panofsky goes on to qualify "physical reality" along a more complex line similar to that pursued in the Marseille Notebooks: "The physical reality of eighteenth-century Versailles—no matter whether it be the original or a Hollywood facsimile indistinguishable therefrom for all aesthetic intents and purposes—or of a suburban home in Westchester; . . . the physical reality of engines and animals, of Edward G. Robinson and Jimmy Cagney" (122).

24. Kracauer's reflections on film sound gesture toward something like an "acoustic unconscious" and foreground experimental uses of sound ("anonymous noises," multilingual speech, etc.) from Fritz Lang through René Clair and G. W. Pabst. They also describe hypothetical practices that were to be realized in different ways by the French and German

New Waves (Godard, Kluge), New Hollywood during the 1960s and '70s (Altman, Coppola), and the "New Talkies" of the 1980s (Duras, Rainer).

25. German-English summary, 8–12 May 1949, 1, Kracauer Papers. Also see "Tentative Outline," 84–85, in Breidecker, *Kracauer-Panofsky Briefwechsel*, 91.

26. In the Marseille Notebooks, the term *dégonflage* (deflating) is often coupled with the shorthand *Sancho Panza*, referring to the Cervantes character through the lens of Kafka's "The Truth on Sancho Panza." Kracauer writes, "Insofar as film, by representing materiality, promotes the work of disenchantment, it can be called the Sancho Panza who exposes the Donquichoteries of hollow ideologies and intentional constructions" (*W* 3:621). Kracauer resumes Kafka's Sancho Panza aphorism in *H* 216–17.

27. In *History*, Kracauer discerns a contemporary incarnation of that ideology in the notion of the "integrated personality," one of the "favorite superstitions of modern psychology" (*H* 148), by which I take him to be referring to American ego psychology.

28. See, for example, texts by Jean-Louis Baudry, Christian Metz, Laura Mulvey, Stephen Heath, et al., repr. in *Narrative, Apparatus, Ideology*; as well as Bordwell, *Narration in the Fiction Film*.

29. I am thinking in particular of Epstein, *Le Cinématographe vu de l'Etna* (1926). See Stuart Liebman, "Visitings of Awful Promise: The Cinema Seen from Etna," in Allen and Turvey, *Camera Obscura, Camera Lucida*, 91–108; and Jennifer Wild, "Distance Is (Im)material: Epstein versus Etna," forthcoming in *Jean Epstein: Critical Essays and Translations*, ed. Sarah Keller and Jason Paul (Amsterdam: University of Amsterdam Press, 2011). For later examples in that tradition, see Steven Shaviro, *The Cinematic Body* (Minneapolis: University of Minnesota Press, 1992), and Sobchack, *Carnal Thoughts*; also see Linda Williams, "Film Bodies: Gender, Genre, and Excess," *Film Quarterly* 44.4 (Summer 1991): 2–13.

30. On the influence of *film d'art*, in particular its sophisticated pictorialism and staging, on the development of the American narrative film, see Tom Gunning, "Le Récit filmé et l'idéal théâtral: Griffith at 'les films d'Art' français," in *Les Premiers ans du cinéma français*, ed. Pierre Guibbert (Perpignan: Institut Jean Vigo, 1985).

31. Kracauer, "Chaplin: Zu seinem Film 'Zirkus,'" *FZ*, 15 Feb. 1928, in *W* 6.2:34.

32. German-English summary, 8–12 May 1949, Kracauer Papers; first chapter outline dated 19 Nov. 1940.

33. Adorno, in a letter to Kracauer of 5 February 1965, comments with approval on Kracauer's troping on the Perseus myth but goes on to reassert the unrepresentability in the register of the image of "the complex instantiated by the word *Auschwitz*" (*AKB* 688). Kracauer responds briefly by defending postwar documentaries on the concentration camps; see letter of 3 March 1965, *AKB* 691.

34. A version of this chapter, entitled "The Photographic Approach," was published in *Magazine of Art* 44.3 (March 1951): 107–13.

35. See Rudolf Arnheim, "Melancholy Unshaped," *Journal of Aesthetics* 21.3 (Spring 1963): 291–97. The aesthetics of melancholia that Arnheim imputed to the whole book is no doubt one of the traces of its initial commitment to Benjamin's treatise on the Baroque *Trauerspiel*.

36. Elena Gualtieri makes a similar argument in "The Territory of Photography: Between Modernity and Utopia in Kracauer's Thought," *New Formations* 61 (Summer 2007): 84–86.

37. He emphasizes the term *Entfremdungschancen* in the Marseille Notebooks, *W* 3:567.

38. See Sergei Eisenstein, "Beyond the Shot," in *Selected Works*, 1:138–50.

39. In the Marseille Notebooks, the woman is identified as (the translator) Geneviève du Loup (*W* 3:577, 790). It is precisely this dimension of mimetic identification in Kracauer's concept of "camera reality" that eludes Arnheim when he criticizes the following sentences from the epilogue as a "bold *nonsequitur*": "The moviegoer watches the images on screen in a dream-like state. So he can be supposed to apprehend physical reality in its concreteness" (*T* 303; Arnheim, "Melancholy Unshaped," 295).

40. Cavell emphasizes the difference between representation and projection in *The World Viewed*, 17. I am indebted to Dan Morgan for making me aware of the significance of the category of projection in late Godard.

41. Also see *H* 6, 78–79.

42. Friedrich Kittler, *Discourse Networks 1800/1900*, trans. Michael Metteer, with Chris Cullens (Stanford: Stanford University Press, 1990), 338–39; and Adorno, "The Curious Realist," 177. Also see Stern, "'Paths That Wind through the Thicket of Things.'"

43. Doane, *Emergence of Cinematic Time*, 68.

44. Martin Heidegger, *Discourse on Thinking: A Translation of Gelassenheit* (1959), trans. John M. Anderson and E. Hans Freund (New York: Harper & Row, 1966).

45. Helmut Lethen, "Sichtbarkeit," 201–5; Lethen, *Cool Conduct*; and Lethen, "Refrigerators of Intelligence," *Qui Parle* 5.2 (Spring–Summer 1992): 73–101.

46. On Kracauer and Bergson, see Paula Amad, *Counter-archive: Film, the Everyday, and Albert Kahn's Archives de la Planète* (New York: Columbia University Press, 2010), 301–2 and passim. On the revisionist relation to *Lebensphilosophie* in his Weimar writings, see above, ch. 1. Also see Inga Pollmann, "Cinematic Life: Vitalism and the Moving Image," dissertation in progress, University of Chicago, ch. 4.

47. Edmund Husserl, *The Crisis of the European Sciences and Transcendental Phenomenology: An Introduction to Phenomenological Philosophy* (1936), trans. David Carr (Evanston, Ill.: Northwestern University Press, 1970). Indebted to both Dilthey (*Lebenszusammenhang*, context and relationality of living, life-nexus) and Heidegger (being-in-the-world), the concept of *Lebenswelt* marked a turn in Husserl's phenomenology and became an influential concept for, among others, Maurice Merleau-Ponty, Alfred Schütz, and Habermas.

48. In *History*, Kracauer engages extensively with the Annales School, especially Marc Bloch and Fernand Braudel, not only for their focus on everyday life and the *longue durée* but also for their sustained effort to make the research perspectives and methodologies of more scientifically oriented disciplines—geography, economics, sociology, anthropology—productive for historiography.

49. Husserl, *Crisis*, 108–9.

50. Gabriel Marcel, "Possibilités et limites de l'art cinématographique," *Revue internationale de filmologie*, 5.18–19 (July–Dec. 1954): 164. In the epilogue, Kracauer spells out the implications of this statement in terms of efforts to open up Eurocentric perception to an awareness of global interconnectedness and recognition of commonality and differences. The last section, "'The Family of Man,'" invokes Edward Steichen's exhibition by that title

(shrewdly analyzed by Roland Barthes in *Mythologies* [1957]), and somewhat naively confirms, by citing a viewer's response to Satyajit Ray's *Arapajito,* that the photographic media fulfill the "task of rendering visible mankind" (310).

51. Letter to Adorno, 11 May 1965, *AKB* 704. Kracauer is responding to Enno Patalas's review of the book's German version, "Der Philosoph vor der Leinwand: Siegfried Kracauers 'Theorie des Films,'" *Frankfurt Allgemeine Zeitung,* 10 April 1965. Lethen ("Liebeslehre," 220) cites Brecht's poem that I repeat here because it seems to me to capture Kracauer's stance perfectly: "Außer diesem Stern, dachte ich, ist nichts und er / Ist so verwüstet. / Er allein ist unsere Zuflucht und die / Sieht so aus" (Brecht, *Gesammelte Werke* [Frankfurt a.M.: Suhrkamp, 1967], 10:959).

52. Among other things, such a mode of vision allows cinema to juxtapose "phenomena overwhelming consciousness" at macro and micro levels, that is, "elemental catastrophes, the atrocities of war, acts of violence and terror," with the imperceptible disasters and dreadfulness of ordinary individual life (*T* 57) and to register at once their interconnectedness and cognitive disjuncture.

53. On the impact aesthetic of digital film, see, for example, Geoff King, "Spectacle, Narrative, and the Spectacular Hollywood Blockbuster," in *Movie Blockbusters,* ed. Julian Stringer (New York: Routledge, 2003). On the ludology-narratology debate in game studies, see, among others, Gonzalo Frasca, "Ludology Meets Narratology: Similitude and Differences between (Video)games and Narrative," http://www.ludology.org/articles/ludology.htm, 1999; Henry Jenkins, "Game Design as Narrative Architecture," in *First Person: New Media as Story, Performance, and Game,* ed. Noah Wardrip-Fruin and Pat Harrigan (Cambridge, Mass.: MIT Press, 2004); and Ian Bogost, "Video Games Are a Mess" (2009), http://www.bogost.com/writing/videogames_are_a_mess.shtml.

54. Kracauer quotes Roger Caillois: "There is no Cosmos on the screen, but an earth, trees, the sky, streets and railway: in short, matter" (*T* 266). See Caillois, "Le cinema, le meurtre et la tragédie," *Revue internationale de filmologie* 2.5 (1949): 91. In the same spirit, André Bazin states, "There are no wings to the screen." "Theater and Cinema—Part Two" (1951), in *What is Cinema?* vol. 1, trans. Hugh Gray (Berkeley: University of California Press, 1967), 105. Cavell makes a similar argument in *The World Viewed,* 23–25.

55. The whole section in the Marseille Notebooks that discusses the narrative fiction film is titled "Gestalt und Zufall" (Form and Chance), which puns on the title of Kracauer's 1925 essay, cited in chapter 1, "Gestalt und Zerfall" (Form and Disintegration). This revisionist allusion encapsulates the distance between the eschatological overtones of his Weimar stance and the stoic position he assumes in *Theory of Film.*

56. In his typed correction to the carbon copy of "Tentative Outline," Kracauer inserted the note "an idea inconceivable without Joyce" (12).

57. Philippe Despoix and Nia Perivolaropuolou, introduction to the book's French translation, *Théorie du film: La redemption de la réalité matérielle [sic]* (Paris: Flammarion, 2010), xvi–xvii. Also see Didi-Huberman, *Images in Spite of All,* 175.

58. Bordwell, Staiger, and Thompson, *Classical Hollywood Cinema,* 19–23.

59. Through most of the book, Eisenstein—specifically the later, "totalitarian" Eisenstein—stands in for any attempt to subordinate the material, sensory qualities of film to a tight and a priori discursive structure. In Kracauer's critique, his overestimation of "the

signifying power of images" and "upward drive toward the significant" (*T* 208) is wedded to an organicist conception of the work of art as a closed economy, "a whole with a purpose" (*T* 221). As emerges from Kracauer's extensive correspondence with Arnheim during this period, as well as the latter's review of the book, he must have had a similar problem with Arnheim's notion of "significant form," though this issue was not confronted overtly.

60. Also see *T* 302. Kracauer had read and met Greenberg, who was on the editorial board of *Commentary* and invited him to publish his much-noted article, "Hollywood's Terror Films: Do They Reflect an American State of Mind?" *Commentary* 2.2 (Aug. 1946), an *avant-la-lettre* assessment of film noir.

61. See Hansen, *Babel and Babylon*, chs. 5, 8, and 9.

62. "Tentative Outline for a Book on Film Aesthetics (Title not yet fixed)," dated 8 Sept. 1949, 5; German translation in *W* 3:829.

63. Kracauer cites Eisenstein's memorable account of getting a "flashing glimpse" of a passerby in one of the street scenes of the modern story of *Intolerance*, while remembering next to nothing of the couple that is the subject of the shot (*T* 231). See Eisenstein, "Dickens, Griffith, and Film Today" (1944), in *Film Form: Essays in Film Theory*, ed. and trans. Jay Leyda (New York: Harcourt Brace, 1949), 199. For a more recent translation of a revised version of the essay, see Eisenstein, "Dickens, Griffith and Ourselves," in *Selected Works*, vol. 3, *Writings, 1937–47*, ed. Richard Taylor, trans. William Powell (London: British Film Institute, 1996), 196.

64. Kluge, "On Film and the Public Sphere."

65. Bordwell, *Narration in the Fiction Film*, 30.

66. The former reference is to Malcolm Turvey, *Doubting Vision: Film and the Revelationist Tradition* (New York: Oxford University Press, 2008), the latter to Doane, *Emergence of Cinematic Time*, 230 and 11. Doane draws her concept of contingency primarily from Niklas Luhmann's systems theory; at the end of the book she grants the possibility of a nonideological understanding of contingency as the "negation of impossibility" (231–32). Also see Harbord, "Contingency's Work."

67. This is more explicitly the case in *History*. See especially ch. 8, "The Anteroom."

68. Kracauer's observation that film is for "a split second meaningless" occurs in "Tentative Outline," 5; it was removed on the advice of Robert Warshow.

69. Kracauer borrows the image of the "blind drive of things" from Albert Laffay, "Les grands thèmes de l'écran," *La Revue du cinéma* 2.12 (April 1948): 13.

70. A collection of Kracauer's American essays, *Affinities: Siegfried Kracauer's American Writings, 1941–1966*, ed. Johannes von Moltke and Kristy Rawson, is forthcoming from the University of California Press.

71. Kracauer invokes Riesman's phrase *suburban sadness* in *Theory of Film*, 180. Riesman analyzes the emergence of a new, "other-directed" character type in terms of the "radar" or X-ray metaphor he borrows from the Marxist economic historian Karl August Wittfogel, a collaborator of the Frankfurt (later New York) Institute for Social Research from the 1920s on. On this connection, see Lethen, *Cool Conduct*, ch. 5.

INDEX

actor: Benjamin and, 96–97, 175–76, 185, 198,
312n5; Kracauer and, 63, 175
actuality, 133–34, 305n3, 308–9n36; Benjamin,
75–83, 90–92, 119, 133–34, 201, 305n3;
Kracauer, 76, 133–34, 305n3
Adorno, Theodor W., xi, 3, 5, 207–50;
abstraction, 217; aesthetic semblance, 200,
217, 244; and aura, 114, 118, 196, 207–8, 221,
233, 346n61, 350n118; Bauer and, 282n5;
censorship charges against, xii, 84; eccentric
figure, 166; and Eisenstein, 209, 216, 217, 222,
240, 343n29, 345n53; experience (Erfahrung),
xiv, 213–14, 223, 231; and Freud, 197, 227, 243,
291n75, 295n75, 344n47; Germany return
after World War II, 209; Institute for Social
Research, xi, 77, 209, 300n54; Jameson
and, ix; and Kluge, xviii, 210, 218, 222,
225, 249–50, 342n12; Marx Brothers, xviii;
mimesis, 146–47, 214, 223, 228–29, 233–36,
240, 248, 345n50, 346n64; moviegoing,
xviii; reification, 8, 17, 20, 26, 54, 110, 197,
207, 227–29, 238, 286n16, 314n18; "Research
Project on Anti-Semitism," 209; social
status, 20; translations, 4; in U.S., 28, 209;
wife Gretel Karplus, 76, 307n22
Adorno, Theodor W.—Benjamin critiques,
207, 212, 213, 214, 223, 232; artwork essay,
83–84, 96, 99, 141, 161, 165–66, 195–99,
207–8, 215, 219, 221, 233–35, 240–41, 311n66,
332n13; aura, 118, 233, 346n61, 350n118;

after Benjamin's death, 163; Disney, 163–64,
165–69, 180, 181–82, 332n10; experience
and forgetting, 110, 314n18; humor, 181–82;
and Klages, 124, 233; language, 233–35,
346n62; "Little History of Photography," 259;
mimetic faculty, 146–47, 228, 233–34; The
Origin of German Tragic Drama, 225; play,
xviii, 195–99, 217, 239, 340nn48,49,50,51;
sport, 197–99; Werfel, 343n28; writing, 226
Adorno, Theodor W.—culture industry,
xvii, 207–10, 341n1; "Culture Industry
Reconsidered" (1963), 209, 215, 218; and
Federal Republic administrative cultural
order, xii, 210; hieroglyphic writing, 52,
224–29, 238, 344n47; immediacy, 217, 244;
independent film and, 219; Kluge and, 249;
Minima Moralia (1944–47), 208, 217–18;
·"Prologue to Television" (1953), 226, 227;
radio, xvii, 215–16, 237, 347n78; reception,
249; reproduction technologies, 212, 215–16,
218; television, xvii, 209, 226, 227; time,
238–39; variété, 238–39. See also Adorno,
Theodor W.—film aesthetics; Dialectic of
Enlightenment (Horkheimer and Adorno,
1944; 1947)—culture industry chapter
Adorno, Theodor W.—film aesthetics, 207–50;
Aesthetic Theory (1970), 196, 197, 210–12, 217,
224, 226, 228, 229–30, 233, 346n62; "Art and
the Arts" (1966), 220–21, 245; Bilderverbot,
224–25, 229; determinate negation, 224–25,

357

technology, 104–6, 111, 113–14, 117, 122–23, 125, 183, 202; trace, 107, 110, 157, 312n6
Benjamin, Walter—Baudelaire, xv; Adorno and, 346n61; aura, 106, 109, 110, 114–15, 117–18; Collège de Sociologie, 337n23; experience, 81, 173, 306n18; Kracauer as Baudelairean *chiffonnier* ("ragpicker"), 24, 329n79; masses, 95; "On Some Motifs in Baudelaire," 106, 169, 185, 336n14; play, 185, 186–87, 195; Proust, 31, 313n13; reception, 169; self-alienation, 129; shock, 136, 169, 336n14
Benjamin, Walter—Brecht, 84, 161; aura, 104; "The Author as Producer" (1934), 83, 102; barbarism, 81; "culinary" attitudes, 100; Epic Theater, 102, 111, 169; Marxism, 127; Mickey Mouse and, 172, 173; mysticism, 312n2; sportification, 198; trace, 312n6
Benjamin, Walter—capitalism, 4, 65, 82, 89, 201–2; *Arcades Project*, 76; artwork essay, 76, 78; aura, 88; "dreamsleep," 328n64; experience, 336n14; innervation and, 132, 133, 139, 141, 143, 144, 160–61; Mickey Mouse and, 181, 201; mimetic faculty, 150, 154, 155, 187; optical unconscious, 158, 160–62; screen actor, 96–97; war-as-cosmic-mating fantasy, 181
Benjamin, Walter—childhood: "Berlin Childhood," 94, 149, 184, 327n53, 339n38; "Child Hiding," 184; mimetic faculty, 149–50, 328n62; "Old Forgotten Children's Books" (1924), 328n62; play, 150, 328n62, 339n38; "Program for a Proletarian Children's Theater" (1928–29), 185
Benjamin, Walter—death: "Little History of Photography," 107, 113, 157, 313n8; and play, 187, 194, 197; suicide, 257, 258, 313n8; *Trauerspiel*, 265
Benjamin, Walter—dreams, 109–12, 118–27, 318n57, 343n20; "dreaming collective," 166, 328n64; "dreamsleep," 328n64; Klages on, 125–26, 318n57
Benjamin, Walter—experience *(Erfahrung)*, xiv, xvii, 306n18, 312n3, 314n18, 336n14; artwork essay, 78, 81, 103, 173; aura, 105, 109, 128, 314n18; Baudelaire essay, 81, 173, 306n18; color, 329nn78,80; in crisis, 332n21; "Experience and Poverty" (1933), 81, 92, 103, 117, 171–72, 173, 307n24, 312n6, 333n23; Mickey Mouse, 171–73; optical unconscious, 315n26; "The Storyteller" (1936), 173, 307n24,

312n6, 332n22; World War I, 105, 307n24. *See also* Benjamin, Walter—hashish experience
Benjamin, Walter—fascism, 82, 88, 91–92, 97, 98–99; aura, 85, 117; and collective laughter, 99, 165, 166, 168, 181–82; experience, 173; innervation, 132, 146, 161–62; "mass ornament" and, 52, 98; Mickey Mouse, 165, 166, 168, 181–82; mimetic faculty, 147; play, 188, 189; Popular Front vs., 77; self-alienation, 82; war, 188
Benjamin, Walter—film, xviii, 20, 76, 78–79, 85–87, 93, 132–33, 175–76; Americanism, 153; animation and live-action, 175, 329n78; antinomies, 82–83; *Battleship Potemkin* defense, 16, 159–60, 311n65, 314–15n25; body, 142–44, 176, 177–78; Chaplin, 78, 99, 129–30, 151, 161, 178, 182, 193, 223, 299n41, 311n71; Disney, 160, 163–83, 193, 201, 329n78, 332n10, 332n17; distraction, 101–2; French films, 16, 68; historic role, 79, 132, 191, 203–4; imaginary city, 200, 202; innervation, 88, 113, 117, 129–30, 131, 132–33, 141–42, 160–61; kinesthetic dimension, 101; Klages, 126–27; "most intrinsic project of," 159; "On the Present Situation of Russian Film" (1927), 309n43; optical unconscious, 156–59, 200; play, 139, 142–43, 182, 183, 192–203; and psychoanalysis, 164–65; repetition, 195; shock, 169; slapstick comedy, 47–49, 182, 193; sports and, 198. *See also* Benjamin, Walter—aesthetic theory; Benjamin, Walter—Mickey Mouse
Benjamin, Walter—Fourier, 325n34, 326n39; "cracking open the teleology of nature," 171, 176–79, 326n41; and Scheerbart, 333n23; technology, 78, 134, 171, 178, 181, 192
Benjamin, Walter—Freud: aura, 314n19; *Beyond the Pleasure Principle*, 136, 184, 187, 194, 336n14; forgetting and remembering, 111; innervation, 134, 135–37; optical unconscious, 156–57, 201; repetition, 184; repression, 64, 145; traumatic shock, 336n14
Benjamin, Walter—hashish experience, 310n59; aura, 104, 106, 116, 119–20, 128, 312n5; dreaming, 29; "Hashish in Marseilles" (1932), 94; mimesis, 102; similitude, 94, 310n57
Benjamin, Walter—history, 76, 194–95; backward-flying Angel of History, 36, 161; historic role of film, 79, 132, 191, 203–4; *Jetztzeit* (time of the Now), 75, 76–77,

cultural politics, 77, 82, 87. *See also* Soviet
films
Speer, Albert, 70
Spengler, Oswald, 56, 122
Speyer, Jaap, *Der Frauenkönig* (1923), 9
Spiel: meanings, 183–86. *See also* play
Spiel-Raum ("room-for-play"), xvii–xviii, 19–20,
143, 182, 183, 189–95, 338n32
sports, 188, 189, 196–99, 338n25, 339n40
Stam, Mart, 152
Steiner, Rudolf, 16, 118, 119, 120, 127, 130, 349n102
Stockhausen, Karlheinz, 219, 243, 244, 245
Stoessel, Marleen, 111
Stone, Sasha, 134
Straub, Jean-Marie, 239; *Fortini/Cani* (1976) and
Too Early, Too Late (1982), 231
Stravinsky, Igor, 242, 243, 348n93; *Three Poems
from the Japanese,* 245
Sturges, Preston, *Sullivan's Travels* (1942), 168
Süddeutsche Zeitung, x
surface, Kracauer, 4, 5, 25–26, 42–43
surrealism: Adorno and, 222; cinema's
"primitive" heritage, 87; film aesthetics and,
346n67; kitsch, 93, 329n76; Kracauer and,
23, 24, 36, 68, 291n80. *See also* Benjamin,
Walter—surrealism/surrealism essay
(1929)

Tanizaki Jun'ichiro, 235, 347n67
Tashlin, Frank, 175
Tati, Jacques, 194; *Playtime,* 240
Taut, Bruno, 333n23
Taylorism: Benjamin and, 81; Disney, 167, 331n6;
Kracauer and, 40–46, 49–50, 66, 120
technology, 163–64; Adorno and, 210–24,
229–31, 236, 342n15; animation and live-
action, 175; Bloch and, 66; Kracauer and, 40,
41–42, 45, 49, 66–67, 326n38; Mickey Mouse
and, 179–80; supernatural phenomena
transmitted by, 314n20; and technique,
210–24, 342n15. *See also* apparatus;
Benjamin, Walter—technology; cinema;
digital technology; film
television, 338n28; Adorno on, xvii, 209, 226,
227; *Antithèse,* 246, 248; Kracauer and, 279;
NBC miniseries *Holocaust,* xi
Telos journal, xv
temporality: Adorno and, 237–41, 243–48;
Benjamin, 82, 113, 314nn19,20, 325n34,
326n40, 336n11; photography, 33. *See also*
time

Tendenzkunst, 38
Theory of Film. See Kracauer, Siegfried—*Theory
of Film*
theosophy, Benjamin vs., 104, 105, 118–20, 130
Thérèse Raquin (Jacques Feyder, 1928), 16
Tiller Girls, 297n20; Kracauer and, 45, 46, 49,
50, 293n93, 299n45
time: music, 239–41; "time-image," 239. *See also*
modernity; temporality
Tönnies, Ferdinand, 285n10
tourism, Kracauer on, 19
Toynbee, Arnold J., 273
trace, 312n6; forgotten, 110; logic of the trace,
107, 157, 170, 279
travelogues, 15, 231, 345n57
Trenker, Luis, 15
Tretyakov, Sergei, xii, 192, 309n41, 324n22
tselem, kabbalistic, 105, 127–28, 131, 321n90
Tudor, Andrew, 254
Tzara, Tristan, 134

Uexküll, Jakob von, 154
Ullstein, Hermann, 29
Ulm, film academies, x
United States: Adorno, 28, 209; African
American culture, 167; Critical Theory
writers, xi; film instruction/archiving/
research, x; Kracauer's escape to, 258.
See also Americanism; Hollywood
University of Chicago, Ph.D.-granting
Committee for Cinema and Media Studies,
xvi
urban planning, 66–68. *See also* architecture
Urson, Frank, *Chicago,* 71
utopianism: Benjamin and, 78, 142–46, 178–79,
181, 182, 193, 198, 203, 207, 295, 310n61,
328n64, 333n23; cinema, 249; Fourier, 171,
178; Kracauer and, 24, 69–70, 260, 277;
music, 245

Valentino, Rudolph, xiii, xiv
Valéry, Paul, 109, 110, 212
Van Gogh, Vincent, 120, 317n49
Vertov, Dziga, xii, 242; Adorno and, 222, 235;
Benjamin and, 87, 96, 200, 202, 309n43;
"cinema's Trotsky," 87; Kracauer and, 68,
87, 293n101, 303–4n104, 309n43; *Man with
a Movie Camera* (1929), 87, 293n101, 303–
4n104, 309n43; *The Soviet Sixth of the
Earth,* 309n43; *Three Songs of Lenin*
(1934), 87, 96

Viennese School, 92; Second, 209, 241
Vigo, Jean, 68, 200
Vogt, Oskar, 141
Vygotsky, L. S., 148

Wagner, Richard, 241
war: cosmic-mating fantasy, 144–45, 162, 181; play and, 187–88. *See also* World War I; World War II
Warburg, Aby, 320n74, 330n91
Warburg School, 320n74
Warner Brothers, 175, 332n10, 333n32
Warshow, Robert, 255, 258, 277, 351n9
Weber, Max, 6, 23, 43
Webern, Anton, 8, 241
Wedekind, Frank, 239
Weill, Kurt, 170
Weimar period, 20; actuality, 305n3; Amerika, 22, 40, 41, 49, 69, 71; Benjamin, 145–46, 149, 150, 162, 171; Eisler, 209; film theory, xv; *flâneur*, 10, 68, 109–10, 149, 150; Kisch, 301n74; *Kuhle Wampe* (Dudow), 209; Mickey Mouse and jazz, 167. *See also* Kracauer, Siegfried—Weimar period writings
Weisgerber, Leo, 148
Welles, Orson, 239; *Touch of Evil* (1958), 247
Wellmer, Albrecht, 345n55, 346n64
Wenders, Wim, xii, 350n6
Werfel, Franz, 88, 343n28

Whale, James, *Frankenstein* (1931), 66
Wickhoff, Franz, 92
Wilde, Oscar, 65
Witte, Karsten, x, xi, xii–xiii, 281n2, 283n1
Wohlfarth, Irving, 80, 90, 122, 145
Wolfskehl, Karl: Benjamin and, 120, 121, 318–19nn62,63, 338n26; "Lebensluft" (1929), 121; "Spielraum" (1929), 338n32
Wollen, Peter, 174
women: cinema, xiii–xiv; employee culture, 59, 302n78. *See also* feminism; Kracauer, Siegfried—girl cult
workers. *See* labor
World War I: Benjamin, 79, 105, 143, 144, 162, 170, 171–72, 307n24; Kracauer, 7, 31, 56
World War II: Adorno return to Germany after, 209; Eisenstein, 174. *See also* Auschwitz; Nazis/National Socialism
Das Wort, 87, 309n44
writing: Adorno and, 52, 210, 224–29, 236–37, 238; Benjamin and, 148, 151–52, 226; graphology, 121, 149, 315n31, 318n56, 327n58; hieroglyphic, 52, 224–29, 238, 344n47

Young German Cinema, 210, 218

Die Zeit, x
Zeitschrift für Sozialforschung, 77
Zelnick, Friedrich, *Die Männer der Sybill*, 9

WEIMAR AND NOW: GERMAN CULTURAL CRITICISM
Edward Dimendberg, Martin Jay, and Anton Kaes, General Editors

1. *Heritage of Our Times,* by Ernst Bloch

2. *The Nietzsche Legacy in Germany, 1890–1990,* by Steven E. Aschheim

3. *The Weimar Republic Sourcebook,* edited by Anton Kaes, Martin Jay, and Edward Dimendberg

4. *Batteries of Life: On the History of Things and Their Perception in Modernity,* by Christoph Asendorf

5. *Profane Illumination: Walter Benjamin and the Paris of Surrealist Revolution,* by Margaret Cohen

6. *Hollywood in Berlin: American Cinema and Weimar Germany,* by Thomas J. Saunders

7. *Walter Benjamin: An Aesthetic of Redemption,* by Richard Wolin

8. *The New Typography,* by Jan Tschichold, translated by Ruari McLean

9. *The Rule of Law under Siege: Selected Essays of Franz L. Neumann and Otto Kirchheimer,* edited by William E. Scheuerman

10. *The Dialectical Imagination: A History of the Frankfurt School and the Institute of Social Research, 1923–1950,* by Martin Jay

11. *Women in the Metropolis: Gender and Modernity in Weimar Culture,* edited by Katharina von Ankum

12. *Letters of Heinrich and Thomas Mann, 1900–1949,* edited by Hans Wysling, translated by Don Reneau

13. *Empire of Ecstasy: Nudity and Movement in German Body Culture, 1910–1935,* by Karl Toepfer

14. *In the Shadow of Catastrophe: German Intellectuals between Apocalypse and Enlightenment,* by Anson Rabinbach

15. *Walter Benjamin's Other History: Of Stones, Animals, Human Beings, and Angels,* by Beatrice Hanssen

16. *Exiled in Paradise: German Refugee Artists and Intellectuals in America from the 1930s to the Present,* by Anthony Heilbut

17. *Cool Conduct: The Culture of Distance in Weimar Germany,* by Helmut Lethen, translated by Don Reneau

18. *In a Cold Crater: Cultural and Intellectual Life in Berlin, 1945–1948,* by Wolfgang Schivelbusch, translated by Kelly Barry

19. *A Dubious Past: Ernst Jünger and the Politics of Literature after Nazism,* by Elliot Y. Neaman

20. *Beyond the Conceivable: Studies on Germany, Nazism, and the Holocaust,* by Dan Diner

21. *Prague Territories: National Conflict and Cultural Innovation in Franz Kafka's Fin de Siècle,* by Scott Spector

22. *Munich and Memory: Architecture, Monuments, and the Legacy of the Third Reich,* by Gavriel D. Rosenfeld

TEXT
10/12.5 Minion Pro

DISPLAY
Minion Pro

COMPOSITOR
Toppan Best-set Premedia Limited

INDEXER
Barbara Roos

PRINTER AND BINDER
Maple-Vail Book Manufacturing Group